A Dream of the Past

DREAM
OF THE PAST

Pre-Raphaelite and Aesthetic Movement

Paintings, Watercolours and Drawings

from the Lanigan Collection

UNIVERSITY OF TORONTO ART CENTRE

Notes to the reader on the catalogue:

Dimensions given are for height followed by width

Dimensions given are for exact sheet size, unless otherwise indicated

References refer to the Bibliography at the end of the catalogue.

CANADIAN CATALOGUING IN PUBLICATION DATA

Main entry under title:

A dream of the past : Pre-Raphaelite and aesthetic movement paintings, watercolours, and drawings from the Lanigan Collection

Catalogue of an exhibition held at the University of Toronto Art Centre, Apr. 8 - Sept. 22, 2000.

Includes bibliographical references.

ISBN 0-7727-0646-8

1. Pre-Raphaelitism – England – Exhibitions. 2. Art, English – Exhibitions. 3. Art, Modern – 19th century – England – Exhibitions. 4. Lanigan, Dennis T. – Art collections – Exhibitions. I. University of Toronto. Art Centre. II. Title: Lanigan Collection.

N6767.5.P7D72 2000 759.2'09034'074713541 C00-930944-6

The Univeristy of Toronto Art Centre wishes particularly to thank the Abraham and Malka Green Foundation and the 'Friends' of the Art Centre for their generous support, which made the publication of this catalogue possible.

Contents

Acknowledgements

I would like to thank David and Sheila Latham who first suggested the idea of this exhibition to the University of Toronto Art Centre, and Liz Wylie, the curator, who supported the idea from the very beginning. David Silcox, the director of the University of Toronto Art Centre, gave his enthusiastic support, without which this project would never have been carried to completion. Many times over the past three years I felt this exhibition would never come to fruition, but it was David who was confident we could do it from the start of his involvement and who kept it moving along to a successful conclusion.

The following individuals and their associated galleries/institutions, who contributed to the success of this catalogue by answering my many inquiries for information and advice, thereby furthering my research, have earned my profound thanks: John Abbott, Sue Ashworth, Philip Athill, Jim and Cathy Baker, Dr. Mary Ann Beavis, J. Bennett, Sandy Berger, Dr. Judith Bronkhurst, Simona Brusa, Jon Catleugh, Dr. John Christian, Peter Cormack, Natalie Duff, Simon Edsor, Betty Elzea, Douglas Franklin, the late Dr. W.E. Fredeman, Dr. Catherine Gordon, Bennie Gray, Susan Grayer, Richard Green, Dr. Dennis Hadley, Fiona Halpin, Julian Hartnoll, Dr. Anthony Hobson, Martin Hopkinson, Ian Hoy, Alison Inglis, Richard Jefferies, Joanna Karlgaard, Mark Samuels Lasner, Dr. Katharine A. Lochnan, Kenneth A. Lohf, the late Jeremy Maas, Rupert Maas, Dr. Dianne S. Macleod, Dr. Margaret F. MacDonald, Neil MacMillan, Dr. Debra Mancoff, Dr. Jan Marsh, John Morris, Peter Nahum, Charles Nugent, Judy Oberhausen, Simon Reynolds, Dr. Christopher Ridgway, Leonard Roberts, Peyton Skipwith, Dr. Lindsay Stainton, Dr. Vern G. Swanson, Hiliary Underwood, Malcolm Warner, Bill Waters, Stephen Wildman, and Eriko Yamaguchi. I would also like to thank the staffs of the Witt and Conway Libraries, Courtauld Institute of Art, the National Art Library at the Victoria and Albert Museum, and Christie's archives, London, where I carried out much of my research into provenance.

Dr. Susan Casteras and Liz Wylie read my manuscript and offered valuable suggestions. Dr. Douglas Schoenherr, in particular, has helped me at every point of this project. Not only did he write a wonderful introduction, but his skilful editing of my catalogue entries has made me appear better than I deserve. Much of the credit for the success of the catalogue and exhibition belongs to him. The catalogue has been carried to a wonderful conclusion through the efforts of Grant Kernan, photographer, and Stan Bevington of Coach House Press, who with his team created a fine and legible design out of a vast amount of information. Stan's use of William Morris's Golden Type is especially pleasing to me.

Two individuals have acted as my principal art agents in London since I started collecting – the late Daniel Perrin, and Rachel Moss. I have benefited enormously, not only from their advice, but also from their friendships. Rachel Moss, in particular, was a major help in preparing for this exhibition. Not only was she good enough to welcome me into her home, but allowed me access to her own library where much valuable research was conducted.

Finally I would like to thank my wife Sharon and my son Liam for their understanding and for putting up with my not being available to do as many things as a family. I dedicate this catalogue to them.

Dennis T. Lanigan

Preface

This catalogue and exhibition signal a new phase in the Art Centre's role within the University: our newly-expanded facilities can accommodate changing exhibitions that bring to our students and our larger community the works of imagination of distant societies and times, as well as reflecting our own. The Art Centre will thus become a major resource that enriches the academic purposes of the University, even as it provides pleasure for all.

We are pleased to be able to show Dr. Lanigan's remarkable collection in the company of complementary works from other collectors of the Pre-Raphaelites and from some public institutions. The strong emphasis on drawings and preparatory works in his collection is one that I personally find attractive, because drawings always come closest to the initial germ of an artist's thought. For students especially, drawings are a key point of entry into the mind behind the expression. Even more are we at the Art Centre pleased to publish this informative catalogue in celebration of our expansion and as a welcome to the International William Morris Symposium, which is being sponsored by the William Morris Society of Canada in Toronto in June.

The catalogue in your hands would not have materialized without the generous assistance of the Abraham and Malka Green Foundation and of the Friends of the Art Centre; nor without the meticulous labours of Dr Lanigan himself, the fine editing of the catalogue and the introduction by Dr Douglas Schoenherr, the editorial astuteness of our curator Liz Wylie, and the imaginative layout and design by Stan Bevington at Coach House Printing. Heidi Overhill designed the exhibition with her usual enthusiasm and skill. On behalf of the Board of Trustees, I thank them all for a superb achievement.

For the supplementary works loaned to the exhibition, but not included in the catalogue, I would like to thank R. Fraser Elliott, Sheila and David Latham, John Morris, Joan Randall, Mary Williamson, the National Gallery of Canada, the Art Gallery of Ontario, and the Royal Ontario Museum. In addition, Dr Lanigan loaned us some additional works, which are not catalogued, and some books and illustrations that add a further dimension to the exhibition. Dr. Katherine Lochnan, curator at the Art Gallery of Ontario, was most helpful with her advice and support.

Finally, I would like to thank the members of the Board of the Art Centre and those few intrepid individuals (at the Delta Gamma fraternity in particular) who, a few years ago, had the vision and the determination to create the Art Centre. The University of Toronto has long needed a central place in which to keep its valuable collections and in which to show works of art that demonstrate the achievements of artists of different times and places. If the Art Centre develops as it should over the years ahead, then it will repay the debt to those who saw to its birth and guided its initial steps.

David P. Silcox, Director

From the Pre-Raphaelites to the Last Romantics:
An Introduction to the Lanigan Collection

Douglas E. Schoenherr

The year 1848 was one of revolutions throughout Europe. In February the French forced Louis-Philippe to abdicate and established the Second Republic, triggering a whole series of related events. Within the Austrian Empire there were revolts by the Viennese, Czechs and Hungarians, while in Italy rebellions occurred in Lombardy, Venice, Piedmont, Sicily and the Papal States. Across the German Confederation there were many uprisings for constitutional reform and a national parliament.[1] Although the last Chartist demonstration took place in London and there were the perennial anti-English hostilities in Ireland, Britain's main revolution of the year was cultural rather than political. Three brilliant young art students, two of whom had joined in the Chartist procession, decided to start their own parade called Pre-Raphaelitism, a revolutionary artistic movement that transformed Victorian art and had repercussions well into the 20th century.[2]

In 1840, at the tender age of eleven, the child prodigy John Everett Millais entered the Royal Academy Schools as their youngest-ever pupil, going on to win prizes for his precocious talents as a draughtsman and painter. Four years later he was joined by William Holman Hunt, the most conscientious and doggedly persevering of the group, who almost immediately formed a deep bond with him. That same year the charismatic and bohemian Dante Gabriel Rossetti also enrolled as a probationer, although he did not come into close contact with the other two for four more years. After reading the first two volumes of John Ruskin's *Modern Painters* (1843 and 1846), where he was impressed by the critic's doctrine of "truth to nature," and discovering Keats, whose poetry was then by no means universally known, Hunt embarked on a major painting for the 1848 Royal Academy exhibition. This marked a new departure in his work. Based on Keats' "The Eve of St. Agnes", Hunt's picture, *The Flight of Madeline and Porphyro during the Drunkenness Attending the Revelry* (Guildhall Art Gallery, Corporation of London), was skied – hung near the ceiling – in the Architectural Room. Although not at all in the best spot, it was in sufficiently good light that it was admired at a preview by Rossetti, who declared it the best work in the show. The triumvirate of like-minded young artists was now complete.

Following traditional practice, Hunt had prepared his picture with a series of drawings for the overall composition and individual figures, all in a bold outline style influenced by line-engravings by the German Friedrich August Moritz Retzsch. Hunt's compositional study, very close to the finished painting, is one of the great treasures of the Lanigan Collection and a rare document from the very birth of the Pre-Raphaelite Brotherhood (cat. no. 34). The striking figure of the drunken porter, sprawled on the floor, is reminiscent of similarly foreshortened figures in Uccello and Mantegna. The figure was actually inspired by a book illustration by Frederick Richard Pickersgill,[3] then an associate of the Royal Academy, whose Etty-like pictures in the grand manner of Titian represented the moribund tradition against which the

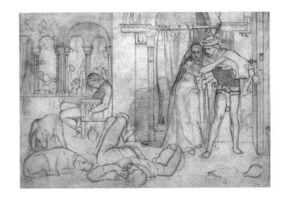

Pre-Raphaelites rebelled. Pickersgill's Germanic illustrations, however, were obviously admired and studied carefully by them. Given his connection with Hunt's picture, it is interesting to discover that the Lanigan Collection contains a Pickersgill drawing, probably from the same decade of the 1840s, in a strong outline style that betrays its ultimate source in the engravings of John Flaxman (not in catalogue).

Rossetti soon introduced his two new friends to Ford Madox Brown, never an official member of the group, but an important elder mentor, who was to be influenced himself by the bright colour and minute detail of the high Pre-Raphaelite style. Having studied on the continent, Brown brought to the movement a knowledge of contemporary European art, especially the Nazarenes in Rome, who shared some of the same goals as the PRB. One of Brown's early

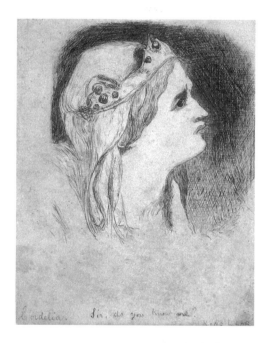

drawings from the 1840s is in the Lanigan Collection (cat. no. 5), a study for a projected *King Lear* painting, Shakespeare being another god in the Pre-Raphaelite literary pantheon.

After deep and passionate discussions that revealed their common ambitions, Millais, Hunt and Rossetti founded the Pre-Raphaelite Brotherhood around September 1848. Also invited to join were two other painters, James Collinson and Frederic George Stephens, the sculptor Thomas Woolner, and a non-artist secretary, William Michael Rossetti, Gabriel's brother, to bring the number up to seven – another Group of Seven! Deploring the degenerate tradition of soul-less, formulaic art they felt that Raphael and his School had spawned – Raphael was then considered the highest perfection of Western European painting – the young artists favoured the honesty, sincerity and truth of art before Raphael, hence the name "Pre-Raphaelite". It must be admitted, however, that at this point they had hardly seen one authentic example of a real 14th- or 15th-century painting, beyond Van Eyck's *Arnolfini Marriage* in the National Gallery, but had only studied reproductions of them in print form. The concept of a secret Brotherhood was apparently the suggestion of Rossetti, a bit of a lark to tweak "Establishment" noses.

In 1849 the first pictures to bear the secret PRB initials were publically exhibited, including Millais' *Isabella* (Walker Art Gallery, Liverpool), again based on Keats. A fascinating contemporary watercolour of the same subject, but of uncertain attribution, is included in the exhibition (cat. no. 46). At first critics were generally favourable to the PRB, but the mood turned ugly the following year when they savaged Millais' *Christ in the House of His Parents* (Tate Gallery, London) for his painfully realistic, unidealized handling of the Holy Family, which many, including Dickens, found revolting and blasphemous. Since the meaning of the initials PRB had been discovered at a time of fierce anti-Catholic sentiments, many people smelled a Papal rat, or at least an Anglo-Catholic (Tractarian) one, behind these strange archaic pictures. When their work was attacked again in 1851, the leading art critic of the day, John Ruskin, came to their defense, just as he had to Turner's a decade before. In his two celebrated letters to *The Times* and in a follow-up pamphlet, he declared that the Brotherhood

was following his great principle of "truth to nature". With his deep interest in contemporary German art and a pioneering appreciation of the so-called Italian Primitives, it is not surprising that Prince Albert was also sympathetic to the cause, though it must be recorded with disappointment that no major Pre-Raphaelite works were ever acquired for the Royal Collection.

The success of the movement and the dissolution of the PRB were almost simultaneous. Millais' *A Huguenot* (Makins Collection) in the 1852 Royal Academy exhibition was universally praised, propelling the young artist into one of the most popular of the Victorian age and perhaps turning his head. He was soon to renounce his PRB principles to paint sentimental and fashionable pictures in a broad style based on Hals and Velázquez. This earned him great financial rewards and finally the presidency of the Royal Academy, the very institution that as a young artist he had rebelled against. Despite recent and honourable attempts to rehabilitate Millais' later work, which is not without interest and has been unjustly neglected, his career remains the saddest disappointment in 19th-century British art.[4] Already in May 1850 Collinson had resigned from the Brotherhood, and two years later Woolner emigrated, at least temporarily, to Australia. Stephens had given up painting to begin a distinguished career as an art critic. Since the latter's works in any medium are extremely rare, the watercolour portrait in the Lanigan Collection is notable (cat. no. 84). By 1854 Hunt was in Palestine pursuing ethnographic and historical authenticity for his biblical pictures. He was the only member of the group who remained true to his Pre-Raphaelite ideals to the end of his life. Rossetti renounced public exhibitions, abandoning oil painting for watercolour and drawing. He was soon to become the centre of the second generation of Pre-Raphaelites and embark on a new course.

Since the Pre-Raphaelites used members of their own circle or families as models for their pictures, often casting against canonical type to give their works a shocking contemporary resonance, they were always on the lookout for new sitters, especially unconventionally beautiful women, whom Rossetti dubbed "stunners." Introduced into their orbit through the Deverell family, for whom she worked as a dressmaker,[5] the flamed-haired Elizabeth Siddal, known as Lizzie or "the Sid," was already an aspiring artist when she began sitting for many of the group. As Rossetti's muse, mistress and finally wife, she blossomed into a considerable artist in her own right, receiving warm encouragement from Ruskin and Madox Brown. Since her complete oeuvre amounts to fewer than sixty works, almost entirely drawings and watercolours, the design of angels in the Lanigan Collection (cat. no. 76) is a particularly poignant and precious relic of one of the great Pre-Raphaelite icons, whose haunting face gazes out from so many works and whose life and then death from an overdose of laudanum have become the very stuff of popular legend.

Although the Brotherhood itself was dispersed, Pre-Raphaelite painting was flourishing, gaining more and more adherents each year. Two of the earliest converts were the tragically short-lived Walter Deverell and Charles Allston Collins, brother of the 'sensation' novelist Wilkie Collins. Charles Collins was himself later to adandon painting for writing. Soon the ranks were further swelled with a host of gifted artists: the figure painters Arthur Hughes, William Shakespeare Burton and Henry Wallis, the sculptor Alexander Munro, and the landscapists John William Inchbold, John Brett and Thomas Seddon, who all contributed important works to the movement. Obviously the radical ideas of the original rebels were enthusiastically embraced by a large number of sympathetic young disciples. So persuasive were the new ideas, in fact, that even major, established artists like William Dyce changed their style to produce masterpieces in the new idiom. *The Germ*, as the PRB had named its prophetic magazine, had found fertile ground.

DOUGLAS E. SCHOENHERR 11

Although Pre-Raphaelitism was centred for the most part in London, there were pockets of loyal support in the provinces, most notably in Liverpool. There the artists William Lindsay Windus and William Davis found patronage from a local collector, John Miller, who was also among the first to buy major pictures from the London group. So committed was Liverpool to the cause that its Academy awarded the annual prize of £50 to a Pre-Raphaelite picture no less than six times during the crucial 1851-58 period. Provincial museums, including Liverpool's, often therefore have rich collections of such work, the reward for their early championship of the movement. Windus' two most important paintings are now considered minor classics: *Burd Helen* (1855-56, Walker Art Gallery, Liverpool) and *Too Late* (1857-58, Tate Gallery, London), one of the famous Pre-Raphaelite modern-life subjects with a strong moral message. The preparatory oil sketch for *Too Late*, a little gem which originally belonged to Miller, is one of the highlights of the exhibition (cat. no. 100).

The members of the Brotherhood continued to work and exhibit together, even though it had been officially disbanded. In 1857 Brown organized a Pre-Raphaelite exhibiton in rented

rooms in Russell Place, to which the three founding figures, as well as some twenty friends and followers, contributed. The following year Rossetti and Brown launched the Hogarth Club, named after the revered founder of the modern English School, as an exhibition society and social centre independent of the Royal Academy. All of the original members of the PRB joined, except Millais and Collinson. John Miller, who was one of the non-artist members, lent the Lanigan oil sketch for *Too Late* to its very first exhibition.

Hunt, Millais and Rossetti also appeared together publically as illustrators to *Poems by Alfred Tennyson*, published by Edward Moxon in 1857.[6] With their strong literary orientation, the Pre-Raphaelites were seriously interested in book illustration from an early date. An original etching had been included in each issue of *The Germ* in 1850. In the Moxon Tennyson the Pre-Raphaelites took on their older academic colleagues – Thomas Creswick, John Callcott Horsley, Daniel Maclise, Clarkson Stanfield and William Mulready had also been asked to contribute – winning this one-on-one competition hands down. Because of the two divergent approaches, the book as a whole has an odd, schizophrenic character. Millais contributed eighteen blocks, Hunt seven and Rossetti five, which were cut by a team of wood-engravers, including the famous Dalziel (pronounced "Dee-ell") Brothers. All of Rossetti's illustrations are marvels of inventive design, especially the alarming *St. Cecilia*, who is receiving a vampire kiss from her guardian angel. Hunt's are generally less successful, although his *Lady of Shalott* is justly one of the most famous of Victorian images. The Lanigan Collection boasts no fewer than two of Hunt's preliminary sketches for "Recollections of the Arabian Nights", a poem he specifically selected because it appealed to his interest in Near Eastern exoticism (cat. no. 35). Millais was perhaps the most naturally gifted illustrator of the three, going on to create a considerable body of work during the Golden Age of wood-engraved book illustration in the 1860s. One of his masterpieces for the Moxon Tennyson, his tiny but monumental embracing

lovers to illustrate "Locksley Hall", is an outstanding feature of the exhibition (cat. no. 48). Executed in the same year (1857) and demonstrating bravura pen-work worthy of Rossetti, John Brett's little-known illustration to Elizabeth Barrett Browning's "Aurora Leigh" must be considered one of the greatest Pre-Raphaelite drawings to appear on the market in recent years (cat. no. 4). Recognized above all as a landscapist in the Ruskinian tradition of minute transcriptions of nature, Brett's figure and portrait drawings are only slowly coming to light as they emerge from the artist's descendants.[7]

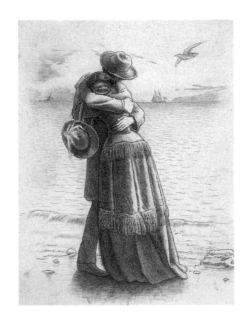

While the original triumvirate was re-established for the Moxon Tennyson collaboration, that same year Rossetti assembled a team of enthusiastic young artists to paint murals in the Oxford Union's new building, thus inaugurating a new phase of Pre-Raphaelitism. Foremost among the wide-eyed recruits for the "jovial campaign" were William Morris and Edward Burne-Jones, who had met as undergraduates at Oxford and had recently decided to dedicate their lives to art, being then very much under the sway of Rossetti. The other participants were Arthur Hughes, Val Prinsep, John Roddam Spencer Stanhope and John Hungerford Pollen. (Alexander Munro contributed a sculpted tympanum.) With plenty of larks and pranks along the way, the group undertook to execute episodes from Malory's *Morte d' Arthur* on the bays between the windows in a bright two-dimensional style that was consistent with Rossetti's contemporary watercolours on medieval and chivalric themes. Inspired by his work on these Arthurian murals, Hughes began in the early 1860s several easel paintings on related subjects, most notably *The Knight of the Sun*, but also a Sir Galahad composition. A preliminary drawing for the latter is included in the Lanigan Collection (cat. no. 31). Works by other members of the group include a later study by Prinsep (cat. no. 65) and a very important early watercolour by Stanhope (cat. no. 83). Having received his first training with George Frederic Watts at Little Holland House, where Thoby and Sara Prinsep, parents of Val, held court to a literary and artistic set, Stanhope had laboured side by side with Burne-Jones on the Oxford Union murals, developing a close friendship with him. In the early 1860s they produced major watercolours together. While Burne-Jones was painting *The Annunciation (The Flower of God)* (Lord Lloyd-Webber Collection), Stanhope was executing the first version of one of his most famous works, *The Wine Press* (cat. no. 83). In their religious pictures, the Pre-Raphaelites were anxious to develop new and unorthodox Protestant images that broke from the mainly Catholic iconographic tradition stemming from the Counter Reformation. As a new archetypal image of Christ, conceived as an elaborate allegory, Stanhope's *The Wine Press* has been compared to Hunt's *The Light of the World* (Keble College, Oxford).

During the Oxford campaign another "stunner" was discovered in the person of Jane Burden, the daughter of an ostler, who with her long neck, sensuous lips, and cascades of wavy black hair became Rossetti's second muse and the other great icon of Pre-Raphaelite beauty. After her marriage to William Morris in 1859, the young couple moved the next year into their new home, the celebrated Red House, which Philip Webb had designed for them in

an apple orchard in Bexley Heath, Kent. Just as Morris' and Burne-Jones' bachelor digs at Red Lion Square had earlier provided a welcome opportunity for do-it-yourself decoration, now Red House became a positive laboratory for design experiments by all their friends. Embroideries were begun for the bedroom and dining room and during the summer and autumn of 1860, Burne-Jones undertook a series of wall paintings in the drawing room that must have seemed a reprise of the Oxford murals, but on a smaller, domestic scale. On either side of the great built-in settle, on the doors of which Rossetti had painted his *Salutation of Beatrice* (now in the National Gallery of Canada, Ottawa), Burne-Jones executed scenes from the English medieval romance, *Sire Degrevaunt*, a favourite Arthurian story of his and Morris' that they would later reprint at the Kelmscott Press, at the end of their life-long artistic partnership. For the culminating episode, the wedding feast of Sir Degrevaunt and his bride Melidor, the artist cast the newly-wed Morris and Janey in the principal roles, making a number of preliminary drawings, one of which, a watercolour study of a serving wench and a reading figure, is in the Lanigan Collection (cat. no. 8). The naive charm of this beautiful

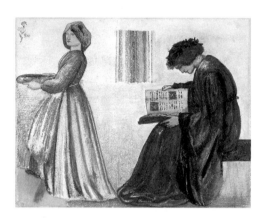

work wafts us back to the idyllic early days of life in that Kentish orchard.

Out of this burst of decorating activity at Red House was born the idea of Morris, Marshall, Faulkner and Co. in 1861. Of the original Pre-Raphaelite group, Rossetti and Madox Brown had shown a pronounced interest in furniture and stained-glass design, so they were understandably recruited as partners in the new company. Other partners included Philip Webb and Burne-Jones. The latter, even as a very young artist, had shown a remarkable talent for stained glass, becoming the principal designer of the firm after its reorganization as Morris and Co. in 1875. Although the firm would become famous for its fine hand-made wallpapers and textiles, which revolutionized British taste, at first their reputation was established with stained glass. Initially this was often commissioned by the Gothic Revival architect, George Frederick Bodley, for his new churches. One of the first was All Saints, Selsley, Gloucestershire, which is a veritable jewel-box full of early Morris glass. For the western rose window, which depicted the Creation, Webb designed three lobes, the cartoons for two of which are in the Lanigan Collection (cat. nos. 96 and 97). The descending dove in *The Spirit of God on the Waters* and *The Birds and Fishes* are typical of Webb's designs, since he specialized particularly in animal subjects. Among the other stained-glass designers in the firm, both Brown and Burne-Jones are well represented in the Lanigan Collection. Brown's cartoon for *The Sacrifice of Zacharias* (cat. no. 6) is a characteristic example in grey and black wash, with his customary warning: "This cartoon is the property of the artist F. Madox Brown, copyright for stained glass only granted to Morris & Co." Usually the cartoons became the property of the firm, entering their portfolios for reuse in other windows, but Brown, who was a difficult and irascible man, insisted on retaining ownership of his. Burne-Jones' marvellous cartoons for stained glass, however, invariably became the property of the firm, unless he decided to turn the odd one into an independent work of art. This was the case with the Lanigan *The Raising of Lazarus* (cat. no. 17), a typical linear extravaganza, which the artist had returned to him to colour in pastel.

A statistical analysis of the Lanigan Collection is highly revealing: of the seven decades

covered, from the 1840s to the 1900s, works from the 1860s constitute by far the largest group, forming over a third of the whole. If one also includes works from the late 1850s and early 1870s, this preponderance becomes even more obvious. The concentration on the 1860s period is indeed no coincidence, for the collector's heart corresponds to the heart of his collection. The 1860s are, in fact, difficult years to define precisely, when British art was in transition, but when various apparently contradictory currents – the second phase of Pre-Raphaelitism, Aesthetic Classicism and Academic Classicism – all came close together in their goals, prefiguring in a fascinating way the Aesthetic Movement of the 1870s and 1880s. The hard-edged Pre-Raphaelite transcriptions of nature had given way to a softer, more painterly and more imaginative approach. As dominant influences, the ascetic linear art before Raphael was rejected in favour of the sensuality, rich colour and painterliness of Giorgione, Titian and the 16th-century Venetian School. Moralizing narratives were replaced by almost subjectless themes, with emphasis on mood, colour harmonies and formal values, although the use of symbol and allegory continued. Above all there was a pervading interest in the connections between music and painting ("correspondences"), not only in the pictorial depiction of music-making, but in the new equation of painting as music. The second phase of Pre-Raphaelitism centred in the beginning on Rossetti and the young disciples in his orbit, such as Burne-Jones, Simeon Solomon and Frederick Sandys, but Burne-Jones and Solomon also came very close for a time to the Aesthetic Classicism of Albert Moore and James McNeill Whistler, while Frederic Leighton, Edward John Poynter and Lawrence Alma-Tadema emerged as the leading Academic Classicists. The inimitable George Frederic Watts remained in a class of his own. All these artists are extremely well represented in the Lanigan Collection.

Although Rossetti had virtually ceased from exhibiting in public, he was, nonetheless, the undisputed leader of the most progressive painting of the time. After devoting himself almost exclusively to medievalizing watercolours, in 1859 he struck out with something completely new in *Bocca Baciata* ("The Kissed Mouth", Museum of Fine Arts, Boston), a small oil painting of a voluptuous Titianesque woman depicted half-length with cascading hair, revealing bodice, exotic jewelry and banks of flowers. Modelled by the artist's house-keeper-mistress Fanny Cornforth, the picture aspired to nothing more than an unabashed celebration of female beauty and an overt appeal to the senses. While the puritanical Holman Hunt, and no doubt many others, were appalled by its gross sensuality, the picture fascinated more than it repelled. It was, in fact, the Helen that launched a thousand imitations. Rossetti himself went on to mine the vein exhaustively, almost to the end of his life. Very much in this new mode was his 1864 watercolour *Morning Music* (Fitzwilliam Museum, Cambridge) for one of his most important patrons, William Graham, a compositional study for which is in the Lanigan Collection (cat. no. 69). Depicting a languorous woman having her hair dressed to the strains of a cithern, *Morning Music* epitomizes Rossetti's new aesthetic concerns in the 1860s, with its colour harmonies, evocation of indolent mood, hair-fetishism and musical accompaniment.

The Norwich artist Frederick Sandys (pronounced "Sands") was an intimate member of the Rossetti circle in the late 1860s, even living with him at Cheyne Walk for a time in 1866. Although Sandys executed a number of fine oil paintings with the minute detail and enamel finish of high Pre-Raphaelitism, he was chiefly a draughtsman, one of the greatest of his or any other age. His elaborate pen-and-ink masterpiece, *King Pelles' Daughter Bearing the Vessel of the Sanc Graal* of 1861, is an undoubted pinnacle of the Lanigan Collection (cat. no. 71). It combines the new sensual Rossettian female half-length formula of *Bocca Baciata* with a revived interest in mystic Arthurian subject matter, all rendered in pen and ink in a bravura

style. This virtuoso penwork had precedents in recent drawings by Rossetti and Burne-Jones, but ultimately goes back to the engravings of Albrecht Dürer, a major influence on Sandys' graphic work. A tour de force of intricate penmanship, this exquisite drawing is as highly wrought as the gold chalice the maiden holds. The composition is reminiscent of traditional treatments of Mary Magdalene with her ointment box, a subject which Sandys in fact borrowed from Rossetti, but which he transformed here into a completely new theme. As a gifted graphic artist, Sandys designed some of the most memorable wood-engraved magazine and book illustrations of the 1860s. The penultimate study for *Manoli*, published in *The Cornhill Magazine* in 1862, is also in the Lanigan Collection (cat. no. 72). The final version, with a few changes, had been drawn directly on the woodblock and therefore was destroyed as it was cut, although a photograph was taken to record what it looked like. Sandys had a decided taste for the macabre, which reached a sinister highpoint in *Manoli*. In a story worthy of Edgar Allan Poe, a husband bricks his frantically pleading wife into the construction of a tower to ensure its long-term preservation.

In the early 1860s Burne-Jones enjoyed a very close friendship with Simeon Solomon, a gifted young Jewish artist whom he had met through Rossetti around 1858 and whom he considered "the greatest artist of us all."[8] Very interested in Hebraic subjects because of his Jewish heritage, Solomon was an ideal candidate to produce designs for the famous *Dalziel Bible Gallery*, an illustrated Old Testament. The young artist produced twenty drawings on the woodblock in the early 1860s, although only six were published in 1881. These pen-and-ink designs, however, frequently became a source for finished watercolours or oil paintings, one of which is in the Lanigan Collection (cat. no. 78). The watercolour *In the Temple of Vesta* of 1862 is actually based on a biblical illustration entitled *Jewish Women Burning Incense – Jeremiah*, and this may have been the watercolour's original title as well. At this time Solomon

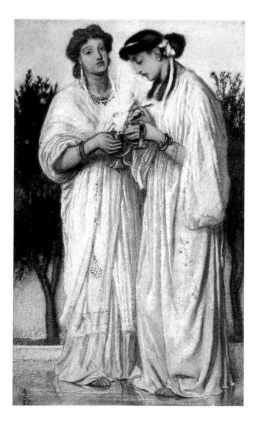

was moving away from his Hebraic subjects towards Aesthetic Classical ones, under the not always salutary influence of the poet Algernon Swinburne. We do not know who gave the Lanigan watercolour the title *In the Temple of Vesta*, or when, but an old label carries this inscription on the frame backing. It is extremely revealing, however, that two Old Testament upper-class, Jewish women have been treated in such a way that they could easily be converted, by the artist or someone else, into Roman priestesses in the temple of Vesta, a type of subject that Solomon later treated frequently. This watercolour can therefore be seen as a pivotal work in the artist's career, documenting the very moment when his Jewish subjects imperceptibly meshed with Aesthetic Classical ones. A moving testimony of Solomon's affection for Burne-Jones is his important drawing *Mors et Amor* ("Death and Love") which he gave to "his dear friend Ned" on his thirty-second birthday, August 30, 1865 (cat. no. 80). Although Solomon was ostracized by most of

his artist friends, including Rossetti, after he was convicted of a homosexual offense in 1873 – becoming a proto-martyr to Oscar Wilde in the gay pantheon – Burne-Jones remained steadfastly loyal to his fallen friend, retaining the latter's birthday present to the end of his life. As an allegory, *Mors et Amor* looks forward in an important way to Symbolist themes at the end of the century. Solomon was one of the major British exponents of this movement, who continued to produce such drawings and watercolours through the alcoholic haze of his later workhouse days (see cat. no. 82).

When Solomon attended the Royal Academy Schools as a student, he was one of a group of fellow artists that are well represented in the Lanigan Collection: Henry Holiday and William De Morgan, who were to become famous designers of stained glass and ceramics respectively, and the painters William Blake Richmond and Albert Moore, the latter being with Whistler a central figure in the development of the Aesthetic Movement. Perhaps inspired by one of the illustration projects like the *Dalziel Bible Gallery* that were underway at the time, Moore exhibited the large drawing *Elijah Running to Jezreel before Ahab's Chariot* (cat. no. 49) at the 1861 Royal Academy show. With its minute finish, angular figures and orientalist exoticism, this precociously elaborate exercise reveals Moore's debt to the earlier Pre-Raphaelite tradition, evoking especially the biblical subjects of Holman Hunt and Madox Brown. It is a mark of the collector's depth of interest in Moore that he prefaced his fine collection of more characteristic, mature drawings with this eccentric, yet compelling, early work. Moore began to find his true style on a visit to Rome in 1862-63, when he discovered classical sculpture, reinforcing this interest by a study of the Elgin Marbles at the British Museum on his return. Further inspiration came from Japanese art, to which he was introduced by Whistler, the two artists being very close at this time. By the mid 1860s Moore had synthesized his Greek and Japanese influences to produce the subjectless, decorative arrangements of classically draped figures in subtle colour harmonies that became the major preoccupation of his creative life. Like *The Four Seasons*, which he exhibited at the Royal Academy in 1864, the gem-like gouache *The Elements* in the Lanigan Collection (cat. no. 50) uses personification merely as a pretext for the orchestration of formal and chromatic counterpoints. Shown in 1866 at the Dudley Gallery, a hot-bed for the development of Aestheticism, *The Elements* proclaims the birth of "Art for Art's Sake" in Britain. Aside from groups of sitting or reclining figures, as seen in this gouache, Moore's other main compositional type was the single standing draped figure, represented by two examples in the Lanigan Collection. The first is the fine study for *A Garden* (cat. no. 51), one of his most distinguished early paintings (Tate Gallery, London), and the second, the marvellously fresh study for *A Reader* (cat. no. 53), a picture from his mature period (Manchester City Art Gallery).

When the Pre-Raphaelite Brotherhood was formed in 1848, Frederic Leighton was living in Brussels and Paris, having previously studied in Berlin, Frankfurt and Florence. After further studies in Frankfurt and Rome, he returned in the summer of 1855 to London, where his *Cimabue's Celebrated Madonna* was exhibited at the Royal Academy to great acclaim and was purchased by Queen Victoria. A pencil drawing in Leighton's early German style is in the Lanigan Collection (cat. no. 37), possibly a rejected study for his first masterpiece. He was soon back in Paris, only settling permanently in London towards the end of 1859. As a result of almost two decades of continental training, Leighton was something of a stylistic outsider in 19th-century British art, but paradoxically rose to the very top of the art establishment, becoming the distinguished president of the Royal Academy and the first artist ever raised to the peerage. Tackling, often on a grand scale, the great biblical and classical subjects that were considered the summit of academic history painting, he developed an Olympian Classicism that at times can be as glacial as it is splendid. During the mid 1860s,

however, his painting sometimes approached quite closely the Aesthetic Classicist concerns of such artists as Moore and Whistler. His oil sketch for *Greek Girl Dancing* of 1867 (cat. no. 40) is a case in point. On the left is the statuesque dancing girl, balanced on the right by a Moore-like group of seated figures, all thrown against a moonlit background of sea and sky. The composition aims more for rhythm and rhyme than any specific narrative. As a result of his rigorous academic training, Leighton was fastidious in preparing his paintings with many detailed studies. These included compositional sketches, drawings of the nude and draped figure in his distinctive black-and-white-chalk style on blue or more usually brown paper, as well as small delicious oil sketches, like the one for *Greek Girl Dancing*, to establish the general colour harmonies. He even sometimes made preparatory sculptures. Among several fine figure studies in the Lanigan Collection, the one for the head and arms of Iphigenia in *Cymon and Iphigenia* of 1883 (cat. no. 42) must be singled out as an outstanding example, showing a passionate response to the female figure that reached a climax in his most famous work, *Flaming June* (R.A. 1895, Museo de Arte, Ponce, Puerto Rico).

Another entirely foreign-trained artist, who settled in London only in 1870, Lawrence Alma-Tadema was in many ways the reverse of Leighton's classical coin. If Leighton was the Greek tragedian Aeschylus, assailing the big themes on a monumental scale, Alma-Tadema was the Roman sentimental comedian Terence, at his best in small genre scenes of ancient life that have been described as "Victorians in Togas".[9] Born in the Netherlands but trained at the Antwerp Academy, Alma-Tadema brought the same meticulous finish to his amazing renderings of marble and brass as the 17th-century Dutch masters who inspired him. Unlike Leighton, who left a mass of working drawings for his pictures, Alma-Tadema very seldom made preparatory studies, preferring to paint his figures directly onto the canvas or panel from fully costumed models. Oddly enough he sometimes made exquisite drawings of certain details in his finished pictures to record a painted passage that particularly pleased

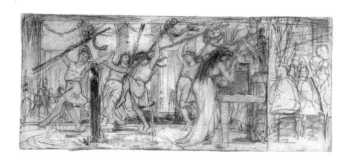

him. These drawings, which look like preparatory studies, were actually made after the completed painting, not before it.[10] A very rare compositional study on a large scale for one of Alma-Tadema's most important pictures, *The Vintage Festival*, is in the Lanigan Collection (cat. no. 1). Radically different from the finished picture of 1870 (Hamburger Kunsthalle, Hamburg), this roughly executed sketch depicts an almost Bacchic frenzy of dancers that was tamed in the final work into a much more sedate procession, like those in Leighton's *Syracusan Bride* (R.A. 1866, Private Collection) or *The Daphnephoria* (R.A. 1876, Lady Lever Art Gallery, Port Sunlight).

As we have seen, the Moxon Tennyson of 1857 inaugurated over a decade of distinguished book illustration that is well represented in the Lanigan Collection. In addition to the already mentioned drawing by Sandys for *Manoli*, there are original designs by Leighton, Bell Scott, Burne-Jones, Hughes and Madox Brown that encompass various illustration projects of the period, including etching and manuscript illumination. Those by Hughes and Brown, executed in the same year (1871), reveal that artists in the Pre-Raphaelite circle were still very committed to producing high-quality designs for wood-engraved illustrations. After painting some of the most memorable Pre-Raphaelite pictures of the 1850s, Arthur

Hughes began a successful career as a book illustrator, primarily for children's books by such authors as Thomas Hughes *(Tom Brown's School Days*, 1869), George Macdonald *(At the Back of the North Wind*, 1871) and Christina Rossetti *(Sing-Song*, 1872), two drawings for which are in the Lanigan Collection (cat. no. 32). A gentle man with a sweet disposition, who was the doting father of five children of his own, Hughes was the perfect choice to illustrate these children's books. His charming drawings for *Sing-Song*, in a minature-like vignette format, have a simplicity and delicacy entirely suited to the poems they accompany, although neither author nor illustrator shied away from such grim subjects as the high mortality rate for women in childbirth. If Hughes was a prolific designer of book illustrations, producing no fewer than 120 drawings for *Sing-Song* alone, Ford Madox Brown, who admired Hughes' work enormously, made only nine in his whole career. Among the best are those for Dante Gabriel Rossetti's poem "Down Stream", two designs for which are in the Lanigan Collection (cat. no. 7). Brown seized on two incidents in Rossetti's story of a tragic love affair between an Oxford "swell" and a local girl: the seduction, which occurs in a punt, with the girl's twisted scarf in her lap suggesting the soon-to-be developing fetus in her womb, and the subsequent suicide of the abandoned mother with her baby, an Ophelia-like drowning in the same river. Together the Hughes and Brown designs – both in their own way about mothers and babies – demonstrate the extraordinary range from Innocence to Experience found in the best book illustrations of the era.

Two years after Albert Moore created *The Elements*, his close friend James McNeill Whistler achieved his own breakthrough synthesis of classical sculpture and Japanese art in a group of largish oil sketches, the so-called "Six Projects" (1868, Freer Gallery of Art, Washington, D.C.). American-born but trained in France, Whistler first allied himself with the avant-garde Realism of Courbet, but in 1859 he moved to London, soon frequenting the Rossetti circle. By the mid 1860s he had met Moore, after admiring his *The Marble Seat* at the Royal Academy exhibition of 1865. Only identified as the "Six Projects" after Whistler's death, these Aesthetic masterworks are freely brushed colour studies for a series of decorative pictures that may or may not have been conceived as an ensemble for his major patron, Frederick R. Leyland, who was later to commission the Peacock Room. Referred to by the artist merely as "sketches of figures and sea",[11] most of the compositions, which are heavily influenced by Japanese woodblock prints, show groups of women attired in classical-like draperies of sublimely delicate colour harmonies, walking with parasols and fans along a beach or beside a balustrade by the sea. In one compositional variation, studied only in the pastel *Sea Beach and Figures* (Fitzwilliam Museum, Cambridge), the artist depicted four draped women on a beach, separated from the sea by a waist-high railing like an unsupported ballet bar. The figure on the far right is shown facing forward and leaning with both hands against the bar, a nude study for which is in the Lanigan Collection (cat. no. 98). Only one of the six colour studies ever advanced to a full-scale picture for Leyland. Entitled *The Three Girls* (whereabouts unknown), the painting was never finished because the artist was never satisfied with it. The problem was that Whistler felt he lacked proper training as a draughtsman, lamenting in a much-quoted letter to Henri Fantin-Latour: "Ah! how I wish I had been a pupil of Ingres!" (the latter being especially renowned as the consummate champion of line).[12] Colour, no matter how ravishing, was not enough without the mastery of drawing. The Lanigan sheet is therefore particularly interesting as evidence of the artist's concerted efforts to improve his draughtsmanship at this time by making numerous nude studies of the figures in his "Six Projects" and related compositions.

As Whistler was struggling to perfect his drawing, Dante Gabriel Rossetti was working on his largest oil painting, the immense *Dante's Dream at the Time of the Death of Beatrice*

(1869-71, Walker Art Gallery, Liverpool). Derived from Dante's *Vita Nuova* ("New Life"), which had a deeply personal significance for the artist named after him, the subject of Dante witnessing in a dream the death of his beloved Beatrice had been treated in an early water-colour of 1856. Perhaps because the canvas was so vast, Rossetti chose particularly large sheets of pale greenish-grey paper for his numerous figure studies, which were executed in an attractive combination of coloured chalks. One of several known studies for Love is now in the Lanigan Collection (cat. no. 70). Perennially short of "tin" (money), Rossetti had negotiated the sale of eight of these drawings in 1870 to his somewhat shady facto-tum and agent, Charles Augustus Howell, only adding the Lanigan sheet to the group in 1874. Since the preparatory drawings were incomplete at the time of the original deal, in some cases only drapery studies without heads or hands, additional work was neces-sary before they could be considered saleable; hence the gap of four years before the artist actually finished and handed over the present work. The unusual pose of the figure may be explained by Love's action in the picture: leading Dante with his extended right hand, Love with his traditional arrow bends over to kiss the corpse of Beatrice. This carefully finished drawing is an impressive example of Rossetti's later style in chalk.

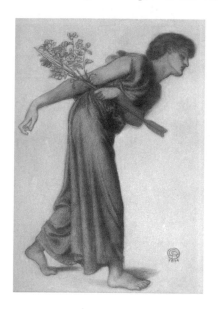

Known primarily as a successful illustrator of books, especially those for children colour-printed by Edmund Evans, Walter Crane, the Arts-and-Crafts designer and educator, also nursed serious ambitions as an easel artist. One of his most delightful paintings is the impor-tant gouache *The Earth and Spring* of 1875 in the Lanigan Collection (cat. no. 19). The discovery of Burne-Jones' unorthodox work at the Old Water-Colour Society in 1865 had been an epiphany for Crane, who became one of his most ardent disciples and a friend after 1871. Together with such like-minded artists as Robert Bateman, Edward Clifford, Henry Ellis Wooldridge, Theodore Blake Wirgman, Alfred Sacheverell Coke and E.H. Fahey, Crane exhibited at the Dudley Gallery in Piccadilly, where an unsympathetic critic dubbed them the "Poetry Without Grammar School." Their work was described as peculiar, eccentric and anachronistic, though not without evocative imagination. An incubator for the developing Aesthetic Movement, the Dudley had shown Albert Moore's *The Elements* in 1866 and E. J. Poynter's *Obedience* in 1869 (cat. no. 58) and would feature Crane's *The Earth and Spring* in their 1875 exhibition of watercolours. Like many of Burne-Jones' works in that medium, Crane's picture is painted in gouache or opaque watercolour (on paper laid down to linen) in such a way that it resembles an oil painting. Inspired by Quattrocento artists like Piero di Cosimo and suggesting the long, horizontal format of panels on early Italian *cassoni* or marriage chests, the work is a sweet allegory. Child Spring pipes awake the splendid recum-bent figure of Earth, appropriately derived from classical funerary effigies. The figures are engulfed in an enchanting deep-green landscape, dotted with daffodils and sheep, that stretches to a distant strip of sky along its high horizon. Under the pink haze of flowering trees, a solitary shepherd, right out of Blake's eclogues, pipes his own response to Spring's music. As with so many other works in the Lanigan Collection, *The Earth and Spring* epito-mizes and perfectly defines the art-historical moment that gave it birth.

There are more works by Edward Burne-Jones in the Lanigan Collection than by any other single artist, an indication of the collector's heartfelt admiration for and commitment to his art and an acknowledgement of Burne-Jones' supreme status as a draughtsman. We have already noted his early watercolour for Red House and his stained-glass design for Morris and Co. Design work continued to be an important part of Burne-Jones' oeuvre throughout his life, from his contribution to the decoration of the Green Dining Room at the South Kensington Museum, now the Victoria and Albert Museum, London ("*February*," cat. no. 10), to his collaboration with Morris on the illuminations for the latter's calligraphic master-piece, Virgil's *Aeneid (Study for the "Burning of the Boats*," cat. no.14). But that is only one facet of Burne-Jones' artistic achievement. He was also an exceptional painter, the two aspects of his work influencing and cross-fertilizing each other in a unique way. Many of Burne-Jones' masterpieces were executed for his major patron, William Graham, who commissioned the oil version of *Blind Love* (cat. no. 12) to hang between *Le Chant d'Amour* ("The Song of Love", 1868-77, Metropolitan Museum, New York) and *Laus Veneris* ("Praise of Venus", 1873-78, Laing Art Gallery, Newcastle upon Tyne). Like the latter pictures *Blind Love* was based on an earlier watercolour showing a blindfolded Cupid "crowned with flowers, groping his way through the street of a city in the early morning, seeking the house he shall enter", as the artist's widow described it.[13] Unfortunately the oil version was never completed and as it stands now, the unfinished figure of Love, with his delicately painted wreath of roses, was cut out of the larger canvas and preserved as a poignant memorial of the masterwork that might have been.

There are unexpected points of comparison between Burne-Jones' *Blind Love* and another of his greatest pictures, *The Wheel of Fortune* (1875-83, Musée d'Orsay, Paris) exhib-ited in 1883 at the Grosvenor Gallery. It was at the opening of the Grosvenor Gallery in 1877 that the artist burst upon an astonished art world as the star exhibitor, the leader of the second generation of Pre-Raphaelites and the high priest of the Aesthetic Movement. Both pictures express the profound fatalism of a man who had received his share of Love's pains and Fortune's rewards: Blind Love, groping through a city street at dawn and randomly entering a house, and Blind Fortune, originally conceived blindfolded but finally shown with her eyes closed to signify the same thing, rolling her massive wheel at dusk down a city street – a narrow Italian street like those Burne-Jones delighted in sketching – about to crush anyone in its path like a juggernaut. *The Car of Love* (begun 1870, Victoria and Albert Museum, London) depicts a similar headlong rush of humanity, impelled down a street by forces they can neither control nor resist, the mighty wheels on Love's chariot being identical to Fortune's. The idea of blind forces unleashed through a city street into a helpless world is the same in all three pictures. The Lanigan Collection boasts not one, but two studies for the Michelangelesque *Wheel of Fortune*: a brooding monochrome oil sketch of Fortune's head (cat. no. 15) and a superb anatomical rendering of the Slave (cat. no. 16), who with the King and the Poet is strapped to Fortune's ever-revolving wheel. It is a remarkable achievement for a collector to have united these two important studies for the same picture in a collection so richly representative of Burne-Jones' graphic genius.

George Frederic Watts is an artist whose work is difficult to characterize, being part of, but remaining distinct from, the mainstream of Victorian painting. Although he was an accomplished portraitist, striving in his "Hall of Fame" (National Portrait Gallery, London) to capture the soul rather than merely the outward likeness of his contemporary worthies, Watts preferred the idealism of "High Art", insisting that painting must take on the great spiritual and philosophical questions as its prime subject matter. With his didactic allegories or "suggestive pictures" as he called them, he wanted to build up an encyclopedic series called

"The House of Life" to document mankind's spiritual progress through the ages. In these works he shared many of the same goals as the pan-European *fin-de-siècle* Symbolists, and it is no coincidence that it was only towards the end of the century that Watts' ideal pictures were first appreciated. Central to his "House of Life" scheme is his enormous canvas *Time, Death and Judgement* (1870s-1886), the prime original of which is almost certainly the version that the artist gave to the National Gallery of Canada in 1886, shortly after the foundation of that institution, on the occasion of Queen Victoria's forthcoming Jubilee. It is shameful and scandalous that the picture has never been exhibited in the new building in Ottawa, though it is frequently requested for loan abroad. Universal in its theme like Burne-Jones' *Wheel of Fortune*, it depicts an eternally youthful Time with his scythe, hand-in-hand with Death, a chalk-faced woman with pale, voluminous robes, as they wade knee-deep through the stream of humanity. Behind them is Judgement, with her flaming sword, raising her terrible scales. In

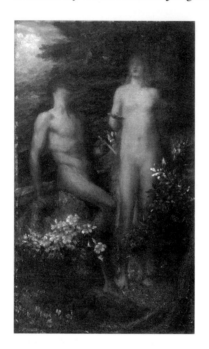

the Lanigan Collection there is a large impressive red-chalk study for the figure of Death, who gathers into the folds of her skirts the flowers Time has harvested (cat. no. 93).

Many Adam and Eve subjects were also designed for Watts' "House of Life", including the 1896 painting in the Lanigan Collection (cat. no. 95) *Adam and Eve before the Temptation,* with which the artist was photographed in his study in the same year the picture was executed. An extraordinarily elongated Eve – one is not surprised to learn that Watts nicknamed his favourite model "Long Mary" – is shown standing beside a seated Adam, the evocative chiaroscuro shading Eve's face partly and Adam's completely, while revealing the naked splendour of their prelapsarian innocence, symbolized by the profusion of white flowers in the Garden of Eden. Besides these two characteristic later works, there is also a beautiful sketch of Ellen Terry, who was sixteen when she married the forty-six-year-old artist. The

drawing (cat. no. 91) is a preparatory study for a celebrated portrait of her in the National Portrait Gallery, London. With a total of six works by Watts in his collection, Dr. Lanigan is something of a pioneer in recognizing the merits of this still neglected Titan of 19th-century British art.

Many of the strands of Victorian painting continued unabated into the 20th century, the British art establishment being notoriously reluctant to embrace the avant-garde currents of Modernism that developed in quick succession on the continent. In the first place, some of the principal Victorian artists lived on well into the new epoch, for example Arthur Hughes (for a late work, see cat. no. 33) or Edward John Poynter. A successful painter as well as administrator, becoming first the director of the National Gallery and then president of the Royal Academy, Poynter continued to paint decorative classical subjects well into the new century (cat. no. 64). A group of interesting younger artists who carried on these essentially conservative traditions have been called "the Last Romantics" – a suggestive name derived from a poem by Yeats.[14] They also form a link between the later Pre-Raphaelites and the so-called Neo-Romantics of the 1940s and 1950s. As the last great Pre-Raphaelite, Burne-Jones was identified as the "father figure" of the Last Romantics, whose disciples and followers contin-

ued in his artistic footsteps, including Simeon Solomon (cat. no. 81), John Melhuish Strudwick (cat. no. 85), Thomas Matthews Rooke (cat. no. 67), Charles Fairfax Murray (cat. no. 54) and Evelyn De Morgan (cat. no. 22), all well represented in the Lanigan Collection. Perhaps the greatest of the Last Romantics was John William Waterhouse, who, strange as it may seem, successfully combined the Academic Classicism of Leighton and Alma-Tadema with the poetic Romanticism and subject matter of Burne-Jones, executing his works, moreover, in a vigorous, freely-brushed style derived from the French plein-air painting of Bastien-Lepage. As a fitting chronological conclusion, the Lanigan Collection contains a fine group of Waterhouse drawings. There are three female head studies, including a stunningly beautiful one for his painting *Lamia* (cat. no. 87), its title derived from Keats' poem, thus taking us back to the very birth of Pre-Raphaelitism. The collection ends with three attractive pages from a sketchbook with loosely rendered compositional studies for a number of Waterhouse's later pictures (cat. no. 89).

When one collects paintings and drawings, one acquires not only pictures, but also their previous owners, known as their provenance, who sometimes quite literally left their (collector's) mark on a work of art (see cat. nos. 64 and 77). While this history is interesting in its own right, it also adds a cachet to the collection, since the authority and judgement of earlier connoisseurs who were previous owners augment the prestige and importance of the works themselves. If there were any doubt about the quality of the Lanigan Collection, a glance at the list of very distinguished former owners confirms by historical precedent the significance of what Dr. Lanigan has amassed. Four of the most famous early collectors of the Pre-Raphaelites are represented: the Liverpool shipowner John Miller, who owned Windus' oil sketch for *Too Late* (cat. no. 100); the London solicitor James Anderson Rose, who bought Sandys' *King Pelles' Daughter* (cat. no. 71) and was Sandys' most important early patron; George Rae of Birkenhead, who acquired Stanhope's *The Wine Press* (cat. no. 83); and Samuel Mendel of Manley Hall, Manchester, who owned no fewer than fifteen of Millais' original drawings for the Moxon Tennyson, including *Design for the Headpiece of "Locksley Hall"* (cat. no. 48). It seems likely that Albert Moore's *Study of a Female Head in Profile, Looking Down* (cat. no. 52) belonged to Ralph Thomas, a solicitor in partnership with James Anderson Rose and the son of another of the earliest Pre-Raphaelite supporters, Sergeant Ralph Thomas. William Graham, an India merchant, MP for Glasgow and Burne-Jones' staunchest patron, commissioned the oil version of *Blind Love* (cat. no. 12), but never received the picture because it remained incomplete. A wealthy financier and connoisseur, as well as a trustee of London's National Gallery, John Postle Heseltine bought Crane's *The Earth and Spring* (cat. no. 19) off the wall of the Dudley Gallery in 1875 and also owned Poynter's *Study of a Female Head for "Diadumene"* (cat. no. 60). The greatest collector of Pre-Raphaelite drawings of all time, Charles Fairfax Murray, whose collections now adorn museums in Birmingham and Cambridge, among many others, owned Rossetti's pen sketch of his mother (cat. no. 68) and Siddal's design of angels (cat. no. 76). Laurence W. Hodson, the Wolverhampton brewer and High Churchman, whose house Compton Hall was decorated by Morris and Co. in the 1890s – the wallpaper and chintz "Compton" were named after it – possessed a celebrated collection of Victorian paintings and drawings, including Leighton's study of the head and arms of Iphigenia (cat. no. 42).

As we move into the first half of the 20th century, the taste for Pre-Raphaelite and Victorian art sharply declined, making those who collected it true pioneers of its revival, which only really began in the 1960s. Sir Edmund Davis, whose gift of pictures to the French State in 1915 now forms the nucleus of the British collection at the Musée d' Orsay, owned the late Watts oil *Adam and Eve before the Temptation* (cat. no. 95). Two of the famous "Pre-

Raphaeladies," who were leaders in the serious study of the Brotherhood, possessed drawings in this collection: Virginia Surtees, the author of the Rossetti catalogue raisonné, acquired Burne-Jones' *Study for "The Wedding Feast of Sir Degrevaunt"* (cat. no. 8), while Lady Mander (Rosalie Glynn Grylls), who with her husband Sir Geoffrey Mander left their family home and Pre-Raphaelite shrine, Wightwick Manor, to the National Trust, bought Siddal's design of angels that had once belonged to Fairfax Murray (cat. no. 76). An authority on Victorian poetry and Fellow of Balliol College, Oxford, John Bryson owned no fewer than thirty-eight of Hughes' illustrations for *Sing-Song* – all of which had originally belonged to Christina Rossetti – including the Lanigan example (cat. no. 32). H.S. Reitlinger's vast collection of Old Master and 19th-century drawings, which were dispersed after his death in no fewer than five auction sales, included Leighton's *Cain* (cat. no. 39) and likely Millais' drawing for "Locksley Hall" (cat. no. 48) among a mass of similar works. A number of Old Master drawing connoisseurs who are not ordinarily associated in any way with Victorian art saw to their great credit the merit in such work and added sheets to their personal collections: Sir Karl Parker, keeper of Oxford's Ashmolean Museum, owned Millais' graphite sketch for *Romeo and Juliet: The Balcony Scene* (cat. no. 47); Paul J. Sachs, associate director and benefactor of Harvard's Fogg Art Museum, acquired Albert Moore's *Study of a Standing Draped Figure for "A Garden"* (cat. no. 51); and James Byam Shaw, long associated with the London art dealers P. and D. Colnaghi, snapped up Hughes' study for "Sir Galahad" (cat. no. 31) two days after his firm acquired it. One of the central figures of the Etching Revival in Britain, Harold Wright, also of Colnaghi's, owned Whistler's *A Muse* (cat. no. 99), which had been given to his wife by the artist's sister-in-law and executrix, Rosalind Bernie Philip.

Both Millais' drawing for "Locksley Hall" (cat. no. 48) and Burne-Jones' *Study of the Head of Fortune for "The Wheel of Fortune"* (cat. no. 15) belonged to the late Professor William E. Fredeman of Vancouver, whose *Pre-Raphaelitism: A Bibliocritical Study* (1965) remains the bedrock of all subsequent research. Watts' *Study for "The Messenger"* (cat. no. 94) was once owned by John Christian, the distinguished Pre-Raphaelite scholar and leading expert on Burne-Jones. Lord Sherfield bought Leighton's *Oil Sketch for "Greek Girl Dancing"* (cat. no. 40) for the celebrated Makins Collection, part of which has recently migrated to the United States. The most popular painter of his day in Britain, L.S. Lowry, whose naive industrial scenes populated with stick figures could not be further from the Pre-Raphaelite aesthetic, was a passionate collector of Rossetti, possessing his compositional *Study for "Morning Music"* (cat. no. 69). The former director of the Detroit Institute of Arts, Frederick Cummings, passed on to the Lanigan Collection two of its greatest drawings: Leighton's *Study of the Head and Arms of Iphigenia* (cat. no. 42) and Sandys' *King Pelles' Daughter* (cat. no. 71). On a dark and stormy night, Waterhouse's *Study of a Young Woman in Profile* (cat. no. 86) emits the ghastly aura of its previous owner, horror-film star and sometime marchand-amateur, Vincent Price. During the recent Dark Ages, when things Victorian were in total eclipse, public museums both in Britain and America sometimes de-accessioned, i.e., sold, unwanted works of art (for risible sums) that they were sure would never be of any interest to their institutions, but which they now, no doubt, regret selling. Two such examples have found a haven in the Lanigan Collection: Watts' *Study for "The Messenger"* (cat. no. 94), sold by the Whitworth Art Gallery, University of Manchester, in 1935; and Solomon's *Revenge* (cat. no. 77) from the Alfred de Pass Collection, sold by the Royal Institution of Cornwall, Truro, in 1966. Two well-known art historians of the present day in Britain, Lindsay Stainton and John Physick, owned drawings by Henry Holiday (cat. no. 27) and Waterhouse (cat. no. 89) respectively. Physick is, in fact, Waterhouse's nephew. Finally two prominent and very active American collectors of Victorian art, Frederick R. Koch and Stuart Pivar, both

contributed items to the Lanigan Collection. From Koch came Hunt's *Compositional Study for "The Flight of Madeline and Porphyro During the Drunkenness Attending the Revelry (The Eve of St. Agnes)"* (cat. no. 34), Madox Brown's two studies for *The Lovers* and *Down Stream II* (cat. no. 7), Frederic Leighton's *Cain* (cat. no. 39) and George Howard's *Study of Cupid for "Venus and Cupid"* (cat. no. 30), from Pivar, Hughes' *The Nativity* (cat. no. 33).

It is self-evident that Dr. Dennis T. Lanigan, though in mid-career, has already taken his rightful place in this honour roll of distinguished collectors past and present. A perusal of his catalogue entries will quickly reveal that he is not only an outstanding collector, but also a scholar to be reckoned with, worthy of the long tradition of scholar-collectors before him.

1 For the historical background to the 1848 revolutions, see Richards, Dennis and Cruikshank, J.E.: 1962, pp. 93-144.
2 The bibliography on Pre-Raphaelitism is vast. For the early works see Fredeman, William E.: 1965. The Tate exhibition catalogue (London 1984) and their accompanying Education Department brochure *What is Pre-Raphaelitism?* remain useful summaries. A good thematic treatment by a new young scholar is Barringer, Tim: 1999.
3 See Judith Bronkhurst's note in Sotheby's, London: *Victorian Watercolours and Drawings including the Burt Collection of Holman Hunt Drawings*, 10 October 1985, lot 10. Her catalogue raisonné of Hunt's work is eagerly awaited.
4 The attempt to rehabilitate Millais' later work was made significantly with his portraits, not with his less palatable genre pieces, in National Portrait Gallery, 1999.
5 Marsh, Jan: The Ruskin Gallery, 1991, p. 11. Although most accounts say Walter Deverell and his mother spotted Lizzie Siddal working in a milliner's shop, this new evidence comes from an obituary in the *Sheffield Telegram*.
6 For a good recent study of the Golden Age of Victorian wood-engraved illustration, see Goldman, Paul: 1994.
7 Hickox, Mike: 1996, pp. 13-19.
8 Reynolds, Simon: 1984, p.8.
9 Metropolitan Museum of Art: 1973.
10 See, for example, Peter Nahum: 1995, cat. no. 31 (illus. p.17).
11 Young, Andrew McLaren, MacDonald, Margaret and Spencer, Robin: 1980, (text), nos. 82-87, p. 47.
12 Spencer, Robin: 1989, p. 82.
13 Burne-Jones, Georgiana: 1904, Vol. I, p. 257.
14 Barbican Art Gallery: 1989.

A Dream of the Past:
Personal Recollections of a Pre-Raphaelite Collector

Dennis T. Lanigan

The title of this exhibition is derived from John Everett Millais' *A Dream of the Past: Sir Isumbras at the Ford* (Lady Lever Art Gallery, Port Sunlight). This painting was exhibited at the Royal Academy in 1857, a landmark year since the second phase of Pre-Raphaelitism is generally acknowledged to have started then with the decoration of the Oxford Union Debating Hall by Rossetti and his colleagues. Works by the artists associated with Pre-Raphaelitism and Aesthetic Classicism constitute the vast majority of my collection. These artists are frequently referred to as "Dreamers."[1,2] Early in their association even Rossetti described Burne-Jones in a letter to William Allingham as "one of the nicest young fellows in – *Dreamland."*[3] In their search for an ideal beauty devoid of an overt narrative content, these painters frequently portrayed women with expressionless faces in a state of reverie, dreaming, or sleep. Aesthetic Movement artists looked to the middle ages and classical antiquity as times that were simpler and far nobler than the 19th century. As Renée Free has noted: "The late Pre-Raphaelites ... searched for a lost world only perceived in dream and reverie. The search for Olympus, the Hesperides, or Avilion [*sic*] is a shared aspect of Romanticism. Dreamer and dream world are depicted."[4] Despite being inspired by the art of the past, these artists were not interested in a "slavish imitation". William Morris, in an interview late in his life regarding the "Holy Grail Tapestries", designed by Burne-Jones and made by Morris & Co., summed up what most of the artists in this exhibition felt about beauty in 19th-century England: "Good gracious!" replied Mr. Morris, "what is there in modern life for the man who seeks beauty? Nothing – you know it quite well. To begin with, if you want to make beautiful people you've got to drop modern costume ... Besides, the line of tradition is broken, and you must work in some skin. Here are people with high art interests – what are they to do? 'Make a new style,' you say? But that takes a thousand years! The Holy Grail people were working in a straight line of tradition – that line is broken; we have nothing like a stream of inspiration to carry us on. The age is ugly – to find something beautiful we must 'look before and after.' Of course, if you don't want to make it beautiful, you may deal with modern incident, but you will get a statement of fact – that is, science. The present days are non-artistic and scientific – that is at the bottom of the whole question, and we are not to be blamed ... No, if a man nowadays wants to do anything beautiful he must just choose the epoch which suits him and identify himself with that – he must be a thirteenth-century man, for instance. Though, mind you, it isn't fair to call us copyists, for in all this work here, which you complain of as being deficient of a particle of modern inspiration, there is no slavish imitation. It is all good, new, original work, though in the style of a different time."[5]

Those attending this exhibition hoping to see great Victorian paintings may, I am afraid, be very disappointed. My collection is not close to the quality of the Makins Collection or that of Lord Lloyd-Webber, although it is not devoid of scholarly interest. Despite its being composed of more modest works, forming this collection has been a source of great pleasure to me for many years. I now have well in excess of one hundred items in my collection, principally drawings, but also watercolours, paintings, original prints, sculpture, and stained glass. A total of forty-four artists are included in the collection, although many are represented by only a single work. Some artists, such as Rossetti and Whistler, are underrepresented in terms of their importance, but the costs of acquiring their works have limited my ability to collect them. Although I have managed to acquire some rare works by artists such as F.G. Stephens,

William De Morgan, and Philip Webb, there are still many other artists I would like to own works by, including William Morris, James Collinson, Thomas Woolner, Charles Allston Collins, Walter Deverell, Michael Halliday, Henry Wallis, G.P. Boyce, James Smetham, Frederic Shields and Marie Stillman. I would also like to acquire early works of the "Poetry Without Grammar School" by its other members besides Walter Crane and Edward Clifford. The reason that these artists are not represented in my collection is either that no works by them have come on the market, or I have tried to buy works by them and failed, or I have not found exactly the work by them that I wish to add to the collection. I therefore still have goals as a collector that I have not achieved.

I would now like to discuss how I became interested in the Pre-Raphaelite and Aesthetic Movements and how I came to form my collection. I was born and raised in Regina, Saskatchewan. The year of my birth was the centenary of the foundation of the Pre-Raphaelite Brotherhood – which might have some significance for Freudian psychoanalysts. I was exposed to Victorian painting virtually from my cradle, since my great-uncle Charlie, with whom we lived for a short period of time when I was an infant, had a painting by Thomas Sidney Cooper R.A. hanging above his mantelpiece. This was one of his typical Canterbury meadow scenes of sheep and cows – and it could hardly be further from the works that would later interest me. Despite this questionably promising beginning, I do not come from a particularly artistic family. There were no original oil paintings or watercolours hanging in our house when I was a child. I can only remember visiting the public art gallery in Regina, the Norman Mackenzie Gallery, once during my childhood years. At that time I was probably in grade six and I went with one of my friends, whose father was a university professor who worked on campus close to the gallery. In view of this background it is therefore surprising that both my brother and I are now very much involved in collecting art. My brother, who lives in Calgary, has very different interests from mine, and his collection focuses on early Western Canadian, particularly Saskatchewan artists. In fact it is the family joke that my brother collects art to recapture his roots, while I collect art to escape mine!

The only thing from my childhood that probably led to my predilection for the Pre-Raphaelites was my taste in literature. Unlike most boys of my generation I was not interested in Hardy Boy mysteries or in science fiction. Instead my favourite books were the stories of King Arthur and his knights, and the Greek myths and legends. These were probably unusual tastes for the 1950s, but ones that later allowed me to relate readily to the subject matter of the Pre-Raphaelites. Although I have not slept with *The Broad Stone of Honour* by my bedside throughout my life, as did Edward Burne-Jones, I have no doubt we were kindred spirits and I would have had no problem joining him in "dreamland". It was a great thrill for me in February 1999, during a visit with Sandy Berger in Carmel, California, when he showed me Burne-Jones' personal volumes of K.H. Digby's *The Broad Stone of Honour*. I have no recollection of ever hearing the term "Pre-Raphaelite" as a child, but I have no doubt that some of the illustrations in the books I read featured reproductions of paintings by the artists I would later come to admire and collect. In fact I recently pulled out some of my old books to check. In *Classic Myth and Legend* by A.R. Hope Moncrieff I found illustrations by Leighton, Waterhouse, Rossetti, Burne-Jones, Harry Bates, Poynter, Watts, Alma-Tadema, and Strudwick – all artists represented in my collection. Had my subconscious retained these images long after I had apparently forgotten them?

In 1967 I started university and passed up my one and only opportunity to take a class in Art History. My friends, who had taken the course the semester before, had warned me I would have to memorize too many slides. I have long since regretted my decision not to take this class. In 1968 I left Regina to go to Saskatoon, when I was accepted into the College of

Dentistry at the University of Saskatchewan. In the summer of 1972, during my final year at dental school, my best friend and I decided to visit Britain for a month. It was during this trip, while doing the usual touristy things, that I first spent any time at art galleries. In London the museums I visited included the National Gallery, the Victoria and Albert Museum, and the British Museum, but not the Tate Gallery. It was on this vacation that I became aware of how much I enjoyed looking at art. No art of any one particular period or country had a special attraction for me, as I had not been exposed to enough to have developed any definitive tastes. I did, however, develop the habit of visiting the public art gallery of any large city I visited thereafter.

In the fall of 1972 I graduated from dentistry. Immediately after graduation I went to visit my brother who was working in Toronto. My parents very generously had given me $500 as a graduation present to spend any way I saw fit. I had decided I would spend it on a piece of art of some kind, although I had no preconceived notion of what type of art I would buy. Fate seems to have intervened, however, as a few days after my arrival my brother and I were driving downtown when I spotted a sculpture in the window of an antique shop – Green & Son – which was on Yonge Street in the Rosedale area. I told my brother to stop, but as there was no place to park, we continued to drive until he found a place that was convenient to leave the car. We got on the subway, rode it back until we were sure we had gone past the antique shop, and then walked back until we found it. The sculpture turned out to be Parian porcelain, c. 1851, produced by Minton & Co. It was entitled *Love Restraining Wrath*, a Victorian Symbolist title, which surely even Watts would have been proud of. The price was $450, almost exactly what I had to spend. I liked it and so I bought it. This then became the first piece of art I ever owned, and it just so happened to be British and Victorian.

When I graduated from dental school I had been accepted into a dental residency program at the University Hospital in Saskatoon. As part of my program I was expected to go to an underserviced area of Saskatchewan to provide dental care to children. In November 1972 I was sent off for a month to Uranium City, which was as far north as you could get in Saskatchewan. Uranium City at that time was a town of about 2000 people, primarily serving the nearby mining community of Eldorado. Not surprisingly I did not have a particularly active social life when I first arrived. After I read whatever books I had brought with me, I headed to the local drugstore to buy a new one. The drugstore was the only store in the community other than the Hudson's Bay Co. – which in Uranium City made it hard not to think of the Bay! As you might imagine, there was not an extensive selection of fine literature and most of my choices were either Westerns or Harlequin romances. The only book that appeared remotely interesting was entitled *I, James McNeill Whistler*, by Lawrence Williams, which was a fictional autobiography of the artist. Although there is much in the book which is not in a strict sense historically true, it was, nonetheless, a very interesting one and portrayed very accurately Whistler's general philosophy of life. It also introduced me to many other important Victorian personalities, including Rossetti, Burne-Jones, Leighton, Moore, Ruskin, and Swinburne. It was this book that first aroused my interest in Victorian art.

In May 1974, at a time when I was teaching in the Department of Oral Diagnosis at the College of Dentistry in Saskatoon, I went to New Orleans for a conference. While there I visited many antique shops. At Chartres Antiques I bought my first painting, a portrait of a distinguished elderly gentleman which I liked because it reminded me of my grandfather. I remember I paid the princely sum of $175 and they promised to ship it to me by train. I half expected that it would never arrive, but surprisingly it did eventually. The painter was Alexander Roche, who I later found out was a member of the Royal Scottish Academy and one of the so-called "Glasgow Boys". Roche had won a medal for his painting *The Window*

Seat at an exhibition in Pittsburgh in 1899 and subsequently had been popular as a portrait painter amongst wealthy Americans. He is known, for instance, to have painted Andrew Carnegie's wife and daughter. I had now purchased my first painting, which also turned out to be British and Victorian. I would over the next few years acquire a number of other Scottish paintings from this time period, all landscapes, primarily because I liked them, but also because they were so inexpensive compared to anything else of comparable quality I found. Some people even then found my tastes in art somewhat eccentric. I well remember Jim Hooley, the head of the oral surgery department at the University of Washington in Seattle, remarking at my graduation banquet in 1980: "You know Dennis has the largest collection of Scottish Impressionists in Seattle – but then, of course, Dennis has the only collection of Scottish Impresssionists in Seattle!"

In the fall of 1974 I went back to university to take medical school in preparation for applying to do a residency in oral and maxillofacial surgery. I started in the third year because certain classes overlapped with what I had taken in my dental training. The second half of my fourth year was an elective period, and I had arranged to spend my time in the U.K. Three months were to be spent at the plastic and maxillofacial unit at Canniesburn Hospital in Glasgow, and my final month in London at the Institute of Child Health writing a paper on the etiology and pathogenesis of craniofacial malformations. I arrived in London on January 2, 1976. I could not go directly to Glasgow because I needed to obtain a temporary license, so I would actually be able to do some hands-on work while at the unit in Glasgow. When I arrived in London, the dental licensing body was still closed for the holidays, so I found myself with time on my hands. While riding the underground, I noticed a poster advertising a major Burne-Jones retrospective exhibition being held at the Hayward Gallery. I had arrived just in time to see the final day of the exhibition. This was my first introduction to the Pre-Raphaelites and the first "blockbuster" exhibition I had ever attended. If there is such a thing as a "road to Damascus" for a collector, then this exhibition surely was mine. What an eye-opener it was for a small-town boy from Saskatchewan – I was totally enthralled. When I later read the reminiscences of Graham Robertson in his book *Time Was,* I could well imagine how he felt when he attended the first exhibition of the Grosvenor Gallery in 1877. He described the opening as "a genuine offering at the shrine of Beauty, a gallant blow struck in the cause of Art ... I can well remember the wonder and delight of my first visit. One wall was iridescent with the plumage of Burne-Jones's angels, one mysteriously blue with Whistler's nocturnes, one deeply glowing with the great figures of Watts, one softly radiant with the faint, flower-tinted harmonies of Albert Moore ... The impression left upon me – and upon most other people – was unforgettable ... there has been no such delightful surprise in the world of pictures since."[6] This pretty well summed up my feelings following my visit to the Burne-Jones exhibition. Although I saw the most recent Burne-Jones retrospective exhibition in both New York and Birmingham in 1998, no matter how enjoyable this exhibition was, nothing could ever recapture the magic of that first show. I well remember leaving it in 1976 and thinking that if I could one day own even one drawing by Burne-Jones, I could die happy. Little did I know that twenty-four years later I would own two oil sketches, one watercolour, eight drawings, and an early domestic stained-glass window designed by Burne-Jones – the largest number of works by any artist in my collection. I certainly would never have imagined as well that one day I would actually know and be a friend of John Christian, the curator of the exhibition, and a scholar for whom I have always had the utmost respect and admiration.

A few days later I took the train to Glasgow, where I spent the next three months. Because I did not have any clinical responsibilities on the weekends, nor did I have money to spare for travel, I spent a lot of time visiting the local art galleries, particularly the Kelvingrove, but also

the Hunterian. At the Kelvingrove my favourite paintings were Whistler's *Arrangement in Grey and Black, No. 2: Portrait of Thomas Carlyle* and Albert Moore's *Reading Aloud*, even though they also owned fine works by Burne-Jones, Rossetti, and J.N. Paton. I also saw my first examples of "New Sculpture" in the works of Harry Bates, and that is why he is still probably my favourite sculptor of the group. At the Hunterian I found they had the most extensive collection of works by Whistler in the world, with the possible exception of the Freer Gallery in Washington. Their collection was not housed in the sumptuous surroundings it now enjoys, however, but was displayed in the dingy basement of one of the University buildings. While in Glasgow I also came across a boxed set of William Gaunt's trilogy on Victorian art – *The Pre-Raphaelite Tragedy*, *The Aesthetic Adventure*, and *Victorian Olympus* – still a very good introduction for the novice to the art and artists of this era and certainly a goldmine of information to me at my stage. By the time I got back to London, I had learned much more about Victorian art and where to see works by the artists I admired. In Glasgow I had spent the half-day a week of free time I was granted as an honorary registrar working at the medical library researching journal articles for the paper I was to write. Because I had already completed my research by the time I returned to London, I spent the mornings slaving away at my paper and the afternoons I had free to visit galleries and museums.

My first visit was to the Tate Gallery. Even in 1976 the Pre-Raphaelites were not particularly fashionable, and the only works I found were in one small room in the basement. On display were mainly the early works associated with the PRB, but none of the later, more decorative works of Rossetti and his circle. I do recall seeing, however, J.W. Waterhouse's hauntingly beautiful *Lady of Shalott* and Whistler's *Harmony in Grey and Green: Miss Cicely Alexander* on display in the upper galleries.

From William Gaunt's book I now knew of the existence of Leighton House, but I had no idea where to find it, and my map did not cover the area outside of central London. I knew Leighton House was in the Holland Park area so I took the tube to Holland Park station and started asking anyone who I thought might know if they had ever heard of it. Finally I met a traffic warden who knew its location and who was able to point me in the right direction. On the afternoon I came to visit I was the only visitor there, so I basically had the house to myself except for the guard. I very much enjoyed my initial visit, although I can assure you the house was not nearly so grand as it is now, primarily due to the efforts of Stephen Jones to restore it during his time as curator.

At this time I also made my first visits to commercial galleries dealing in Victorian art. I had been aware of the Maas Gallery even prior to coming to London, because my parents had given me Jeremy Maas' book *Victorian Painters* as a Christmas present in 1974 – the first of many books I was to acquire on Victorian art. I can not begin to tell you of the kindness of Jeremy Maas and his colleague Henry Ford. At a time when I could scarcely tell an early Burne-Jones drawing from a Rossetti, they were good enough to show me many things and to tell me about them, even though they knew that as a struggling student I could not afford to buy any of the works on display in their gallery. I have enjoyed visiting the Maas Gallery ever since, and the warm relationship I developed with Jeremy Maas has continued with his son Rupert. When "young Rupert", as we called him then, first started dealing, I'm sure he would be the first to admit that he did not know a great deal in general about the period. He did, however, right from the beginning have a very good eye – something that can not necessarily be learned regardless of one's artistic education. It has therefore been with a great deal of pleasure that I have watched his development over the years until he is now certainly one of the most knowledgeable dealers in Victorian art. On one of my recent visits to London he and I shared a good laugh when he told me that I used to intimidate him when he was a young

dealer. He must have been one of the few people that I have ever intimidated – with the possible exception of students during an oral examination.

Another thing that happened during my London visit as a medical student was that I made my first appointment to see works of art not normally on display in a museum. Since that time I have been into the basement storage facilities of many of the great museums in the U.K., the U.S.A., and Canada looking at paintings, or in their prints and drawings departments looking at drawings. My first such excursion, interestingly enough, was to the so-called Guildhall Art Gallery. This was not really a gallery at all at that time since it had been totally destroyed in the Blitz in May 1941, although fortunately most of the paintings had by that time been moved to safety. The gallery has only recently reopened. I had remembered several paintings that interested me in Jeremy Maas' book, and had called and arranged an appointment to see them. I found my way to the Guildhall and was met by a gentleman who took me around. I found George Frederic Watts' *Ariadne in Naxos* hanging in a barren hallway across from the kitchen. I was shocked when my guide pulled out William Shakespeare Burton's *The Wounded Cavalier* and Holman Hunt's *The Eve of St. Agnes*, both stashed away in a small closet. I could not believe at the time that they could treat works which I considered to be masterpieces in such a cavalier fashion, but fortunately most Victorian art has now come out of the closet. Many years later I bought the original pencil design for Hunt's *The Eve of St. Agnes* (cat. no. 34) when it came up for auction at Sotheby's, London, on November 5, 1997. It had previously sold at the Elizabeth Burt sale at Sotheby's, London, on October 10, 1985. Elizabeth Burt was Gladys Holman Hunt's adopted daughter. I had attempted to buy the drawing at the Burt sale, but had not even come close as the price had soared well beyond its pre-sale estimate. When I bought it in 1997, I paid less than forty percent of what it had sold for in 1985, but much more than I had bid originally. I was delighted to finally buy this drawing, however, because I feel it is a key landmark on the road to the Pre-Raphaelite Brotherhood.

At the end of April 1976 I left London to return to Saskatoon to start my medical internship. In July 1977 I started my residency program in oral and maxillofacial surgery at the University of Washington in Seattle. Because I was hungry for some Canadian news, I arranged to take the paper, the *Vancouver Sun*. One day I noticed an advertisement that a gallery was opening in Vancouver specializing in British art from 1850-1950, and its inaugural exhibition would contain works by artists in whom I was particularly interested, including D.G. Rossetti, E. Burne-Jones, G.F. Watts, L. Alma-Tadema, F. Sandys, Simeon Solomon, and E.J. Poynter. The weekend the gallery had its opening I drove to Vancouver. I was amazed when I walked into the MacMillan and Perrin Gallery on Granville Street. I have never before or since encountered a commercial exhibition with the quality and quantity of such superb works offered for sale as I saw on display there. The show included not only paintings and watercolours, but the most wonderful De Morgan pots. Imagine my surprise at seeing Burne-Jones' *The Four Seasons*, which I had seen the year before at the exhibition at the Hayward Gallery. Personally, if I could have afforded to buy just one work, it would have been Rossetti's *The Marriage of St. George and the Princess Sabra*, which if my memory serves me correctly was priced at $50,000. The exhibition also included one of the early masterpieces of Pre-Raphaelitism, Walter Deverell's *Twelfth Night*. I introduced myself to Dan Perrin and Neil MacMillan. This was the beginning of my friendship with Dan Perrin who would help shape my collection over almost the next twenty years. As a resident making $1000 a month, however, I was not really in the position to buy anything from them. I must confess at this stage I still harboured hopes that one day I would actually be able to buy paintings by major Victorian artists and I had never really thought about buying primarily drawings. It was only

later when the prices for the paintings had risen out of sight, and my tastes had developed somewhat, that I began to appreciate drawings more. I have now grown to love drawings to the extent that even if I could afford to collect paintings by major Pre-Raphaelite artists, I would still continue to concentrate on drawings.

From April to December 1979 I did a rotation at a maxillofacial unit in Arnhem, the Netherlands. Since I was only on call one weekend out of three, I spent the other two travelling. I visited many galleries and museums, primarily in the Netherlands and Belgium, but also in Germany, France, and Switzerland. This broadened my knowledge of 19th-century European art in general, and particularly the Symbolist Movement. In September I travelled to Jersey to see the *Millais Commemorative Exhibition.* In mid December I took the train to Paris for the weekend as a Fernand Khnopff exhibition was being held at the Musée des Arts Décoratifs. I also made my third attempt that year to try to see Whistler's *Arrangement in Grey and Black: Portrait of the Artist's Mother* at the Louvre. Unfortunately that section of the gallery was again closed. When I complained that this would be my last chance to see the painting, they reluctantly agreed to permit me to view it but no others. As luck would have it, however, *Whistler's Mother* was in a small room surrounded by several paintings by Puvis de Chavannes and the guard that escourted me allowed me to look at them as well.

At the end of June 1981 my residency training ended and in July I began my academic appointment at the University of Saskatchewan. In September I flew to Halifax and had to make connections in Toronto. I phoned the MacMillan and Perrin Gallery from the airport, since they had moved from Vancouver to the fashionable Yorkville area of Toronto. I reintroduced myself, mentioned again my interest in the Pre-Raphaelite and Aesthetic Movements, and asked that they let me know if they acquired anything they thought I would be interested in. On February 27, 1982 I got a letter from Dan Perrin telling me of a recently acquired oil sketch by Frederic Leighton for *Greek Girl Dancing* (cat. no. 40) that he thought I might be

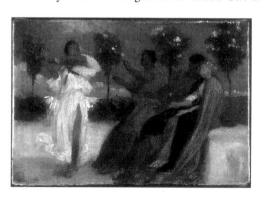

interested in. I wrote back expressing interest, they sent me a transparency on March 11, and the rest, as they say, is history. This then turned out to be the first piece of art I acquired by the group of Victorian artists I particularly admired and whom I had long wanted to collect. It is somehow fitting that it should date from 1867, and be an example of a work by Leighton in his early "Aesthetic" style, since works of this type and from this period have gradually become the major focus of my collecting. In fact for the past several years I have collected primarily within the period of 1855-70. I think this a very important and interesting period in British art since it includes the formation of the second phase of Pre-Raphaelitism and the beginning of Aesthetic Classicism, the fusion of which would produce the Aesthetic Movement. At no other time were all the major artists associated with this movement working in greater harmony with each other, and the cross-influences on each other's work make it a particularly fascinating period. In my collecting I have therefore particularly looked for works that I feel show this cross-fertilization between artists. I have also been especially interested in buying works that showed how the art of the 1860s was inspired by ancient Greek sculpture, Japanese art, and the Renaissance.

I would now like to discuss how I came to acquire some of the more interesting and important works in my collection. When I first started collecting drawings, I was primarily

interested in buying working drawings for major paintings. As time went on I started to buy drawings as independent works of art or those related to design, particularly for illustration or stained glass. I was interested in acquiring works by the same artist showing him or her working in various media and at different periods of his or her career. Drawings came more and more to fascinate me because, as Agnes Mongan, the former curator at the Fogg Art Museum at Harvard, has stated: "It is in drawings that the real intention and essential character of an artist are most clearly revealed."[7]

In September 1982 I was in Toronto for a conference. One afternoon what was being discussed was not of significant interest to me so I left and spent it sitting in the MacMillan and Perrin Gallery. Neil and I were the only ones in the gallery that day, and he showed me various things on display and in storage. After a couple of hours he said to me: "You know you really should have something by Watts in your collection." "I agree," I answered, "but I don't really like the oil sketches on display, which are the things you have in my price range." "Well how about this painting," he said, pointing to Watts' *Adam and Eve before the Temptation* (cat. no. 95). I replied that I had liked that painting since I had first seen it on display at their initial exhibition in Vancouver in 1977, but it was out of my price range. Neil responded: "Well, we've had it for a long time. Let me see what we paid for it and I'll see what sort of price I can offer you on it." He came back with a price that was considerably reduced from what it said on the label, but what for me was still a considerable sum of money. In all honesty it was more money than I had ever spent before on anything, with the exception of my house. I said, "Let me sleep on it and I will let you know tomorrow." If the truth be known, I do not think I slept at all that night, but the next day I phoned Neil and told him I would buy it.

Shortly after I bought the Watts, the MacMillan and Perrin Gallery closed in Toronto. The year 1982 was a poor one for the economy and many well-established galleries closed in Toronto about this time. It was tough enough to make a living as a dealer selling mainstream Canadian art, much less the Pre-Raphaelites. With the windup of the gallery the remainder of their stock was to be sold at auction in London. After Dan and Neil moved to London, we kept in touch and I advised them of the types of works I was interested in acquiring. Dan had agreed to be my agent, buying for me at auction, and keeping an eye out for things that he thought would interest me in the various London galleries. In March 1983 I got a call from Dan advising me that a Burne-Jones oil sketch for the head of Fortune in the *Wheel of Fortune* (cat. no. 15), which I had always admired in their gallery in Toronto, was coming up for auction at Christie's and was I interested? Interested I certainly was and Dan undertook to place the bid for me. I did not hear from him until about a week after the sale, and by that time

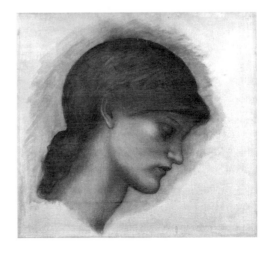

I assumed that I had been unsuccessful. I was therefore delighted when he rang and told me the work was mine. This oil sketch had previously belonged to Dr. W.E. Fredeman, who had bought it from Colnaghi's in 1957. It proved to be my introduction to Dick Fredeman as Dan advised me that I should contact him and tell him I had bought it and that it would be staying in Canada. In June of that year I happened to go to Vancouver to visit one of my best friends from medical school. It was with some trepidation that I contacted Dr. Fredeman to tell him about my purchase, as I felt uncomfortable simply

phoning someone I had never met before. He was most gracious, however, and in fact invited me over for lunch the next day. I went and met Dr. Fredeman, who treated me with the utmost kindness and hospitality, and showed me his art collection and extensive library. This was the beginning of a warm friendship that continued until his recent death in July 1999.

In September 1983 I got a letter from Dan Perrin telling me that an Albert Moore drawing I had always liked, a study for *Kingcups*, had been bought in when it had initially come up for auction and asking me if I was interested. I called Dan and said that, although I liked the Moore very much, I would be even more interested in the Rossetti drawing of Love for *Dante's Dream at the Time of the Death of Beatrice* (cat. no. 70) if it was still available. I had always particularly admired this coloured-chalk drawing whenever I had gone into their gallery. As it turned out, the Rossetti also had not sold, but it was already consigned to an upcoming Sotheby's auction. I therefore had to pay extra to have it withdrawn from the sale. I have never regretted the decision to buy it, since coloured-chalk drawings of this quality are now out of my price range, as are most Rossetti drawings. In fact for the last four Rossetti drawings I have tried to buy over the past several years I have bid over the high estimate in each case, but have not even come close to acquiring any of them. If I had known Rossetti's market was going to increase so much, I would have bought more works by him earlier on.

On January 25, 1984 I got a letter from Derek Lowery, who ran the Kelmscott Gallery in Vancouver. I had seen an advertisement in *Vanguard*, an art magazine, for the Kelmscott Gallery, with a red-chalk drawing by Simeon Solomon of *The Shadow of the Cross* illustrated. I wrote a letter inquiring about works for sale and Derek wrote back offering me a number of items. The most interesting was a large orange-chalk drawing by Watts, said to be a study for Ceres, but which was obviously a study for Death in *Time, Death and Judgment* (cat. no. 93), the major version of which is in the National Gallery of Canada as a gift from the artist. Although not in perfect condition, it is still one of the loveliest drawings I have ever seen by Watts. I did not have the money to buy anything at that time, but in March he wrote back offering me the Watts at a very favourable price and I bought it.

In May 1984 I went to London to see the major Pre-Raphaelite exhibition organized by the Tate Gallery – a truly magnificent show perhaps not to be repeated in my lifetime. It is

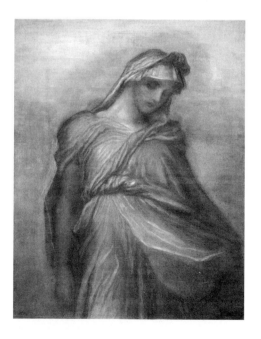

hard to believe, but this was the first time I had been back to London since 1976. Up until 1981 I had neither the time nor the money to travel to London, and while the MacMillan and Perrin Gallery was in Toronto, I did not have to go to London in order to find interesting art to buy. While in London I visited the principal dealers in Victorian art. I have to tell you in all honesty I was disappointed with what I found. I had not realized how much I had been spoiled by my trips to the MacMillan and Perrin Gallery and their enormous stock. I had expected to find a similar situation, or even better, with the principal London dealers, and I was astounded to find how little material they had specifically related to my area of interest. It was during this trip I made my first ever visit to Julian Hartnoll's gallery. He was out at the time and I was therefore

looked after by his female assistant, who proceeded to bring out some recent acquisitions from a drawer to show me. Included in these was a very powerful Burne-Jones study for the Slave in the *Wheel of Fortune* (cat. no. 16), obviously influenced by Michelangelo. I liked this drawing very much, but she had no idea what the asking price was, or even if Mr. Hartnoll had priced it yet. As I was due to return to Canada the next day, I discussed the drawing with Dan Perrin and he talked to Mr. Hartnoll about it after I left. It turned out Mr. Hartnoll was furious that I had seen this drawing because he had not shown it to his major client, who he thought would be interested in it. Much later I found out this client was Frederick Koch, who at that time was the foremost buyer of Pre-Raphaelite works – both paintings and drawings. It is no wonder Mr. Hartnoll was not pleased since he obviously would not wish to alienate his most important customer. Nevertheless he agreed to sell me the study of the Slave and it probably remains the favourite of all my Burne-Jones drawings. Despite this rather inauspicious start to my relationship with Julian Hartnoll, I would over the next few years buy some of the best works in my collection from him.

This trip to London in 1984 started a trend and I have usually been back to London at least once a year since then. I have also tried, if at all possible, to attend every major exhibition involving the Victorian artists I admire. In some instances I have visited multiple venues if it was a show that particularly interested me. I have often found that an exhibition can look and feel quite different depending on how a particular gallery chooses to display and hang it.

In July 1984 I received in the mail from Dan Perrin a copy of a Christie's catalogue for their July 24th auction. Two drawings from this sale specifically interested me – a study by Edward Poynter for *The Cave of the Storm Nymphs* (cat. no. 64), and J.W. Waterhouse's study for the head of *Lamia* (cat. no. 87). This second drawing was not illustrated in the catalogue, but I was familiar with it since it had been reproduced in Anthony Hobson's first book on Waterhouse. I therefore asked Dan to bid on these two for me. I was successful in buying the Poynter, but not the Waterhouse, which was bought by Julian Hartnoll. I decided I still really wanted the Waterhouse, however, and arranged for Dan to buy it for me from Mr. Hartnoll within a week after the sale. This was the first, but not the last time I ended up buying something from the dealer who outbid me, if it was a work I really wanted.

In September 1984 I went to New York for a conference. While there I visited a number of dealers who sold Pre-Raphaelite drawings, including Barry Friedman who at that time had marvelous works by Rossetti, Burne-Jones, Solomon and Hunt, but which were all very expensive. I also went to the Shepherd Gallery, which had a number of works including drawings by Rossetti, Moore and Watts (cat. no. 90). The most interesting drawing they showed

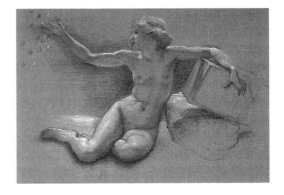 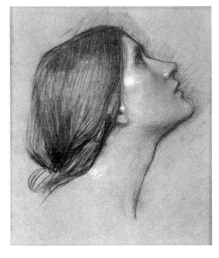

me was attributed to Edward Poynter, based on its E.P. monogram, but it was obviously a compositional study by Evelyn De Morgan for *Hope in the Prison of Despair*, done before her marriage to William De Morgan when she was still Evelyn Pickering. I pointed this out to them, but I am still not sure that I managed to convince them it was not by Poynter. I have always regretted not buying it, as it was one of the finest De Morgan drawings I have ever seen. The day previously, however, I had been to the Knoedler Gallery, since I had heard they were going to do a Whistler exhibition later in the year to mark the 150th anniversary of his birth. I wanted to see if they had any drawings by him for sale and they had a few, even at that time, including a nude study for the "Six Projects" (cat. no. 98) which I was decidedly interested in. A few days after I left New York I definitely made up my mind to buy the Whistler. The woman who had shown it to me was Hope Davis, from whom I would later buy my second Whistler drawing during a trip to New York in November 1987 when she was dealing on her own. I had seen *A Muse* (cat. no. 99) later in 1984 when I had returned for the Whistler exhibition at Knoedler's. At that time it was on loan from a private collection and I had particularly admired it.

In October 1984 I visited one of my friends, a local Saskatoon antique dealer. He subscribed to the *Christie's International Magazine* and had just received the current issue, which he thought I might like to look at. Coming up for sale on October 23 was a preliminary drawing by Lawrence Alma-Tadema for *The Vintage Festival* (cat. no. 1). I phoned Dan Perrin and asked him to place a bid for me, which was successful. It is one of Alma-Tadema's few surviving working studies, and it is probably his most frequently reproduced drawing. As I would not have been aware of it but by pure chance, I decided it was time I started a subscription to regularly receive the auction catalogues from Christie's dealing with British drawings and watercolours. Some years later I also started to receive the catalogues from Sotheby's.

In July 1985 I got a call from Dan Perrin that he had seen an extraordinary drawing by Frederic Leighton, which Julian Hartnoll had just received from Frederick Cummings. It

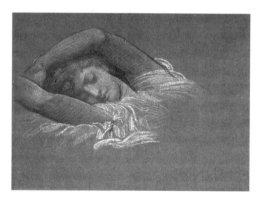

was a study of the head and arms of Iphigenia for *Cymon and Iphigenia* (cat. no. 42). I asked Dan to reserve it for me and to have Julian Hartnoll send me a photograph. As soon as I saw the photograph, I realized that this was one of Leighton's greatest drawings and I immediately agreed to buy it. Although it was expensive compared to other Leighton drawings at the time, within a few years average sheets by him were bringing the same price. I have never regretted buying this drawing, which remains one of my favourites in the collection. It taught me a lesson to never pass up something which you think is particularly good or important, just because it is expensive for that artist's work. If something is that good, eventually the market catches up and surpasses the price you paid.

In February 1986 I went with my future wife to Ottawa to meet her brother and his family. I called and tried to arrange an appointment with the prints and drawings department of the National Gallery. Although the department was apparently officially closed to the public because of the move into the new building, when I asked to see some of the very fine Pre-Raphaelite drawings in their collection, the voice on the phone immediately agreed to an appointment. This was my introduction to Dr. Douglas Schoenherr, then associate curator of European and American prints and drawings, who to my surprise shared my interest in the art

of this period. It was the beginning of a close friendship that has continued to this day. In 1989 Douglas gave me a copy of the catalogue *Master Drawings from the National Gallery of Canada* for the exhibition then being shown at the National Gallery of Art in Washington, D.C.[8] He had written the catalogue entries for the Victorian drawings in the show, and I very much enjoyed reading them. In fact it was my admiration for his catalogue entries that inspired me to try my hand at writing ones for the works in my own collection. When I started to do this, it was only for my own enjoyment and to allow me to learn more about my own collection. It certainly never occurred to me that one day they might be published. Fortunately I have managed to build up a good collection of reference books, exhibition catalogues, and auction-sale catalogues, so most of my entries were written at my leisure in the comfort of my own home. The catalogue entries published here have gradually evolved and have been under constant revision – one of the beauties of the modern word processor. Much new information on Victorian art has also become available, particularly in the last decade. It has therefore been an exciting time to be a collector and to have benefitted from all this recent scholarship. Lately I wonder if Douglas would have given me the *Master Drawings* catalogue if he had known what a monster he was going to create and that I would drag him out of retirement to help with this exhibition!

On February 21, 1988 Dan Perrin called and told me he had found at the Maas Gallery exactly the Albert Moore drawing I was looking for. I had wanted a Moore drawing for some time, and although I had had numerous chances to buy one, nothing had come along that matched exactly what I was looking for. I had told Dan that what I wanted was a very finished draped figure study in black chalk heightened with white. When the photograph arrived of the study for *A Reader* (cat. no. 53), it was indeed precisely what I had specified – very finished and very fresh, with the white chalk still very crisp. Again it was a premium price, but exactly what I wanted and I bought it without hesitation. I now own three other drawings by Moore, and an early gouache, and I think I have been fortunate with each of my purchases to obtain interesting works. The drawing of *Elijah Running to Jezreel before Ahab's Chariot* (cat. no. 49) I had seen and greatly admired earlier, but since it was so uncharacteristic of Moore, I had passed up the chance to buy it. Once I had an example of a more typical drawing in Moore's mature style, I was glad of the opportunity to add it to the collection, particularly because it shows so clearly the early Pre-Raphaelite influences on Moore's work. In November 1995 a very fine head study by Moore (cat. no. 52) came up for auction at Sotheby's, London. Unfortunately in early December a watercolour by F.G. Stephens (cat. no. 84) was being sold by Christie's, and I was forced to decide which I would try to buy. I opted for the Stephens, knowing that I would likely never get another opportunity, since this is the only work by him I have ever seen appear on the market. I hoped that one of the principal London dealers would buy the Moore so I would get a second chance at it. When I was in London in mid February 1996, I first checked with Julian Hartnoll to find that he had not bought it. I then went to the Maas Gallery. Rupert had indeed purchased it, but he still had not decided what price he was going to ask. I therefore requested the right of first refusal and ultimately this drawing also entered the collection. It is beautifully drawn and one of Moore's few works done on blue paper.

In February 1989 my wife and I travelled to London for a vacation. While there I became aware of a Walter Crane exhibition being held at the Whitworth Art Gallery, University of Manchester. Because I very much wanted to see this show, I took the train to Manchester, a city I had never visited. The Crane exhibiton was excellent and I enjoyed it very much. I then went to the Manchester City Art Gallery, which has a fabulous collection of Victorian art. In the late afternoon I walked to the Manchester Town Hall, hoping to see Ford Madox Brown's

mural paintings in the Great Hall. When I arrived I was stopped by a guard who told me: "Sorry mate – it's closed to the public this afternoon for a senior citizen's dance." He then added, half jokingly, "Unless, of course, you'd like to dance with the old lovelies." My desire to see Brown's murals must have been such that I don't suppose I hesitated more than a few seconds before I replied: "Of course, I would be delighted to dance with the ladies." I am not sure what the "old lovelies" thought about this young Canadian asking them to dance, but because the women greatly outnumbered the men, they were undoubtably happy to have any partner – even someone who dances as poorly as I do! This is probably the most unusual way anyone has ever viewed Madox Brown's murals. You will have to imagine me chatting to my elderly partners while casting furtive glances at the paintings as we danced by. Since I have only been back to Manchester once since then, to see the *Pre-Raphaelite Women Artists* exhibition in January 1998, it was a good thing I took advantage of this memorable and unique opportunity.

In late June 1989 I received a catalogue in the mail from the Maas Gallery about an exhibition entitled *Pre-Raphaelites and Romantics*, which included a watercolour study by Burne-Jones for *The Wedding Feast of Sir Degrevaunt* (cat. no. 8) for William Morris' Red House. Interestingly enough, earlier that year I had been at the Maas Gallery when this work arrived and Jeremy and Rupert had shown it to me. Although I had liked it from first sight, since I am particularly fond of Burne-Jones' watercolours from the 1860s, I had not talked to them about price at that time. I knew from experience they would not have priced it yet, and I just assumed I would be unable to afford it anyway. It was only when the catalogue arrived, and luckily Rupert had pencilled in the prices for each item, that I realized that I could afford this work. You can not imagine the agony I went through and another sleepless night worrying that someone else would have already bought it by the time I could phone the next morning. To my relief nobody had and I was able to acquire it.

In October 1989 I received a catalogue from the Shepherd Gallery in New York, *English Romantic Art 1850-1920*, which included an early gouache by Albert Moore entitled *The Elements* (cat. no. 50). Although the illustration was in black and white, it looked a very

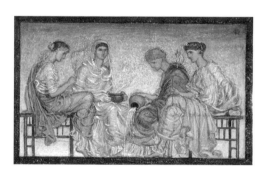

intriguing work. I knew it had come from Julian Hartnoll as part of its provenance was the so-called Pre-Raphaelite Inc. I therefore waited until the exhibition was over in New York, hoping it would not sell in the meantime, since I knew that to buy it there would be more expensive than in London. Happily it did not sell and Julian immediately sent me a colour photocopy. I particularly like this gouache because it is one of the first works done by Moore after he came into contact with Whistler and it shows the fusion of the classical and Japanese elements in Moore's work. It had been exhibited at the Dudley Gallery in 1866. I have a special interest in the Dudley Gallery, which served as the focus for the avant-garde artists associated with the nascent Aesthetic Movement, before the opening of the Grosvenor Gallery.

In June 1990 I got a phone call from Dick Fredeman saying the roof of his house was leaking and he needed to put on a new one as soon as possible to protect his library. He wanted to know if I was interested in buying his Burne-Jones coloured-chalk drawing of a female head. Although this was a very attractive drawing, I have to confess that the work I had always coveted from the first time I had visited him was a sketch by Millais for the headpiece of

"Locksley Hall" in the Moxon Tennyson (cat. no. 48). I mentioned to Dick my fondness for this work. I got the Millais I wanted and he got his roof, although I think I got the better of the deal. It remains another of my favourite items in the collection. Right after this I bought from the Maas Gallery two studies by Holman Hunt for "Recollections of the Arabian Nights" (cat. no. 35), also in the Moxon Tennyson. These works had been part of the Burt Collection sold at Sotheby's in 1985.

From October 1991 to April 1992 my family and I were in Oxford during my first and only sabbatical. This was a wonderful opportunity for me, not only professionally to undertake some research I had wanted to do for some time, but also to pursue my interests in Victorian art and architecture. Douglas Schoenherr came to visit us one day and he and I had

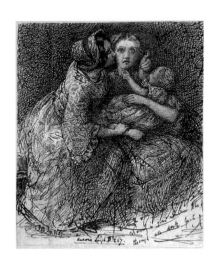

a most enjoyable time looking at Morris & Co. stained glass windows, examining drawings in the Ashmolean Museum, and visiting the Oxford Union to view the murals carried out by Rossetti and colleagues during the "jovial campaign." This latter was a big thrill for both of us and we found the murals not to be in quite as deplorable a state as we had always been led to believe. In my spare time I made some trips to London to the Witt library at the Courtauld Institute of Art, and the National Art Library at the Victoria and Albert Museum, where I did much of the preliminary research on provenance for my catalogue entries. In late March, soon before my family and I were due to return to Canada, I received a letter from Dan Perrin with a photocopy of a pen-and-ink drawing by John Brett for "Aurora Leigh" (cat. no. 4), that was coming up for auction at Phillips on April 6. Dan suggested that I should try to preview this drawing before I left England, so I made an appointment and went into London to see it. After viewing it, I agreed completely that this drawing was a tour de force and I decided that I would try to buy it if at all possible. I still feel it is the best drawing by Brett I have ever seen.

In late October 1992 I received the Christie's catalogue for a sale coming up on November 13. Included in it was something I had been looking for for some time – an early work by Walter Crane. This was a gouache entitled *The Earth and Spring*, which had been bought off the walls of the Dudley Gallery in 1875 by J.P. Heseltine. It epitomizes the "Poetry Without Grammar School" in which I am particularly interested. At the same sale I was also very pleased to buy Arthur Hughes' study for *Sir Galahad* (cat. no.

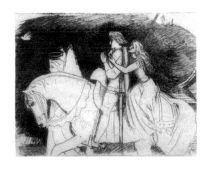

31), as a drawing on an Arthurian theme was exactly what I had been wanting by him.

In June 1993 I received Peter Nahum's latest catalogue *Burne-Jones – A Quest for Love*, which included John Roddam Spencer Stanhope's *The Wine Press* (cat. no. 83). As soon as I saw it, I knew this was precisely the Stanhope I needed for my collection. It had a distinguished provenance, having belonged to George Rae. More importantly, from my standpoint, it had been executed at the same period as Burne-Jones' *A Merciful Knight*, which it resembled structurally. Since I knew I could never own this wonderful Burne-Jones, I hoped to be able to acquire this early Stanhope instead. One could not find a better example of the

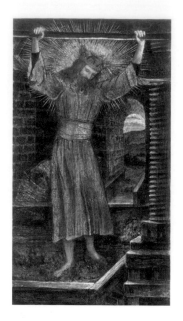

influence of the early Renaissance on an artist of the second phase of Pre-Raphaelitism. I again had a sleepless night wondering if someone had already bought it. I phoned Peter Nahum the next morning to find that the Tate Gallery had put a reserve on it, since they owned the later oil version. I asked Peter to give me the next chance on this work. I thought about it for another two weeks and then called Mr. Nahum back. I asked him to talk to the staff at the Tate on my behalf. I basically told him to tell them if they decided not to buy it, I would promise to lend it whenever they wanted it for an exhibition. I do not know whether that swayed their decision or not, but fortunately they decided not to buy it. The Tate immediately borrowed it from me to show with their oil version in an exhibition of drawings by Burne-Jones from their own collection.

In 1993 I lent a number of drawings and watercolours and a De Morgan plate to the exhibition *The Earthly Paradise: Arts and Crafts by William Morris and His Circle from Canadian Collections* organized by the Art Gallery of Ontario. In June my wife and I attended the opening of the exhibition, as well as the symposium sponsored by the William Morris Society of Canada. Here we met other lenders to the show and visitors, including Sandy and Helen Berger who by chance sat down next to us at lunch. The Bergers invited us to visit them in Carmel which we have now done on two occasions. It has been a pleasure to know a collector as knowledgeable and as enthusiastic as Sandy. Two of the best days of my life were the ones I spent with him looking at his splendid Morris collection. It was also during *The Earthly Paradise* exhibition that my wife and I became better acquainted with Rachel Moss, who has now become a close friend and my principal dealer. I knew Rachel somewhat previously, as I had always enjoyed visiting the Moss Galleries when she had a shop on the Brompton Road close to the Victoria and Albert Museum. Since she was by herself at *The Earthly Paradise* opening, Sharon and I invited her to join us and we socialized during the remainder of our time in Toronto. Because Dan Perrin had recently tragically died, Rachel agreed to be my agent in London. This has worked out very advantageously for me and if I have succeeded as a collector, much of the credit must go to Dan Perrin and Rachel Moss.

In January 1995 I purchased a small series of old Sotheby's Belgravia catalogues from Michael Bennett. In a catalogue for October 1, 1979 was a painting by William Bell Scott from 1866, being sold under the title *The Poet – An Idyll,* although I have subsequently identified its correct title as *The Arcadian Poet* (cat. no. 74). I thought when I first saw it that it was one of the more interesting works I had ever seen by Scott, because it showed an artist of an earlier generation responding to the work of the avant garde. I decided that if this picture ever came onto the market again, I would be interested in acquiring it. As luck would have it, it appeared in a sale a few months later at Sotheby's, London on March 29, 1995 and I bought it through Rachel Moss.

In September 1995 the annual meeting of the Victorian Studies Assocation of Western Canada was held in Saskatoon. The organizers of the conference had approached me early in 1995 asking me if I would be interested in curating a show of my collection for the Kenderdine Gallery, at the University of Sakatchewan, to coincide with their meeting. In conjunction with this exhibition, entitled *The Victorian Avant Garde,* I also organized another entitled *Illustrations by the Pre-Raphaelites and Associates* for the Special Collections Department of

the Main Library. This show focused primarily on illustrations of the 1860s period, and featured book and magazine illustrations and proof engravings from my own collection and that of the University of Saskatchewan. Curating these exhibitions was a challenge for me that I enjoyed, but I thought probably these would be the first and only ones I would ever do.

On October 27, 1995 I received a fax from Douglas Schoenherr telling me about two drawings he thought I might be interested in coming up for sale on November 1, 1995 at Sotheby's, New York, including Frederick Sandys' *King Pelles' Daughter Bearing the Vessel of the Sanc Graal* of 1861 (cat. no. 71). I was familiar with this drawing and had admired it ever since I had seen it illustrated in Betty Elzea's catalogue for the Sandys exhibition at the Brighton Museum and Art Gallery in 1974.[9] This drawing is one of Sandys' masterpieces and is another of my favourite works from the collection. It is the only work for which I have ever left a bid with an auction house, because I did not know anyone in New York I could ask to bid for me. You can not imagine my exhilaration when the auction house phoned to let me know I had bought it.

At Sotheby's, London, on November 6, 1996, the original oil sketch by W.L. Windus for *Too Late* (cat. no. 100) came up for sale. Because one seldom gets a chance to buy an original sketch for a work regarded as one of the minor masterpieces of the first phase of Pre-Raphaelitism, I was very happy when I proved to be the successful bidder. Although very small, it is truly a little gem. On July 8, 1998 I purchased a fragment of the unfinished painting by Burne-Jones entitled *Blind Love* (cat. no. 12) which had come up at auction at Christie's, London on June 25, 1998, but had been bought in. After the sale Rachel Moss phoned to say that it had not sold, but she thought it might be something that would interest me. She arranged for Christie's to send me a catalogue and a photograph, and we later put in an offer which was accepted. I not only liked the image, but the fact that it had been originally intended for William Graham, the Victorian collector I most admire, was an extra incentive. I have always wanted to own something from his collection

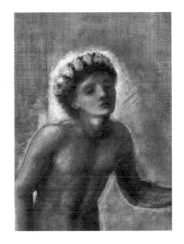

and this is likely as close as I will ever come. When I bought the painting, it was framed only by a strip of dilapidated liner, covered in green velvet, which did nothing to enhance the aesthetics of the work. Rachel Moss agreed to try to find a more suitable contemporary frame for it. I told her what I wanted was a plain gilt oak frame. I had been very pleased when she had previously found me perfect antique frames for two other works (cat. nos. 74 and 78). Each time I did not think she could do as well as she had the time before, but what she found always exceeded my expectations. The frame she found for the Burne-Jones was exactly what I wanted and it looks as if it has always belonged on the painting.

Three years ago David and Sheila Latham asked me if I would be willing to lend my collection for an exhibition to coincide with the William Morris symposium scheduled for Toronto in June 2000. I told them I was interested, but nothing further happened until January 1999 when I met with David Silcox, the Director of the University of Toronto Art Centre, while in Toronto to give a lecture to the William Morris Society entitled "All for Art: Confessions of a Pre-Raphaelite Collector". Some time later David approached Douglas Schoenherr asking him if he would be interested in writing a catalogue to accompany the exhibition. Douglas told him that there was not sufficient time for him to research and write the entire catalogue, and besides which I had already catalogued my collection and he was not

sure he could do it better. He therefore suggested that David ask me to do the catalogue. I had only shared my catalogue entries with a few close friends like Douglas, and I thank both Douglas and David for their vote of confidence in me. Writing these catalogue entries has truly been a labour of love, although it has taken a great deal of additional work to get them into a form suitable for publication. I hope you will enjoy reading them as much as I have enjoyed writing them. They have certainly fulfilled my initial primary objective, which was to learn more about my own collection. If just one young person sees this exhibition and develops a life-long interest in Victorian art because of it, the show will have been worthwhile from my perspective. In this year, the centenary of Ruskin's death, I can only hope that if he were alive to see this exhibition and read the catalogue, his comments would not be as harsh as those after seeing Millais' *A Dream of the Past* at the Royal Academy exhibition of 1857: "The change in his manner ... is not merely Fall – it is Catastrophe."[10]

1 Larkin, David : 1975.
2 Christian, John: 1989b.
3 Hill, George Birbeck: 1897, p. 174, letter of March 7, 1856.
4 Free, Renée: Art Gallery of New South Wales, 1975.
5 *Journal of William Morris Society*: Vol.XI, No. 2, pp. 3-4, 1995. *Daily Chronicle*: "Art, Craft, and Life. A Chat with Mr. William Morris", October 9, 1893.
6 Robertson, W. Graham: 1931, pp. 46-47.
7 Harvard Art Museum Review: Spring, 1994, Vol. III, No. 2, p. 10.
8 National Gallery of Canada, Ottawa:1988–89, cat. nos. 87-90, pp. 275-291.
9 Brighton Museum and Art Gallery: 1974, cat. no. 135, p. 35.
10 Cook, E.T., and Wedderburn, Alexander (Eds.): 1904, Vol. XIV, p. 107.

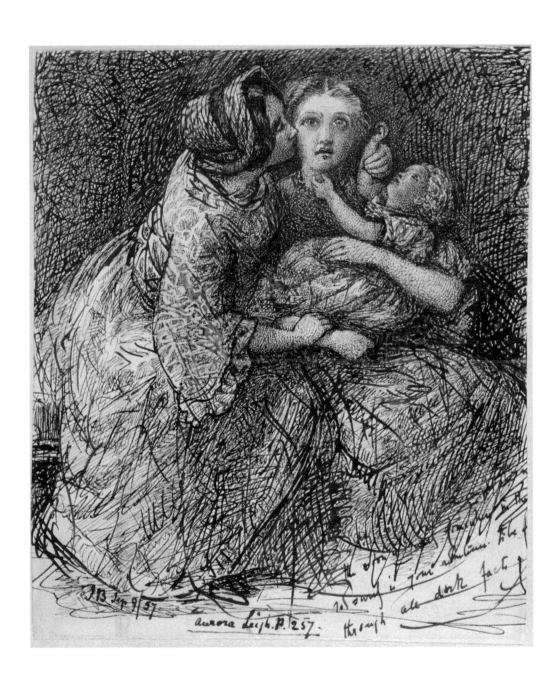

4 A Study of Two Women with a Child

JOHN BRETT

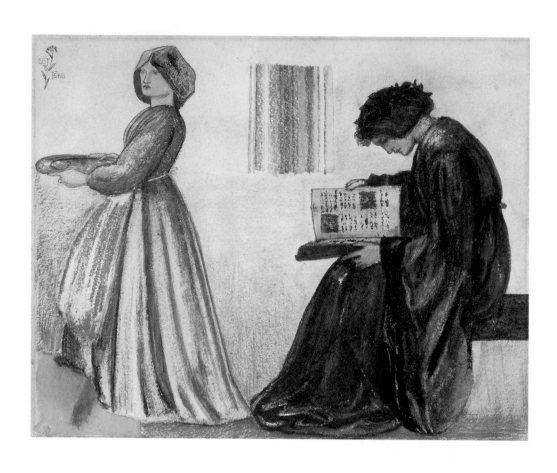

8 Study for "The Wedding Feast of Sir Degrevaunt"
SIR EDWARD COLEY BURNE-JONES

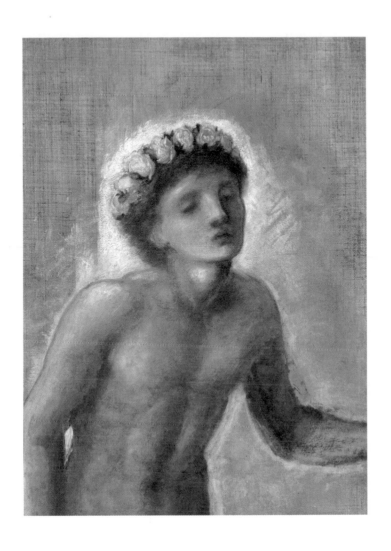

12 Blind Love
SIR EDWARD COLEY BURNE-JONES

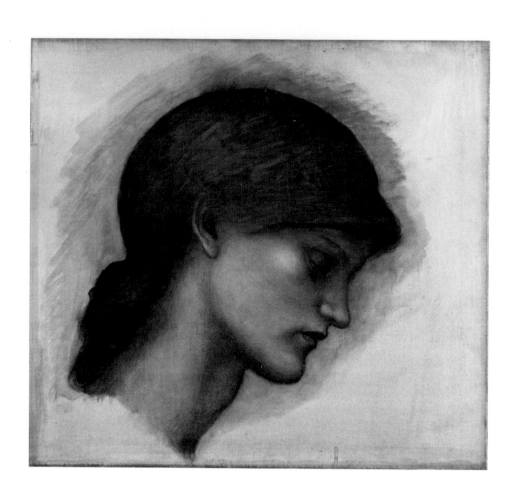

15 Study of the Head of Fortune for "The Wheel of Fortune"
SIR EDWARD COLEY BURNE-JONES

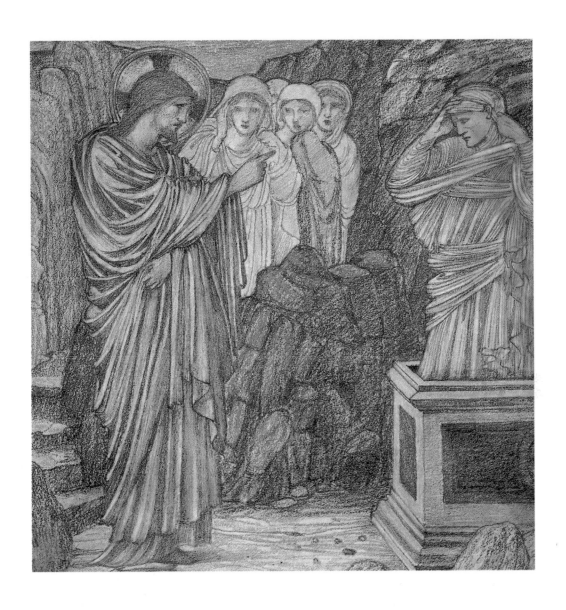

17 The Raising of Lazarus
SIR EDWARD COLEY BURNE-JONES

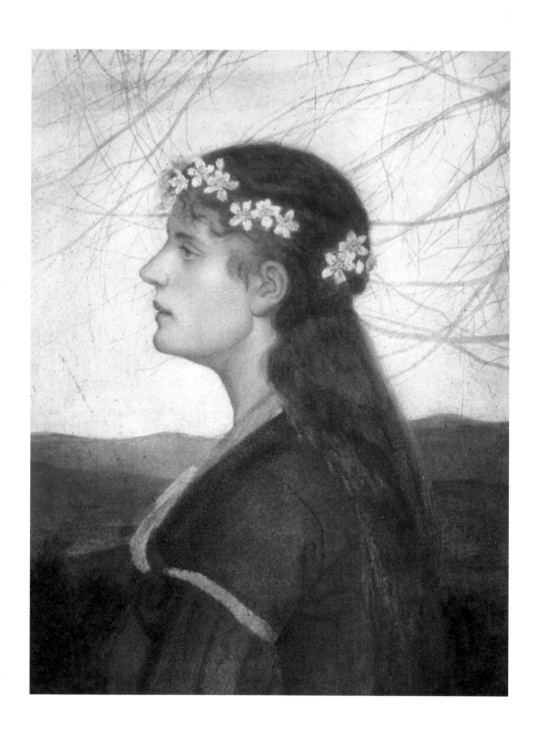

18 Mens Conscia Recti ("A Mind Conscious of Rectitude")
EDWARD CLIFFORD

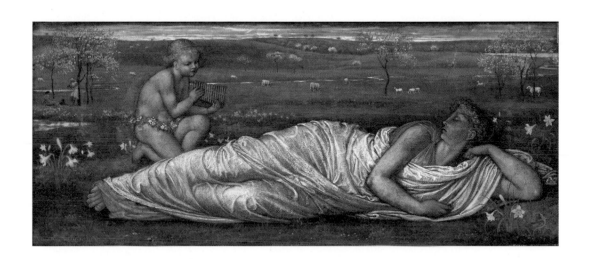

19 The Earth and Spring
WALTER CRANE

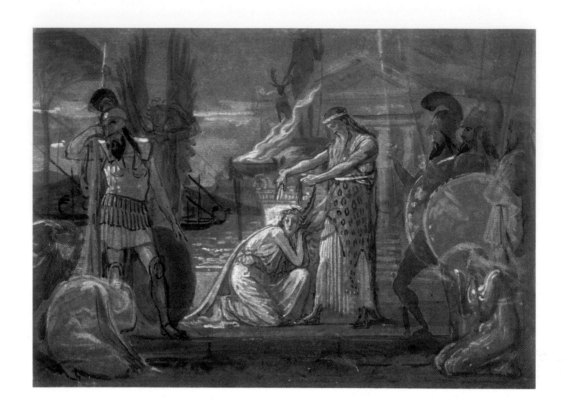

21 The Sacrifice of Iphigenia
WALTER CRANE

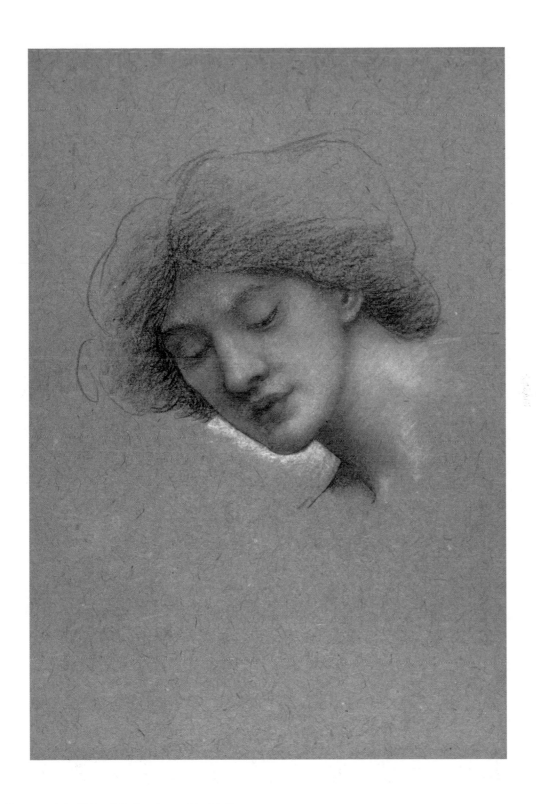

22 Head of a Girl for "The Daughters of the Mis,"
EVELYN PICKERING DE MORGAN

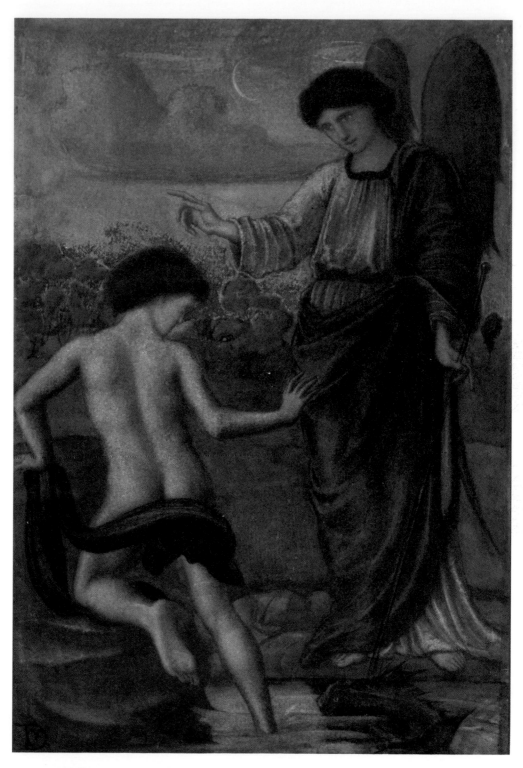

24 Tobias and the Angel at the River Tigris
WILLIAM DE MORGAN

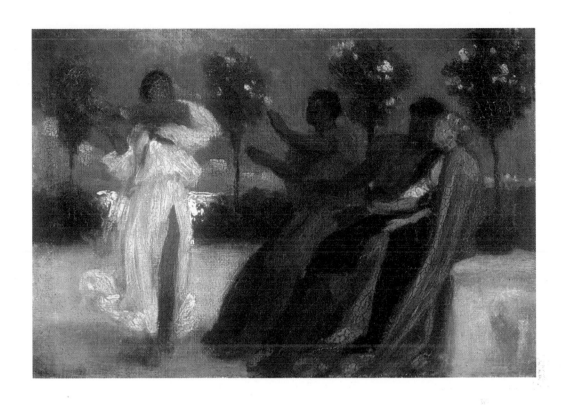

40 Oil Sketch for "Greek Girl Dancing"
LORD FREDERIC LEIGHTON

42 Study of the Head and Arms of Iphigenia for "Cymon and Iphigenia"
LORD FREDERIC LEIGHTON

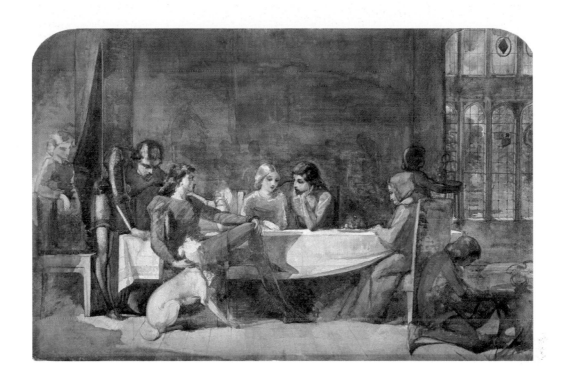

46 Lorenzo and Isabella

SIR JOHN EVERETT MILLAIS

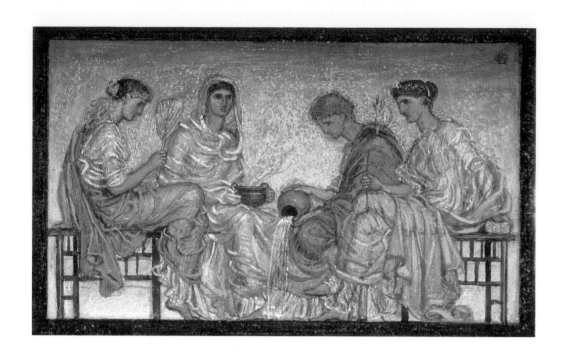

50 The Elements
ALBERT JOSEPH MOORE

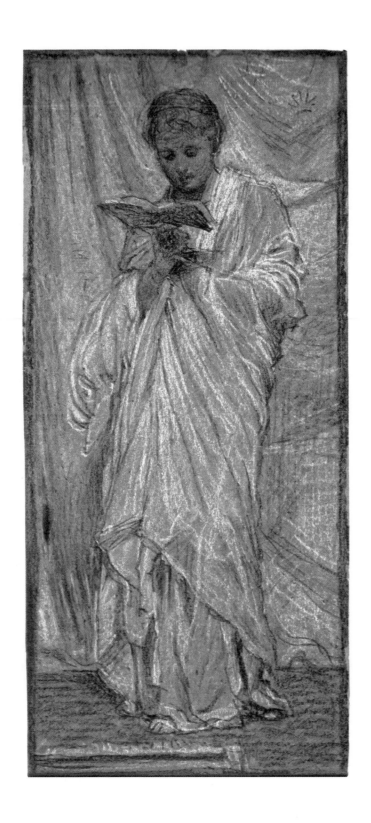

53 Classical Draped Figure Study for "A Reader"
ALBERT JOSEPH MOORE

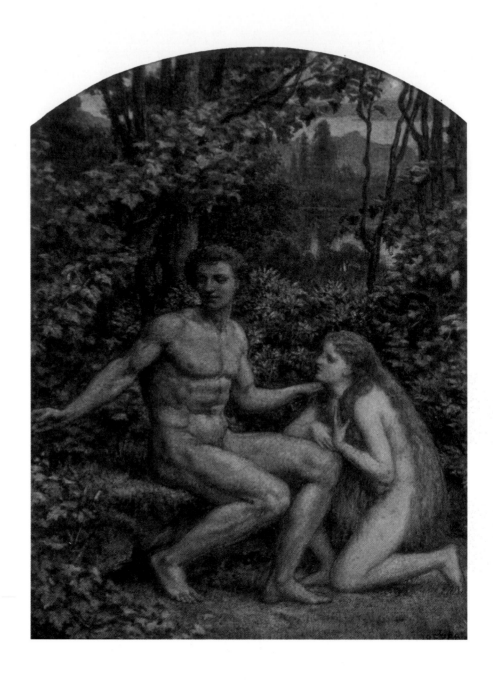

58 Obedience
EDWARD JOHN POYNTER

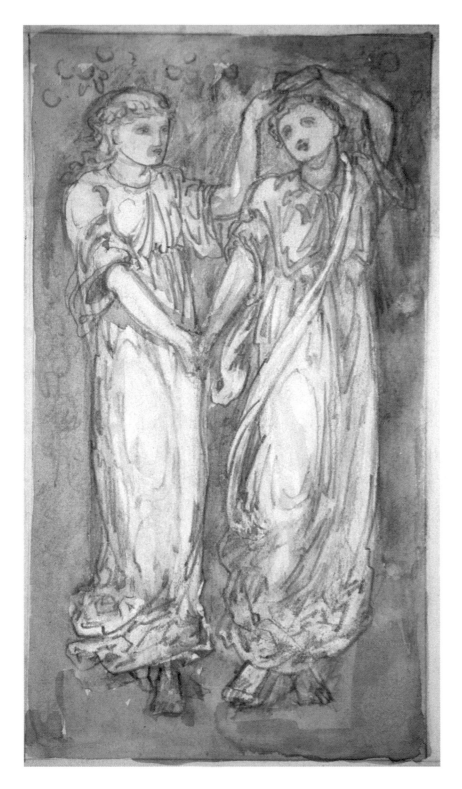

67 Study of Two Classical Maidens Dancing
THOMAS MATTHEWS ROOKE

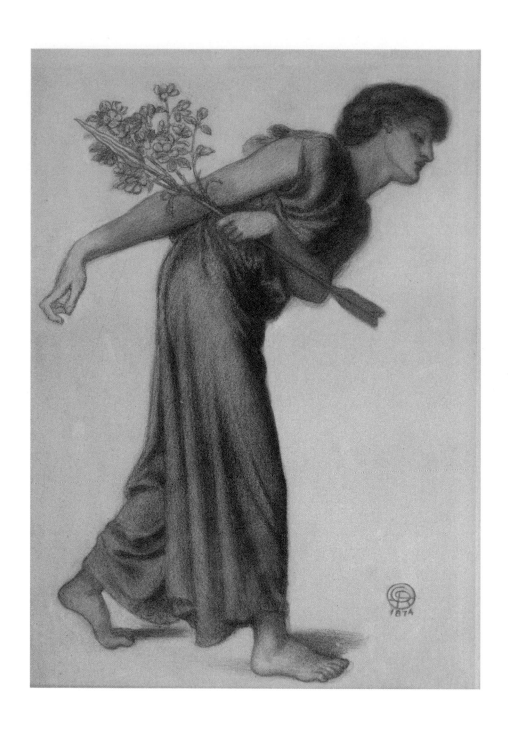

70 A Study of the Figure of Love for "Dante's Dream at the Time of the Death of Beatrice"
DANTE GABRIEL ROSSETTI

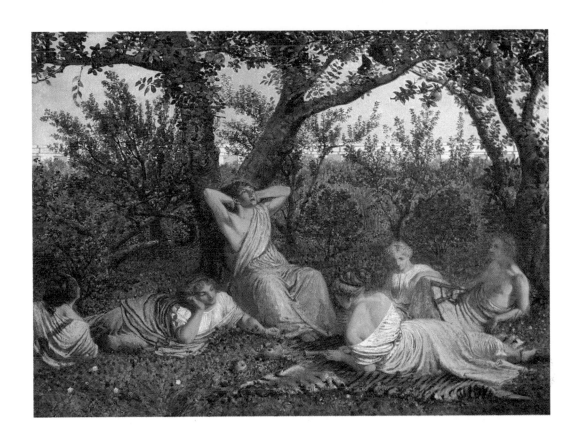

74 The Arcadian Poet
WILLIAM BELL SCOTT

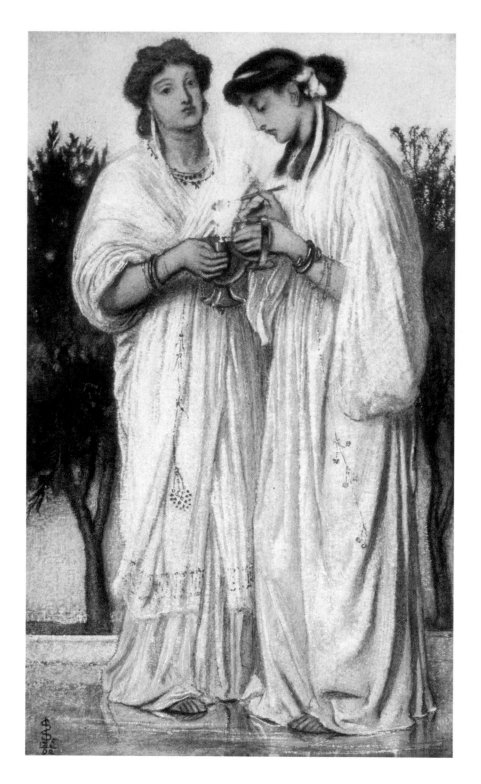

78 In the Temple of Vesta
SIMEON SOLOMON

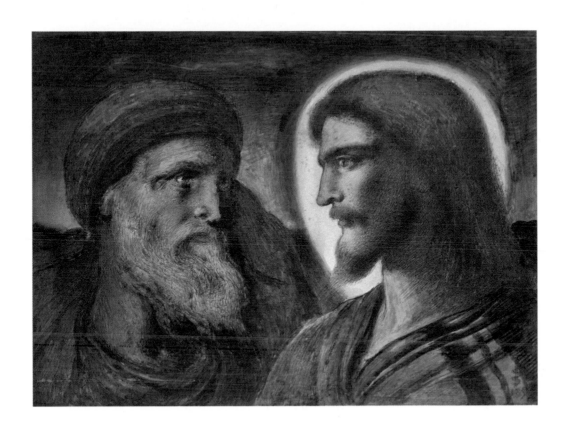

82 Christ and Peter
SIMEON SOLOMON

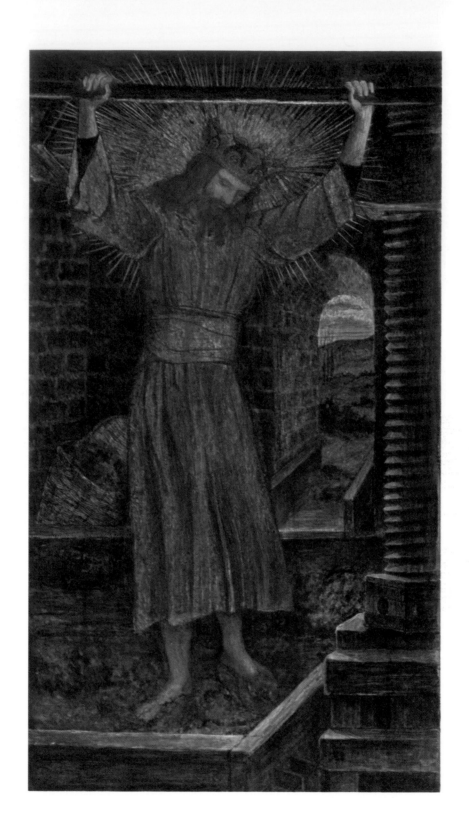

83 The Wine Press
JOHN RODDAM SPENCER STANHOPE

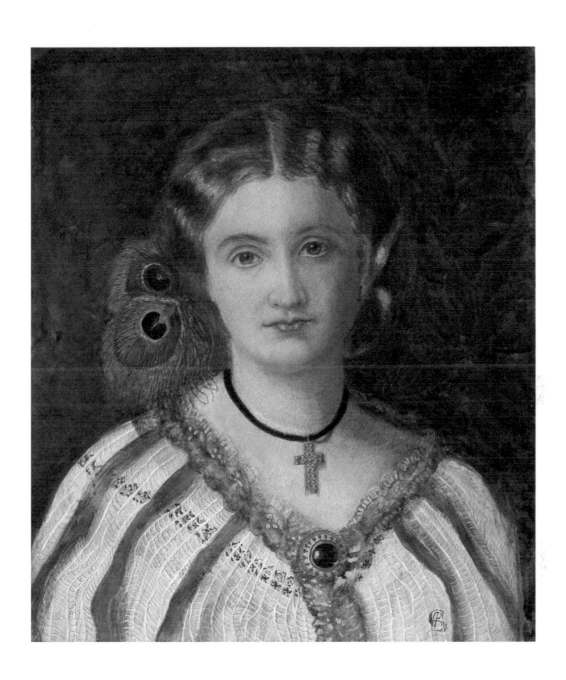

84 Portrait of a Young Woman
FREDERIC GEORGE STEPHENS

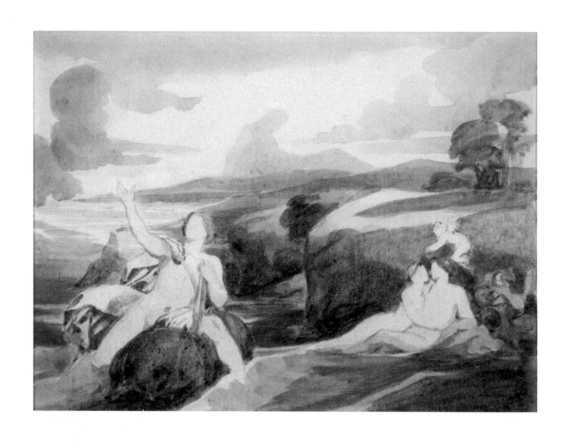

90 Colour Sketch for "Arion"
GEORGE FREDERIC WATTS

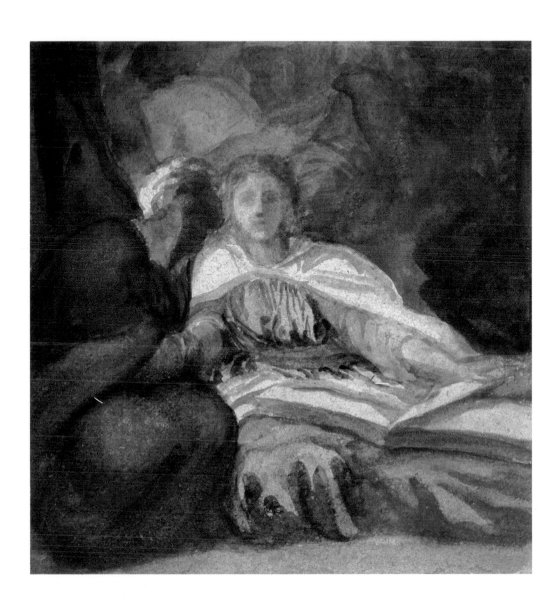

92 Colour Sketch for "Britomart and Her Nurse"
GEORGE FREDERIC WATTS

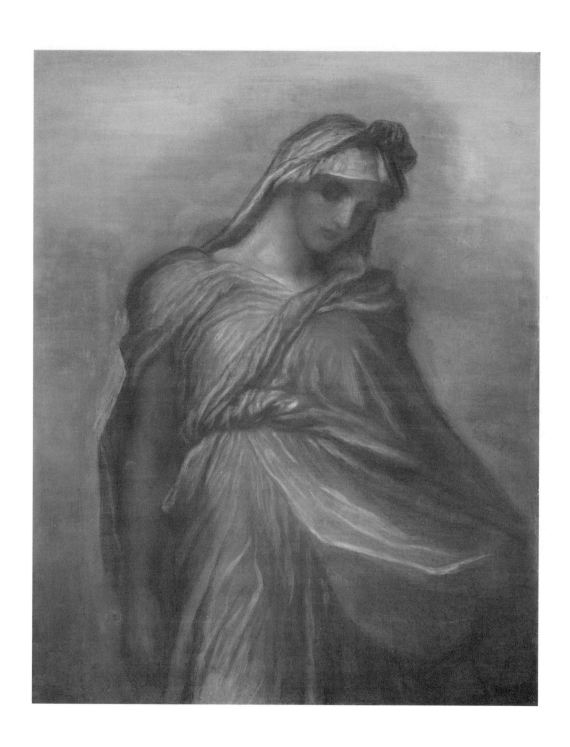

93 Study of the Figure of Death for "Time, Death and Judgment"
GEORGE FREDERIC WATTS

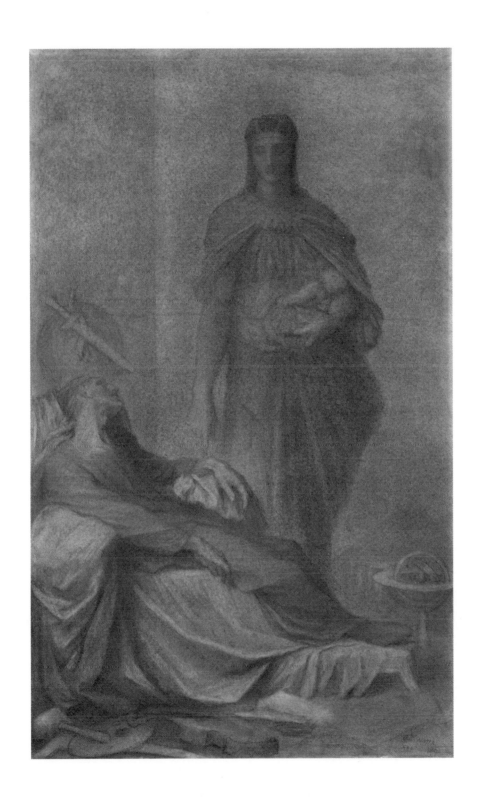

94 Study for "The Messenger"
GEORGE FREDERIC WATTS

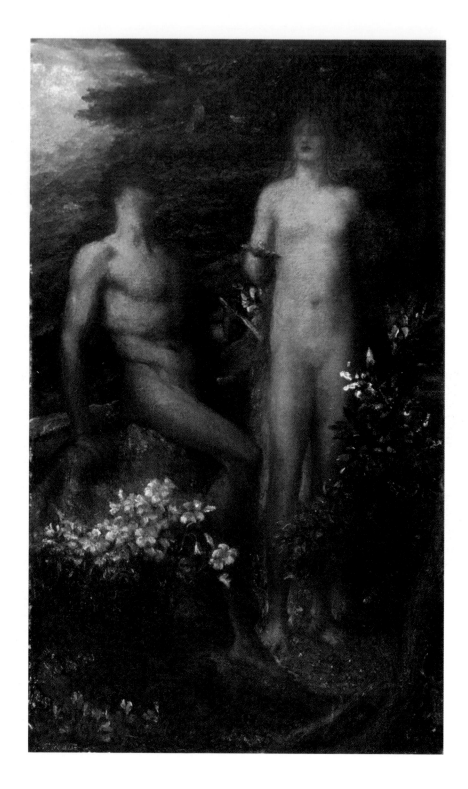

95 Adam and Eve before the Temptation

GEORGE FREDERIC WATTS

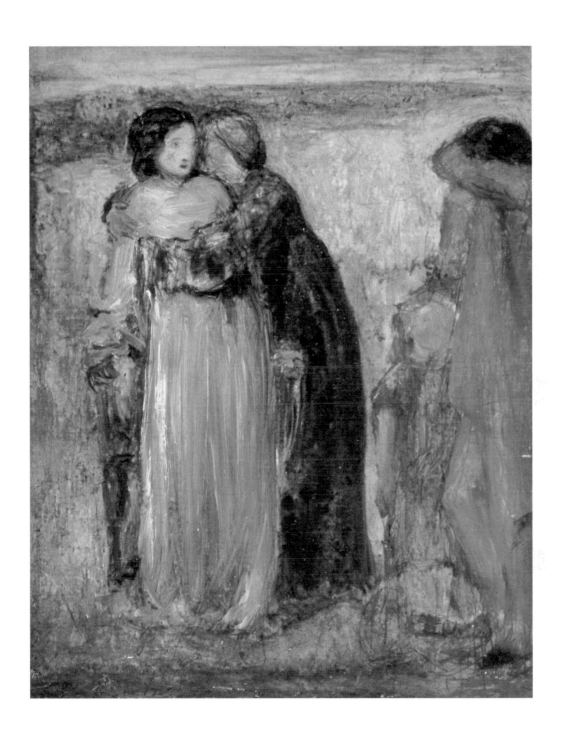

100 Oil Sketch for "Too Late"
WILLIAM LINDSAY WINDUS

Catalogue

Dennis T. Lanigan

SIR LAWRENCE ALMA-TADEMA (1836-1912)

Alma-Tadema was born on January 8, 1836 in Dronrijp in Friesland, The Netherlands, the son of a notary, Pieter Tadema. In 1852 he was accepted by the Antwerp Academy, where he studied under Gustave Wappers and Joesph Laurens Dyckmans. In 1859 he was chosen to enter the studio of Baron Hendrik Leys, the most highly regarded studio in Belgium at that time. There he completed his first major painting, *The Education of the Children of Clovis*, which was a great critical success when exhibited in Antwerp in 1861. In 1864 he exhibited *Pastimes in Ancient Egypt* at the Paris Salon, for which he won a gold medal. In 1870 Alma-Tadema moved to England, where his work was well received. He was elected an associate of the Royal Academy in 1876, and a full academician in 1879. He was awarded a knighthood in 1899. In 1905 the Order of Merit was conferred on him by King Edward VII. Alma-Tadema was only the third painter to receive this award. He died on June 28, 1912 and was buried in the crypt of St. Paul's Cathedral in London.

1 First Sketch for "The Vintage Festival," c. 1869

Graphite and black chalk on extended off-white paper; signed in ink, lower right and inscribed to *Mrs. J. Barrett* 9⅝ × 22 in. (24.3 × 55.8 cm)
PROVENANCE: Gift of the artist to Mrs. Jerry Barrett; by descent to Mrs. Eileen de Carteret; her sale, Christie's, London, October 23, 1984, lot 204.
LITERATURE: Blackburn, Henry G.: 1882, p. 47; Gosse, Edmund W.: 1882, p.82 (illus.); Dumas, F.G: 1883, pl. 21, before p. 83; *Christie's International Magazine*: Oct.- Nov., 1984, p. 67 (illus.); *Apollo*: No. 272, 1984, p. 20 (illus.); Swanson, Vern G.: 1991, no. 122, p. 37 (illus.); Becker, Edwin: 1996, pp. 17-18, fig. 8, p. 18; Dcan, Sonia: 1998, pp. 24, 27, and 33 n.15.
EXHIBITED: Grosvenor Gallery: 1882, cat. no. 287; Kenderdine Gallery: 1995, cat. no. 1.

Alma-Tadema's major early works are primarily concerned with Merovingian or Egyptian themes, but in the mid 1860s he, like many European artists, began to paint classical subjects. In 1865 the influential art dealer, Ernest Gambart, commissioned twenty-four paintings from Alma-Tadema, a contract which took nearly four years to fulfil. A large number of these paintings were classical subjects, characterized stylistically by the high finish, technical precision, and historical accuracy for which the artist was renown. In 1865 Gambart showed three paintings by Alma-Tadema at the French Gallery, the first time his work had appeared in London. When his first contract was successfully completed in the latter part of 1868, Gambart offered another contract for forty-eight pictures, to be divided into three classes based on their importance. In 1870, just before his move to London, Alma-Tadema completed *The Vintage Festival,* showing a procession in Pompeii devoted to Bacchus. Gambart immediately recognized that this painting was more important than anything Alma-Tadema had previously painted, not only in terms of size, but also in the number of figures and the design. Just before the completion of this painting Gambart gave a dinner to the artists of Belgium, with Alma-Tadema as the "guest of the evening". As well as a present of an inscribed silver goblet, he received a cheque for an additional £100 beyond the arranged price for *The Vintage Festival.* In a letter to William Holman Hunt of December 6, 1870 Gambart wrote that Alma-Tadema "has however finished one picture, 'The Vintage Fete'... which I fancy will be a hit and which I propose to get engraved by Blanchard."[1] It created a sensation when exhibited at the French Gallery in London in 1871.[2]

The painting is now in the collection of the Hamburger Kunsthalle in Hamburg, Germany. A smaller second version, completed in 1871, is in the National Gallery of Victoria, Melbourne. *The Vintage Festival* is the first of Alma-Tadema's many paintings dealing with the Roman religious festival or Bacchanalia dedicated to Bacchus, the god of wine. This festival had appropriated many of the elements of the Greek Dionysiac orgy, including the involvement of women devotees known as maenads in ancient Greece or bacchantes in Rome. The dancing bacchantes are likely based on dancing maenad relief figures, which are known from Roman copies of a Greek original that dates to the 5th century B.C.[3] Not surprisingly, Alma-Tadema's interest in the Bacchanalia did not escape censure from the critics. In 1883 John Ruskin wrote: "It is the last corruption of this Roman state, and its Bacchanalian phrenzy, which M. Alma Tadema seems to hold it his heavenly mission to pourtray [sic]."[4]

Michelle Bonollo feels *The Vintage Festival* was influenced by William Blake Richmond's *The Procession of Bacchus at the Time of the Vintage,* which Alma-Tadema would have seen at the Royal Academy exhibition in 1869.[5] Alma-Tadema had come to London from Brussels in the summer of that year to seek medical treatment from the noted physician Sir Henry Thompson. Edmund Gosse, Alma-Tadema's brother-in-law, later recalled that the artist had undertaken studies for *The Vintage Festival* in 1869 while in London.[6] In the finished painting Alma-Tadema treats the procession in a much more stately and restrained fashion than the reckless abandon shown by the bacchantes in the much more lively preliminary sketch. Bonollo has suggested that this may be because "Alma-Tadema had noticed that the classical school of painters arising in Britain 'stilled' their figures in order to explore the aesthetic possibilities of composition and form ... Whereas in the preparatory sketch referred to earlier the central figures wave their thyrsus and dance wildly, in the two final compositions the leading figures are restrained, and are segregated into orderly groups. The more unencumbered and enthusiastic Bacchic dancers are just barely visible between the pillars of the atrium."[5] The thyrsus, a well-known attribute of Dionysus, was a sharp spear the point of which was concealed by a pine cone. It was used by maenads to spear animals as powerful as leopards during Bacchanalian frenzies.[5]

Rough compositional studies by Alma-Tadema are very rare, and this is one of the few to survive. The final composition of the finished painting differs significantly from this first sketch. In the finished painting there is little impression of movement, which is typical of many of Alma-Tadema's procession scenes, reflecting other Aesthetic Classical painters like Leighton, Blake Richmond, and Walter Crane. The pose of the dancing woman, third from the left in the sketch, influenced a similar figure in *A Bacchic Dance* of 1871 and *Autumn* of 1877. Another dancing bacchante was chosen by Alma-Tadema to decorate the book to which Gambart's artist friends contributed designs.[7] Two additional studies for *The Vintage Festival* were shown at the Winter Exhibition of the Royal Academy in 1913.[8]

This drawing was given to Mrs. M. Barrett, the wife of the noted Victorian historical and genre painter Jerry Barrett, a close friend of Alma-Tadema's, whom he had first met in 1866. When Alma-Tadema moved to London in late 1870 he lived at No. 62 Avenue Road, Regent's Park, just a few houses along the street from his artist friends the Barretts at number 15.

1 Maas, Jeremy: 1975, p. 226.
2 Maas, Jeremy: p. 23. "Alma-Tadema's 'The Vintage Festival' was shown by his [Gambart's] successors at his old gallery in King Street from Monday 17 April, drawing reviews favourable enough to gladden the heart of Gambart in his self-imposed exile. The Art Journal indulged in hyperbole when it claimed in its May issue that it was 'in the best sense of the term, *great* ... it cannot fail to be regarded as amongst the most perfect examples of modern art; indeed, it may be said, of the art of any period'."
3 Barrow, Rosemary: in Becker, Edwin: 1996, cat. no. 46, p. 200.
4 Ruskin, John: "Classic Schools of Painting: Sir F. Leighton and Alma Tadema" in Cook, E.T. and Wedderburn, A.: 1908, Vol. 33, p. 322.
5 Bonollo, Michelle: "From Old World to New: English and Australian Responses to Sir Lawrence Alma-Tadema's *The Vintage Festival*" in Dean, Sonia: 1998, pp. 24, 27 and 30.
6 Gosse, Edmund W.: "Lawrence Alma Tadema, R.A." in Dumas, F.G.: 1883, p. 87.
7 Shepherd Gallery: 1989, cat. no. 1, on loan from the Maas Gallery, London.
8 Royal Academy: 1913, cat. no. 111, pencil, each 9 × 15 in., lent by the Misses Alma-Tadema.

2 Portrait of Laura Epps, c. 1870-71

Graphite on off-white wove paper; signed *L. Alma-Tadema*, lower right 7¼ × 5¼ in. (18.5 × 13.5 cm) - sight
PROVENANCE: Mrs. Edmund Gosse; anonymous sale, Sotheby's Belgravia, London, July 30, 1974, lot 334, bought W.H. Connell; anonymous sale, Christie's, London, July 22, 1986, lot 183.
EXHIBITED: Royal Academy: 1913, cat. no. 104; Kenderdine Gallery: 1995, cat. no. 2.

In 1863 Alma-Tadema married his first wife, a Frenchwoman, Marie Pauline Gressin de Boisgirard. She died from smallpox in 1869. In October 1870, due to the outbreak of the Franco-Prussian war, Alma-Tadema moved to England. To help support his family during the period of relocation he took on a number of pupils, including the seventeen-year-old Laura Theresa Epps. He had first met her on December 26, 1869 at a party at Ford Madox Brown's. She was the daughter of a London homeopathic physician, Dr. George Napoleon Epps, and from a family famous in Victorian times for the manufacture of cocoa. Alma-Tadema had apparently fallen in love with her the first time they met.[1] On July 29, 1871 they were married. It appears the marriage was a happy one. One wonders, however, if her family was initially pleased with the match. In an undated letter to Ford Madox Brown in August of 1871, D.G. Rossetti mentions that his assistant H.T. Dunn "tells me of having met the Epps's

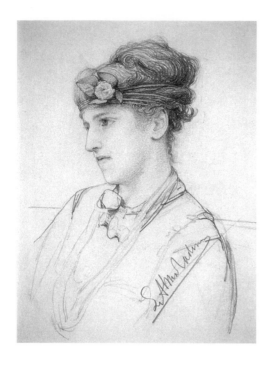

at the International, and says that they seemed quite crusty at Laura's marriage and spoke with sarcasm of Tadema. Marry come up, I say!"[2]

Julian Hawthorne has described Laura Alma-Tadema as "one of the London beauties, of good stature, auburn-haired, with the warm body of a milkmaid, and a gentle, Greek face."[3] She was frequently used by her husband as a model in his paintings. In 1871 he began a portrait of her, but this was left unfinished.[4] Laura Alma-Tadema was a well known artist in her own right and exhibited for many years, not only at the Royal Academy from 1873, but also at the Grosvenor and New Galleries. Prior to being taught to paint by Alma-Tadema, she had received drawing lessons from William Cave Thomas, William Bell Scott, and Ford Madox Brown.[5] In 1878 she was one of two women artists invited to contribute to the International Exhibition in Paris. She won a gold medal at the Berlin Exhibition of 1896, and a silver medal at the Paris Exposition Universelle of 1900. Lady Alma-Tadema died in 1909, and was buried at Kensal Green cemetery. This drawing once belonged to her sister, Ellen (Nellie) Epps, the wife of the noted critic Edmund Gosse. Dr. Vern Swanson thinks it was probably given to her about 1871, at a time when Alma-Tadema was attempting to ingratiate himself with the family.[6]

The handling of this drawing was probably influenced by Van Dyck's famous series of etchings of friends and fellow artists from the late 1620s and early 1630s, published under the title *Iconographia*. In his trial proofs Van Dyck drew the heads in detail while the area of the torso was very loosely handled. This same series had inspired Whistler's similar etchings of friends and associates done in 1859-60, such as his famous portrait of the sculptor Drouet.[7] A more recent source of inspiration for these artists could have been portrait drawings by Ingres which combined faces finished in exquisite detail with more loosely sketched bodies.[8]

1 Maas, Jeremy: 1975, p. 226. In a letter to William Holman Hunt of December 6, 1870 Gambart writes: "Tadema went last Boxing day to a Danse [sic] at Maddox [sic] Brown's, fell in love at first sight with Miss Epps, the Surgeon's daughter, & is going to marry as soon as she names the day – it plays havoc with his painting; he cannot turn to work since."

2 Doughty, O. and Wahl, J.R.: 1967, Vol. III, letter 1147, pp. 971-972.

3 Hawthorne, Julian: 1928, p. 123. Quoted in Maas, Jeremy: 1984, p. 123.

4 Swanson, Vern G.: 1977, p. 136, cat. no. XC.

5 Christie's, London: *Important Victorian Pictures*, October 24, 1980, lot 68, Lawrence and Laura Alma-Tadema, *The Epps family screen*, 1870-71. This screen seems to have been started by Lawrence Alma-Tadema as a means of teaching Laura how to paint. William Cave Thomas, William Bell Scott, and Ford Madox Brown were all intimates of the Pre-Raphaelite circle. Letitia Bell Scott, William Bell Scott's wife, had been at school with Laura's mother Ellen Epps. It was William Bell Scott who introduced the Epps to members of the Rossetti circle.

6 Swanson, Vern G.: personal communication, letter dated November 23, 1999.

7 Lochnan, Katharine A.: 1984, pp. 102-104.

8 Ksander, Yael: Miriam and Ira D. Wallach Art Gallery, 1995, cat. no. 70, pp. 121-123.

3 Study of a Draped Reclining Female Figure, undated

Graphite on off-white wove paper, taken from a sketchbook; signed by Miss Anna Alma-Tadema with the initials "LAT", lower right 4⅞ × 7¾ in. (12.3 × 19.7 cm)

PROVENANCE: ? Misses Anna and Laurence Alma-Tadema; anonymous sale, Sotheby's Belgravia, March 25, 1980, lot 28; Julian Hartnoll, London; Christie's, London, July 21, 1987, part of lot 7, bought Abbott and Holder, London; bought Roger Plant, London; sold back to Abbott and Holder in 1992; purchased March 17, 1992.

EXHIBITED: ? Royal Academy: 1913, cat. no. 115 (iii), lent by the Misses Alma-Tadema; Kenderdine Gallery: 1995, cat. no. 3.

This rough study is one of a number of surviving works from a travel sketchbook, of which all the drawings were later monogrammed by Alma-Tadema's daughter Anna.[1] This drawing, although characteristic of those found in his sketch-books, is very different from his more elaborate highly finished drawings, and is reminiscent of studies by the Viennese Symbolist painter Gustav Klimt. This drawing does not appear to correspond exactly to any figure found in a painting by Alma-Tadema, and Vern Swanson doubts that it was used for any specific picture.[1] Similar reclining figures can be found in many of Alma-Tadema's compositions, including *The Dinner*, the first version of which dates to 1873, *The Favourite Poet* of 1888, and *In a Rose Garden* of 1889. The pose of the figure in this drawing may have been inspired by the famous ancient Greek sculpture of Ariadne. Although the original sculpture is lost, several versions exist in Roman copies, including one in the Vatican Museum, Rome.[2]

Alma-Tadema's working drawings are rare, unlike his fellow Aesthetic Classicists Leighton, Poynter, and Moore, who followed a more academic tradition with many preliminary drawings for major compositions, including both figure and drapery studies. In some of Alma-Tadema's paintings, in fact, he did not even use a preliminary charcoal sketch on the prepared ground. Instead he worked directly onto the white canvas with siennas, earth greens, and ochres, trying to form groups of figures and spatial relationships, a process which continued in a state of flux until he was satisfied with the composition.[3] Many of the drawings by Alma-Tadema that survive are not preparatory, but are records in fine pencil of a head or a figure done for pleasure, after he had already perfected them on canvas or panel.[4]

1 Swanson, Vern G.: Personal communication, letter dated November 23, 1999.
2 Hobson, Anthony: 1980, pp. 104-105. The sculpture from the Vatican is reproduced as fig. 92, and a Victorian copy in alabaster is reproduced as fig. 93.
3 Swanson, Vern G.: 1977, p. 56.
4 Treuherz, Julian: "Introduction to Alma-Tadema", in Becker, Edwin: 1996, p. 17. One such example of this type of drawing, entitled "Ask me no more", from 1906, was reproduced as fig. 4, p. 16. A series of such drawings sold at Sotheby's, London, *Victorian Pictures*, November 2, 1994, lots 209 - 213, purchased by Peter Nahum at the Leicester Galleries.

JOHN BRETT (1831-1902)

John Brett was born on December 8, 1831 near Reigate, Surrey, the son of an army veterinary surgeon attached to the 12th Lancers. In 1851 he began receiving art lessons from J.D. Harding, and also took lessons in drawing from Richard Redgrave. He entered the Royal Academy Schools in 1853. His early work was influenced by the writings of John Ruskin, particularly the fourth volume of *Modern Painters*. In May 1853 he had his first contact with the Pre-Raphaelite circle, when he was introduced to Millais and Holman Hunt at the home of the poet Coventry Patmore. In the summer of 1856 Brett travelled to Switzerland where he met J.W. Inchbold and watched him work on *The Jungfrau, from the Wengern Alp*. Inchbold's work was a revelation to Brett and changed the direction of his art. Brett painted the *Glacier of Rosenlaui* in Switzerland, which D.G. Rossetti later arranged to show to Ruskin, who was not yet acquainted with Brett. In September 1857 Brett exhibited the *Glacier of Rosenlaui* at the first exhibition devoted entirely to the Pre-Raphaelites, held at No. 4, Russell Place, Fitzroy Square. In 1858 Brett exhibited at the Royal Academy his most famous Pre-Raphaelite picture, *The Stonebreaker*, which received high praise from Ruskin. In the early 1860s Brett began to have less contact with the inner Pre-Raphaelite circle. After 1863 his work moved away from the minutely detailed Pre-Raphaelite style and began to broaden, although retaining a highly wrought finish and brilliant colouring. He also began to abandon landscape subjects to concentrate on coastal scenes and seascapes. In 1881 he was elected an associate member of the Royal Academy, although he never became a full member. On January 7, 1902 he died at Putney.

4 A Study of Two Women with a Child, 1857

Pen and two different brown inks on light tan wove paper, laid down; signed with initials *JB*, and dated *Sep. 9/57*, lower left. Extensively inscribed, including *Aurora Leigh. P. 257*. On the verso of the old frame was this inscription: "This little pen and ink drawing was made by my father John Brett A.R.A. when he was twenty-five years old, just after leaving the Royal Academy Schools. It was the year this was also made that he was first brought before the British public by the picture known as 'The Storebreaker'. Given to Nellie Chaplin, by Lillian & Jasper Brett, Xmas 1908." 6⁹⁄₁₆ × 5⁷⁄₁₆ in. (16.8 × 13.9 cm)
PROVENANCE: Lillian and Jasper Brett; given to Nellie Chaplin in 1908; anonymous sale, Phillips, London, April 6, 1992, lot 58.
LITERATURE: Hickox, Mike: 1995, p. 8.
EXHIBITED: University of Lethbridge Art Gallery: 1993; Kenderdine Gallery: 1995, cat. no. 5.

John Brett, although usually thought of as an important Pre-Raphaelite landscape artist, originally intended to be a figure painter. His first exhibits at the Royal Academy consisted of three portraits, including one of the wife of Coventry Patmore. His best known figural work, *Lady with a Dove*, dated 1864, is in the collection of the Tate Gallery, London. Even his most famous Pre-Raphaelite painting, *The Stonebreaker*, contains the depiction of a child-labourer.

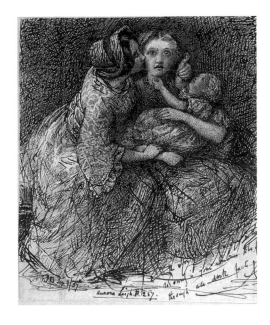

This drawing, dating from 1857, is arguably one of Brett's finest. It is similar in style and quality to Rossetti's best works in pen and ink from this period, which may have influenced it. In 1857 Brett's friendship with Dante Gabriel Rossetti and his family was at its height.[1] After this time it appears that only William Michael Rossetti kept on good terms with him. There is some speculation of a romantic relationship between Brett and Christina Rossetti. Christina apparently refused his proposal of marriage in 1857, which is said to have inspired her poem, "No thank you, John", even though this poem was written later, in March, 1860.[1] Not only did Christina have an aversion to Brett, but it is well known that her brother Gabriel also came to have a strong personal dislike for him. In Arthur Munby's diary for May 12, 1863 he records a violent attack by Rossetti on Brett.[2]

John Brett apparently drew several works illustrating Elizabeth Barrett Browning's *Aurora Leigh*. On October 7, 1857 he wrote from Dorking to his sister Rosa Brett: "I will send you *Aurora Leigh* but beg you will not keep it more than a fortnight. I am sure you will be very glad to read it. I can't tell you how much I admire it – it is beyond admiration – a Divine book. I have only slightly read it once, and begun it a second time, but I got it chiefly to draw out of, this is the reason why I gave you such a short lease of it. You can read it through in a couple of days or so if you try – you can read it again another time, as it belongs to me."[3]

It is possible Brett did drawings based on *Aurora Leigh* with the possibility of book illustrations in mind. On March 27, 1857 D.G. Rossetti wrote to Thomas Woolner: "I want to introduce you to Linton the engraver who would like to know you, and has a project for an illustrated Mr. & Mrs. Browning to be *done solely* by ourselves & under our control. You ought to join, with portraits certainly & I think with designs too. Ought you not? The affair had better not be spoken of to anyone yet, except Hunt if you should see him – indeed no one I think till Linton has spoken to Chapman & Hall."[4] This project was never carried out, but Rossetti may also have spoken about the possibility to Brett. *Aurora Leigh* certainly might have been one of the works chosen to be illustrated. In 1860, in fact, Rossetti was asked by Chapman & Hall to be the sole illustrator for an edition of *Aurora Leigh*, but this project also came to nothing.[5]

Aurora Leigh was much admired by members of the Pre-Raphaelite circle. William Michael Rossetti, in a letter to W.B. Scott of January 4, 1857 wrote: "*Aurora Leigh* was sent to Gabriel, (as also to Woolner) by Mrs Browning herself; and both of them are unboundedly enthusiastic about it. I have read as yet something less than two books of it, stuffed and loaded with poetic beauty and passionate sympathy and insight."[6] In a follow-up letter of February

17, 1857 W.M. Rossetti wrote: "*Aurora Leigh* I am still reading. It is a most wonderful thing. One scarcely knows at what point to stop one's enthusiasm, the wealth of poetic thought and sympathy is so magnificent, and yet one feels that there is a certain excess in it. Ruskin calls it the most splendid thing in the English language."[6] Despite the admiration of the Pre-Raphaelites for this book, it appears that only Arthur Hughes painted a work based on it.[7]

1 Hickox, M.S.H.: 1985, p. 105.
2 Hudson, Derek: 1972, pp. 160-161. "For when we came to talk of Brett about whom he knew Ralston and myself to be interested, he spoke with so much unfairness & malignanty of Brett as a man and as a painter … Brett's opiniative and enteté; true: therefore Rossetti called him insufferable, ignorant, and (with unconscious irony) the very opposite of himself (!): Brett paints landscapes & Rossetti ideal portraiture; therefore Rossetti called him a stupid literalist, and said that he had 'no more eye for colour than a pig'."
3 Hickox, Mike: 1995, p. 5.
4 Woolner, Amy: 1917, pp. 132-133.
5 Fredeman, William E.: 1996, p. 11. The fact that Rossetti failed to do these illustrations was not due to a lack of admiration for the book, which he described as "almost beyond anything for exhaustless poetic resource" and "an astounding work, surely".
6 Peattie, Roger W.: 1990, letter 45, p. 73, and letter 47, p. 77.
7 Roberts, Leonard: 1997, cat. no. 46, p. 148, *Aurora Leigh's Dismissal of Romney*, 1860, oil on panel, 15¼ × 12 in.

FORD MADOX BROWN (1821-1893)

Brown was born on April 16, 1821 at Calais, the son of a ship's purser. His early years were spent largely on the continent, except for occasional visits to England to visit relatives. He received a sound academic art training, initially at Bruges under Albert Gregorius, then at Ghent under Pieter van Hanselaer, and finally from 1837-39 at the Antwerp Academy under Gustave Wappers. In 1844 he settled in London for the first time. In 1845 he visited Rome. Important new influences occurred as a result of this visit that changed the direction of his art, including the Holbeins he saw en route in Basle, the paintings of the Italian Old Masters in Rome, and the works of the German Nazarenes, Cornelius and Overbeck. His first works after his return to England in 1846 included *Chaucer at the Court of Edward III* and *Wycliffe Reading his Translation of the Bible to John of Gaunt*. These were painted in his new naturalistic style with daylight effects and a delicate fresco-like palette. In March, 1848 Rossetti applied to him for painting lessons, initiating a close friendship that was to last until Rossetti's death in 1882. Through Rossetti he met the other members of the Pre-Raphaelite Brotherhood. Although Brown was never a member, he was in close sympathy with them, and both influenced, and was influenced by their work. In 1851 he painted *The Pretty Baa-Lambs*, his first major landscape painted out of doors, which showed a new direction in terms of light and brighter colours. Brown's work received little public recognition in the 1850s and these were financially difficult years. After 1853 Brown ceased to exhibit at the Royal Academy, although he continued to show elsewhere, including the provincial societies. He won prizes at the Liverpool Academy in 1856 and 1858. In 1858 he began to acquire important patrons among the merchant class, including James Leathart, George Rae, B.G. Windus, and John Miller. In 1861 he was a founding member of Morris, Marshall, Faulkner & Co., for which he designed stained-glass cartoons, tiles, and furniture. In 1865 he held a solo exhibition of his principal works at the Burleigh Gallery, London. A period of relative prosperity lasted until 1874, due to new patrons such as W. Craven, Charles Rowley, and J.H. Trist. His style became

influenced by Rossetti's later Aesthetic works. In 1876 *Chaucer* was purchased by the Sydney Art Gallery, his first work to enter a public collection. In 1878 Brown was commissioned to create mural decorations for the Manchester Town Hall, which continued to be his chief occupation until his death, in London, on October 6, 1893.

5 Study of the Head of Cordelia, c. 1844

Pen and brown ink on light tan paper; inscribed in Brown's hand, on the lower margin, *Cordelia. Sir, do you know me?* KING LEAR 5⁹⁄₁₆ × 4½ in. (14.1 × 11.4 cm)
PROVENANCE: Beth Lipkin, The Little Gallery, London; purchased August, 1985.
EXHIBITED: Kenderdine Gallery: 1995, cat. no. 6.

In 1843-44, while in Paris, Brown executed a series of sixteen pen-and-ink drawings, based on Shakespeare's *King Lear*, "as remarkable for their nervous, expressive line and inventiveness as any of the century and the first to announce Ford's distinctive quirky genius."[1] These designs were used later, at intervals, for paintings or large cartoons. One of them formed the basis for the etching *Cordelia Parting from her Sisters* for *The Germ* in 1850. The first version of

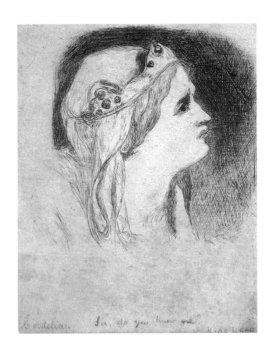

Cordelia at the Bedside of Lear was begun in November, 1848 and completed in March, 1849. *Cordelia Parting from her Sisters*, the next subject to be painted, was completed in 1854. *Cordelia's Portion* exists in several versions, the first of which was planned in 1863, and completed initially as a watercolour, dated 1866-72. In 1867 an oil version was begun, which was completed in 1875.

This drawing does not appear to relate directly to any of the sixteen early pen-and-ink designs, or to any of the finished paintings. The face, however, is characteristic of Brown's early work, so it is likely to have also been executed in Paris. The sixteen early pen-and-ink designs are now at the Whitworth Art Gallery, Manchester.[2] A number of these other early drawings in pencil, pen and ink, and black chalk for the *King Lear* series are in the collection of the Birmingham City Museum and Art Gallery.[3] A pencil study for *Lear and Cordelia* is in the Fogg Art Museum, Harvard.[4]

The face in this drawing bears a remarkable similarity to that of Desdemona in J. E. Millais' painting *Othello and Desdemona* of the early 1840s.[5]

1 Newman, Teresa and Watkinson, Ray: 1991, p. 17.
2 Whitworth Art Gallery: 1972, cat. nos. 7-22, all pen and brown ink.
3 Birmingham City Museum and Art Gallery: 1939, cat. nos. 754'06, 755'06, 756'06, 757'06, and 758'06, pp. 29-30.

4 Fogg Art Museum: 1946, cat. no. 3, p. 21, pencil, 7⅛ × 9¾ in.
5 Poulson, Christine: 1980, p. 249, no. 41, panel, 33 × 23 cm, fig. 28, p. 248, collection of The National Trust, Wightwick Manor, Wolverhampton.

6 The Sacrifice of Zacharias, 1867

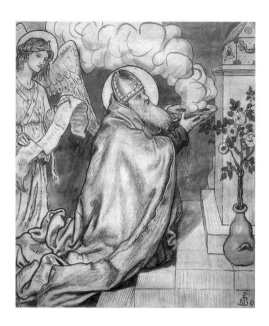

Brush and grey and black wash, over graphite, on off-white wove paper; signed with monogram and dated *67*, lower right; inscribed by Brown at the bottom, *This cartoon is the property of the Artist F. Madox Brown, Copyright for stained glass only granted to Morris & Co.* 20¾ × 18¼ in. (52.8 × 46.4 cm)

PROVENANCE: Ford Madox Brown's estate sale, London, T.G. Wharton, auctioneer and estate agent, May 31, 1894, lot 260; Allan F. Vigers by 1896; anonymous sales, Christie's, South Kensington, London, October 15, 1992, lot 8; Bonhams, London, May 14, 1993, lot 21, bought Daniel Perrin, London; purchased May, 1993.

LITERATURE: Hueffer, Ford Madox: 1896, p. 446; Bendiner, Kenneth: 1998, p. 119.

EXHIBITED: New Gallery: 1896a, cat. no. 452; National Gallery of Canada: 1994, not in catalogue; Kenderdine Gallery: 1995, cat. no. 7.

Ford Madox Brown was one of the most important stained-glass designers for the firm of Morris, Marshall, Faulkner & Co., and between 1862 and 1874 he produced almost 130 designs.[1] In 1865, in the preface to his catalogue for *Exhibition of WORK and Other Paintings*, held at the Burleigh Gallery, London, Brown stated that what he required in a good stained-glass design was "invention, expression and good dramatic action." Nineteen cartoons for stained glass were included in this exhibition, which indicates the importance he attached to his design work. Brown, unlike the other designers for the firm, retained his original cartoons as his own property. This particular cartoon was included in the estate sale held after his death. Brown's stained-glass design work for the firm was unique in its use of vigorous dramatic action. It is regrettable that the arguments that occured upon the breakup of the original partnership, and its reorganization into Morris & Co., deprived it of a designer of such formidable power.

In 1896 *The Magazine of Art*, in a "Note on the Cartoons of Ford Madox Brown", discussed Brown's work in this area: "For the rest, with all their faults of draughtsmanship and sometimes lack of dignity of form (though never of sentiment) the all-pervailing merit of these designs is the elevated sense of style with which they are saturated. The limitations of Madox Brown's art often included a curious lack of beauty, notwithstanding the exquisite passages that might be contained in the selfsame work – an irritating sacrifice, or omission, of dignity in some detail, or in a single figure of a composition otherwise overwhelming in its lofty inspiration. At times, Madox Brown revealed himself as the Bunyan of the brush –

homely, sincere, and convincing; yet to those who cannot appreciate his tremendous qualities, the greatness of his design is lost in the looseness of his drawing, the wilful inattention to *les convenances artistiques*, and the excess of individuality which often substitutes grotesque-ness or caricature for expression and character … In this series, then, we have an iconography, so to say, of Madox Brown's merits and failings as a designer. But it must be borne in mind that the beauties infinitely outweigh the faults; and that, moreover, these shortcomings are not such, by their very obviousness, as can hurt the student, while the excellences are of the kind to exert the best and highest influence on his imagination and his art. There is a display, not only of originality and breadth, but of a sense of decoration, at once dramatic and discreet."[2]

This cartoon was for the north aisle, west window at the Church of St. Edward the Confessor in Cheddleton, Staffordshire, with the design listed under the year 1866 in Brown's account book.[1] The design was repeated only once, in 1870, as one of the subjects in the left window of the apse of Holy Trinity Church at Meole Brace, Shropshire.[1] This cartoon depicts the elderly rabbi Zacharias burning incense in the temple, when suddenly an angel appears standing by his side at the altar. The angel tells Zacharias that God has heard his prayers, and that his wife is to have a son who is to be named John. The child will grow up to become John the Baptist.

Brown also did another design for Zacharias, dated 1872, for the Church of St. John the Baptist at Knavesborough, Yorkshire. The cartoon for this design is in the Birmingham City Museum and Art Gallery.[3]

1 Sewter, A. C.: 1974, Vol. I, p. 68 and 1975, Vol. II, pp. 50 and 131.
2 *Magazine of Art*: 1896, pp. 29-30.
3 Birmingham City Museum and Art Gallery: 1939, cat. no.149'12, p. 49, black chalk, 37 × 19 in.

7a The Lovers 7b Down Stream II, 1871

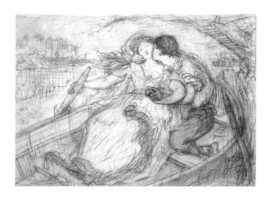 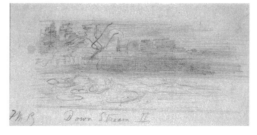

Graphite on off-white wove paper; the first drawing is signed with initials and dated lower right, *FMB/72*; in the upper right-hand corner of this sheet is a study of entwined hands for the lovers; intermediate between the study of the lovers and the study of the hands is a very faint rough preliminary sketch for *Down Stream II*; the second drawing is signed with initials and inscribed lower centre, *FMB/Down Stream II*; this drawing has writing in pencil on the verso: *The Lovers* 5⁷/₁₆ × 8¹⁵/₁₆ in. (13.8 × 22.7 cm) - sheet size 5 × 6⁹/₁₆ in. (12.7 × 16.7 cm) - image size *Down Stream II* 5⁷/₁₆ × 9¹/₁₆ in. (13.8 × 23 cm) - sheet size 2⁷/₁₆ × 5⁷/₈ in. (6.1 × 15 cm) - image size

PROVENANCE: Ford Madox Brown's estate sale, T.G. Wharton, auctioneer and estate agent, London, May 30, 1894, lot 172; anonymous sale, Christie's, London, October 29, 1985, lot 31, bought by Julian Hartnoll for F. R. Koch; his sale Sotheby's, London, November 5, 1997, lot 201.

LITERATURE: Hueffer, Ford Madox: 1896, pp. 263-264; Welby, T. Earle: 1929, p. 52; Newman, Teresa and Watkinson, Ray: 1991, fig.127; Doughty, Oswald and Wahl, J.R.: 1967, letter 1141, p. 961; letter 1153, p. 986; letter 1160, p. 999; letter 1163, p. 1002; letter 1174, p. 1015; letter 1175, p. 1016; Bendiner, Kenneth: 1998, p. 120 and fig. 61.

These preparatory studies are for two of the only nine drawings on wood that Ford Madox Brown ever undertook. Eric de Mare noted that "most are in the top rank" but that Brown had done "an outstanding one for Rossetti's poem 'Down Stream'."[1] Brown's two illustrations for "Down Stream" were published in October 1871, in the short-lived magazine *Dark Blue*, edited by John C. Freunds, which lasted only from March 1871 to March 1873. Forrest Reid has characterized Brown's first illustration to "Down Stream" as "powerful" and a "masterpiece".[2] Reid commented about Brown's woodblock illustrations that: "Uneven as we may find them, all the drawings of Madox Brown are worthy of study. The beauty he puts into them is his own, and if it occasionally exists side by side with what we must regard as a failure in beauty, or even as a wilful departure from beauty, it is never obvious, and still less does it ever decline into prettiness."[2] Rodney Engen has called Brown's first drawing for "Down Stream" his "best known drawing."[3] Goldman stated that: "In 1871 Brown made his most memorable and sensual designs for D.G. Rossetti's poem 'Down Stream' … the main drawing shows a brawny and lustful scene of a remarkable and most un-Victorian frankness. It is amazing that such a work managed to be published at this time without censorship or restraint. Additionally Brown provided a tailpiece, which in comparison is of less distinction."[4]

D.G. Rosssetti wrote the poem "Down Stream", originally titled "The River's Record", in the summer of 1871, while living together with Jane Morris at Kelmscott Manor in Oxfordshire, near Lechlade. The poem consists of five verses and tells the story of a doomed love affair. Brown chose to illustrate the two main episodes of the poem. The first drawing, of the embracing lovers, illustrates the opening stanza of the poem:

> Between Holmscote and Hurstcote
> The river-reaches wind,
> The whispering trees accept the breeze,
> The ripple's cool and kind:
> With love low-whispered 'twixt the shores,
> With rippling laughters gay,
> With white arms bared to ply the oars,
> On last year's first of May.

Reid felt that: "Madox Brown's drawing really suggests the entire poem, its tragic ending being implicit in the half ugly and wholly animal abandon of the two figures adrift in the neglected boat."[2]

The second drawing illustrates the poem's fourth stanza, which describes the situation one year later. The male lover has betrayed his mistress, and abandoned her and their illegitimate child, whose bodies lie drowned in the river:

> Between Holmscote and Hurstcote
> The summer river flows

With doubled flight of moons by night
And lilies' deep repose:
With lo! beneath the moon's white stare
A white face not the moon,
With lilies meshed in tangled hair,
On this year's first of June.

The second illustration showing the drowned mistress clutching a baby is not as successful as the first. Susan Casteras feels this illustration was influenced by John Everett Millais' painting *Ophelia* of 1851-52, as both incorporate "doomed heroines floating to their death in flower-strewn waters."[5] Fontana has also noted the similarity of this illustration to Millais' *Ophelia*.[6] The similarity between Millais' painting and the illustration is much more obvious in the preliminary drawing than in the final engraving. The final engraving fails to capture the subtleties of Brown's initial drawing, and must have been a disappointment to the artist, if the drawing on the woodblock was similar to his initial study. The engraver for Brown's illustrations was C.M. Jenkin.

The progress of Brown's illustrations for "Down Stream" can be traced in the letters that D.G. Rossetti wrote from Kelmscott Manor in 1871. In the summer, in an undated letter, Rossetti wrote to Brown: "Your plan of illustration is much the best, but I think you should ask at least 20 guineas. You will see by the enclosed short note that I do not mean to fare as O'Shaughnessy did – i.e. send a poem on invitation and have it returned."[7] On August 25, 1871 Rossetti wrote to W.B. Scott: "Brown wrote to me from the *Dark Blue* for a poem which he was to illustrate, and I sent him that 'Holmscote' thing now called *Down Stream*, which removes your just objection to title."[8] On August 31 Rossetti wrote to Brown: "A word to say – send the verses on to *Dark Blue* if you think best, and *if the bargain for them is concluded*. But perhaps it might seem more natural now to send them with your drawing. Certainly the Mag: must want *something* to get a little attention – the last advertisement of contents is absolute vacuity. I hope you asked 20£ for the drawing. Do you think of seeking a background here? We have a punt of our own where you could study actions."[9] On September 2 Rossetti wrote to Thomas Gordon Hake: "Brown is making a drawing to illustrate my verses about *Hurstcote* &c., which I have now called *Down Stream* (as the other title seemed dubious) and which are to appear in the *Dark Blue* as an appropriate outcome of Oxfordshire scenery and Oxford morals."[10] This latter comment seems a strange one for Rossetti to make in view of the fact that he was at that time living at Kelmscott Manor in Oxfordshire with Jane Morris, the wife of his friend William Morris.

On September 10 Rossetti wrote to his brother William Michael: "P.S. – I'm Dark-Blued at last, owing to Brown, who was asked to illustrate something of mine for them if I would contribute. It's a little sort of ballad I wrote here – to appear in October."[11] On about September 25 Rossetti wrote to Brown: "The other day I noticed an Advt. that the *Dark Blue* had changed its publisher – a bad omen – and today Scott writes me that he hears from young Gosse, that it is going to stop. I write you word of this at once, that you may if necessary take steps to get paid, as your work must have taken time. Mine gave no trouble so I'll just chance it."[12]

On October 1 Rossetti wrote to Brown: "I expect to see you in a few days, but must write meanwhile to say how very excellent I think your drawing in *Dark Blue*. It is like a tenderer kind of Hogarth, and seems to me much the most successful of your book illustrations, unless perhaps the *Traveller*, and I think it licks that. The little one is very pretty too. I can't of course judge of the cutting, but I think it looks well on the whole. At any rate an eye new to the design finds nothing out of harmony. At first sight the two people in the boat look both like

rustics, but I suppose this may be otherwise when one considers the costume. I *meant* my unheroic hero for an Oxford swell, though you may say certainly that the internal evidence is rather less perspicuous than Lord Burleigh's shake of the head in the *Critic*. By the bye you have certainly not minced the demonstrative matter – but would there perhaps be a slight danger of overbalancing? At any rate whatever may happen to the boat, I should think there was no doubt of the Mag's capsizing (to say nothing of *our* share in its cargo) when it contains one article on Browning as a Preacher and another on Walt Whitman."[13] On October 2 Rossetti wrote to William Bell Scott: "Brown's drawing to my verses (stanza 1) in the *Dark Blue* is a very fine one, I think – two indeed there are, and the minor one (stanza 4) also is very nice."[14] On November 6 Rossetti wrote to Algernon Swinburne from 16 Cheyne Walk, London: "Did you see two illustrations of Brown's to a little poem of mine – a mere triffle – in the October *Dark Blue*? I sent it because he has been asked to do a drawing and wanted something illustrable."[15]

A similar drawing of two figures in a boat is contained in a sketchbook in the collection of the Fitzwilliam Museum, Cambridge. The model for the female figure would appear to be Brown's wife Emma. The dating on the first drawing of 1872 is problematic, and was likely added later. These drawings would appear to be preparatory studies for the engraving, rather than drawings done afterward, particularly since the figures are in the opposite direction to the finished engraving. It may be that Madox Brown signed and dated them much later, and forgot the exact year he had originally drawn them. Bendiner has noted that Brown added inscriptions to his drawings at various points in his career.[16]

The writing on the back of the second drawing may be a draft for a lecture, but more likely relates to Brown's application for the Slade Professorship at Cambridge. If so this writing would almost certainly date to 1872. On November 30, 1872 Brown wrote to W.M. Rossetti telling him that he intended to try for the Slade Professorship. On January 3, 1873 William Michael Rossetti recorded in his diary: "Nolly Brown brought round the printed address which his Father has issued, with a view to the Slade Professorship of Cambridge. There is a certain good deal of sound matter in it, and well put too in a certain sense; but I rather fear the executive mould of the whole thing is not such as would tend to advance his cause with University dignitaries, and the other persons on whom the election depends."[17] This *Address to the Very Reverend the Vice-Chancellor of the University of Cambridge* had been privately printed in London for Ford Madox Brown on December 20, 1872.[17]

1 de Mare, Eric: 1980, pp. 113-114.

2 Reid, Forrest: 1928, pp. 8 and 50. On p. 8 Reid stated: "*Dark Blue* and *The Shilling Magazine* will only be discovered by a stroke of luck. The last two publications, however (both very short-lived), contain little of interest with the exception of a couple of masterpieces – Ford Madox Brown's design for Gabriel Rossetti's *Down Stream*, and Sandys's more famous drawing for Christina's *Amor Mundi*."

3 Engen, Rodney: 1995, p. 118.

4 Goldman, Paul: 1996, pp. 9-10.

5 Casteras, Susan: 1991, p. 15.

6 Fontana, Ernest: 1998, pp. 33 and 35.

7 Doughty, Oswald and Wahl, J.R.: 1967, Vol. III, letter 1141, p. 961.

8 Doughty, O. and Wahl, J.R.: 1967, letter 1153, p. 986, MS Princeton.

9 Doughty, O. and Wahl, J.R.: 1967, letter 1163, p. 1002, MS University of British Columbia. Doughty and Wahl date this letter September 7, but Prof. W.E. Fredeman dates it to August 31.

10 Doughty, O. and Wahl, J.R.: 1967, letter 1160, pp. 999-1000, MS British Library.

11 Doughty, O. and Wahl, J.R.: 1967, letter 1165, p. 1003.

12 Fredeman, W.E.: 2000, letter 71.155, MS University of British Columbia.

13 Doughty, O. and Wahl, J.R.: 1967, letter 1175, p.1016, MS University of British Columbia. Doughty

and Wahl date this letter as October 5, while Professor Fredeman dates it to October 1.

14 Doughty, O. and Wahl, J.R.: 1967, letter 1174, p.1014, MS Princeton.
15 Fredeman, W.E.: 2000, letter 71.177, MS Kansas.
16 Bendinger, Kenneth: 1998, p. 5.
17 Bornand, Odette: 1977, p.224, diary entry for Friday, 3 January, 1873, and n.3.

SIR EDWARD COLEY BURNE-JONES (1833-1898)

Burne-Jones was born at Birmingham on August 28,1833, the son of a gilder and frame-maker. His mother died within a few days after his birth. From 1844-52 he attended King Edward's School in Birmingham, where he was influenced by the teachings of Pusey and Newman, and decided to become a Church of England priest. In 1853 he went to Exeter College, Oxford where he met William Morris, with whom he formed a life-long friendship. In 1854 he saw Pre-Raphaelite paintings for the first time. In the summer of 1855 he toured the cathedrals of northern France with Morris, and on the way home he decided to give up his study for the Church to become a painter. In January, 1856 he met Rossetti and Ruskin. In May he left Oxford to settle in London. He received a few informal art lessons from Rossetti and, until February 1859, attended evening classes at Leigh's life class in Newman Street. In 1857 he was one of a group of artists recruited by Rossetti to paint murals in the Oxford Union. In 1861 he was a founding member of Morris, Marshall, Faulkner & Co. He was elected an associate of the Old Water-Colour Society (O.W.S.) in 1864, but encountered hostility from fellow members and critics due to his unorthodox watercolour techniques and unusual subject matter. He began to attract important patrons, however, such as William Graham and F.R. Leyland. In 1867 he moved to The Grange, North End Lane, Fulham, where he lived until his death. He resigned from the O.W.S. in 1870, when he was asked to remove his painting *Phyllis and Demophoön*, because of objections about the nudity of Demophoön. He virtually ceased to exhibit publically for the next seven years and depended on private patronage. In 1877 he exhibited eight paintings at the first Grosvenor Gallery exhibition, where his work caused a sensation, and he became regarded as one of the leaders of the Aesthetic Movement. In 1885 he accepted with reluctance an associateship of the Royal Academy, but exhibited there only once, in 1886, and resigned in 1893. In 1888 he began to exhibit at the New Gallery. In 1894 he accepted a baronetcy. On June 17, 1898 he died, and on June 23 a memorial service was held in Westminster Abbey, the first time a painter was so honoured. He was buried at St. Margaret's Church in Rottingdean, Sussex, where he had owned a summer home.

8 Study for "The Wedding Feast of Sir Degrevaunt," 1860

Watercolour and gouache over graphite, with scraping out, heightened with gum arabic, on cream wove paper; signed upper left corner with brush, in brown watercolour, *E.B.J. to F.E.H.B.*, and with a decorative design of a brown flower with a blue centre
$10\frac{1}{4} \times 11\frac{5}{8}$ in. (26.2 × 29.5 cm)
PROVENANCE: Gift of the artist to "F.E.H.B." (unidentified); anonymous sale, Sotheby's, London, June 15, 1982, lot 100, bought Virginia Surtees; sold in 1989 to Maas Gallery, London; purchased July 6, 1989.

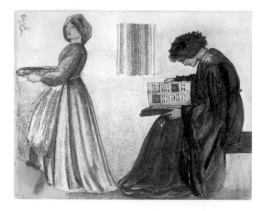

LITERATURE: Lochnan, K.A.; Schoenherr, D.E.; Silver, C.: 1993, cat. no. A:2 (illus.), pp. 42-43; Wildman, Stephen and Christain, John: Metropolitan Museum, 1998, cat. no. 11, p. 66, n. 3.
EXHIBITED: Maas Gallery: 1989a, cat. no. 13 (illus.); Art Gallery of Ontario: 1993, cat. no. A:2 (illus.); Kenderdine Gallery: 1995, cat. no. 8 (illus.).

The adventures of Sir Degrevaunt were a favourite with Edward Burne-Jones and William Morris. They were familiar with these tales through the *Thornton Romances*, published in 1844 by the Camden Society. In 1860 William Morris moved to the Red House, Bexley Heath, Kent, designed for him by Philip Webb. Amongst Burne-Jones' contributions to the decoration of the house was to have been a mural of seven tempera paintings depicting the tale of Sir Degrevaunt.[1] The paintings were to have run around the drawing room on the first floor, but only three were ever executed, *The Marriage*, *The Musicians*, and *The Wedding Feast*. *The Wedding Feast* features William Morris as the model for Sir Degrevaunt, and Jane Morris as the model for his bride Melidor, surrounded by a group of figures at the marriage feast. The figures portrayed in this watercolour are in the centre foreground. In the finished wall painting the design of the serving girl's dress and headpiece differs, as does the headpiece of the seated male figure.[2]

In this study for *The Wedding Feast of Sir Degrevaunt* it has been suggested that the model for the seated bard is William Morris.[3] Swinburne, with his famous red hair, would seem to be a more likely candidate than Morris, however, as not only does this figure not resemble the appearance of William Morris, but it is highly unlikely that Morris would have been the model for both the bard and Sir Degrevaunt in the same painting. Swinburne had been first introduced to Burne-Jones in 1857 during the painting of the murals in the Oxford University Union debating hall. The period around 1860 was the time of Swinburne's greatest intimacy with Edward and Georgiana Burne-Jones.[4] Swinburne undoubtedly served as a model for his Pre-Raphaelite friends. The male figure in a watercolour by D.G. Rossetti of 1864, *Roman de la Rose*, appears very similar to the figure of the bard in this work. This watercolour is based on a preliminary sketch for the title page of *The Early Italian Poets*, of 1860-61, where Swinburne is known to have been the model for the male figure.[5] Burne-Jones used Swinburne as a model in another of his paintings from 1860, *The Adoration of the Kings and Shepherds*, where Swinburne's features can be seen in the figure of the shepherd with bagpipes.[6] The features of the shepherd closely resemble that of the reading figure in *The Wedding Feast of Sir Degrevaunt*. Douglas Schoenherr has previously identified him as the anonymous author of the tale of Sir Degrevaunt, reading the story aloud at the wedding feast.[7]

The model for the female figure is probably Fanny Cornforth, as has been suggested.[3] She frequently sat to Burne-Jones at this time,[8] and the figure closely resembles others that Fanny is known to have modelled for. In 1860 she was a very attractive woman. William Michael Rossetti has described her thus: "She was a pre-eminently fine woman, with regular and sweet features, and a mass of the most lovely blonde hair – light-golden or 'harvest-yellow'."[9] Her physical attractiveness is confirmed by D.G. Rossetti's drawings and paintings of her at this period.

The design for this watercolour derives much from the lessons Burne-Jones learned from his study of Italian Quattrocento painting. The chief inspiration for his interest in the art of this period was Ruskin, although in 1858 G.F. Watts had also impressed upon Burne-Jones the importance of early Italian art. In 1859 Burne-Jones made his first visit to Italy and had toured Genoa, Pisa, Florence, and Venice, but had not yet been to Padua. The colour bars seen in the upper central portion of this drawing are derived from Giotto's fresco in Padua of *The Wedding Procession of the Virgin*. One of the other panels of the Sir Degrevaunt mural, *The Musicians*, is based on the right-hand portion of Giotto's rendering of the *Virgin Mary Returning Home after Her Betrothal*, another fresco in the Arena Chapel at Padua, which the artist knew from Arundel Society prints.[10] The brilliant colouring of this watercolour and the mood conveyed show a debt to Venetian Renaissance painting. This watercolour design is similar to many of Burne-Jones' watercolours produced in the early 1860s, and also resembles his early decorative designs for Morris, Marshall, Faulkner and Co., including tile designs and his contributions for a cabinet designed by J.P. Seddon illustrating King René's Honeymoon. This drawing has a flat, two-dimensional appearance, which is characteristic of the avant-garde movement at this time, particularly in England, but also to some extent in France in the work of artists such as Puvis de Chavannes. The shallow space of the paintings served to emphasize the decorative qualities of the work.

A similar study, but in brown wash, for *The Wedding Feast of Sir Degrevaunt* is in the collection of the Yale Center for British Art in New Haven, Connecticut.[11] This drawing incorporates many more figures into the composition. Another watercolour study is in the collection of the Fitzwilliam Museum.[12] Other designs for the Red House murals include studies for *The Wedding Procession* in the Birmingham City Museum and Art Gallery, the Royal Institute of British Architects, and the Fitzwilliam Museum, Cambridge.[13,14]

1 Watkinson, Raymond: 1970, p. 172. "As we talked of decorating it, plans grew apace. We fixed upon a romance for the drawing room, a great favorite of ours called 'Sir Degrevaunt'. I designed seven pictures from that poem, of which I painted three that summer and autumn in tempera."

2 Victoria and Albert Museum: 1996, p. 139, fig. 8. In the finished work the resemblance of the bard to Swinburne, and the serving maid to Fanny Cornforth, is less obvious.

3 Maas Gallery, London: 1989a, cat. no. 13, p. 15.

4 Harrison, Martin and Waters, Bill: 1973, p. 66. "Swinburne was at work on *Poems and Ballads* from 1860, the period of most intimacy with Jones; Georgiana records how he would often rush into their house in Russell Place bringing fresh poems to recite."

5 Gosse, Edmund: 1917, p. 75. Algernon Charles Swinburne, letter to Richard Moncton Milnes, October 15, 1860. Swinburne must have felt it was a good enough likeness to write: "Rossetti has just done a drawing of a female model and myself embracing – I need not say in the most fervent and abandoned style ... Everybody, who knows me already, salutes the likeness with a yell of recognition. When the book comes out, I shall have no refuge but the grave."

6 Metropolitan Museum of Art: 1998, cat. no. 10, pp. 63-64. Also included in the painting are figures based on William and Jane Morris, and on Burne-Jones himself.

7 Schoenherr, Douglas in Lochnan, K.A.; Schoenherr, D.E.; Silver, C.: 1993, cat. no. A:2, pp. 42-43.

8 Surtees, Virginia: 1981, p. 200. Madox Brown's diary for January 27, 1858: "I called on Rossetti ... Then on with him to Jones'. Saw there, Fanny, their model."

9 Rossetti, William Michael: 1895, Vol 1, p. 203.

10 Christian, John: " 'A Serious Talk': Ruskin's place in Burne-Jones's Artistic Development" in Parris, Leslie: 1984, p. 199. This work is illustrated in Metropolitan Museum of Art, 1998, fig. 61, p. 81.

11 Wood, Christopher: 1998, p. 33. The work is pen, pencil, brown ink and brown wash, 11 5/8 × 13 7/8 in. This drawing originally belonged to Charles Augustus Howell who gave it to Henry Wallis. It was shown at the Burlington Fine Arts Club, 1899, cat. no. 136. It sold Christie's London, *Victorian Drawings and Watercolours*, March 13, 1973, lot 35.

12 Metropolitan Museum of Art, 1998: cat. no. 11, pp. 65-66, watercolour, signed and dated E. Jones, 1860, 11⅞ × 18½ in. The watercolour in Cambridge is very similar in colouring and technique to this one.

13 Birmingham City Museum and Art Gallery: 1939, cat. no. 452'27, p. 52, pencil on blue paper, 10⅝ × 10½ in.

14 Hayward Gallery: 1975-1976, cat. no. 64, p. 36, pen and ink over pencil, 22.2 × 34.3 cm, 1860, Royal Institute of British Architects.

9 Study of Princess Sabra for "The Return of the Princess," 1865-66

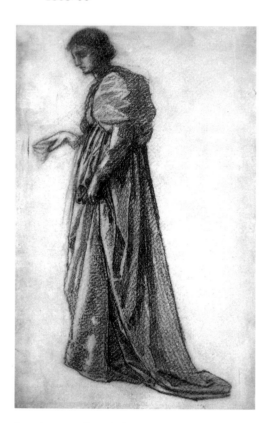

Black chalk on off-white paper 14⅟₁₆ × 9 in. (35.8 × 22.7 cm)

PROVENANCE: Anonymous sales, Sotheby's Belgravia, June 17, 1980, lot 20; Christie's, London, November 18, 1980, lot 203; Sotheby's, London, January 25, 1989, lot 442; Bonhams, London, June 10, 1998, lot 16.

The legend of St. George and the Dragon was known to Burne-Jones through Jacobus de Voragine's *The Golden Legend* and Thomas Percy's *Reliques of Ancient English Poetry*. In the legend a dragon terrorizes the town of Selene in Libya. After the people of the town sacrifice their herds to it, they are forced to offer their children. Initially the king manages to withhold his daughter from the drawing of lots, which was the method used to choose who was to be sacrificed. After some time, however, when many had been killed, the princess' name was included and shortly thereafter her lot was chosen. On the appointed day she was led to the place of sacrifice. St. George, who was passing through the city, heard of the predicament, slayed the dragon, and rescued her. St. George returned with the princess to the town. The king and his people converted to Christianity and St. George married the princess, who in one account is named Sabra. The story of St. George and the Dragon had previously been treated by D.G. Rossetti in a series of designs for stained glass for Morris, Marshall, Faulkner & Co. in 1861-62.[1]

This tonal black-chalk study is characteristic of Burne-Jones' drawings from the 1860s. It is a study of Princess Sabra for *The Return of the Princess (The Return of St. George)*, the last in a series of seven paintings on the theme of St. George. The series was commissioned in 1864 by the watercolour-artist Myles Birket Foster to hang in the dining room of his house, The Hill, at Witley in Surrey. The house had been completed in 1863. Birket Foster commissioned the firm of Morris, Marshall, Faulkner & Co. to undertake decorations for the house, but this series of paintings was independent of that commisssion. Burne-Jones' paintings date from 1864-67. The first three were installed by the end of 1865, while the remaining four

were eventually completed with the aid of his studio assistant Charles Fairfax Murray. The paintings remained at The Hill until 1894, when Birket Foster left the house. The series was sold at Christie's on April 28 of that year, and was subsequently reworked by Burne-Jones in 1895. The series of paintings included: *The King's Daughter*; *The Petition to the King*; *Princess Sabra Drawing the Lot*; *The Princess Led to the Dragon*; *The Princess Tied to the Tree*; *St. George Slaying the Dragon*; and *The Return of the Princess*. This series of paintings is now dispersed. *The Return of the Princess* is at the Bristol City Art Gallery.

Bill Waters feels Burne-Jones' series was influenced by the St. George murals of Vittore Carpaccio, in the Scuola di San Giorgio in Venice.[2] Burne-Jones had seen them during his visit to Venice in 1862. Carpaccio was one of the painters that Burne-Jones most admired at this time.[3] The face of Princess Sabra in this drawing is quite exotic, and would not appear to have been drawn from an English model. Burne-Jones no doubt selected a model from London's thriving ethnic communities, perhaps Italian, Greek or Jewish, who could better represent the Semitic face of a Libyan princess. Her facial features are also highly characteristic of ancient Greek sculpture, and may have been derived from the classical works Burne-Jones was copying at this time to improve his draughtsmanship. In the final paintings, however, the Princess Sabra's features are more conventional and more beautiful.

Burne-Jones made an exhaustive series of preparatory drawings for this series of paintings, including a set of highly finished ones, six of which are now in the British Museum, London.[4,5] In the City of Birmingham Museum and Art Gallery are more than sixty drawings relating to the St. George series, including fourteen that specifically relate to *The Return of the Princess*.[6] A preparatory study for *The Princess Sabra* is in the Ashmolean Museum, Oxford.

1 Surtees, Virginia: 1971, Vol. 1, cat. nos. 145-150, pp. 85-86. Five original drawings, in pen and ink, are in the Birmingham City Museum and Art Gallery. The designs include: *The Skulls Brought to the King*; *The Princess Sabra Drawing the Lot*; *The Princess Sabra Taken to the Dragon*; *St. George and the Dragon*; *The Return of the Princes*; and *The Wedding of St. George*.

2 Harrison, Martin and Waters, Bill: 1973, p. 89.

3 Lago, Mary: 1982, p. 167, conversation from January 7, 1898. Rooke recorded Burne-Jones' conversation: "I remember after my stay in Venice, when I came back thinking there could be no painting in the world but Carpaccio's and the other Venetians."

4 Metropolitan Museum of Art: 1998, cat. no. 32, p. 102, cat. no. 35, p. 105, cat. no. 36, p. 106. In the finished drawing for *The Return of the Princess* the model appears different, and the drapery differs from the preliminary drawing, as does slightly the pose of the right arm. The drapery in the preliminary drawing is more reflective of Victorian dress than is that in the finished drawing which is more medieval.

5 Gere, John: 1994, cat. nos. 58-61, pp. 86-88, and p. 145. These drawings had at one time belonged to Edward Poynter and then to Cecil French.

6 Birmingham City Museum and Art Gallery: 1939, pp. 66-76.

10 "February," c. 1866

Black chalk on light brown wove paper; signed with initials and dedicated *EBJ to HM*, upper right; inscribed with title *FEBRUARY*, upper left 11¹³⁄₁₆ × 6¹⁄₁₆ in.

(30 × 15.5 cm)

PROVENANCE: Given by Edward Burne-Jones to Hannah Macdonald; by descent in the Macdonald and Baldwin families; Sotheby's, London, November 2, 1994, lot 182.

EXHIBITED: Kenderdine Gallery: 1995, cat. no. 9.

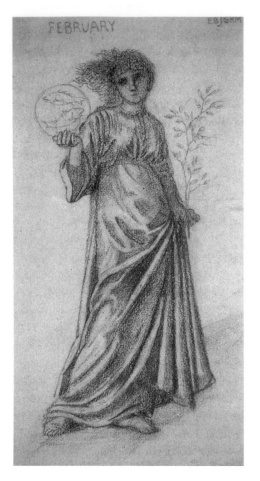

In 1866 Morris, Marshall, Faulkner & Co. received their first two important commissions for non-ecclesiastical decorative work. The first was for the decoration of the Tapestry Room and Armoury of St. James's Palace. The second, carried out in 1867, was for the refurbishment of the Green Dining Room at the South Kensington Museum, now the William Morris Room of the Victoria and Albert Museum. Although the cost of the commision was heavy, it did not make a great deal of money for the firm, but was of great value at the time in making their name and the specific character of their work better known. The decorative plan for the room was largely Philip Webb's work. Among its outstanding features are the painted panels with figures holding the Signs of the Zodiac, designed by Burne-Jones, which alternate with painted sprays of various foliage and fruit designs on a gold background, set into the green-stained oak panelling. William Morris was initially dissatisfied with the painting of the figurative panels designed by Burne-Jones, since the work was carried out by different painters, and was not uniform enough in style to form a harmonious scheme.[1] Charles Fairfax Murray was therefore employed to do the paintings over again, although it has also been claimed that he was assisted by Harry Ellis Wooldridge.[2,3]

Eleven charcoal drawings on white paper by Burne-Jones of the Signs of the Zodiac, similar in design to the figures in the Green Dining Room, now hang in the North Hall at Kelmscott Manor. The "Ram" sign and the pendant sketch for "Sol" are missing from the series. In the Green Dining Room the figure in this drawing of "February" is actually used to represent Sagittarius. In the painted version the figure holds in her right hand a centaur with a bow, instead of a bowl with fish, but otherwise the pose is identical with the drawing. The corresponding drawing to "February" at Kelmscott Manor also depicts Sagittarius, and there are noticeable differences in the background.[4] The Victoria and Albert Museum has a study for "Luna", in black chalk on brown paper, similar in technique to this study for "February." The V&A drawing features a figure holding a ship, which is found on the left of the entrance to the Green Dining Room.[5] The V&A also has three sheets, each with four studies on them (12 in all), in red chalk on white paper, as well as four sheets, each with three studies (12 in all), in graphite on white paper, for panel decorations for the Green Dining Room.[6] None corresponds to the pose of "February."

"February" was later used by Burne-Jones as the basis for his figure of "Spring" for *The Four Seasons*, a series of gouaches executed in 1869-70 for Frederick Leyland.[7]

This drawing was given by Burne-Jones to Hannah Macdonald, the mother of the artist's wife Georgiana. When Mrs. Macdonald died in 1875, she may have left it to her daughter Louisa, who married Alfred Baldwin, as it descended in the Macdonald and Baldwin families.

1 Vallance, Aymer: 1897, p. 82.
2 Sotheby's Belgravia: *Fine Victorian Paintings, Drawings and Watercolours*, February 14, 1978, lot 41, "Luna", black chalk, 17 × 8¼ in.
3 Harrison, Martin: 1980, p. 154. Harrison noted that Wooldridge in 1866 acted as Burne-Jones' studio assistant for a short period of time and painted one of the panels (that representing the moon) for the decoration of the Green Dining Room.
4 Ashworth, Sue: personal communication, letter dated August 9, 1999. Ashworh, the Custodian at Kelmscott Manor, points out that the figure is not holding a tree branch in her left hand, there is an oak tree to the figure's right, and she is wearing closed shoes, not sandals. A stream is depicted at the bottom of the drawing, with reeds to the lower right, and a classical building in the middle background to the right.
5 Mappin Art Gallery: 1971, cat. no. 35, black chalk touched with white, 10¾ × 5¾ in., inscribed by C. Fairfax Murray "study for the Moon, South Kensington panel, South Kensington, E.B.J".
6 Victoria and Albert Museum: 1996, cat. no. 1.8, p. 151, eight designs for the Green Dining Room panels, pencil and chalk.
7 Inglis, Alison: I am grateful to her for pointing out the relationship between "February" and "Spring", in a letter of August 4, 1999.

11 Lachesis Measuring the Span of her Victim by Reading from the Book of Life, for "The Fates," 1866

Red and black chalk, on white paper; signed with initials and dated 1866, lower left
11¾ × 6¾ in. (29.1 × 16.2 cm)
PROVENANCE: Anonymous sale, Bonhams, London, November 19, 1997, lot 48.

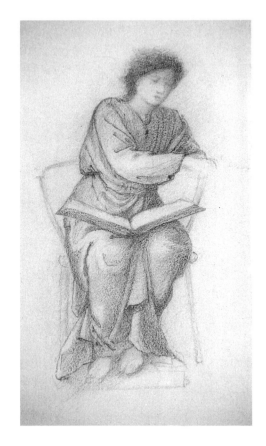

This is a study of Lachesis for Burne-Jones' painting *The Fates*. The Fates were the daughters of Themis (the goddess of justice and law) and Zeus. These three sisters determined the course of human life. The youngest Clotho presided over human birth and spun the thread of Life, while Lachesis held it and fixed its length, and the eldest Atropos cut it off. *The Fates* was one of a number of classical paintings Burne-Jones started in the 1860s, which also included *The Lament* and *The Hours*. He began *The Fates* in 1865, made several studies for it, and then abandoned the project temporarily.[1] He returned to it in the early 1870s, when he made numerous pencil sketches for this subject. The painting was never carried further, however.

In the late 1850s Burne-Jones' best drawings were those done in pen and ink. In a letter to William Bell Scott of February 1857 Rossetti stated: "Jones's designs are marvels of finish and imaginative detail, unequalled by anything except perhaps Albert Dürer's finest works."[2] By the 1860s, however, Burne-Jones'

finest drawings were those done in red chalk. George du Maurier, in a letter to Thomas Armstrong of December 25, 1864, wrote: "Jones's studies for decoration in red chalk have been much raved about."[3] Bill Waters has remarked upon his drawings from the 1860s: "The drawings of the period show an acute sensitivity to abstract elements. Typical of this time are the red-chalk drawings in which the form emerges from textural variations; only an artist who had considerable experience in drawing could model with such asssurance, allowing his subject-matter to dissolve into the overall texture."[4] Burne-Jones did not find it easy to master drawing in red chalk. In a conversation late in life with his studio assistant T.M. Rooke, about drawing in various media, particularly pencil, Burne-Jones remarked: "There's no drawing I consider perfect. I often let one pass only because of expression, or facts I want in it, but unless – if I've once india-rubbered it, it doesn't make a good drawing. I look on a perfectly successful drawing as one built up on a groundwork of clear lines till it's finished. It's the same kind of thing in red chalk. It mustn't be taken out. Rubbing with the finger's all right. In fact you don't succeed with any process until you find out how you may knock it about and in what you must be careful."[5]

Christopher Newall has pointed out Burne-Jones' debt to the influence of classical sculpture on his works from this period: "Burne-Jones was one of a number of English artists who in the mid-1860s sought to introduce a balance and harmony into their compositions which was inspired by a study of Classical sculpture. Since 1863 he had been making intensive study of the Antique, and particularly of the Parthenon frieze of the Elgin Marbles at the British Museum, as may be judged from his surviving sketchbooks. This was in part a response to the advice he received from Ruskin that as an artist without academic training he needed to teach himself how to draw well, and by this means be able to control and choreograph the figurative elements of his compositions. However, Burne-Jones's interest in ancient sculpture was more than self-educational. Like Moore and Whistler who similarly sought qualities of equilibrium and calm in compositions such as *The Marble Seat* by the former, and *Symphony in White No. 3* by Whistler, both of 1865, Burne-Jones learnt from relief sculpture how to place his figures in a foreground plane and thus to emphasize the abstract decorative patterns of the arrangement."[6] A similar influence of classical relief sculpture is seen in Albert Moore's *The Elements* of 1866 (cat. no. 57).

The City of Birmingham Museum and Art Gallery owns thirteen sheets of studies for *The Fates*, and in some cases studies are present on both sides.[7,8] One of the compositional studies at Birmingham shows, at the top of the drawing, the three Fates seated looking down upon two lovers, a young man and woman, standing in the foreground.[8] Other studies show that at a later time, probably in the 1870s, Burne-Jones considered adding a seated figure and a child crawling, at the lower left of the painting.[7] A rough compositional sketch, possibly for *The Fates*, was offered for sale at Sotheby's Belgravia on October 25, 1977.[9] A study, purported to be for Clotho, was shown in the exhibition *Visions of Love and Life* which toured the United States in 1995.[8] This figure, although differing in composition from this drawing for Lachesis, is also shown holding the Book of Life. A study for *The Fates* was exhibited at the Shepherd Gallery, New York, in 1994 and 1998,[10] and at the Maas Gallery, London, in 1996.[11] A study, likely for Clotho, was with Peter Nahum, London, in the late 1980s.[12]

Although Burne-Jones never completed his painting of *The Fates* he did, however, incorporate depictions of them into his painting *The Feast of Peleus*. The first version of this painting was started in 1872 and completed in 1881.[13] Burne-Jones' follower and former studio assistant, John Melhuish Strudwick, painted a work on a similar theme, *The Golden Thread*, of 1885. This painting is in the collection of the Tate Gallery, London.[14] In 1883 Marie Stillman did a watercolour of *The Fates*.[15]

1 Bell, Malcolm: 1903, p. 35.
2 Doughty, Oswald and Wahl, JR: 1965, Vol. I, letter 262, p. 319.
3 du Maurier, Daphne: 1951, p. 249.
4 Harrison, Martin and Waters, Bill: 1973, pp. 75-76.
5 Lago, Mary: 1982, p. 84, conversation of January 18, 1896.
6 Tate Gallery: 1997-1998, cat. no. 25, *The Lament*, 1864-66, pp. 127-128.
7 Birmingham City Museum and Art Gallery: 1939, cat. nos. 1'04, 2'04, 3'04, 4'04, 5'04, 6'04, 7'04, 8'04, 231'04, 480'27, 481'27, 482'27, 483'27. These works are in various media, including red and/or black chalk, black and white chalk, pencil, and a brush drawing in sepia.
8 Wildman, Stephan: 1995, cat. no. 81, pp. 248-249, *The Fates: Study for Clotho (?)*, c. 1865, black chalk, 21 × 13¾ in. Also reproduced as fig. 74 is an overall compositional study for *The Fates* from the Birmingham collection (no. 1'04), c. 1865, brush with sepia and white chalk on brown paper, 12½ × 7 in.
9 Sotheby's Belgravia: *Fine Victorian Paintings and Watercolours*, October 25, 1977, lot 31a, black and red chalk, 3¼ × 5½ in.
10 Shepherd Gallery: 1994, cat. no. 21, and 1998-1999, cat. no. 7, study for *The Fates*, pencil and red chalk, c. 1865, 9½ × 8¾ in, lent by Maas Gallery.
11 Maas Gallery: 1996, cat. no. 14, p. 12. It had originally been purchased Sotheby's, London, *Victorian Paintings, Drawings and Watercolours*, June 14, 1989, lot 370.
12 Peter Nahum: 1985, cat. no. 8, p. 12, and 1989, Vol. 1, cat. no. 48, p. 69, black chalk on white paper, 15½ × 10½ in. This drawing is similar, but not as beautiful or as finished as study 7'04 in the Birmingham City Museum and Art Gallery. (see n. 8) This drawing had likely been purchased at Sotheby's Belgravia, *Highly Important Victorian Paintings & Drawings*, March 23, 1981, lot 24. It had previously been offered for sale at Christie's, London, April 25, 1978, lot 318, when it was bought by Julian Hartnoll.
13 Metropolitan Museum: 1998, cat. no. 51, p. 153.
14 Christian, John: 1987, cat. no. 41, p. 109.
15 Maas Gallery: 1979b, cat. no. 87, watercolour and bodycolour, 21 × 19 in.

12 Blind Love, c. mid to late 1860s

Oil on canvas 17¼ × 12½ in.(43.8 × 31.6 cm)
PROVENANCE: By descent to the artist's daughter Margaret Mackail; her estate sale, Christie's, London, December 3, 1954, lot 41, bought by Robert Abbott of Abbott and Holder, London; in the collection of a private Swiss collector for approximately forty years; his sale Christie's, London, June 25, 1998, lot 321; bought in at sale and purchased later, on July 8, 1998.
LITERATURE: Burne-Jones, Georgiana: 1904, Vol. 1, p. 257; Wildman, S. and Christian, J.: Metropolitan Museum,1998, cat. no. 63, p. 167 and p. 169, n. 4; cat. no. 84, p. 212.

This is a fragment of what was once a much larger unfinished oil painting, which has obviously been cut down at some stage in the past.[1] As Bill Waters has noted: "Today

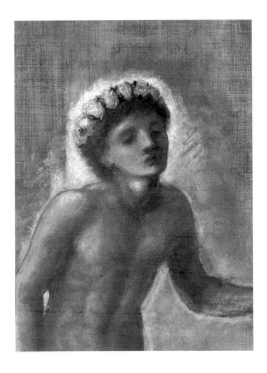

there exists a huge corpus of paintings which emanated from the studio in an incomplete form. The Master supervised all stages and was responsible for the finishing touches, correcting any errors or unsatisfactory textures."[2] The fact that so many unfinished works exist is not surprising, considering that Burne-Jones started more works than he could possibly complete. As he himself remarked relatively early in his career: "I have 60 pictures, oil and water in my studio & every day I would gladly begin a new one."[3] Charles Eliot Norton, in a letter from 1869, described the studio at The Grange: "Burne-Jones's studio is a large room on the garden side of the house. There is a pleasant look of work about it, and a general air of appropriate disorder. All round the wall, upon the floor, and on easels, lie and stand sketches or pictures in every stage of existence. Jones's lively imagination is continually designing more than he can execute. His fancy creates a hundred pictures for one that his hand can paint. It keeps him awake night after night with its animated suggestions, and each morning he covers the canvas with the outline of a new picture."[4]

Burne-Jones eventually realized the problems this large number of unfinished pictures had created for him and his family. T.M. Rooke recorded a conversation with him on January 23, 1896: "I suddenly woke up one night and thought what a bore it would be to Phil and Georgie to be left with such a lot of pictures that weren't finished. Is it inexcusable in me to have such a lot? Say I did it instead of going out visiting. They wouldn't like to destroy them. I know Phil wouldn't out of affection for me, yet what could he do with them?"[5] Near the end of his life Burne-Jones therefore made an effort to finish off as many of these works as he could. He may have been spurred on in this endeavor by the comments of his life-long friend William Morris, in the year prior to his death, who suggested that: "The best way of lengthening out the rest of our days now, old chap, is to finish off our old things."[6]

This painting was begun in the mid to late 1860s, based on an earlier watercolour version of *Blind Love* of 1862.[7] The early watercolour version differs from the later oil version in that Love was posed facing in the opposite direction, and with his head looking downwards rather than upwards. The arrangement of the arms was also somewhat different. This earlier watercolour was one of five works shown at the Old Water-Colour Society in 1865. The other works included *Green Summer*, *Astrologia*, *Cupid and Delight*, and *Merlin and Nimue*. These paintings were severely ridiculed by the critics. The reviewer from the *Art Journal* commented: "But there can, at all events, be little doubt that upon him has fallen to an eminent degree the common lot of being loved by the initiate few and laughed at by the profligate many. The fate which has come upon this artist, we are bound to say, he heartily deserves. At the outset we confess ourselves one of the uninitiate multitude who are wholly unworthy of the rare revelation of which Mr. Jones is the favoured recipient. We certainly admit most readily that the artist possesses some gifts which move to sympathy. Even his confirmed medievalism is not without winning charm. Its quaintness, bordering on the grotesque, and even touching the impossible, is far removed at least from the modern modes of commonplace, lies close upon the marvellous, and constitutes, as it were, a species of pictorial miracle ... for it cannot be denied that some of the works by this painter have in colour a subdued and shadowed lustre; that they possess in their subjects, seen for example in the pretty conceit called 'Blind Love', originality of thought."[8]

Despite this hostile criticism, the exhibition of his watercolours at the Old Water-Colour Society attracted the notice of some influential collectors, including William Graham, perhaps Burne-Jones' greatest patron. Graham was an India merchant and a Member of Parliament for Glasgow. He commissioned the oil version of *Blind Love*, which he intended to hang between two other large works by Burne-Jones in his collection, *Le Chant d' Amour* and *Laus Veneris*. Both of these paintings were also based on earlier watercolours, of 1861 and

1865 respectively. The early watercolour version of *Le Chant d' Amour* also belonged to Graham. If *Blind Love* had been completed, the three works would have functioned as a sort of triptych. They were intended to be comparable in scale and format, and to have the rich Venetian colouring and tone that Graham favoured. All dealt with similar themes of love and music, and as the other two paintings are amongst Burne-Jones' greatest masterpieces, it is a shame that the third was never completed.

Georgiana Burne-Jones, in her *Memorials*, quoted from a letter to John Ruskin of 1862 that: "'Ned has begun another water-colour, a figure of Love quite blind, crowned with flowers, groping his way through the street of a city in the early morning, seeking the house he shall enter.' This design Edward always meant to carry out on a larger scale in oils; indeed he began it, and the wreath of roses is painted on Love's head."[9] Roses are symbolic of love in the language of flowers. Even in this rough sketch Burne-Jones' handling of the flowers is masterful. As Sidney Colvin commented: "A flower painted by him is like a flower described by Keats; all the fragrance and colour and purity of it are caught and concentrated."[10]

It is uncertain why this commission for Graham was never completed. Burne-Jones may have felt it was not as important as some of the other compositions on which he was working. Perhaps it was because it was to be carried out in the Venetian style that Graham preferred, in order to blend in with his other two works. By the time Burne-Jones got around to being able to work on this painting again, however, his style may have changed, so that the painting would thus no longer be in sympathy with the earlier ones. Regardless of the reasons, following Graham's death in 1885, Burne-Jones may have no longer felt compelled to complete it, in view of the many other commissioned works lying unfinished in his studio.

The unfinished nature of this work does give us some insights into Burne-Jones' working methods. Fotunée De Lisle has pointed out: "It became his custom to have always a great number of pictures in hand at different stages of completion, working on that for which he felt in the mood, then perhaps putting it aside till greater experience had given him the power to tackle some difficult problem it presented, – taking it up again and carrying it a stage further, and then perhaps laying it aside while some other work was being completed. It stands to reason, from this method of work, that the finished works of Burne-Jones, the earlier watercolours excepted, do not lend themselves to chronological classification."[11] This practice of having many works under production at one time was similar to that of his friend G.F. Watts.

Burne-Jones' preparation for a painting was as elaborate as that of his academic colleagues like Leighton and Poynter. De Lisle has explained Burne-Jones' standard practice later in his career: "The first stage of a picture was, of course, the sketch, the rough indication of its plan, and, this being settled, studies for the figures and careful drawings of the heads, hands, and feet were drawn from life ... The next stage was the execution on brown paper, in water-colour, or pastel, or both, of a highly-finished full-size cartoon. The outlines were then traced and transferred to the canvas by the skilled assistants Burne-Jones had trained to help him in these matters, and filled in in monochrome, the surface of the lightest parts only being prepared with pure flake white which was allowed to become absolutely dry before the work was proceeded with. Then the real painting began, and each part as it was taken up, was carried to a high degree of finish, – the cartoon and studies being used to work from, and constant reference being also made to the living model."[11] Although Burne-Jones used much the same preparatory methods as the academic classical painters, his methods of doing the actual painting were quite unorthodox. As W. Graham Robertson noted: "In water colour he would take no advantage of its transparency, but load on body colour and paint thickly in gouache; when he turned to oil he would shun the richness of impasto, drawing thin glazes of colour over careful drawings in raw umber heightened with white."[12] John Christian,

drawing on notes made by Charles Fairfax Murray, has pointed out that there was little difference in how Burne-Jones handled the two media, oil and watercolour: "In both cases he would model the forms with stiff white bodycolour, glaze them, and then repeat the process – refining the forms with bodycolour and the tones by glazing – until the picture was finished."[13] It is hard to be certain if this fragment is all the work of Burne-Jones, or whether a studio assistant was involved with part of it. At the early date at which it was carried out, the studio assistant would most likely have been Charles Fairfax Murray, since Thomas Matthews Rooke did not start until 1869.

The portrayal of Love as blind, and with roses in his hair, was not new in Burne-Jones' art. In 1865 he painted his first version of *Le Chant d' Amour*, now at the Museum of Fine Arts, Boston, and which was exhibited at the Old Water-Colour Society in 1866. This water-colour featured a blindfolded figure of Love or Cupid, with roses in his hair, working the bellows of the organ. In 1868 he started the definitive version in oil of *Le Chant d' Amour*, now at the Metropolitan Museum of Art, New York. This painting was worked on again in 1872-73 and finally completed on 1877. In this version Love has his eyes closed to suggest blindness, rather than a blindfold, and he no longer has flowers in his hair. In 1865 Burne-Jones designed seventy subjects for the Story of Cupid and Psyche, which were intended as illustrations for William Morris' *The Earthly Paradise*. Although this illustrated book never came to fruition during their lifetimes, Burne-Jones did work up many of the designs into finished paintings. Although his first version of *Cupid Delivering Psyche*, painted in 1867, does not feature roses in Cupid's hair, a later version, painted for George Howard's dining room at 1 Palace Green, Kensington, did. A drawing for the head of Cupid for *Cupid Delivering Psyche*, dated 1865, in which Cupid's head is encircled by a band of roses, sold at Sotheby's, London, on November 3, 1993.[14] Burne-Jones clearly had this figure of Cupid in mind when designing the oil version of *Blind Love* in the mid to late 1860s.

Blind Love may also have been influenced by Simeon Solomon's masterpiece from 1866, *Love in Autumn*, which is similar in design and mood. Although this work was not exhibited until 1872, when it was shown at the Dudley Gallery, Burne-Jones would obviously have been aware of one of Solomon's major paintings at this stage of his career. *Blind Love*, in fact, has much in common with Solomon's work from this period, when their friendship was close. The face of Love in *Blind Love* also owes a debt to Rossetti's *Beata Beatrix*, where Beatrice is portrayed in a trance-like state before being "suddenly rapt from Earth to Heaven."[15]

A pencil study for the nude figure of *Blind Love*, for this later oil version, was with Julian Hartnoll, London, in 1998.

1 Christie's, London: *Catalogue of Studies by Sir Edward Burne-Jones. The property of his daughter the late Mrs. Margaret Mackail*, December 3, 1954, lot 41, Cupid unfinished, oil, 47 × 23 ½ in. Abbott and Holder likely cut this work down to its present dimensions to make it easier to sell, while retaining the most interesting and finished parts of the composition.
2 Waters, Bill: Peter Nahum, London, 1993, p. 23.
3 Waters, Bill: p. 23. J. Comyns Carr: *New Gallery Catalogue*, 1889, p. 13.
4 Norton, Sara and Howe, M.A. De Wolfe: 1913, Vol. I, p. 346.
5 Lago, Mary: 1982, p. 87. Burne-Jones was talking about *Venus Concordia* at the time.
6 Mancoff, Debra N.: 1998, p. 117.
7 Agnew's: 1966, cat. no. 45, watercolour on canvas, 15 × 8 in. This watercolour once belonged to G.P. Boyce and is now in a private collection.
8 Harrison, Martin and Waters, Bill: 1973, p. 84.
9 Burne-Jones, Georgiana: 1904, Vol. 1, p. 257.
10 Colvin, Sidney: 1870b, p. 19.
11 De Lisle, Fortunée: 1904, pp. 82 and 169-170.

12 Robertson, W. Graham: 1931, p. 83.

13 Christian, John: Metropolitan Museum of Art, 1998, p. 111.

14 Sotheby's, London: *Victorian Pictures*, November 3, 1993, lot 193, coloured chalks, signed with mono-
 gram, 8 × 7 in.

15 Surtees, Virginia: 1971, cat. no. 168, pp. 93-94. This painting was probably taken up again by Rossetti
 in 1864, but not completed until 1870. I am indebted to Susan Casteras for pointing out the relation-
 ship between this work and *Blind Love*.

13a Study of a Draped Female Figure, for "The Garden Court," 1870

Graphite on off-white paper; inscribed lower left *1870* and lower right BRIAR ROSE and signed *EBJ*
7¹/₁₆ × 5 in. (17.9 × 12.7 cm)

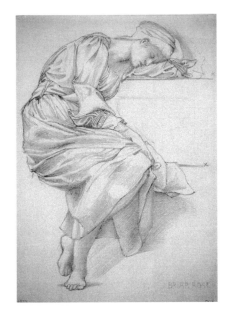

13b Study of Another Draped Female Figure, for "The Garden Court," 1870

Graphite on off-white paper; inscribed BRIAR ROSE lower left, and signed *EBJ* and dated *1870*, lower right 7¹/₁₆ × 5 in. (18 × 12.6 cm)
PROVENANCE: An unidentified Austrian no-bleman; bequeathed to his nephew Dr. Ivan Schagel; given by Dr. Schagel, c. 1939, to his companion Florence Reid; bequeathed by her to a family friend Patricia Mitchell of Ottawa, Ontario, c. 1975; purchased June, 1995.
EXHIBITED: ? Berlin: 1898.

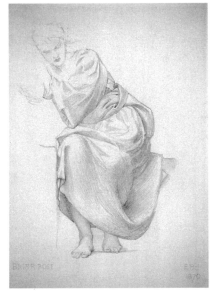

The story of Sleeping Beauty was first handled by Burne-Jones in 1864 in a tile panel carried out as part of Morris, Marshall, Faulkner & Co.'s decoration of Myles Birket Foster's house, The Hill, Witley, Surrey. The Briar Rose series may have been inspired by versions of the fairy tale as told in the 17th century by Charles Perrault, or later by the Brothers Grimm. Tennyson's poem *The Day Dream*, published in 1842, is another likely possibility. By 1869 Burne-Jones had conceived of treating the Sleeping Beauty story as a series of paintings. By 1871 he began his first

versions, the so called "small Briar Rose set" for his patron William Graham. This set, consisting of three paintings, was completed in 1873 and is now at the Museo de Arte at Ponce, Puerto Rico. Included in this early set are *The Briar Wood*, showing the Prince and the sleeping knights, *The Council Chamber* with the aged king and his courtiers asleep, and *The Rose Bower* showing Sleeping Beauty and her attendants. A canvas for the fourth subject usually included in the series, *The Garden Court*, was never completed, although a watercolour sketch exists for this subject.[1] Stylistically this watercolour likely dates from this time, and can only be as late as 1873, based on the fact that Graham's set was completed by that time. These pencil drawings, dated 1870, are obviously for this watercolour sketch, rather than for any of the later oil versions of *The Garden Court*. Even though these drawings are dated 1870, it is uncertain whether Burne-Jones dated them at that time, or later from memory when he was preparing his drawings for exhibition at the Fine Art Society in 1896. There are many known instances where he dated drawings incorrectly at that time.

Although an oil version of *The Garden Court* was never completed in the series for Graham, it appears that Burne-Jones had initially thought in terms of four paintings, since an entry in his work-list under 1872 reads as follows: "4 pictures of Sleeping Beauty – painted in oil for Graham, begun in 1871."[1] This suggests that a fourth painting was likely begun, but abandoned at a later date. In 1874 Burne-Jones began a much larger set of four canvases for the Briar Rose series, although these were not completed until 1890. This set was bought by the financier Alexander Henderson, later the 1st Lord Faringdon, and was installed at his house, Buscot Park, Oxfordshire, where they remain today. During the long gestation period of this larger series, three canvases had been abandoned, but these were later taken up again by Burne-Jones and completed from 1892-94. This series is now dispersed with *The Council Chamber* at the Delaware Art Museum in Wilmington, *The Garden Court* at the Bristol Museum and Art Gallery, and *The Rose Bower* in the Municipal Museum of Modern Art in Dublin.

These two beautiful pencil studies are characteristic of Burne-Jones' drawings from this period. J. Comyns Carr has discussed the importance of Burne-Jones' studies: "It is this which gives to the drawings of Burne-Jones their extraordinary charm and fascination. He who possesses one of these pencil studies has something more that a leaf torn from an artist's sketchbook. He has in the slightest of them a fragment that images the man: that is compact of all the qualities of his art; and that reveals his ideal as surely as it interprets the facts upon which he was immediately engaged. And yet we see in them how strenuously, how resolutely, he set himself to wring from nature the vindication of his own design."[2] A.L. Baldry has similarly commented on Burne-Jones' drawings: "These drawings show well with what power of design and with what sensitiveness of hand he puts down his conceptions; how sincerely and unaffectedly he studies so that nothing may be lacking in the constructing and fitting together of his compositions; how systematically he applies his power of selection to the collecting of what is necessary for his scheme of expression. Nothing is careless or merely tentative. There is a purpose in every touch, a motive for every experiment: and there is always clearly visible the intention to uphold that lofty ideal of pictorial art which has influenced him all through his busy life. Without such an ideal it would have been hardly possible for him to have faced and grappled with the accumulation of close study which his method has made inevitable."[3]

Two comparable pencil drawings for the early watercolour version of *The Garden Court*, both dated 1870, are in the Fitzwilliam Museum, Cambridge.[4] Three additional similar pencil drawings, c. 1873, are at the Tate Gallery, London, as is a pencil study of a sleeping woman's head.[5] A study of two female figures, c. 1870, in chalk and watercolour on green

tinted paper is at the York City Art Gallery.[6] A gouache of the same two sleeping attendants sold at Sotheby's, London in 1981.[7]

1 Christian, John: Christie's, London, *Fine Victorian Pictures, Drawings and Watercolours*, June 11, 1993, lot 93, pencil and watercolour, 12¾ × 23¾ in., bought Maas Gallery, London. It was subsequently exhibited at the Shepherd Gallery: 1994, cat. no. 29.
2 Comyns Carr, J.: 1914, pp. 61-62.
3 Baldry, A.L.: 1896, p. 344.
4 Galleria Nazionale d'Arte Moderna: 1986, cat. nos. 28 & 29, p. 162, illus. p. 116. Benedetti and Piantoni state these drawings were originally purchased at Philip Burne-Jones' sale at Christie's, London, on June 5, 1919. These works were bequeathed by C. Ricketts and C. Shannon to the Fitzwilliam. At the sale at Christie's in 1919, lots 14 and 16 contained studies of sleeping figures for the Briar Rose, but these were bought by Reitlinger, likely H.S. Reitlinger. At Burne-Jones' estate sale at Christie's, London on July 16, 1898, lots 118 and 126 both contained two studies for the Briar Rose and were purchased by Agnew's. Neither lot was bought from Agnew's by either Ricketts and Shannon or by an Austrian nobleman.
5 Tate Gallery: 1993, cat. nos. 40-42.
6 Mappin Art Gallery: 1971, cat. no. 197, p. 34, 32 × 23 in.
7 Sotheby's, London: *Important British Paintings and Drawings from 1840 to 1960*, November 10, 1981, lot 31, gouache on canvas, 11½ × 7½ in., dated 1872.

14 Study for the "Burning of the Boats," 1874

Two types of graphite on off-white wove paper; inscribed in an unknown hand, below the image, "For the illustrated 'Virgil' (never completed)/ 'Burning the boats' – by E. Burne-Jones" 9⅞ × 7 in. (25.2 × 17.7 cm)
PROVENANCE: Anonymous sale, Phillips, London, April 28, 1986, lot 117.
LITERATURE: Lochnan, K.A.; Schoenherr, D.E.; Silver, C: cat. no. A:26 (illus.), pp. 74-75.
EXHIBITED: Art Gallery of Ontario: 1993, cat. no. A:26 (illus.).; Kenderdine Gallery: 1995, cat. no. 10.

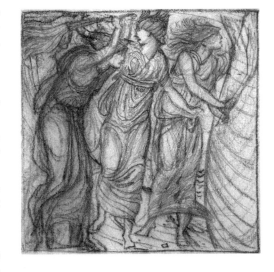

This drawing is a preliminary study for one of Burne-Jones' illustrations for William Morris' masterpiece of illuminated calligraphy, *The Aeneid* of Virgil. J.W. MacKail, in writing about this manuscript, felt that "in beauty of handwriting and splendour of ornament it takes far the first place among all his manuscripts."[1] Morris and Burne-Jones had first become interested in medieval illuminated manuscripts while they were students at Oxford. They had studied painted books of the 13th and 14th centuries at the Bodleian Library and, even at this time, Morris had experimented in producing illuminated manuscripts. Morris' chief preoccupation with producing illuminated manuscripts, however, occurred between 1869 and 1875. When he returned to the art of illumination in 1869, it soon became one of his prime leisure activities. In 1872 Morris moved to Horrington House, in Turnham Green, which was a half-hour's walk from Burne-Jones' home, The Grange, in Fulham. Morris

began a habit at this time of breakfasting with the Burne-Joneses every Sunday, and spending the rest of the morning in the studio.

It was during these Sunday morning sessions that Morris and Burne-Jones together evolved the idea for an illuminated manuscript of *The Aeneid*. In 1874 Burne-Jones wrote to his friend Charles Eliot Norton: "Every Sunday morning you may think of Morris and me together – he reads a book to me and I make drawings for a big Virgil he is writing – it is to be wonderful and put an end to printing."[2] This project went on for more than a year. Burne-Jones designed twelve large pictures, and many initial letters and other ornaments, for the twelve books of *The Aeneid*. Aymer Vallance stated that he made pencil designs at intervals from 1873-75 inclusive, producing nearly thirty designs in all.[3] Although these drawings are characteristic of his work of the early 1870s, Harrison and Waters feel Burne-Jones' designs for *The Aeneid* show how far he had progressed as a designer: "In their skilful use of decorated letters, their asymmetry, their brilliantly controlled but unpredictable line, they anticipate the art nouveau illustrators of the late nineties. At the same time the strength of his bizarre images intensifies the text and creates an almost surreal mood".[4]

Burne-Jones' drawings for this project are mainly in the Fitzwilliam Museum, Cambridge,[5,6] although additional studies are in the Whitworth Art Gallery, Manchester, and the Ashmolean Museum, Oxford. Another drawing sold at Sotheby's Belgravia on April 19, 1974.[7] If one compares Burne-Jones' preliminary drawing for the *Burning of the Boats* with the final design chosen, the final drawing is more finished and less compressed, with three more figures incorporated into it, and even the figures that have been retained from the earlier drawing are in somewhat different configurations.[5] The characteristic Burne-Jones boat has been omitted from the far right, and an almost art nouveau-like tree has been introduced to the left. Whether the final design is more successful than Burne-Jones' initial conception is debatable. Although the emotions displayed by the figures in the final design are more powerful, the artist has captured a much more realistic portrayal of movement in his preliminary design, and the loss of the boat from the final design is regrettable. This drawing shows three Trojan women, at Juno's instigation, trying to burn the fleet of boats that was about to convey Aeneas to Italy.

William Morris began working on the calligraphy for *The Aeneid* in late 1874, and continued until the middle of 1875. He completed to the foot of page 177, almost at the end of Book VI. Although Morris did begin one of the pictures for the project, he found it unsatisfactory, and on May 27, 1875 he wrote to Charles Fairfax Murray in Italy: "also I have begun one of the Master's pictures for the Virgil: I make but a sorry hand of it at first, but shall go on with it till (at the worst) I am wholly disconforted [sic]. Meantime whether I succeed or not in the end 'twill be a long job: so I am asking you if you would do some of them & what it would be worth your while to do them for."[8] Murray did execute a great deal of the illumination after his return to England. He repainted all of the opening page miniature begun by Morris, with the exception of the head of Aeneas, and also contributed some marginal historiated initials between pages 45 and 72 inclusive. Morris himself, however, never resumed work on the project due to the pressures of other work, although Jack MacKail remembered seeing him turn over the sheets and hearing him talk of finishing it as late as some fifteen years later.[1]

The manuscript was eventually sold to Charles Fairfax Murray in about 1890. He subsequently employed Grailey Hewitt and Louise Powell to collaborate with him to finish it, although it remains incomplete. The manuscript sold at the Estelle Doheny Collection sale at Christie's, New York, on May 19, 1989, where it was bought by Andrew Lloyd Webber. It was exhibited at the William Morris exhibition at the Victoria and Albert Museum in London in 1996[9] and at the Burne-Jones exhibition at the Metropolitan Museum, New York, in 1998.[10]

1 MacKail, J. W.: 1899, Vol. I, p. 320.
2 Burne-Jones, Georgiana: 1904, Vol. II, p. 56.
3 Vallance, Aymer: 1900, p. 18.
4 Harrison, Martin and Waters, Bill: 1973, p. 121.
5 Wood, T. Martin: 1907, pls. V–XII. The finished study for the *Burning of the Boats* is reproduced as pl. VII. These drawings initially belonged to Laurence Hodson, and subseqently to J.R. Holliday, who bequeathed them to the Fitzwilliam Museum in 1927. They are all approx. 17.5 × 17 cm., and are signed and dated 1874.
6 Galleria Nazionale d'Arte Moderna: 1986, cat. nos. 136–146, p. 273. Three designs for pictures, and eight designs for initials, for *The Aeneid*, from the Fitzwilliam Museum were included, and are reproduced as figs. 136–146, pp. 252–255.
7 Sotheby's, Belgravia: *Fine Victorian Paintings, Drawings and Watercolours*, April 9, 1974, lot 61, *The Sirens*, pencil, c. 1873, 10 × 5¼ in.
8 Kelvin, Norman: 1984, Vol. I, letter 273, p. 254.
9 Victoria and Albert Museum: 1996, cat. n. 14, pp. 308–309.
10 Metropolitan Museum of Art: 1998, cat. no. 66, p. 173.

15 Study of the Head of Fortune for "The Wheel of Fortune,"
c. 1875-83

Oil, in brown monochrome, on canvas; the frame is original and is the type used by Burne-Jones for his oil sketches of heads 14⅝ × 15½ in. (37.3 × 39.6 cm)

PROVENANCE: Probably by descent to the artist's daughter Margaret Mackail and her estate sale, Christie's, London, December 3, 1954, part of lot 43 (Head of Girl, with eyes closed), bought Colnaghi; P. & D. Colnaghi and Co., London; sold in 1957 to Dr. William Fredeman, Vancouver; sold in 1979 to MacMillan and Perrin Gallery, Toronto; their sale, Christie's, London, June 5, 1981, lot 102; Sotheby's, London, June 15, 1982, lot 103; Christie's, London, March 18, 1983, lot 49.

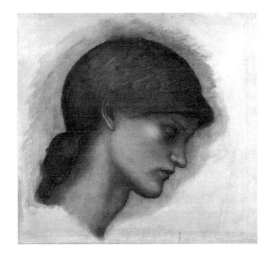

LITERATURE: Cartwright, Julia: 1894, p. 16 (illus.).; Christian, John: 1984, pp. 208–209, fig. 11; Wildman, S. and Christian, J.: 1998, cat. no. 53, p. 155, n. 3.

EXHIBITED: MacMillan and Perrin Gallery: 1979, cat. no. 7 (illus.); Kenderdine Gallery: 1995, cat. no. 11 (illus.).

This study is for the head of Fortune in *The Wheel of Fortune*. In the painting Fortune is seen turning her wheel to which three mortals are bound – a Slave at the top, a King in the centre, and a Poet below. The design was originally conceived as part of a complex polyptych, the "Troy Triptych," begun in 1870, which was to illustrate the story of the fall of Troy. This ambitious project was never realized and the incomplete work, as it exists in the Birmingham City Museum and Art Gallery, is largely the work of studio assistants. Burne-Jones did, however, take some of the designs for this polyptych and develop them into independent paintings. Of these *The Wheel of Fortune* came to have a significance for him out of proportion

to all the rest. John Christian felt this was no doubt partly because he liked the composition, but also because it represented much of his personal philosophy.[1] In March 1893, in a letter to Helen Mary Gaskell, Burne-Jones wrote: "my Fortune's Wheel is a true image, and we take our turn at it, and are broken upon it."[2]

Burne-Jones painted at least six versions of this composition in various media.[1] The most important, which was exhibited at the Grosvenor Gallery in 1883, is now in the Musée d' Orsay in Paris. Two other large oils exist, one in Melbourne and the other in Cardiff. A smaller, but probably the second best version, is a gouache in the collection of the London Borough of Hammersmith and Fulham, currently on loan to Leighton House. An early version from 1871 is in the Watts Gallery at Compton, while an even earllier version, in gouache, somewhat different in composition, is in the Carlisle Museum and Art Gallery.

The concept of the Wheel of Fortune had been popular in Western art and iconography since the Middle Ages. Burne-Jones would have been familiar with many examples, including Dürer's famous engraving, and the intaglio design on the pavement of Siena Cathedral.[1] The major influence on this particular work, however, is Michelangelo. In September 1871 Burne-Jones travelled to Italy, visiting Genoa, Florence, Pisa, Siena and Rome. In Rome Burne-Jones bought the best opera glasses he could find and, lying on his back, he examined the ceiling of the Sistine Chapel from beginning to end, revelling in its execution. On his return from Italy he wrote: "So that now I care most for Michel Angelo, Luca Signorelli, Mantegna, Giotto, Orcagna, Botticelli, Andrea del Sarto, Paolo Uccello, and Piero della Francesca."[3] Fortune, in spirit as well as in the form of her dress, was influenced by the Sibyls on the ceiling of the Sistine Chapel.[1] Her headdress, although derivative of the headgear of the Sibyls, was designed by Mrs. J. Comyns Carr, a costume designer, and the wife of one of the directors of the Grosvenor Gallery. Contemporary critics recognized Burne-Jones' debt to Michelangelo in this work. F.G. Stephens wrote in *The Athenaeum* on April 28, 1883 that Fortune was like "a gigantic statue of grey and golden coloured marbles ... her beauty is sculpturesque, and her face has the sadness of Michael Angelo's 'Night'."[4]

The large oil version of *The Wheel of Fortune*, shown at the Grosvenor Gallery in 1883, was begun in 1875 and worked on fairly consistently for the next few years. It is said to have been Burne-Jones' personal favourite among his finished oil paintings.[1] The numerous studies that exist show how carefully he considered every detail, particularly the head of Fortune. Not only are there many pencil drawings for her head, at least fifteen different sheets of studies, some with more than one drawing of the head of Fortune on a sheet, but also drawings done in coloured washes. Two other large monochrome sketches in oil on canvas also exist.[5,6] Surely the head of no other figure in Burne-Jones' major paintings can have been planned so meticulously. The oil sketch exhibited here would appear to most closely resemble the head of Fortune in the gouache version in the collection of the London Borough of Hammersmith and Fulham, or perhaps the oil version in Melbourne. If this is the case, it is likely to be the first oil study for the head of Fortune, since these versions were begun before, but completed after, the version at the Musée d' Orsay.

The model for Fortune is generally said to have been Lily Langtry,[7,8] although Margaret Benson has also been mentioned as a possibility.[9] Although this study may have been modelled from Lily Langtry, it looks like a typical Burne-Jones face, and could just as easily be thought a study for the head of *Flamma Vestalis*, an oil painting from 1886, for which Margaret Burne-Jones is known to have been the model. Burne-Jones' use of models in his works had often more to do with his artistic vision than with conventional portraiture. As Graham Robertson remarked: "I have often watched him drawing from the life, and so strong was his personal vision that, as I gazed, Antonelli the model began to look very like Burne-

74

Jones's study, although the study never began to look like Antonelli."[10] Although not a particularly effective portrait of Lily Langtry in a conventional sense, this oil sketch with the woman's long neck and prominent chin, is nonetheless a very representative example of what constitutes the striking "Pre-Raphaelite type" of face. The painters associated with the second phase of Pre-Raphaelitism, particularly Rossetti and Burne-Jones, completely revolutionized ideas of feminine beauty in the 19th century, and instituted a concept of facial esthetics that remains to this day.[11]

1 Christian, John: Tate Gallery, 1984, cat. no.155, p. 236. In the first two treatments of the subject, at the Carlisle Art Gallery and the Watts Gallery, Compton, Fortune is depicted blindfolded.
2 Fitzgerald, Penelope: 1975, p. 245.
3 Harrison, Martin and Waters, Bill: 1973, p.104.
4 Wildman, Stephen: Metropolitan Museum of Art, 1998, cat. no. 52, p. 155. F.G. Stephens, *The Athenaeum*, April 28, 1882, p. 547.
5 Harrison, Martin: 1971, pl. 45. This oil study, which is very similar to the present work, was at that time in the possession of the dealer T.M. Whiteway in London.
6 Another monochrome oil study was included at sales at Christie's, London, May 19, 1978, lot 203; Sotheby's, London, June 15, 1982, lot 104; and Christie's, New York, February 15, 1985, lot 217. This study had originally sold at Burne-Jones' studio sale, Christie's, London, July 16, 1898, lot 66.
7 Dixon, Annette: National Gallery of Victoria, 1978, cat. no. 4, p.17. The actress Lily Langtry informed the Trustees at the time of purchase that she had sat for the figure of Fortune.
8 Brough, James: 1975, p. 159. Brough claims Langtry approved of the way Burne-Jones depicted her in *The Golden Stairs*, but always disliked her depiction as Fortune in *The Wheel of Fortune*.
9 Depas, Rosalind: 1988, p. 80.
10 Robertson, W. Graham: 1931, p. 83.
11 Haweis, Mrs. H.R.: 1878, pp. 273-274. "Those dear and much abused 'pre-Raphaelite' painters, whom it is still in some circles the fashion to decry, are the plain girls' best friends … Morris, Burne-Jones, and others have made certain types of face and figure once literally hated, actually the fashion. Red hair – once, to say a woman had red hair was social assassination – is the rage. A pallid face with a protruding upper lip is highly esteemed. Green eyes, a squint, square eyebrows, white-brown complexions are not left out in the cold. In fact, the pink-cheeked dolls are nowhere; they are said to have 'no character' and a pretty little hand is occasionally voted characterless too. Now is the time for plain women."

16 Study of the Slave for "The Wheel of Fortune," c. 1875-83

Black chalk on off-white wove paper 11¾ × 6¾ in. (29.8 × 16.1 cm)
PROVENANCE: Sidney Morris, of S. & K. Morris Gallery, Stratford-upon-Avon; sold in approximately 1975 to Douglas Franklin, Wolverhampton; sold on March 30, 1984 to Julian Hartnoll, London; purchased June 12, 1984.
EXHIBITED: Kenderdine Gallery: 1995, cat. no. 12.

This drawing is a study for the figure of the Slave in *The Wheel of Fortune*, a painting that epitomizes, more than any other of his major works, the influence of Michelangelo on Burne-Jones' work. In view of his admiration for this High Renaissance master, it is not surprising that Burne-Jones should be particularly distressed when his friend John Ruskin, who had had an important influence on his artistic development, delivered a savage attack on Michelangelo in a Slade lecture at Oxford in the summer of 1871. Ruskin, at his home in Denmark Hill, had read the lecture to him prior to its delivery in Oxford. The rift between the two brought on by this attack never completely healed, and even ten years later Burne-Jones remarked: "He read it to me just after he had written it, and as I went home I wanted to drown myself in the Surrey Canal or get drunk in a tavern – it didn't seem worthwhile to strive any more if he could think

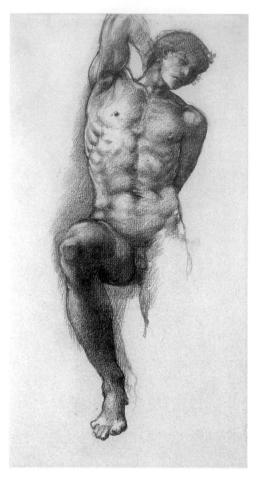

it and write it."[1] Ruskin's attack was on the artists of the High Renaissance who he felt had debased the purity and piety of the art of the Quattrocento, with Michelangelo being the "chief captain in evil."[2] Ruskin attacked Michelangelo for his bad workmanship, violence of transitional action, physical instead of mental interest, with the body and its anatomy made the entire subject of interest, and emphasis on evil rather than good. Ruskin noted: "On the face itself instead of joy or virtue, at best, sadness, probably pride, often sensuality, and always by preference, vice or agony as the subject of thought."[2] What must have been especially painful to Burne-Jones was the fact that Ruskin attacked not only Michelangelo himself, but also those who admired him: "But it is one of the chief misfortunes affecting Michael Angelo's reputation that his ostentatious display of strength and science has a natural attraction for comparatively weak and pedantic persons."[2] Ruskin's outbursts against Michelangelo understandably drew widespread criticism, and prominent artists such as Edward Poynter and William Blake Richmond, whose own works had been influenced by Michelangelo, delivered lectures giving the contrary view.[3,4]

In *The Wheel of Fortune* Burne-Jones' debt to Michelangelo is obvious. The contorted poses and massive torsos of the Slave and King, with their detailed portrayal of anatomical features, recall those of Michelangelo's *The Dying Slave* in the Louvre, or the *Captives* in the Accademia in Florence. Burne-Jones owned a small plaster copy of the former and had sketched the latter work during his 1871 trip to Italy. The pose of the King from *The Wheel of Fortune* may have been inspired by Annibale Carracci's *Christ in Glory*, or Michelangelo's *The Deposition*.[2] The pose of the Slave, particularly the legs, is also similar to that of Fortune in Burne-Jones' first version of *The Wheel of Fortune*, a gouache that must predate 1871, in the Carlisle Museum and Art Gallery. This early version is quite different in composition than his later versions.[5] Several sketchbooks and numerous preliminary studies for *The Wheel of Fortune* exist, including many drawings for the figures of the Slave, King, and Poet. A study for the Slave is in the collection of the National Gallery of Victoria in Melbourne.[6] A study for the Slave sold at Sotheby's Belgravia on March 21, 1981.[7] A drawing at the British Museum inscribed "study for the Slave" is actualy a study for the King.[8] An oil sketch for the nude figure of a man, likely the Slave, for *The Wheel of Fortune*, is in the Birmingham City Museum and Art Gallery.[9]

This drawing shows Burne-Jones' mastery of the figure, particularly of a model in a difficult pose with the right leg drawn up, which makes it difficult to keep it in perspective and correct proportion to the rest of the body. When *The Wheel of Fortune* was exhibited at the Grosvenor Gallery in 1883, it received favourable reviews. The critic of the *Art Journal*

described it as "the most noteworthy among the imaginative pictures of the year."[10] Tom Taylor, the critic of *The Times*, a paper that had so often been hostile to Burne-Jones in the past, noted that: "The artist is not one who varies his types ... But never has the type been more splendidly realized than here; nor has any painting of this unquestioned but unequal genius ever been more completely successful ... the wonderful technical skill ... the admirable drawing of the figures, which shows that the artist has quite got rid of the faults of draughtsmanship which were noticeable in his work only a few years ago."[11]

It is surprising that Burne-Jones managed to develop his proficiency in draughtsmanship to the extent that he did, in view of the fact that he did not decide to devote himself to art until 1856, at the age of 22. He therefore lacked formal academic training and was, in fact, largely self-taught as an artist. D.G. Rossetti, his first real teacher, gave him the confidence to develop his talents, although Rossetti was not known for his rigorous draughtsmanship or technical expertise, and tended to feel that anyone with imagination could paint. Rossetti himself had little use for formal academic training in which students were taught to make studies of casts, draperies, etc. before progressing to the study of the human figure. Rossetti felt Academies developed facility without vision and he was more interested in sincerity and purity of inspiration which, if present in an artist, would show itself regardless of his or her training. Burne-Jones also attended evening life-drawing classes for about three years at the art academy run by James Matthew Leigh in Newman Street, Bloomsbury. He later claimed: "I went to Lee's [sic] for a very short time, but did nothing at all. I went home and made a school of practice for myself out of the studies for my designs; I drew a very great many as well as I could."[1] In 1858 Burne-Jones fell seriously ill and was carried off to recover at Little Holland House under the care of Sara Prinsep. It was here that he came under the influence of G.F. Watts, who recognized the deficiencies of Rossetti's impromptu instruction, and who made Burne-Jones recognize his need for a sounder basis in his work. Twenty years later Burne-Jones stated "Watts compelled me to try and draw better."[2] Georgiana Burne-Jones, in her *Memorials*, recalled a conversation her husband had with William De Morgan, early in their friendship, when De Morgan inquired about a fresh canvas he saw in the studio: "'Yes,' said Edward, quoting the stereotyped newspaper criticism of Pre-Raphaelite work; 'I am going to cover that canvas with flagrant violations of perspective and drawing and crude inharmonious colour'; but later in the evening he said to De Morgan, 'You know that was all gammon I was talking about perspective and drawing – I only do things badly because I don't know how to do them well; I do want to do them well'."[1]

Burne-Jones perfected his drawing techniques over the years from constant practice. As W. Graham Robertson noted: "I have seen it laid down by critics that Burne-Jones could not draw. He was pre-eminently a draughtsman, and one of the greatest in the whole history of Art. What the critics meant, I imagine, was that, in some of his earlier work, his figures were not anatomically correct; which was true to a certain extent, and he took great pains in later days to rectify this fault – with some slight loss of freshness and spontaneity. But as a master of line he was always unequalled; to draw was his natural mode of expression – line flowed from him almost without volition. If he were merely playing with a pencil, the result was never a scribble, but a thing of beauty however slight, a perfect design. The possession of this faculty, even in a much slighter degree, is to be met with amongst artists far less often than might be imagined."[12]

1 Burne-Jones, Georgiana: 1904, Vol.II, pp.18 and 294 and Vol. I, p. 260.
2 Harrison, Martin and Waters, Bill: 1973, pp. 41, 104, 116, and 132.
3 Arscott, Caroline: "Poynter and the arty" in Prettejohn, Elizabeth: 1999, pp. 138-148. In her essay Arscott points out that in the late 1860s and the1870s Poynter and Ruskin "were locked into a dispute

over Michelangelo and the human figure" which was similar to the later, more famous confrontation between Ruskin and Whistler. "In this debate, too, an Aesthetic Movement position concerning work, morality and aesthetic value was elaborated in opposition to Ruskin."

4 Cook, E.T.: 1911, Vol. I, pp 210-211.
5 Tate Gallery: 1997, cat. no. 28, p. 132. In this version the figure of Fortune is within the wheel, and the poses of all the figures are quite different. This watercolour originally belonged to G.F. Watts and has much in common with his works.
6 Dean, Sonia: National Gallery of Victoria: 1978, cat. no. 12 (illus.), p. 32, c. 1870, black chalk, heightened with white body colour and touches of blue oil on brown paper, laid on panel. This drawing, although it shows the pose of the slave in its entirety including the left leg, lacks the intensity and precision of the anatomical features portrayed in the present work.
7 Sotheby's Belgravia: March 24, 1981, lot 51, pencil, 10¼ × 5¼ in. This drawing shows the figure in its entirety except for the top of the right arm, but it is not as close to the final pose in the painting, or as powerful as the present drawing.
8 Gere, John A.: 1994, Appendix, p. 145, pencil, 1879, 10¾ × 7¹⁄₁₆ inches. It is illustrated in Wood, Christopher: 1998, p. 100.
9 Birmingham City Museum and Art Gallery: 1939, cat. no. 224'04, p. 95, oil on canvas, 12 × 7½ in., nude figure of a man to below the knees, leaning back against the wheel, his arms raised above his head.
10 Wildman, Stephen: Metropolitan Museum of Art, 1998, cat. no. 52, p. 154.
11 Christian, John: Tate Gallery, 1984, cat. no.155, p. 237. *The Times*, May 4, 1883, p.4.
12 Robertson, W. Graham: 1931, p. 84.

17 The Raising of Lazarus, 1877

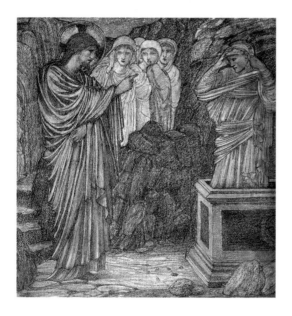

Graphite and coloured chalks on buff wove paper, with a dark brown wash border (slightly trimmed)

23¾ × 22¾ in. (59.5 × 56.8 cm)

PROVENANCE: Probably Sir Philip Burne-Jones, the artist's son; his sale, Christie's, London, June 5, 1919, part of lot 95, bought Gooden & Fox, London; anonymous sale, Christie's, London, February 4, 1986, lot 252; bought in at the sale and purchased afterwards.

LITERATURE: Sewter, A. C.: Vol. I, 1974, fig. 535, Vol. II, 1975, p. 200; Lochnan, K.A.; Schoenherr, D.E.; Silver, C.: 1993, cat. no. A:10 (illus.), pp. 52-53.

EXHIBITED: Art Gallery of Ontario: 1993, cat. no. A:10 (illus.); Kenderdine Gallery: 1995, cat. no. 14.

Edward Burne-Jones was the most distinguished British stained-glass designer of the 19th century, and ranks as one of the greatest designers in this medium of all times. In 1856 he left Oxford without completing his degree to devote his life to art. Despite his lack of formal academic training, Burne-Jones seemed from the beginning to have "an instinctive, and highly developed sense of design."[1] Burne-Jones received his first commissions for stained-glass designs from two leading firms, James Powell and Sons, and Lavers and Barraud. Both firms were anxious to employ young artists to improve the quality of their designs in order to

produce stained glass that was not merely an imitation of medieval work. Burne-Jones produced a number of designs for Powell's from 1857-61 that were boldly original and unmistakably modern, although inspired by medieval forms.[1] As Sewter has stated: "Before the foundation of the Morris firm, his work had advanced English stained glass from imitative mediaevalism to a modern creative art far ahead of anything being produced elsewhere."[2]

In April, 1861 Burne-Jones became a partner in the firm of Morris, Marshall, Faulkner & Co. From this point on he designed stained-glass windows exclusively for the firm, where his "rapid execution, versatility, and endless powers on invention" made him of crucial importance.[1] In 1875, after its reorganization into Morris and Co., Burne-Jones became its only stained-glass figure designer, although even prior to the dissolution, there had been a gradual decline in the number of designs supplied by the other members. From 1872 on a sudden increase in cartoons for stained glass is noted in Burne-Jones' account book. Sewter has estimated that between 1872 and 1878 he made over 270 cartoons, an average of thirty-nine per year.[2] As Sewter points out, this would be a remarkable achievement for an artist who was solely occupied with designing for stained glass, but it must be remembered that during the 1870s Burne-Jones was also particularly prolific as a painter.[1] Because of the heavy demands on his time, the quality of his cartoons began to vary widely, as he himself was quite well aware.[2] That Burne-Jones was able to sustain this level of productivity is attributable, not only to his extraordinary facility as a designer, but also to his well-organized studio system.

The majority of Burne-Jones' stained-glass cartoons became the property of Morris and Co., for subsequent re-use. The more important ones, however, were returned to his studio to be coloured and then, hopefully, sold.[3] A complex design, which was specifically made for a particular church, was often impossible to adapt for a second use, but was decorative enough when coloured to be attractive in its own right. This drawing is obviously an example of this practice, and is a design for a predella panel beneath the central light of a three-light window in the St. John of Beverley church in Whatton, Nottinghamshire.[4] If one compares the cartoon to the finished window, it is obvious that the cartoon was not coloured as a guide to the glass painters, but must have been completed sometime later.

The Raising of Lazarus is characteristic of Burne-Jones' work at this date in its drapery designs and its limited, almost monochromatic, colour scheme. The rocky background is based on a design by Giotto at the Arena Chapel in Padua, which Burne-Jones had seen in 1862, during his second trip to Italy. In Giotto's fresco the scene is set in a similar rocky landscape, with Christ on the left, gesturing in a similar fashion to Lazarus on the right, who is wrapped in his funeral shroud and rising from the tomb. In Giotto's work a compressed cluster of heads is placed between the two principal figures, which Burne-Jones has transformed into a similar group of women.[5]

1 Christian, John: Hayward Gallery, 1975-1976, p. 33, and p. 70, cat. no. 200.
2 Sewter, A. Charles: 1974, Vol. I, pp. 15 and 45-47.
3 Harrison, Martin and Waters, Bill: 1973, p. 117
4 Sewter, A.C.: Vol. II, p. 200. The Raising of Lazarus is for a window in the south aisle, lower part of the central light. This design is listed in Burne-Jones' account-book for 1877: 'Whatton. 3 designs, Raising of Lazarus, Beautiful Gate of Temple, Blind Bartimaeus £12 ea. £36." The entry in Morris and Co.'s Catalogue of Designs is dated March, 1878. In Vol. I, pl. 535, the window is reproduced in black and white.
5 Schoenherr, D.: Art Gallery of Ontario, 1993, cat. no. A:10, p. 53.

EDWARD CLIFFORD (1844-1907)

Edward Clifford was born in Bristol, the son of the Reverend John B. Clifford. He initially studied at the Bristol School of Art for one year (1861) and was awarded a medal. He trained at the Royal Academy Schools from 1862 to 1865. In the mid 1860s and the 1870s he was associated with a circle of young artists nicknamed "The Poetry Without Grammar School". He exhibited at the Dudley Gallery, Royal Academy, Grosvenor Gallery, and the New Gallery. A deeply religious man, in later life he was involved with religious and philanthropic work. He was the co-founder and honorary secretary of the Church Army. He travelled widely throughout Britain, Europe and America.

18 Mens Conscia Recti ("A Mind Conscious of Rectitude"), 1868

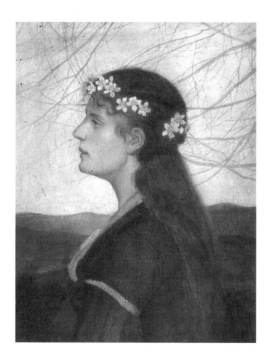

Watercolour on off-white paper, laid down; on the back of the frame on an old label is "No. 3 Mens conscia recti Edward Clifford 5 Gordon Street Gordon Sq. W.C." 16⅞ × 12⁹⁄₁₆ in. (42.9 × 32.1 cm)
PROVENANCE: Anonymous sale, Phillips, London, July 12, 1999, lot 103, bought Rachel Moss of Moss Galleries, London; purchased November 12, 1999.

Clifford was an artist on the periphery of the Pre-Raphaelite circle. As a young student at the Royal Academy Schools in the mid 1860s, he became aware of the work of Burne-Jones when it was exhibited at the Old Water-Colour Society and was "made captive for ever" by its charms.[1] Georgiana Burne-Jones, in her *Memorials* of her husband, recorded: "And there was Edward Clifford, one of a new group of Royal Academy students who had discovered and were enthusiastic about some pencil heads that Edward sent to a Winter Exhibition of the Old Water Colour Society. He came to ask from whom they were drawn, 'for,' says Mr. Clifford, 'we did not fully realize that the drawings depended more on him than on the model.' But he went away taking with him the address of Miss Augusta Jones, a noble-looking girl, who sat for 'Astrologia' amongst many other things."[2] Augusta Jones was subsequently secured as a model by Clifford and his "Poetry Without Grammar" friends.[3] Drawings by Clifford of Augusta Jones were offered for sale by the Moss Galleries, London in 1989.[4]

Clifford was a great admirer of Burne-Jones' early watercolours from the 1860s and owned a number of them, including *Chant d' Amour*. He also made copies of many others, some of which have appeared on the art market in recent years.[5-8] His copies were so good that it has been claimed that even Burne-Jones found it dificult to distinguish them from his own originals.[5] Burne-Jones and Clifford became friends, and on a number of occasions Burne-Jones asked Clifford to act as a studio assistant to help him on large-scale compositions.

Clifford painted primarily in watercolour and bodycolour, in a technique similar to that he learned from copying Burne-Jones' work. As an artist he is best known for his religious pictures, poetic landscapes, and portraits, generally of the aristocracy. He was a friend of many of the titled families of England. The novelist Angela Thirkell, Burne-Jones' grand-daughter, has recorded her childhood reminiscences of Edward Clifford: "Further along [in Kensington Square] was Edward Clifford who so astonishingly united a deep and active feeling of religion, a passion for duchesses, and a marvellous gift of watercolour painting ... Clifford is dead now, with his funny affected voice, his strange mixture of romantic snobbism and religion, his kindness and capacity for friendship."[9]

The Latin title that Clifford gave to this watercolour derives from a famous passage in Virgil's *Aeneid*, when Aeneas is addressing Queen Dido of Carthage (Book I, line 604): *mens sibi conscia recti* ("a mind conscious within itself of rectitude").[10] The artist has not chosen to illustrate this episode, however, but rather personified the abstract epithet in the form of a grave young woman with long virginal hair crowned with a wreath of flowers, likely apple blossoms. The work can be dated with confidence to 1868, based on the address on the old label on the back of the frame. Clifford lived on Gordon Street for only this one year. This early date puts it right in his "Poetry Without Grammar" period. Clifford exhibited at the Dudley Gallery from 1867. Although he showed two watercolours there in 1868, this was not one of them, but it would have been highly appropriate for that venue. It shows the influence, not only of Burne-Jones, but also of the Renaissance masters Clifford admired, particularly in the landscape background. The unusual inclusion of tree branches extending into the composition may have been inspired by Japanese art. Flowering tree branches can be seen in Burne-Jones' *The Lament* of 1866, Albert Moore's *Pomegranates* of 1866, and Whistler's *Symphony in White No. 3* of 1867.

This work by Clifford is similar to a smaller watercolour entitled *Leal* of c. 1869, that was offered for sale twice at Sotheby's Belgravia in the 1970s.[11,12] It features the same model in an identical pose with flowers in her hair, but without the imaginative landscape in the background.

1 Clifford, Edward: 1890, p. 49.
2 Burne-Jones, Georgiana: 1904, Vol. I, p. 302.
3 Crane, Walter: 1907, p. 88.
4 Moss, Rachel: Personal communication, May 28, 1999.
5 Waters, Bill: Norham House Gallery: 1973, cat. no. 43, a copy of Burne-Jones' *An Idyll*, watercolour and gum, 30.5 × 29 cm., signed EBJ 1862, copy by Ed.C 1869.
6 Sotheby's, London: *Victorian Pictures*, November 6, 1995, lot 210, *Merlin and Nimue*, Edward Clifford after E. Burne-Jones, watercolour and bodycolour, 24¾ × 20 in.
7 Sotheby's, London: *Victorian Pictures*, November 2, 1994, lot 192, *Chant d' Amour*, watercolour and pencil, heightened with white, 13¾ × 19¾ in.
8 Shepherd Gallery, New York: 1989, cat. no. 22, *Dorigen of Bretagne*, watercolour and bodycolour, 10½ × 14¼ in.
9 Thirkell, Angela: 1931, pp. 37 and 39.
10 Schoenherr, Douglas: I am grateful to him for pointing out the Latin derivation of this phase in a letter of November 24, 1999.
11 Sotheby's Belgravia: *Fine Victorian Paintings, Drawings and Watercolours*, July 10, 1973, lot 34, watercolour, 11½ × 9¾ in., provenance W. Graham Robertson and Mrs. C. Kirk.
12 Sotheby's Belgravia: *Victorian Paintings, Drawings and Watercolours*, May 6, 1975, lot 31.

WALTER CRANE (1845-1915)

Walter Crane was born on August 15,1845 at Liverpool, the son of Thomas Crane, a portrait painter. From 1859-62 he was apprenticed to the wood engraver W.J. Linton. He continued to work as an illustrator following his apprenticeship. In 1862 he exhibited his first work at the Royal Academy, *The Lady of Shalott*. In 1863 he met Edmund Evans, a pioneer in colour woodblock printing. Crane's reputation as an illustrator of children's books was founded on the enormously popular coloured illustration work he did for cheap sixpenny and shilling books printed by Evans and published by Routledge between 1865 and 1875. In 1866 Crane began to exhibit at the Dudley Gallery. In 1871 he was introduced to Burne-Jones, William Morris, Philip Webb, William De Morgan, and E.J. Poynter at the home of George Howard. On September 6, 1871 he married Mary Frances Andrews and left for Italy, not returning to London until 1873. In Rome in the winter of 1872 Crane became better acquainted with Frederic Leighton, who introduced him to Giovanni Costa. Both artists were later to exert an influence on his work. In 1877 he was invited to exhibit at the first Grosvenor Gallery exhibition. In 1888 he was elected an associate of the Royal Society of Painters in Watercolours, and became the first President of the Arts and Crafts Exhibition Society. He was Master of the Art Workers' Guild from 1887-89, and was part-time Director of Design at the Manchester School of Art from 1893-97. In 1898 he became Principal of the Royal College of Art, South Kensington. He became a full member of the R.W.S. in 1903. In 1905 he received the Albert Gold Medal at the Society of Arts. He died in London on March 14, 1915.

19 The Earth and Spring, 1875

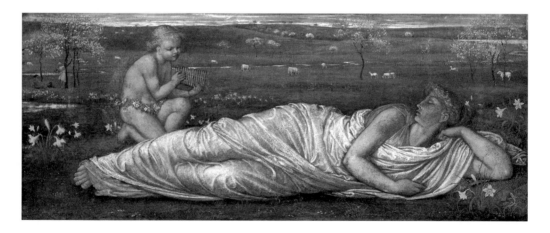

Gouache on paper, laid down on linen; signed with monogram, and dated *75*, lower left; titled and inscribed on the back of the frame, on an old label, "No. 2. The Earth and Spring. Walter Crane, Florence House, Wood Lane, Shepherd's Bush W"; inscribed on another old label, on the stretcher, in Crane's hand, his sonnet written especially for the painting:

> "Child Spring, escaped from harsh dame Winter's rod
> Upon the still green meads stole forth to play
> Glad in the sun's first smile that early day
> Fresh daffodils declaring where he trod

Fall softly, while upon the tender sod
Amid the quickening blooms, asleep Earth lay
Though Spring to her had many a word to say
And token sweet to bear from day's bright god
Then on his pipe made sweet noise, that woke
The singing fowl by every wood and hill
And soaring treble from the answering sky
Until the sweet unrest Earth's slumber broke
Though, fearing it a dream, yet bode she still
A little space, till Spring to her did cry"

12½ × 29 in. (31.5 × 74 cm)

PROVENANCE: Dudley Gallery, 1875, bought by John Postle Heseltine; bequeathed to his wife Sarah Heseltine; Heseltine sale, Sotheby's, London, May 29, 1935, lot 398, bought Ulysses; anonymous sales, Sotheby's, London, June 20, 1989, lot 71; Sotheby's, New York, February 28, 1990, lot 46; Christie's, London, November 13, 1992, lot 135.

LITERATURE: *The Art Journal*: 1898, p. 24.; Konody, P.G.: 1902, p. 133.; Crane, Walter: 1907, p. 165; Christian, J.: 1989a, p. 89, under cat. no. 36.

EXHIBITED: Dudley Gallery: 1875, cat. no. 456; Kenderdine Gallery: 1995, cat. no. 14 (illus.).

In 1870 a reviewer from the *Art Journal*, when discussing Burne-Jones' *Phyllis and Demophoön*, stated: "Mr. Burne Jones in the Old Water-Colour Society stands alone: he has in this room no followers; in order to judge how degenerate this style may become in the hands of disciples, it is needful to take a walk to the Dudley Gallery."[1] The Dudley Gallery, in the Egyptian Hall, Piccadilly, held its first exhibition in 1865. It was a gallery founded on genuinely liberal principles, open to both professional and amateur artists. Its exhibitions were very heterogeneous but, until the opening of the Grosvenor Gallery in 1877, it was the principal forum for the artists associated with the nascent Aesthetic Movement. Walter Crane was a member of a group of young artists, united in their admiration for Burne-Jones, who exhibited at the Dudley Gallery and who were dubbed by hostile critics the "Poetry Without Grammar School." The group consisted of Crane, Robert Bateman, Edward Clifford, Harry Ellis Wooldridge, Alfred Sacheverell Coke, Edward Henry Fahey, and Theodore Blake Wirgman. In 1870 the reviewer for the *Art Journal*, when discussing Crane's watercolour *Ormuzd and Ahriman*, wrote: "These Dudley people are proverbially peculiar. Thus it would be hard to find anywhere talent associated with greater eccentricity than in the clever, yet abnormal, creations of Walter Crane, Robert Bateman, and Simeon Solomon ... Such a style may be set down as an anachronism; yet, beset as we are by the meanest naturalism, we hail with delight a manner which, though by many deemed mistaken, carries the mind into the regions of the imagination ... Though not wholly satisfactory, we hail with gladness the advent of an Art which reverts to historic associations, and carries the mind back to olden styles when painting was [the] twin sister of poetry."[2]

In his *Reminiscences* Crane recalled seeing Burne-Jones' work for the first time at the exhibition of the Old Water-Colour Society in 1865: "The curtain had been lifted, and we had a glimpse into a magic world of romance and pictured poetry, peopled with ghosts of 'ladies dead and lovely knights,' – a twilight world of dark mysterious woodlands, haunted streams, meads of deep green starred with burning flowers, veiled in a dim and mystic light, and stained with low-toned crimson and gold, as if indeed one had gazed through the glass of 'Magic casements opening on the foam / Of perilous seas in faerylands forlorn'. It was,

perhaps, not to be wondered at that, fired with such visions, certain young students should desire to explore further for themselves."[3] Edward Clifford, another member of the group, recalled that: "The charge of eccentricity was a natural charge for the Philistines to make against him, but it was a bewildering one to the victim, for he had painted things quite naively, as they appeared to him. Only he had no academic proclivities."[4] Even a critic like F.G. Stephens, whom one might have expected to be favourably disposed to Burne-Jones, noted his problems with draughtsmanship in a review in *The Athenaeum* in 1864: "There is a great deal of bad drawing in Mr Jones's *Fair Rosamund* but the romantic feeling, luxury of colour, and poetic realisation of a youthful dream, redeem worse faults than those of imperfect training."[5] Almost exactly the same comments could be made about Crane's *The Earth and Spring*. The major difference between Crane and Burne-Jones, however, is that with constant practice Burne-Jones rapidly overcame his deficiencies in draughtsmanship, while Crane never totally did.

The Earth and Spring was shown at the *General Exhibition of Water-Colour Drawings* at the Dudley Gallery in 1875. One possible inspiration for this work could be Sandro Botticelli's *Venus and Mars*, which had recently been purchased by the National Gallery, London, in 1874. The most obvious source of derivation for this painting, however, is the mythological subject by Piero di Cosimo, of c. 1495, traditionally known as the *Death of Procris*. The general placement of the figures, and even the similar treatment of the flowers in the foreground, suggest its influence. Crane certainly would have been familiar with this painting, since it had been acquired in 1862 by the National Gallery in London. *The Earth and Spring* appears to have been influenced as well by Burne-Jones' *Pan and Psyche* of 1872-74, and possibly by J.R. Spencer Stanhope's *Procris and Cephalus* of 1872,[6] both of which were also based on Piero di Cosimo's painting. One wonders whether Crane might have been inspired to paint his own version based on this early Renaissance masterpiece after seeing Burne-Jones' painting. *Pan and Psyche* was not exhibited until 1878, when it was shown at the Grosvenor Gallery, but Crane had likely seen it earlier in Burne-Jones' studio.

Crane was closely associated with Burne-Jones at this time, when he was helping him to decorate George Howard's house at 1 Palace Green, Kensington, with a painted frieze of twelve designs based on the story of Cupid and Psyche. It is possible that Burne-Jones would have discussed his working methods with Crane during the time they worked together. *The Earth and Spring* is painted on paper backed onto linen, a technique frequently used by Burne-Jones for his gouaches. Although this painting was exhibited at the Dudley Gallery as a watercolour, and Crane mentioned it in his *Reminiscences* as such,[3] two independent conservators who have recently examined it claim that it is an oil. Burne-Jones frequently had his gouaches mistaken for oil paintings. In 1893 his *Love among the Ruins* was sent to Paris by the Goupil Gallery to be photographed. The photographer, thinking it was an oil, used egg-white as a varnish to saturate the colours, which caused the painting to be damaged.

The source for the figure of the Earth is unknown, but it may be based either on an Etruscan tomb effigy or a classical funereal frieze. The facial features are certainly derived from ancient Greek sculpture. One possible source is the portrait of the Roman matron Alpia Epigone, shown on her funerary relief, which dates to c. AD 80.[7] Crane could have seen this sculpture during his honeymoon spent in Italy from 1871-73, since it is in the Vatican Museum in Rome. The pose of Earth is also reminiscent of works by Frederic Leighton, such as his *Mother and Child (Cherries)* of 1865, or *Actea, the Nymph of the Shore* of 1868.

The theme of spring was one that obviously fascinated Crane, as he returned to it time and time again. In 1871 he exhibited *A Herald of Spring*, in 1873 the *Advent of Spring*, in 1876 *Winter and Spring*, in 1878 *The Fate of Persephone*, in 1883 *La Primavera*, and finally in 1901

Sorrow and Spring. Of these works *La Primavera* is the one closest in format to *The Earth and Spring*, with the same long horizontal format, high skyline, and spring flowers dotting the landscape. While *The Earth and Spring* epitomizes the "Poetry Without Grammar School", *La Primavera* more closely betrays Crane's association with the "Etruscan" school, through his friendship with Giovanni Costa and George Howard. Crane has included a lizard in the right foreground of *The Earth and Spring*, which is a Christian symbol of rebirth.[8] Not only was the lizard able to rejuvenate itself by shedding its skin, but also as a hibernator it would disappear in the fall before being miraculously "reborn" in the spring.[8]

The Earth and Spring was bought from the Dudley Gallery exhibition of 1875 by J.P. Heseltine, a wealthy financier and a well known connoisseur of works by both old and modern masters. He was later one of the trustees of the National Gallery, London, from 1893. Heseltine was a friend of many artists, particularly Charles Keene, Edward Poynter, and W.F. Burton.

The frame is original and was made by Lambert and Co., Knightsbridge. It is similar to those used by Albert Moore for his pictures in the 1860s and 1870s.

1 Newall, Christopher: 1987, p. 103.
2 Newall, C: Tate Gallery, 1997-1998, cat. no. 29, p. 134. *Art Journal*, 1870, p. 87.
3 Crane, Walter: 1907, pp. 84 and 165.
4 Clifford, Edward: 1890, p. 51.
5 Christian, John: Tate Gallery, 1984, cat. no. 235, p. 297.
6 Sotheby's Belgravia: April 4, 1978, lot 52, *Procris and Cephalus*, 37½ × 66 in. As Stanhope's painting was exhibited at the Royal Academy in 1872 (no. 270), Crane would obviously have been aware of this work.
7 Spivey, Nigel: 1996, fig. 117, p. 186.
8 Smith, Elise Lawton: 1998, p. 59.

20 Female Nude Study for "The Renascence of Venus", 1876

Black chalk, heightened with white, on tan wove paper; inscribed upper left *Dec: 5 '76*
11⁵⁄₁₆ × 8⅝ in. (28.8 × 21.9 cm)
PROVENANCE: Fine Art Society by 1891; anonymous sale, Christie's, London, March 10, 1995, part of lot 190.
EXHIBITED: Fine Art Society: 1891, ? cat. no. 93, 114, or 115; Kenderdine Gallery: 1995, cat. no. 15.

This study is for one of the bathers, in the background to the right, in *The Renascence of Venus*. This painting has long been considered to be Crane's masterpiece and was his first large-scale painting dealing with a classical subject. It was exhibited at the first Grosvenor Gallery exhibition in 1877 and in the English Fine Arts section of the Universal Exhibition held in Paris in 1878.

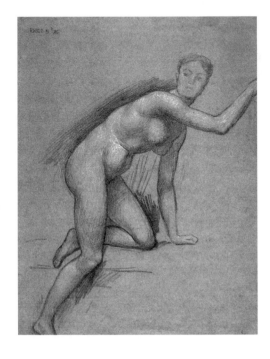

In 1882 the painting was bought by G. F. Watts. In 1913 it was given by his widow to the National Gallery of British Art (now the Tate Gallery), in accordance with Watts' wishes. When the painting was exhibited at the Grosvenor Gallery in 1877, it was hung in the large west gallery, near a group of paintings by Burne-Jones.

The critics were generally favourable in their reviews. The reviewer for the *Examiner* wrote: "Mr. Crane has still much to learn in the manner of expressive draughtsmanship, as the nude figure of Venus testifies; but the design of his work as a whole exhibits a very remarkable feeling for ornamental beauty, and the execution of certain parts of it – of clear sea water, distant landscapes, and the almond tree delicately traced against the sky – is a marvel of pure colour and sound workmanship. Of all the younger essays in imaginative painting to be found in the Gallery, this is, indeed, to our thinking, the most original and the most hopefull."[1] William Michael Rossetti, writing in the *Academy*, noted: "Mr. Crane's chief contribution is rather high up; however, it can be adequately estimated. It is named 'The Renaissance of Venus', a title which one has to think over a little before one hits upon any genuine meaning for it; but we suppose it to signify substantially 'The Re-birth of Beauty'; Venus, as the symbol of beauty, re-born at the period of art and culture. At any rate, Mr. Crane has painted a charming and delicious picture, full of gracious purity – one which holds its own well even against such formidable competition as that of Mr. Burne-Jones."[1] Alison Smith feels that in the late 19th century, painters such as Crane and Leighton may have intended to place their work within the high-art tradition of the Italian Renaissance, relating their "subject to artistic tradition rather than classical mythology *per se* … Venus, as I have argued, was elevated as a paradigm of female beauty and perfection and not as a pagan goddess of mythology."[2] F.G. Stephens, in discussing Leighton's *Venus Disrobing* of 1867, stated: "Of course, as it was in antiquity, the painter [Leighton] merely took the name of 'Venus' as the aptest designation for a feminine type of whatever was graceful, exalted, amorous, and voluptuous, and did not insist upon the goddess-ship of his sumptuous and naked lady."[2,3]

The uncertainties in the drawing of the nude figures noted by the critics were partly the result of Crane's lack of formal academic training, but also because his wife refused to allow him to study from the female nude figure. Crane was therefore forced to engage male models to pose for his female figures. Venus in *The Renascence of Venus* was drawn from the well-known model Alessandro di Marco. Despite the anatomical alterations made by the artist, W. Graham Robertson has recorded that when Crane prevailed upon Frederic Leighton to come out to his studio in Shepherd's Bush to pronounce upon the painting, Leighton remarked: "But my dear fellow, that is not Aphrodite – that's Alessandro!"[4] The painting itself shows the influence of Burne-Jones, and the works of the Florentine Renaissance masters, particularly Botticelli's *The Birth of Venus*. In September 1871 Crane had set off to Italy for an extended honeymoon. There he was most attracted by works of the Quattrocento, and at the Uffizi Gallery in Florence he particularly admired Botticelli, whose painting at that time was still out of fashion, not having been re-discovered by the critics.

This is the only study known to survive for this painting, although in 1891, at the Crane exhibition held at the Fine Art Society, London, three sketches for it were exhibited.

1 Crane, Walter: 1907, p. 174.
2 Smith, Alison: "Nature Transformed: Leighton, the Nude and the Model" in Barringer, Tim and Prettejohn, Elizabeth: 1999, pp. 22-23, and 33.
3 Rhys, Ernest: 1896, p. xxxi.
4 Robertson, W. Graham: 1931, p. 39.

21 The Sacrifice of Iphigenia, c. 1886-87

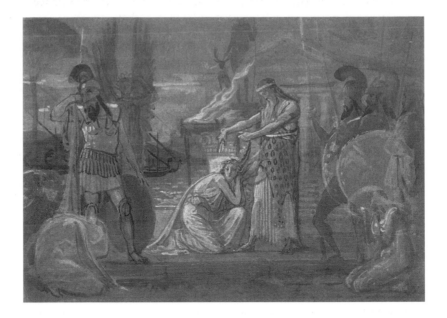

Pen and brown ink and wash, heightened with white, on brown paper, laid down; inscribed on the verso, in Crane's hand, *Walter Crane Sacrifice of Iphigenia* and *153* 9⅞ × 13⅞ in. (25.0 × 35.3 cm)

PROVENANCE: Fine Art Society, London, by 1891; Mary Buxton; Sotheby's Susssex, March 7, 1984, bought Abbott and Holder, London; anonymous sale, Christie's, London, March 10, 1995, lot 113.

EXHIBITED: Fine Art Society: 1891, cat. no. 91; Kenderdine Gallery: 1995, cat. no. 16.

Iphigenia was the daughter of Agamemnon, king of Mycenae, and the leader of the Greek expedition against Troy in the Trojan War. After two years of preparation, the Greek army and fleet assembled at the port of Aulis in Boeotia, but Agamemnon while hunting killed a stag that was sacred to Artemis. The goddess in retribution caused a pestilence to infect the army and produced a calm that made it impossible for the ships to leave port. The soothsayer Calchas announced that Artemis' anger could only be appeased by the sacrifice of a virgin on her altar, and that none but the daughter of the offender would be acceptable. Agamemnon yielded his consent with extreme reluctance. Just as she was about to be killed, however, Artemis relented and Iphigenia, enveloped in a cloud, was carried off to Tauris, where the goddess made her priestess of her temple.

This drawing likely had its origin in a series of tableaux and dramatic interludes, arranged by various artists, including G.F. Watts, Frederic Leighton, Henry Holiday, and Walter Crane.[1,2] It could also be a study Crane worked up in conjunction with the eighty-two illustrations he designed for *The Echoes of Hellas: The Tale of Troy & the Story of Orestes from Homer & Aeschylus*, published in 1887.[2] The impetus for this book was the preceding tableaux vivants. The illustrations were made with the brush upon lithographic zinc plates. Crane's designs took the form of friezes, borders, and figure groups, depicting the leading incidents from the tale of Troy, the wanderings of Ulysses, and the story of Orestes. Crane noted that: "These classic themes of course presented a variety of subjects by no means the

easiest in the world to treat, and yet by their very nature and associations extremely attractive to a designer in line."[1]

This drawing is typical of Crane's work, not only in the techniques used, but in the style of the figures and of the tree and ships in the background to the left. In the drawing Agamemnon, with his face averted in grief, is to the left. Iphigenia kneels before the altar of Artemis, where her hair is being shorn by the high priest Calchas in preparation for her sacrifice. In *The Echoes of Hellas*, "Até, or The Sacrifice of Iphigeneia" is the first plate in *The Story of Orestes*. This illustration contains only four figures and the composition is very much compressed in an almost circular design. The pose of Calchas is treated in a very similar fashion to the drawing. Iphigenia is again depicted kneeling, but in front of a very different altar. The position of her legs is virtually identical, but she is naked to the waist with her hands bound behind her. Agamemnon is again to the left, but instead of turning his face to his right, he puts his cloak up to shield his gaze. In the drawing the winged figure behind Agamemnon probably represents the avenging deity Até. In the illustration she is placed just behind the altar, about to light it with a brand. Water and ships are represented in the background of both the drawing and the plate.

1 Crane, Walter: *Art Journal*: 1898, p. 9.
2 Warr, George C.: 1887. In the preface Professor Warr stated that: "'The Tale of Troy' was performed in Greek and in English at Cromwell House, the residence of the late Sir Charles Freake, Bart., in 1883, and, in English, at the Prince's Hall, Piccadilly, in 1886. The 'Story of Orestes' was performed at the Prince's Hall at the same time. Several of the illustrations are founded, though freely, on the scenic representations. The picture of 'Aphrodite's pledge redeemed' is adapted from a tableau arranged by Sir Frederick [sic] Leighton, P.R.A. ... The Parting of Calypso from Ulysses was designed by Mr. Henry Holiday, the Sacrifice of Iphigeneia by Mr. G.F. Watts, R.A., and some of the architectural backgrounds are partly suggested by the scenery designed by Mr. E.J. Poynter, R.A. ... Mr. Walter Crane, to whom the illustration of the whole volume has been entrusted, has, however, preserved a uniform style in all the pictures, including those just mentioned."

EVELYN PICKERING DE MORGAN (1855-1919)

Evelyn Pickering was the eldest child of Percival Pickering of Cannon Hall, Barnsley, and the niece of John Roddam Spencer Stanhope. Her family was wealthy and of distinguished lineage. Her artistic inclination was discouraged by her family. In 1873, at the age of seventeen, she was reluctantly allowed to enrol in the Slade School of Art. In 1873-74 she won first prize for painting from the Antique, and in 1874-75 she gained the first prize for painting from the Life, as well as a Slade Scholarship. In 1875 she left the Slade to work on her own and to visit Rome. In 1877 she was invited to exhibit at the opening exhibition of the Grosvenor Gallery. She continued to exhibit annually at the Grosvenor Gallery for many years, and later exhibited at the New Gallery. She also exhibited in the provincial centres such as Birmingham, Manchester, and Liverpool. In 1887 she married the ceramicist and novelist William De Morgan. Although she continued to paint throughout her life, she largely stopped exhibiting her works in London in later years, as she felt it was not in sympathy with the modern world. She continued to exhibit in the provincial centres, however. She died on May 2, 1919.

22 Head of a Girl for "The Daughters of the Mist," c. 1908

Pastel on light brown wove paper
13¹³⁄₁₆ × 9⅞ in. (35.2 × 25.1 cm)
PROVENANCE: William De Morgan; anonymous sale, Christie's, London, February 22, 1966, lot 78, bought Agnew's, London; sold to M.F.B. Fitch, June, 1966; Richard Craig; bequeathed to his widow who sold it on March 19, 1991 to Julian Hartnoll, London; purchased January 23, 1992.
EXHIBITED: Agnew's: 1966, cat. no. 41; Julian Hartnoll: 1992; Kenderdine Gallery: 1995, cat. no. 18.

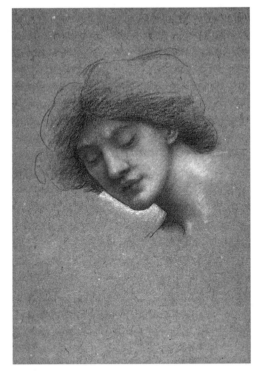

This drawing is a study for the head of the uppermost figure in *The Daughters of the Mist*, one of Evelyn De Morgan's most beautiful allegorical works. Patricia Yates feels this painting may have a literary source, possibly Hans Christian Andersen's *The Little Mermaid*.[1] This story would have been attractive to De Morgan, as Andersen's fairy tales often have an underlying spiritual meaning. In this story the Little Mermaid longed not only for the earthly love of a prince, but also for an immortal soul. In 1885-86 De Morgan had painted two other works based on this story, *The Little Sea Maid* and *The Sea Maidens*. *The Daughters of the Mist* may be inspired by the "daughters of the air," who welcomed the Little Mermaid after she died for love. They tell her that they have no natural immortal souls, but can win them by striving to do good for three hundred years. The connection of the subject of De Morgan's painting with Andersen's story is likely. His concepts seem in harmony with Evelyn's ideas, as expressed in the book *The Results of an Experiment*, published anonymously in 1909 just after *The Daughters of the Mist* was painted, and based on Evelyn and William De Morgan's automatic writings.[1]

Another possible literary source for *The Daughters of the Mist* is Aristophanes' *The Clouds*. In 1881 Oscar Wilde published a translation of various classical fragments, including that of a chorus of cloud maidens who bring refreshing showers to earth.[1] These cloud maidens could be the inspiration for the painting, as they are described as "cloud maidens that float on forever, dew-sprinkled fleet bodies and fair." *The Daughters of the Mist* could also relate to classical mythology and represent the Horae, the goddesses of the changing seasons, and the female attendants of Apollo and Aurora.[2]

The model used by De Morgan for this drawing posed for others of her paintings as well. Although the style of the face and the technique are characteristic of De Morgan's work, the state of scholarship in the 1960s was such that this drawing was sold at auction at Christie's, and later at Agnew's, as the work of Edward Burne-Jones. There is no doubt that Edward Burne-Jones was a major influence on her work, as he was on every artist associated with the second phase of Pre-Raphaelitism. Other important influences were her uncle J.R. Spencer Stanhope, G.F. Watts, and the great painters of the Italian Renaissance. During the period 1875-77 she travelled and studied Renaissance art throughout Italy. In 1893 William De

Morgan was advised by his doctors to leave England during the winter, for the sake of his health. The De Morgans therefore spent the winters in Florence, and on the weekends visited the Spencer Stanhopes at their nearby villa on the Bellosguardo hills. These annual trips to Italy from 1893-1908 gave her additional opportunities to study the Florentine masters.

The finished painting is in the collection of the De Morgan Foundation, London, and is currently on loan to the National Trust, Cragside, Northumberland.

1 Yates, Patricia: "Evelyn De Morgan's use of literary sources in her paintings" in Gordon, Catherine: 1996, pp. 60-61.
2 Oberhausen, Judy: Personal communication, letter dated February 8, 1995.

23 Two Kneeling Female Nudes, for "The Captives," c. 1910

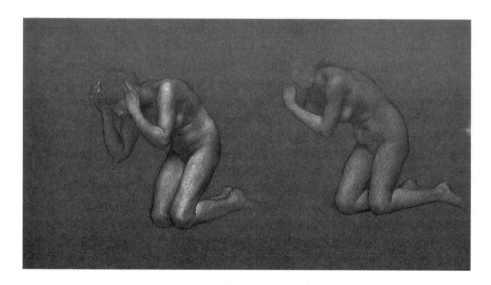

White, black and tan chalk on dark brown wove paper 16⅛ × 24¾ in. (41 × 62 cm)
PROVENANCE: Grace Coolidge Pell, Boston; bought in 1987 by Childs Gallery, Boston; purchased December 9, 1987.
EXHIBITED: Kenderdine Gallery: 1995, cat. no. 17.

Evelyn De Morgan was the most talented woman painter of the second phase of Pre-Raphaelitism, and one of the most important late 19th-century British Symbolist painters. George Frederic Watts was a great admirer and gave this verdict on her work: "She is a long way ahead of all the women and considerably ahead of most of the men. I look upon her as the first woman-artist of the day – if not of all time."[1] In addition to her abilities as a painter, she was a first-rate draughtsman, perhaps the finest of her generation. If her later paintings are sometimes not entirely satisfactory due to their overwrought symbolism, her drawings never fail to be successful. As William Blake Richmond remarked: "If her later work is sometimes overcharged with detail, a little over-weight, Evelyn De Morgan was a finished artist of no mean quality … She drew beautifully; indeed, the many volumes which remain containing drawings of the nude, and draperies … are, perhaps, the most complete efforts of her genius."[1] A similar technique of using chalk on dark brown papers can be found in the work of Edward Burne-Jones and Edward Poynter (see cat. no. 71).

Although De Morgan's early works were often based on classical mythology, and influenced by classical, Renaissance, and Pre-Raphaelite art, it is impossible to interpret her late works without understanding their link with the 19th-century movement of Spiritualism.[2] Spiritualism, which originated in the United States, was introduced to Britain in the mid-19th century as a reaction to the materialism and religious uncertainty that were a result of biblical criticism and current scientific theories, such as Darwinism. Spiritualists sought to prove the existence of the human soul, that it survived death, and presumably continued to evolve through a series of progressive states towards ultimate spiritual enlightenment. Many members of the Pre-Raphaelite circle, including Rossetti and Whistler, had taken part in Spiritualist practices such as séances in the 1860s. Evelyn De Morgan's association with William De Morgan, whom she first met in the mid 1880s, and his mother, Sophia Frend De Morgan, may have introduced her to the spiritual and aesthetic possibilities of Spiritualism.[2] Sophia De Morgan had devoted considerable study to Spiritualism and her book, *From Matter to Spirit*, published in 1863, described and adapted earlier Swedenborgian notions to 19th-century Spiritualism. Mrs. Stirling has recorded a visit by William De Morgan and his mother to Burne-Jones' studio: "'What I *do* appreciate in your painting' she said, at last, judicially, turning to him after studying it for some time with great solemnity, 'is its depth of meaning – its profound symbolism! How well I read your intention here – and here – and here' – enumerating rapidly several mystical interpretations of the subjects before her. 'My dear fellow,' said Burne-Jones to De Morgan with amazement when she was gone, 'I am so delighted she saw that in it – *I* never knew it was there!'"[1]

Although Burne-Jones may not have intended a Spiritualist symbolic meaning to be read into his paintings, there is no doubt that Evelyn De Morgan certainly did in her works. De Morgan believed in an evolution from a physical, to a spiritual, and finally to a celestial plane. In her paintings an iconographic system is used to delineate the moral struggle between good and evil, truth and error.[2] Light is a visual metaphor for a divine presence in the universe, which acts against evil by instilling love, hope, and wisdom within the human soul. Darkness, on the other hand, is symbolic of the malevolent forces of ignorance, egotism, and despair, that can inhabit the human spirit and thereby threaten our well-being. Symbolic agents of good and evil, in their various guises, such as angels and demons, are used in her moral allegories. It appears that she never spoke openly of her spiritual beliefs.[3] Like most Symbolists she did not expect that the underlying spiritual content of her paintings would be understood by all. De Morgan's reluctance to explain their underlying symbolic meaning, however, may have lead to a lack of critical attention or understanding of her work.[3]

Although this drawing was sold as a study for *The Daughters of the Mist* it is obviously a study for *The Captives*. It would be difficult to interpret the symbolic meaning of *The Captives*, one of the earliest of De Morgan's allegorical paintings, unless the mythical monsters that terrorize the captive maidens can be seen as forces of evil, preventing the women's struggle to be free, and impeding their spiritual growth. In this case the captivity of their spiritual well-being to their animal instincts may be self-imposed, since De Morgan has portrayed the innocent-appearing maidens as blind or groping in darkness, somehow unable to clearly identify what is threatening them. Most of the figures appear to have succumbed to temptation or despair without much resistance, with the exception of the one central figure, who seems to be resisting and is moving towards the light at the entrance to the cave.[3] It appears that her awakened moral conscience has restored her sight, enabling her to save herself from the fate of the others. In De Morgan's work instruments of confinement, such as fetters, chains, and prison cells, are symbolic of the moral, psychological, and physical bonds that earth-bound spirits must struggle to free themselves from before the next phase of spiritual evolution can begin.[2]

Another possible explanation for the symbolic meaning of this painting is that it was influenced by the neo-platonism of Michelangelo's captive figures for the Tomb of Julius II, who struggle against the bonds of their base instincts. Evelyn De Morgan's work was strongly marked by Michelangelo, an artist whose own allegorical works had been influenced by the neo-platonic ideas of his own time.[3] The finished painting of *The Captives* is in the collection of the De Morgan Foundation.

1 Stirling, A.M.W.: 1922, pp. 11, 73 and 193.
2 Oberhausen, Judy: 1994, pp. 1-19.
3 Oberhausen, Judy: "Evelyn De Morgan and spiritualism" in Gordon, Catherine: 1996, pp. 41, 48, and 51, n. 49.

WILLIAM DE MORGAN (1839-1917)

William De Morgan was born in London on November 16, 1839, the son of the distinguished mathematics professor Augustus De Morgan. William was educated at University College school and University College, but also attended evening classes at Cary's art school. In 1859 he gained a place at the Royal Academy Schools, but completed only half of the required eight-year course. By 1863 De Morgan was already acquainted with members of the Morris/Burne-Jones circle. De Morgan was largely unsuccessful as a painter and, encouraged by William Morris, he turned to painting decorative furniture and to stained-glass design. By the late 1860s and early 1870s his interest was already turning towards the design of lustre pottery and decorative tiles. De Morgan was a founding member of the Arts and Crafts Exhibition Society. In 1906 he became a successful writer following publication of his first novel *Joseph Vance*. His writings provided the financial success that his pottery never achieved, despite the fact that he is now generally forgotten as a novelist, but regarded as the most important British Arts and Crafts potter. He died on January 15, 1917 and was buried in Brookwood Cemetery, London.

24 Tobias and the Angel at the River Tigris, c. 1865

Watercolour, gouache, and gold on buff wove paper; signed with monogram, lower left; some old repairs to the angel's gown 18⅛ × 12¼ in. (46 × 31.2 cm)
PROVENANCE: Anonymous sale, Christie's, London, March 13, 1992, lot 65.
EXHIBITED: National Gallery of Canada: 1994, not in catalogue; Kenderdine Gallery: 1995, cat. no. 19.

William De Morgan left the Royal Academy Schools dissatisfied with the training he had received. His sister-in-law, Mrs. Stirling, outlined his transition from unsuccessful painter to successful designer: "So, too, with unflinching courage, he accepted his own limitations and rebounded from the recognition braced to novel effort. It must here be remarked as curious that, so long as he attempted to paint on conventional lines, so long was his work redeemed only from mediocrity by a certain quaintness of expression; but even to the untrained eye, it was anatomically uncertain, stiff in outline, and somewhat hard in colour. No sooner, however, as we shall see later, did he give free rein to his imagination than the beauty of line

developed and his fine draughtsmanship became apparent, as did the mingled originality, humour and facile execution which enhanced the decorative quality of his work."[1] William Blake Richmond, De Morgan's friend and fellow student at the Royal Academy Schools, remembered: "As an Academic artist he did not count for much; his genius did not lie in a groove or grooves."[1] De Morgan himself was well aware of his limitations as a painter. Many years afterwards he wrote: "I certainly was a feeble and discursive dabbler in picture-making. I transferred myself to stained-glass window-making, and dabbled in that too till 1872."[1]

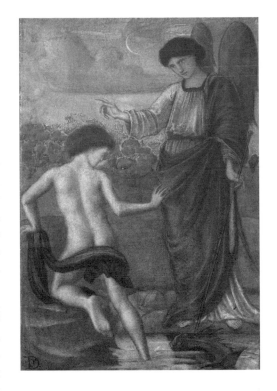

During the 1860s De Morgan designed stained glass for James Powell & Sons.[2] From 1869-72 he shared a studio at 40 Fitzroy Square, London, with the stained-glass designer and maker, James Tennent Lyon, with whom he likely collaborated. It appears that De Morgan may also have designed stained glass for Morris, Marshall, Faulkner & Co.[3,4] Sewter, however, does not list any windows whose designs are attributed to De Morgan.[5] Even though De Morgan himself underestimated his powers as a stained-glass designer, William Blake Richmond remarked: "His designs for stained-glass windows were often remarkable and I have seen some very interesting work from his hand in that difficult branch of the art into which incompetence too often strays and where genius is so rarely visible."[1] De Morgan stopped making stained glass in 1872 when his kiln set fire to the roof of 40 Fitzroy Square, and his landlord told him to find premises elsewhere. He therefore abandoned this phase of his artistic career, and turned instead to making the pottery and tiles that would later win him lasting fame. De Morgan would appear to have been financially successful as a stained-glass maker. In 1906, in a letter to his American friend Louis Joseph Vance discussing this early period in his career, he stated that: "I started afresh as a potter, but I lost my stained glass, which was bringing me more than I have ever earned since."[1]

Tobias and the Angel may be a preliminary design for stained glass. It is also possible that this watercolour was intended as an independent work of art, since De Morgan exhibited two watercolours at the Dudley Gallery in 1866 and one in 1867. Other watercolour designs for stained glass are included in the De Morgan Foundation in London, including designs for a lancet window with apostolic figures, an Annunciation scene, and a full-sized cartoon for *St. Michael Killing the Dragon*.[6] These early works by De Morgan are extemely rare, and seldom appear on the art market. This watercolour exhibits little evidence of De Morgan's later individuality, with the exception of the fish in the lower right-hand corner, which certainly prefigures the quirky grotesque animal designs that were to become such a distinctive feature of his pottery.

Tobias and the Angel is a rather obscure biblical story taken from Chapter 5 of the *Book of Tobit*, in *The Apocrypha*. *The Apocrypha* would not have been well known in Victorian England because it was outside the canon of the Church of England. Tobias and the Angel,

however, had been a popular subject for artists since the Renaissance. Other Victorian artists to portray this subject included his future wife, Evelyn Pickering, who painted an oil version of *Tobias and the Angel* dated 1875. A watercolour entitled *Tobit and the Angel* by Lord Leighton was exhibited at the Leighton exhibition at the Fine Art Society in 1896.[7] James Smetham also treated this subject as one in a series of small oil panels based on the story of Tobias, formerly in the Handley-Read Collection.[8] *The Apocrypha* tells of how Tobias healed the blindness of his father Tobit, eight years after it occured. Tobit was a Jewish captive in Nineveh who became blind after being spattered by the droppings of sparrows while lying down in the street to sleep. Tobit sent his son on a mission to retrieve some money owing to him. After a long journey Tobias, in the company of the Archangel Raphael, encountered a monstrous fish said to have leaped out of the river Tigris. The angel told Tobias to seize and eat the fish, but to keep back its liver, heart, and gall which could be used for healing. When Tobias returned to his father, he restored the old man's vision with the gall of the fish.

1 Stirling, A.W.M.: 1922, pp. 9-10, 58-59, and 77-79.
2 Hadley, Dennis: personal letter dated February 11, 1996. Hadley notes that the only mention of De Morgan in the Powell's Window Books occurs for the 1871 east window at Flamborough, Yorkshire. Hadley is aware, however, that De Morgan certainly provided earlier designs for Powell's. A poster dated December 10, 1866, now at the Museum of London, offers a reward for the return of cartoons stolen from the glass works. Under the heading of De Morgan it lists Crucifixion, small; Nativity, small; Ascension, large. Ticks are placed against all these entries, which appears to suggest that the cartoons were recovered. It is not known whether any of these designs were ever used. Neither Hadley or Martin Harrison are aware of any likely Powell's windows from that period which are unattributed and which might have been done by De Morgan.
3 Mackail, J. W.: 1907, Vol. I, p. 154. "The designing of the work carried out by the firm was of course mainly done by the firm themselves. But other artists, including Albert Moore, William De Morgan, and Simeon Solomon, made occasional designs for glass and tiles." This reference to De Morgan, however, may refer only to tiles and not to stained glass.
4 Rose, Andrea: 1981, p. 135. Rose mentions that it was Simeon Solomon who introduced Albert Moore and William De Morgan to Edward Burne-Jones. It was through this connection that all three artists were commissioned to design stained-glass windows for Morris, Marshall, Faulkner & Co. between 1861 and 1866.
5 Sewter, A. Charles: 1975, Vol. II.
6 Harrison, Martin and Waters, Bill: 1973, p. 109, fig. 154. This illustrates De Morgan's stained-glass window of 1872, *St. Michael Killing the Dragon*, in the Chancel of St. Michael's church, Rochester, Staffordshire.
7 Fine Art Society: 1896, cat. no. 72.
8 Fine Art Society: 1974, cat. no. 77, *Scenes from the Story of Tobias*, oil on panel, four panels 3⅛ × 3⅛ in., four roundels 3⅛ in. diameter, No.2, *Tobias slays a giant fish with the angel's help*, roundel.

WILLIAM MAW EGLEY (1826-1916)

William Maw Egley is best known as a painter of literary, historical and genre subjects. His father William Egley was also an artist, largely a miniaturist. William Maw Egley first exhibited at the Royal Academy in 1843. In 1847 he exhibited in the Westminster Hall Competition. From 1843-55 he concentrated mainly on subjects from literature or the theatre, especially from Shakespeare, Molière or Tennyson. From about 1855-62 he primarily painted contemporary genre scenes, influenced by his friend William Powell Frith. After this time he painted largely 18th-century costume pieces or historical pictures in the manner of Marcus Stone or G.D. Leslie. Egley worked in both oils and watercolours. In addition to

the Royal Academy he also exhibited at the British Institution, the Society of British Artists in Suffolk Street, later the Royal Society of British Artists, and the Royal Institute of Oil Painters. He was also an art instructor, primarily to amateur women artists.

25 Compositional Study for "Holyrood," 1867

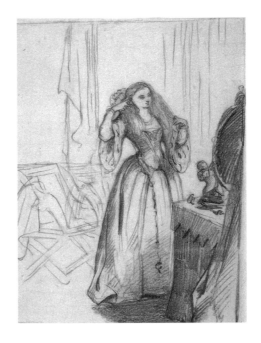

Graphite on off-white wove paper; inscribed on upper margin *Holyrood - 1565*
8⁵⁄₁₆ × 5⁷⁄₈ in. (21.1 × 14.9 cm)
PROVENANCE: Anonymous sale, Christie's, London, June 4, 1982, part of lot 68, bought in; purchased with a group of other works by Egley from a "runner" by Abbott and Holder, London in 1997; purchased January 3, 1998.

Although Egley is known primarily as a painter of literary and historical subjects, he was influenced by Pre-Raphaelitism, particularly in the 1850s and 1860s. His best known Pre-Raphaelite painting in the early hard-edge style is *The Talking Oak* (Detroit Institute of Arts), painted in 1857.[1] As Christopher Wood has noted "the intense detail and meticulously high finish of all his pictures reflect the influence of Pre-Raphaelite technique."[1]

Holyrood is not the first example of Egley responding to the influence of the second phase of Pre-Raphaelitism, as can be seen in his painting *The Lady of Shalott* of 1858.[2]

Mary Queen of Scots was a popular subject. In fact, between 1820 and 1897, no less than fifty-six works depicting events in her life were shown at the Royal Academy alone.[3] In Victorian art she was generally portrayed as a tragic heroine, and certainly not as a *femme fatale*. In *Holyrood,* however, Egley has chosen to portray her with loose flowing hair. In Pre-Raphaelite painting loose, luxuriant hair is frequently considered an emblem of female sexuality, as well as being symbolic of the *femme fatale*.[4] De Girolami Cheney has discussed this area in depth: "The paradoxical nature of the *femme fatale* – woman in possession of both virginal and demonical powers – is captured by Pre-Raphaelite painters in their representation of hair. The unbounded, long hair in their depictions of Eve, Venus, or Mary Magdalene commonly symbolizes the power of evil ... hair represented temptation, power and beauty ... The female as a temptress can also be seen in Pre-Raphaelite paintings of mermaids, fallen women, and young brides-to-be. In these images the treatment is of the lady at her toilet or the lady fondling her hair. The attributes included in these images are usually reflective surfaces – glass, mirror, pond, sea – and toilet items – brush, combs, jewelry. The action of the woman varies: she may be combing, braiding, pulling, cutting, or even biting her hair. In these images, the treatment of the hair can be seen free flowing or bound. The protagonist manipulates her hair as she admires herself in a reflective surface or contemplates her life ... This action alludes to the concept of Vanitas ... The Pre-Raphaelite artists were concerned to depict female beauty in an erotic, opulent manner; and very characteristically, sumptuous accessories were used to dramatize this aesthetic quest."[4] This drawing by Egley of Mary

Queen of Scots as the young bride-to-be incorporates all of these features. She is depicted brushing her hair, while looking in a mirror.

The decision by Egley to portray Mary Queen of Scots as a *femme fatale* with loose flowing hair may have been prompted by the work of Rossetti and his circle. The figure of Mary certainly bears a striking resemblance to that of Rossetti's *Lucrezia Borgia*, initially painted in 1860-61. In this painting the standing figure of Lucrezia, with her luxurious hair, washes her hands free of poison in a copper basin. A mirror is present on the back wall. The first design for this watercolour was shown at the Hogarth Club in 1860. Although he was not a member of the Hogarth Club, Egley could have perhaps seen this exhibition. Egley's painting is much closer to Rossetti's revised version of *Lucrezia Borgia* than it is to the original, but since Rossetti probably patched over and repainted the initial version in 1868, this second version could not have been the source of Egley's painting.[5] Rossetti certainly may have been the general inspiration for Mary's flowing hair, however, since he did a number of paintings and watercolours of women combing or dressing their hair in the 1860s, including *Fazio's Mistress* of 1863, *Morning Music* of 1864 (see cat. no. 69), *Woman Combing Her Hair* of 1864, and *Lady Lilith* of 1868. If Egley did not have access to Rossetti's paintings, another potential source is Frederick Sandys' *Morgan Le Fay*, which he undoubtedly would have seen at the Royal Academy exhibition of 1864.

Egley's inspiration for a Mary Queen of Scots subject is almost certainly derived from Algernon Swinburne's tragedy *Chastelard*, published in 1865. This five-act play in blank verse would have had a following as a cult text circulating in artistic and bohemian circles. Samuel Chew clearly felt Swinburne intended Mary to be seen as a *femme fatale* when he stated that the poet "implied in the motto from Maundeville prefixed to 'Chastelard' … that Mary was one of those women of the North who, if any man behold them, slay him with their eyes as doth the basilisk. The tragedy is that of the victims of *une belle dame sans merci*, beautiful, generous, wayward, terrible, before whom successively Chastelard, Rizzio, Darnley, Bothwell and Babington lay down their lives."[6] Cassidy stated: "*Chastelard* has no discernible theme except for the strange love of a rather abnormal youth for a most abnormal woman."[7] Ruskin had advised Swinburne not to publish the work, which, not surprisingly, created considerable controversy. Tennyson's objections to it were "as deep as Heaven and Hell."[7] The *Spectator* objected to Swinburne reveling in the bestial passions of lust and confessed that it put *Chastelard* away "with a sense of profound thankfulness that we have at last got out of the oppressive atmosphere in that forcing-house of sensual appetite into the open air."[8] Swinburne in the 1860s was to challenge Victorian middle-class moral values with his writings on other notorious women from history, including Sappho (see cat. no. 79) and Lucrezia Borgia, as part of his l'art-pour-l'art promotion of new artistic and sexual viewpoints.[9]

Mary Queen of Scots was the daughter of James V and Mary of Guise. In 1558 she married the heir to the French throne, who succeeded as Francis II in 1559. Francis died in 1560, and in 1561 Mary returned to Scotland. In 1565 she was remarried to her first cousin Henry Stewart, Lord Darnley. Darnley had been raised in England and was at least nominally a Protestant. He had arrived in Scotland in February 1565. Although he was three years younger than Mary, she was at once attracted to this tall handsome man. Egley's painting portrays her in 1565, likely just before her marriage to Darnley, when she was still very much in love with him. The Cupid on the dressing table, for instance, would suggest their relationship at this time was a loving one. Their marriage took place on July 29, 1565, but it did not take long for Mary to discover that Darnley was completely unfit to share political power with her.

1 Wood, Christopher: 1994, pp. 66-67.
2 Marsh, Jan: 1987, pp. 150-151, fig. 128. When this painting was initially exhibited the critic of *The Athenaeum* described it as an "ill-favoured specimen ... of flagrant Pre-Raphaelitism."
3 Strong, Roy: 1978, p. 106, fig. IX, and pp. 133 and 162-163. Strong lists the subjects of the works shown at the Royal Academy, which were all apparently conventional depictions of Mary Queen of Scots' life.
4 De Girolami Cheney, Liana: "Locks, Tresses and Manes in Pre-Raphaelite Paintings" in De Girolami Cheney, Liana: 1992, pp. 159, 163-165, and 172.
5 Marillier, H.C.: 1904a, p. 70. The first design, which Rossetti destroyed when he repainted this water-colour, is reproduced, as is the repainted version.
6 Chew, Samuel C.: 1931, p. 197.
7 Cassidy, John A.: 1964, pp. 94-95.
8 *Spectator*: Vol. XXXVIII, December 2, 1865, pp. 1343-44.
9 du Maurier, Daphne: 1951, p. 235. George du Maurier, in a letter to his mother of April 1864, wrote: "As for Swinburne, he is without exception the most extraordinary man not that I ever met only, but that I ever read or heard of; for three hours he spouted his poetry to us, and it was of a power, beauty and originality unequalled. Everything after seems tame, but the little beast will never I think be acknowledged for he has an utterly perverted moral sense, and ranks Lucrezia Borgia with Jesus Christ; indeed says she's far greater, and very little of his poetry is fit for publication."

ALFRED HASSAM (active 1858-97)

Not a great deal is known about Alfred Hassam, a painter and designer who was active in the middle of the 19th century, particularly in the early 1860s. He is probably now best known as one of the principal, and most innovative, stained-glass designers for the firm of Heaton, Butler and Bayne. As an artist he was principally a watercolour painter, but also painted in oils. He lived and worked for at least part of his life in Birmingham. Between 1865-68, while living in London, he exhibited at the Society of British Artists, the Dudley Gallery, and at the Royal Academy. For some reason he appears to have given up art, or at least exhibiting as a professional artist, at an early stage. He is known to have visited the Middle East, and to have painted Orientalist subjects. In 1897 he edited a book on Arabic by C.A. Thimm entitled *Arabic Self-Taught*.

26 A Maiden Anxiously Tending a Young Man, 1862

Pen and ink on off-white paper; initialed on verso *A.H.* and dated *12/62*; 4⁵⁄₁₆ × 4⁵⁄₈ in. (11.1 × 11.8 cm)
PROVENANCE: ? ex-collection Robert Smith; Abbott and Holder, London; bought July 26, 1996.
EXHIBITED: Abbott and Holder: List no. 301, November, 1995, cat. no. 197.

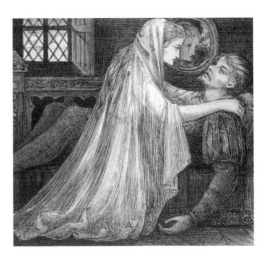

The subject of this drawing is unknown. It may have been taken, however, from the Arthurian legends, which were popular with artists in the 1860s, particularly those influenced by Pre-Raphaelitism. It certainly

has the appearance of a preliminary drawing for a woodblock engraving, but while it is possible that Hassam did some illustrations, he is not known to have worked as an illustrator for books or magazines.[1] Many young struggling artists in the 1860s used illustration work as a means of supplementing their incomes, and Hassam may have practiced doing illustrations in the hope that he could attract work in this area.

Hassam's drawing may very well have dealt with the doomed love of Elaine, the Fair Maid of Astolat, for Sir Lancelot. Sir Lancelot had fought against the Knights of the Round Table at a tournament held during the Feast of the Assumption of Our Lady. Although he won the tournament, he was grievously wounded when Sir Bors' spear struck him in the side, and the head of the spear broke off and was left in the wound. Elaine nursed him back to health, which is possibly the subject of the present design. Although Elaine fell in love with Lancelot, her love could not be reciprocated because he was already in love with Queen Guinevere. Elaine therefore died of her unrequited love after Lancelot's return to Camelot. Her body was then placed on a barge which floated down to Camelot. Sir Lancelot took pity on her and requested that he be buried by her side after his own death.

Hassam seems to have been on the periphery of the avant garde in the 1860s. It is not known whether he had personal contact with any of the artists within the Pre-Raphaelite circle, but he was obviously familiar with Pre-Raphaelite illustration. This drawing, in particular, shows knowledge of the Moxon Tennyson, a landmark in British illustration published in 1857 and a major influence on many British illustrators of the 1860s (see cat. nos. 35 and 48). The background derives directly from Millais' drawing for "Mariana". It also appears to have been influenced by Rossetti's *The Lady of Shallot* and *The Weeping Queens* for "The Palace of Art," Hunt's second drawing for "Oriana," and Millais' second drawing for "A Dream of Fair Women".

Alfred Hassam's work is rare. A drawing similar to the present one, entitled *Pelleas and Melisande*, sold at Sotheby's Belgravia in 1979.[2] Perhaps Hassam did a series of illustrations of doomed lovers.

1 Houfe, Simon: 1981.
2 Sotheby's Belgravia: *Victorian Paintings, Drawings and Watercolours*, October 16, 1979, lot 48, 4 × 4½ in., pen and ink and grey wash.

HENRY GEORGE ALEXANDER HOLIDAY (1839-1927)

Henry Holiday was born on June 17, 1839 in London. He decided early in his childhood to become an artist and, in 1852, with his parents' encouragement, he became a pupil of William Cave Thomas, a close friend of Ford Madox Brown. Holiday later worked for some months in Leigh's art school. In 1855 he entered the Royal Academy Schools. His early work was strongly influenced by the Pre-Raphaelites. In 1858 he exhibited his first painting at the Royal Academy. By 1861 he was already intimately associated with the artists of the Pre-Raphaelite circle, including Holman Hunt, Burne-Jones, and Rossetti, and with the architect William Burges for whom he executed some decorative paintings. In late 1862 the turning point in Holiday's career occurred when he was asked by James Powell & Sons to prepare some stained-glass designs. In 1865 Holiday began his association with the firm of Heaton, Butler, and Bayne, which produced some of his most successful windows over the next fifteen years. In 1867 he set off for Italy to study the achievements of the great Renaissance masters in the decorative arts. This changed the direction of his art away from the earlier medieval

influences towards a more classical style and Holiday became a leader in Aesthetic Movement stained-glass design. In 1878 he received the first of his many commisions for work in the United States, when he designed two large windows for Holy Trinity Church in Boston. In 1891 he founded his own glass works. Holiday continued to execute stained-glass designs until 1926. He died on April 15, 1927 at the age of eighty-seven.

27 Study of a Nude Figure for "Music," 1876

Graphite, lightly squared for transfer, on grey-green wove paper; inscribed *St for Music*, lower right 22⁵⁄₁₆ × 18⁷⁄₈ in.
(56.7 × 47.8 cm)
PROVENANCE: ? Henry Holiday's studio contents, consigned to Walker Galleries, London, 1930; ? by descent to A.B. Holiday; Abbott and Holder, London; bought in the early 1980s by Dr. Lindsay R.C. Stainton; her sale, Christie's, London, November 6, 1995, lot 64.
EXHIBITED: William Morris Gallery: 1989, cat. no. 52.

Although Holiday is best known as a decorative artist, and particularly for his work in stained glass, he also painted portraits, landscapes, and classical, medieval, and allegorical subjects. His best known painting, *Dante and Beatrice*, was exhibited at the Grosvenor Gallery in 1883 and is now in the Walker Art Gallery, Liverpool.

This drawing is a study for *Music*, a watercolour dated 1876.[1] The pose differs from the finished watercolour principally in the position of the arms, especially the right arm, which in the watercolour is raised and holding a harp. The turn of the back and shoulder is slightly altered, and the drapery is carried to a much greater degree of finish in the watercolour. As Peter Cormack has pointed out, this is "an archetypally 'Aesthetic' subject", with its vaguely classical theme of a nude figure of a Muse holding a musical instrument and the Japanese motif of a plant in a vase at the lower left.[2] *Music* is reminiscent of many other earlier Aesthetic Movement paintings, particularly Edward Poynter's *The Siren* exhibited at the Royal Academy of 1864. It is also similar in theme to such works as Leighton's *Actea, the Nymph of the Shore* of c. 1868, Watts' *Thetis* of c. 1866-69, and Moore's *Sea Gulls* of 1870-71. Figures playing musical instruments are common in Aesthetic Movement art and serve to represent the correspondences between art and music. This concept had, in particular, been emphasized in Rossetti's works from the late 1850s and the 1860s, but even in later works such as *A Sea Spell* of 1877, the mood is similar to Holiday's *Music*.

1 Wood, Christopher: 1983, p. 196, fig. 4. This watercolour sold at Christie's, London, *Important Victorian Pictures, Drawings and Watercolours*, October 16, 1981, lot 47, 24³⁄₄ × 19¹⁄₂ in. This lot also included another preparatory pencil study for the watercolour, which was considerably smaller than this drawing, as it was only 14¹⁄₂ × 10¹⁄₂ in.
2 Cormack, Peter: William Morris Gallery, 1989, cat. no. 52, p. 12.

28 Woman with a Ewer, a Study for "Humility," c. 1885

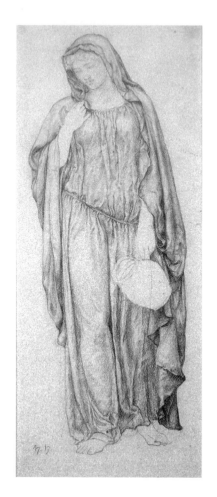

Graphite and brown and blue chalk on off-white paper; signed *h.h.* in graphite, lower left;
14⅝ × 5¹³⁄₁₆ in. (37.1 × 14.8 cm)

PROVENANCE: Henry Holiday's studio contents, consigned to Walker Galleries, London, 1930; by descent to A.B. Holiday; ? his sale Sotheby's Belgravia, November 2, 1971, part of lots 47 or 48; anonymous sale, Sotheby's Belgravia, October 22, 1974, lot 17, bought J. Blond of Blond Fine Art; Jonathon Blond, personal collection, 1974-91; sold to Rachel Moss of Moss Galleries, London; purchased March 19, 1991.

EXHIBITED: Kenderdine Gallery: 1995, cat. no. 21.

In the late 1850s and early 1860s James Powell & Sons turned to progressive artists, such as Ford Madox Brown, Edward Burne-Jones, E.J. Poynter, and Albert Moore, to provide them with designs for stained glass. In 1862, with the formation of Morris, Marshall, Faulkner & Co., Burne-Jones began to design exclusively for this firm. Albert Moore had been approached by Powell's to be Burne-Jones' successor as principal designer, but Moore was unwilling to undertake this and instead suggested his friend Henry Holiday. In December 1862 Holiday was approached by Mr. Moberley, the head of James Powell & Sons stained-glass works, and was asked to produce some designs.[1,2] Holiday, who had never done anything of this kind before, accepted the commission. He began work at the office of his friend, the architect William Burges. Burges gave him valuable assistance with technical points, and allowed Holiday to consult his books on stained glass.[1,2] Holiday's designs were admired so much that in the autumn of 1863 he was visited by the elderly Nathaniel Powell who said that "If I would make designs for them only they would guarantee as much work as I could do ... the arrangement should be terminated at the wish of either of us."[2] Although this exclusive contract was suspended in 1864, Holiday continued to be Powell's principal stained-glass designer until the end of 1890. In January, 1891 this relationship ceased when Holiday opened his own stained-glass works in Hampstead.

This is a study for a stained-glass window of 1885, made by James Powell and Sons, in the apse of the church at Abbeyleix, Ireland.[3] This window was commissioned by the De Vesci family. In the window the pitcher is replaced by a vessel with a watering-can-like spout, so that a stream of water can flow well clear of Humility's garment.[3]

1 Cormack, Peter: William Morris Gallery, 1989, p. 3 and cat. nos. 13 and 14, p. 7.
2 Hadley, Dennis and Hadley, Joan: 1989-90, p. 50.
3 Hadley, Dennis: Personal communication, letter dated February 11, 1996.

29 Dancing Figure, c. 1903

Red-brown chalk over graphite tracing, on off-white wove paper; inscribed in pencil, in an unknown hand, "Deborah", on front of the old mount, lower right 14³⁄₁₆ × 6⅞ in. (37.7 × 17.5 cm)

PROVENANCE: Henry Holiday's studio contents, consigned to Walker Galleries, London, 1930; by descent to A.B. Holiday; ? his sale Sotheby's Belgravia, November 2, 1971, part of lots 47 or 48; anonymous sale, Sotheby's Belgravia, October 22, 1974, lot 17, bought by J. Blond of Blond Fine Art; Jonathon Blond, personal collection, 1974-1991; sold to Rachel Moss of Moss Galleries, London; purchased March 19, 1991.

EXHIBITED: Kenderdine Gallery: 1995, cat. no. 22.

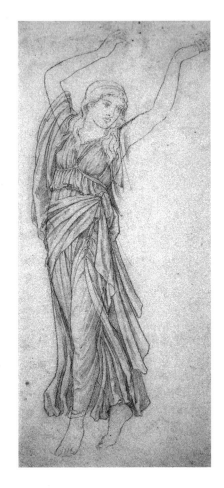

This drawing appears to be a preliminary idea for a cymbal-playing figure at the front right of a 1903-04 window at St. Stephen's Church, Wilkes Barre, Pennsylvania.[1] Baldry calls this window design "David Dancing before the Ark of the Covenant".[2] The name "Deborah", a prophetess from the Book of Judges, may have mistakenly been given to this dancing figure at a later date.

Henry Holiday was, after Edward Burne-Jones, the leading English stained-glass designer of his day. Both were part of a progressive elite among designers whose aim was to break out of the stylistic limitations of the early phases of the Gothic Revival instituted by A.W.N. Pugin.[3] A turning point in Holiday's career came after his return from Italy in 1867, when he adopted a "modernist" approach to design, because of what he considered a lack of vitality in the current decorative arts in England.[3] Holiday felt that "no art is genuine which is not modern in the sense of expressing the best of which the artist and his age are capable".[4]

By 1871 a marked change in approach can be noted in Holiday's windows for James Powell and Sons, where scenes of tiny Gothic figures set in vast quarry backgrounds were replaced by large and clearly defined figures, in cool tones, clad in classical draperies. This change was likely at the artist's insistence, once his reputation as a leading stained-glass designer became established. Holiday was interested, however, not just in the design, but also in the technical aspects of stained-glass production. In the late 1860s he collaborated with the firm of Heaton, Butler and Bayne for some of his most important commissions, as he was dissatisfied with the standard of the execution of some of his designs by Powell's.[3] In 1891 Holiday set up his own stained-glass workshop, which at last gave him freedom and control, not only in glass design, but also in execution, thus liberating him from the restrictions that are inevitable when working for a commercial firm.

1 Hadley, Dennis: Personal communication, letter dated February 11, 1996.

2 Baldry, Alfred Lys: 1930, p. 61. Baldry lists this window as being at Wilkes Barre, Philadelphia, Pennsylvania, apparently in the mistaken belief that Wilkes Barre was a suburb of Philadelphia.

3 Cormack, Peter: William Morris Gallery, 1989, pp. 1-2.

4 Holiday, Henry: "Modernism in Art", a paper read to the Architectural Association, March 14, 1890 and published in *The Builder*, March 22, 1890, p. 212.

GEORGE HOWARD (9th Earl of Carlisle) (1843-1911)

George Howard was born on August 12, 1843. His mother Mary Parke, the daughter of Lord Wensleydale, died following his birth. His father was the Hon. Charles Howard, the younger brother of the 7th Earl of Carlisle. George Howard seems to have had a predilection for drawing from an early age. He was educated at Eton and later at Trinity College, Cambridge. In 1866 he enrolled at Heatherley's art school in Newman Street under William Cave Thomas. He was later a student at the South Kensington Schools under Alphonse Legros. Howard was a frequent visitor to Little Holland House, and by 1865 he was intimate with leading members of the Pre-Raphaelite circle including E. Burne-Jones, D.G. Rossetti, W. Morris, W. Holman Hunt, J.E. Millais, V. Prinsep, G.F. Watts, J. Ruskin, and F. Leighton. Howard had originally asked Burne-Jones to teach him how to paint, but as Burne-Jones was unwilling to undertake this task, he suggested Legros. In January 1866, while in Rome, Howard met Giovanni Costa, the Italian landscape painter. Costa's ideas on landscape painting greatly appealed to Howard and had a profound effect on his art. Years later, in the 1880s, Howard became one of the loose fraternity of British, American, and Italian artists centred around Costa, known as the Etruscans. Howard exhibited his paintings and drawings in London from 1867 at the Dudley Gallery, the Grosvenor Gallery, the New Gallery, and the Royal Society of Painters in Watercolour. In 1889 Howard became the 9th Earl of Carlisle. He was a trustee of the National Gallery for thirty years. He died on April 16, 1911 and is buried in Lanercost Priory.

30 Study of Cupid for "Venus and Cupid," 1869

Red, white, and black chalk on blue paper; dated l. r., *1869* 21¾ × 13%₆ in. (54.3 × 34.5 cm)
PROVENANCE: George Howard's estate; part of a large album into which were pasted many drawings dating from the late 1860s, early 1870s; by descent to his daughter Celia Roberts and thence to her son Wilfred Roberts; bought from him by Bill Waters in the late 1970s; sold to Julian Hartnoll by 1979; bought by Frederick R. Koch; his sale Sotheby's, London, October 30, 1997, lot 56.
EXHIBITED: Julian Hartnoll: 1979, cat. no. 10 (illus.).

This study is for a large finished red-chalk drawing of *Venus and Cupid*, dating from the late 1860s, which shares the same provenance.[1] This drawing is in the collection of the York City Art Gallery. There is no evidence to suggest that it was ever worked up into a painting.

Howard's drawing of *Venus and Cupid* may relate to an early episode in "The Story of Cupid and Psyche," one of the twenty-four stories that comprise William Morris' epic poem *The Earthly Paradise*. In 1864-65 Morris and Burne-Jones had initially planned to produce an edition of *The Earthly Paradise* illustrated with two to three hundred woodcuts. It was finally published in 1868-70, but was unillustrated except for a single woodcut on the title page, because the typography available at the time was felt to be incompatible with the bold wood-

cut illustrations. Burne-Jones, however, had designed a complete series of seventy illustrations for "Cupid and Psyche," and forty-four woodblocks had already been cut by Morris and his associates in preparation for printing.[2]

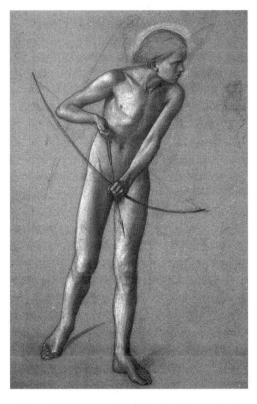

The "Story of Cupid and Psyche" derives from Apuleius, a Roman writer of the 2nd century A.D. Psyche was a young princess of such beauty that men and women worshipped her and paid her the homage due only to Venus. Venus was incensed about this mortal and was prepared to tolerate no rivals. She therefore sent her son Cupid to shoot Psyche with his arrows and cause her to love the most low, unattractive, and unworthy of mortals, and thus repent of possessing such an unlawful beauty. Cupid filled two amber vases from the two fountains in Venus' garden, one of which contained bitter water and the other sweet. He hastened to Psyche whom he found asleep. He placed a few drops of water from the bitter fountain over her lips, then touched her side with his arrow's point. At the touch she awoke, and so startled Cupid that he accidently wounded himself with his own arrow. He fell in love with her at once. From this time on, however, Psyche derived no benefits from her beauty. Although all men sung her praises, no man fell in love with her or asked to marry her. Her anxious father, concerned that his family had unwittingly incurred the wrath of the gods, asked for advice from the oracle of Apollo at Miletus. The oracle replied that Psyche was destined to be the bride of no mortal lover. Her future husband was a monster who awaited her on the top of the mountain. Although this prophecy filled her parents with grief, Psyche asked that she be lead to that rock which her unhappy fate had destined her. She was abandoned on the mountain, but was carried by Zephyr, the west wind, to Cupid's castle where he visited her nightly. He did this in total darkness lest Psyche should discover that he was a god. One night, however, Psyche lit a lamp and beheld Cupid. Cupid awoke and left, admonishing her as he went. At about this time Venus, while bathing at the seaside, was told by a seagull of Cupid's duplicity. She swore to punish the lovers, particularly the mortal Psyche. As Psyche wandered distraught in her search for Cupid, she walked by mischance into Venus' temple. Venus had her seized and then set her a number of superhuman tasks, with the threat of eternal destruction in the event of failure. With the aid and intervention of the gods she accomplished all the tasks, was made immortal by Jupiter, forgiven by Venus, and reunited with Cupid.

The large drawing at York would seem to illustrate an early episode in the story, when Venus orders Cupid to help her gain revenge on her rival Psyche. Certainly the countenace of Venus in the drawing suggests that she is anything but pleased, as she gives orders to her son. In the background we can see a figure who is presumably Psyche, along with one of her serving maids, talking to a shepherd. Other studies also exist for this composition, or variants of it.[1] A similar, but smaller study for Cupid, sold at Sotheby's Belgravia on December 11, 1979.[3]

Another drawing for Cupid that likely relates to this composition sold at Sotheby's, London, in 1988.[4] A sheet with two other studies of Cupid, but with Cupid kneeling rather than standing, were included in Julian Hartnoll's exhibition in 1979.[1] This kneeling figure of Cupid was incorporated into a pencil drawing, showing a similar design to *Venus and Cupid*, but without Venus. In this design the grouping of Psyche, her maid, and the shepherd is brought forward, while a seascape background has been added. A study for the maid holding a jug, having the same provenance, was exhibited at the Shepherd Gallery in New York in 1983.[5]

Although Howard is now generally regarded as a landscape artist, this exquisite study for Cupid reflects the training in draughtsmanship he received at Heatherley's art school and at the South Kensington Schools. Both the figures of Cupid and Venus are carefully modelled, suggesting they were drawn from life. Howard's teacher, Alphonse Legros, may have influenced not only his drawing technique, but also the subject of this drawing, since he had exhibited a painting of *Cupid and Psyche* at the Royal Academy of 1867.[6] The pose of Venus is derived from that of the Apollo Belvedere. It may also have been influenced by G.F. Watts' painting of a female nude, *Thetis*, shown at the Royal Academy of 1866, Frederic Leighton's *Venus Disrobing*, exhibited at the Royal Academy of 1867, or Albert Moore's *A Venus*, exhibited at the Royal Academy of 1869. Howard's figure of Venus is also similar to Edward Burne-Jones' *Venus Epithalamia*. This work was painted in 1871, but studies for it had perhaps been executed earlier which Howard could have seen. All these works demonstrate how progressive English artists in the 1860s experienced a renewed interest in Classicism and a desire to paint the nude again.[6]

Howard became interested in the subject of "Venus and Cupid" in 1868, as revealed in his wife Rosalind's diary entries. On March 19, 1868 she recorded: "Howard himself seems to have been especially struck with the subject and the figure of Cupid, for in the Spring of 1868 he had been shown around the British Museum and in particular 'all the Cupids'." On March 21, 1868 Rosalind noted that George had done "a good drawing for his Cupid." The drawing of *Venus and Cupid* is mentioned shortly afterwards on March 23, 1868. This composition, and related ones, were to occupy Howard for the following year and entries pertaining to it are to be found in Rosalind's diary for May 28, 1868, February 6, 1869, and May 1, 1869.[7]

The pose of Cupid is obviously derived from that of Demophoön in Edward Burne-Jones' *Phyllis and Demophoön*. It echoes almost exactly the torso and legs of Burne-Jones' figure. Although this painting was not finished until 1870, when it was exhibited at the Old Water-Colour Society summer exhibition in April, Howard would probably have seen it earlier in Burne-Jones' studio. A study for this painting, c. 1868, is in the William Morris Gallery, Walthamstow.[8] The figure of Cupid may also have been influenced by Simeon Solomon's *Love in Autumn* of 1866, although this was not exhibited until 1872, when it was shown at the Dudley Gallery. The alternative pose for Cupid that Howard explored, with Cupid kneeling, shown in two other studies for this design, may have been influenced by another early Burne-Jones' watercolour, *Cupid's Forge* of 1861. This was exhibited at the Old Water-Colour Society in 1865. Cupid is shown kneeling with his arms arranged in a somewhat similar positions.[9]

1 Hartnoll, Julian: 1979, cat. nos. 9–12. Cat. no. 9 was *Venus and Cupid*, red chalk, 21 × 26 in., signed GH and dated 186?, as the paper was cut deleting the final figure. Cat. no. 11 was *Two Studies of Cupid*, red and black chalk on grey paper, 10 × 15 in. Cat. no. 12 was *Preliminary design without Venus*, pencil, 13 × 18½ in.

2 Dufty, A.R.: 1974, p. 4.

3 Sotheby's Belgravia: *Fine Victorian Paintings, Drawings and Watercolours*, December 11, 1979, lot 22, coloured chalks, 9½ × 4½ in.

4 Sotheby's, London: *Early English Drawings and Victorian Watercolours*, April 27, 1988, lot 405, *Cupid Preparing to Draw*, pencil, 12¼ × 18 in.

5 Shepherd Gallery, New York: 1983, cat. no. 42, white and black chalk on brown paper, 14 ½ × 5 ½ in. This drawing was subsequently offered for sale at Christie's, London, *Fine Victorian Pictures, Drawings and Watercolours*, November 6, 1995, lot 58.

6 Smith, Alison: 1996, p. 126, fig. 31.

7 Ridgway, Christopher: "'A Privileged Insider': George Howard and Burne-Jones", lecture delivered at the Burne-Jones Centenary Day, sponsored by the Victorian Society and held at the Paul Mellon Centre for Studies in British Art, London, October 31, 1998. I am grateful to Dr. Ridgway for sending me the information with regard to Rosalind Howard's diaries in a letter of July 21, 1999. The diaries are in the Castle Howard Archives, J23/102/14-15.

8 Harrison, M. and Waters, B: 1973, fig. 138, p. 99.

9 Waters, Bill: Peter Nahum: 1993, cat. no. 1, p. 42, fig. 1, p. 5.

ARTHUR HUGHES (1832-1915)

Arthur Hughes was born on January 27, 1832 in London. He entered the School of Design at Somerset House in 1846, where he studied under Alfred Stevens. In 1847 he entered the Royal Academy Schools after winning a scholarship. In 1849 he was awarded the Silver Medal for Antique Drawing. He exhibited his first painting at the Royal Academy in 1849. Hughes became interested in Pre-Raphaelitism in 1850, after reading *The Germ*, and met Rossetti, Hunt, and Brown that same year, although he did not meet Millais until 1852. In 1852 he exhibited his first Pre-Raphaelite painting, *Ophelia*, at the Royal Academy. In the 1850s and early 1860s, inspired by Millais, he painted a series of important Pre-Raphaelite paintings including *April Love*, *The Long Engagement*, and *Home from Sea*. From 1852 to 1858 he shared a studio with the sculptor Alexander Munro. He began his career as an illustrator in 1855 and, after the early 1860s, his finest work was produced in this area. In 1858 he left London to live in the suburbs, where he gradually lost contact with the Pre-Raphaelite circle. Although he was asked to be a founding member of Morris, Marshall, Faulkner & Co., he declined as he was living out in the country, which would have made attending meetings of the firm difficult. Although he exhibited his last work at the Royal Academy in 1908, he died in relative obscurity at Kew on December 23, 1915.

31 Transitional Sketch for "La Belle Dame Sans Merci" / "Sir Galahad," c. 1861

Pencil, pen and brown ink on light-tan wove paper, laid down; signed with monogram in black ink, lower right 4¾ × 5⁹⁄₁₆ in. (11.1 × 14.1 cm)

PROVENANCE: Arthur Hughes' estate; Walker Galleries, London, by 1916, and probably bought at that time by Sydney Morse; E. Kersley (? bequeathed to him by Mrs. J.M. Morse; her sale was held at Christie's, London, on March 19, 1937 and did not include this work); sold to P. & D.

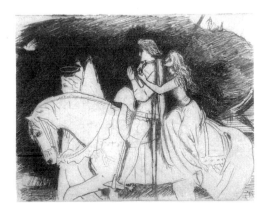

Colnaghi and Co., London, on March 23, 1937; bought on March 25, 1937 by James Byam Shaw; bequeathed to his widow in 1992; her sale Christie's, London, November 13, 1992, lot 96.

LITERATURE: Gibson, Robin: 1970, p. 455; Roberts, Leonard: 1997, cat. no. 294.2 (illus.), p. 219.

EXHIBITED: Walker Galleries: 1916, cat. no. 46; University of Lethbridge Art Gallery: 1993; Kenderdine Gallery: 1995, cat. no. 23.

Arthur Hughes' finest works were produced in the 1850s and early 1860s, and included a number based on Arthurian and related themes.[1] His first involvement with the Arthurian legends was in 1857 when he joined with Rossetti, Burne-Jones, Morris and others in painting murals for the Oxford Union Debating Hall. Hughes' subject was *The Passing of Arthur*. His greatest masterpiece of this kind was *The Knight of the Sun*, of 1860, which was purchased by Thomas Plint, a Leeds stockbroker. Plint also commissioned another painting in a similar vein, *La Belle Dame Sans Merci*, although he died before Hughes completed it. On January 9, 1863 Hughes wrote to James Leathart, another of his patrons: "I am only just finishing the large knight and lady for Plint's estate … I hope it will be in the R.A. as I think it has some of my best work in it now".[1] It was, however, rejected by the Royal Academy and was exhibited instead at the Cosmopolitan Club, Berkeley Square, in 1863. The painting is now in the collection of the National Gallery of Victoria, Melbourne. Roberts lists four preliminary studies for it, all in pen and ink, and all were originally purchased from the Hughes Memorial Exhibition held at the Walker Galleries, London, in 1916.[2] Two are in the British Museum, while the third is in the Carlisle City Art Gallery, and the fourth is in the Ashmolean Museum, Oxford. When compared to these four studies, the present drawing is by far the closest to the final composition of the painting. In it, however, the knight is standing on the ground, and the position of the woman on the horse, as well as the horse itself, are considerably altered, and the horse is shown in its entirety. The angel and the bird are missing from the final composition, not surprisingly, since they are not described in Keats' poem.

It would therefore seem more likely, based on the dove, the angel, and the knight with his hands clasped in prayer, that this drawing was originally conceived as a study for Sir Galahad's quest for the Holy Grail. Indeed it was exhibited as a sketch for *Sir Galahad* at the Hughes Memorial Exhibition at the Walker Galleries. Hughes would have been familiar with this episode from Thomas Malory's *Morte d' Arthur* because the "Attainment of the Sanc Grael" was one of the subjects Rossetti had chosen for the decoration of the Oxford Union Debating Hall in 1857. Although Rossetti never started this mural at Oxford, he made studies for it in pen and ink. In 1864 he completed a watercolour of this design entitled *How Sir Galahad, Sir Bors and Sir Percival Were Fed with the Sanc Grael; But Sir Percival's Sister Died by the Way*. This design incorporates angels and the Holy Dove.

Although Leonard Roberts in the Hughes catalogue raisonné dates this drawing to 1894, I feel the evidence suggests that this sketch is earlier and was primarily intended as a study for *Sir Galahad*, but was also adapted for Plint's *La Belle Dame Sans Merci*. At the Hughes Memorial Exhibition in 1916 the drawing was listed as "Sir Galahad, a sketch, about 1860." This dating doubtless would have come from a member of Hughes' family who was familiar with his work. This earlier date is also supported by documentary evidence. In December 1861, in a letter to Pauline, Lady Trevelyan, Hughes wrote: "And 'what am I painting?' – ever so many things. Shall I tell you about them? Very well then. The largest is for the executors now, I am sorry to say, of my good friend Mr. Plint who died two or three months ago, and whose widow, never rallying, died only a day or two ago: it is 'La Belle Dame Sans Merci' …

Then another of a knight on horseback going thro' a wood, and an angel walking at the horse['s] head, evening, the knight's praying as he rides along."[3] This description fits the drawing perfectly. If Hughes ever began such a painting, it was not completed in the 1860s, but it is likely that he would at least have made studies for it. This drawing is stylistically similar to Hughes' drawings for *La Belle Dame Sans Merci*, which are dated to 1861-62, and some of which are signed with a similar monogram.[2] The monogram on the drawing for *Sir Galahad* is in black and not in brown ink like the rest of the drawing. It may not be by Arthur Hughes, but may have been added later by his son Arthur Foord Hughes for the Memorial Exhibition. In fact it appears that Hughes' son may have added his father's monogram to a number of works in this exhibition.[4] In 1870 Hughes exhibited *Sir Galahad - The Quest of the Holy Grail* at the Royal Academy, which is now in the Walker Art Gallery, Liverpool. Although this painting was begun in 1865, its composition differs significantly from this drawing and that of the painting Hughes described to Pauline Trevelyan.

It appears that it was not until the mid 1890s that Hughes actually undertook a painting of *Sir Galahad* based on this drawing. On November 20, 1892 he wrote to Alice Boyd: "And in consequence I want to paint another Galahad, one that I thought of in the old days and didn't do, and I feel I can't die happy unless I do it yet!"[5] This drawing, on which this painting is based, could easily date back to 1861, however, since Hughes retained many of his early studies, some of which were shown at his Memorial Exhibition in 1916. It is likely that he reviewed his previous sketches for this subject before proceding with the composition. The landscape background was probably well in hand by January 1893, but by this time Hughes had evidently changed the subject to *La Belle Dame Sans Merci*![6] On January 11, 1893 he wrote to Agnes Hale-White: "I'm … starting 'La Belle Dame Sans Merci', which takes a long time to start – the lady is so difficult in her action. I think I've got it now, but I've been so thinking for weeks daily."[6] It is surely no coincidence that Hughes transformed his *Sir Galahad* into *La Belle Dame Sans Merci* after reviewing this transitional sketch that had inspired previous compositions on both these subjects. *La Belle Dame Sans Merci* gave Hughes considerable difficulty and it was not until 1894 that it was sent to the Royal Academy exhibition, where it was accepted but not hung. In June 1894 Hughes wrote to Alice Boyd: "I had such very uninviting news however to tell of my luckless 'La Belle Dame'. I was evidently in the evil web, and at my time of life it seems a little despicable, doesn't it? Well, anyhow they didn't hang it at last, tho' it was not rejected, but out from want of space with 'regret', as they courteously phrase it."[6]

Nothing further is recorded about this painting until it was sold to W.W. Sampson in the posthumous sale of Hughes' work at Christie's, London on November 21, 1921. According to Leonard Roberts, by this time the figure of La Belle Dame, which had caused so much trouble, had apparently been obliterated. The picture had been transformed back into its original conception as a "Sir Galahad" subject, likely by Hughes' sons![6] The composition of this painting is somewhat similar to this sketch, but obviously without the seated lady. The position of the horse is almost identical, but more of the horse is shown without its legs being cropped. Sir Galahad bends forward on the horse to receive a sword from the central of the three angels, rather than being upright and praying. The foremost angel cradles the Holy Dove to its breast, rather than the dove flying in the air.

Another reason for dating this drawing to 1861 rather than 1894 is that the most obvious influence on it is Millais' painting of 1857, *A Dream of the Past: Sir Isumbras at the Ford*. The poses of the horse, knight, and child behind the knight, are reflected in a very similar fashion in the drawing. Probably the main reason Hughes modified the composition of his painting *La Belle Dame Sans Merci* of 1863 is because the influence of Millais' painting would have

been obvious to any critic, if he had based the painting on this drawing. The other possible influence on this sketch is Edward Burne-Jones' pen-and-ink drawing *Sir Galahad*, of 1858, which Hughes had likely seen, either in Burne-Jones' studio, or when it was shown at the Hogarth Club in 1859.[7] Both drawings formerly belonged to Sydney Morse. Hughes' drawing is even closer in composition to another sheet by Burne-Jones, sold at Christie's, London on March 13, 1973.[8] In the latter, which was presumably a rejected design for *Sir Galahad*, a woman is mounted behind the knight. This drawing belonged to Henry Wallis, another painter within the Pre-Raphaelite circle, so Hughes could have been aware of it.

1 Gibson, Robin: 1970, pp. 452 and 455.
2 Roberts, Leonard: 1997, cat. no. 53.2, p. 151, illus. p. 151, c. 1861, pen and brown ink, 4 × 2½ in., signed lower left with AH monogram; cat. no. 53.3, p. 151, illus. p. 151, c. 1861, pen and black ink, 3¼ × 3½ in., signed lower right with AH monogram; cat. no. 53.4, p. 152, illus. p. 152, c. 1862, pen and black ink, 3¾ × 3½ in., signed lower right with AH monogram; cat. no. 53.5, p. 152, illus. p. 152, c. 1862, pen and brown ink, 11¼ × 9 in., unsigned.
3 Roberts, Leonard: Appendix A, letter 1, p. 283, MS Newcastle.
4 Roberts, Leonard: Personal communication, February 25, 1998.
5 Roberts, Leonard: Appendix A, letter 17, p. 286, MS University of British Columbia.
6 Roberts, Leonard: cat. no. 294, pp. 218–219, illus. p. 219.
7 Fogg Art Museum: 1946, cat. no. 5, p. 14.
8 Christie's, London: *Victorian Drawings and Watercolours*, March 13, 1973, lot 37, pencil, pen and black ink, and grey wash on four sheets of paper, laid down, 12½ × 15 in.

32 Illustrations to Christina Rossetti's "Sing-Song," 1871
a. "Motherless Baby and Babyless Mother"
b. "Crimson Curtains Round My Mother's Bed"

Graphite and pen and black/grey ink on off-white paper; each signed with the AH monogram, lower right; inscribed to the lower right of each image: *116. Motherless baby and babyless mother / Bring them together to love one another 117. Crimson curtains round my mother's bed / Silken soft as may be* 10 × 7 in. (25.5 × 18 cm) – sight a. 3½ × 3 in. (8.9 × 7.6 cm) – image size b. 3 × 3 in. (7.6 × 7.6 cm) – image size

PROVENANCE: Christina Rossetti; bequeathed in 1894 to her brother William Michael Rossetti; by descent to his daughter Mrs. Helen Rossetti Angeli; consigned by her in 1936 to R.E.A. Wilson of Walford, Wilson & Co., London; with John N. Bryson by 1953; anonymous sale Phillips, London, June 2, 1964, lot 9, bought Maas Gallery, London; sold to Mrs. P. Gibson; anonymous sale, Christie's, London, December 19, 1989, lot 150, bought by Maas Gallery, London; bought on March 22, 1993 by Alan B. Gately, Wolverhampton; purchased in February 1995 by Leonard Roberts; bought on March 25, 1998.

LITERATURE: Walford, Wilson & Co.: 1936, part of cat. no. 435b, p. 50; Engen, Rodney: 1995, p. 111, fig. 71; Roberts, Leonard: 1997, cat. nos. B36.117 and B36.118, pp. 266–267, illus. p. 267.

EXHIBITED: Arts Council of Great Britain: 1953, cat. nos. 77 and 78; Maas Galery, London: 1965, cat. no. 50; Bunkamura Gallery, Tokyo: 1990, cat. no. 23; Maas Gallery, London: 1991, cat. no. 87a & b, p. 49 (illus.).

Arthur Hughes' drawings for *Sing-Song* are amongst his most delightful works for book illustration. Georgina Battiscombe has noted that "never was there a happier partnership between author and illustrator; pictures and poems are welded into an indivisible whole."[1] In view of this it is somewhat surprising to learn the circumstances of how Hughes came to illustrate this book of poems.

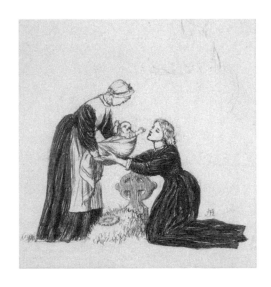

Christina Rossetti had first approached Macmillan, who had previously published her *Goblin Market and Other Poems* in 1862, and *The Prince's Progress and Other Poems* in 1868. They were not particularly interested in this project, however, so she next had discussions with the publisher F.S. Ellis. According to Kooistra, Ellis first approached Charles Fairfax Murray about doing the illustrations.[2] It has even been claimed that Christina Rossetti had planned to illustrate these poems herself, since her manuscript has sketches in black and red pencil at the top of each verse.[3] This misconception appears to be based on Dante Gabriel Rossetti's letter of February 21, 1870 to A.C. Swinburne about the publisher F.S. Ellis: "My sister is now going to him with a joint edition of her old things (including additions) and also with a book of 101 Nursery Rhymes (illustrated by herself!), which she has lately produced."[4] Although Christina had received some artistic instruction earlier, it seems highly unlikely that she ever seriously contemplated illustrating her own work. In a letter dated February 23, 1870 to the publisher F.S. Ellis, she wrote: "Sir, I understand from my brother Mr. Rossetti that you are desirous of seeing some Nursery Rhymes I have just completed, and which I send you by book-post. I shall be very glad if we can come to terms for the publication. I fear you may have misconceived what the illustrations amount to, as they are merely my own scratches and I cannot draw, but I send you the MS just as it stands."[5] Even William Michael Rossetti, who eventually owned this original manuscript, stated: "The vignettes are interesting to people who care about Christina and her work, but of course are highly primitive from an art point of view."[6]

Although Christina wished her friend Alice Boyd to be the illustrator, Boyd's designs were not considered professional enough to satisfy either D.G. Rossetti or F.S. Ellis.[7] The latter had previously published Christina Rossetti's collection of prose tales entitled *Commonplace*, which suffered from poor sales. Ellis therefore cooled to the idea of publishing another book by her, particularly after he saw Miss Boyd's weak illustrations for it. Christina wrote to Ellis suggesting that if Miss Boyd perhaps made no further large figure designs, the illustrations for *Sing-Song* might still be saved. She then added: "I can readily imagine that if

Commonplace proves a total failure, *Sing-Song* may dwindle to a very serious risk: and therefore I beg you at once; if you deem the step prudent, to put a stop to all further outlay on the rhymes, until you can judge whether my name is marketable."[8] On February 9, 1871 W.M. Rossetti wrote in his diary: "Ellis writes to Christina that he gives up the idea of publishing her *Nursery Rhymes*, because he can't see his way to getting illustrations suitable to his position as connected with the best artists … It has been a tiresome affair and I think not well managed on Ellis's part."[5] By April 19, 1871 W. M. Rossetti recorded in his diary: "Brown thinks that he, Gabriel, and two or three others, might club to illustrate Christina's book – each doing three or four designs of a simple kind. I wish this might take effect, but doubt it; the simpler the designs the better, I have always thought and said, for this particular book."[5]

In April 1871 Christina wrote to the engravers the Dalziel Brothers, with whom she was negotiating for the English edition of her book, that her acceptance of their offer would be conditional on her approval of the artist who was to illustrate the book. "I gladly agree to the terms you propose and will send you a formal note to that effect, if you will first inform me whom you intend employing to design the illustrations and if of course the name pleases me."[9] On May 4, 1871 W.M. Rossetti recorded in his diary that the Dalziel Brothers had written to Christina proposing Johann Baptist Zwecker for birds and animals, Thomas Sulman for flowers, and Francis Arthur Fraser for figures. As W.M. Rossetti was unfamiliar with Fraser, he wrote to the Dalziels asking them to show him any previously engraved designs by him.[5] On May 15, 1871 William Michael recorded: "Obtained some specimens of the wood-designs of F.A. Fraser, whom Dalziels propose for illustrating Christina's book. I don't think him, from the evidence of these designs, at all a desirable man. Wrote to Dalziels to say so, and strongly recommended that Hughes should be invited."[5] On May 18, 1871 W.M. Rossetti wrote in his diary: "Dalziels acquiesce and apparently with full cordiality, in my proposal that Hughes should be employed as the illustrator of Christina's book: they even say the *only* illustrator and to this I quite assent."[5] Despite this the Dalziel Brothers appear to have been quite demanding about the output asked of Hughes for his designs.[8] Hughes produced many of his drawings for *Sing-Song* while living at a cottage on Holmwood Common, Surrey. William advised Christina, who was then convalescing at Folkestone from a serious attack of Graves' disease, to watch for evidence of "speedy execution" in some of the illustrations.[8] Hughes subsequently reworked some designs to Christina's satisfaction. On July 28, 1871 she wrote to William Michael: "By the by, one other letter has come for you, but it is only from Dalziel with a second proof of *Sing Song*. Mr. Hughes continues charming."[6] On September 1, 1871 she wrote to William Michael: "What a charming design is the ring of elfs producing the fairy ring – also the apple-tree casting its apples – also the three dancing girls with the angel kissing one – also I like the crow soaked grey stared at by his peers."[6]

On September 10, 1871 William Michael Rossetti wrote to William Holman Hunt: "There is a book on nursery songs of hers to come out probably in November – Arthur Hughes is illustrating it with some very charming designs, in the right spirit for such semi-childish semi-suggestive work; and I think the book ought to be a decided success."[10] On October 19, 1871 W.M. Rossetti recorded in his diary: "Brown called. I showed him the proofs of Christina's *Sing Song*, with Hughes's illustrations. He was singularly pleased with both; going so far as to say that the poems are about Christina's finest things, and Hughes the first of living book-illustrators."[5] On November 13, 1871 William Michael Rossetti recorded in his diary the details of a dinner party at Dante Gabriel's house at Cheyne Walk, attended by F. M. Brown's family and Arthur Hughes: "Hughes says that the illustrations of Christina's book took up his whole time for a while. At first he worked terribly leisurely: but after a certain time Dalziels asked him to furnish ten designs per week; he furnished twenty the first time."[5]

The book, after much delays, was finally published simultaneously in England by Routledge, and in the United States by Roberts Brothers, in November 1871. Christina was so pleased with Hughes' illustrations that she felt they "deserve to sell the volume" and she insisted that his name be put in larger print on the title page.[8,9]

Christina received her copy on November 18, 1871, with general publication following a few days later. She was to receive ten per cent of every copy sold. William Michael felt "it *ought* to be a great selling success, and even perhaps *may* be."[6] Although sales initially were a little disappointing, by the first four months over a thousand copies were sold in Britain, and eight hundred copies in the United States. The reaction of both family and friends, as well as the critics, was enthusiastic. On November 30, 1871 D.G. Rossetti wrote to Thomas Gordon Hake: "Arthur Hughes has just illustrated my sister's *Sing-Song* so exquisitely. By the bye you ought to try and get him for your book. He is a dear old friend of mine and a true poet in painting. There is no man living who would have done my sister's book so divinely well."[11] D.G. Rossetti also wrote to A.C. Swinburne: "Christina's book is I think divinely lovely both in itself and in Arthur Hughes's illustrations which are quite unequalled for sweetness. I shall get some copies. I will send you one."[12] On December 11, 1871 W.M. Rossetti noted in his diary that Swinburne, who had received a copy of *Sing-Song* from Dante Gabriel, was "most enthusiastic about Christina's book."[5] On February 29, 1872 W. M. Rossetti wrote in his diary about a meeting with Mathilde Blind at a dinner party at F.M. Brown's: "Mathilde Blind is a very intense admirer of Christina's *Sing-Song*: had written a notice of it, which she offered to the *Academy*, but Appleton seemed to think it too fervently expressed, and Colvin wrote an article instead."[5] This article by the critic Sidney Colvin appeared in the *Academy* on January 15, 1872. Colvin wrote: "The volume written by Miss Rossetti and illustrated by Mr. Hughes, is one of the most exquisite of its class ever seen, in which the poet and artist have continually had parallel felicities of inspiration."[5]

Christina was obviously pleased enough with Hughes' work to ask him to illustrate her next book *Speaking Likenesses*, a fairy-story published in 1874 by Macmillan. On April 20, 1874 she wrote to Alexander Macmillan: "About illustrations: nothing would please me more than Mr. Arthur Hughes ... His in my 'Sing Song' were reckoned charming by Gabriel, not to speak of other verdicts."[13] Christina was once again delighted with Hughes' illustrations, and on November 5, 1874 sent a presentation copy of her book to her brother D.G. Rossetti: "Here is my book at last; and I hope Mr. Hughes will meet with your approval, even if you skip my text."[6] Hughes, however, felt his illustrations to *Speaking Likenesses* were inferior to his for *Sing-Song*. On January 11, 1895 he wrote to Agnes Hale-White: "You will have seen in the papers the death of Christina Rossetti ... I have thought for a long time that hers was the most beautiful mind living – indeed I think ever since the old Germ days even. And I like to think I did the 'Sing Song', and regret dreadfully I did not make better drawings to the 'Speaking Likenesses'.[14]

The admiration for Hughes' illustrations for *Sing-Song* has continued well into the 20th century. On January 16, 1911 the illustrator John William North wrote to Harold Hartley, the well-known collector of Victorian wood-block illustrations: "[Hughes'] illustrations to Christina Rossetti's *Sing Song* engraved by the Dalziels, are simply the best things of the sort ever done since this world was created – and he would be a wise man in his generation who got together every copy now obtainable."[14] John Gere has commented that: "Christina Rossetti's book of children's poems *Sing Song* (1872), for which Hughes made a hundred and twenty-five drawings, [is] outstanding even in that golden period of book illustration."[15] More recently Whalley and Chester have commented about *Sing-Song* how the "great simplicity in both the words and the accompanying pictures ... set a new standard in children's books at a

time when the illustration – and indeed the whole page – was becoming cluttered with detail and obsessive colour."[16]

Hughes' illustrations to Christina Rossetti's poems are very appropriate to the text and seem to focus on the principal idea in each poem. In view of this it is interesting to discover that the elements of the poem he chose to illustrate were not necessarily the same ones chosen by Rossetti herself. Hughes worked directly from Christina Rossetti's own illustrated manuscript.[2] She had hoped that the "scratches" she included "would help to explain my meaning" to the artist chosen to illustrate her poems.[2,9] George and Edward Dalziel, in remembering their collaboration with Rossetti and Hughes on *Sing-Song*, recalled: "We also published her charming little Nursery Rhyme Book, 'Sing Song', which was very tastefully illustrated by Arthur Hughes. The manuscript of this book was somewhat of a curiosity in its way. On each page, above the verse, was a slight pencil sketch, drawn by Miss Rossetti, suggesting the subject to illustrate, but of these Mr. Hughes made very little use, and only in two instances actually followed the sketch."[17] Kooistra argues that George Dalziel's comments have misdirected critics for nearly a century.[2] She has re-examined Christina's original manuscript and feels Hughes used the poet's sketches as the basis for his own designs in forty-nine of the illustrations.

Hughes' drawings for *Sing-Song* were first drawn in pencil, then in pen and ink, and were subsequently photographically transferred to the woodblock for the engraver to follow.[3] These two drawings are typical of the whole series and are among Hughes' most charming designs for the book. Of the remaining 120 drawings, thirty-eight are in the Ashmolean Museum, Oxford, fourteen in the Houghton Library, Harvard University, Cambridge, MA, seven in the British Museum, London, six in the National Gallery of Canada, Ottawa, four in the Victoria and Albert Museum, London, two in the Art Museum, Princeton University, and two in the private collection of Mark Samuels Lasner, Washington, D.C. [14]

These two drawings at one time belonged to John Bryson, who was the Emeritus Fellow of Balliol College, Oxford. He was a Pre-Raphaelite collector and an authority on Victorian poetry. At one time he owned thirty-eight of the drawings for *Sing-Song*, bequeathing thirty-four of them to the Ashmolean Museum in 1977.

1 Battiscombe, Georgina: 1981, p. 142.
2 Kooistra, Lorraine Janzen: 1999, pp. 57-59.
3 Engen, Rodney: 1995, p. 110.
4 Doughty, O. and Wahl, J.R.: 1965, Vol. II., letter 928, p. 797.
5 Bornand, Odette: 1977, p. 37, n. 2 and pp. 43, 56, 60, 61, 63, 116, 126, 137, and 170 n. 2.
6 Rossetti, William Michael: 1908, pp. 34, 35, 47, 81 and 209.
7 Marsh, Jan: 1999, p. 414. Marsh states that "Gabriel had asked Alice Boyd to do the illustrations for *Sing-Song*, which proved beyond her competence. Ellis then withdrew his offer."
8 Weintraub, Stanley: 1977, pp. 173-174 and 177.
9 Harrison, Anthony H.: 1997, pp. 342, 369, and 375.
10 Peattie, Roger: 1990, p. 278.
11 Doughty, O. and Wahl, J.R.: 1967, Vol. III., p. 1035, letter 1196.
12 Doughty, O. and Wahl, J.R.: Vol. II., letter 934, p. 808, n. 2. This information was included in a P.P.S. attached to a letter to Swinburne of February, 1870, but obviously not part of it. This attachment was obviously misfiled and the P.P.S. most likely dates to November 1871.
13 Packer, Lona Mosk: 1963, p. 100.
14 Roberts, Leonard: 1997, Appendix A, p. 286, letter 19 and cat. no. B36, pp. 266-268.
15 Ironside, Robin and Gere, John: 1948, p. 44.
16 Whalley, Joyce Irene and Chester, Teresa Rose: 1988, p. 44.
17 Dalziel, George and Dalziel, Edward: 1901, pp. 91-92.

33 The Nativity, a Study for "The Adoration of the Kings and the Shepherds," c. 1902

Graphite on off-white wove paper 14½ × 9¹¹⁄₁₆ in.
(36.9 × 24.4 cm)
PROVENANCE: Bill Waters; bought by Ian
Hodgkins & Co. Ltd., London, in 1975; bought in
November, 1975 by Justin Schiller, New York;
bought by Stuart Pivar, New York; bought from
Pivar by the previous owner in November, 1982;
his sale Sotheby's, London, June 5, 1996, lot 131;
bought in at the sale and purchased in July, 1996.
LITERATURE: Ian Hodgkins & Co. Ltd: 1975, cat.
no. 424, p. 20, p. 119 (illus.); Fredeman, William
E.: 1975-1976, p. 60; Roberts, Leonard: 1997, cat.
no. 409.2, p. 236 (illus.).

This drawing may be a preliminary study for the
painting *The Adoration of the Kings and Shepherds*,
dated 1902.[1] It differs from the painting primarily
in the treatment of the kings. The first king with his white hair, for instance, appears much
older in the painting. The garments are also different on all three kings, as are the head-gear of
the first and third kings. The stable is also changed, as is the arrangement of the angels along
the top of the composition. Because of these differences, it is possible that the drawing was
conceived earlier as an independent work, perhaps for an illustration. It is not unusual,
however, for Hughes' compositional studies to differ significantly from his final paintings.

In 1876 William Bell Scott had recommended Hughes to illustrate a dramatic poem on
the Nativity by the cleric G.A. Simcox. Since there is no such volume listed in the catalogue of
the British Library, it likely was never published. A related drawing exists, of c. 1890-1900, of
The Adoration of the Kings and Shepherds. This is apparently a study for an illustration in *The
Life of the Blessed Virgin* by Julian Moore.[2] On July 23, 1899 Hughes wrote to F. G. Stephens:
"Do you happen to know a Mr. Julian Moore, late of 54 Shepherds Bush Rd.? He turned up
some time ago and gave me a commission for a set of drawings (of a religious character)...He
is by his own account by way of being rather [a] literary amateur and publisher amateur, a
collector of books and so on. I have been very slow with my work and possibly he may despair
of me – but [he] always was most amiable when calling on me and I should like to carry out his
scheme to the end."[2] Since Moore's book was also never published, Hughes may have worked
his preliminary drawing up into a more finished state, which he subsequently used as a study
for the painting.

A similar black-and-white Nativity drawing entitled *Bethlehem* was reproduced in the
December 1911 issue of *The Vineyard*.[3] This drawing was also used as a study for another
painting, *The Adoration of the Shepherds*, completed c. 1912.[4] In this painting the kings are also
included, but this time they are present on the left rather than on the right side, which is occu-
pied by the shepherds.

The subject of Jesus' birth was obviously a favourite with Hughes. His first treatment of
it is a painting *The Nativity*, dated 1858, that once belonged to James Leathart and which is
now in the Birmingham City Museum and Art Gallery. Hughes also used the subject for two

illustrations in *Christmas Carols, New and Old*, of 1871.[5] The frontispiece most closely resembles the present drawing. Both of the drawings in *Christmas Carols, New and Old* featured Mary and the infant Jesus, while the three kings and two shepherds are included only in the frontispiece. Another Nativity drawing entitled *Bethlehem*, of quite a different composition than the previously referred to illustration of this title, was exhibited at the Shepherd Gallery, New York in 1983.[6] An illustration based on this second drawing was published in *The Vineyard* in December 1910. It included Mary and Joseph and the Christ Child, as well as two angels, but no kings or shepherds. Jan Marsh has pointed out that "traditionally, shepherds and kings are kept separate in Christian art. Bringing them together, with asserted equality, was a radical Victorian notion, challenging orthodox iconography."[7]

1 Roberts, Leonard: 1997, cat. no. 409, p. 235, oil on panel, 19¾ × 14½ in.
2 Roberts, Leonard: cat. no. B53.12, p. 273, white and black chalk on grey paper, 10 × 8 in., signed lower left with AH monogram.
3 *The Vineyard*, Vol. III, Special Christmas Issue, Dec. 1911, p. 190.
4 Roberts, Leonard: cat. no. 409.3, p. 236, oil on panel, 13¾ × 10½ in.
5 Bramley, Henry Ramsden and Stainer, John: 1870, frontispiece, and an illustration to "Sleep Holy Babe," p. 18.
6 Shepherd Gallery: 1983, cat. no. 44, pencil and chalk on white paper, signed with monogram, 10½ × 9 in. This drawing was recently for sale at Sotheby's, London, *Victorian Pictures*, June 4, 1997, lot 169. A separate predella drawing shows a demon being driven into a hole by an angel.
7 Marsh, Jan: 1999, p. 160.

WILLIAM HOLMAN HUNT (1827-1910)

Holman Hunt was born in Cheapside on April 2, 1827, the eldest son of William Hunt, a merchant manager. In July 1844, on his third attempt, he was accepted as a probationer at the Royal Academy Schools, and as a full student in January 1845. He exhibited at the Royal Academy for the first time in 1846. In 1847 he began to discuss independent artistic ideas with J.E. Millais. His painting *The Eve of St. Agnes* was exhibited at the Royal Academy in 1848, which led to a close friendship with D.G. Rossetti. Hunt became a founding member of the Pre-Raphaelite Brotherhood, and his first major Pre-Raphaelite painting, *Rienzi*, was exhibited at the Royal Academy in 1848. From 1850-52 he painted some of his most important Pre-Raphaelite paintings, but many of his works received hostile receptions and he struggled financially. In 1851 *Valentine Rescuing Sylvia* was awarded the Liverpool prize, amid great controversy, while in 1853 *Claudio and Isabella* received the second Liverpool prize. Hunt's painting *Our English Coasts (Strayed Sheep)* was awarded the Birmingham prize in 1853. On the threshold of success, with his work generally praised, Hunt left England on January 13, 1854, to paint religious subjects in the Holy Land. On this trip he began important paintings such as *The Finding of the Saviour in the Temple* and *The Scapegoat*. He returned to England in February 1856. In February 1869, he was elected to the Old Water-Colour Society. On August 31, 1869, he arrived at Jerusalem on his second visit to the Holy Land and did not return to England until July 1872. In 1905 he was awarded the Order of Merit, and an honorary D.C.L. by Oxford University. On September 7, 1910 he died in London and was buried in St. Paul's Cathedral.

34 Compositional Study for "The Flight of Madeline and Porphyro During the Drunkenness Attending the Revelry (The Eve of St. Agnes)," 1848

Graphite on off-white paper; in-scribed by Edith Holman Hunt on the reverse 5⁷⁄₁₆ × 7³⁄₄ in. (13.8 × 19.7 cm)

PROVENANCE: The artist's widow, Edith Holman Hunt; by descent to Gladys Holman Hunt and then to Mrs. Elizabeth Burt; on loan to the Ashmolean Museum, Oxford; Burt sale, Sotheby's, London, October 10, 1985, lot 8, bought by Julian Hartnoll for for Frederick R. Koch; his sale Sotheby's, London, November 5, 1997, lot 190.

LITERATURE: Hunt, William Holman: 1905, Vol. I, p. 79; Bronkhurst, Judith: Tate Gallery, 1984, cat. no. 10, p. 58; Bennett, Mary: 1988, cat. no. 1635, p. 66.

EXHIBITED: National Gallery, Millbank: 1923, cat. no. 152; Birmingham City Museum and Art Gallery: 1947, cat. no. 147; Walker Art Gallery: 1969, cat. no. 94 (illus.); Portsmouth City Museum and Art Gallery: 1976, cat. no. 11.

This compositional study for *The Flight of Madeline and Porphyro During the Drunkenness Attending the Revelry (The Eve of St. Agnes)* likely dates from early 1848, although earlier rough compositional studies exist, probably dating from 1847-48.[1] This particular design was the one used as the basis for the painting that Hunt exhibited at the Royal Academy in 1848 and which was a key landmark on the road to the formation of the Pre-Raphaelite Brotherhood. Because of the importance of this painting to the history of Pre-Raphaelitism, this drawing has been included in many important drawing exhibitions and Hunt retrospectives. It differs from the final painting only in minor details, such as the angle of Madeline's head and the handling of her hood. In the drawing certain features are as yet incompletely resolved, such as the chain and the horn in the right foreground and the fresco in the banqueting hall in the left background.[1] Very early designs had shown Madeline and Porphyro on the left, and that the revellers were not part of Hunt's original composition. The final composition shows that Hunt decided on a deliberate misreading of Keats' poem to increase its dramatic impact. When the painting was shown at the Royal Academy of 1848, it was accompanied by this excerpt from Keats' poem "The Eve of St. Agnes":

> They glide, like phantoms, into the wide hall.
> Like phantoms to the iron porch they glide,
> Where lay the porter, in uneasy sprawl,
> With a huge empty flagon by his side:
> The wakeful bloodhound rose and shook his hide,
> But his sagacious eye an inmate owns;
> By one, and one, the bolts full easy slide:-

The chains lie silent on the foot-worn stones:
The key turns and the door upon its hinges groans.

This drawing owes much to German outline illustration of the early 19th century. Judith Bronkhurst feels that the moving of the lovers to the right, near the slightly open door, may have been influenced by the engraving *Bester Mann!* which is Plate 17 from F.A.M. Retzsch's illustrations to Goethe's *Faust*, dating from 1816.[2,3] Certainly Porphyro's cap and half-cloak, as well as the positioning of his legs, although reversed, are derived from this engraving. Mary Bennett has suggested a drawing by Karl Friedrich Lessing as another possible source of inspiration.[4] Although Bennett feels Lessing is the source for the figure of the sprawling porter, Kathryn Smith has suggested that it is derived from the sprawling nude in the foreground of Rubens' *The Brazen Serpent*.[5] The knight in Frederick R. Pickersgill's illustration for the frontispiece of *The White Lady*, in 1846, has also been suggested.[6]

The picture, which was the first subject from the poetry of John Keats that Hunt painted, was commenced on February 6, 1848. It had to be completed by April in time for the sending-in-day for the Royal Academy. Hunt, in his book *Pre-Raphaelitism and the Pre-Raphaelite Brotherhood*, recorded: "I had been talking to Millais of Keats and one day took occasion to show him my design for 'The Eve of St. Agnes', representing the escape of Porphyro and Madeleine from the castle; he confirmed me in the intention of painting this subject."[7] Hunt told Millais that "the story in Keats' *Eve of St. Agnes* illustrates the sacredness of honest responsible love and the weakness of proud intemperence, and I may practice my new principles to some degree on that subject."[7] Mary Bennett has noted that the interior architectural setting and artificial lighting gave Hunt the opportunity to try out his developing theories of truth to nature in every detail, and to attempt unusual effects of lighting.[4] In the composition Hunt experimented with vigorous movement and problems of recession and foreshortening. It provided elements of contrast between silence and noise, stillness and movement, light and shadow, as well as innocence and youthful purity as opposed to revel and intemperance.[4] Judith Bronkhurst feels that the bloodhounds may have been used symbolically, since the association of dogs with fidelity could counterbalance the intemperance symbolized by the figure of the sprawling porter.[2]

Hunt had been introduced to the poetry of John Keats, then a relatively neglected and obscure poet, in 1847, when he bought an old volume of his poems for fourpence. Hunt introduced his friend John Everett Millais to Keats' work saying the book was "brimful of beauties that will soon enchant you."[7] Hunt reported that when he started *The Eve of St. Agnes*, he was also working on *Christ and the Two Marys* and Millais asked him if he was giving up the latter painting. Hunt replied: "Not, I hope, finally, but you see I am obliged to paint portraits to get money. I shall spend less on 'The Eve of St. Agnes'; I can do much of it by lamplight, and I think it is more likely to sell. We are now in the middle of February, I began it on the 6th, and I could not hope to do both. I must finish 'The Resurrection Morning' another year."[7] Hunt therefore continued his attendance at the evening Life School at the Royal Academy. He recorded that: "Coming home at nine, I worked on my canvas by the light of a lamp. The architecture I had to paint with but little help of solid models, but the bough of mistletoe was hung up so that I might get the approximate night effect upon it; the bloodhounds I painted from a couple possessed by my friend, Mr. J.B. Price; my fellow student, James Key, sat to me for the figure of the sleeping page and for the hands of Porphyro, so I was enabled to advance the picture with but little outlay. Still I was pinched both for want of time and money. Some days in each week I had to sacrifice to paint a portrait."[7] Hunt recalled: "The date for sending in works came alarmingly near. Millais had progressed more bravely than I, but he had yet

more to do, and we agreed that neither of us could finish without working far into, and even all through, the last nights. For company's sake, he invited me to bring my picture to his studio; his parents also urged this, and so we worked, encouraging one another hour by hour."[7] He continued: "On the date for receiving the works of outsiders at the Academy, our pictures were forwarded, literally at the eleventh hour, and very glad each of us was to go to his long-neglected bed ... When the Academy Hanging Committee had completed their work I was surprised and distressed to learn that Millais' painting of 'Cymon and Iphigenia' had not been placed ... My picture of 'The Eve of St. Agnes' being not nearly so large, had more easily met with better fortune, not withstanding the absence of close finish. It was hung somewhat high up in the Architectural Room, but in a good light, as was proved on the touching-up morning by the amount of attention which fellow-exhibitors bestowed upon it ... Rossetti came up to me, repeating with emphasis his praise, and loudly declaring that my picture of 'The Eve of St. Agnes' was the best in the exhibition. Probably the fact that the subject was from Keats made him the more unrestrained, for I think no one had ever before painted any subject from this still little-known poet."[7,8] It was Rossetti's sincere admiration for Hunt's painting, as well as "our common enthusiasm for Keats [that] brought us into intimate relations,"[7] and subsequently led to the formation of the Pre-Raphaelite Brotherhood.

Two versions exist for Hunt's *The Eve of St. Agnes*. The first and the larger is in the collection of the Guildhall Art Gallery, Corporation of London.[2] A second, smaller painting is in the Walker Art Gallery, Liverpool.[4] The latter had been described by Hunt as an "original sketch", taken up and finished in the 1850s.[7] Although it is dated 1847-57, it is on a white ground, which Hunt used only in his strictly Pre-Raphaelite period. In addition the colour of this painting is generally brighter than the original version, reflective of Hunt's more vivid palette following his journey to Palestine and the Near East. This suggests it is likely to be virtually all from the 1857 period.[4]

Hunt was not the only Pre-Raphaelite artist who illustrated Keats' "The Eve of St. Agnes". In 1856 Arthur Hughes painted a triptych of this subject. The panel on the left portrays Porphyro approaching the castle, the centre panel Madeline being awakened by Porphyro in her bedchamber, and the right-hand panel the escape of the lovers. The latter is close in composition to Hunt's painting, as it portrays Madeline and Porphyro sneaking silently past the drunken porter and a bloodhound. A drawing by James Smetham from 1858, entitled *The Flight of Porphyry*[sic], also illustrates the same scene where the lovers steal past the sleeping porter and the bloodhound.[9] This composition is quite different from Hunt's painting, however. Millais' *The Eve of St. Agnes*, exhibited in 1863 at the Royal Academy, depicts a scene earlier in the poem, and shows Madeline undressing in the moonlight watched secretly by Porphyro from a closet. Simeon Solomon made a drawing of *Madeline*, praying in her bedroom before undressing for bed, from a sketchbook of c. 1857-60.[10] Walter Crane painted a version of *The Eve of St. Agnes* in 1864.[11]

1 Bronkhurst, Judith: Sotheby's, London, *Victorian Watercolours and Drawings including the Burt Collection of Holman Hunt Drawings*, October 10, 1985, lots 2, 3, 5, 7 and 8.

2 Bronkhurst, Judith: Tate Gallery, 1984, cat. no. 9, pp. 57-58.

3 Vaughan, William: 1979, p. 129, fig. 52.

4 Bennett, Mary: 1988, cat. no. 1635, pp. 64-68. In Lessing's drawing of a similar subject, *Walter and Hildegunde Stealing from the Palace* of 1831, there are similarities in the principal figures, in the sprawling man asleep in a chair, and in the type of Romanesque architectural setting. See Cincinnati Art Museum: 1972, cat. no. 1882/49. As this drawing does not appear to have been engraved, however, it is uncertain whether Hunt would ever have seen it.

5 Smith, Kathryn A.: 1985, p. 43, fig. 2. The Rubens had been purchased by the National Gallery, London, in 1837 and certainly would have been known to Hunt.

6 Bronkhurst, Judith: Sotheby's, London, October 10, 1985, lot 10.
7 Hunt, William Holman: 1905, Vol. I, pp. 79-81, 85, 98, 99, 101, and 107.
8 Hunt, William Holman: 1905, pp. 105-106. Hunt was incorrect, however, in thinking that no paintings based on Keats' poetry had ever been previously exhibited at the Royal Academy. In 1840 Joseph Severn, a friend of Keats who accompanied him to Rome in 1820, had exhibited a painting entitled *Isabella and the Pot of Basil*. G.F. Watts had exhibited a painting titled *Isabella e Lorenzo* at the Royal Academy of 1840, but his version was likely based on Boccaccio and not Keats. See Graves, Algernon: 1906, Vol. VII, p. 82, Joseph Severn, Royal Academy, 1840, cat. no. 113, with a quotation from Keats "And so she fed it with her tears, etc." Vol. VIII, p. 175, George Frederic Watts, Royal Academy, 1840, cat. no. 408, with a quotation from Boccaccio.
9 Ironside, Robin and Gere, John: 1948, p. 25, fig. 3, pen and ink touched with colour, $3\frac{1}{4} \times 4$ in., Tate Gallery, London.
10 Kolsteren, Steven: 1984, fig. 1, pp. 62-63. See also Lambourne, Lionel: 1967, p. 59, fig. 3.
11 Crane, Walter: 1907, p. 71. A study for this early painting by Crane is shown opposite p. 70. Like Solomon's drawing it shows Madeline praying on her knees.

35 Two Studies for the Headpiece of "Recollections of the Arabian Nights," 1856

The larger sketch is pen and Indian ink over graphite, with some incised outlines, on off-white wove paper; the smaller sketch is pen and brown ink, on the back of a tailor's visiting card. *Reclining figure* $4\frac{5}{16} \times 4\frac{1}{4}$ in. (11×10.8 cm) - sheet size $3\frac{1}{4} \times 3\frac{3}{4}$ in. (8×9.5 cm) - image size. *Scent of a Lily* - $2\frac{3}{8} \times 3\frac{9}{16}$ in. (6.2×9 cm)

PROVENANCE: The artist's widow, Edith Holman Hunt; by descent to Gladys Holman Hunt and then to Mrs. Elizabeth Burt; on loan to the Ashmolean Museum, Oxford; Burt Sale, Sotheby's, London, October 10, 1985, lot 39, bought Maas Gallery, London; purchased July 19, 1990.

LITERATURE: Bennett, M.: Walker Art Gallery, 1969, cat. no. 180, pp. 80-81.

EXHIBITED: ?National Gallery, Millbank: 1923, cat. no. 154; Birmingham City Museum and Art Gallery: 1947, cat. no. 259; Maas Gallery: 1989a, cat. no. 32.; Maas Gallery: 1989b, cat. nos. 42 and 43; Kenderdine Gallery: 1995, cat. no. 24.

Edward Moxon's edition of the early poems of Alfred, Lord Tennyson, published in 1857, is now generally regarded as a landmark in 19th-century book illustration. The Pre-Raphaelite designs in this book were very influential on the later course of book illustration in England

and Europe. The Pre-Raphaelites supplied thirty illustrations for the Moxon Tennyson, with Millais contributing eighteen blocks, Holman Hunt seven, and Rossetti five. One has only to compare their illustrations to those by members of the earlier generation in the same book to appreciate the originality of the Pre-Raphaelite approach.

Hunt first learned of Moxon's commission from J.E. Millais' letter of August 28, 1854. In 1901 Holman Hunt wrote: "I rejoiced at the prospect of taking my part in the project, and began to consider whether in some of the poems of Oriental story I could not use my special opportunities, and I made experimental sketches at once. Certain poems had already been assigned to other artists, but the 'Recollections of the Arabian Nights' was not amongst these."[1] While in Palestine in 1855 he looked for suitable backgrounds. The form of the boat and the landscape background to the headpiece of the poem were based on a visit by Hunt to Constantinople in January 1856. "I pursued my way to Constantinople, and there the caiques on the Bosphorus furnished me with the form of the boat for the Dreamer floating down the Tigris in Tennyson's poem; and the mosque domes, and minarets in the background of the drawing, I designed from those in Stamboul. Intimate study of Orientalism served me in other particulars for the two illustrations of the Arabian poem."[1]

It is possible that the smaller sketch (*Scent of a Lily*) was also executed in Constantinople in January 1856, but lack of models would have impeded his progress with the design until his return to England in February 1856. Hunt also adapted his designs for the endpiece of the "Lady of Shalott", which were never utilized, to the design of the Mussulman Haroun al Raschid reclining in a boat.[2,3] This design of the Lady of Shalott reclining in the boat was executed by Hunt prior to January 30, 1855, when Rossetti wrote to him asking to be allowed to do a design for this poem, to which Hunt consented. The smaller sketch (*Scent of a Lily*) appears to be the first design for the figure of the Mussulman cruising in his "Shallop", "Adown the Tigris ... By Bagdat's shrine of fretted gold." The sketch at the lower left can be compared with the roundel to the left of the Lady of Shalott in Hunt's drawing of 1850, in the National Gallery of Victoria, Melbourne.[4] The design in the upper left of the Mussulman sniffing a lily, is an attempt to convey Tennyson's vivid evocation of the floral scents of the East as described in the sixth stanza.[2]

The larger study for *Haroun al Raschid* forms the basis, albeit in reverse, for the final engraving used in the book. The size of the drawing is identical to that of the illustration. The incisions indicate how the artist transferred the design to the woodblock for the engraver Thomas Williams to cut. The figure in the drawing lacks as yet his shoes and cloak, as seen in the finished illustration. The model for the figure in the boat in the final engraving was William Michael Rossetti. In 1866 Hunt worked this preliminary drawing up into a water-colour on vellum.[5] The figure in the watercolour faces in the same direction as in this drawing, rather than reversed as in the engraving. This design had originally been requested to be worked up in watercolour in 1858 by William Bell Scott, on behalf of his friend, a Mr. T.E. Crawhall of Newcastle. As Hunt was preoccupied at that time, he did not begin the water-colour until 1866. A similar drawing to the larger design for the Mussulman reclining in the boat was exhibited at the Holman Hunt exhibition at the Walker Art Gallery in 1969.[6] This design was also in reverse as compared to the printed image, but differs in the pose of the man, who here is crouching in the boat. One other study, in pen and ink, current location unknown, is known to exist based on a photograph in the Mellon Centre for Studies in British Art, London. This is likely the drawing exhibited at the Stone Gallery, Newcastle, in the early 1970s.[7] Another drawing, entitled *Stamboul*, which is a study for this illustration, sold at Sotheby's, London in 1987.[8] A drawing of the second illustration for "Recollections of the Arabian Nights" is in the Courtauld Institute of Arts, London.[9]

Hunt's contributions to the Moxon Tennyson are somewhat uneven, but, in contrast to Millais, his designs are at least consistent in style. His drawing for "The Lady of Shalott" is certainly one of the finest of all the Moxon illustrations. Hunt, like Rossetti, was disappointed in the cutting of his designs by the engravers.[1] He first met Tennyson sometime in 1857 or 1858. Tennyson himself was dissatisfied with Hunt's illustrations. Hunt relates their first interview in detail in *Pre-Raphaelitism and the Pre-Raphaelite Brotherhood*. Tennyson told him he felt that "an illustrator ought never to add anything to what he finds in the text" and "I think that the illustrator should always adhere to the words of the poet." To which Hunt replied: "Ah, if so, I am afraid I was not a suitable designer for the book."[10]

1 Hunt, William Holman: 1901, pp. xix, xx, and xxiii.
2 Bronkhurst, Judith: Sotheby's, London, October 10, 1985, lots 39 and 37.
3 Landow, George P.: 1980, p. 82. Figs. 3 and 4, opposite p. 83, reproduce additional designs for "The Lady of Shalott."
4 Dean, Sonia: National Gallery of Victoria, 1978, cat. no. 23, p. 43, black chalk and pen and ink.
5 Bronkhurst, Judith: Tate Gallery, 1984, cat. no. 242, p. 302, *The Golden Prime of Haroun al Raschid* (*Recollections of the Arabian Nights*), watercolour on vellum, 4 × 5½ in., 1861, National Museums of Wales, Cardiff. The information that William Michael Rossetti posed for the figure is confirmed in a letter from him to Herbert M. Thompson, December 2, 1898; MS National Museum of Wales.
6 Bennett, Mary: Walker Art Gallery, 1969, pp. 80–81, cat. no. 180, pen and sepia ink and wash, 4¾ × 5½ in.
7 Stone Gallery: 1970, cat. no. 10 and 1971, cat. no. 28, *Design for Haroun el Raschid*, ink, 4 × 4 in., initialled, provenance Edith Holman Hunt, who gave it to Ernest Richmond in 1927.
8 Sotheby's, London: *Early English Drawings and Watercolours and Victorian Watercolours*, September 24, 1987, lot 527, inscribed with title and dated 55, pencil heightened with white, 7 × 10 in.
9 Bartram, Michael: 1985, fig. 89, p. 96, pencil, 6 × 6½ in. This is quite a finished drawing, and in the same orientation as the print. This suggests that the drawing may be after the print, rather than a preliminary design.
10 Hunt, William Holman: 1905, Vol. II, p. 125.

36 The Raising of Jairus' Daughter, c. 1856-58

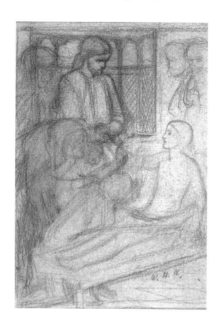

Graphite on off-white wove paper; signed with initials, lower right; inscribed in pencil, on the verso of the drawing, "Early Design by W Holman Hunt For Oliver Lawson Dick from Gladys Joseph. 1938 Jairus' daughter"; inscribed on the back of the old frame was: "The Raising of Jairus' Daughter by Holman Hunt. Given to me by his daughter, Oliver Lawson Dick, 1963" (The date 1963 probably relates to the date Oliver Lawson Dick gave the drawing to his sister.) 5¹¹⁄₁₆ × 4³⁄₁₆ in. (14.6 × 10.6 cm)

PROVENANCE: The artist's widow, Edith Holman Hunt; by descent to her daughter Gladys Holman Hunt (Mrs. Michael Joseph); given by her to Oliver Lawson Dick, 1938; O.L. Dick's family by descent; Sotheby's, Sussex, U.K., January 31, 1989, lot 103, bought Peter Nahum, London; purchased February 17, 1989.

The biblical story of the raising of Jairus' daughter is found in Luke, chapter 8, verses 41-56. Jairus was the ruler of a synagogue who asked for Jesus' help as his daughter of twelve lay dying. Jesus agreed to help, but on the way was told she had died in the meantime. He came to the house, took her by the hand, and told her to arise.

Dr. Judith Bronkhurst feels this drawing dates from c. 1856-58, since it is similar to Hunt's designs for the Moxon Tennyson.[1] It is unusual for the period in terms of subject matter, and may be a projected, but unexecuted, biblical illustration.[1] Hunt was involved, along with many other artists, including Ford Madox Brown, Edward Burne-Jones, Simeon Solomon, Frederic Leighton, G.F. Watts, and Edward Poynter, in producing designs for the *Dalziel Bible Gallery* commissioned by the Dalziel Brothers. This project appears to have been planned, and the artists commissioned to make drawings in the early 1860s. The book itself did not appear until 1881. *Eliezer and Rebekah at the Well* was the only design by Holman Hunt eventually utilized. Hunt's designs for the *Dalziel Bible Gallery* are dated 1863, but it is likely that he was making sketches for his biblical subjects prior to this time.

If Judith Bronkhurst is correct in dating this drawing to 1856-58, it is unlikely that this is an early design for the *Dalziel Bible Gallery*, although she does not completely discount the possibility.[1] All the published designs for the *Dalziel Bible Gallery* relate to Old Testament subjects, although the Dalziel Brothers may have initially envisioned a more ambitious project that would include New Testament designs as well.[2] It is also possible that this drawing was executed in anticipation of another project. In 1854 the publisher Macmillan proposed a Life of Christ to be illustrated by Hunt, John Everett Millais, and Dante Gabriel Rossetti.[3] This project was not undertaken, although Hunt may have made designs for it. During the early 1860s Joseph Cundall was competing with the Dalziel Brothers to secure the best illustrators for their respective Bible galleries. Cundall's project also did not come to fruition, although Hunt is known to have done designs for this project.[4] Hunt's *The Raising of Jairus' Daughter* may have been influenced by Theodor Von Holst's large British Institution prize-winning picture of 1841, or the later steel engraving published by S.C. Hall in 1845 in *Gems of European Art*.[5] Holst was an artist much admired by members of the Pre-Raphaelite Brotherhood, especially Rossetti.[5]

In c. 1872 Holman Hunt executed a black chalk drawing with a similar theme, but it had only two figures, Jairus and Christ.[6] As far as Judith Bronkhurst is aware, Hunt never worked this subject up in oils.[1]

1 Bronkhurst, Judith: personal communication, letters dated 11/5/90 and 6/6/90.
2 Goldman, Paul: 1994, p. 106. Goldman notes that, in the end, the New Testament drawings were never even properly begun.
3 Fredeman, William E.: 1996, p. 11.
4 Goldman, P.: pp. 105-106. On September 7, 1863 Joseph Cundall wrote to the Dalziel Brothers, handing his project over to them: "I find that it is quite impossible for me to carry on my project for an Illustrated Bible without in some degree clashing with yours. We go to the same artists – we are getting drawings of the same size ... I will hand over to you four drawings by Cope, Dyce, Tenniel and F. Leighton ... Millais, Hunt and Watts have each promised me drawings which they have in hand – you can take these also if you wish." British Library, Dept. of Manuscripts, Add. 39, f.168.
5 Browne, Max: 1994, pp. 11 and 44. The engraving of *The Raising of Jairus' Daughter*, after Holst's painting, is cat. no. 71, pp. 98-100.
6 Maas Gallery, London: 1962, cat. no. 43, *The Raising of Jairus' Daughter*, black chalk, 10½ × 9 in.

FREDERIC, LORD LEIGHTON (1830-1896)

Leighton was born on December 31, 1830 at Scarborough, Yorkshire, the son of a physician Dr. Frederic Septimus Leighton. From 1833-38 the family lived in London. From 1841 they travelled and lived on the continent. In the winter of 1845-46 his family was in Florence where Leighton attended the Accademia delle Belle Arti. The Leightons returned to Frankfurt in early 1850. Frederic enrolled at the Städelsches Kunstinstitut where he studied under Edward von Steinle, the Nazarene painter. In 1853 in Rome he met the painters Giovanni Costa and George Heming Mason, and the architects George Aitchison and William Burges. Leighton was in England during the summer of 1855 where he made contact with various artistic circles, meeting G.F. Watts, D.G. Rossetti, and John Ruskin for the first time. In the autumn of 1855 Leighton moved to Paris and did not return to London until the summer of 1859. During his early years he was closely associated with a group of independent progressive younger artists, with affiliations to the Pre-Raphaelite and Aesthetic Movements, and his work found strong opposition from an older, more conservative faction within the Royal Academy. In 1864 Leighton was elected an associate of the Royal Academy, and commissioned George Aitchison to build a house for him in Holland Park Road. In 1868 he was elected a full member of the Royal Academy. In 1878 Leighton was elected president of the Royal Academy and was knighted by Queen Victoria. Leighton was created a Baronet in 1885. In 1895 he was raised to the peerage, as Lord Leighton of Stretton. On January 25, 1896 he died at his house in London. He was buried in St. Paul's Cathedral.

37 Study of a Male Figure for "Cimabue's Madonna," 1853

Graphite on paper; signed with monogram and dated *1853* on right; inscribed "Cimabue's Madonna," in an unknown hand, l.r. 10¾ × 6¾ in. (27.3 × 17.2 cm)
PROVENANCE: Julian Hartnoll, London; sold on January 27, 1990 to Maas Gallery, London; sold in March, 1990 to Daniel Perrin, London; purchased April 4, 1990.
EXHIBITED: Kenderdine Gallery: 1995, cat. no. 26.

This drawing is apparently a rejected study for one of the figures in Leighton's first masterpiece, *Cimabue's Celebrated Madonna is Carried in Procession through the Streets of Florence*. The subject of the painting is based on an incident described in Vasari's *Lives of the Painters*. The painting caused a sensation at the Royal Academy exhibition of 1855, and was bought by Queen Victoria, on the advice of Prince Albert, for the Royal Collection. It went on loan to the National Gallery, London, in 1989.

Leighton had likely chosen the subject for this painting even prior to arriving in Rome in November 1852.[1] He began work on the designs in early 1853. Progress on the painting was slow because of problems with his health, both physical and mental. In a letter to his father of January 5, 1853 Leighton complained of the state of his eyes and "with regard to composing, however, I still feel the same paralysing diffidence, I cannot make up my mind to draw compositions like those I hitherto produced, but, at the same time, I feel that I am as yet incapable of drawing any in the manner I should wish."[2] In July 1853 Leighton left Rome and travelled to Bad Gleisweiler for the sake of his health. He later went on to Frankfurt, where he took his cartoons for *Cimabue's Madonna* to show to his mentor Edward von Steinle, and to obtain his criticism and advice.[2] From early November Leighton was in Florence collecting source material for the painting, but he was back in Rome by January 1854.[1] In a letter of January 19, 1854 to his mother he told her he intended to paint his Cimabue picture "on a large scale" thus "giving the Florentine picture a size more commensurate to the art-historical importance of the event it represents."[2] In a letter to Leighton from his mother of April 17, 1854 she wished "I could see your studies, for I suppose you have made a great many for your great undertaking. Models are probably cheaper than in Germany – are you conscious of improvement?"[2] In Leighton's reply of April 29, 1854 he stated: "It is impossible for me to give you any decisive answer about my progress, for you know I have been busy all winter drawing studies; I shall see when I come to the picture itself what steps I have made forwards; I reckon on its being the best thing I shall have done, I can say no more."[2] This drawing is probably one of the many studies of heads and hands, figures, costumes, and accessories, he made during the course of the painting's development, which show the care he took to plan each detail of the painting. Studies of heads for *Cimabue's Madonna*, signed and dated in a similar fashion, are illustrated in books on Leighton.[3,4] A particularly beautiful example, a study for the head of one of the women in the procession, is in the collection of the Beaverbrook Art Gallery, Fredericton, New Brunswick.[5]

In 1854 Leighton began work on another painting, *The Reconciliation of the Montagues and Capulets over the Dead Bodies of Romeo and Juliet*, which he worked on simultaneously with *Cimabue's Madonna*. Studies for both paintings are sometimes found on the same sheet, as if they represented facets of a single problem.[6] Since this drawing is inscribed "Cimabue's Madonna" in an unknown hand, this notation may have been added after Leighton's death by one of his executors, perhaps someone like Val Prinsep who would have known Leighton's work well. Because of the date 1853, it might have been assumed that this drawing obviously related to *Cimabue's Madonna*. Although a similar figure can not be seen in either finished painting, a young man wearing a comparable hat, although in an entirely different pose, can be seen in the lower right of the compositional study for the *Reconciliation of the Montagues and Capulets* dated 1853-54.[7] Leighton made pencil drawings from models for all the figures in these two paintings, and carefully researched the historical details. For the costumes, including the hat in this drawing, he may have used sources such as Bonnard's *Costume Historique des XII^e, XIII^e, XIV^e, et XV Siècles*, just as his Pre-Raphaelite contemporaries like Millais and Rossetti did.[8] Leighton also based his costumes for *Cimabue's Madonna* on the frescoes by Andrea di Firenze in the Spanish Chapel in the cathedral of Santa Maria Novella in Florence.[1]

The beautifully executed, delicate technique of this drawing of a male head corresponds closely to other Leighton drawings of this period. Although one might be tempted to think that it was influenced by the work of his master Edward von Steinle, who had a major impact on his early work, this does not appear to be the case. Leighton had sent Steinle a similar drawing as a present, depicting the head of Vincenzo, whom Leighton had described as "the

prettiest and wickedest boy in Rome", which is now in the collection of Leighton House, London.[2] Steinle, in a letter of August 6, 1854 made these comments about this drawing: "If I am to express my thoughts of the very beautiful head of Vincenzo, it seems to me that Leighton ought to guard against striving for excessive fineness, for works of art can only be produced by quite the contrary method. A certain roughness must bring out fineness, but if everything is fine, nothing remains fine, &c. But believe, though this head half displeases me, especially on account of these theories, I think it beautiful and masterly in drawing, and am consequently proud to possess it, as I am of all that I have from your hand."[2]

1 Ormond, Leonée: Royal Academy of Arts, 1996, cat. no. 8, pp. 106-107.
2 Barrington, Mrs. Russell: 1906, Vol. I, pp. 113, 136, 141, 145, 147, and 152.
3 Ormond, L. and Ormond, R.: 1975, figs. 40 and 41.
4 Barrington, Mrs. Russell: Vol. I, drawings adjacent to pp. 112, 145, and 152.
5 National Gallery of Canada: 1976, graphite, 10¾ × 8½ in., inscribed "Giacinta 1853", collection of the Beaverbrook Art Gallery, Fredericton.
6 Ormond, L. and Ormond, R.: 1975, p. 20.
7 Ormond, L. and Ormond, R.: 1975, pl. 46, opposite p. 16.
8 Arts Council of Great Britain: 1979, p. 13. An illustration from Bonnard's *Costume Historique*, with the male figure wearing a hat similar to the one in this drawing, is reproduced.

38 Figure Study of Elias for the "Transfiguration," c. 1863

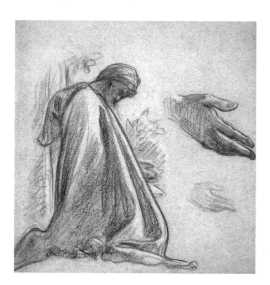

Black and white chalk on light blue paper 6¹⁵⁄₁₆ × 6¹¹⁄₁₆ in. (17.7 × 17 cm)
PROVENANCE: Fine Art Society, London, December 1896, bought N.C. Pannelt, Whitby; anonymous sale, Christie's, London, March 10, 1995, part of lot 190.
EXHIBITED: Fine Art Society: 1896, ? cat no. 143, 144, or 145.

This drawing is a study for the figure of Elias in the design of the *Transfiguration*, for the eastern apse of St. Paul's Cathedral, which Leighton undertook in early 1863. Frederic George Stephens wrote a description of the design in *The Athenaeum* in 1863: "The artist has given an air of extreme repose and immobility to his composition, fit for the situation proposed for it: that aspect is attained by the sobriety and simplicity of the actions, general breadth and massing of the draperies ... Before the feet of the Saviour ... are figures of worshippers in an ecstasy of adoration ... Moses is placed in the left hand of this division ... On the other side is Elias who, kneeling, bends his head and sinks his hands as in adoration."[1] Since the known drawings for this composition show Moses to the right and Elias to the left, either Leighton later transposed the two figures, or Stephens was in error when he described their relative positions. Leighton was one of four artists invited to submit designs for the apse of St. Paul's Cathedral, the others being G.F. Watts, Alfred Stevens, and Edward de Triqueti. The commission eventually went to de Triqueti, but it was never carried out. This drawing, as well as a study for

Moses which was offered for sale at Christie's, London, on June 11, 1993, and again on November 7, 1997, are the only known surviving records of Leighton's design for the competition.[2] At the Leighton exhibition at the Fine Art Society in 1896, three drawings of *Christ and the Apostles*, all designs for St. Paul's Cathedral, were included as nos. 143, 144, and 145. The cataloguer had apparently mistaken the figures of Old Testament prophets for apostles.

In the early 1880s Leighton also collaborated with Edward Poynter and Hugh Stannus on a plan to complete Alfred Stevens' earlier scheme for a projected mosaic decoration for the dome of St Paul's Cathedral. Leighton agreed to design eight large roundels with subjects based on the Apocalypse, of which *And the sea gave up the dead which were in it* was the first. When Poynter's cartoon for the scheme, which incorporated Leighton's roundels, was placed in the dome, it failed to make a significant impact and violent opposition finally lead to the project being abandoned in 1885. A reduced version of Leighton's design for *And the sea gave up the dead*, in the Tate Gallery, London, was commissioned by Henry Tate and shown at the Royal Academy in 1892.

1 Ormond, L. and Ormond, R.: 1975, p. 57. F. G. Stephens, *The Athenaeum*, May 5, 1863, pp. 264-265.
2 Christie's, London: *Fine Victorian Pictures, Drawings and Watercolours*, June 11, 1993, lot 71, and *Fine Victorian Pictures, Drawings and Other Works of Art*, November 7, 1997, lot 38, pencil and black chalk, heightened with white, 18 ½ × 15¼ in. This drawing was sold as a study for Elias at both sales, but it does not fit Stephens' description for this figure, and it must therefore be for Moses. The only other possibility is that F.G. Stephens was totally confused about which of the two Old Teatament prophets was which when he wrote his article.

39 Cain, c. 1863

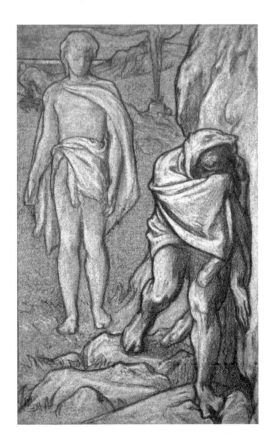

Black and white chalk on grey-blue wove paper, laid down; studio stamp, lower left; H.S. Reitlinger's collector's stamp on verso 5½ × 3¾ in. (14.0 × 8.6 cm)
PROVENANCE: Fine Art Society, London, by 1896; Henry S. Reitlinger; his estate sale, Sotheby's, London, May 26, 1954, part of lot 483, bought Jeudwine; Eric Slack; purchased by Fine Art Society, London, on September 22, 1981; sold to Frederick Koch, New York in September 1983; his sales, Christie's, London, June 11, 1993, lot 84, bought in; Christie's, London, March 10, 1995, lot 121.
EXHIBITED: Kenderdine Gallery: 1995, cat. no. 27.

This is possibly an early drawing related to the *Dalziel Bible Gallery*. In 1863-64 Leighton made designs, originally commissioned by Joesph Cundall for his illustrated Bible, but which Cundall eventually relinquished to the Dalziel Brothers when it

became apparent that his own project would not come to fruition.[1] Leighton's nine designs for the *Dalziel Bible Gallery* are his finest works as an illustrator. In these designs and those for *Romola*, Leighton first sketched his ideas in chalk in a soft generalized style that allowed his imagination free rein. The designs were then redrawn in pen and ink in a sharp linear fashion for the woodblock.[1] In these works Leighton, with great skill, took advantage of the technical possibilities of the compressed form of the woodblock to produce such dramatic images as *Samson Carrying the Gates*, *Samson and the Lion*, and *Cain and Abel*. Ernest Rhys reported: "one has also heard many illustrators not merely extol these drawings – notably the Bible subjects – as his masterpieces, but jealously refuse to consider him entitled to serious regard as an artist in any other medium."[2] The pen-and-ink finished drawing on the woodblock for *Cain and Abel* is in the collection of the Victoria and Albert Museum, London. A drawing of the *Death of Abel* had been presented by Leighton to G. P. Boyce.[3]

If one compares the finished design for *Cain and Abel* to this preliminary drawing, the crouched figure of Cain can be seen to superficially resemble the same figure in the finished engraving, as he hugs the rocks, overcome with remorse after slaying his brother. The upright figure is more problematic, however. Although this figure again superficially resembles that of Abel in the finished engraving, it does not make sense that Cain would be slinking away if his brother were still alive, nor is this figure convincing as that of an angel bringing down God's wrath on Cain. In c. 1867-68 G.F. Watts began working on a painting *The Denunciation of Cain*, which appears partly to be based on Leighton's illustration, particularly the figure of Abel. This painting was exhibited at the Royal Academy in 1872 under the title *My punishment is greater than I can bear*.[4] In Watts' painting spirits bringing down God's condemnation are seen in the sky.

The powerful figure of Cain in this preliminary drawing may have been influenced by Michelangelo, an artist whom Leighton always spoke of "with the greatest seriousness and reverence."[5] Leighton's treatment of the heroic male nude, derived from Michelangelo, would come to occupy his attention even more in the 1870s.[6,7]

1 Ormond, L. and Ormond, R.: 1975, pp. 57 and 58.
2 Rhys, Ernest: 1900, p. 70.
3 Christie's, London: *Catalogue of the Remaining Work and the Collection of G.P. Boyce, R.W.S.*, July 1, 1897, lot 143, chalk, 7 × 6½ in.
4 Staley, Allen: Manchester City Art Gallery, 1978, cat. no. 24, pp. 81-83.
5 Ward, James: 1896, p. 373.
6 Østermark-Johansen, Lene: "The Apotheosis of the Male Nude: Leighton and Michelangelo" in Barringer, Tim and Prettejohn, Elizabeth: 1999, pp. 111-131.
7 Jones, Stephen: "Leighton's debt to Michelangelo: the evidence of the drawings", *Apollo*, Vol. 143, no. 408, February 1996, pp. 35-39.

40 Oil Sketch for "Greek Girl Dancing," 1867

Oil on canvas 5½ × 8 in. (14.2 × 20.4 cm)
PROVENANCE: G. Ward; sold on May 27, 1964 to Maas Gallery, London; sold at Bonhams, London, June 13, 1968, ?lot 228, bought by Roger Makins, 1st Lord Sherfield; sold to Agnew's, London, by 1969; sold to Mitsukoshi, Japan, in 1970; private collection, Toronto; sold in 1982 to MacMillan and Perrin Gallery, Toronto; purchased March 16, 1982.
LITERATURE: Lang, Mrs A: 1884, p. 6, no. 6; Ormond, L. and Ormond, R.: 1975, cat. no. 128, p. 157.

EXHIBITED: Maas Gallery: 1964b, cat. no. 62; Kenderdine Gallery: 1995, cat. no. 28 (illus.).

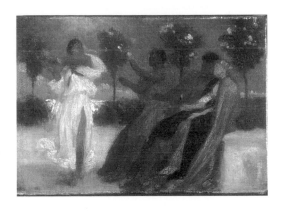

This is the colour sketch for *Greek Girl Dancing*, one of the first of the Aesthetic Classical subjects that Leighton began to paint in the mid 1860s, as distinct from his classical subjects based on mythology or history which he exhibited at the Royal Academy, such as *Orpheus and Eurydice* in 1864, and *Helen of Troy* in 1865. In 1866 he exhibited one of the finest of his early classical subjects, *The Syracusan Bride Leading Wild Beasts in Procession to the Temple of Diana*, which was the most outstanding painting exhibited at the Royal Academy that year. In 1867 Leighton exhibited five works at the Royal Academy, including *Greek Girl Dancing*, also known as *Spanish Dancing Girl: Cadiz in the Old Times*. It is a moonlight scene that features a classically draped woman dancing on the left, with three seated spectators to the right, clapping to music. M.H. Spielmann, in an article on Leighton for *The Magazine of Art* in 1896, stated: "In 1867 there followed the brilliant 'Venus Disrobing for the Bath' and 'The Spanish Dancing Girl' – pictures which proved the artist was nearing the height of his power."[1] Barrow points out that the series of paintings that Leighton completed in the 1867-68 period introduced his early experimentation with light gauze-like drapery, which sought to highlight rather than to mask the underlying figure.[2] Up until this time his drapery tended to fall in thick heavy folds that richly swathed the whole body.

Richard Ormond has noted that *Greek Girl Dancing* is one of several of Leighton's paintings exhibited in the late 1860s that exemplify the decorative aspect of his art: "The figure of the dancer is balanced by a group of three spectators seated on a marble bench, who clap in unison. Through its repetitive forms (notice the patterns of the arms, and the four symmetrically placed rose-bushes), the composition expresses the rhythms of the dance through musical metaphors. In this conjunction of art and music, the picture is close in spirit to contemporary paintings by Whistler and Moore, and represents the same Aesthetic impulse."[3] The figure of the elegant statuesque dancer is eminently successful, but those of the spectators are less so, as they are rather stiff and lifeless. The drapery of the dancing figure reveals Leighton's close study of ancient Greek sculpture. The Elgin Marbles, in particular, were a source of inspiration. Leighton owned casts of the Parthenon frieze, which ran around the upper wall of the studio in his home. Behind the figures in this painting is a resplendent view of the sea, with the town of Cadiz in the distance. Leighton had visited Spain in the late summer or early autumn of 1866, and had made many colour landscape sketches, one of which is in the Tate Gallery and another is at Leighton House. The sketch that unquestionably served as the background for this painting was included in a sale at Christie's, London on November 8, 1996.[4] This oil sketch *The Bay of Cadiz - Moonlight* is unusual for Leighton's sketches in that it contains figures. The two male figures in the lower centre would later form the basis for the two male figures clapping in *Greek Girl Dancing*. This oil sketch is probably unique in that it is a night scene and is as abstract as the nocturnes that would later be painted by Whistler in the 1870s.

Leighton was to continue to use the compositional device, established in *Greek Girl Dancing*, of figures in the foreground, water, and an imaginative landscape in the background,

in most of his major paintings from this time onwards. In many ways, however, this loosely handled fluid sketch for *Greek Girl Dancing* is more appealing than the elaborate, laboured finished painting. This lack of spontaneity in Leighton's work was noted even by his contemporaries. His friend G.F. Watts once remarked: "how much finer Leighton's work would be if he would admit the accidental into it."[5] Watts' wife Mary noted that if Watts could have influenced Leighton he "would fain have persuaded Sir Frederic to retain more of the beauty of his sketches in the finished work."[6] James Ward, Leighton's studio assistant from 1878-87, has recorded about him: "Although he had a great regard for the opinion of his brother-artists, he placed the opinion of Mr. Watts before them all."[7] It is a shame Leighton did not pay more attention to Watts' advice in this matter.

The figure of the dancing girl in this painting may have served as an inspiration for one of the five life-sized figures that Leighton designed about this time for the staircase of the Hon. Percy Wyndham's home at 44 Belgrave Square, London. Three of these paintings sold at Christie's, London on June 7, 1996.[8] The decorative scheme for the staircase was carried out under the supervision of Leighton's close friend, the architect George Aitchison. In Aitchison's sketch for the stairway, dated 1869, can be seen one of the other two figures. This figure, which is the one to the far left side of the three paintings represented in the sketch, closely reproduces the pose of the legs of the dancing girl in *Greek Girl Dancing*. The drapery and the pose of the arms and head are quite different, however. In c. 1886 Leighton was to return once again to the pose of the figure of the dancing girl for another of his well-known decorative schemes, the ceiling for the American banker Henry Marquand. In this design the pose and the drapery overlying the legs of the muse Erato in the left-hand panel closely echoes that of the dancing girl.[9]

There are a number of preparatory drawings known to exist for *Greek Girl Dancing*, including one at Leighton House, and another on tracing paper in the Royal Academy Library. A study for the overall composition was exhibited at the National Gallery of Art in Washington, D.C. in 1993.[10] A sheet of studies for the nude figure of the dancer was exhibited at the Shepherd Gallery in New York in 1989.[11] A drawing of a *Spanish Dancing Girl*, which relates to this painting, was with Agnew's, London in 1969.[12] The finished painting sold at Christie's, London, on March 22, 1985, and is currently in a private collection.[13]

1 Spielmann, M.H.: 1896, pp. 203-204.
2 Barrow, Rosemary: "Drapery, Sculpture and the Praxitelean Ideal" in Barringer, Tim and Prettejohn, Elizabeth: 1999, p. 51.
3 Ormond, Richard: "Leighton and his Contemporaries" in Royal Academy of Arts: 1996, p. 32.
4 Christie's, London: *Fine Victorian Pictures, Drawings and Watercolours*, November 8, 1996, lot 53, pp. 56-57.
5 Newall, Christopher: 1990, p. 36.
6 Watts, Mary Seton: 1912, Vol. I, p. 200.
7 Ward, James: 1896, p. 379.
8 Christie's, London: *Victorian Pictures, Drawings and Watercolours*, June 7, 1996, lots 569 - 571. Aitchison's design for the Wyndham staircase is reproduced p. 52, fig. 1. This sketch is in the collection of the Royal Institute of British Architects, London.
9 Ormond, L. and Ormond, R.: 1975, p. 124, figs. 158 and 159.
10 Grasselli, M. M. and Brodie, J.: National Gallery of Art, Washington, 1993, cat. no. 55.
11 Shepherd Gallery: 1989, cat. no. 71, pencil heightened with white chalk on blue paper, 11 × 15 in., on loan from Julian Hartnoll, London. It was subsequently offered for sale at Sotheby's, London, *Early British and Victorian Drawings and Watercolours*, January 31, 1990, lot 362.
12 Agnew's: 1969, cat. no. 3, black and white chalk on blue paper, 5¾ × 7 in.
13 Christie's, London: *Important 19th Century Pictures and Continental Drawings of the 19th and 20th Centuries*, March 22, 1985, lot 85, oil on canvas, 35 × 46 ½ in.

41 Studies for "Phryne at Eleusis," c. 1874-75

Graphite on the recto of an envelope; inscribed in an unknown hand "Phryne," lower right; studio stamp, lower centre $2\frac{5}{8} \times 4\frac{1}{8}$ in. (6.5 × 10.5 cm)

PROVENANCE: Fine Art Society, December 1896, ? purchased by N. Bacon, 4 Lyndhurst, Hampstead; Julian Hartnoll, London; purchased July 16, 1986.

EXHIBITED: ?Fine Art Society: 1896, cat. no. 128.; Shepherd Gallery: 1986, cat. no. 52 (illus.); Kenderdine Gallery: 1995, cat. no. 29.

These sketches are for *Phryne at Eleusis*, exhibited at the Royal Academy in 1882. Phryne was a famous Greek hetaira (courtesan), the model and mistress of Praxiteles. During a festival to Poseidon at Eleusis, she disrobed and descended into the sea, for which she was later brought to trial, accused of profaning the Eleusinian mysteries. Preliminary designs for *Phryne at Eleusis* can be found in a sketchbook (Royal Academy, XXXV) dating from the mid 1870s, while further developments for the composition are found in a second notebook (Royal Academy, XV), dating from about 1880, and other independent sketches.[1,2] These early drawings show that at one time Leighton had envisioned Phryne standing in the sea or, as in these sketches, surrounded by spectators in the background. He had also contemplated portraying her draped, disrobing before the surrounding crowd. The finished painting shows Phryne alone, but with the same architectural background, and in a very similar pose, as that depicted in the sketch on the left. The painting is still untraced.

The key to dating this drawing is the study in the upper right for *The Daphnephoria*, a painting commissioned in early 1874, which took Leighton over two years to finish. The figures of the woman and child, who sit on a wall on the right side behind the processional route of the Daphnephoria, are absent from Leighton's initial sketch for this painting.[3] The woman and child were thus a later addition that Leighton may have included to better balance the composition. This would suggest that this sketch for *Phryne at Eleusis* must date from c. 1874-75, making it one of his earliest compositional ideas. The fact that it was sketched on the back of an envelope, rather than in one of his notebooks, may be significant in terms of the spontaneity of the idea that he wished to capture. Additional studies for *Phryne at Eleusis* are at Leighton House[2] and the Royal Academy, London. A drawing that included studies for *Phryne* was sold at Sotheby's Belgravia in 1974.[4] A larger and more finished study for the woman and child for *The Daphnephoria* was exhibited by Peter Nahum.[5]

The motif in *Phryne at Eleusis* of a woman wringing out her hair was inspired by several

classical sculptures, including the *Aphrodite* in the Vatican, and the *Lady Arranging Hair* in the Palazzo Colonna in Rome.[1] The torso of Phyrne was based on the *Venus Anadyomene*, found at Cyrene, and now at the Museo Nazionale delle Terme, Rome.[1,2] Phyrne is supposed to have been the original model for the *Venus Anadyomene*.

Although Leighton had previously exhibited full-length nudes at the Royal Academy, Alison Smith feels that in *Phyrne* "the attitude shows greater daring than his earlier nudes; the figure is more prominent and open in terms of gesture than hitherto, justified only by the risqué pretext of undressing."[2] Not surprisingly Leighton's painting was controversial and some critics were censorious. Smith reports that the *Art Journal,* for instance, felt he was offering "a very questionable service to English Art" by exhibiting a work so redolent of the Paris Salon, and even speculated whether this painting marked the start of a degeneration in national art. Critics for the *Illustrated London News* and the *Athenaeum* equated Leighton with Praxiteles and contended that by elevating the female nude the works of both artists marked the beginning of a decline in national morals and culture.[2] The *Art Journal,* quoting Walter Perry, noted: "that an incident such as our President has placed on canvas 'would have been impossible at the earlier and nobler period of Greek Art, and that it clearly shows to what an extent the worship of mere beauty has lowered the tone of national morality'."[2] Praxiteles was felt to be a corrupting influence whose sensuous sculpture of the human figure had replaced the nobler and more austere standard of Phidias of the preceding century.

Leighton later used a very similar pose to Phyrne's for a partially draped figure of a woman admiring herself in a mirror in *The Arts of Industry Applied to Peace*, which he painted for the South Court of the South Kensington Museum (now the Victoria and Albert Museum, London). Although the mural was not completed until 1886, it had also been designed in the early 1870s.[2]

1 Ormond, L. and Ormond, R.: 1975, pp. 128-129 and figs. 178-182.
2 Smith, Alison: "Nature Transformed: Leighton, the Nude and the Model" in Barringer, Tim and Prettejohn, Elizabeth: 1999, pp. 31, 34-36, and 38-39. Fig. 20, p. 35, *Study for Phyrne at Eleusis*, c. 1869-70, black and white chalk on blue paper, 16.5 × 23.6 cm.
3 Ormond, L. and Ormond, R.: figs. 124 and 125.
4 Sotheby's Belgravia: May 7, 1974, lot 5, bought in, and July 9, 1974, lot 48a.
5 Nahum, Peter: 1985, cat. no. 27 and 1989, Vol. I, p. 106, cat. no. 103, Vol. II, pl. 75. It was subsequently offered at Sotheby's, London, *Victorian Pictures*, June 4, 1997, lot 198.

42 Study of the Head and Arms of Iphigenia for "Cymon and Iphigenia," 1883

Black and white chalk on brown wove paper; bears studio stamp, lower left 8⅝ × 11⅝ in. (21.9 × 29.4 cm)

PROVENANCE: Fine Art Society, December 1896, bought by Laurence W. Hodson; his sale, Christie's, London, June 26, 1906, lot 66, bought Brown & Phillips of the Leicester Galleries, London; sold to Lawrence B. Phillips by 1908; Frederick Cummings, Detroit; sold in 1985 to Julian Hartnoll, London; purchased July 13, 1985, through Daniel Perrin.

LITERATURE: Fine Art Society Ltd.: 1898, pl. XXVII; Spielmann, Isidore: 1908, cat. no. 988, p. 217, illus. between pp. 216-217; Ormond, L. and Ormond, R.: 1975, cat. no. 313 (studies), p. 168.

EXHIBITED: Fine Art Society: 1896, cat. no. 153; Fine Art Palace: 1908, Fine Art Section, cat. no. 988 (illus.); Kenderine Gallery: 1995, cat. no. 30.

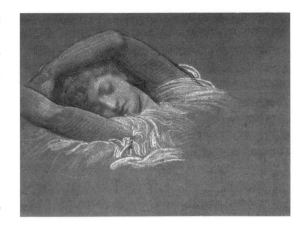

This drawing, undoubtedly one of Leighton's most outstanding works on paper, is for the head and shoulders of the sleeping Iphigenia in the painting *Cymon and Iphigenia*. The latter was exhibited at the Royal Academy in 1884 and is now in the collection of the Art Gallery of New South Wales, Sydney. The story is taken from *The Decameron* of Boccaccio and was also treated as a poem by John Dryden. Iphigenia was the daughter of Agamemnon, the King of Mycenae (see cat. no. 21). Cymon, a simple, coarse shepherd, came across the sleeping figures of Iphigenia and her attendants in a grove by the sea. In the painting Cymon is shown gazing spellbound at the radiant vision of the beautiful Iphigenia, the sight of which is enough for him to realize the incompleteness of the rustic existence he leads, and he becomes transformed by love and beauty. Mrs. Barrington felt this painting expressed "most explicitly Leighton's creed of creeds – namely, the enobling and elevating influence of beauty in the lives of men and women."[1]

The figure of Iphigenia is one of the most memorable in all of Leighton's paintings. The surviving preparatory drawings show that Leighton experimented with various poses for her reclining figure before finally deciding to turn the body to the right with both arms placed above the head as in this drawing. The final pose was based on Ingres' *The Odalisque and the Slave*.[2] Finished studies of the head and shoulders of major figures in a composition are unusual in Leighton's work, and drawings more commonly show the full figure, either nude or draped. A drapery study of the lower limbs for Iphigenia was Leighton's diploma work for the Royal Society of Painters in Water-Colours. Additional studies are at the British Museum, Leighton House, and the Royal Academy, London, the Ashmolean Museum, Oxford, and the National Gallery of Victoria, Melbourne.[3] A nude study in bronze for Iphigenia is at the Royal Academy of Arts, London.[4]

Leighton's favourite model for his late paintings, Ada Alice Pullen, better known by her stage name Dorothy Dene, is said to have been sat for the figure of Iphigenia.[5] She first posed for Leighton in 1879 and subsequently modelled for the principal figure in most of his important subject paintings including *The Last Watch of Hero*, *The Garden of the Hesperides*, and *Clytie*. The passion and sensuality found in Leighton's late works, in contrast to the icy-cold Classicism inherent in many of his early ones, was in no small measure due to the dramatic instinct of the model who posed for them. Dorothy Dene became one of Leighton's many protégés. He encouraged her ambitions and through his influence aided her theatrical career. Although their names were linked romantically, their relationship was apparently purely platonic, and Leighton acted as a father figure to her and her sisters. "'I go to see them,' he used to say, 'when I want to let my back hair down and get off the stilts'."[1]

1 Barrington, Mrs. Russell: 1906, Vol.II, pp. 258 and 272-273.
2 Jones, Stephen: Royal Academy of Arts, 1996, cat. no. 89, pp. 199-200. Ingres' painting exists in two versions. The first from 1839 is at the Fogg Art Museum, Cambridge, Massachusetts, while the second of 1842 is at the Walters Art Gallery, Baltimore. Leighton owned a beautiful drawing by Ingres for this painting, which is now in the collection of the Petit Palais, Paris. It is illustrated in Ormond, L. and Ormond, R.: 1975, fig. 105.

3 Art Gallery of New South Wales: 1975, cat. no. D8, "studies for sleeping groups", black chalk on brown paper, 9¼ × 13 in., and cat. no. D9, "studies for sleeping group", black chalk on brown paper, 9¼ × 12¾ in., both collection of National Gallery of Victoria, Melbourne.
4 Jones, Stephen: cat. no. 91, bronze, c. 1882–83, 10.2 × 59.4 × 23.8 cm.
5 Wood, Christopher: 1983, p. 75. I can find no other reference to support this contention.

43 Preparatory Sketch for "The Last Watch of Hero," c. 1887

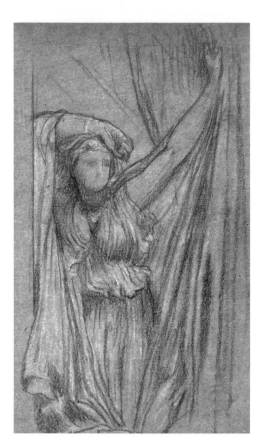

Black and white chalk on brown wove paper, laid down 9⅝ × 5¾ in. (24.5 × 14.7 cm)
PROVENANCE: ? Fine Art Society, December 1896, bought by Miss Battye, 7 Portman Sq., London; anonymous sale, Sotheby's, London, May 22, 1986, lot 151, bought Julian Hartnoll, London; purchased January 6, 1987.
LITERATURE: Hartnoll, Julian: 1986, cat. no. 22 (illus.).
EXHIBITED: ? Fine Art Society: 1896, cat. no. 158; Kenderdine Gallery: 1995, cat. no. 31.

This drawing is a preparatory study for the overall composition of the painting *The Last Watch of Hero*, exhibited at the Royal Academy in 1887, and purchased at that time by the Manchester City Art Gallery. Hero was a priestess in Scstos, a Thracian town on the European side of the strait that separates Europe from Asia. She was loved by Leander, a youth who swam the Hellespont nightly to visit her, guided by a torch from her tower. One night a tempest arose and Leander was drowned. When Hero became aware of his death, in her despair, she threw herself from the tower into the sea and perished.

The painting, and its predella below, *Leander Drowned*, were exhibited at the Royal Academy with a quotation from *Hero and Leander* by Musaeus, as translated by Edwin Arnold: "With aching heart she scanned the sea-face dim … Lo! at the turret's foot his body lay, Rolled on the stones, and washed with breaking spray."[1] In a letter to Charles Pooley, Leighton wrote: "at the casement of her watch tower you see her worn & weary of soul with the night long limitless watch – The dawn has still found her at her window."[2] In the painting Hero dressed in white represents the force of love, while the dark cloak and curtain which frame her represent the finality of death.[2] The drawing captures well the anguish of Hero as she clutches the curtain which she has drawn aside as she searches over the sea for Leander, not knowing that by this time he is already dead. The tension inherent in this scene is accentuated by the contorted pose of her arms, and the agitated folds of her drapery.[3]

When the painting was exhibited at the Royal Academy in 1887, F.G. Stephens, the critic of *The Athenaeum*, commented: "There is poetry of a fine sort in this part of the design [the

figure], while the execution of the picture exhibits the scholarship and care which the President's position demands ... Its draughtsmanship, coloration, and chiaroscuro are, within his intentions, simply perfect. It is useless to say that he is neither Michael Angelo nor Rubens, but simply an artist who does his duty nobly, and in a manner few at any time have done."[3]

Leighton was not the only prominent Victorian artist to paint this subject. Edward Burne-Jones' *Hero Lighting the Beacon for Leander*, 1875-77, is in the Owens Art Gallery, Sackville, New Brunswick.[4] Evelyn De Morgan painted a gouache on paper, dated 1885, entitled *Hero Holding the Beacon for Leander*.[5] G.F. Watts also painted a small work entitled *Hero*, showing Hero at a window watching for Leander.[6] Simeon Solomon created a painting *Hero at Abydos*,[7] while Frederick Sandys did a *Hero*.[8] William Blake Richmond, late in his career, exhibited *The Last Watch of Hero for Leander* at the New Gallery in 1902.[9]

Additional studies for Leighton's *The Last Watch of Hero* are at the City Art Gallery, Manchester,[10] Leighton House, London, and the Royal Academy, London.

1 Rhys, Ernest: 1900, p. 47.
2 Ormond, Leonée and Ormond, Richard: 1975, p. 126, MS John Rylands Library, Manchester.
3 Ormond, Leonée and Ormond, Richard: Manchester City Art Gallery, 1978-1979, cat. no. 54, p. 117. F.G. Stephens, *The Athenaeum*, no. 3103, April 16, 1887, p. 520.
4 Lochnan, K., Schoenherr, D., and Silver, C.: 1993, cat. no. B:1, p. 101.
5 Christopher Wood Gallery: 1982, cat. no. 29. This work subsequently sold at Christie's, London, March 25, 1994, lot 339.
6 Pearsall, Ronald: 1981, illus. p. 61. The painting sold at Sotheby's Belgravia, March 27, 1973, lot 82.
7 Maas Gallery, London: 1979, cat. no. 33, signed with initials and dated '94, oil on canvas, 15 × 20 in. This work later sold at Sotheby's Belgravia, June 23, 1981, lot 234. It was exhibited at the Geffrye Museum, 1985, cat. no. 73.
8 Agnew's, London: 1961, cat. no. 59, p. 39. The oil painting was finished sometime before April 1871. A red chalk drawing by Sandys of *Hero* was sold at Phillips, London, *Fine English Drawings and Watercolours*, April 18, 1988, lot 110, 13 × 9¾ in.
9 Reynolds, Simon: 1995, p. 290.
10 Ormond, L. and Ormond, R.: pl. 163, study of drapery, black and white chalk, 16 × 8⅝ in., and pl. 164, study of drapery, black and white chalk, 19½ × 11⅝ in.

44 Drapery Study for "The Garden of the Hesperides," c. 1892

Black and white chalk on brown-grey wove paper 10⅞ × 14½ in. (27.7 × 36.9 cm)
PROVENANCE: ? Christie's, London, October 21, 1975, lot 144; anonymous sale, Christie's, London, May 14, 1985, lot 189.
EXHIBITED: Kenderdine Gallery: 1995, cat. no. 32.

This drawing is a study for the central figure of the three Hesperides for *The Garden of the Hesperides*, one of Leighton's most important late works, now in the collection of the Lady Lever Art Gallery, Port Sunlight. The

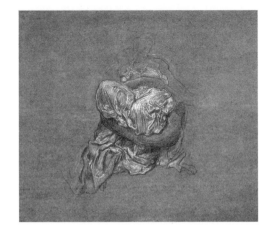

painting illustrates the legend of the island of the Hesperides where three nymphs, Aegle, Arethusa, and Hesperia, aided by the dragon Ladon, guarded the golden apples that Gaia, the goddess of the Earth, gave Hera as a wedding gift when she married Zeus. One of the labours of Hercules for Eurystheus was to pluck three golden apples from the garden of the Hesperides, which he accomplished with the aid of Atlas. In Leighton's painting, however, the nymphs are resting against an orange tree and not an apple tree. Leighton's painting may be based on Alfred Tennyson's early poem *The Hesperides* or, more likely, John Milton's poem *Comus*. Frederic George Stephens, writing in *The Athenaeum* in 1891, stated the painting was inspired by the following passage from *Comus*: "All amid the Gardens fair, / Of Hesperus and his daughters three, / That sing about the golden tree."[1] In Milton's poem the Hesperides are the daughters of Hesperus, the evening star, and the nieces of Atlas. In Leighton's painting the dragon is represented as a huge serpent, which can be seen in this drawing curling around the body of the central nymph. Leonée Ormond feels that Leighton's choice of a snake rather than a conventional dragon may be based on a Graeco-Roman bas-relief reproduced in C. Daremberg and E. Saglio's *Dictionnaire des antiquités greques et romaines*, first published in 1877.[1] The serpent also brings to mind the temptation of Eve.

This drawing shows Leighton's mastery in handling drapery. In his paintings the draperies display a crisp sculptural quality, which balance exactly with the model's underlying anatomy. Leighton once remarked: "I can paint a figure in three days, but it may take me thirty to drape it."[2] Leighton followed an elaborate technical method in working up his paintings, and it was not unusual for him to produce thirty to forty working drawings for a major composition.[3] Having once determined the composition in his mind, Leighton generally made an initial sketch to fix his idea. Even in this initial sketch, prior to a model being called in, it was evident from the care with which the folds of the drapery had been broadly arranged, that the drapery design was not haphazard, but had already been carefully worked out. A model was then posed, and a careful outline of the nude body was made, usually with black chalk on brown paper. The figures were then drawn in their setting, and established in exact relation to the picture plane, resulting in the first true cartoon of the entire compostion, figure and background. This drawing would then be squared up and transferred to the canvas. A small oil sketch would also be made to determine the colour scheme to be used in the finished painting. The nude figures were then carefully painted from life in monochrome on the canvas, even though this careful painting was shortly to be hidden by the draperies. Leighton took considerable trouble to ensure that the draperies were painted correctly. At this stage he would return to drawing elaborate drapery studies on brown paper. The draperies were arranged with infinite care on the living model, and made to approximate, as closely as possible, the design already chosen in his initial sketch. This arrangement was effected with special reference to the painting, giving not only form and light and shade, but also the relation and "values" of tone. The draperies were made to conform exactly to the forms copied from the nudes of the underpainted picture. The draperies were then transferred to the canvas with flowing monochrome colours, and the background and accesories were added. Once the basic structure of the picture was complete, Leighton could then concentrate on colour.[3] Not every critic understood or appreciated Leighton's bravura handling of drapery. Claude Philips, when writing of *The Garden of the Hesperides* in the *Art Journal* in 1892, complained that "many of the intricate bunches of artfully crumpled tissues in which the President has revelled, with the object, no doubt, of giving an added Classicality of aspect to his picture, are quite arbitrary in arrangement."[4]

Leighton's drawings tended to be working drawings in the truest sense, and seldom evolved into finished drawings for sale. At his death over a thousand sheets were left in his

studio. Mrs. Barrington has recorded her concerns about Leighton's carelessness with his drawings, which led to the crispness of his touch being blurred by rubbing: "Leighton kept these precious studies he made for his pictures in a drawer where I was often invited, rather apologetically, to turn them over as if they were absolutely of no importance. I protested against the cursory treatment they received at the hand of their creator; and on seeing one superlatively beautiful study of drapery pinned on his easel one day, I implored him to have it glazed and framed before it ran any danger of being rubbed. He did so, and always alluded to it after as 'that sketch you lost for me,' because, being framed, he lent it to some one – he did not remember to whom – and it never came back. Periodically I asked if it had been returned; 'No – some one, I suppose, has taken a fancy to it,' Leighton would reply. The pace at which he had to live in order to fulfil the work he had set himself, enforced great carelessness about his own interests in such matters. Unfortunately, after Leighton's death, the sketches were exposed to much defacement, a natural consequence of their being moved before being secured under glass."[5] This drawing for *The Garden of the Hesperides* is still very fresh, having obviously been framed for a long time, and thereby protected. It must have left Leighton's hands before his death, since it does not have a studio stamp. Other studies for the painting are in the collections of Leighton House, London, the National Gallery of Canada, Ottawa, and the Royal Academy, London. A sketch sold at Sotheby's Belgravia on September 9, 1975.[6] Additional drawings sold at Christie's, London, on April 23, 1974[7] and June 13, 1978.[8] A study in bronze of the three nymphs and Ladon is in the collection of the Royal Academy of Arts, London.[9]

This subject also attracted other prominent artists of the period. Burne-Jones painted beautiful versions of the *Garden of the Hesperides*, the first of which was completed in 1869-72.[10] Spencer Stanhope did a charcoal drawing of *The Garden of the Hesperides* about 1873, but it is uncertain whether this was ever worked up into a finished painting.[10]

1 Ormond, Leonée: Royal Academy of Arts, 1996, cat. no. 118, pp. 232-233.
2 Harlow, James: 1913, p. 38.
3 Rhys, Ernest: 1900, pp. 55-58.
4 Barrow, Rosemary: "Drapery, Sculpture and the Praxitelean Ideal" in Barringer, Tim and Prettejohn, Elizabeth: 1999, p. 55. *Art Journal*, 1892, p. 188.
5 Barrington, Mrs Russell: 1906, Vol. II, p. 259, n.1.
6 Sotheby's Belgravia: *Victorian Paintings, Drawings and Watercolours*, September 9, 1975, lot 8, black and white chalk on grey paper, signed with studio stamp, 10½ × 14 in.
7 Christie's, London: *Victorian Drawings and Watercolours*, April 23, 1974, lot 23, reclining figures of three nymphs, black and white chalk on grey paper, 10 × 14 in. and lot 24, reclining figure of Arethusa, black and white chalk on grey paper, 13 × 9¾ in., bought Maas Gallery.
8 Christie's, London: *English Drawings and Watercolours*, June 13, 1978, lot 167, study of two reclining figures for the central nymph for *The Garden of the Hesperides*, black and white chalk on grey paper, 10¾ × 14⅛ in..
9 Valentine, Helen: 1999, cat. no. 38, p. 97, bronze, 18 × 35 × 21 cm.
10 Harrison, Martin and Waters, Bill: 1973, pl. 17, fig. 265, p. 176, and fig. 184, p. 128. Interestingly both Burne-Jones and Stanhope chose to portray the dragon Ladon as a serpent as well. Burne-Jones also did a design of *Feeding the Dragon in the Garden of the Hesperides*, carried out in gesso on a cassone, by an assistant likely T.M. Rooke, where Ladon is portrayed as a more conventional dragon. The cassone is now at Wightwick Manor, on loan from the Birmingham City Museum and Art Gallery.

45 Study for "Clytie," c. 1895

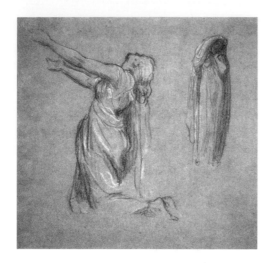

Black and white chalk on brown wove paper; inscribed "Clytie," in an unknown hand, lower centre; studio stamp, lower right
8¾ × 9¾ in. (21.5 × 24 cm) - sight
PROVENANCE: Fine Art Society by 1896; Lucy Cohen; Neil Primrose; Col. Robert Charles Goff (deceased 1923); possibly his estate sale, Christie's, London, December 7, 1925, part of lot 129, bought Huett; anonymous sale, Christie's, London, October 27, 1987,
EXHIBITED: ?Fine Art Society: 1896, cat. no. 233, 234 or 235; Kenderdine Gallery: 1995, cat. no. 33.

This is a study for Leighton's second version of *Clytie*, the last of his great classical mythological subjects. F.G. Stephens, in his review of the Royal Academy exhibition of 1896, remarked that the subject of Clytie had been a favourite of Leighton's.[1] The story of Clytie is taken from Book IV of Ovid's *Metamorphoses*. Clytie was a water-nymph who was in love with Apollo, the sun-god. Apollo abandoned her because of her jealousy, and she pined away with unrequited love, gazing all day at the sun with her face turned constantly on him. At last her limbs rooted in the ground and became transformed into the stems of a plant, and her face became a sunflower. *Clytie* was the only painting by Leighton to be exhibited at the Royal Academy in 1896, and it is currently in a private collection.[2]

Clytie was painted in the latter part of 1895, during the last year of Leighton's life, when he was already seriously ill. It remained unfinished in his studio at the time of his death in January 1896. In discussing this work with a writer preparing a monograph on *Clytie* for the Fine Art Society, Leighton told him: "Thank goodness my ailment has not interfered with my capacity for work, for I have never had a better appetite for it, nor I believe done better. I was idle for five months in the summer, but since my return I have been working hard and have produced the pictures you see...You know the story. I have shown the goddess in adoration before the setting sun, whose last rays are permeating her whole being. With upraised arms she is entreating her loved one not to forsake her."[3] The result is one of his most dramatic and passionate paintings dealing with the themes of loneliness and love, so prevalent in his work. This drawing shows Clytie kneeling with her head thrown back, her hair nearly touching the ground, and her arms raised up to the setting sun. The first version of *Clytie*, now at the Fitzwilliam Museum, Cambridge, and exhibited at the Royal Academy in 1892, had been on Leighton's mind for fifteen years. It is largely a landscape painting, with only a diminutive figure of Clytie visible at the lower right. The pose of Clytie appears to relate back to *Ariadne*, an early drawing by Leighton for *The Cornhill Magazine* in 1860.[4] Dorothy Dene, his favourite model, posed for it.

Christopher Newall feels that *Clytie* conveyed a personal and intensely felt symbolism for Leighton.[5] He suggests that Leighton himself identified with Clytie's longing for Apollo, since Apollo, the god of music and poetry, embodied the attributes that the artist held most dear. On a number of occasions Leighton painted subjects relating to the cult of Apollo, including in particular *The Daphnephoria* of the mid 1870s. Alison Smith has speculated that

Leighton's interest in solar myth and the ancient practice of sun-worship influenced his choice of subject matter in additional works than *Clytie*, for instance *Daedalus and Icarus*, and *Helios and Rhodos*. According to Smith: "Leighton believed the custom of sun-worship had been conducive to the flourishing of the arts in ancient Greece... Thus for Leighton the sun was equated with the conditions that led to the development of the cult of physical beauty in the high classical period and which he sought to emulate in his own work."[6]

Other studies for the second version of *Clytie* are in the British Museum, Leighton House, and the Royal Academy, London. A study of the nude figure was sold at Sotheby's, London, June 5, 1996.[7] Evelyn De Morgan painted this subject in 1886-87, showing Clytie's transformation into a sunflower. G.F. Watts' famous bust of *Clytie* was exhibited in an unfinished state at the Royal Academy in 1868, but not completed until 1878.

1 Stephens, Frederic George: 1896, p. 587.
2 Sotheby's, London: *Victorian Pictures*, November 6, 1995, lot 237, bought in, and June 4, 1997, lot 154. This painting had originally belonged to Sir James Knowles and for many years had been in a private collection in India.
3 Rhys, Ernest: 1900, p. 52.
4 Ormond, L. and Ormond, R.: 1975, p. 58. The illustration was published in *The Cornhill Magazine*, Vol. II, 1860, opposite p. 674, illustrating the poem "Ariadne at Naxos" by Elizabeth Barrett Browning.
5 Newall, Christopher: Royal Academy of Arts, 1996, cat. no. 125, p. 240.
6 Smith, Alison: "Nature Transformed: Leighton, the Nude and the Model" in Barringer, Tim and Prettejohn, Elizabeth: 1999, pp. 40 and 42.
7 Sotheby's, London: *Victorian Pictures*, June 5, 1996, lot 124, black and white chalk on buff paper, $14 \times 10\frac{1}{2}$ in.

SIR JOHN EVERETT MILLAIS (1829-1896)

Millais was born on June 8, 1829 at Southampton, the youngest child of an officer in the Jersey Island militia. In 1833 the family moved to Jersey, where Millais spent much of his early life. In 1838 the family moved to London, which enabled Millais to take lessons at Sass' Art Academy. The same year he won the Silver Medal of the Society of Arts for his drawing *The Battle of Banockburn*. On July 17, 1840 he entered the Royal Academy Schools as a probationer, and on December 12 was admitted as a student. Millais won a medal for drawing from the antique in 1843. In 1844 he met Holman Hunt. He exhibited his first painting at the Royal Academy in 1846. In 1847 he won the R.A. Gold Medal for *Benjamites Seizing their Brides*. He became a founding member of the Pre-Raphaelite Brotherhood in 1848. In 1849 he exhibited his first Pre-Raphaelite work at the Royal Academy, *Isabella*, which was well received, while in 1850 his *Christ in the House of His Parents* was harshly criticized. In June 1851 he met the critic, John Ruskin. In 1853 Millais was elected as an associate of the Royal Academy. The years 1857-59 were a transitional period leading to an increasingly freer, more fluid painting style. In 1863 Millais was elected a full Royal Academician. The years 1863-67 were again a transitional period, with increased breadth to his painting style. He achieved great popular success with his domestic genre pieces, especially those of children, and later with his popular subject pictures, such as *The Boyhood of Raleigh*. In 1880 Oxford University conferred on Millais the distinction of an honorary D.C.L. He was created a Baronet in 1885. In 1896, following Leighton's death, he was elected President of the Royal Academy. He died on August 15, 1896 and was buried at St. Paul's Cathedral.

46 Lorenzo and Isabella, 1848

Watercolour over graphite, on off-white paper; 9⁷⁄₃₂ × 13¹⁵⁄₁₆ in. (23.4 × 35.4 cm); arched top
VERSO: studies for a hooded male figure and the elderly nurse, graphite on off-white paper
PROVENANCE: Purchased by Eric Halderson while on vacation in the Costa de Sol area of
Spain in the early 1980s; in his personal collection until 1997 when he transferred it to his
gallery, Belmont Art & Antiques, Ottawa; purchased July 30, 1997.

The story of Lorenzo and Isabella is based on one by Boccaccio, as retold in the poem
"Isabella or The Pot of Basil" by John Keats. The watercolour illustrates these lines from
Keats' poem (Stanzas I and XXI):

Fair Isabel, poor simple Isabel!	These brethren having found by many signs
Lorenzo , a young palmer in Love's eye!	What love Lorenzo for their sister had,
They could not in the self-same mansion dwell	And how she loved him too, each unconfines
Without some stir of heart, some malady;	His bitter thoughts to other, well nigh mad
They could not sit at meals but feel how well	That he, the servant of their trade designs,
It soothed each to be the other by …	Should in their sister's love be blithe and glad,
They could not, sure, beneath the same roof sleep	When 'twas their plan to coax her by degrees
But to each other dream, and nightly weep	To some high noble and his olive-trees.

 This watercolour has been thought by several Pre-Raphaelite scholars and dealers to be
an early work by Millais, and thus his first version of *Isabella*. The leading Millais scholar, Dr.
Malcolm Warner, is not convinced that this work is by Millais, however, although he does
admit it is by "someone intimately connected with the PR circle. For me, the problem with
the Millais attribution is that the pencil strokes don't carry quite the sense of supreme
confidence that I associate with him, and the thin floating use of watercolour is uncharacteris-
tic."[1] The fact that it is unsigned, and that there is no supporting documentary evidence to
suggest Millais did an earlier version of *Isabella*, also militates against this watercolour being
by him. The question must remain, therefore, if it is not by the young Millais, who within the
immediate circle of the Pre-Raphaelite Brotherhood was capable of doing such a work at this
time? Certainly Hunt and Rossetti would seem to be even less likely candidates, and it does
not appear characteristic of the work of F.M. Brown, James Collinson, Walter Deverell, or
Charles Collins. It is doubtful whether Thomas Woolner, F.G. Stephens, or W.M Rossetti
would have possessed the technical capabilities of executing this watercolour. Older artists

associated with the PRB, such as William Dyce, Lady Waterford, or Augustus Egg, are also possible but unlikely candidates.[2] Millais therefore remains the most likely, although certainly not the only possibility.

Millais exhibited an oil painting, of a very different version of *Isabella*, at the Royal Academy in 1849, his first exhibited work as member of the Pre-Raphaelite Brotherhood and his first Pre-Raphaelite masterpiece. It is now in the collection of the Walker Art Gallery, Liverpool. This early watercolour is intermediate in style between *Cymon and Iphigenia*, which Millais submitted to the Royal Academy in 1848, and *Isabella*. It is also much more conventional in composition than the more progressive oil painting. The watercolour probably dates from mid-1848, since Millais began painting the oil version late in the autumn, likely November, of 1848. The watercolour cannot be from any earlier than 1848, since Millais was not even acquainted with Keats' poetry until Holman Hunt brought it to his attention: "I had been talking to Millais of Keats, and one day took occasion to show him my design for 'The Eve of St. Agnes'." (see cat. no. 37). This must have been prior to February 6, 1848 since Hunt commenced the painting on that date. Hunt continued: "My first attempt to communicate to Millais my enthusiasm for Keats was for the moment a ludicrous failure. Going to his studio, I took the volume of *Isabella* from my pocket, and asking him to sit down and listen, read some favourite stanzas. Either from the solemnity of the verses, or perhaps because I had unknowingly contracted a droning delivery, after half-a-dozen verses he burst out with, 'It's like a parson!' Although nettled, I laughed. 'I'll lend you the volumes, and you'll find the poems will bear a wonderful deal of spoiling. The poem of *The Eve of St. Agnes* is earlier than *The Pot of Basil*, and not at such a high level, but it is brimful of beauties that will soon enchant you."[3] It is possible that Millais began this watercolour at about this time, or perhaps shortly after he had submitted *Cymon and Iphigenia* to the Royal Academy.

By about April 1848 Hunt remarked that: "Millais had now become as ardent an admirer of Keats as myself, and we soon resolved to begin a series of illustrations in slightly shaded outline; we worked these with a fine brush in line in preference to a pen for the sake of greater freedom. The drawings were to be preparations for copperplate etchings in illustration of the magnificent poem of *Isabella* ... While I made thus but scant progress with my Keats outline, Millais had completed his. We could not apply ourselves to finishing the whole Keats series until we could hope to tempt a publisher to co-operate with us in the venture."[3] This project was the first undertaken after the formation of the Pre-Raphaelite Brotherhood.[3,4] It was intended to "show forth to the public their close connexion and purpose in work."[4] The designs by Hunt and Millais were "made to explain the position of the lover in the house of the two brothers."[3] Hunt's *Lorenzo at his Desk in the Warehouse* is illustrated in his book *Pre-Raphaelitism and the Pre-Raphaelite Brotherhood*.[5] At one time D.G. Rossetti had proposed that he should also contribute to this series, but apparently he never produced his drawing.[3] This scheme to publish a series of etchings never came to fruition because, as Hunt informed Rossetti on May 29, 1850: "Moxon has the copyright of Keats's [illustrations] and is very jealous of the slightest infringement."[6]

Even earlier in 1848, prior to the formation of the PRB, Rossetti had proposed eight subjects from "Isabella" to be drawn by members of the Cyclographic Society.[7] Original members of the PRB, such as Rossetti, Millais, Hunt, J. Collinson, T. Woolner, and F.G. Stephens, as well as close associates like Walter Deverell and John Hancock all belonged to this society. Members of the Cyclographic Society were supposed to make drawings, sometimes on set subjects, which were then circulated for written criticism by other members. The society did not last long, and the more progressive members became associated with the PRB. Whether Millais could have made an earlier design of *Lorenzo and Isabella* for the

Cyclographic Society, which formed the basis for this watercolour, is not known. The drawing on the verso, however, suggests this watercolour may have been done after the formation of the PRB. This spare angular "spiky" style is characteristic of early Pre-Raphaelite drawings with their elongated mannered figures. If so, the chronology between this watercolour and Millais' brush-and-ink drawing for *Isabella*, which also dates from 1848,[8,9] is very confused and will likely never be known. Stylistically, however, the watercolour must predate the drawing. Even exactly when Millais made the brush-and-ink drawing is uncertain. It also displays the characteristic features of the early drawings done after the formation of the Pre-Raphaelite Brotherhood, but it is not signed with the initials PRB, and therefore may have been executed earlier in the year, and possibly even associated with the Cyclographic Society project.[8] The composition of this drawing was prefigured by Millais' earlier outline drawing for *Hospitality*, one of a series of designs for lunettes for a decorative scheme for John Atkinson which he was completing in the late summer of 1848.[9]

The composition of the brush-and-ink drawing was also obviously influenced by the 1833 engraving after F.A.M. Retzsch for Act III, Scene IV, of *Macbeth*.[8] Another possible source is the feasting group on the right of the engraving after Benozzo Gozzoli's *Marriage of Rebecca and Isaac*, plate XXVIII in Lasinio's volume of engravings after the frescoes in the Campo Santo in Pisa.[9] If this is correct, this suggests a date for the work after the formation of the Pre-Raphaelite Brotherhood. Holman Hunt records a meeting at Millais', soon after the formation of the Brotherhood, where "Millais had a book of engravings of the frescoes in the Campo Santo at Pisa which had by mere chance been lent to him."[3] Grieve has commented that: "Though Millais' 'Isabella' drawing can again be likened to Retzsch's outlines, it is a work of extraordinary, disconcerting, originality. We do not find in Retzsch the emphatic contours of deep shadow set against large areas of pure white, the pronounced individuality and contrasts in facial expressions, the awkward, strained gestures, the rapt intensity of the lovers, the racing yet abruptly halted recession of space."[8] Compared to this drawing, or even the drawing on the verso of the watercolour, the figures in the present watercolour are not handled in such a mannered fashion.

Another painting that has been suggested as a source of inspiration for Millais' *Isabella* is Paolo Veronese's *Marriage Feast at Cana*.[10] This painting is also surely the principal influence for this earlier watercolour version. The kneeling figure to the far right in the watercolour is clearly derived from the crouching figure in the left foreground of Veronese's work. This painting also has a dog in the left foreground. The pose of the stooping brother in the watercolour may have been suggested by that of one of the servants in the left background. The pose of Isabella mirrors that of Christ, while one of Christ's disciples looks at Christ much as Lorenzo gazes at Isabella. The horizontal disposition of the table in the watercolour and the decoration on the tablecloth may have been influenced by another of Veronese's paintings, the *Banquet in the House of Levi*, of 1573, in the Accademia in Venice. The position of Isabella in this watercolour also echoes that of Christ in many Renaissance depictions of the Last Supper.

This watercolour bears some resemblance to works by Millais of this time. It is somewhat similar in its handling of figures to Millais' oil sketch for *The Death of Romeo and Juliet* of c. 1848, which is based on a pen-and-ink drawing dated 1848.[11] The face of Isabella is reminiscent of the women's faces in the series of architectural lunettes that Millais painted between 1847 and 1848 for John Atkinson, Little Woodhouse, Leeds, which are now in the Leeds City Art Gallery.[12] The lunette for *Youth*, c. 1847, also contains two greyhounds, one in a pose remarkably similar to the greyhound in the watercolour version of *Lorenzo and Isabella*.[13] The faces of Lorenzo and the seated brother have much in common with the male faces,

particularly that of James, in Millais' drawing from 1847 of *The Meeting of James with Margaret, daughter of Henry the Seventh at the Abbey of Newbattle*.[14] The pencil drawing on the verso of the watercolour, of one of the brothers standing in a hooded cloak, is not just characteristic of the sharp featured individuals so common in Millais' work at this time. The brother also bears a strong resemblance in his facial features to the brother in the background in Hunt's *Lorenzo at his Desk in the Warehouse* of 1848-49.[5] Millais' drawing of the brother is also similar to the image of Dante, in D.G. Rossetti's drawing *Dante Drawing an Angel on the First Anniversary of the Death of Beatrice* of 1848-49.[15]

This watercolour not only looks backwards, but also serves as an indicator of the work that Millais would later produce. The figure of the brother leaning over on the left is somewhat suggestive of the figure and pose of Ferdinand in *Ferdinand Lured by Ariel* of 1849-50, but even more so of the pose of the assistant carpenter to the left in *Christ in the House of His Parents*, also from 1849-50. The placement of the figure of the second brother in red is similar to that of the oil version of 1848-49, while the figure of the old nurse in the watercolour occupies a similar position to that of Isabella in the oil. In both the watercolour and the oil versions a landscape is seen at the right, but in the watercolour it is viewed through a stained-glass window rather than from a balcony. Millais was to incorporate a stained-glass window, also with a heraldic motif, into his *Mariana* of 1850-51. The background behind the dining table in the watercolour appears to be a tapestry, rather than a flat damask hanging as in the oil painting.[9] The handling of the tapestry background foreshadows Millais' similar use of tapestry twenty years later in his watercolour *The End of the Chapter* of 1869.[16]

Millais was not the first, or the only major Victorian artist to paint scenes from "Isabella". George Frederick Watts had exhibited an *Isabella e Lorenzo*, at the Royal Academy of 1840 and another *Isabella* in 1859.[17] D.G. Rossetti made a drawing, *The Pot of Basil*, but this was never worked up into a painting.[18] William Holman Hunt painted *Isabella and the Pot of Basil* in 1866-68. This work illustrates a later episode in the poem when Isabella has discovered that her brothers have murdered Lorenzo and buried his body in a forest. She digs up the body, cuts off his head, and places it in a garden pot planted with basil. J.M. Strudwick's *Isabella*, a painting of 1879, represents a slightly later episode after the brothers discover that Isabella has hidden Lorenzo's head in the pot. The brothers then steal the pot, which is the incident portrayed in the picture. Isabella later dies of a broken heart. Simeon Solomon did versions of *Lorenzo and Isabella*, *Isabella*, *Isabella with the Head of Lorenzo*, and *Isabella with the Basil Pot*. J.W. Waterhouse's *Isabella and the Pot of Basil*, exhibited at the Royal Academy in 1907, shows Isabella kneeling and clutching the garden pot where Lorenzo's head is buried. The subject of Keats' poem thus continued to attract painters even into the beginning of the 20th century.

1 Warner, Malcolm: personal communication, letter dated May 27, 1998.
2 Leicester Museums and Art Gallery: 1958. A painting by Augustus Egg, that is similar in feeling to this watercolour, is cat. no. 55, p. 18, illus. no. 8B, *Launce's Substitution for Proteus' Dog*, oil on canvas, 21⅝ × 31¾ in., signed and dated Augustus Egg 1849. It was exhibited at the Royal Academy in 1849, no. 473. The subject is taken from *The Two Gentlemen of Verona*, Act IV, Scene 4. Egg was one of the few artists of the older generation to be sympathetic to and to aid the youthful members of the PRB.
3 Hunt, William Holman: 1905, Vol. I, pp. 79-80, 103-104, 130, and 142.
4 Hunt, William Holman: 1886, p. 482. "The first works that we agreed to do after this was a series of designs for Keat's 'Isabella'. These were to be executed entirely on our new principles, and subsequently etched for publication. Millais chose as his subject the household of Lorenzo's brothers at meals. Rossetti at first made excuses for procrastination. I did one of Lorenzo at his desk in the warehouse, in order that thus the lover's position in the house should be made clear to the spectator from the outset. Though Millais had much oil work on hand which still had to be finished in the old style, he was impatient to begin with a new manner, and he announced his determination to paint his design."

5 Hunt, William Holman: 1905, p. 143. This work is initialled W.H.H. 1849 PRB, lower left. It illustrates the lines: "He knew whose gentle hand was at the latch, Before the door had given her to his eyes." This drawing incorporates Isabella, Lorenzo, the two brothers, two dogs, one of which is obviously a greyhound, and additional workmen hired by the brothers. It had been started in 1848, but was only completed in 1849. The drawing is now in the Musée National d'Art Moderne, Paris.

6 Troxell, Janet Camp: 1937, p. 35.

7 Wood, Esther: 1894, p. 60.

8 Grieve, Alastair: "Style and Content in Pre-Raphaelite Drawings," in Parris, Leslie: 1984, pp. 25-26, and figs. 4 and 5, p. 31.

9 Bennett, Mary: 1988, cat. no. 1637, pp. 118-127, fig. 49, p. 120, fig. 50, p. 121. Fig. 48, p.120, *Hospitality*, is in the collection of Wightwick Manor.

10 Smith, Kathryn A.: 1985, p. 46. Although Veronese was not included in the Pre-Raphaelite Brotherhood's "List of Immortals", other great Venetian Masters were, such as Giorgione, Titian, and Tintoretto. It is obvious that the young Pre-Raphaelites must have been familiar with the works of these Venetian painters, at least through reproductions, to have included them in their list of artists and writers that they particularly admired. Hunt made at least two oil sketch copies of paintings by Titian. Certainly the one, and probably both, were made while he was a student in the Royal Academy Schools. See Sotheby's Belgravia: *Fine Victorian Paintings, Drawings and Watercolours*, November 16, 1976, lots 43 & 44. Lot 43 was a sketch of a copy by Geddes of Titian's *Sacred and Profane Love*, while lot 44 was a copy of *Bacchus and Ariadne*. Veronese was also admired by the young Pre-Raphaelites. While on his honeymoon in Paris, D.G. Rossetti wrote to his brother William Michael, on June 9, 1860, describing Veronese's *Marriage Feast at Cana* in the Louvre as the "greatest picture in the world beyond a doubt."

11 Treuherz, Julian: 1980, p. 32. The oil sketch is reproduced as fig. 12, while the pen-and-ink drawing, which is in the collection of the Birmingham City Museum and Art Gallery, is reproduced as fig. V.

12 Bennett, Mary: Walker Art Gallery, 1967, cat. nos. 10-15.

13 Millais, Geoffroy: 1979, p. 31. The lunette for *Youth* is illustrated. A small oil version, probably painted after the lunettes were completed, was offered for sale at Sotheby's, London, November 5, 1993, lot 168, bought in and reoffered on November 4, 1994, lot 85.

14 Shepherd Gallery: 1986, cat. no. 61. This drawing is one of a series of nine outline drawings from Scottish history that Millais submitted in 1847 to a competition organized by the Association for the Promotion of Fine Arts in Scotland. This particular drawing was number seven in the series. It was subsequently offered for sale at Sotheby's, London, September 24, 1987, lot 531.

15 Grieve, Alastair: fig. 11, p. 34.

16 Maas Gallery, London: 1997, cat. no. 27, watercolour and bodycolour, 8¾ × 11 in., signed with monogram and dated 1869, lower left. It had sold previously at Sotheby's, London, March 12, 1997, lot 196.

17 Graves, Algernon: 1906, Vol. VIII, p. 175, Royal Academy, 1840, no. 408, with a quotation from Boccaccio; Royal Academy, 1859, no. 438.

18 Agnew's, London: 1968, chalk, 13½ × 12 inches.

47 Romeo and Juliet: The Balcony Scene, 1852

Graphite on off-white laid paper 5¹¹⁄₁₆ × 4⅛ in. (14.5 × 10.7 cm)
PROVENANCE: P. & D. Colnaghi Ltd., London by 1967; Sir Karl Parker; anonymous sale, Christie's, London, July 19, 1988, lot 101.
LITERATURE: Millais, John Guille: 1899, Vol. I, p. 164; Bennett, Mary: Walker Art Gallery, 1967, cat. no. 17, p. 24; Poulson, Christine: 1980, p. 249, no. 47; Wildman, Stephen: 1995, cat. no. 11, p. 92.
EXHIBITED: ? Fine Art Society: 1901, cat. no. 54; University of Lethbridge: 1993; Kenderdine Gallery: 1995, cat. no. 34.

This design from 1852, during Millais' Pre-Raphaelite period, and executed at Worcester Park Farm, is characteristic of drawings done at this date. On April 18, 1852 Millais wrote to his friend Thomas Combe: "Next week, or rather this, I mean to commence painting again,

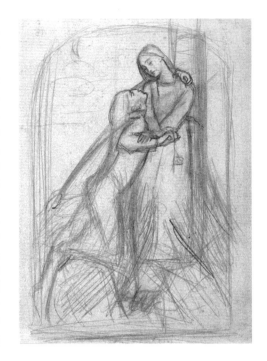

for I cannot stand entire laziness. 'Romeo and Juliet' is to be my next subject – not so large as either of this year's. It is an order from a Mr. Pocock, one of the secretaries of the Art Union."[1] Lewis Pocock had entered the Pre-Raphaelite sphere in 1852, when he allowed D.G. Rossetti, W.H. Hunt, and F.M. Brown to participate in the Old Water-Colour Society's winter exhibition.[2] Nothing was done for this painting of *Romeo and Juliet* beyond two pencil sketches, of which this is likely the later of the two designs. The other is illustrated in John Guille Millais' book on his father.[3] The illustrated sketch is similar to this design, differing in many minor details, such as the placement of Juliet's left arm. *Romeo and Juliet* was eventually abandoned and, after discussing various subjects with Pocock, *The Proscribed Royalist* was approved. This was exhibited at the Royal Academy in 1853.

Millais had previously considered producing a painting from the last act of *Romeo and Juliet*, and an oil sketch of this subject, from c. 1848, is in the Manchester City Art Gallery.[4] A pen-and-pencil sketch of this subject is at the Birmingham City Museum and Art Gallery.[4] The stylistic qualities of this more forceful, angular, early Pre-Raphaelite drawing are quite different from those of the present drawing of 1852, executed only four years later.

The most famous versions of the balcony scene from *Romeo and Juliet* by the Pre-Raphaelites are those by Ford Madox Brown. Early in his career G.F. Watts made drawings of this subject, but like Millais he never worked them up into a finished painting.[5]

1 Millais, John Guille: 1899, Vol. I, p. 163.
2 Macleod, Dianne Sachko: 1996, p. 162. Pocock in addition to being honorary secretary of the Art Union of London, of which he was a co-founder, was also treasurer of the Graphic Society and secretary of the Old Water-Colour Society. In addition to *The Proscribed Royalist* by Millais, Pocock also owned oil sketches by Holman Hunt and F.M. Brown.
3 Millais, John Guille: Vol. I, p. 120. This drawing belongs to Raoul Millais.
4 Treuherz, Julian: 1980, p. 32. The oil sketch, 6⁵⁄₁₆ × 10⁵⁄₈ in., is illustrated, as is the pen-and-ink design for the same subject at Birmingham.
5 Whitechapel Art Gallery: 1974, cat. no. 55, pen and ink, 6½ × 8⅛ in. This drawing is similar in composition to that by Millais.

48 Design for the Headpiece of "Locksley Hall," c. 1857

Pen and black ink on off-white wove paper, laid down; inscribed in ink, at bottom of mount, "Bought at Sam Mendel's sale, 24th [sic] April 1875 by Edward S. Palmer, 30 Golden Square W. London" 4¾ × 3⁵⁄₁₆ in. (11.1 × 8.4 cm)
PROVENANCE: Wigzell, London dealer; bought on April 8, 1867 by Agnew's, London; sold on April 9, 1867 to Samuel Mendel, Manchester; Mendel's sale, Christie's, April 17, 1875, part of lot 280, bought Edward S. Palmer, London; his sale, Christie's, London, January 25,

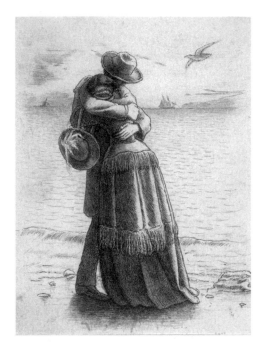

1878, lot 374, bought Hogarth; probably Henry S. Reitlinger; his estate sale, Sotheby's, London, May 26, 1954, part of lot 479, bought Colnaghi; P. & D. Colnaghi & Co. Ltd, London; Abbott and Holder, London; sold in 1957 to Dr W.E. Fredeman, Vancouver; purchased June 26, 1990.

LITERATURE: Millais, John Guille: 1899, Vol. II, p. 492; Fredeman, William: 1965, pl. VIII following p. 154.

EXHIBITED: Lakeview Center for the Arts and Sciences: 1971, cat. no. 52; Kenderdine Gallery: 1995, cat. no. 35.

In 1854 the publisher Edward Moxon decided to bring out a deluxe illustrated edition of the poems of Alfred Tennyson, reprinting a volume initially printed in 1842, but which included material from the 1830s. This was an opportunity to reintroduce Tennyson's early poems, which had previously suffered from both hostile criticism and meager sales.[1] The eight artists chosen to illustrate it included five older, well known figures, Daniel Maclise, Thomas Creswick, William Mulready, John Callcott Horsley, and Clarkson Stanfield, and the three lesser established Pre-Raphaelite artists, John Everett Millais, William Holman Hunt, and Dante Gabriel Rossetti.

How this odd grouping came about is a matter of conjecture. George S. Layard felt that Moxon was the principal person responsible for choosing the collaborators, although Tennyson himself may have taken the initiative in suggesting the Pre-Raphaelites.[1,2] In May 1854 Tennyson and Moxon called upon four of the painters, including Millais, who had been asked to contribute. Millais wrote immediately to Holman Hunt in Jerusalem and to D.G. Rossetti to enlist their contributions.[3,4] In November 1854 Millais visited Tennyson at his house Farringford on the Isle of Wight to discuss the Moxon project and to make specimen illustrations. He apparently did not begin to work on his final designs, however, until the next summer, for on July 8, 1855 Effie Millais wrote to her mother that he was intending to commence that day.[5] Most of the illustrations were finished by the latter part of 1856, as Millais wrote to Holman Hunt on September 7, 1856 that he was at work on the last of them.[5]

Millais produced eighteen drawings for the Moxon Tennyson, but there is considerable disparity amongst these designs. He appears to have worked in two different styles, as has been pointed out by Walter Armstrong.[6] Some of the illustrations are relatively spare, with restrained hatching and a loss of definition towards the edge of the image. This style is usually associated with the poems that have a contemporary setting. The other style is busier, more densely hatched, and generally darker in tone, with the detail carried right to the edge. Most of the illustrations of the latter kind were engraved by the Dalziel Brothers, which suggests that they favoured the richer style and may have encouraged Millais to use it. Millais went to a considerable amount of effort to make his designs as perfect as possible, as his letters to his engravers W.J. Linton and the Dalziel Brothers prove.[7] The engraver of the woodblock for the headpiece to "Locksley Hall" was John Thompson. Millais made preparatory studies for

the drawings, similar to those undertaken for his paintings. He took infinite pains with the engravings to make sure he obtained the results he sought, perhaps because of his inexperience in drawing on wood. His success in this project set the stage for his successful career as an illustrator.

Millais' illustrations for the Moxon Tennyson are somewhat uneven in their excellence. Geoffrey Millais felt that "Locksley Hall" was amongst his best.[8] Emily Tennyson, Alfred's wife, did not like it, however, an opinion she expressed in a letter to Thomas Woolner of early 1857.[9] It has been suggested that this was because she had complained that most of the drawings were unfaithful to the text,[9] although this design would appear to illustrate very well the lines: "Many an evening by the waters did we watch the stately ships, And our spirits rush'd together at the touching of the lips." Emily Tennyson's dislike of this image may have been unfairly influenced by Woolner's earlier comments about it, in a letter to her dated May 28, 1856: "I saw the illustrations, some time ago and liked some of Millais' extremely: … in nearly all Millais' was great excellency but one of lovers embracing on sea-shore, which I did not like at all."[10]

This drawing for the headpiece of "Locksley Hall" epitomizes what Stein has characterized as the qualities of the Pre-Raphaelite illustrations for the Moxon Tennyson: "The Pre-Raphaelites' images are dense. Their characters are richly costumed and intensely thoughtful. Their landscapes are moody and evocative. Their dramatic situations are passionate. Almost every one of their illustrations is in some important sense of the word psychological; almost none strives for the simple depiction of the details of a poetic scene as distinguished from some heightening of its attendant emotions."[1] It continues a theme frequently seen in Millais' art of embracing lovers, which he had previously explored successfully in such paintings as *A Huguenot* of 1852, or *The Order of Release* of 1853.[11]

Of Millais' fifteen finished drawings for the Moxon Tennyson that once belonged to Samuel Mendel, two are at the Victoria and Albert Museum, five are at the Ashmolean Museum, Oxford, one is at the Houghton Library, Harvard University, one belongs to a descendent of Thomas Woolner, and two were sold at Christie's, New York, on January 7, 1981, lots 196 and 197. Malcolm Warner believes these drawings were done after the wood-engravings, about 1857, rather than being preparatory studies.[12] The drawing that belongs to Major-General C.G. Woolner is for "Edward Gray." Designs for "A Dream of Fair Women" (Cleopatra; Queen Eleanor) are in the Victoria and Albert Museum, London. At the Ashmolean Museum in Oxford are designs for "Mariana," "The Death of the Old Year," "St. Agnes Eve," "The Day Dream; The Sleeping Palace," and the "Lord of Burleigh." The drawings at the Ashmolean are laid down on mounts with a black line and two gold lines, as is this drawing for "Locksley Hall." These mounts must therefore be the ones that were on the drawings when they belonged to Mendel. Finished studies for "Edward Gray," "St. Agnes Eve," and "Dora" are in the Birmingham City Museum and Art Gallery.[13] An early compositional study for "The Talking Oak" is in the Lanigan collection.

1 Stein, Richard: 1981, pp. 289 and 300.
2 Layard, George S.: 1894, pp. 4-5.
3 Harris, Jack: 1983, pp. 26-37.
4 Warner, Malcolm: Arts Council of Great Britain, 1975, p. 35. "Millais had been asked to contribute to the Moxon Tennyson by 22 May, 1854 when he wrote to Rossetti suggesting he might also take part." The letter is in the Huntington Library, and is quoted in the Walpole Society Journal, 1972-4, pp. 14-16.
5 Warner, Malcolm: p. 35. Effie Millais' letter is in the Pierpont Morgan Library, while J.E. Millais' letter to W. H. Hunt is in the Huntington Library.

6 Armstrong, Walter: 1885, p. 22.
7 Marsh, Jan: 1989, pp. 11-17.
8 Millais, Geoffroy: 1979, p. 59.
9 Tennyson, Emily: incomplete letter to Thomas Woolner of early 1857, MS Bodleian Library. An excerpt is reproduced in Ormand, Leonée: 1981, p. 6. "For instance in the Lord of Burleigh what has the Lady to do where she is in a cottage surrounded by peasants instead of Burleigh with her own weeping Lord by her side. Her face is beautiful, & the group altogether good it seems to me if it had the remotest connection with the poem. The Millers daughter I positively loathe – Locksley hall I like not."
10 Woolner, Amy: 1917, p. 114..
11 Casteras, Susan: 1991, pp.21-22. Casteras discusses the importance of *A Huguenot* on Millais' subsequent work. "For Millais, love was an overriding theme in his book illustrations as in many paintings, whether a scene of innocence, ardor or frustration. The transitory moments of love stolen between lovers who are often shown locked in intense unions are both tender and eloquently moving, and Millais became a master of the monumental embrace or encounter."
12 Warner, Malcolm: Personal letter, March 26, 1996.
13 Wildman, Stephen: 1995, cat. no. 41, p. 160. Wildman notes that the Birmingham collection has twenty studies by Millais for the Moxon Tennyson, ranging from slight thumbnail sketches to more complete compositional designs. A complete list of these drawings is in the Birmingham City Museum and Art Gallery: 1939, pp. 271-273.

ALBERT JOSEPH MOORE (1841-1893)

Albert Moore was born at York in September 1841, the youngest of fourteen children of William Moore, a portrait and landscape painter. He received artistic instruction as a child from his father and older brothers, four of whom became artists. In 1853, after a brief period of study at the York School of Design, he was awarded a medal by the Dept. of Science and Art for one of his drawings. He moved to London in 1855. In 1857 he exhibited for the first time at the Royal Academy. He entered the Royal Academy Schools in May 1858, but studied there for only a few months as he found its teachings too restrictive. In the 1860s Moore received several commissions to decorate the interior of churches and country houses through his friendship with the architect William Eden Nesfield. Towards the end of 1862 he travelled to Rome, where he spent four or five months. This visit hastened his conversion to classical subjects. In 1876 he was offered the headmastership of the Birmingham School of Art, but refused it, as he did not wish to leave London, and because he felt the time he would have to commit to teaching would not allow him enough to paint. In 1877 he exhibited at the first Grosvenor Gallery exhibition. In November 1877 he testified on Whistler's behalf in the famous Whistler versus Ruskin law suit. Moore was elected an associate of the Royal Watercolour Society in 1884, the only official recognition he ever received. In 1890 he experienced the first symptoms from the tumour in his leg that would ultimately lead to his death. He died on September 25, 1893 and was buried in Highgate Cemetery.

49 Elijah Running to Jezreel before Ahab's Chariot, 1861

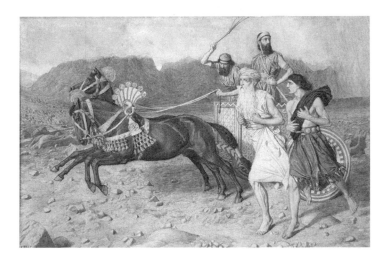

Brush, pen and brown ink over graphite, heightened with scratching out, on light tan laid paper; signed with monogram and dated *1861*, lower left; nine-inch tear centre right, repaired 19¾ × 27¹⁵⁄₁₆ in. (49.2 × 71 cm)
PROVENANCE: Edward Bollans, by 1894; anonymous sale, Sotheby's, London, June 18, 1985, lot 52, bought Julian Hartnoll, London; his sale, Sotheby's, London, January 31, 1990, lot 354, bought in; purchased from Julian Hartnoll, February 26, 1991.
LITERATURE: Baldry, Alfred Lys: 1894, pp. 27, 83, and 102; Green, Richard: Laing Art Gallery, 1972, pp. 9 and 12; Hedberg, Gregory: Manchester City Art Gallery, 1978, p. 130, and cat. no. 67, p.138; Green, Richard: Julian Hartnoll, 1986, cat. no. 12 (illus.).
EXHIBITED: Royal Academy: 1861, cat. no. 909; Grafton Galleries: 1894, cat. no. 173; Shepherd Gallery: 1986, cat. no. 64 (illus.); Kenderdine Gallery: 1995, cat. no. 36.

During the early and mid 1860s Moore produced a number of works illustrating stories from the Old Testament. The first to be exhibited was this drawing, *Elijah Running to Jezreel before Ahab's Chariot*, taken from I Kings, V, viii, along with a small oil painting, *The Mother of Sisera Looked out a Window*, which were shown at the Royal Academy in 1861. This drawing appears to be unique in Moore's work. The choice of subject matter, the head of the prophet Elijah, and the landscape background recall the work of William Holman Hunt. A similar landscape background was used in Moore's major painting from this period, *Elijah's Sacrifice*, which was painted almost entirely in Rome in early 1863. This landscape was adapted from a desolate spot in the district between Rome and Tivoli. Baldry commented on this drawing: "The drawing of 'Elijah running before Ahab's chariot in Jezreel', of which another version in pen-and-ink is in [the] possession of Mr. Hollyer, has an interest, even beyond what it possesses as a dramatic composition, as one of the first of the biblical illustrations with which the young artist tentatively concerned himself while he was feeling his way towards the more absolutely individual methods of expression and types of subjects that afterwards almost exclusively occupied him."[1]

The closely related drawing in pen and black ink is in the collection of the York City Art Gallery.[2] The York drawing is possibly, although not necessarily, a preparatory study for the large sepia wash drawing. The two drawings are very close in composition, although there are slight differences in the figures, particularly the head of the charioteer, and in the back-

ground. Green has noted that this second drawing is just as unique in Moore's work, but more oddly so, leading him to speculate about its function.[3] Was it merely experimental, or was Moore working with a book illustration in mind? During the early 1860s both the Dalziel Brothers and Joseph Cundall were competing to secure illustrators for their respective Bible galleries, and it is possible that this drawing was worked up in connection with either of these two projects. Another version of this subject, described as a pencil drawing and dated 1865, was no. 229 in the Moore memorial exhibition held in 1894 at the Grafton Galleries. As this was lent by Frederick Hollyer, Green feels that there is a possibility that it is actually the previously mentioned pen-and-ink drawing, mistakenly described as pencil.[3] A pencil study for the head of Elijah is in the Birmingham City Museum and Art Gallery.[4]

The technical skill exhibited in this drawing foreshadows Moore's later artistic development. The convincing representation of figures in action is unusual, considering his later work where he was primarily concerned with creating an atmosphere of quiet detachment. Baldry reported that the realistic gesture of the charioteer whipping his horses was "secured by giving the model a cushion to flog and by noticing the recurrence of particular details of movement which produced the impression of strong action."[1] Although Moore's later work generally featured passive figures, he was capable of realistically painting figures in motion, as in *Kingcups*, *Follow My Leader*, and *The Loves of the Winds and the Seasons*.

1 Baldry, Alfred Lys: 1894, pp. 27 and 83.
2 Baldry, A.L.: This drawing is reproduced in the large paper edition following p. 80.
3 Green, Richard: Julian Hartnoll, 1986, cat. no. 12.
4 Birmingham City Museum and Art Gallery: 1939, no. 912'27, 10½ × 8 in. This drawing is said to relate to *Elijah's Sacrifice*, but it is obviously a study for the head of Elijah for *Elijah Running to Jezreel before Ahab's Chariot*.

50 The Elements, 1866

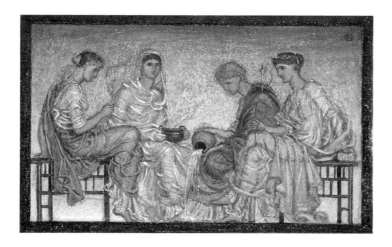

Gouache on paper, with black wash border; signed with anthemion upper right; inscribed on an old mount, present when the drawing sold at Sotheby's Belgravia in 1976, "Dr. Albert, please let them have the drawing as soon as possible. Sorry I did not find you in." 5 × 8⅞ in. (12.7 × 22.5 cm) – sheet size 4⅝ × 7⁹⁄₁₆ in. (11.8 × 19.2 cm) – image size
PROVENANCE: Anonymous sale, Sotheby's Belgravia, June 29, 1976, lot 281, bought J. Hartnoll for Pre-Raphaelite Trust (Pre-Raphaelite Inc.); their sale, Sotheby's, London, June

21, 1989, lot 115, bought in; Julian Hartnoll, London; sold in February, 1990 to Daniel Perrin, London; purchased February 14, 1990.

LITERATURE: Baldry, Alfred Lys: 1894, p. 102; Prettejohn, Elizabeth: 1999, pp. 122-123, fig. 30.

EXHIBITED: Dudley Gallery: 1866, cat. no. 669; York City Art Gallery: 1980, cat. no. 76 (illus.); Shepherd Gallery: 1989, cat. no. 87 (illus.); Kenderdine Gallery: 1995, cat. no. 37.

The art of Albert Moore evolved through several stages before reaching the mature style for which he is best known. Most of his paintings executed between 1860 and 1865 were "low in tone and vigorous rather then delicate in effect."[1] In 1862-63 Moore visited Rome and discovered ancient Greek art, while in 1865 the Elgin Marbles, which had undergone restoration, were reinstalled in the Elgin Room at the British Museum. Classical sculpture was to exert a major influence on him, and he began to eliminate narrative elements from his art, and to concentrate on decorative arrangements of figures in classical drapery. As Robyn Asleson has noted: "By 1866, in his gouache drawing *The Elements*, Moore had entirely excised this narrative dimension. The four female figures are now physically interchangeable and psychologically remote. Blank-faced, each bears a simple emblem symbolic of her elemental nature: a branch for earth, a Japanese fan for wind, a flaming pot for fire and a flowing jug for water. By stripping down the symbolism and eradicating most of the picture's extra-aesthetic significance, Moore forces the viewer to concentrate on purely visual qualities, such as the flow of drapery and the arrangement of colour. The 'subject' of the picture has already become its least compelling feature."[2]

In 1864 Moore exhibited a fresco at the Royal Academy entitled *The Four Seasons*. In this painting he began to move towards the style and the allegorical subjects subsequently seen in *The Elements*. Sidney Colvin described *The Four Seasons* as: "Spring, Summer, Autumn, and Winter, sat side by side, clad in thin raiment, and having behind them the dusk. No great care had been taken with the symbols by which each was identified, still less with their expressions of feature; but immense care had been taken with the pose of their limbs and the adjustment and colour of their draperies."[3] Baldry noted that: "To us, now, this fresco has an interest beyond what it possessed then as a declaration of the artist's faith, for it seems to have been, to some extent, the means of leading him into the more delicate colour harmonies, and more gentle tone arrangements which were soon to become essentially characteristic of his productions."[1] The years 1863-65 must be considered transitional in his style, however, since at the same time as he produced *The Four Seasons*, he also painted *A Girl Dancing* and *A Dancing Girl Resting*, which have the more somber restraint and manner of his earlier canvases.[1]

By 1865 Moore had moved fully towards his mature style, concerned only with the colour relationships and decorative patterns that were to occupy him for the rest of his life. *The Marble Seat*, exhibited at the Royal Academy in 1865, is without any narrative content and is purely a harmony of tone and colour. Whistler was greatly impressed by this painting when he saw it at the exhibition and immediately struck up a friendship with Moore that was to last until Moore's death in 1893. Between 1865 and 1870, the period of their greatest intimacy, Moore was by far the most significant artistic influence on Whistler and vice-versa. In 1863 Whistler had discovered Japanese art and, within two years, he had incorporated Japanese principles of composition and design into his work. While Moore introduced Whistler to the art of classical Greece, Whistler introduced Moore to Japanese art. These dual influences were essential for the development of Moore's mature style. As Muther has pointed out: "He was influenced indeed by the sculptures of the Parthenon, but the Japanese have also penetrated his spirit. From the Greeks he learnt the combination of noble lines, the

charm of dignity and quietude, while the Japanese gave him the feelings for harmonies of colour, for soft, delicate blended tones. By a capricious union of both these elements he formed his refined and exquisite style."[4] Not everyone approved of the influence of Whistler on his art, however. William Blake Richmond wrote: "During the period of our probationership and studentship Moore and I were close friends; afterwards he joined the Whistler clique, which was not at all to my liking. However clever Whistler was – and there could be no doubt that he was talented in a high degree – he was narrow, his interests in Art were centred round himself … However much he taught Moore to attain freshness of [illegible] and colour, in my opinion his influence destroyed almost completely the imaginative faculty which was evinced in Moore's early work … Moore had great genius, some of it bloomed splendidly, some of it – and not the least part of it – was killed."[5]

The Elements, which was exhibited at the Dudley Gallery in 1866, shows how quickly Moore had assimilated the influence of both Greek and Japanese art. The figures, with their classical Grecian faces with flat nasofrontal angles and retrusive chins, their poses, and draperies, are clearly influenced by classical Greek sculpture. Richard Green, however, also feels that this early work by Moore was influenced by Roman wall paintings, particularly the frescoes at Pompeii.[6] Even as early as 1867 Sidney Colvin concluded about Moore's art: "With him form goes for nearly everything, expression for next to nothing. He does not attempt realism … but paints in low keys of colour figure-subjects with little dramatic purpose, that seem prompted by an aesthetic turn radically akin to that of the Greeks … In these small and slightly tinted works he achieves a perfection of design, a delicacy of decorative colour, a large grace and harmonious repose, that have hardly a parallel in modern art."[7]

In this work Moore is already beginning to move away from the hot colour schemes of his early religious and classical paintings towards a lighter, cooler palette.[8] The subtle colour harmonies are an arrangement in blue and salmon pink, and the fan being held by the figure representing Wind (Air) is obviously Japanese inspired. Moore is already demonstrating his theory of colour harmonies, which he would utilize throughout the rest of his career. His paintings generally involve two shades of a dominant colour, which in the case of *The Elements* are light and dark blue, plus one or sometimes two gradations of a near-complementary colour, in this case salmon pink. These three or four hues were then arranged into a harmonious pattern across the surface of the composition.

The allegorical figures appear to be sitting on a bench which Green feels may have been suggested by Pompeian prototypes,[6] but which also resembles much of the Anglo-Japanese Aesthetic Movement furniture popular in the 1870s, designed by progressive architects like E. W. Godwin.[8] Moore may have been aware of such designs through his friendship with the architect William Eden Nesfield. Moore's friend Simeon Solomon had painted a group of medieval figures sitting on a similar piece of Aesthetic Movement furniture as early as 1862.[9] There are also two early drawings by Whistler, c. 1865-70, at the Freer Gallery of Art in Washington, which show draped Greek female figures seated on what Curry calls "attenuated neo-Grecian furniture," which are also similar to Aesthetic Movement pieces.[10]

About 1866, the year of this painting, Moore and Whistler began to use devices as signatures. Moore used a Greek anthemion, as in this gouache, while Whistler adopted a butterfly, which evolved over the years.

1 Baldry, Alfred Lys: 1894, pp. 27, 30, and 31.
2 Asleson, Robyn: "Nature and Abstraction in the Aesthetic Development of Albert Moore" in Prettejohn, Elizabeth : 1999, p. 122.
3 Colvin, Sidney: 1870a, p. 4.
4 Muther, Richard: 1895, Vol. III, p. 353.

5 Stirling, A.M.W.: 1926, p. 160.
6 Green, Richard: York City Art Gallery, 1980, cat. no. 76, p. 32.
7 Colvin, Sidney: 1867, p. 473.
8 Green, Richard: Fine Art Society, 1978, pp. 19-20. Green feels there was a definite link between Moore and Godwin. Moore's influence is seen in the painted panels in Godwin's furniture. Godwin was well enough acquainted with Moore to give a fairly elaborate account of his studio in a lecture printed in *Building News*, XXXVI, 1879, pp. 261-262.
9 Cooper, Jeremy: 1987, illus. no. 432.
10 Curry, David Park: 1984, pls. 205 and 206, p. 238.

51 Study of a Standing Draped Figure for "A Garden," 1869

Black and white chalk on brown paper
13¹⁵⁄₁₆ × 8 in. (35.4 × 20.4 cm)
PROVENANCE: Professor Paul J. Sachs, prior to
1929; on loan for summer storage at the Fogg
Art Museum, Cambridge, July 18- September
25, 1929; given away by Sachs on September
25, 1929; anonymous American estate,
Christie's, London, March 14, 1997, lot 40.

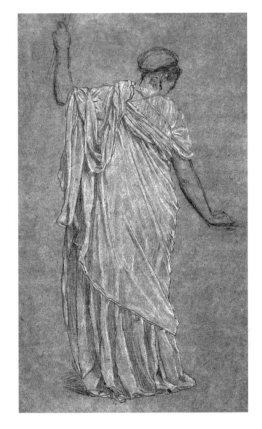

Albert Moore, unlike his contemporaries Lawrence Alma-Tadema or Edward Poynter, was not interested in painting classical subjects with strict archeological accuracy, nor did he portray the highly dramatic myths or incidents of the ancient world, as did Frederic Leighton, G.F. Watts, Edward Burne-Jones, or John William Waterhouse. Moore's major concern in painting was creating the beautiful colour harmonies that made him one of the chief exponents of the Aesthetic Movement. As Swinburne stated: "His painting is to artists what the verse of Théophile Gautier is to poets; the faultless and secure expression of an exclusive worship of things formally beau-
tiful."[1] The narrative content in Moore's art is minimal, and the classically draped figures are merely another element in the formation of a satisfactory composition with the same aesthetic values as any other object. Moore's art verges on the abstract. Although his subject matter of classically draped women remained almost constant once his mature style had evolved, it served only as a theme upon which he could introduce slight variations in form and constantly impose new schemes of colour. As the critic Sidney Colvin wrote in the *Portfolio* in 1870 about Moore "he colours not to imitate life but to produce an agreeable pattern."[2]

This drawing is a study for *A Garden*, that Moore commenced in 1869, and which was his only exhibit at the Royal Academy of 1870. Baldry feels this painting was influenced by Moore's 1869 designs for mosaic panels for the Central Hall of the Houses of Parliament, which were unfortunately never executed.[3] Baldry stated about *A Garden* that: "It was a

study of a single figure, and in colour, arrangement, and general effect it had much in common with the mosaic designs of the year before. In all probability it was commenced about the same time as these drawings, and into it the artist put, as was his wont, the special knowledge which he had gained while carrying out the smaller and simpler designs ... There is, too, great dignity in the easy action of the figure, and in the proportions of the body and limbs; a suggestion of perfect construction expressed through the medium of able draughtsmanship."[1] Vickers feels the figure was influenced by the second of two figures in an earlier smaller composition, *Apricots*, of 1866.[4] The general pose of these two figures is somewhat similar, and both compositions occur within walled gardens.

The critic of the *Art Journal*, in his review of the Royal Academy exhibition of 1870, had these comments on *A Garden*: "The picture is, of course, an anomaly and perhaps an anachronism; in style it has no precise place in time or space: its nearest belongings would seem to be among the mural paintings of Pompei: and yet the figure is so flat that the manner is rather that of a bas-relief, than of a Picture. In colour the artist has an unaccountable liking for washed out greens and feeble, faded tones generally. And yet the work merits respectful consideration."[5] In this drawing the pose of the figure, and the outline of the drapery, is very close to that used in the finished painting, with the exception of the right arm. In the painting the right arm is slightly higher up and further away from the body. Two full-size cartoons, showing the figure both nude and draped, are in the collection of the Victoria and Albert Museum, London.[6]

The painting is in the Tate Gallery, London. This drawing at one time belonged to Professor Paul J. Sachs, who was a distinguished Associate Director of the Fogg Art Museum at Harvard University from 1924-44.

1 Morley, Catherine: 1981, p. 98.
2 Colvin, Sidney: 1870a, p. 6.
3 Baldry, Alfred Lys: 1894, pp. 39-40.
4 Vickers, Jane: Laing Art Gallery, 1989-1990, cat. no. 76, p. 76. The painting is in the collection of the London Borough of Hammersmith and Fulham, and is currently on loan to Leighton House, London.
5 Sotheby's Belgravia: *Highly Important Victorian Paintings and Drawings*, October 1, 1979, lot 42. *Art Journal*, June 1870, p. 171.
6 Green, Richard: Laing Art Gallery, 1972, cat. no. 28, p. 18. The cartoon of the draped figure is in charcoal and white chalk on brown paper, $46\frac{1}{2} \times 23\frac{1}{2}$ in.

52 Study of a Female Head in Profile, Looking Down, late 1860s

Black chalk on pale blue-grey paper; signed with anthemion device, lower right; on an old label on the back of the frame is inscribed "Original Albert Moore, bought by R.S.T."
$9\frac{1}{4} \times 7\frac{1}{2}$ in. (23.5 × 19 cm) - sight
PROVENANCE: Acquired from the artist by R.S.T.; by descent to his great-grandson; his sale Sotheby's, London, November 6, 1995, part of lot 220, bought Maas Gallery, London; purchased April 16, 1996.
EXHIBITED: Maas Gallery: 1996, cat. no. 54, p. 51 (illus.).

This masterful study of a female head is a good example of Moore's wonderfully evocative draughtsmanship. This drawing does not appear to relate precisely to any known painting, although it superficially resembles the head of the figure to the far right in *The Shulamite* of 1866. This is likely a coincidence, since examples of these idealized heads wearing caps can be

found in his work from the 1860s up until his last major painting, *The Loves of the Winds and the Seasons*, which he finished in 1893. This drawing was sold at Sotheby's in 1995 with a companion study of roughly the same size, done from the same model, but with the head erect rather than looking down.[1] The companion drawing does not relate to *The Shulamite*, making this drawing's relation to it less likely. The fact that the present drawing is on pale blue rather than brown paper, however, suggests that it was created relatively early in the painter's career.[2]

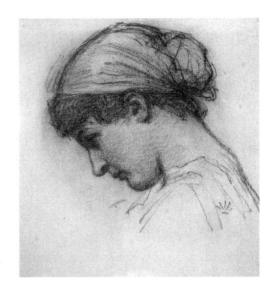

The initials "R.S.T." in the provenance may relate to Ralph Thomas, the son of Sergeant Ralph Thomas. Ralph Thomas was a solicitor who was in partnership with James Anderson Rose until 1875. J.A. Rose was a well known early Pre-Raphaelite collector (see cat. no. 71). Sergeant Thomas had been a voracious collector and part-time dealer in paintings, who had dealt with many of the leading artists of his day and had been one of the earliest buyers of Pre-Raphaelite paintings.[3] Ralph Thomas could have come in contact with Albert Moore through James Whistler. Whistler admired Moore's paintings "more than the production of any living man."[4] Upon Moore's death in 1893 Whistler commented: "Albert Moore – Poor fellow! The greatest artist that, in the century, England might have cared for and called her own – how sad for him to live there – how mad to die in that land of important ignorance and Beadledom."[5] It is certainly possible that Whistler could have encouraged Thomas to buy works from Moore.

1 Sotheby's, London: *Victorian Pictures*, November 6, 1995, lot 220, black chalk on blue paper, 9¼ × 7½ in. The companion drawing was included in Maas Gallery: 1996, cat. no. 55, p. 51.
2 Richard Green: In a telephone conversation on September 2, 1999 he agreed that Moore's mature drawings were almost exclusively made on brown paper and he also felt that this study must be an early work. He noted that drawings by Moore on blue paper are extremely rare. Mr. Green was not aware of any friendship or correspondence between Moore and Ralph Thomas.
3 Maas, Jeremy: 1975, pp. 45 and 57.
4 Spencer, Robin: 1989, p. 85.
5 Baldry, Alfred Lys: 1894, p. 25.

53 Classical Draped Figure Study for "A Reader," c. 1877

Black and white chalk on buff wove paper, with black chalk border; signed with anthemion device, upper right 10⅝ × 4¹³⁄₁₆ in. (27.1 × 12.7 cm)
PROVENANCE: ? Christie's, London, October 21, 1975, part of lot 145, bought Julian Hartnoll; anonymous sale, Sotheby's, Sussex, UK, October 20, 1987, lot 1914; bought Maas Gallery, London; sold in March 1988 to Daniel Perrin, London; purchased March 9, 1988.
EXHIBITED: ?Leicester Galleries: 1949, cat. no. 55; Kenderdine Gallery: 1995, cat. no. 38.

Although Moore was considered a relatively minor artistic figure in his day, his work was admired by such diverse personalities as Whistler and Frederic Leighton. Leighton had

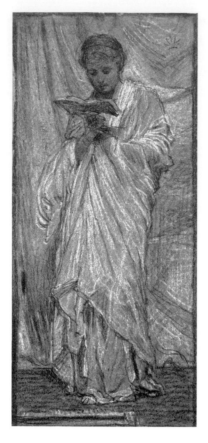

works by Moore in his collection and, on occasion, entertained socially his near neighbour in Holland Park. Moore's reputation has undergone a reappraisal over the past twenty years, and he is now generally regarded as one of England's most original and important Victorian artists. Moore was a shy, reclusive, rather eccentric bachelor, who was totally devoted to his art and who made no attempt to advance his artistic reputation or acquire worldly honours or wealth. His outspoken views on artistic matters and his aloof retiring nature ensured that he would not be elected to the Royal Academy, despite his frequent exhibitions at that institution and Leighton's attempts to bring him into the Academy.[1] Moore's method of working was in the academic tradition. He was a perfectionist, which accounts for his relatively small output. Like Leighton's, his laborious method of working up a composition included cartoons of the whole group, studies of each figure, nude and draped, and an oil sketch. Although most of Moore's drapery studies were done in chalk, he even relied, at times, upon photographic studies of draperies. The painting itself went through four different stages, with painstaking applications of successive layers of paint.

By the mid 1870s Moore's mature style had evolved, and it continued basically unchanged until his death. Paintings from his mature period consist of two main types, either single standing female figures painted on narrow upright canvases, or frieze-like groups of three or four female figures. *A Reader*, for which this drawing is a study, is a typical example of the first type. The best known version is in the collection of the Manchester City Art Gallery. A second version was sold twice through the auction houses in recent years.[2] The colour harmonies in the two versions are slightly different, as are the accessories, such as the woman's hat and the rug on the floor. *A Reader* was frequently grouped with another similar work by Moore, such as *Birds of the Air*, a version of which is also at the Manchester City Art Gallery, or *The End of the Story*. These three paintings date from the same period and feature a single standing female figure, clad in Grecian draperies, standing in front of a cloth curtain with different floral designs. The critic Frederick Wedmore discussed these types of compositions in 1878: "But now we have single figures wholly … single figures in which some accessories, of lovely and chosen form, play their part, and the part is not a small one, in completing the composition … To *draw* a single figure as a study is one thing: to make with it a composition is quite another … Now this year Mr. Moore has exhibited three of these single figures: two at the Grosvenor Gallery, and one at the Academy, and their beauties – so independent of incident or story – so wholly matters of expression, line, and hue, are very little fitted for description, but much repay to be seen … You cannot translate into words the charms of the type nor the perfection of its record … The nobility and distinction of the type and the expression raise it, as Mr. Moore's is wont to be raised, above work purely decorative."[3]

Moore frequently made replicas of his paintings and applied different colour schemes to identical compositions. Although he was criticized for this, Moore's position was defended in

an article in the *Art Journal* in 1893: "People said he was narrow, and he repeated himself, using over again and again ideas which were too slight to bear reiteration; but they were blind to the fact that this repetition was a progressive development of a particular brand of study ... Beauty of colour, of form, of line, of type, was the chief motive of every picture that he ever produced ... People talked nonsense about him as 'a painter of Greek maidens.' He was nothing of the kind. He painted draperies because they are more beautiful than modern dress; he painted women because in their faces and figures beauty shows more plainly than in any other created thing; he painted faces without emotion because emotion distorts the features and destroys beauty of form. His art was Greek in nothing but its simplicity and single-mindedness."[4]

There has been one other drawing by Moore featuring a woman reading that has appeared on the market, but it is not a study for *A Reader* or for any known painting by him.[5] It is uncertain whether it is this latter drawing, or the present study for *A Reader*, which was for sale at the Leicester Galleries, London, in 1949.[6]

1 Barringer, Tim and Prettejohn, Elizabeth: 1999, pp. xxvii and 315. A.G. Robins reported: "The Royal Academy minutes show that Albert Moore's name was put up for election repeatedly throughout the 1880s, which suggests that Leighton continued to maintain his known early interest in Moore's art. But there was virtuallly no support for Moore from the rest of the Council."
2 Sotheby's, London: *Nineteenth Century European Paintings and Drawings*, June 19, 1990, lot 54, oil on canvas, 34 × 12 in. Its companion work, *The End of the Story* sold as lot 55. These two paintings had previously sold at Parke Bernet, New York, June 4, 1975, lots 267 and 266.
3 Wedmore, Frederick: 1878, pp. 343 and 345.
4 Hedberg, Gregory: Manchester City Art Gallery,1978, cat. no. 79, p. 150. *Art Journal*, "Albert Moore", 1893, pp. 334-335.
5 Agnew's: 1990, cat. no. 75, *A Girl Reading*, black and white chalk on grey paper, 12½ × 7 in. It had been purchased Sotheby's, London, June 21, 1989, lot 117. This drawing was subsequently offered for sale at the Shepherd Gallery: 1994, cat. no. 75, on loan from Agnew's. This drawing was still with Agnew's as late as January 1998.
6 Leicester Galleries: 1949, cat. no. 55.

CHARLES FAIRFAX MURRAY (1849-1919)

Murray was born on September 3, 1849, the son of a shopkeeper. He taught himself drawing by copying in the National Gallery. He was introduced into the Pre-Raphaelite circle in 1866 by Murray Marks. In November 1866 he entered Burne-Jones' studio as his first assistant, where he was employed primarily as a copyist who made second versions of existing paintings. He also worked, on occasion, as a studio assistant for D.G. Rossetti and G.F. Watts. He exhibited his first painting at the Royal Academy in 1867. In 1868 he first worked as a decorative artist for Morris, Marshall, Faulkner & Co. He was a very skilful copyist, and in 1871 Ruskin sent him to Italy to make copies of Old Masters. From 1873-83 he lived in Italy working as a copyist for Ruskin. In 1879 he began to exhibit at the Grosvenor Gallery and later exhibited at the New Gallery. He despaired of achieving much as a creative artist, however, because he thought he lacked the necessary imagination, so gradually he began to devote more and more of his time to collecting and selling works of art. He was a connoisseur and an acknowledged expert, not only in Pre-Raphaelite art, but in the earlier English Schools, and Renaissance Flemish and Italian painters. Murray was closely associated with the art dealers Thomas Agnew & Sons. He died on January 25, 1919 at his home in Chiswick.

54 Study of a Reclining Draped Figure, c. 1870s

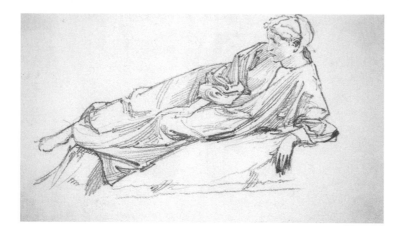

Graphite on off-white wove paper 4¹⁄₁₆ × 7¼ in. (10.4 × 18.4 cm)
VERSO: study of a throned figure
PROVENANCE: Charles Fairfax Murray's studio; by descent to his son Arthur Richmond Murray; his sale Sotheby's, London, February 15, 1961, part of lot 5, bought Maas Gallery, London; purchased May 10, 1989.
LITERATURE: *Apollo*: Vol. 129, no. 325, March 1989, p. 24 (illus.).
EXHIBITED: Kenderdine Gallery: 1995, cat. no. 39.

Percy Bate had a high opinion of Murray's work: "The painter is by no means an imitator, but an artist of great original power; and since poetic inspiration and accomplished presentation, such as mark his work, can ill be spared, it is justly a matter of great regret to his sympathisers that artistic pursuits of another kind should have precluded Fairfax Murray from practicing his craft to the full."[1] Most modern critics would probably not agree with Bate's assessment and would argue that Murray probably made a greater contribution to Pre-Raphaelitism through his art dealing. Certainly the Pre-Raphaelite collections of the Birmingham City Museum and Art Gallery and the Fitzwilliam Museum, Cambridge would be much the poorer without Fairfax Murray. He also acted as advisor to Samuel Bancroft, and thus made an important contribution to this important Pre-Raphaelite collection in the United States.[2]

This drawing may relate either to a painting or to a decorative scheme. In addition to his work for Morris, Marshall, Faulkner & Co., where he prepared stained-glass cartoons, painted windows, and painted decorative panels on furniture and woodwork, Murray also painted numerous small figure subjects on panel for Collinson and Lock, a Fleet Street firm of decorators. Surprisingly, in terms of style, this drawing seems closer to that of James McNeill Whistler, in his lithographs of classically draped female figures, than to Murray's mentor Burne-Jones.

1 Bate, Percy: 1910, p. 109.
2 Elzea, Rowland: 1980.

156

SIR JOSEPH NOEL PATON (1821-1901)

Noel Paton was born on December 13, 1821 at Dunfermline, Scotland. His father was a designer in the local damask mills, and Paton himself, early in life, spent three years as head designer in one of the largest sewn-muslin factories in Paisley. In 1842 he went to London and in 1843 he obtained entry to the Royal Academy Schools. It was here as a probationer, in the spring of 1843, that he met John Everett Millais, who was to remain a life-long friend. In 1845 and 1847 Paton won prizes in the Westminster Hall competitions. After his return to Scotland he was made an associate of the Royal Scottish Academy in 1847, and a full member in 1850. In 1866 Queen Victoria appointed him as Her Majesty's Limner for Scotland. He was knighted in 1876. In 1875 he was awarded the honorary degree of L.L.D. by the University of Edinburgh. Early on in his career he was primarily a painter of historical, mythical, fairy, and allegorical subjects, but after 1870 he devoted himself largely to religious works. Besides being a painter, he was a sculptor and book illustrator, as well as a poet. Although he mostly exhibited at the Royal Scottish Academy, he also showed at the Royal Academy from 1856-83. He died in Edinburgh in 1901.

55 Ferdinand Being Entranced by the Spells of Prospero, 1855

Pen and brown ink on off-white paper, laid down; signed *J.N.P.*, and dated *May 1855*, lower right; inscribed on a label which was previously attached to the old mountboard "Sitting on a bank, / Weeping again the King my Father's wreck, / This music crept by me upon the waters, / Allaying both their fury and my passion / With its sweet air. / The Tempest" 7$\frac{1}{16}$ × 8 in. (18.2 × 20.4 cm)
PROVENANCE: Anonymous sale, Christie's, South Kensington, July 11, 1997, lot 2, bought by Maas Gallery, London; purchased March 26, 1998.
EXHIBITED: Maas Gallery: 1998.

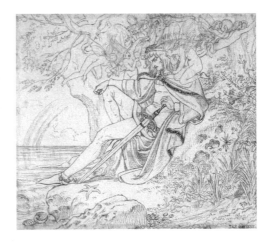

This drawing, dated 1855, illustrates a scene from *The Tempest* by William Shakespeare. Paton had previously illustrated *Compositions from Shakespeare's 'Tempest'*, first published in 1845 and reprinted in 1877.[1,2] These early illustrations, done when he was only twenty-four years old, and executed before the formation of the Pre-Raphaelite Brotherhood, reflect contemporary German outline drawing. In this later drawing, however, the figure of Ferdinand is much stronger and more masculine looking than in these early illustrations. The influence of these early outline illustrations on the figures of the fairies is evident, however. There is no scene illustrated in the book that corresponds exactly to this drawing, although Plate VII shows one slightly later, where Fredinand is being guided by Ariel and the other fairies to Miranda and Prospero.[2]

The year 1855 marks the zenith of Pre-Raphaelite influences on Paton. That year he completed his most Pre-Raphaelite painting, *The Bluidie Tryste*, in the collection of the Glasgow City Art Gallery and Museum. This painting has much in common with this

drawing for *The Tempest*. Both have cliffs in the right background, twisted gnarled trees in the upper parts of their compositions, and water, rocks, and plants in the foreground. The clothes worn by Ferdinand and by the dead lover in *The Bluidie Tryste* are very similar. This drawing was surely influenced by his friend J.E. Millais' painting of 1849-50, *Ferdinand Lured by Ariel*, which was exhibited at the Royal Academy in London in 1850. In Millais' painting the sprite Ariel leads Ferdinand to Prospero, after giving him the false but disturbing information that his father, the king of Naples, has died in the shipwreck off Prospero's island.

Another major influence on this drawing is the work of the Saxon artist F.A.M. Retzsch, particularly his outline drawings for Goethe's *Faust*, first published in 1816,[1] and his illustrations for many of Shakepeare's plays, including those for *The Tempest* published in 1841. Retzsch's Shakespearian drawings inspired many British artists in addition to Paton. Vaughan has noted: "The first and most persistent application of outline was to Shakespearian drama, and among these, *The Tempest* appears to have offered the right degree of fantasy for a Retzschian treatment. Certainly, this play seems to have had an almost uncanny fascination for outline illustrators, right up to the version by Noel Paton in 1845."[1] Of the British artists who worked in a German manner, H.C. Selous produced an *Outlines to Shakespeare's Tempest*, published in 1836.[1] Paton was undoubtedly familiar with this work. The pose of Ferdinand in his drawing may, in fact, be derived from the figure to the far left in the foreground of Plate 4 of Selous' *The Tempest*.[3] This plate also has a rocky cliff in the background and a tree in the left foreground. The figure of the sprite Ariel in this composition has much in common with those of the fairies in Paton's drawing.

This drawing by Paton is of particular interest because of the fairies incorporated into the composition. Paton was amongst the best known of the Victorian fairy painters and, in fact, first made his reputation in this field. His painting *The Reconciliation of Oberon and Titania*, dated 1847, was entered in the Westminster Hall competition in 1847 where it was awarded a £300 prize. This work was painted in a microscopically detailed manner that predated the formation of the Pre-Raphaelite Brotherhood.[4] Paton's first fairy painting, *The Quarrel of Oberon and Titania*, was exhibited in 1846 at the Royal Scottish Academy as his diploma work. A later larger version, containing many more fairy figures, was shown at the Royal Scottish Academy in 1850, where it was judged to be "Picture of the Exhibition". Paton's *The Fairy Raid, Carrying off the Changeling, Midsummer Eve* of 1867 was considered one of the most successful fairy paintings of the Victorian era. After 1870 Paton concentrated on religious themes, although he still continued to produce an occasional fairy painting. The writer Percy Bate felt "his true power shows itself in his pictures from the realms of fancy, wholly delightful presentations of myth and legend … rather than in his more ambitious and less successfully realized religious conceptions."[5]

A pen-and-ink drawing from 1852, a design for a picture of *Ferdinand Listening to the Music* from *The Tempest*, was exhibited at the Fine Art Society, London, in 1902.[6]

1 Vaughan, William: 1979, pp. 140 and 142.
2 Paton: Noel J.: 1877.
3 Vaughan, William: fig. 64, p. 143.
4 Gere, Charlotte and Lambourne, Lionel: Royal Academy of Arts, 1997-1998, p. 108.
5 Bate, Percy: 1910, p. 74.
6 Fine Art Society: 1902, cat. no. 153, dated June 9, 1852. It would be interesting to know how this study relates to the present drawing.

SIR EDWARD JOHN POYNTER (1836-1919)

Edward Poynter was born in Paris on March 26, 1836, the son of the architect Ambrose Poynter. The family moved back to London while Edward was still an infant. In 1853 he travelled to Rome, where in November he met Frederic Leighton. Poynter was already thinking of becoming an artist, but his friendship with Leighton strengthened his resolve to pursue an artistic career. In 1854 he returned to London where he studied first at Leigh's Academy, then at the studio of W.C.T. Dobson, R.A., and finally at the Royal Academy Schools. In 1856 he went to Paris where he enrolled in the studio of Charles Gleyre. He returned to London in 1859. In 1861 he exhibited his first work at the Royal Academy. He achieved his first success there in 1865 when he exhibited *Faithful unto Death*. In 1866 he married Agnes Macdonald, the sister of Georgiana Burne-Jones. In 1867 his painting *Israel in Egypt* was exhibited at the Royal Academy to great critical acclaim, which consolidated his reputation. He was elected an associate of the Royal Academy in 1869. In the 1870s and 1880s Poynter became increasingly involved in official duties like teaching and administration, which left him less time for painting. From 1871-75 he was the first Slade Professor at University College, London, and from 1871-81 he was appointed director for art and principal of the National Art Training School at the South Kensington Museum. In 1876 he was elected to full membership in the Royal Academy. In the 1880s the direction of his art changed away from dramatic classical subjects to more decorative classical genre subjects, similar to those of Lawrence Alma-Tadema. He was elected a member of the Royal Watercolour Society in 1883. In 1884 he accepted the directorship of the National Gallery, a post he occupied until 1906. In 1896 he was elected president of the Royal Academy, and received a knighthood. This rank was raised to a baronetcy in 1902. He resigned as P.R.A. in 1918. In 1919 he died in London, and was buried in St. Paul's Cathedral.

56 Judith and Holofernes, c. 1856-59

Watercolour and bodycolour, heightened with gum arabic, on paper 8⅝ × 5¾ in. (22 × 14.6 cm)
PROVENANCE: E.J. Poynter's studio contents; by descent to his son Hugh Poynter: given to A.W. Baldwin, c. 1965; by descent in the Baldwin family; Sotheby's, London, November 2, 1994, lot 218.
EXHIBITED: Kenderdine Gallery: 1995, cat. no. 40.

This watercolour must be very early, probably dating from the late 1850s, before Poynter's distinctive style was fully formed. Very early works by Poynter rarely come on the market, although a watercolour of *Abigail*, another Old Testament heroine, done in a similar technique and dated 1856, was offered for sale by Sotheby's, London, on June 3, 1998.[1] This work had been executed during the same year Poynter enrolled in Gleyre's atelier in Paris. As Christopher Newall has pointed out: "During this period he began to look for

serious and uplifting subjects for his works and to introduce a monumental and crafted approach in terms of treatment and composition."[1] *Judith and Holofernes* is treated in a slightly more confident manner and thus is probably somewhat later than 1856. Alison Inglis feels that both works are very similar in style and treatment, in particular the rather dark palette, the long faces and white headdresses of the two women, and Poynter's interest in authentic biblical details – jewelry, armour, etc. She even feels that *Abigail* may have been misidentified and that this subject could just as easily represent Judith and her maid going to the camp of the Assyrians. If this is the case, then *Judith and Holofernes* would simply represent a later scene within the narrative.[2]

The story of how Judith, a chaste but attractive widow, saved the Jewish city of Bethulia from capitulation to the Assyrian army beseiging it, is taken from the Book of Judith in the Old Testament. Judith, with her maid, went to the Assyrian general Holofernes and pretended to be fleeing from the Israelites. Holofernes invited her to eat and drink with him, hoping to seduce her later. When he passed out from the wine, Judith took down his sword which hung above his bed, and severed his head from his body. She gave Holofernes' head to her maid, who put it in her food bag, and they returned to Bethulia. The next morning the Israelites hung the head on the city walls. The Assyrians fled from their camp in consternation and confusion and were slaughtered by the Israelites.

As Judith and Holofernes is an Old Testament subject, one might have been tempted to associate this watercolour with the studies Poynter carried out in conjunction with the *Dalziel Bible Gallery,* to which he was an important contributor. In these illustrations, however, which date from 1863-65, the faces are already much more characteristically "Poynter"-like in appearance than are those in this early watercolour. One apparent influence on this watercolour is that of Ford Madox Brown, particularly in the figure of Holofernes, which bears a definite resemblance to the figure of King Lear in Brown's painting *Cordelia at the Bedside of Lear*, dated 1848-59. This is one of Brown's most famous early works, and Poynter would probably have seen it at some time, perhaps even earlier than when it was lent by James Leathart to the Fine Art section of the London International Exhibition of 1862. Brown's influence on Poynter's early work was not confined to this watercolour. Forrest Reid, in commenting on Poynter's designs for the *Dalziel Bible Gallery*, remarked that: "Indeed in most of them, one seems to trace the influence of Madox Brown."[3] A series of drawings by Poynter of ancient authors, likely for decorative furniture panels, dating from c. 1860, also show the definite influence of Madox Brown in the artist's handling of old men.[4] The other major influence on this work would appear to be contemporary French academic painting, to which Poynter would have been exposed while a student in Paris. Alison Inglis feels this work is more French than English in spirit, and thinks it more likely Poynter was looking to contemporary French painting for inspiration.[2] He had been much struck by the works of such painters as Alexandre-Gabriel Decamps at the 1855 Paris Exhibition, which had influenced his decision to study there. Inglis feels both the *Abigail* and *Judith and Holofernes* reflect the French interest in orientalist images of the Old Testament in which a rich expressive handling is combined with "authentic" details. The figure of the maid in *Abigail* also recalls some of Gleyre's orientalist images.[2]

Much later in his career Poynter did a fine watercolour entitled *Judith*, which he exhibited at the Grosvenor Gallery in 1881.[5] Although Judith and Holofernes was not frequently portrayed by the British artists associated with the Aesthetic Movement, it was a popular subject with European Symbolist painters who tended to transform Judith from a pious Jewish heroine into a *femme fatale*. In 1864 Frederick Sandys did a striking *Judith* in pen and ink, similar in composition to the present work by Poynter.[6] Sandys also did an oil version of

Judith in the early 1860s, consisting just of Judith's head and upper torso, similar to Poynter's watercolour of 1881.[7] J.R. Herbert's *Judith and Holofernes* of 1863 is in the collection of the Walker Art Gallery, Liverpool. Simeon Solomon painted a watercolour of 1863 entitled *Judith Going to the Assyrian Camp.*[8]

1 Sotheby's, London: *Victorian Pictures*, June 3, 1998, lot 198, signed with monogram and dated lower left 1856, 9¾ × 3½ in. This watercolour had previously been offered for sale by the Fine Art Society, London. Abigail was King David's second wife. Despite the hostility of Abigail's first husband Nabal to David, she won David's love by taking food to his army in the wilderness. In this watercolour a woman is portrayed escorting a servant, who is apparently carrying food in a basket on her head.

2 Inglis, Alison: personal communication, letter dated July 22, 1999. If she is correct, Poynter's inspiration to paint two scenes from this story may have been two small pictures by Sandro Botticelli in the Uffizi Gallery, Florence, of c. 1467-72. In one painting Botticelli depicts the Assyrians finding Holofernes' decapitated body, while the second shows Judith and her maid returning to Bethulia with Holofernes' head in a basket.

3 Reid, Forrest: 1928, p. 96.

4 Norham House Gallery: 1973, cat. nos. 36-39. These drawings included studies for Phidias, Froissart, Moses, Herodotus, and Philipe De Comynes. They had sold at Sotheby's Belgravia, *Victorian Paintings*, February 1, 1972, part of lot 62.

5 Sotheby's Belgravia, London: *Highly Important Victorian Paintings & Drawings*, April 9, 1980, lot 49, 17½ × 11 in., signed with a monogram and dated 1881. This watercolour consists of a study of the head and upper torso of Judith.

6 Wood, Esther: 1896, frontispiece.

7 Sotheby's, London: *Victorian Pictures*, June 5, 1996, lot 118, 15¾ × 11¾ in., oil on board. This painting was bought in and reoffered at Sotheby's, London, November 5, 1997, lot 188.

8 Galerie du Luxembourg: 1972, cat. no. 5, p. 26, watercolour and gouache, 50 × 33 cm, signed with monogram and dated 1863.

57 A Young Woman Sprawled in a Chair, 1861

Graphite on white wove paper; dated *1861*, lower right 4⁷⁄₁₆ × 7 in. (11.3 × 17.7 cm)

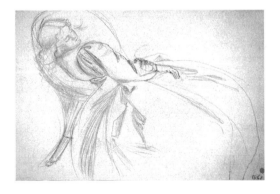

PROVENANCE: The Poynter family by descent; included in a large group of early drawings bought by John Philips, Gallery Downstairs, London; Abbott and Holder, London; purchased March 13, 1998.

EXHIBITED: Abbott and Holder, London: List no. 317, March, 1998, no. 99.

This drawing of a young woman reclining in a chair or chaise longue serves to illustrate just how closely Poynter was involved with members of the avant-garde in the early 1860s. It is very reminiscent of D.G. Rossetti's many studies from the 1850s of Elizabeth Siddal lounging in chairs,[1] and later, in the 1860s, those depicting Fanny Cornforth.[2] It is also similar to Whistler's famous etching *Weary* of 1863, depicting his mistress Joanna Hiffernan.[2] This drawing by Poynter is dated 1861, but the date appears to have been added later, since it is in a different shade of graphite. Although it appears to be in Poynter's hand, the date may be inaccurate, depending on how much later it was added.

By 1861 Poynter was well acquainted with many of the most progressive British painters

and architects of the age. At the age of seventeen, while in Rome in 1853, he had met Frederic Leighton and the architect William Burges. From 1856–59 Poynter trained at Gleyre's studio in Paris. For a short time he shared rooms with James Whistler. He also met other artists studying in Paris, including George du Maurier, Thomas Armstrong, and Val Prinsep, and became acquainted with Luke and Alecco Ionides. In 1859 Poynter returned to live in London. George Price Boyce's diary records that on February 2, 1859, after calling on D.G. Rossetti, he had dinner at the home of Ambrose Poynter, where his son Edward was also present.[3] Boyce was an intimate of the inner Pre-Raphaelite circle, as well as a member of the Hogarth Club, and could therefore have introduced the young Edward to a number of his progressive artist friends. On April 30, 1859 Boyce records that he "found Simeon Solomon and Poynter in Burges' room and appropriated (by leave) a caricature by Simeon of Morris and his wife."[3] George du Maurier's letters from the early 1860s contain many references to Poynter, including a visit the two of them made to Tulse Hill, the home of Alexander Ionides, in November 1860.[4] The Ionides family patronized many of the young avant-garde artists including Whistler, Poynter, Rossetti, Burne-Jones, and particularly G.F. Watts. Rossetti apparently did not make his first visit to Tulse Hill until 1863,[5] although Luke Ionides says 1862 in his book of reminiscences.[6] It is not certain when in the early 1860s Poynter first made the acquaintance of Edward Burne-Jones, but by February 1862 his friend George du Maurier had already met Edward and Georgiana Burne-Jones through Val Prinsep.[4]

It is certainly possible, therefore, that Poynter could have had personal contact with Rossetti by 1861, but it is impossible to know whether or not he had actually seen similar studies by Rossetti at that time. It would be tempting to think that Poynter might have seen such works at the home of his friend G.P. Boyce, since Boyce owned a large collection of works by Rossetti. Boyce owned only one drawing depicting Elizabeth Siddal, however, and this was an almost full-length standing figure.[7] Although Boyce owned a drawing of Fanny Cornforth reclining on a sofa, this work is dated Dec. 7, 1862.[8] If the present drawing by Poynter actually dates from 1861, it could not have been influenced by Boyce's Rossetti.

This drawing likely came from a sketchbook. Whether it is of a professional model, a relative, or a friend is uncertain. Whoever the sitter was, her clothing appears typical of the 1860s period. Because of the very full skirt, this does not appear to be an early example of the "aesthetic dress", which was popular with the wives of Pre-Raphaelite painters, such as Elizabeth Siddal or Jane Morris. If this drawing does date to 1861, it is too early to be a study of Poynter's future wife Aggie Macdonald, whom he married on August 9, 1866. It could be a study of his sister Clara Bell, however, whom du Maurier described as 'very pretty" in a letter to his mother of June 1860.[4] It may have been a study created purely for his own pleasure, or could perhaps be a rough sketch for an illustration. By 1861 Poynter was drawing illustrations for magazines. One design of a woman asleep sprawled in an armchair appeared in *Once A Week* on October 4, 1862, as an illustration to "A Dream of Love". This drawing, however, is not a preliminary study for this illustration. Although the illustration shows a definite Pre-Raphaelite influence, it is most reminiscent of the work of Frederick Sandys and not of Rossetti. A study for this illustration sold at Christie's, London in 1969.[9]

1 Surtees, Virginia: 1991, figs. 22, 31, 44, and 51.
2 Lochnan, Katharine A.: 1984, fig. 181, p. 150, and fig. 182, p. 151.
3 Surtees, Virginia: 1980, pp. 26-27.
4 du Maurier, Daphne: 1951, pp. 4, 21 and 114.
5 Ionides, Julia: "The Greek Connection – The Ionides Family and their Connections with Pre-Raphaelite and Victorian Art Circles" in Casteras, S. P. and Faxon, A. C.: 1995, p. 162.
6 Ionides, Luke: 1996, p. 11. "In 1862 Jimmy and Tom Armstrong brought Rossetti to our house. It was

my first acquaintance with Rossetti. I had heard a great deal about him from Jimmy, who had a great admiration for him."

7 Surtees, Virginia: 1971, cat. no. 514, p. 197. This drawing is illustrated in National Gallery of Victoria: 1978, cat. no. 32, p. 52. Alastair Grieve has subsequently identified it as a study for Rossetti's painting *St. Catherine* of 1857.

8 Agnew's: 1990, cat. no. 78, pencil 12½ × 7½ in. See Surtees, Virginia: 1971, cat. no. 219, p. 161.

9 Christie's, London: *English Prints, Drawings and Watercolours*, July 15, 1969, lot 105, pencil on light brown paper, 9 × 7¾ in., bought Maas Gallery.

58 Obedience, 1868

Watercolour on wove paper; signed with monogram and dated *1868*, lower right; inscribed on the mount, under the image, "E.J. Poynter A.R.A." with a quotation from Milton "My author and disposer! what thou bidst, unargued I obey. Paradise Lost"
6 × 4½ in. (15.3 × 11.2 cm) - image size
PROVENANCE: Warne & Co. Ltd; their sale Christie's, London, March 5, 1870, lot 30, bought Johnson; Lynch White, Leigham House, Streatham SW, London; his sale, Christie's, London, June 6, 1889, lot 92, bought Fraser; anonymous sale, Christie's, South Kensington, May 4, 1995, lot 62, bought Neil MacMillan, London; purchased June, 1995.
LITERATURE: *The Architect*: 1870, p. 62.
EXHIBITED: Dudley Gallery: 1869, cat. no. 519d; Kenderdine Gallery: 1995, cat. no. 41.

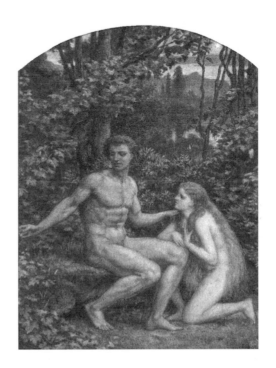

Obedience is one of a series of four watercolours that Poynter executed as illustrations for *The Nobility of Life, its Graces and Virtues*, published by Frederick Warne and Company in 1869.[1] This image of Adam and Eve appeared as a colour plate on page 125, accompanied by a quotation from *Paradise Lost:* "'Obedience. / My author and disposer, what thou bidd'st / Unargued I obey; so GOD ordains.' – MILTON". Milton's poem was apparently so popular with Poynter that his son recalled that the artist was able to quote it in its entirety by heart.[2] The other three watercolours Poynter produced for the book were *Mercy*, *Cheerfulness*, and *Youth*. The 1868 watercolour version of *Mercy*, *The Prodigal Son* is in the Forbes Magazine Collection, New York, as is the larger oil version exhibited at the Royal Acdemy in 1869.[3] The watercolour has a similar arch-shaped frame, suggesting this was the type of frame the works were in when they were exhibited at the Dudley Gallery in 1869.[1] *Cheerfulness* sold at Sotheby's Belgravia in 1971.[4]

This watercolour of *Obedience* is typical of Poynter's work from this period. The figure of Adam closely resembles the heroic male nudes seen in his *Israel in Egypt* of 1867 and *The Catapult* of 1868. Both paintings were exhibited at the Royal Academy to great acclaim, and helped secure Poynter's election as an associate of that body in 1869. The figure of Adam is clearly influenced by Michelangelo, a painter for whom Poynter had a life-long admiration. As Malcolm Bell stated: "This passionate devotion – it can be adequately described in no

colder phase – was of very early growth, dating from his first visit to Rome in 1853 … That he did and does fully appreciate the distinguished qualities of the other artists named above need not be doubted, but no one of them has exercised so deep and lasting an influence on his artistic development as Michel Angelo. On a close and intelligent study of his methods he has very largely founded his own, and the spirit that inspired both may pardonably be denoted a rightly scientific one."[5] In 1879, in his ninth Slade lecture, Poynter praised Michelangelo: "The third condition, that which distinguishes the true artist from the mere painter possessed of poetic conceptions, is that the action of the figure shall be expressed in the most beautiful manner, and shall be studied so as to give the artist an opportunity for the display of the highest beauty of the form, whether it be nude or draped … All these conditions Michelangelo fulfilled in a higher degree than any artist that has lived since the best Greek period."[6] Poynter was obviously influenced by Michelangelo long before his brother-in-law Edward Burne-Jones.[7] Poynter's enthusiasm for this Renaissance master may have been at least partially resposible for Burne-Jones' later interest in him.

The pose of the figure of Eve may have been influenced by that of the Virgin Mary in Burne-Jones' early watercolour *The Annunciation (The Flower of God)* of 1862-63. It is interesting to speculate if Poynter, either consciously or unconsciously, used the pose of the Virgin Mary, known as the new Eve, who was to help redeem mankind through the death of her son Jesus Christ on the cross, for the woman whose temptation in the garden of Eden had led to the "original sin".

Obedience shows Poynter's considerable skill as a water-colourist. He had been taught the rudiments of watercolour drawing while still a teenager by Thomas Shotter Boys. Poynter excelled in this medium, particularly in the landscapes he painted for his own pleasure. In 1883 he was elected first an associate, and then a full member of the Royal Society of Painters in Water Colours.

A study entitled *Adam and Eve* was exhibited by the Fine Art Society in 1889, and at their Poynter exhibition in November 1903.[8]

1 Valentine, L.: 1869. Poynter was one of several artists, including H. Le Jeune, F. Walker, J.D. Watson, E. Duncan and others who contributed a total of twenty-four illustrations to this book. The illustrations were printed in colour, with elaborate borders, headings and vignettes. I am grateful to Alison Inglis for this information, in a letter of July 22, 1999.

2 Baldwin, A.W.: 1960, p. 165.

3 Metropolitan Museum of Art, New York: 1975, cat. no. 56, *The Prodigal's Return*, oil on canvas, 47 × 36 in., dated 1869. It had sold Christie's, London, July 14, 1972, lot 107, bought Fine Art Society.

4 Sotheby's Belgravia: *Fine Victorian Paintings*, October 19, 1971, lot 71, *The Merry Dance of May*, 6 × 4½ in., dated 1868. Alison Inglis has identified this work as being *Cheerfulness* for *The Nobility of Life*, but does not know if it is still in its original arch-shaped frame.

5 Bell, Malcolm: 1906, pp. 3-5.

6 Arts Council of Great Britain: 1978, cat. no. 46, p. 70. Edward Poynter: *Ten Lectures on Art*, 1879, pp. 236-237.

7 Arscott, Caroline: "Poynter and the arty" in Prettejohn, Elizabeth: 1999, pp. 135-149. Arscott discusses in depth Michelangelo's influence on Poynter.

8 Fine Art Society: 1889, cat. no. 151 and 1903, cat. no. 78.

59 Study of a Nude Female Figure with Upraised Arms for "The Festival," c. 1875

Black chalk on light brown wove paper
13¼ × 11¼ in. (33.7 × 28.7 cm)
PROVENANCE: ? the artist's sale, Christie's, London, January 19, 1920, part of lot 11, bought J. Rimell & Son, London; anonymous sale, Phillips, London, May 23, 1988, lot 265, bought Abbott and Holder, London; purchased February 17, 1989.
EXHIBITED: Kenderdine Gallery: 1995, cat. no. 42.

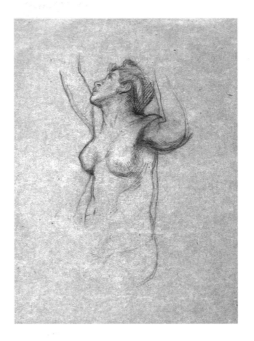

Poynter was one of the finest academic draughtsmen of the 19th century and a thoroughly conscientious worker. Because of his technical skill, his studies of the nude are always masterful, although as Graham Robertson has pointed out, he was "helpless without the model before him."[1]

This drawing is a study for the lower of the two female figures in *The Festival*, one of a pair of paintings exhibited at the Royal Academy in 1875. These pictures were with Colnaghi's, London in 1972 but are currently untraced.[2] They were based on a pair of earlier watercolours of Summer and Autumn, entitled *The Festival* and *The Golden Age*, dated 1870, formerly in the Handley-Read Collection,[3] and subsequently owned by the MacMillan and Perrin Gallery, Vancouver and Toronto.[4] This drawing is obviously a study for the figure in the later oil painting, however, rather than the earlier watercolour.

The early watercolours have much in common with preparatory drawings Poynter made in connection with his commission for the decoration of the Grill Room at the South Kensington Museum, later the Victoria and Albert Museum, London. Poynter designed twelve tile panels representing the months of the year, four tile panels of the Seasons, and a series of roundels representing mythological subjects. These designs date from 1868-71. The tiles are blue and white, as is the colour scheme in the early watercolours, but the watercolours do not correspond to any of the tile designs.

Other figure studies for *The Festival* sold at Christie's, London on November 1, 1990.[5] A drapery study sold at Christie's, London on July 18, 1989.[6] A more finished study for this drapery is in the Princeton University Art Museum, Princeton, New Jersey.

1 Robertson, W. Graham: 1931, p. 85.
2 *Burlington Magazine*: Vol. CXIV, No. 837, December 1972, p. lxiv, each oil on canvas, 54 × 21 in., dated 1875.
3 Royal Academy of Arts: 1972, cat. nos. D149 and D150, p. 80.
4 MacMillan & Perrin Gallery: 1977, cat. no. 10.
5 Christie's, London: *Victorian Pictures, Drawings and Watercolours*, November 1, 1990, lot 23, pencil, 8¾ × 11 in.
6 Christie's, London: *British Drawings and Watercolours*, July 18, 1989, part of lot 18.

60 Study of a Female Head for "Diadumene," c. 1883

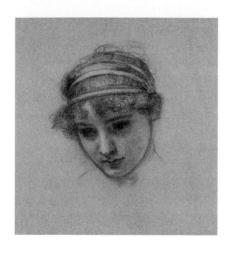

Black chalk on light brown wove paper; inscribed on the verso in red ink, in an unknown hand, "J: P: H:" 8¾ × 9¾ in. (22.2 × 24.8 cm)
PROVENANCE: J.P. Heseltine; ?his sale, Sotheby's, London, May 29, 1935, part of lot 346 or lot 347; David Routledge; sold on March 26, 1985 to Maas Gallery, London; purchased September 26, 1985.
EXHIBITED: Kenderdine Gallery: 1995, cat. no. 43.

The head in this drawing is characteristic of the typical "Poynter" face. It is a study for *Diadumene*, a painting showing a young Roman woman at her toilette. The painting exists in two versions. The first, dated 1883, was shown at the Royal Academy in 1884 and is in the collection of the Royal Albert Museum in Exeter.[1] The second, a larger version, was shown at the Royal Academy in 1885, and was sold at Sotheby's, London in 1989.[2] Poynter later added drapery to this second composition as the totally nude figure of Diadumene shocked the public, and led to accusations of indecency.[3] This controversy was generated initially by a letter to *The Times* from "A British Matron," which appeared on May 20, 1885, condemning "the indecent pictures that disgrace our exhibitions" with "nakedness in all perfection of representation."[4,5] The pictures were felt to be "an insult to the modesty which we should desire to foster in both sexes."[4] Her position was supported by John Ruskin, then in an unstable mental state. Poynter defended his original conception, however, by claiming the figure was based on a classical prototype, the "Esquiline Venus". This was unearthed in 1874 on the Esquiline Hill in Rome and is now in the Capitoline Museum.[6] The painting was named after the similarly posed "Diadumenos" of Polycleitus, although this was a statue of a nude male figure. Diadumenos is a Greek word that describes the action of a figure tying a fillet around the head.[1] Poynter had followed the convention of representing a female nude tying a fillet around her head, as had previously Albert Moore in his *A Venus* of 1869, and Lawrence Alma-Tadema in *A Sculptor's Model* of 1878.[6]

Poynter was not the first Victorian artist to base a painting on the "Esquiline Venus", since the model in Alma-Tadema's *A Sculptor's Model* also reproduced the pose of this statue.[1,7] His nude female figure also aroused considerable protest when the painting was exhibited in London and Liverpool in 1878.[3,7] The figure type of the "Esquiline Venus" therefore already had a controversial history in contemporary debate on the nude figure in art when Poynter chose to copy it yet again in *Diadumene*.[1] In a letter of May 28, 1885 to the editor of *The Times*, Poynter defended his *Diadumene* by claiming he wished his painting "to give some idea of what the bath-room of a lovely Greek or Roman girl might be."[1] He thus attempted to make the painting more respectable by presenting it as a form of research into Roman bathing customs, which was supported by the archeological specificity of the sumptuous antique Roman interior.[1] Poynter later came to regret his decision to repaint the second version of this painting. In 1915 he wrote: "After the picture came back from the M'chester Exhibition I painted a drapery over the figure, for which I am now very sorry – I still have it, & of course shd be glad to dispose of it."[4]

Additional studies were with Peter Nahum, London in 1985 and 1989.[8,9] Another study is reproduced in Malcolm Bell's book on Poynter's drawings.[10]

1 Prettejohn, Elizabeth: Bristol City Museum and Art Gallery,1996, cat. no. 56, pp. 152-154, oil on canvas, 20 × 20 in.
2 Sotheby's, London: *Nineteenth Century European Paintings, Drawings and Sculpture*, June 20, 1989, lot 38, oil on canvas, 88 × 52½ in.
3 Smith, Alison: 1996, pp. 186-187 and 202-209. Fig. 59 shows the second version after Poynter had repainted it to add drapery to cover the abdomen and lower parts of the body.
4 Kestner, Joseph A.: 1989, pp. 221 and 227, MS Victoria and Albert Museum, London.
5 Smith, Alison: "The 'British Matron' and the body beautiful: the nude debate of 1885" in Prettejohn, Elizabeth: 1999, pp. 217-234. In Smith's excellent essay the background to this debate is covered in detail.
6 Smith, Alison: "Nature Transformed: Leighton, the Nude and the Model" in Barringer, Tim and Prettejohn, Elizabeth: 1999, pp. 37 and 47 n.45. Although the Venus Esquilina was discovered in 1874, it emerged as a series of fragments. First the head, then the torso, and finally the legs and left hand were found, but the arms were never recovered.
7 Becker, Edwin: 1996, cat. no. 47, pp. 202-203. The Bishop of Carlisle, for instance, in a private letter, commented on Alma-Tadema's painting: "for a living artist to exhibit a life-size, almost photographic representation of a beautiful naked woman strikes my inartistic mind as somewhat, if not very, mischievous."
8 Nahum, Peter: 1985, cat. no. 49, brown chalk on white paper, 11¼ × 7⅞ in., dated Feb. 13, 82. This drawing has subsequently been offered for sale at Christie's, London on June 11, 1993, lot 89A and March 10, 1995, lot 122 and at Sotheby's, London on March 12, 1997, lot 200. It was sold at Sotheby's, London, on November 11, 1998, lot 288 where it was bought by Abbott and Holder. It was offered by them in their list no. 323, January 1999, no. 101.
9 Nahum, Peter: 1989, Vol. I, cat. no. 112, Vol. II, pl. 78, red chalk on white paper, 14½ × 10 in., dated Dec. 20, 81. This drawing was offered for sale at Christie's, London on June 3, 1994, lot 87, and then at Sotheby's, London, November 11, 1998, lot 294.
10 Bell, Malcolm: 1906, pl. XXVIII, dated June 13, 84.

61 Nude Studies of Three Dancing Female Figures for "The Wandering Minstrels," 1886

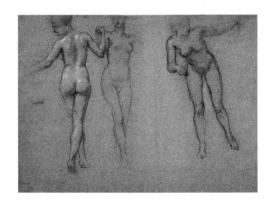

Black chalk, heightened with white, on dark orange wove paper; bears studio stamp, lower right; dated *Jan.11.86*, on left
13⅞ × 20 in. (35.3 × 51.3 cm)
PROVENANCE: ? artist's sale, Christie's, London, January 19, 1920, part of lot 19, bought C. Huggins, London; anonymous sale, Phillips, London, April 15, 1985, lot 45.
EXHIBITED:? Fine Art Society: 1903, cat. no. 1, 15, or 68; Kenderdine Gallery: 1995, cat. no. 44.

Since this drawing is dated 1886, it is more likely a study for *The Wandering Minstrels*, painted for the keyboard panel of the Steinway piano, designed and decorated by Lawrence Alma-Tadema in the 1880s for Henry Marquand, a New York banker and real estate entrepreneur.[1-4] Poynter later reused part of the composition of this panel for a painting entitled *Horae Serenae*, dated 1894, in the collection of the Bristol City Art Gallery.[5] The compositions of the two versions differ somewhat, particularly in the side portions. Poynter was impressed with this piano, and in a letter written to Marquand stated: "I have no hesitation in saying that

it is the most beautiful piece of work, both for the design and the workmanship that I ever saw. In fact, I do not believe that anything has ever been done to equal it."[1] It was Alma-Tadema that suggested Poynter to execute the painting for the keyboard panel. In a letter of February, 1886 Alma-Tadema wrote to Henry Marquand: "I took the liberty of ordering Poynter, as you know one of our very best artists, to paint the inside lid of the piano. He is a classic artist, who will I am sure make something beautiful of it."[1]

Horae Serenae ("Peaceful Hours") is one of the most successful of Poynter's late decorative paintings, and the themes of both music and dancing make it very much an Aesthetic subject. In Greek mythology the Horae were personifications of the seasons, and only later did they come to represent the hours. When the painting was exhibited at the Royal Academy in 1894, the critic of *The Athenaeum*, likely F.G. Stephens, reported that it was "a charming picture, full of light, action and colour."[5] This drawing is a study for the dancing figures in the central part of the composition in both the piano panel and the painting. This study again shows Poynter's technical mastery in drawing the nude figure, especially the figure on the far right, which is in a difficult pose to capture correctly.

Edward Burne-Jones told his studio assistant Thomas Rooke that he much preferred the earlier version done for the piano, when Rooke, on December 23, 1896, mentioned that there was an engraving of a picture by Poynter about everywhere just now of a dance. Burne-Jones remarked: "I know, where the people are not dancing much....He first did a little one that was very nice, but when he enlarged it to this one the design didn't bear it. Never looked as though it were meant for that scale. A most pretty thing the little one was – it was a panel in a piano that Tadema partly designed in a rather expensive manner. The whole piano cost about £8000. It was done for a rich man in Liverpool [sic] named Marquand. In that piano this little picture was the gem. A pretty dance with a pretty landscape background and trees and clipped hedges with rather dull ends, especially on the left hand side. I think it was a philosopher sitting down; something going on in other corners. Now a philosopher doesn't do in a picture, he's always such a bore."[2]

The painting depicts an entertainment in a coastal villa in ancient Rome, perhaps a Vintage Festival. The landscape background evokes the Bay of Naples, where there were fashionable country estates for the wealthy of the Imperial period.[6] In the centre of the composition a vine-wreathed maiden twirls a bacchic thyrsus and leads her five companions in a dance.[1] The frieze-like arrangement refers back to classical precedents, such as the famous "Aldobrandini Wedding" in the Vatican Museum in Rome.[6] Elizabeth Prettejohn feels that: "The central group of dancing figures has the appearance of a quotation; it might be to an expanded group of Graces, or a reference to Poussin's *Dance to the music of time* (Wallace Collection, London). The central figure with pale fluttering draperies, seen from behind, is reminiscent of the dancing figures that float in the centres of panels in Pompeian wall decorations."[6] The group of three dancers to the right in *Horae Serenae* may have also been influenced by the three nymphs in Walter Crane's *The Sirens*, exhibited at the Grosvenor Gallery in 1879.[7]

Additional studies for *The Wandering Minstrels* and/or *Horae Serenae* sold at auction at Phillips, London, on April 15, 1985.[8] Some of these drawings were subsequently exhibited at the Shepherd Gallery, New York, in 1986, 1989, and 1994.[9-11] Another study was exhibited at the Maas Gallery in 1996.[12] Studies for *Horae Serenae* sold at Christie's, London on July 23, 1974,[13] September 19, 1978,[14] May 22, 1990,[15] October 29, 1991,[16] and March 13, 1992.[17] A study of dancing figures and other drawings for *Horae Serenae* are reproduced in Malcolm Bell's book on Poynter's drawings.[18]

1 Christian, John: Christie's, London, *Fine Victorian Pictures, Drawings and Other Works of Art*, November 7, 1997, lot 86, the Alma-Tadema-Poynter piano, pp. 70-87.

2 Lago, Mary: 1982, fig. 10 and pp. 126-127. In 1903 the piano was bought by William Barbour of New York at Marquand's sale at the American Art Association on January 31, 1903, lot 1363. In the 1920s the piano was bought by Martin Beck, who placed it in the mezzanine of the Martin Beck Theatre in New York. In 1980 it was bought at auction by a New York investment banker. It is now in the Sterling and Francine Clark Art Institute, Williamstown, Massachusetts.

3 Treuherz, Julian: "Alma Tadema, aesthete, architect and interior designer" in Becker, Erwin: 1996, p. 50.

4 Kisluk-Grosheide, D.O.: 1994, pp. 151-181.

5 *The Athenaeum*: no. 3471, May 5, 1894, p. 584.

6 Prettejohn, E.: Bristol City Museum and Art Gallery, 1996, cat. no. 61, pp. 164-165.

7 Crane, Walter: 1907. A sketch for *The Sirens* is illustrated on p. 207.

8 Phillips, London: *Fine 18th and 19th Century English Drawings and Watercolours*, April 15, 1985, lots 44, 46, 53 and 57. Some of these studies were obviously solely for the earlier piano panel, while others were just for the later painting.

9 Shepherd Gallery: 1986, cat nos. 74 and 75. These drawings were later with Christopher Wood (see n. 11). Cat. no. 75 was with Abbott and Holder, London in November 1999.

10 Shepherd Gallery: 1989, cat. no. 102. This drawing was later sold at Christie's, London on October 29, 1991, lot 3 (see n.16).

11 Shepherd Gallery: 1994, cat. nos. 110 and 111, on loan from Christopher Wood, London. Cat. no. 110 was with Abbott and Holder, London, in November 1999.

12 Maas Gallery: 1996, cat no. 59, but mistakenly illustrated as cat. no. 58. This drawing originally sold Phillips, London, April 15, 1985, part of lot 45, charcoal on brown paper, $9\frac{1}{2} \times 15$ in.

13 Christie's, London: *Fine Victorian Pictures, Drawings and Watercolours*, July 23, 1974, lot 18, black and white chalk on grey paper, $13\frac{1}{4} \times 9\frac{3}{4}$ in.

14 Christie's, London: *English Drawings and Watercolours*, September 19, 1978, lot 68, black and white chalk on grey paper, $13\frac{3}{4} \times 9\frac{3}{4}$ in.

15 Christie's, London: *British Drawings and Watercolours*, May 22, 1990, part of lot 8, draped female figure seen from behind.

16 Christie's, London: *Victorian Pictures, Drawings and Watercolours*, October 29, 1991, lot 3, black and white chalk on brown paper, $13\frac{3}{4} \times 10$ in. For another drawing of this same figure see Art Gallery of New South Wales: 1975, cat. no. D15, p.35, illus. p.70.

17 Christie's, London: *Victorian Pictures, Drawings and Watercolours*, March 13, 1992, lot 74, Study of a woman in a classical dress, black and white chalk on brown paper, $15 \times 9\frac{1}{2}$ in.

18 Bell, Malcolm: 1906, pl. IV (1886), pl. XXV, dated Jan.5.8.86, and pl. XIII (1894). The drawing illustrated in Plate IV was with Abbott and Holder, London, in January 2000.

62 Study of a Female Nude with Crossed Arms (possibly for "The Ionian Dance"), c. 1895

Black and white chalk on orange-brown wove paper; bears studio stamp, mid lower right $10 \times 13\frac{7}{8}$ in. (25.4×35.4 cm)

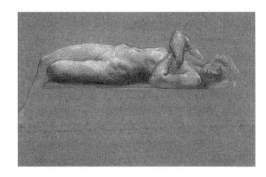

63 Study of a Female Nude Stretching (probably for "The Ionian Dance"), c. 1895

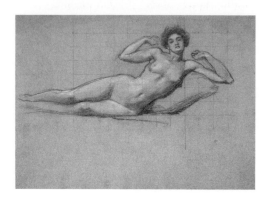

Black and white chalk on pale orange-buff wove paper, squared for transfer; bears studio stamp, lower right 10¾ × 14 in. (26.3 × 35.7 cm)

PROVENANCE: ? artist's sale, Christie's, London, January 19, 1920, part of lot 19, bought C. Huggins, London; anonymous sale, Phillips, London, April 15, 1985, lot 56 (both works).

EXHIBITED: Kenderdine Gallery: 1995, cat. nos. 45 and 46 respectively.

These two drawings may be preliminary studies for reclining figures in *The Ionian Dance* or *The Skirt Dance*, although they do not correspond to any of the figures in the final compositions. Poynter did, however, explore various alternative poses in his studies for the spectators. The technique used in the first drawing corresponds closely to other drawings known for *The Ionian Dance*.[1] This drawing of a sensuous female nude on brown paper is reminiscent in its technique of similar drawings by Poynter's brother-in-law Edward Burne-Jones, particularly his studies for *The Golden Stairs*.[2] Other studies for the spectators in *The Ionian Dance* were included in the sale at Phillips, London on April 15, 1985.[3] Studies closely corresponding to the two drawings exhibited here were purchased from this sale by the Maas Gallery and Julian Hartnoll, London.[4]

Alison Inglis has examined photographs of these two works and feels that the drawing of the reclining figure on brown paper is less of a match with the *Ionian Dance/Skirt Dance*, as the horizontal ledge on which the figure reclines does not suggest the curving seat in the pictures. She feels the thin, somewhat angular model is reminiscent of those depicted in later works, such as *The Love Philtre*. After considering various other possible contenders which include reclining female figures, such as *A Little Mishap* and *The Wonders of the Deep: An Idyll*, or *The Sea-Bath* which shows female figures on the end of a square-ledged bath, she concluded that none of these seemed any more likely as the source for this study. Inglis also found it curious in looking at the second drawing that Poynter would square a figure for transfer and then not use it, although apparently there are other precedents for this. She felt, however, the features of this model were very similar to others employed in the *Ionian Dance/Skirt Dance* images.[5]

The Ionian Dance was exhibited at the Royal Academy in 1895, while the closely related painting *The Skirt Dance* was shown there in 1898. Both paintings depict a young woman in diaphanous drapery dancing in a resplendant marble hall to a woman playing on pipes, while women and girls watch in the background to the left and right. There are significant differences between the two versions of this composition, particularly in the arrangement of the spectators on the right-hand side.

The theme of dancing figures appears to have appealed strongly to Poynter, and dancers are incorporated into many of his important paintings, including his *Horae Serenae* of 1894 (see cat. no. 61). Even as early as 1867 Poynter exhibited an extraordinary watercolour, *The Serpent Dance*, at the Dudley Gallery, now in the collection of the Art Gallery of Ontario.[6]

1 Bell, Malcolm: 1906, pl. XLI.
2 Art Gallery of Ontario: 1993, cat. no. A:38, p. 88, illus. p. 89.
3 Phillips, London: *Fine 18th and 19th Century English Drawings and Watercolours*, April 15, 1985, lot 58, bought Maas Gallery, London. This drawing subsequently sold at Christie's, London, March 10, 1995, lot 123.
4 Shepherd Gallery: 1986, cat. nos. 72 and 73, on loan from Julian Hartnoll, London. A possible related study to cat. no. 72 was offered for sale at Sotheby's, London: *Early British and Victorian Drawings and Watercolours*, January 31, 1990, lot 382, nude with arms outstretched, black and white chalk on brown paper, 13 × 9½ in.
5 Inglis, Alison: Personal communication, letter dated July 25, 1999.
6 Waddington's, Toronto: *Important British, European and American Oil Paintings, Watercolours, Drawings and Prints*, December 9, 1994, lot 1585, 17½ × 12½ in., dated 1866. It was exhibited at the Dudley Gallery: 1867, cat. no. 586, p. 24.

64 Study of a Nymph for "The Cave of the Storm Nymphs," 1901

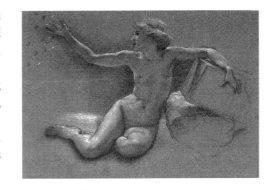

Black and white chalk, lightly squared, on dark grey-green wove paper; unknown oval collector's stamp, lower right 8⅝ × 12⅝ in. (21.9 × 31.9 cm)
PROVENANCE: Fine Art Society in 1903; anonymous sale, Christie's, London, July 24, 1984, lot 215.
LITERATURE: *Pall Mall Magazine*: 1902, p. 70 (illus.); Fyffe, Henry E.: 1902, p. 162 (illus.); Bell, Malcolm: 1906, pl. XLIV.
EXHIBITED: Fine Art Society: 1903, ? cat. no. 12, 16, 21, 49, 63, 75 or 89; Kenderdine Gallery: 1995, cat. no. 47.

This drawing, one of Poynter's finest, is for the central figure in *The Cave of the Storm Nymphs*. Christopher Newall has remarked: "Poynter's drawings in black and white chalk on coloured paper for *The Cave of the Storm Nymphs* belie the long gestation of the subject by their spontaneity and sensuousness of visual response."[1] Joseph Kestner feels that Poynter's studies for this painting "indicate he is feminizing the massive features of some of the Sistine Chapel figures, particularly of Michelangelo's sybils, who while feminine have a masculine solidity. Poynter retains their poses, but converts them to svelte women."[2] The pose in the present drawing is very close to that chosen by Poynter for the finished painting, but in the final composition the hair is much wilder and free-flowing, thereby increasing the eroticism of the image.

Poynter painted two versions of this subject, the smaller exhibited at the Royal Academy in 1902, and the larger, differing in many details, shown in 1903. The latter is considered the masterpiece of Poynter's late career. When it was shown at the Royal Academy in 1903 A.L. Baldry, the reviewer for the *Art Journal*, reported: "In the post of honour on the north wall is Sir E.J. Poynter's 'The Cave of the Storm Nymphs', a larger version of the little composition which he exhibited last year. It has both the merits and the faults of his work – sound drawing, careful modelling, and agreeable line arrangement ... There is more learning than inspiration in the picture; it is laborious and strangely lacking in spontaneity."[3] This second version has appeared a number of times recently on the London art market,[4] and at one time had set a record for the highest price paid for a Victorian painting.

When this painting was exhibited at the International Exhibition in St. Louis in 1904, the handlist for the exhibition noted that it was intended to suggest the indifference of nature to destruction and the worthlessness of the prizes of life. A poem was inscribed on a label on the reverse of the frame:

> Careless of wreck or ruin, still they sing
> Their light songs to the listening ocean caves,
> And wreathe their dainty limbs, and idly fling
> The Costly tribute of the cruel waves.
> Fair as their mother – foam, and all as cold
> Untouched alike by pity, love or hate;
> Without a thought for scattered pearl or gold,
> And neither laugh nor tear for human fate.

The storm nymphs could represent Nereids, but are more likely Sirens, sea nymphs whose singing was so lovely that it charmed all who heard it, causing mariners who were passing their island to be irresistibly impelled to cast themselves into the sea to their destruction. Poynter had treated this subject much earlier in *The Siren*, one of the early masterpieces of the Aesthetic Movement, which had been exhibited at the Royal Academy in 1864.[5] In *The Cave of the Storm Nymphs* the singing of the nymphs has apparently lured a sailing vessel to its destruction, and the nymphs can be seen examining treasures from the wreck, including gold coins, jewelry, and fine fabrics. One posssible source of inspiration for this painting could be George Pinwell's illustration *The Sirens*, which appeared in the magazine *Once a Week* on November 21, 1863. The general composition of Poynter's painting, as well as the figures of the nymph at the top and the reclining nymph in the foreground, has much in common with Pinwell's drawing. Poynter had contributed to this same magazine earlier in 1863. The cave in Poynter's painting appears to be based on studies of cliffs he did at Tintagel in September, 1901.[6,7,8]

Malcolm Bell's book on Poynter reproduces four drawings from 1901 for *Storm Nymphs*, including this one.[6] Another study is in the collection of the Art Gallery of Ontario, Toronto. A drawing of the head of the uppermost nymph, with the hair bound up, is at the Ashmolean Museum, Oxford. A study was with Christopher Powney and Julian Hartnoll in 1979.[9] Additional drawings have sold at Sotheby's, London on July 10, 1995[7] and at Christie's, London, on June 4, 1982,[10] October 31, 1989,[11] and March 13, 1992.[12]

The theme of sirens was a popular one in Victorian art and was treated by other important artists associated with the Aesthetic Movement, including Frederic Leighton, D.G. Rossetti, Edward Burne-Jones, Walter Crane, J.W. Waterhouse, and Herbert Draper.

1 Newall, Christopher: Sotheby's, London, *Victorian Pictures*, November 2, 1994, lot 215, p. 134.
2 Kestner, Joseph A.: 1989, p. 225.
3 Baldry, Alfred Lys: "The Royal Academy Exhibition of 1903", *Art Journal*, 1903, p. 168.
4 It sold at Christie's, London on March 21, 1969 for £3,518; Sotheby's Belgravia on March 23,1981, lot 74 for £198,000; Christie's, London, November 25, 1988, lot 119 for £440,000; and Sotheby's, London, November 2, 1994, lot 215 for £551,500.
5 Christie's, London: *Fine Victorian Pictures, Drawings and Watercolours*, November 5,1993, lot 172, pp. 126-127.
6 Bell, Malcolm: 1906, figure studies are pl. XXXI, dated Oct,1901; pl. XLIII, dated Ap. 15, 1901; pl. XLIV, and pl. XLVI. Studies of the cliffs at Tintagel include pl. XXXIX, dated Sep. 1901, and pl. XLII, dated Sep 5, 1901.
7 Sotheby's, London: *Drawings from Britain and the Continent*, July 10, 1995, lot 222, study for *Cave of the Storm Nymphs-Tintagel*. Inscribed, lower right, "Tintagel/Sep 6.1901", pencil, 7 × 10½ in.

8 Sotheby's, London: *Victorian Pictures,* November 2, 1994, lot 216, *A Cave at Tintagel,* oil on panel, 9¾ × 14 in., dated 1903. This painting is likely based on his earlier drawings.

9 Powney, Christopher and Hartnoll, Julian: 1979, cat. no. 53, black chalk heightened with white on pale red paper, 11 × 8 in.

10 Christie's, London: *Important Victorian Pictures, Drawings and Watercolours,* June 4, 1982, lot 53, a preliminary study for the reclining nymph in the foreground, black and white chalk on brown paper, 14½ × 20¾ in. Lot 55, studies of a seated nymph, black and white chalk on red-brown paper, 11½ × 9½ in.

11 Christie's, London: *British Drawings and Watercolours,* October 31, 1989, lot 214, study of the head of the uppermost nymph, black and white chalk on buff paper, 8⅝ × 6⅝ in. In this drawing the hair is unbound as it is in the finished painting.

12 Christie's, London: *Victorian Pictures, Drawings and Watercolours,* March 13, 1992, lot 76, study for the nymph in the foreground, black and white chalk on grey paper, dated 1901, 11¼ × 18⅛ in.

VALENTINE CAMERON PRINSEP (1838-1904)

Val Prinsep was born on February 14, 1838 in Calcutta, the second son of Thoby Prinsep, an Indian civil servant, and later a director of the East India Company. At his home in London, Little Holland House, his mother Sara Prinsep entertained much of the literary and artistic elite, including Carlyle, Thackeray, Tennyson, Browning, Rossetti, Holman Hunt, Burne-Jones, and Leighton. The house's resident artistic genius was G.F. Watts, who provided Val Prinsep with his first artistic instruction, and who encouraged him to become an artist rather than join the Indian Civil Service. In 1857 he accepted Rossetti's invitation to join in the mural decorations of the Oxford Union building. In 1859 he went to Paris to study in the atelier of Charles Gleyre, as well as touring Italy with Edward Burne-Jones. He exhibited his first painting at the Royal Academy in 1862. In 1878 he was elected an associate of that institution. Prinsep had great social success and was extremely wealthy after 1884, when he married Florence Leyland, the daughter of Frederick Leyland, the Liverpool shipowner and important Pre-Raphaelite patron. Prinsep was elected to full membership in the Royal Academy in 1894. He died on November 11, 1904. His funeral was held at St. Paul's Cathedral, and he was buried at Brompton Cemetery.

65 Study (possibly for "The Death of Cleopatra"), c. 1870

Black chalk, heightened with white, on blue-grey wove paper 7½ × 11½ in.
(19 × 28.5 cm) - sight
VERSO: a similar study, although smaller, and with an altered compositional scheme
PROVENANCE: ? the artist's sale, Regent's Park; ? Christie's, London, October 7, 1975, part of lot 15 or Christie's, London, December 13, 1977, part of lot 216 or 217; anonymous sale, Sotheby's, London, January 25, 1989, part of lot 449.
EXHIBITED: Kenderdine Gallery: 1995, cat. no. 48.

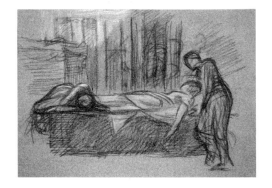

In the early part of his career Val Prinsep was associated with the Pre-Raphaelite circle, the members of which he had been introduced to by G.F. Watts. In 1857 Watts wrote to his friend Lady Duff Gordon: "I have conscientiously abstained from inoculating him with any of my views or my ways of thinking, and have plunged him into the Pre-Raphaelite Styx. I don't mean to say that I held the fine young baby of six foot two by the heels, or wish to imply the power of moulding his opinions at my pleasure; but, to continue my figure, I found him loitering on the banks and gave him a good shove, and now his gods are Rossetti, Hunt, and Millais – to whose elbows more power."[1] Later Watts became concerned about the effect that the dominance of Rossetti's mind was having over Prinsep and wrote to John Ruskin about it, "feeling truly that the mediaevalism natural to Rossetti was but a mere reflection in the younger mind, not his own natural expression."[1] Ruskin, in a letter of October 18, 1858, stated that he agreed with Watts and admitted "that he had encouraged the stiffness and quaintness and intensity as opposed to classical grace and tranquility."[1]

In 1865 Val Prinsep commissioned a house designed by Philip Webb at 1 Holland Park Road, close to G.F. Watts. Frederic Leighton became his next-door neighbour in 1866. His subsequent close friendship with Leighton led to his drifting away from the Pre-Raphaelites and to painting classical and more Aesthetic subjects. This drawing, in fact, is close in style to those of Lord Leighton, although lacking Leighton's finesse and mastery. Leighton frequently used the same type of blue paper early in his career.

This drawing is likely a preliminary design for the painting *The Death of Cleopatra*, although it differs significantly from the final composition. The painting was exhibited at the Royal Academy in 1870. It was sold at Sotheby's, Belgravia in 1973 and Sotheby's, London in 1986.[2] It is currently in a private collection. This drawing also resembles somewhat the composition of Prinsep's *Love's Pledge*, but this painting contains only two figures.[3] The most likely source of influence on this drawing is Leighton's *Hercules Wrestling with Death for the Body of Alcestis* of 1869-71, in the collection of the Wadsworth Atheneum, Hartford. Although this masterpiece was not shown at the Royal Academy until 1871, Prinsep would unquestionably have seen it in Leighton's studio during its development. Prinsep may have modified his final composition for *The Death of Cleopatra* so as to not resemble Leighton's design too closely.

1 Watts, Mary Seton: 1912, Vol.1, pp. 172-173.
2 Sotheby's, Belgravia: *Victorian Paintings, Drawings and Watercolours*, April 10, 1973, lot 174, 50 × 71 in. It sold subsequently at Sotheby's, London, June 17, 1986, lot 27.
3 Sotheby's, Belgravia: *Victorian Paintings, Drawings and Watercolours*, July 24, 1973, lot 176, 23½ × 32 in.

SIR WILLIAM BLAKE RICHMOND (1842-1921)

William Blake Richmond was born in London in 1842, the son of the painter George Richmond, R.A. His early artistic influences were his father and John Ruskin. In 1857 he entered the Royal Academy Schools. Richmond first exhibited at the Royal Academy in 1861. In 1865, after the death of his first wife, he travelled to Italy. In Rome he met Frederic Leighton and Giovanni Costa, both of whom would have a great influence on Richmond's later artistic style. In the late 1860s he began to paint classical subjects. He also painted landscapes and was a member of the Etruscan School, as the English followers of Costa were

known. Athough Richmond was best known for his large-scale mythological or religious subjects, he was also a distinguished portrait painter and a sculptor and medallist. He was appointed Slade Professor at Oxford from 1878-83. In 1888 he was elected an associate of the Royal Academy, becoming a full member in 1895. Between 1891 and 1894 he designed the mosaic decorations in the choir of St Paul's Cathedral. He was knighted in 1896. In 1921 he died in London.

66 Study of Three Draped Figures, undated

Black and white chalk on grey wove paper 12 × 15⁹⁄₁₆ in. (30.6 × 39.5 cm)
PROVENANCE: Anonymous sale, Sotheby's, London, January 25, 1989, part of lot 449.
EXHIBITED: Kenderdine Gallery: 1995, cat. no. 49.

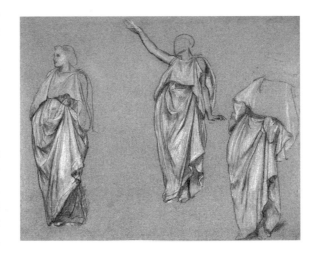

Blake Richmond, in the late 1850s and early 1860s, was influenced by the Pre-Raphaelites. Mrs. Stirling, in her book on Richmond, quotes him as saying early in his carreer that "I tried to paint like Hunt for a while, but I could not; I did not see Nature as he did; much as I admired his work, it was foreign to my temperament and beyond my capacity to emulate."[1] In 1860 he first met Frederic Leighton when they joined the Artists' Rifles. In 1866 he became better acquainted with Leighton when both were in Rome. On March 3, 1866 Richmond wrote a letter to his mother detailing how in February Leighton had introduced him to Giovanni Costa at the Caffè Greco. Richmond related that: "Leighton had already gained my admiration; I liked his sense of line, I like the rhythm of his work, and it had struck me that all the pictures I had seen of his were 'new' – not 'new' in the odious modern sense, but new on the old lines. I had loved the work of Millais and Hunt, and I love it still; but in the work of Leighton there was to me something distinguished, more Greek, more decorative."[2] He later became one of Leighton's most important followers.

Blake Richmond worked in the academic tradition of making studies, both nude and draped, for the figures in his compositions. These sketches of draped figures are similar to those of his fellow academicians Leighton and Poynter, although it is unknown for which painting by Richmond they are studies.

1 Stirling, A.M.W.: 1926, p. 168.
2 Reynolds, Simon: 1995, p. 42.

THOMAS MATTHEWS ROOKE (1842-1942)

T.M. Rooke was born in Marylebone in 1842, the son of a Jermyn Street tailor. In the mid 1860s he trained at the National School of Design at South Kensington, and then at the Royal Academy Schools. In 1869, on leaving the R.A. Schools, he applied to Morris, Marshall, Faulkner & Co. for a post in their workshops, but instead was given a situation as an assistant in Burne-Jones' studio. Rooke's talents as a watercolourist and topographical draughtsman were highly regarded by John Ruskin, who sent him each year from 1878-93 to make drawings of cathedrals and ancient monuments on the continent. Rooke exhibited at the Royal Academy and the Grosvenor and New Galleries. In 1891 he was elected an associate of the Royal Watercolour Society and a full member in 1903. Rooke was also involved with the Arts and Crafts movement, designing painted furniture, gesso panels, and mural decorations. He helped to found the Art Workers' Guild in 1884 and exhibited with the Arts and Crafts Exhibition Society.

67 Study of Two Classical Maidens Dancing, early 1870s

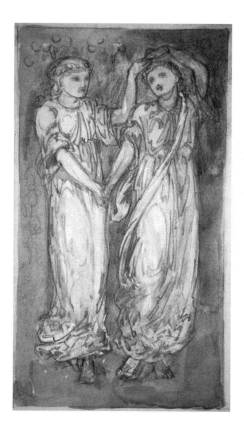

Graphite and watercolour, heightened with white, on light beige wove paper (red chalk on verso for transfer) 9⅛ × 5½ in. (23.2 × 14.0 cm)
PROVENANCE: Noel Rooke, T. M. Rooke's son; bequeathed to his wife; given to Thomas Hancock, London; sold by him to Julian Hartnoll, London, by 1972; Martyn Gregory, London, by 1975; anonymous sale, Christie's, London, October 29, 1991, part of lot 24A.
EXHIBITED: Hartnoll and Eyre: 1972, cat. no. 5; Martyn Gregory: 1975, cat. no. 55 (illus.).

In 1869 Rooke became a studio asistant to Burne-Jones. As such he was involved with the time-consuming preparation process of transferring the artist's designs from sketch to canvas, before the master would begin. Rooke, a gentle modest man, was ideally suited to the role of chief assistant, and he stayed with Burne-Jones until the latter's death in 1898. Rooke's own imaginative paintings were highly derivative of Burne-Jones, and he specialized in Old Testament subjects. In 1877 his triptych, *The Story of Ruth*, was bought by the Chantrey Bequest from the Royal Academy exhibition.

Rooke, like his fellow studio assistant Charles Fairfax Murray, was also employed in decorating furniture. Because of the red chalk used to transfer the design, on the verso, it is likely this drawing is for decorative furniture, rather than for a painting. These figures appear to have been influenced by the dancers in Burne-Jones' early gouache *The King's Wedding* of

1870, at the Clemens-Sels-Museum, Neuss, Germany. Another possible source is *The Mill*, which Burne-Jones began in 1870, but did not complete until 1882, now in the collection of the Victoria and Albert Museum, London. Certainly the draperies in this watercolour more closely resemble those in Burne-Jones' early watercolour, than the draperies in the oil painting completed much later. Bill Waters has dated this watercolour by Rooke to c. 1874, as he feels the draperies stylistically resemble those of the dancing girls in *The Mill*.[1] Waters also feels that some of the preparatory drawing in Rooke's watercolour may be by Burne-Jones.[1] If this is so, it would also tend to support a relatively early date in the 1870s for this watercolour, when Burne-Jones was still helping his studio assistant with his independent work.

A painting by Rooke entitled *The Dancing Girls* was exhibited at *The Last Romantics* exhibition at the Barbican Art Gallery, London in 1989.[2] This work, painted in 1882, although much more confidently handled, still shows the influence of Burne-Jones.

1 Waters, Bill: Hartnoll and Eyre: 1972, cat. no. 5.
2 Barbican Art Gallery: 1989, p. 85, cat. no. 27, oil on canvas, 24 × 38¼ in.

DANTE GABRIEL ROSSETTI (1828-1882)

D.G. Rossetti was born in London on May 12, 1828, the son of an Italian political refugee and Dante scholar, who from 1831 was Professor of Italian at King's College, London. In 1841 D.G. Rossetti entered Sass's Drawing Academy. In the summer of 1844 he entered the Royal Academy Schools as a probationer, becoming a full student in December, 1845. In March, 1848 he became a pupil of Ford Madox Brown for a short time. In 1848 he became friendly with Hunt and Millais and, with them, founded the Pre-Raphaelite Brotherhood. In March, 1849 he exhibited his first Pre-Raphaelite painting, *The Girlhood of Mary Virgin*, at the Free Exhibition, Hyde Park Corner, London. From January - April 1850 the Pre-Raphaelite literary magazine *The Germ* was published, to which he contributed important early poems. In April 1850 he exhibited *Ecce Ancilla Domini* at the National Institution, Portland Gallery. It was harshly criticized, leading Rossetti to rarely exhibit in public again. From this time to about 1860 he worked primarily in watercolour, often on themes taken from Dante or *Le Morte d' Arthur*. In April, 1854 he became friendly with Ruskin. In early 1856 he met Edward Burne-Jones and by the summer an intimate friendship had arisen with Burne-Jones and William Morris. In November 1857 he worked on the Oxford Union Debating Hall murals. He became a founding member of Morris, Marshall, Faulkner & Co. in April 1861. In October 1862 Rossetti moved to Tudor House, 16 Cheyne Walk, Chelsea. In October 1869 the manuscript poems that he had placed in his wife's coffin in Highgate Cemetery were exhumed, and he reworked them for publication. In 1870 *Poems* was published. He took on joint-tenancy of Kelmscott Manor with Morris in July 1871. He spent long periods of time there with Jane Morris until 1874. In 1871 Robert Buchanan reviewed Rossetti's *Poems* in an article in *The Contemporary Review*, and attacked him as the leader of "the Fleshly School of Poetry". Rossetti suffered a "mental collapse" in June 1872, and subsequent to this he saw little of his old friends, other than Madox Brown. He refused an invitation to exhibit at the first Grosvenor Gallery exhibition in 1877, which led to Burne-Jones becoming the most influential artist of the second phase of Pre-Raphaelitism. On April 9, 1882 he died at Birchington-on-Sea in Kent, and was buried in Birchington churchyard.

68 Study of the Artist's Mother Lying on a Sofa, c. 1853

Pen and light and dark brown ink on off-white wove paper 3¹⁄₁₆ × 5⅛ in. (7.8 × 13 cm)
PROVENANCE: Charles Fairfax Murray; private collection, London; sold to Beth Lipkin, The
Little Gallery, London; purchased May 31, 1984.
EXHIBITED: Kenderdine Gallery: 1995, cat. no. 50.

On April 8, 1826 Gabriele Rossetti married Frances Mary Lavinia Polidori. Gabriele Rossetti
was forty-three, while his wife was twenty-five. By birth, Mrs. Rossetti was half Italian. Her
father, Gaetano Polidori, was a teacher of Italian in London, while her mother, a Miss Pierce,
had been a governess in English families of good standing. Frances Polidori had also worked
as a governess. Mrs. Rossetti was greatly loved by all her children. Evelyn Waugh has
described Mrs. Rossetti as "practical, sympathetic, devoted, an excellent housewife, pious,
possessed of great rectitude, and considerable learning, of ample and matronly appearance."[1]
Doughty, in describing Mrs. Rossetti, states: "The strength, the sanity, of Dante Gabriel's
cultured, intellectual mother were eminent and life-long. Her character speaks in a comment
she made on her family, when an old lady over seventy years of age. 'I always had a passion,'
she said, 'for intellect, and my wish was that my husband should be distinguished for intellect
and my children too. I have had my wish; and I now wish that there was a little less intellect in
the family, so as to allow for a little more common sense.' She was, of course, quite right, as
always, but, vague and shadowy though she is to us, we come to feel in time, unfairly it may be,
that perhaps some touch of human weakness in the excellences of Dante Gabriel Rossetti's
mother, might have been better for the son."[2] There can be no doubt, however, of Dante
Gabriel's affection for his mother. In a letter Christina wrote to her brother William, several
years after Gabriel's death, she noted: "on the whole I should say that beyond all possibility of
dispute he petted and worshipped our Mother with exuberant fondness."[3] When Dante
Gabriel Rossetti died in 1882, Frances Rossetti commissioned Ford Madox Brown to design a
Celtic cross for his headstone, and Frederic Shields to design a memorial window for the
church at Birchington. Mrs. Rossetti spent the summer months of 1883 and 1884 at
Birchington, where she made daily visits to her son's grave. Mrs. Rossetti died three years
after Gabriel, at age eighty-six.

Dante Gabriel Rossetti drew many studies of his mother. Virginia Surtees, in her cata-
logue raisonné of his works, lists eight drawings of Mrs. Gabriele Rossetti, and one of Mrs.

Rossetti and Christina together.[4] Five of the eight drawings are from the period 1852-53, and two drawings are in pen and ink. This drawing may be dated to c. 1853, based on its stylistic similarities to other drawings done at this time. The drawing shows his mother, with a cat, lying on a sofa. One wonders if it is the so-called "Shelley Sofa", which belonged to the Rossetti family, and which is the one the poet had slept on the night before he was drowned off the coast of Leghorn.

1 Waugh, Evelyn: 1931, p. 16.
2 Doughty, Oswald: 1960, pp. 28 and 29.
3 Fleming G.H.: 1971, p. 382.
4 Surtees, Virginia: 1971, cat. no. 443, p. 185; cat. nos. 445, 446, 447, 448, 449, 450, p. 187; cat. no. 451, p. 188; Appendix no. 15, p. 235.

69 Study for "Morning Music", c. 1864

Graphite on off-white wove paper; signed with DGR monogram, withinin a circle, lower right 6¾ × 5¼ in. (17.0 × 13.3 cm)
PROVENANCE: The artist's sale, Christie's, London, May 12, 1883, lot 108, bought MacKinlay; Barbizon House, London; David Gould by 1961; Maas Gallery, London, by 1963; sold to L.S. Lowry R.A. in 1963; bequeathed to his heir Diana Greenhill; L.S. Lowry sale, Christie's, London, December 18, 1984, lot 46.
LITERATURE: Destrée, O.G.: 1894, no. 4, p. 81; Marillier, H.C.: 1899, no. 151, p. 245; Surtees, Virginia: 1971, Vol. 1, no. 170, R.I.B., p. 98.
EXHIBITED: Manchester City Art Gallery: 1977, cat. no. 4; Kenderdine Gallery: 1995, cat. no. 51.

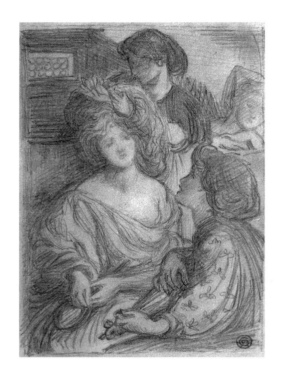

In the 1860s the art of D.G. Rossetti began to move away from its previous medieval inspiration and to fall under the influence of the Venetian masters of the High Renaissance like Titian, Giorgione, Tintoretto, and Veronese. In 1858 John Ruskin became "unconverted" from the Evangelical doctrine to which he had previously subscribed. This loss of spiritual faith and conversion to an agnostic humanism prompted a profound revision of his aesthetic ideas. He moved away from praising the virtues of medieval art and instead began to favour classical Greek art and Venetian painting. In 1858 Ruskin stated: "The Venetians alone, by a toil almost superhuman ... were able finally to paint the highest visible work of God with unexaggerated structure, undegraded colour and unaffected gesture ... no other men but the Venetians ever did it: none of them ever painted the human body without in some degree caricaturing the anatomy, forcing the action, or degrading the hue."[1] Rossetti would

obviously have been aware of Ruskin's views. This may have prompted his own conversion from medievalism to Venetian Cinquecento painting, as may have the enthusiasm in the early 1860s of his friends Watts and Burne-Jones for Venetian painting. In 1860, while Rossetti was in Paris on his honeymoon, he visited the Louvre where he admired Veronese's *Marriage Feast at Cana*, which he called "the greatest picture in the world beyond a doubt."[2]

In the 1860s Rossetti began to paint largely in oils, whereas in the 1850s he had worked primarily in watercolours. During the 1860s he produced some of his finest masterpieces, including *The Beloved, Monna Vanna,* and *The Blue Bower*, where the brilliance of his colour and the richness of his handling of draperies and decorative accessories have rarely been equalled in 19th-century art. Although many of the works appear purely decorative and subjectless to 20th-century viewers, symbolism usually abounds, if one can read the meaning of the flowers and other decorative features.

This drawing is a study for *Morning Music*, a watercolour painted in 1864 for William Graham, one of Rossetti's most important patrons. The watercolour, now in the collection of the Fitzwilliam Museum in Cambridge, features a beautiful golden-haired woman having her hair dressed while music on a cithern is being played in the background by a male youth. The predominant colours are a brilliant red, gold, and white, and the predominant mood is one of languid contemplation and luxuriance. The principal influences are Venetian art, such as Titian's *Young Woman at Her Toilette* in the Louvre. The subject of a woman having her hair dressed while music is played was previously explored by Rossetti in *A Christmas Carol* of 1857-58.

Virginia Surtees, in her catalogue raisonné of Rossetti's work, lists four studies for *Morning Music*, and a replica in watercolour of 1867.[3] This drawing, as well as an almost identical one in the Birmingham City Museum and Art Gallery, would appear to be the most finished of the studies and to most closely resemble the finished watercolour of 1864. It differs from it in several respects, however, the most prominent of which is in the placing of the youth playing the cithern, which in the study is in the right foreground. A female attendant, in the upper right background with her chin resting on her left hand, was omitted from the finished watercolour as she does not appear to add anything to the design. In some respects this drawing more closely resembles in composition the second watercolour version of *Morning Music*, which Rossetti painted in 1867, and which is in the Birmingham City Museum and Art Gallery.[3] This watercolour cannot rightly be called a replica since it differs significantly from the version of 1864, not only in its composition, costumes, and decorative accessories, but also in the mood projected, which is far less wistful.

1 Cook, E.T., and Wedderburn, A: 1905, Vol. XVI, p. 198.
2 Doughty, O. and Wahl, J.R.: 1965, Vol. I, p. 367, letter to W.M. Rossetti, June 9, 1860. Rossetti's admiration for this painting may have been prompted by Ruskin. In a letter of September 24, 1856 to Pauline Trevelyan Ruskin wrote: "Meantime I am enjoying a little of the Louvre ... I always go straight to Paul Veronese if I can ... this time I had very nearly cried; the great painting seemed so inexpressibly sublime ... but Veronese's painting always makes me feel as if an archangel had come down into the room – and were working before my eyes. I don't mean in the *piety* of the painting, but in its power." Surtees, Virginia: 1979, p. 89.
3 Surtees, Virginia: 1971, Vol. I, cat no. 170, pp. 97-98. The watercolour is illustrated in Vol. II, pl. 244, and two studies are illustrated as pls. 245 and 246.

70 A Study of the Figure of Love for "Dante's Dream at the Time of the Death of Beatrice," 1874

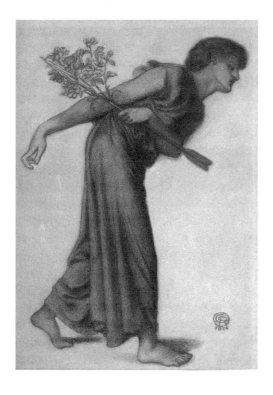

Black, red, brown, and grey chalk on pale grey-green paper; signed with DGR monogram within a circle, and dated *1874*, lower right 23⅛ × 16⁹⁄₁₆ in. (59.1 × 42.3 cm)

PROVENANCE: Charles Augustus Howell; ? C.H. Dancocks; his sale Christie's, London, November 28, 1908, lot 18, bought Sampson of W.W. Sampson & Sons, London; Julian Hartnoll, London; Espace Co. Ltd, Japan, by 1977; Fine Art Society, London, by late 1977; Sotheby's Belgravia, June 17, 1980, lot 21, bought in at the sale and purchased later by the MacMillan and Perrin Gallery, Toronto; their sale, Christie's, London, March 1, 1983, lot 96, bought in; Sotheby's, London, October 27, 1983, lot 241; withdrawn prior to the sale and purchased from Daniel Perrin, London, September 26, 1983.

LITERATURE: Cline, C.L.: 1978, letter 407; Benedetti, Maria Teresa: 1984; cat. no. 536 (illus.); Dante Alighieri: 1985, XXXIX, no. 53, p. 151 (illus.); Lochnan, K.A.; Schoenherr, D.E.; Silver, C.: 1993, cat. no. A:37, p. 87 (illus.); Yamaguchi, Eriko: 1994, p. 55.

EXHIBITED: Miyazaki Yamagataya: 1977, cat. no. 5 (illus.); Fine Art Society: 1977, cat. no. 11 (illus.); Fine Art Society: 1979, cat. no. 216; MacMillan and Perrin Gallery: 1980, cat. no. 15 (illus.); Art Gallery of Ontario: 1993, cat. no. A:37 (illus.); Kenderdine Gallery: 1995, cat. no. 52.

In 1869 Rossetti returned to the subject of Dante and Beatrice, a theme that had dominated his art in the early 1850s. It is not surprising that subjects from Dante should interest him, since his father Gabriele had been a famous Dante scholar. As D.G. Rossetti wrote of himself: "The first associations I have are connected with my father's devoted studies which, from his own point of view, have done so much towards the general investigation of Dante's writings. Thus, in the early days, all around me partook of the influence of the great Florentine, till, from viewing it as a natural element, I also, growing older, was drawn within the circle."[1]

D.G. Rossetti did not begin to read the writings of the early Italian poets until age seventeen, and seems to have shown little interest in Dante until 1848, the year in which he completed his own translation of *La Vita Nuova* ("The New Life"). In the early 1850s Rossetti painted many incidents from *La Vita Nuova*, the autobiography of Dante's youth and early manhood, which deals with his relationship to his love Beatrice Portinari, and her transformation into the ideal of spiritual perfection for Dante. There has long been a controversy as to whether Beatrice was a real historical figure who inspired Dante's poetry, or whether she should be interpreted as an allegorical figure representing greater truths such as Love or Philosophy.[2] The name Beatrice itself means "the one who confers blessing." In *La*

Vita Nuova Dante Alighieri describes his first meeting with Beatrice Portinari, in the year 1274, at a May Feast given by her father Folco Portinari. Although Beatrice was only eight years old at the time, and Dante not much older, he states that "from that time forward, Love governed my soul."[3] It was from Dante, and his contemporaries among the early Italian poets, the *stilnovisti*, and their concept of the secular religion of Love, that Rossetti derived his career as both a love-painter and love-poet.[4] In the conventions of troubadour poetry, later adopted by the *stilnovisti,* the poet is confronted with a conflict between service to his lady and service to God. Bianchi feels that Dante's poetry helped to resolve this conflict, however, as for Dante the "journey to Beatrice coincided with the journey to God ... All who behold her are upifted and can only contemplate the good."[2]

In 1856 Rossetti produced his largest watercolour on the theme of Dante and Beatrice – *Dante's Dream at the Time of the Death of Beatrice*. He had intended as early as 1848 to illustrate the incident where Dante, in a dream, sees the dead Beatrice laid upon a bier.[5] The subject is taken from a passage in *La Vita Nuova* in which Dante describes a dream he had on the ninth day of a feverish illness, the day of the death of Beatrice Portinari, on June 9, 1290:

> Then lifting up mine eyes, as the tears came,
> I saw the Angels, like a rain of mana
> In a long flight flying back Heavenward;
> Having a little cloud in front of them,
> After the which they went and said, 'Hosanna';
> And if they had said more, you should have heard
> Then Love said, 'Now shall all things be made clear'
> 'Come and behold our lady where she lies'
> These 'wildering phantasies
> Then carried me to see my lady dead
> Even as I there was led,
> Her ladies with a veil were covering her;
> And with her was such very humbleness
> That she appeared to say, 'I am at peace.'

In the watercolour version Dante is led, conscious but in a dream-like state, by Love, to the bedside of the dead Beatrice lying on a bunk recessed in the wall. As Love reaches the bier, he bends for a moment over Beatrice to kiss her, before her two lady attendants cover her with a pall covered with May blossoms. The painting is full of elaborate symbolism.[6] Dante walks in the foreground on a lower level than the other figures on a floor strewn with red poppies, symbolic of dreams, and also the sleep of death. Love represents the pilgrim Love of *La Vita Nuova,* and he wears the pilgrim's scallop shell on his shoulder. His flame-coloured costume with blue tunic and red wings relates to Dante's vision of this figure in a mist of fire. Beatrice's attendants are in green, the colour of life. The May blossoms symbolize purity and virginity. In the later oil versions of this subject, not only does the austere medievalism of the early watercolour give way to the richness of Rossetti's High Renaissance style, but various elaborations are also included in the symbolic content of the painting. In the later versions the figure of Love not only carries an arrow, which this time is pointed at Dante's heart, but also a branch of apple blossoms. The apple blossoms may symbolize the love here consummated in death – a blossom picked before the coming of fruit.[6]

The young Johnston Forbes-Robertson posed for the figure of Love in the oil versions.[7,8] Rossetti had never been satisfied with the figure of Love and altered it in both oil paintings during the time he was working to complete the second replica. On April 19, 1878 he wrote to

Jane Morris: "Meanwhile I took up that eternal incubus, the replica of the large picture, and I found myself less satisfied than ever with the figure of Love which I never thought quite right throughout. Thus I found the shortest and most thorough plan was to alter it first in the large picture itself, which I have now done, and can proceed to transfer the figure as altered to the replica."[9]

The initial study of the head of Love, modelled on Johnston Forbes-Robertson, is dated 1870.[5] The present drawing, dated 1874, is mentioned in a letter of December 31, 1874 from D.G. Rossetti to his art agent, Charles Augustus Howell.[10] It differs somewhat from the figure of Love in the oil versions in that the figure is not as stooped, the arrangement of the right hand and arm is slightly altered, the folds of the drapery are different, and it lacks the wings and scallop shell. Virginia Surtees, in her catalogue raisonné, lists one additional study for Love, dated 1875.[11] In this study the stoop forward is also less accentuated than in the painting, and not only are the wings, but also the arrow, are omitted. Surtees lists two studies for the figures of both Beatrice and Love.[5] In the study dated 1875 the figure of Love is again less bent than in the final painting, but the position of the right hand is much closer to the final design, although it holds a flaming torch rather than Dante's hand.[12] The drapery is also much closer to that portrayed in the final design than it is in the drawing from 1874, but the overall quality of the draughtsmanship is lower. Another study of Love and Beatrice, perhaps by H.T. Dunn, Rossetti's studio assistant, is in the collection of the Walker Art Gallery, Liverpool.[13]

Dante's Dream at the Time of the Death of Beatrice is not the only painting by Rossetti to include a personification of Love. Other works featuring Love include *Love's Greeting*, *Roman De La Rose*, and *Beata Beatrix*. The figure of Love from *Dante's Dream* seems to have been the major influence for Edward Burne-Jones' painting *Cupid and Psyche*, the earliest version of which is dated 1866, and based on illustrations the artist made in 1865 for the "Story of Cupid and Psyche" in William Morris' *The Earthly Paradise*. In this painting the pose of Cupid echoes almost exactly that of the figure of Love in *Dante's Dream*.

1 Rossetti, William Michael: 1911, pp. 283-284.
2 Bianchi, Petra: 1999, pp. 28-30.
3 Rossetti, Dante Gabriel: 1912, p. 258.
4 Goff, Barbara Munson: 1984, p. 103.
5 Surtees, Virginia: 1971, cat. no. 81, pp. 42-48.
6 Bennett, Mary: 1988, cat. no. 3091, pp. 173-177.
7 Surtees, Virginia: 1971, p. 44. Henry Treffry Dunn, unpublished papers, Janet Camp Troxell Collection. "Young Edward Hughes a nephew of Arthur Hughes sat for Love as described by Dante; his face was eventually discarded as having too much of a Greek Adonis about it to convey the real idea of Dante's creation. The next selected and finally retained was that of Forbes Robertson. His face lent itself most readily to the medieval Love that Dante's genius invoked."
8 Forbes-Robertson, Johnston: "The Tribute to a Friend", *The Times*, May 11, 1928. "When the picture was nearly finished Rossetti asked my father if I might sit to him for the head of Love and this I did much to my pride and delight. I remember well that the space left for the head was scrumbled over with venetian red on which he painted the profile. I had to pose over a cushion on a sofa." Sir Johnston Forbes-Robertson, 1853-1937, trained as a painter but went on to become one of the leading actors of his day.
9 Bryson, John: 1976, letter 30, pp. 64-65. If Rossetti was altering the figure of Love at this time, one wonders what he was using for studies, since he had already sold his drawings of Love to C.A. Howell. Rossetti may, of course, have altered it directly on the canvas without the use of studies.
10 Cline, C.L.: 1978, letter 407, from D.G. Rossetti to C.A. Howell, dated December 31, 1874. In this letter Rossetti discusses eight studies for *Dante's Dream* which Howell has already received, as well as three others, including this drawing, which Rossetti felt were due to Howell. In a subsequent letter of January 28, 1875 (letter 408) Rossetti says he will deliver these three drawings, as well as another three

drawings if Howell will pay him £30. Howell responded in a letter of January 29, 1875 (letter 409) that he would be happy to pay the £30 on the drawings. On March 16, 1875 Rossetti sent Howell a postcard saying that five Dante drawings were ready for delivery (letter 412). In a subsequent letter from Rossetti to Howell of May 14, 1875 (letter 416) Rossetti writes about completing three more drawings for *Dante's Dream* for Howell, including a "Love full length". This is likely Surtees' Appendix no. 9, rather than this drawing. The whole correspondence between Rossetti and Howell concerning studies for *Dante's Dream* seems somewhat confusing, however, as to which drawings Howell had previously received from Rossetti, and which are currently being sold. See letters 232, 400, 404, 405, 406, 407, 408, 409, 412, 416, 418, and 420. At Rossetti's estate sale held Christie's, London, on May 12, 1883, lots 5-9 and lot 37 were all studies for *Dante's Dream*, while lots 27-29 were studies for the predella for the smaller version. This suggests that obviously Howell did not acquire all the studies for this painting.

11 Surtees, Virginia: 1971, Appendix, no. 9, p. 234, red-brown chalk, 22 × 14¾ in., dated 1875. This figure is very similar to the present drawing, except that it is not carrying an arrow in its left hand. This is doubtless the study for Love discussed by Rossetti in his letters to Charles Augustus Howell of January 28 and May 14, 1875, see Cline, C.L., letters 408 and 416. This drawing belonged to the Hon. Percy Wyndham. It can be seen hanging in Madeline Wyndham's boudoir at Clouds in a photograph from 1910 illustrated in Gere, Charlotte: 1989, p. 19, fig. 12.

12 Rossetti, Dante Gabriel: 1912, pp. 259-260. The drawing (Surtees 81 R.2.E) showing Love holding a flaming torch in his right hand may relate back to an earlier passage in the *Vita Nuova* in which Dante describes another dream he had concerning Love and Beatrice, at the time of her death. "And he who held her held also in his hand a thing that was burning in flames ... he set himself to awaken her that slept; after the which he made her to eat that thing which flamed in his hand; and she ate as one fearing." In the sonnet that Dante composed to accompany this part of the story it is obvious that what is, in fact, flaming in Love's hand is Dante's heart.

13 Bennett, Mary: 1988, cat. no. 381, p. 182, red and black crayon, heightened with white, on grey paper, and inscribed with a DGR monogram. This drawing was said to have originally come from the collection of William Michael Rossetti. The drawing is too weak, however, to be an autograph work by Rossetti himself.

ANTHONY FREDERICK AUGUSTUS SANDYS (1829-1904)

Frederick Sandys was born on May 1, 1829 in Norwich, the son of a drawing master. He received his early artistic education at the Government School of Design at Norwich. From 1839 he exhibited drawings at the Norwich Art Union. In 1846 and 1847 he was awarded silver medals by the Royal Society of Arts. He was living in London by 1851 and exhibited at the Royal Academy for the first time that same year. In 1857 he met D.G. Rossetti, and published anonymously *A Nightmare*, a print parodying Millais' *Sir Isumbras at the Ford*. In the 1860s he received a number of commissions for illustrations from leading magazines such as *The Cornhill Magazine*, *Once A Week*, *Good Words*, *The Shilling Magazine*, *The Quiver*, and *The Argosy*, as well as for books including the *Dalziel Bible Gallery* and Willmott's *English Sacred Poetry*. A disagreement between Sandys and Rossetti in 1869 led to a breakdown in their friendship, although it was resumed in 1875. He was elected a founding member of the International Society of Sculptors, Painters, and Gravers in 1898, which lead to a renewed friendship with Whistler. On June 25, 1904 he died in London and was buried in Brompton Cemetery.

71 King Pelles' Daughter Bearing the Vessel of the Sanc Graal, 1861

Pen and black ink on ivory wove paper; signed with monogram and dated *1861*, lower left; old repair left forehead area 12⅝ × 9¼ in. (32.1 × 23.4 cm)

PROVENANCE: James Anderson Rose; his estate sale, Christie's, London, May 5, 1891, lot 87; bought by Sir Henry L. Doulton; given by 1905 to his daughter, Mrs. Sarah Kinnersley Hooper, of Snowdenham Hall, near Guildford, Surrey; anonymous sale, Sotheby's, London, November 20, 1969, lot 165, bought Maas Gallery, London; sold by 1974 to Monty Bloom, Bournemouth, who later sold it back to the Maas Gallery; sold in 1977 to Dr. Frederick J. Cummings, Detroit; anonymous sale, Sotheby's, New York, November 1, 1995, lot 410.

LITERATURE: Daniels, Jeffery: 1970, p. 224 (illus.); Banham, J. and Harris, J.: 1984, cat. no. 115, p. 170; Wildman, Stephen: 1995, cat. no. 77, p. 240.

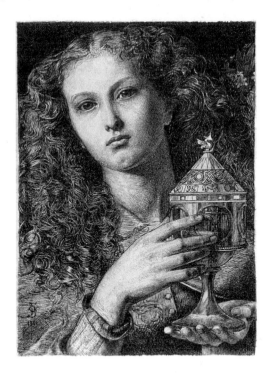

EXHIBITED: Royal Academy: 1905, cat. no. 256, p. 45; Maas Gallery: 1970, cat. no. 88 (illus.); Maas Gallery: 1973, cat. no. 86; Staatliche Kunsthalle, Baden-Baden: 1974, cat. no. 144 (illus.); Brighton Museum and Art Gallery: 1974, cat. no. 135, p. 35 (illus.).

King Pelles' Daughter Bearing the Vessel of the Sanc Graal is one of a series of works based on the Arthurian legends by the Pre-Raphaelites and their circle in the late 1850s and early 1860s. The subject is from Sir Thomas Malory's *Le Morte d' Arthur*, originally printed by William Caxton, although the edition that would have been most accessible to Sandys at this time would have been the so-called Southey edition, published by Longman's & Co. in 1817.[1] Impetus at this time to illustrating incidents from *Le Morte d' Arthur* was given by the murals painted in 1857 for the Oxford Union Debating Hall by Rossetti, Burne-Jones, Morris, Stanhope, Hughes, Prinsep, and Pollen. The illustrations by Rossetti and Hunt for the Moxon Tennyson, published in 1857, were also undoubtedly major influences. Sandys produced a number of works based on Arthurian themes in the early 1860s including *La Belle Yseult* or *La Belle Ysonde* of 1862, *Morgan Le Fay* of 1862-63,[2] and *Vivien* of 1863.

 King Pelles' Daughter Bearing the Vessel of the Sanc Graal is undeniably one of Sandys' finest drawings. The Holy Grail (Sanc Graal, Sancgrael, Sangreal, or Sangraal) is alleged to be the cup of the Last Supper in which Joseph of Arimathea later caught Jesus' blood at the Crucifixion. After the Crucifixion Pontius Pilate gave Jesus' body to Joseph of Arimathea who interred it in his private tomb. Joseph was a secret follower of Jesus and a wealthy and influential member of the Sanhedrin, the Council of Elders that ruled Jerusalem under the Roman authority. It has also been speculated that Joseph of Arimathea was related to Jesus through his mother Mary. Medieval traditions portray Joseph of Arimathea as the custodian of the Holy Grail. It was supposedly he who brought the Grail to England, more specifically

to Glastonbury. His descendants were entrusted with the guardianship of the Sanc Graal, from generation to generation. There are a number of versions as to how the Holy Grail was lost. The most popular one has God removing the Grail because of his displeasure with the dolorous stroke which Sir Balin struck upon King Pelles, the Grail's guardian. Although King Pelles still lived, the wound could not be healed until the Sanc Graal was restored. It was Merlin who sent a message to King Arthur, via Sir Gawaine, directing Arthur and the Knights of the Round Table to undertake the quest to recover the Grail. Merlin informed Arthur that the knight who will accomplish the sacred quest had already been born and was of a suitable age to enter upon it. This knight was Sir Galahad, the grandson of King Pelles and thus a descendant of Joseph of Arimathea, and a knight with a pure heart and a valour beyond all other men. This drawing refers to an earlier incident in the Arthurian legends when Elaine, the daughter of King Pelles, appeared in the presence of her father and Sir Lancelot with a "vessel of gold betwixt her hands" which was the Sanc Graal. A prophecy was fulfilled by the deception of Sir Lancelot into believing that Elaine was his beloved Queen Guinevere, and Sir Galahad, the "perfect knight", was born of their union.

In this drawing the cover of the medieval-style chalice held by Elaine is decorated with Celtic interlace ornament and stylized designs taken from Pictish sources.[1] These are similar to the Pictish designs on the gown of Morgan Le Fay in Sandys' painting of 1862-63.[2] The finial is modelled in the form of a winged dragon. The central part of the chalice is orna-mented with roundels, one of which depicts the Crucifixion. As Betty Elzea has pointed out, this chalice is very much in the style of contemporary metalwork by the architect William Burges.[1] Sandys would surely have known Burges as he was a member of the Pre-Raphaelite circle at this time. The model for Elaine in this drawing seems to be the same as for his paint-ing *Oriana* of 1861.[3] In the Bancroft Collection of the Delaware Art Museum there is a Mansell photographic reproduction of this drawing that has been titled in error "A Magdalen" by Samuel Bancroft Jr.[1]

This drawing has obviously been inspired by the prints of Albrecht Dürer, an artist whom Sandys greatly admired, and on whose monogram he based his own. It also shows the influence of Rossetti, particularly his *Bocca Baciata* of 1859. It is also characteristic of a particular type of finished pen-and-ink drawing produced by artists in the Pre-Raphaelite circle, such as Rossetti, Solomon, and Burne-Jones, in the late 1850s and early 1860s. Burne-Jones' work in particular was notable in this medium, and Rossetti acknowledged them as "marvels of finish and imaginative detail, unequalled by anything except perhaps Albert Dürer's finest works."[4] This letter was written prior to this drawing by Sandys being executed, which in its technical brilliance is the equal of even Burne-Jones' finest works.

This drawing once belonged to James Anderson Rose, a London solicitor who knew many of the Pre-Raphaelites, and who formed a distinguished collection of their works. He also shared their enthusiasm for collecting blue-and-white Chinese porcelain. Rose was prob-ably Sandys' most important early patron. At his posthumous sale at Christie's on May 5, 1891 fourteen drawings by Sandys were included. This drawing likely served as a study for an oil painting of 1862, entitled *King Pelles' Daughter Bearing the Vessel of the Sancgrael* (present whereabouts unknown), which Sandys exhibited at the Royal Academy in 1862.[5] The British Museum owns another drawing by Sandys entitled *The Damosel of the San Grael*, of circa 1874, which is very different in treatment and composition from this drawing.[6]

1 Elzea, Betty: personal communication, letter dated November 16, 1995. It is not surprising Bancroft made this error, since this figure resembles traditional renderings of Mary Magdalene with her oint-ment box.

2 Wildman, Stephen: 1995, cat. no. 77, p. 240. Wildman notes that the source for the Pictish symbols
 may have been the first volume of *Sculpted Stones of Scotland* by John Stuart, published in Aberdeen in
 1856. Sandys also treated the subject of Morgan Le Fay as a pen-and-ink drawing, c. 1862. This draw-
 ing was exhibited at the Tate Gallery, 1997-1998, cat. no. 34.
3 Christopher Wood Gallery: 1984, cat. no. 5, p. 6, oil on panel, 10 × 8 in.
4 Doughty, Oswald and Wahl, JR: 1965, Vol. I, letter 262, p. 319.
5 Wood, Esther: 1896, pp. 23 and 63.
6 Brighton Museum and Art Gallery: 1974, cat. no. 150, p. 36, pl. 109, black and red chalk, heightened
 with white, on green paper, 25¾ × 18⅞ in.

72 Design for "Manoli," 1862

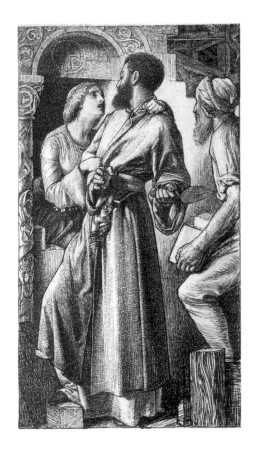

Fine brush and black ink on off-white wove paper; inscribed in faded pen and ink on the back of the frame, on an old label, "Manoli by Fred Sandys bought from F. Sandys [two illegible initials] for £15 10s 1862"

7⅛ × 4⅛ in. (18.3 × 10.5 cm)

PROVENANCE: ? Bought from the artist in 1862 by George Smith of Smith & Elder, the publisher of *The Cornhill Magazine*; George Murray Smith; Reginald Smith; anonymous sale, Sotheby's, London, March 30, 1994, lot 197, bought Julian Hartnoll, London; purchased July 19, 1994.

LITERATURE: Wood, Esther: 1896, pp. 15-16; White, Gleeson: 1897, p. 40; Reid; Forrest: 1928, pp. 59-60; Houfe, Simon: 1981, p. 132; Wildman, Stephen: 1995, cat. no. 83, p. 252, n. 3.

EXHIBITED: Victoria and Albert Museum: 1900; Kenderdine Gallery: 1995, cat. no. 53.

Frederick Sandys has long been considered one of the most brilliant illustrators of the 1860s. Walter Crane was full of praise for Sandys' book illustrations: "It is impossible to speak too highly of Mr Sandys' draughtsmanship and power of expression by means of line; he is one of our modern English masters who has never, I think, had justice done to him."[1] It is all the more amazing that Sandys' reputation as an illustrator stands so high considering that he produced fewer than thirty illustrations, which is a small number compared to other important Victorian illustrators such as J.E. Millais, Arthur Boyd Houghton, George Pinwell, and Arthur Hughes.

With its remarkable draughtsmanship and intricate composition this work, like many of Sandys' illustrations, shows the influence of German artists, particularly Albrecht Dürer, Alfred Rethel, and Julius Schnorr. Sandys was meticulous with his designs for illustration. He first worked up compositional studies in pencil or pen and ink for the figures and drapery,

before preparing a final finished design for the illustration. Sandys always drew his figures from life, and did nothing without a model in front of him. He was a perfectionist and once advised the young George du Maurier "never to let a block go out of my hands unless I was well satisfied that all that patience, time and model could do for it had been done."[2]

There are six known studies of details for *Manoli*, including drawings in the Birmingham City Museum and Art Gallery, the Fitzwilliam Museum, Cambridge, and the British Museum, London.[3,4,5] Sandys apparently used the same architectural drawing for the archway in *Manoli* as he used for the archway in his portrait of the Reverend James Bulwer, now in the collection of the National Gallery of Canada.[6] This archway seems to have been adapted from elements of the "Prior's Door" at Ely Cathedral, which dates from the 12th century.

Perhaps one of the reasons Sandys' work as an illustrator was so successful was his working method on the woodblock, which took into account the limitations of the engraver who was to cut the block. He used India ink to draw in a pure black line, with either a very fine sable brush or a quill pen. He never used Chinese white to lighten or correct. This made it much easier for the engraver to exactly reproduce the drawing. It is interesting to note, however, that there are differences between this drawing and the finished engraving by Swain, particularly in the foreground, which is more elaborate in the engraving. In general, however, the engraving is vastly inferior to the finished drawing in terms of quality and detail. Fortunately photographs exist, taken by W. Jeffrey, of the original drawing on the woodblock before cutting.[7] Betty Elzea has noted that when one compares these photographs of the woodblocks to Sandys' preliminary drawings for illustrations, the subtleties of the original drawing tend to be lost in the hardening-up of the drawing for the benefit of the engraver.[3] According to her there are virtually no differences between the drawing on the block and the print, other than its reversal, and the addition of the engraver's name.[3] Sandys' usual method at this time was to first draw his design on paper, then transfer it to the woodblock by tracing it. There is, however, no evidence of this drawing being traced unless Sandys did it very lightly and did not make any obvious indentations in the paper. He would then complete the design again in precise detail on the woodblock for the engraver to follow. The final design would be lost in the engraving process. The engraved woodblock for *Manoli* is in the Hartley Collection in the Museum of Fine Arts, Boston.[8]

Manoli illustrates a poem by W.M.W. Call which first appeared in *The Cornhill Magazine*, volume VI, 1862, page 346. The engraving was republished in *The Cornhill Gallery* in 1865. The poem is based on a Moldo-Wallachian legend that to entomb a living human body within the walls of a building renders the structure invulnerable to time and decay. Manoli and his fellow-builders, on finding that their work on a mighty tower tended to crumble away under their hands, made a solemn vow that the first person who visited them on the morrow must be sacrificed in this manner. To his horror Manoli found that this was his wife. This tragic drawing deals with his wife's last anguished frantic appeal for mercy and release. It illustrates these lines from the poem:

> From fairest waist to breast more fair than all,
> Love's proper home, till o'er her pleading eyes,
> And lovely, lifted, hands, the marble bower
> Rose, covering all her beauty from the day,
> While thus her loving voice came mixed with tears, –
> 'Now, now the walls close round. I die, I die.
> My lord, farewell! I kiss thee ere I die';

At the foot of the design, as published in *The Cornhill Magazine*, was a quotation from

Lewes' *Life of Goethe*, which emphasized the key-note of the tragedy: "The affections, even in the affectionate, are powerless against the tyranny of ideas."

Forrest Reid felt that, although superb drawing does much to relieve the crude horror of the subject, one can scarcely place *Manoli* in the front ranks of Sandys' designs.[9] Gleeson White, however, was more complimentary in his comments: "F. Sandys is represented by *Manoli*, the second of his three contributions, which deepens the regret that work by this fine artist appeared so seldom in this magazine".[10] Stephen Wildman also considers *Manoli* to be one of the finest of Sandys' illustrations.[11] This drawing is one of the few finished designs for illustration by Sandys still in private hands, and not in a public collection.

From an old printed label on the back of the frame it appears that this drawing was included in a *Loan Collection of Modern Illustration,* sponsored by the Board of Education, South Kensington, and held at the Victoria and Albert Museum in 1900. The National Art Library at the museum has no catalogue for such an exhibition, although there is a *Catalogue of the Loan Exhibition of Modern Illustration* held at the V&A in 1901. In this exhibition, cat. no. 122 was a photograph of the drawing on the woodblock prior to cutting, while cat. no. 123 was a proof wood engraving by Swain of *Manoli*.[12] These items were lent by George Murray Smith, George Smith's elder son, but surprisingly there is no mention in the catalogue of the drawing itself being included in the exhibition.

George Smith had joined with Alexander Elder, another young Scot, to found Smith & Elder in October 1816, a firm originally started as a bookseller's and stationer's. The firm ran for almost 101 years and developed into East India agents, bankers and publishers.[13]

1 Crane, Walter: 1896, p. 172.
2 du Maurier, Daphne: 1951, p. 86. Sandys' advice was quoted in a letter from du Maurier to his mother in October 1861. George du Maurier's admiration for Sandys as an illustrator is evident from his letters from the early 1860s.
3 Elzea, Betty: personal communication, letter dated March 28, 1996.
4 Gere, John A.: 1994, Appendix, p. 154, three sketches of a woman to illustrate "Manoli", pencil, 6.3 × 10 cm.
5 Birmingham City Museum and Art Gallery: 1939. Birmingham has four drawings for "Manoli," including cat. nos. 891'06, 892'06, 893'06, and 894'06, as well as a proof engraving, cat. no. 895'06, all from the collection of James Anderson Rose.
6 O'Looney, Betty: Brighton Museum and Art Gallery, 1974, cat. no. 234, p. 43.
7 Ian Hodgkins & Co. Ltd.: 1990, cat. no. 241, bought by Betty Elzea. W. Jeffrey the photographer had a studio at 114 Great Russell Street and seems to have specialized in photographing these drawings on the woodblock. There is another copy of the photograph at the Birmingham City Museum and Art Gallery. On the mount of this illustration at Birmingham (895'06) is a note, probably made prior to 1906, stating "Mr. Smith (&Elder) has the drawing". By 1906 both George Smith and his son George Murray Smith were dead. This Mr. Smith could refer to Reginald Smith, who took over the firm of Smith & Elder in 1894, and was in control until his death in 1916. Reginald Smith was not related to George Smith, except by marriage, as he had married George Smith's youngest daughter in 1893.
8 Karlgaard, Joanna V.: personal communication, letter dated September 20, 1999.
9 Reid, Forrest: 1928, pp. 59-60.
10 White, Gleeson: 1897, p. 40.
11 Wildman, Stephen: 1995, cat. no. 83, p. 252.
12 Victoria & Albert Museum: 1901, cat. no. 122. This photograph of the woodblock is the one now in the collection of Betty Elzea. George Murray Smith lent a large amount of material relating to *The Cornhill Magazine* to this exhibition.
13 Huxley, Leonard: *The House of Smith Elder,* Printed for Private Circulation, London, 1923.

73 Three Studies for an Illustration, c. 1862-63

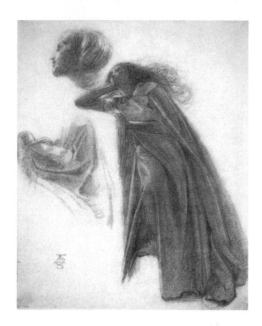

Graphite on grey-white wove paper, laid down; signed with *AFS* monogram, lower left
8½ × 7 in. (21.8 × 17.8 cm)
PROVENANCE: Anonymous sale, Sotheby's, London, January 25, 1989, lot 450, bought Maas Gallery, London; purchased May 10, 1989.
EXHIBITED: Maas Gallery: 1989, cat. no. 58 (illus.); Kenderdine Gallery: 1995, cat. no. 54.

This drawing is a good example of why Frederick Sandys was considered one of the most brilliant draughtsmen of the 19th century. Rossetti considered him to be "the greatest of living draughtsmen", while Millais' opinion of his work was equally high, declaring him to be "worth any two academicians rolled into one."[1] This drawing would appear to be from the early 1860s, his finest period, likely studies for an illustration that was never executed.

The studies include, at the top, a female head in profile facing left, and in the centre, a full-length female figure with the upper half of the body twisting to her right. At the left is a study of drapery over a bent arm. The model may have been Sandys' mistress Keomi, a gypsy woman who also modelled for Rossetti for the right-hand bridesmaid in his painting *The Beloved*, executed in 1865-66.[2] The face illustrated in the drawing certainly does not resemble that of the right-hand attendant in *The Beloved*, but this may be because Rossetti idealized it when he retouched the painting in 1873. Sandys is thought to have used Keomi as the model for his painting *Morgan Le Fay*, executed in 1862-63. The painting, as well as studies for it, are illustrated in the catalogue for the Sandys exhibition held at the Brighton Museum and Art Gallery in 1974.[3] Keomi is also said to have been the model for other Sandys' paintings from the early 1860s, including *Judith* and *Cassandra*.[4] There is a more striking resemblance between the head in the upper left of this drawing and another Sandys' drawing of c. 1862, said to be from the same model who sat for the *Study of the Head of Morgan Le Fay*.[5] Some controversy exists, however, as to whether this model is, in fact, the gypsy girl Keomi, since the model also bears a marked resemblance to the one used by Albert Moore in his painting *The Mother of Sisera Looked out of a Window* of 1861, now at the Carlisle City Art Gallery.[3,6] She was Mrs. Eaton, a mulatto woman who was a respected model in the 1860s among the progressive artists associated with the Pre-Raphaelite circle, including Rossetti, Moore, F. Madox Brown, Simeon and Rebecca Solomon, and Joanna Mary Wells (née Boyce).[7,8,9]

The figure in this drawing, with her long wild hair and long robe, is reminiscent of the Valkyrie in Sandys' illustration *Harold Harfagr* of 1862, and of the queen in his *Rosamund, Queen of the Lombards* of 1861. The pose of this figure is similar to that of Isabella in William Holman Hunt's painting *Isabella and the Pot of Basil* of 1867.[10] At the Birmingham City Museum and Art Gallery is a drawing of a female model, dressed similarly to the figure in this drawing, which also probably dates from the early 1860s, and may have been drawn on the same occasion.[10,11]

1 Wood, Esther: 1896, p. 8.
2 Surtees, Virginia: 1971, cat. no. 182, p. 105 and cat. no.182D, p. 106.
3 O'Looney, Betty: Brighton Museum and Art Gallery, 1974, *Morgan Le Fay*, cat. no. 58, p. 26, illus. pl. 29. *A study for the Head of Morgan Le Fay*, c. 1862, cat. no. 58, p. 26, pl. 30.
4 Newall, Christopher: *Victorian Pictures*, Sotheby's, London, June 5, 1996, lot 118, *Judith*. This painting was bought in and subsequently sold at Sotheby's, London, *Victorian Pictures*, November 5, 1997, lot 188.
5 O'Looney, B.: cat. no. 194, p. 40, pl. 142.
6 Laing Art Gallery: 1972, cat. no. 3, p. 12, pl. 2.
7 Gerrish Nunn, Pamela: 1993, p. 12. *Head of Mrs. Eaton* by Joanna Boyce was exhibited Manchester City Art Gallery: 1997-1998, cat. no. 16, p.112, collection of the Yale Center for British Art, New Haven, Connecticutt.
8 Cherry, Deborah: 1993, pl. 26, *A Young Teacher*. In this picture by Rebecca Solomon, dating from 1861, the model for the "Hindoo Nurse" could perhaps be Mrs. Eaton. Her features appear to be more those of a mulatto than an individual of Indian descent.
9 Bristol City Museum and Art Gallery: 1996, cat. no. 44, *Habet*. In this painting by Simeon Solomon from 1865 the figure of the coloured slave in the background fanning the empress would appear to have been modelled from Mrs. Eaton.
10 Elzea, Betty: personal communication, letter dated March 28, 1996.
11 Birmingham City Museum and Art Gallery: 1939, cat. no. 1024'66, graphite on cream paper, $7\frac{1}{8} \times 4\frac{3}{4}$ in. This drawing shows a female figure in profile, with one leg raised, wearing a long robe and a voluminous cloak, which flows behind her hanging in deep folds. Her head and forearms are barely indicated.

WILLIAM BELL SCOTT (1811-1890)

Scott was born on September 12, 1811 at Edinburgh, the son of the engraver Robert Scott, and the younger brother of the painter David Scott. He initially received training as an illustrator and engraver from his father, and then studied at the Trustees Academy, and later at the Edinburgh School of Art. He was also a poet, with his first verses published in 1831. He moved to London in 1837. In 1842 he competed unsuccessfully in the Westminster Hall decoration competition. In 1843 he was appointed to the mastership of the Government School of Design in Newcastle. In 1846 he published a volume of poetry, *The Year of the World*. On November 25, 1847 Rossetti wrote to express his admiration for his poems and to ask for an introduction. Soon afterwards Bell Scott called on Rossetti in London. Through Rossetti, Bell Scott was introduced into the Pre-Raphaelite circle and began a long-lasting relationship with many of its members and associates. In 1850 Scott contributed two poems to the Pre-Raphaelite publication *The Germ*. In 1854 he met Sir Walter and Lady Pauline Trevelyan. From 1856-61 Scott was commissioned to paint murals for their house, Wallington Hall, in Northumberland. These murals are his finest achievements as a painter. Bell Scott resigned as Master of the School of Design in Newcastle in 1863, and in 1864 he settled permanently in London. In 1870 he moved to 92 Cheyne Walk, Chelsea and became a near neighbour to Rossetti. On November 22, 1890 he died at Penkill Castle.

74 The Arcadian Poet, 1866

Oil on canvas; signed *W.B. Scott* and dated *1866*, lower right 18 × 24 in. (45.8 × 61 cm)
PROVENANCE: The property of a gentleman, likely M.D.E. Clayton-Stamm, Sotheby's Belgravia, July 10, 1973, lot 41, bought Julian Hartnoll of Hartnoll & Eyre; sold to Bill Waters of Norham House Gallery, Cockermouth by 1974; anonymous sales, Sotheby's Belgravia,

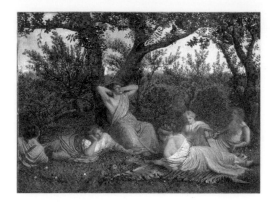

October 1, 1979, lot 17; Sotheby's, London, June 15, 1988, lot 224; Sotheby's, London, March 29, 1995, lot 214.

LITERATURE: Fredeman, William E.: 1975-1976, p. 33.

EXHIBITED: Norham House Gallery: 1974, cat. no. 1; Newcastle University: 1976, cat. no. 50; Kenderdine Gallery: 1995, cat. no. 55.

William Bell Scott is not an artist usually thought of as in the vanguard of the Aesthetic Movement. Although he had previously responded to the influence of the first phase of Pre-Raphaelitism, it is somewhat surprising to see this work from 1866, which is obviously in response to the avant-garde influences of the early 1860s. It was not until Scott left Newcastle and moved back to London in 1864, and came in close contact with members of the Rossetti circle, that he began to introduce current ideas regarding the subjectless, purely aesthetic purpose of painting into his own work. His advanced views on painting are evident from a letter he wrote to Swinburne on December 29, 1867 following publication of Swinburne's book on William Blake: "your warning that Art is the highest thing, and therefore utterly self sufficient … appears to me about the best thing that could be said on that matter."[1] Scott painted very few works of an "Aesthetic" nature, but even when he was Master of the School of Design at Newcastle, he had encouraged local collectors such as James Leathart, Jacob Burnett, Issac Lowthian Bell, and Walter and Pauline Trevelyan to buy works by the Pre-Raphaelites and other painters associated with the early Aesthetic Movement.[2] Although Scott was on the fringe of the Pre-Raphaelite circle for many years, his work was not uniformly appreciated, even by other members of the circle. John Ruskin, for instance, described him as "one of the more limited and peculiarly unfortunate class of artists who suppose themselves to have great native genius" and "of whose work I have never taken any public notice and who attribute my silence to my inherent stupidity of disposition."[2]

Scott's *The Arcadian Poet* was influenced by such important early Aesthetic Movement paintings as Millais' *Spring (Apple Blossoms)* of 1856-59, or Edward Burne-Jones' *Green Summer* of 1864. The general outline of the figures and the trees in the background is also reminiscent of a drawing by Edward Poynter of 1859 of a garden scene from the introduction to Boccaccio's *Decameron*.[3] It is also similar to a drawing by Holman Hunt from the early 1850s of *A Poet Reciting his Verses*, although this drawing, like Poynter's work, is medieval rather than classical in inspiration.[4] Hunt's drawing was never worked up into a more finished composition. Even if Scott had not seen Millais' *Apple Blossoms* when it was exhibited at the Royal Academy in 1859, he would have been familiar with it since the first collector to own it was Jacob Burnett of Newcastle. Scott undoubtedly would have seen Burne-Jones' *Green Summer* at the Old Water-Colour Society exhibition of 1865. In Scott's painting he not only adopts classical motifs, like many English avant-garde painters of the 1860s, but the figures, some of which hold musical instruments, exhibit the listlessness and langour that evoke a mood of poetic reverie similar to that in the works by Millais and Burne-Jones.

The Arcadian Poet is mentioned in Dr. Fredeman's article on William Bell Scott's correspondence with Alice Boyd, but it is listed under the year 1867, despite the painting being dated 1866.[5] Fredeman mentions that it is one of three paintings that Scott worked on in the autumn, the other two being *Rome (A.D. 100 and 150)* and *Sea Children*.[5,6] This painting's

true title of *The Arcadian Poet* was evidently lost for some time, as it had been sold as *The Poet – an Idyll,* and later as *The Poet's Harvest Home,* a title likely derived from the poem "The Song of the Shirt" of 1843 by Thomas Hood, which was popular in the middle years of the 19th century. The title of *The Poet's Harvest Home* for this painting is perhaps an understandable mistake, since Scott used it for a volume of a hundred of his own poems, published in 1882. Although the drawn title page for this volume shows figures in an orchard, it differs significantly from this painting of sixteen years earlier. The motif of apples and the masks of tragedy and comedy interestingly enough reappear on the cover of the book *Poems by W.B. Scott,* published in 1875. Scott was obviously very attracted to the depiction of the Greek masks of tragedy and comedy. In 1856 he had wanted to incorporate them into his mural decorations for the Central Saloon at Wallington in Northumberland, the home of Sir Walter and Lady Trevelyan.[7]

The Arcadian Poet is not Scott's only painting from about this date dealing with classical themes. A watercolour of *Proserpine Gathering Flowers,* which must date from the period 1864-70, sold at Christie's in 1994.[8]

1 Morely, Catherine W.: 1982, p. 51, MS British Museum.
2 Vickers, Jane: Laing Art Gallery, 1989-1990, cat. no. 130, p. 113.
3 Birmingham City Museum and Art Gallery: 1939, p. 299, cat. no.: 124'21, ink slightly washed with sepia, heightened with white bodycolour, 7¹⁄₁₆ × 8⅞ in., signed with monogram, and dated 1859. Another study for this composition, entitled Courtly Medieval Figures Making Music on a Terrace, was exhibited Delaware Art Museum, 1976, cat. no. 4-42, gouache, watercolour and pencil, unsigned and undated, 3½ × 5½ in., lent from a private collection. It had sold Christie's, London, December 12, 1972, lot 27 and had been exhibited at the Maas Gallery in 1973, cat. no. 71, and in 1974, cat. no. 83.
4 Hunt, William Holman: 1913, Vol. I, illus. p. 181. This work was with the Christopher Wood Gallery in 1980-81 and later sold at Christie's, London: *Important Victorian Pictures, Drawings and Watercolours,* October 16, 1981, lot 23, pencil, pen and brown ink, 4¾ × 6¾ in. Judith Bronkhurst, in a letter of July 30, 1999, dates this drawing to c. 1851. Dr. Bronkhurst feels that it is just possible that Scott could have seen this drawing at 1 Tor Villa, since Alice Boyd's diary notes that she and William and Letitia dined at Hunt's on February 15, 1866. Although Bell Scott and Hunt were certainly close friends at this time, Dr. Bronkhurst thinks it unlikely that there is any link between Scott's painting and Hunt's drawing.
5 Fredeman, William E.: 1975-1976, p. 33.
6 Christopher Wood Gallery: 1982, cat. no. 53, *A Messenger in Rome, AD 150,* oil on canvas, 29 × 45½ in., signed, inscribed and dated 1864. This work had sold at Sotheby's Belgravia, *Fine Victorian Paintings and Drawings,* October 2, 1979, lot 209. Although a classical subject, it is not an example of Aesthetic Classicism. It shows a young Roman woman, apparently a convert to Christianity, in angry confrontation with three women sacrificing on pagan altars. In its attempt to represent objects and the architecture of ancient Rome, it is somewhat reminiscent of the works of Lawrence Alma-Tadema, who became a good friend of W.B. Scott in the 1870s. Although not exhibited until it was shown at the Royal Scottish Academy in 1868, Bell Scott had completed this painting by March, 1862. It was at that time known as *A Messenger of the New Faith: Rome A.D. 100.* On November 23, 1862 Bell Scott wrote to W.M. Rossetti: "I have completely repainted my picture of the Household Gods and Christian cousin." See Peattie, Roger W.: 1990, letter 77, pp. 120-122 and n. 1, and letter 84, p. 129. It would appear that Scott still was not happy with this painting and must have reworked it again in 1867. It is likely he reworked *The Arcadian Poet* at the same time.
7 Trevelyan, Raleigh: 1978, p. 122. Trevelyan points out that Sir Walter had to approve every step of Scott's decoration. "Scott's so-called Pompeian motifs were entirely wrong – he had confused them with Etruscan designs. Tragic and comic masks? Certainly not. They must have heads of Roman emperors connected with Northumberland."
8 Christie's, London: *Fine Victorian Pictures, Drawings and Watercolours,* March 25, 1994, lot 357, 27½ × 17¼ inches. It had previously been offered for sale Sotheby's, London, January 31, 1990, lot 353. Inscribed on old labels on the back was "W.B. Scott Esq. 133 Elgin Road, Notting Hill". This watercolour must therefore date from when Scott moved back to London in 1864, until he moved to Bellevue House, Cheyne Walk, Chelsea in 1870.

75 Study for "Thou Hast Left Me Ever, Jamie," c. 1870-71

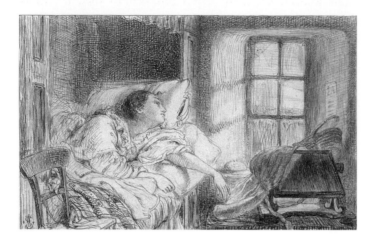

Pen and black ink on off-white wove paper; signed with monogram, lower left. Inscribed below the drawing, in Scott's handwriting, *Thou hast left me ever, Jamie, Thou hast left me ever. Song.* 5³⁄₁₆ × 7⅛ in. (13.3 × 18.2 cm)

PROVENANCE: Alice Boyd, Penkill Castle, Ayrshire; thence by descent in 1897 to her niece Eleanor Margaret Courtney-Boyd, and thence in 1946 to Margaret's half-sister Evelyn May Courtney-Boyd; bought from May Courtney-Boyd in 1971 or 1972 by Ronald Marshall of the Stone Gallery, Newcastle and Burford; Ian Hodgkins and Co. Ltd., Slad, Stroud, Glos.; purchased November 30, 1990.

LITERATURE: Ian Hodgkins & Co. Ltd: 1990, cat. no. 246 (illus.).

EXHIBITED: Kenderdine Gallery: 1995, cat. no. 56.

This is a study for an etching for the *Poetical Works of Robert Burns*. This illustrated edition of Burns, although commissioned and paid for by the publisher, was never published. As Bell Scott recalled in his autobiography for the year 1871: "At this very time I had been engaged to edit the poetry of the Ayrshire bard, to edit and illustrate, a task which occupied a goodly share of study."[1] This drawing is an illustration to one of Burns' most poignant songs:

Thou has left me, Jamie,
Thou has left me ever
Thou has left me, Jamie,
Thou has left me ever
After has thou vow'd that Death
Only should us sever;
Now thou'st left thy lass for ay–
I maun see thee never, Jamie,
I'll see thee never

Thou hast me forsaken, Jamie,
Thou hast me forsaken
Thou hast me forsaken, Jamie,
Thou hast me forsaken
Thou canst love another jo,
While my heart is breaking–
Soon my weary een I'll close
Never mair to waken, Jamie
Never mair to waken.

A series of seventeen proof etchings, before lettering, for the *Poetical Works of Robert Burns*, drawn and etched by W.B. Scott, was eventually published by Thomas C. Jack of Edinburgh in 1885.[2] Two additional pen-and-ink studies, similar to this drawing, for the etchings illustrating Burns' works were included in a sale at Christie's, London, on November 6, 1995.[3]

194

This work clearly shows the influence of Dante Gabriel Rossetti, particularly in the appearance and pose of the languid woman, which are very reminiscent of Rossetti's drawings, especially of his mistress Fanny Cornforth. The model for the female figure in this drawing would appear to be Scott's great love Alice Boyd.[4] William Bell Scott first met Alice Boyd on March 18, 1859, while he was working on a mural commission at Wallington Hall in Northumberland. Miss Boyd was a spinster, aged thirty-three, while Bell Scott was much older. He stated in his autobiographical notes: "She was somehow or other possessed to me, of the most interesting face and voice I had ever seen or heard."[4]

In July, 1860 Bell Scott paid his first visit to Penkill Castle, Ayrshire, Scotland. Spencer Boyd, Alice Boyd's brother, died in 1862 and left her his fortune in iron works and coal mines, as well as Penkill Castle. Scott's mural decorations there of *The King's Quair* began in 1865 and were completed in 1868. From the time of Bell Scott's and Alice Boyd's first meeting, until his death thirty-one years later, they were rarely separated. After the Scotts returned to London to live in 1864, Alice Boyd would spend much of the winter with them in Chelsea, while they, in turn, would spend much of the summer with her at Penkill. Scott had married his wife in 1839, but it would appear to have been a rather loveless match, and she seems to have been unconcerned about the relationship between her husband and Alice Boyd. Alice Boyd was fond of painting, and under Scott's guidance, she became a relatively accomplished artist. Her work was praised by Rossetti who believed her "to possess at least as much power in painting as any woman I know – even the best."[5] There is no doubt that Bell Scott and Alice Boyd were devoted to each other, but it is controversial whether or not she was actually his mistress, or whether their friendship was anything other than platonic.[6,7,8] Alice Boyd nursed Scott through the illnesses of the last ten years of his life. Unlike the love in Burns' poem, the love of Scott and Alice Boyd remained steadfast and was only severed by Scott's death. Alice Boyd is buried next to him in the graveyard of Old Dailly Churchyard near Penkill.

Scott also did a watercolour of this same design.[9] The features of the model in this watercolour, and in the finished etching, are not, however, those of Alice Boyd.

1 Minto, W.: 1892, Vol. II, p. 166.
2 Hoy, Ian: personal communication, letter dated January 23, 1991. I am indebted to Ian Hoy, of Ian Hodgkins and Co. Ltd., for this information. The seventeen etchings all measure approximately 4 × 6⅓ in., on sheets 12⅛ × 10¾ in., with lettered guards to each etching. The finished etching for *Thou Hast Left Me Ever, Jamie* is illustrated in Ian Hodgkins & Co., 1992, item 189.
3 Christie's, London: *Victorian Pictures*, November 6, 1995, lot 96, page 61, from the estate of Ronald Marshall of the Stone Gallery, Burford. These drawings share the same provenance of May Courtney-Boyd, Penkill Castle, Ayrshire. An additional drawing from this series is in another private Canadian collection, purchased from the London dealer Rachel Moss of Moss Galleries.
4 Minto, W.: Vol. II, pp. 56 and 57. An illustration of Miss Boyd, etched by W.B. Scott from a drawing by D.G. Rossetti, between pp. 56 and 57, shows a striking resemblance to the figure in this drawing. The original drawing by Rossetti, on which the etching is based, sold Sotheby's Belgravia: *Fine Victorian Paintings, Drawings and Watercolours*, July 9, 1974, lot 37.
5 Hickey A: 1993, pp. 1-11.
6 Fine Art Society: 1992, cat. no. 4.
7 Fredeman, William E.: 1975-1976, p. 22. Scott, in a letter of February 29, 1864 to Alice Boyd, made quite clear how much he missed her after she left London to return to Penkill: "This last week, dearest Miss Boyd, has been one of the dreariest I ever spent … If only I could run into your room before breakfast instead of sitting here in the dingy cold till the teapot draws! Or at night feel your sweet weight in my arms for ten minutes before turning in, instead of snoozing and thinking of you." This suggests that Scott's love for Alice Boyd was more than platonic.
8 Trevelyan, Raleigh: 1978, p. 149. Trevelyan stated: "And certainly there is no doubt that, despite discreet references in contemporary accounts to a 'platonic' relationship, Miss Boyd became Scott's mistress."

9 Shepherd Gallery: 1994, cat. no. 135, on loan from Julian Hartnoll, watercolour heightened with body-
 colour, 16½ × 26 in., provenance Alice Boyd. This work had previously sold at Sotheby's, London,
 June 15, 1982, lot 62, and again on November 6, 1991, lot 299. The composition differs slightly
 between the present drawing and the watercolour version.

ELIZABETH ELEANOR SIDDAL (1829-1862)

Lizzie Siddal was born in Holborn on July 25, 1829, the third child of Charles Siddal, a cutler. She entered the Pre-Raphaelite circle after being discovered by Walter Deverell in 1849, working as a milliner's assistant at Mrs. Tozer's in Cranbourne Alley, London. She modelled for the figure of Viola in Deverell's painting *Twelfth Night*, and then subsequently for other Pre-Raphaelite painters, including Hunt and Millais. After 1852, however, she sat exclusively for Rossetti. From 1852-61 she worked as an artist. She wrote poetry as well, although her poems were never published during her lifetime. In 1857 she exhibited at the Pre-Raphaelite exhibition at Russell Place, London, and exhibited a watercolour, *Clerk Saunders*, at the exhibition of Modern British Art held at the National Academy of Design in New York. In 1857 she also attended the School of Art in Sheffield for a short period of time. On May 23, 1860 she married D.G. Rossetti at Hastings. Siddal died at their home in Chatham Place, London, on February 11, 1862, from an overdose of laudanum. She was buried in the Rossetti family grave in Highgate Cemetery, London.

76 Angels with Interlocking Wings, c. 1855

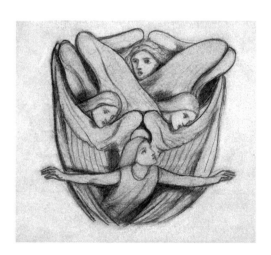

Graphite on off-white wove paper
4⅞ × 6 in. (12.4 × 15.3 cm)
PROVENANCE: Charles Fairfax Murray; by descent to his son Arthur Richmond Murray; his sale Sotheby's, London, February 15, 1961, part of lot 6, bought Sir Geoffrey Mander; sold to Jeremy Maas of Maas Gallery, London; sold to Miss A. Percival, December 1961; anonymous sale, Christie's, London, October 31, 1989, lot 212.
LITERATURE: Lewis, R.L. and Lasner, M. S.: 1978, pl. no. 13; Marsh, J. and Gerrish Nunn, P.: 1991, p. 69; Marsh, Jan: Ruskin Gallery, 1991, cat. no. 40, p. 68 (illus.).
EXHIBITED: Maas Gallery: 1961, cat. no. 99; Kenderdine Gallery: 1995, cat. no. 57.

Elizabeth Siddal had apparently done some drawings, even before entering the circle of the Pre-Raphaelite Brotherhood.[1] After 1852 she became Rossetti's pupil, as well as his main model, although she probably received little formal instruction from him. Rossetti tended to feel that anyone with imagination could paint, and his instruction likely consisted largely of encouraging her to create her own compositions, rather than to follow formal academic training, where pupils were taught to make studies of casts, drapery, etc. before proceeding to make

studies from life.[1] In January, 1853 she completed her first drawing under Rossetti's guidance. Although the figures in her early work tend to be stiff and anatomically awkward, and her drawing technique rather primitive, she was commended for her imaginative originality.[1,2] Although her work was obviously influenced by Rossetti, she retained her own distinctive style, as noted by Algernon Swinburne: "Gabriel's influence and example not more perceptible than her own independence and freshness of inspiration."[3]

When John Ruskin saw Siddal's work for the first time he was favorably impressed. On March 18, 1855 Rossetti wrote to William Allingham about Ruskin's reaction to Lizzie's drawings: "About a week ago, Ruskin saw and bought on the spot every scrap of designs hitherto produced by Miss Siddal. He declared that they were far better than mine, or almost than any one's and seemed quite wild with delight at getting them."[4] Ruskin pressed Lizzie to accept a yearly allowance of £150, in return for the right of first choice of all her works produced up to the value of that sum. While this has been interpreted as an effort to secure Rossetti's gratitude, which it unquestionably was to some extent, it was also consistent with Ruskin's practice of helping artists whom he believed to be in financial need, and who were in sympathy with his own ideas. In April 1855 Ruskin wrote to Siddal: "If you do not choose to be helped for his sake, consider also the plain *hard fact* is that I think you have genius; that I don't think there is much genius in the world; and I want to keep what there is, in it, heaven having, I suppose, enough for all its purposes."[5] The originality and primitiveness of Lizzie's work were comparable to those qualities that Ruskin admired in medieval art, "stiffness and quaintness and intensity."[6] Lizzie, however, quite rightly worried about the cost of Ruskin's patronage. With the allowance from him, which lasted only a year and was relinquished in 1857, came his advice on how she should draw and paint, which frequently ran contrary to her own ideas. Ruskin wished her to stop drawing "fancies" and imaginative scenes and "be made to draw in a dull way sometimes from dull things", such as his own favorite subjects, stones, leaves, and rocks. In 1857 Ruskin wrote to Rossetti: "I want to tell her one or two things about her way of study. I can't bear to see her missing her mark by only a few inches, which she might as easily win or not."[5] Fortunately Lizzie mostly ignored his advice which would have tended to suppress the strongest point of her art, which was originality of design.

This drawing is likely one of several designs produced by Siddal, evidently intended for a carved capital for the library of Trinity College, Dublin.[7,8] In June 1853 Rossetti wrote to his friend, the Irish poet William Allingham: "That building you saw at Dublin is the one. I must have met Woodward the architect of it, at Oxford … He is a particularly nice fellow, and very desirous to meet you. Miss S. made several lovely designs for him, but Ruskin thought them too good for his workmen at Dublin to carve. One, however, was done (how I know not) and is there; it represents an angel with some children and all manner of other things, and is, I believe, close to a design by Millais of mice eating corn. Perhaps though they were carved after your visit."[4] Siddal may have been given the commission for this design via Ruskin, who was a friend of the architects for this project, Deane and Woodward. While Rossetti is unequivocal about Siddal's design being executed, Thomas Deane, the son of Woodward's partner, stated that neither Siddal's or Millais' designs were used.[4]

The four angels in this design are somewhat reminiscent of those in Rossetti's *Beatrice Meeting Dante at a Marriage Feast, Denies Him Her Salutation*, initially painted in 1851, although a replica was completed for Ruskin in 1855, or those in *The Seed of David* of c. 1856. The similarity in styles suggests the cross-influences between Rossetti and Siddal at this time. It may, however, be more a reflection of a shared Pre-Raphaelite style, since the angels are also very similar to those in Arthur Hughes' painting of 1855, *The Nativity*.

1 Marsh, Jan and Gerrish Nunn, Pamela: 1989, p. 66. Siddal apparently showed some of her designs to Walter Deverell's father, who was the principal of the Government School of Design in London. Mr. Deverell was evidently pleased with the drawings and showed them to his son and his Pre-Raphaelite associates, who then encouraged her to practice.
2 Doughty, O., and Wahl, J.R.: 1965, Vol. 1, p. 200. D.G. Rossetti, letter to F.M. Brown of May 23, 1854: "Her power of designing even increases greatly, and her fecundity of invention and facility are quite wonderful, much greater than mine."
3 Rossetti, William M.: 1906, Vol. 1, p. 195.
4 Hill, George Birbeck: 1897, pp. 110, 140-141, and 146.
5 Rossetti, W.M.: 1899, pp. 63 and 183-184.
6 Watts, Mary Seton: 1912, Vol. 1, p. 173.
7 Marsh, J.: Ruskin Gallery, 1991, cat. no. 29. Several other studies of angels are also illustrated.
8 Lewis, Roger and Lasner, Mark Samuels: 1978, p. 26.

SIMEON SOLOMON (1840-1905)

Simeon Solomon was born on October 9, 1840 in Bishopsgate, London, the youngest of eight children. His father was a Leghorn hat manufacturer and a prominent member of the Jewish community in London. His brother Abraham and sister Rebecca were also artists. Simeon initially trained in his brother's studio, at Leigh's Art School, and at Cary's Academy. In 1855 he entered the Royal Academy Schools. In 1858 he exhibited at the Royal Academy for the first time. In the late 1850s and the 1860s Solomon did illustrations for books and magazines, decorative work for William Burges, and stained-glass designs for Morris, Marshall, Faulkner, & Co. In the 1860s he turned from biblical to classical themes. Between 1866 and 1870 he made three visits to Italy, which reinforced his conversion to classical subjects. In 1871 he published his prose poem *A Vision of Love Revealed in Sleep*. After 1873 his promising career disintegrated, when he was arrested and convicted of sodomy. Although the sentence was later suspended, he was afterwards largely shunned by respectable society. For the last twenty years of his life he was an alcoholic vagabond who lived mainly at the St. Giles Workhouse, Holborn. He supported himself as a pavement artist, or as a match and shoelace vendor. He died at St. Giles on August 14, 1905, and was buried in the Jewish Cemetery, Willesden.

77 Revenge, 1859

Pen and brown ink and brown wash over graphite on off-white paper, laid down; signed in pencil *SS* (partly erased), and dated *20/11/59*, lower left; inscribed centre top "REVENGE"; with the stamp of the de Pass Gift (Lugt 2014e) 8⅛₆ × 10¾ in. (20.6 × 26.5 cm)
PROVENANCE: Alfred de Pass; presented in 1928 to Royal Institution of Cornwall, County Museum and Art Gallery, Truro; their sale, Christie's, London, February 22, 1966, part of lot 44, bought Sanders of Sanders Gallery, Oxford; anonymous sale, Christie's, London, February 4, 1986, lot 16, bought J. Hartnoll, London; purchased August 10, 1992.
LITERATURE: Penrose, George: 1936, p. 34, no. 446; Seymour, Gayle: Julian Hartnoll, 1986, cat. no. 11 (illus.).
EXHIBITED: Shepherd Gallery: 1989, cat. no. 125 (illus.); University of Lethbridge Art Gallery: 1993; Kenderdine Gallery: 1995, cat. no. 58.

Solomon's fellow students at the Royal Academy Schools included Henry Holiday, Albert

Moore, William De Morgan, and William Blake Richmond. Richmond, in his reminiscences, recalled: "but the greatest genius of our set was S. Solomon, that wonderful little Jew who might have risen to any height of distinction if he had chosen to encourage his great gifts."[1] While at the Schools Solomon formed part of an informal group, called the "Sketching Club", consisting initially of himself, Henry Holiday and Marcus Stone, but which was later to include Albert Moore, Fred Walker, and William Blake Richmond as well as others.[2] The club met once a week at their respective houses in rotation, where

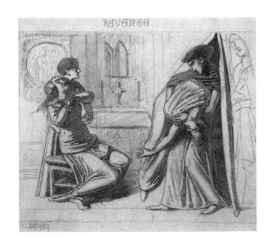

the host would suggest the subject for the evening's work. This drawing, entitled *Revenge*, would have been done during the course of such a meeting. At one time it was one of eight attributed to Solomon which formed part of the Alfred de Pass gift to the Royal Institution of Cornwall, Truro. When these drawings were auctioned at Christie's on February 22, 1966 the subjects also included *Peace*, *Love*, *Triumph*, *Gratitude*, and *Horror*.[3] A number of these works, as well as others carried out for the Sketching Club, have subsequently appeared on the art market.[4] Some of the works in the de Pass Collection attributed to Solomon were actually by other artists. Two of these are in another private Canadian collection, of which *Gratitude* is by Henry Holiday, while the artist responsible for the drawing *Anxiety* remains unidentified. *Anxiety*, initialled "S.C.W.(?)," was sold at Christie's, London on February 4, 1986, as part of the same lot as the present drawing. The *Revenge* drawings by both Henry Holiday and Solomon were included in an exhibition of *English Romantic Art* held at the Shepherd Gallery in New York in 1989.[5]

Solomon's *Revenge*, with its thoroughly "Gothic" style, was probably influenced by the medieval watercolours being produced in the late 1850s by Dante Gabriel Rossetti, or perhaps by the Gothic Revivalist architect William Burges, to whom Solomon had been introduced in 1858 by George Price Boyce. Boyce, in his diary, records a visit to Abraham Solomon's studio on April 7, 1857 where he "saw some remarkable designs by his young brother [Simeon] showing much Rossetti-like feeling."[6] This suggests that Rossetti was a strong influence on Solomon's work, even prior to their being acquainted. It is not known exactly when he and Solomon were first introduced, but it it is most likely to have been in 1858. In October 1857 Solomon wrote to the sculptor Alexander Munro: "I am only just turned 17 and am very small and not advanced enough in manners to become the guest of grown up gentlemen at such a late hour. You know how I should like to meet Mr. Rossetti without my expressing regrets that I am unable to do so."[7] William Michael Rossetti, in a letter to his mother of September 1, 1858, mentioned: "Also that little Solomon's visit must have been paid under a misapprehension of something I said to him 2 or 3 months ago, as I had nothing of Gabriel's at home to show him, but may rather have offered to take him to Blackfriars. He is an unsightly little Israelite: but a youth of extraordinary genius in art – and perhaps otherwise."[8] Solomon, early in his friendship with D.G. Rossetti, is said to have been a frequent visitor to his studio. W.M. Rossetti, however, downplayed this association between his brother and Solomon in a letter written to Julia Ellsworth Ford in 1903: "You say – 'The time Solomon was in my Brother's Studio was the most important period of his life.' I don't quite know what is here implied. True, Solomon was in my Brother's Studio every now and

then, like any other visitor, between some such dates as 1863 and 1871: but, if it is supposed that he attended regularly as a student or practitioner under my Brother, this is quite a delusion. There was nothing of the sort at any time."[8] It is uncertain, however, how much one can trust William Michael's recollections this far back, particularly since he was definitely one of those in the Pre-Raphaelite circle who wished no further association with Solomon following his conviction for homosexual infractions. He may therefore also have wished to protect his brother's reputation by downplaying any association between Dante Gabriel and Solomon.

Although Solomon's early work had dealt largely with Old Testament subjects, by 1859 he had begun to adapt medieval themes. Even in his self-portrait drawing, dated 1/6/59, at the Tate Gallery, London, Solomon included a Gothic stained-glass window in the background at the upper right, similar in feeling to the medieval windows and tapestry depicted in *Revenge*.[9]

The subject of *Revenge* most likely has a literary source, as from his earliest years Solomon had read widely in English literature. This drawing shows a young man returning with a dead body, presumably that of a relative. Previous Pre-Raphaelite sources of inspiration for this drawing could include Holman Hunt's *Rienzi Vowing to Obtain Justice for the Death of his Young Brother, Slain in a Skirmish between the Colonna and Orsini Factions*, exhibited at the Royal Academy in 1849. This painting was based on Bulwer Lytton's novel *Rienzi*, which is set in 14th-century Italy. Solomon was only eight years old, however, when this painting was exhibited at the Royal Academy, so it is not known whether he was familiar with it. The painting was sold in 1849 to John Gibbons.

A drawing by Edward Poynter entitled *Revenge* sold at Christie's, London, on October 16, 1981.[10] Although this drawing is dated 1861, one wonders whether it had its origins in the drawings on this theme done by his friends Simeon Solomon and Henry Holiday, with whom he was on intimate terms at this time.[11]

1 Stirling, A.W.M.: 1922, p. 9.
2 Holiday, Henry: 1914, p. 40.
3 Penrose, George: 1936, p. 34. Included in the catalogue was: cat. no. 445, *Peace*, dated 25/5/58, pencil and sepia wash, $7^5/8 \times 6^5/8$ in.; cat. no. 446, *Revenge*, pencil and sepia wash, dated 20/11/59, $6^1/2 \times 8^1/4$ in.; cat. no. 447, *Gratitude*, pencil and sepia wash, dated 18/1/59, $6^1/2 \times 8^1/4$ in.; cat. no. 448, *Love*, ink and sepia wash, dated 2¼/58, $8^1/2 \times 6^3/4$ in.; cat. no. 449, *Triumph – Orpheus Ransoming Euridice*, pencil and sepia wash, dated 10/11/58, $6^3/4 \times 7^5/8$ in.; cat. no. 450, *Anxiety* (Skit on Millais's Carpenter's Shop), ink and sepia wash, $5^1/4 \times 7^1/8$ in.; cat. no. 451, 1. *Revenge. The Sisters*, sepia, $3^1/2 \times 3^1/2$ in. 2. *Horror. A Storm*, sepia, $5^5/8 \times 5^3/4$ in.; cat. no. 452, Study of Two Ladies Seated, red and black crayon, 10×14 inches; cat. no. 453, *Study for the picture Habet*, red crayon, $9^3/4 \times 13^1/2$ in.; cat. no. 454, "*And His Sister Stood Afar Off To Wit What Would Be Done To Him*", pencil and sepia wash, dated 22/2/59, $8^3/4 \times 6^3/4$ in.; and cat. no. 455, *The Soul Released from the Body*, pencil and sepia wash, dated 17/3/57, $7^1/2 \times 6^3/4$ in.
4 Christie's, London: October 18, 1977, lot 38, *Peace, Triumph, Gratitude*, bought Julian Hartnoll, London; Shepherd Gallery: 1983, cat. no. 101, *Peace*; Christie's, London, July 19, 1988, lot 30, *Love*; Maas Gallery: 1989, cat. no. 65, *Triumph – Orpheus Ransoming Euridice*; Julian Hartnoll, London, *Supplement to Catalogue No. 13*, cat. no. 62, another version of *Triumph: Orpheus Ransoming Eurydice*, dated 10/11/58, $6^3/4 \times 7^1/2$ in.; Geffrye Museum: 1985, cat. no. 36, *The Soul Released from the Body*. Another drawing, likely done for the Sketching Club as it is in a similar style, dated 1857, and which illustrates a work by Mrs. Gaskell, was with the Fine Art Society, London, in 1997-98.
5 Shepherd Gallery: 1989. Henry Holiday's *Revenge: The Sisters* was cat. no. 55, sepia ink and pencil, 5×5 inches, while Solomon's *Revenge* was cat. no. 125. The Holiday drawing had sold at Sotheby's, London: *Victorian Paintings, Drawings and Watercolours*, June 14, 1989, lot 373.
6 Surtees, Virginia: 1980, p. 17.
7 Lambourne, Lionel: 1967, p. 60.
8 Peattie, Roger W.: 1990, letter 64, p. 99, and letter 563, p. 635.

9 Reynolds, Simon: 1985, fig. 5, p. 13, *Self Portrait at Age 19*, pencil drawing, 16.6 × 14.7 cm.

10 Christie's, London: *Important Victorian Pictures, Drawings and Watercolours*, October 16, 1981, lot 25, black chalk heightened with white, 12 × 8¾ in.

11 Solomon, Simeon: *Sketches Invented and Drawn by Simeon Solomon for His Friend E.J. Poynter: 20 photographs*, London: (Issued by Frederick Hollyer), 1865. This gives some idea of the closeness of the friendship between Poynter and Solomon in the 1860s.

78 In the Temple of Vesta, 1862

Graphite and watercolour, heightened with body-colour and scratching out, on wove paper; signed with the artist's monogram, and dated *2 5 62*, lower left; on the back of the frame are remnants of an old typed label, including "145, S Solomon, In … ta." 10¹⁵⁄₁₆ × 6⁹⁄₁₆ in. (27.9 × 16.7 cm)

PROVENANCE: Anonymous sales, Sotheby's, London, January 25, 1988, lot 440; Sotheby's, London, April 27, 1989, lot 577; Christie's, London, November 5, 1993, lot 123.

EXHIBITED: Kenderdine Gallery: 1995, cat. no. 59.

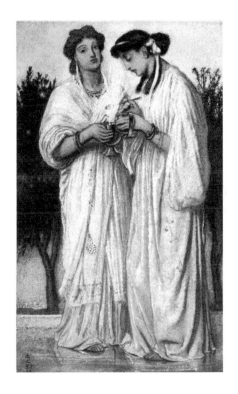

It is uncertain when this watercolour became known as *In the Temple of Vesta*, but it appears to have been exhibited under this title at some time in the past, based on an old label pasted on the back of the frame. This watercolour is derived from one of Solomon's illustrations, also dated 1862, for the *Dalziel Bible Gallery* entitled *Jewish Women Burning Incense – Jeremiah*. In the wood engraving the figures of the two women are reversed, and the background differs significantly. During the early 1860s Solomon prepared twenty drawings to be engraved for the Dalziel Brothers' illustrated Bible, more than any other artist involved in this project, which also included Watts, Leighton, Poynter, Holman Hunt, Madox Brown, Burne-Jones, and Sandys. When the *Dalziel Bible Gallery* was finally published in 1881 only six illustrations by Solomon were included, but all twenty were eventually used when *Art Pictures from the Old Testament* was published in 1894.[1] *Jewish Women Burning Incense* was not the only one of Solomon's designs for the *Dalziel Bible Gallery* which he subsequently modified and worked up into finished watercolours or oil paintings. Some, like his well-known watercolour *Shadrach, Meshach and Abednego*, dated October 1863, are considerably altered from the illustration.

In Solomon's Dalziel illustration, two women, evidently from the upper class judging from their garments, can be seen mixing incense with a spoon. The subject is taken from Jeremiah 44: 15-30. The prophet had been preaching against the wickedness of the Jewish people, including Jewish women who burnt incense to a false goddess whom they called the queen of heaven. It is likely that this watercolour only acquired its title *In the Temple of Vesta* later in its existence, based on a misinterpretation of its subject matter, once its association with the *Dalziel Bible Gallery* illustrations was forgotten. Vesta, one of the principal div-

inities in Roman mythology, was the goddess of the hearth. Her priestesses in the Temple of Vesta were six vestal virgins, who watched over the sacred fire originally brought to Rome by Aeneas. It is possible, however, that John Christian is correct and that Solomon may have intended this watercolour to be one of a pair with *In the Temple of Venus*, another watercolour of two classically draped women, dated April 23, 1863.[2] Christian sees these two watercolours as early phases in Solomon's move from Jewish to classical themes in the 1860s, which reflects his development of Aesthetic values.

The left-hand figure in this watercolour bears a resemblance to Fanny Cornforth. It is possible she was the model, as she was certainly posing for others in the Pre-Raphaelite circle around this time, including Rossetti, Spencer Stanhope, and Burne-Jones (see cat. no. 8).

1 Fox, Aley: 1894. *Jewish Women Burning Incense – Jeremiah* is illus. opposite p. 166.
2 Christian, John: Christie's, London: *Fine Victorian Pictures, Drawings and Watercolours*, November 5, 1993, lot 23. In a conversation with John Christian on March 16, 1994 he told me the watercolour was given the name *In the Temple of Vesta* as this was the title the consignor referred to it by. The water-colour *In the Temple of Venus* is of comparable size, 9½ × 6 in.

79 Erinna Taken from Sappho, 1865

Pen and black ink on white wove paper; signed with the artist's monogram and dated *SS 5 65*,

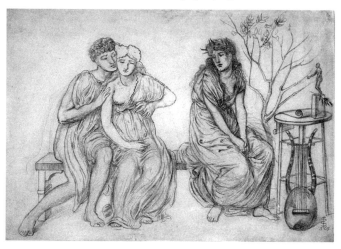

lower right 9⅛ × 12¹¹⁄₁₆ in.(23.2 × 32.3 cm)
PROVENANCE: Anonymous sale, Sotheby's, London, November 12, 1998, lot 4.

Sappho was a famous Greek poetess who was born on the island of Lesbos. Although only a few fragments of her work survive, they established her as one of the eminent poets of the early age of Greek literature. At the beginning of the 6th century B.C., after returning from exile, Sappho joined a community of young girls who worshipped Aphrodite at Mytelene on the island of Lesbos. Sappho wrote poems and songs that praised their way of life.[1] As Erinna was a 4th-century B.C. poetess from the Dorian island of Telos, who died at the age of nineteen, the two women could obviously never have been acquainted. The *Suda*, a 10th-century A.D. lexicon of abridged and corrupt texts, incorrectly placed Erinna at Mytelene with Sappho. It was from this source, or from another that was derived from it, that Solomon

must have obtained his subject. Although Sappho is generally regarded as a lesbian, she was married and bore a daughter, Kleis. In legend she was also said to be passionately in love with a handsome youth named Phaon, a boatman of Mytelene, who failed to return her affection. In her despair she is said to have thrown herself from the promontory of Leucadia into the sea where she drowned. It was believed that those who survived the leap would be cured of their love. This story of Sappho's suicide is now generally discounted by scholars.[2]

This choice of subject, the classical theme of lesbian love, may have been influenced by Solomon's friendship with Algernon Swinburne. Solomon's friendship with him was the principal inspiration that led the artist to begin to paint classical themes.[3] Solomon, although well read, to his regret lacked the classical education of his friend. Swinburne, in his poem *Atalanta in Calydon*, which he wrote in 1863, had already described his principal character Atalanta as possessing many lesbian characteristics. In 1866 Swinburne's *Poems and Ballads* was published. This book included the dramatic monologue "Anactoria," which led to much outraged criticism when it was published, as it described the lesbian and sado-masochistic relationship between Sappho and her lover Anactoria.[4] Although not published until 1866, this poem may have been written earlier in the 1860s. As Christopher Newall has noted, Solomon and Swinburne shared an interest in "all things licentious and bizarrely erotic."[5] Certainly a decision to write about, or to paint, themes dealing with lesbian love, even in a classical context, was a bold move in the 1860s. As Tabor has noted: "In the context of mid-Victorian England's obsession with categorizing respectable and nonrespectable sexual behavior, the passionate poet of Lesbos ... most certainly was an antique precursor of contemporary sexual deviancy, a negation of the feminine ideal, and a threat to the Christian institutions of family, home and empire."[2] Solomon was even more bold in his art than was Swinburne, in that he openly depicted scenes of homosexual love, although this was more explicit in the private drawings he made for friends than in his works for public exhibition.

In 1864 Solomon had painted a watercolour of *Sappho and Erinna in a Garden at Mytelene*, now in the collection of the Tate Gallery, London.[1] The earlier watercolour is more explicit in portraying lesbian love than this drawing done a year later. Swinburne, in an article in the *Dark Blue* of July 1871 on Solomon's work, discussed the earlier watercolour: "Especially in such works as the 'Sappho' and the 'Antinous' of some years since does this unconscious underlying sense assert itself. The wasted and weary beauty of the one, the fault-less and fruitful beauty of the other, bear alike the stamp of sorrow; of perplexities unsolved and desires unsatisfied. They are not the divine faces familiar to us: the lean and dusky features of this Sappho are unlike those of her traditional bust, so clear, firm and pure; this Antinous is rather like Ampelus than Bacchus. But the heart and soul of these pictures none can fail to recognize as right; and the decoration is in all its details noble and significant. The clinging arms and labouring lips of Sappho, her fiery pallor and swooning eyes, the bitter and sterile savour of subsiding passion which seems to sharpen the mouth and draw down the eyelids, translate as far as colour can translate her. The face and figure beside her are soulless and passive, the beauty inert as a flower's; the violent spirit that aspires, the satisfied body that takes rest, are here seen as it were in types; the division of pure soul and mere flesh; the power-ful thing that lives without peace, and the peaceful thing that vegetates without power."[6]

In this review Swinburne definitely did Solomon's reputation no good amongst conser-vative middle-class Victorian society when he stated: "Whether suffering or enjoyment be the master expression of a face, and whether that enjoyment or that suffering be merely or mainly spiritual or sensual, it is often hard to say – hard often to make sure whether the look of loveli-est features be the look of a cruel or a pitiful soul. Sometimes the sensible vibration as of living lips and eyes lets out the secret spirit, and we see the springs of its inner and confluent

emotions. The subtleties and harmonies of suggestion in such studies of complex or it may be perverse nature would have drawn forth praise and sympathy from Baudelaire, most loving of all students of strange beauty and abnormal refinement, of painful pleasures of soul and inverted raptures of sense."[6] His comments that the "perverse" nature of Solomon's work would have drawn forth praise from Baudelaire was no doubt intended as a compliment, as part of Swinburne's promotion of the aesthetic principles of l'art pour l'art in the 1860s and early 1870s. Swinburne had already expounded such avant-garde views in his earlier writings. In 1862, in an article on Baudelaire for the *Spectator*, he stated that "it is not his or any other artist's business to warn against evil" and "perfect workmanship makes every subject admirable and respectable."[7] The Victorians, however, aware of Baudelaire's reputation, were more apt to interpret the term "perverse" as wicked or sinful rather than in an aesthetic sense. Such a word could therefore prove to be both a social and economic disaster for Solomon.

As Morgan has pointed out, either Swinburne miscalculated the impact of his review on most readers, or he was oblivious to it.[4] Solomon was obviously aware of the potential negative impact of the *Dark Blue* review as he wrote to Swinburne in a letter of October 1871: "I saw that there were certain parts which I could have desired to be omitted but I dared not ask you to eliminate or even to modify them … when the article appeared in print one or two very intimate friends said 'eloquent and beautiful as it is, I think it will do you harm … You know, of course, my dear Algernon, that, by many, my designs and pictures executed during the last three or four years have been looked upon with suspicion."[8] Later in October 1871 Solomon wrote again to Swinburne, thanking him for understanding his misgivings about the results of the review and admitting that "I have given grounds for the types of reviews that have been made."[8] Robert Buchanan, in his famous vicious attack on Rossetti and his circle in *The Fleshly School of Poetry and Other Phenomena of the Day*, published in 1872, was also to attack the "perverse" in Solomon's art: "English society of another kind goes into ecstasy over Mr. Solomon's pictures – pretty pieces of morality, such as 'Love dying by the breath of Lust'. There is not much to choose here between the two objects of admiration, except that painters like Mr. Solomon lend actual genius to worthless subjects, and thereby produce veritable monsters – like the lovely devils that danced around St. Anthony."[9]

Although a depiction of lesbianism was perhaps somewhat acceptable, Solomon had been even more flagrant in his disregard for Victorian morality in other works such as his drawing *'Babylon hath been a golden cup''*, which had been shown at the French Gallery in London in 1859.[10] It is based on Jeremiah 51:7, where the prophet laments the Jewish nation's captivity under Babylon and their gradual acceptance of Babylonian hedonism and immorality. In this drawing a naked youth of ambiguous sex, but which certainly could be male, plays a harp while cradling a languorous older king. As its subject had previously been misinterpreted as David playing before Saul, the androgynous youth was obviously interpreted as male.[11] By 1865, the year of this drawing of *Erinna Taken from Sappho*, Solomon was even more explicit in illustrating themes of homosexual love in such works as *Love Among the Schoolboys* and *The Bride, the Bridegroom and Sad Love*.[12] In 1866 Solomon painted *Heliogabalus, High Priest of the Sun*, which was exhibited at the Dudley Gallery in 1868. Heliogabalus or Elagabalus was emperor of Rome under the title Aurelius Antonius from 218–222 A.D., before being murdered by soldiers of the Praetorian guard. He had served as a priest to the sun-deity at Emesa in his homeland of Syria before coming to power in Rome. Swinburne in his article in the *Dark Blue* described this watercolour of Heliogabulus as "symbolic in that strange union of offices at once of east and west, of ghostly glory and visible lordship, of the lusts of the flesh and the secrets of the soul, of the kingdom of this world and the mystery of another."[6] As Prettejohn has pointed out, the more erudite of the Victorian

viewing public would have been aware of Elagabalus' transvestism, his self-appointed title "Empress of Rome" and his lovers of both sexes.[13] His brief reign was marked by excesses of the utmost debauchery.[4] This then was another work by Solomon that the general public would have regarded as "perverse."

In this drawing of *Erinna Taken from Sappho*, Erinna and a male figure are to the left, with Sappho to the right. On the table to the right of Sappho is a small classical sculpture of a nude female figure, most likely representing Aphrodite the goddess of Love whom Sappho and her followers worshipped. Solomon had incorporated a similar statue, although partially draped and larger, into his watercolour of the previous year *Sappho and Erinna*. This statue must be based on an actual classical example, perhaps the Medici Venus or the Aphrodite of Praxiteles. The latter existed in both nude and draped versions. The original nude version was made for Cnidos, while the draped version was for nearby Cos. The nude version, in particular, was frequently copied in antiquity.[14,15]

Solomon was not the only Victorian artist to depict scenes from the life of Sappho. In 1861 Solomon's close friend Henry Holiday had painted a panel of *Sappho Serenading Phaon* for the Great Bookcase (1859-62) commissioned by William Burges for his library at Tower House. This bookcase included works by fourteen prominent young artists, including Simeon Solomon, Edward Burne-Jones, Edward Poynter, D.G. Rossetti, Albert Moore, and Henry Stacy Marks. It is now in the collection of the Ashmolean Museum, Oxford.[16] Sir Lawrence Alma-Tadema painted the most famous Victorian painting of Sappho, *Sappho and Alcaeus* of 1880-81, shown at the Grosvenor Gallery in 1883, and now in the Walters Art Gallery, Baltimore, Maryland.[17] Frederick R. Pickersgill did an illustration of Sappho leaping to her death, for a book of poems by Edgar Allan Poe published in 1858.[2] The most famous versions of this incident are by the French painter Gustave Moreau, one of which is in the collection of the Victoria and Albert Museum, London.[18]

The Maas Gallery, London, had drawings of both *Sappho* and *Erinna*, dating from 1862, for sale in 1964.[19] A drawing by Solomon of *Erinna of Lesbos*, from 1886, sold at Sotheby's, London on September 21, 1988.[20]

1 Lambourne, Lionel: Geffrye Museum,1985, cat. no. 48, 13 × 14½ in., dated 2.64. This work was formerly in the collection of James Leathart of Newcastle. It sold at Sotheby's Belgravia, *Highly Important Victorian Paintings and Drawings*, April 9, 1980, lot 20.

2 Tabor, Paul: Miriam and Ira D. Wallach Art Gallery, Columbia University, 1995, cat. no. 42, pp. 80-81, *Of Her Who Lov'd a Mortal – and So Died*, 1858, wood engraving by W.J. Linton, 4¾ × 3¾ in. This is one of two illustrations by Frederick Pickersgill for the poem "Al Aaraaf", published in *The Poetical Works of Edgar Allan Poe*, J.S. Redfield, New York, 1858. p. 152.

3 Lambourne, Lionel: "Simeon Solomon: Artist and Myth" in Geffrye Museum, 1985 p. 25.

4 Morgan, Thais E.: "Perverse male bodies. Simeon Solomon and Algernon Charles Swinburne", ch. 4 in Horne, Peter and Lewis, Reina : 1996, pp. 66 and 78.

5 Newall, Christopher: In Wilton, A. and Upstone, R.: 1998, cat. no. 35, pp.140-141.

6 Swinburne, Algernon: 1871, pp. 572-575.

7 Swinburne, Algernon: "Charles Baudelaire", in Gosse, E. and Wise, T. J.: 1926, Vol. III, pp. 419 and 423.

8 Lang, Cecil: 1959, pp. 158, 159 and 162.

9 Buchanan, Robert: 1872, p. 38. This book is an expansion of Buchanan's earlier piece in the *Contemporary Review*, XVII, October 1871, pp. 334-350, "The Fleshly School of Poetry. Mr. D.G. Rossetti". This controversial review had been signed with the pseudonym "Thomas Maitland," and it was only later that Buchanan was revealed as the author.

10 Wildman, Stephen: 1995, cat. no. 52, pp. 185-187. This drawing had been shown at the French Gallery: 1859, cat. no. 143.

11 Cooper, Emmanuel: "A Vision of Love: Homosexual and Androgynous Themes in Simeon Solomon's

Work after 1873," in Geffrye Museum: 1985, pp. 31-32, fig. xxi.

12 Lambourne, Lionel: Geffrye Museum, 1985, cat. no. 50, *Love Among the Schoolboys*, 1865. This draw-
ing once belonged to Oscar Wilde. Cat. no. 51, *The Bride, the Bridegroom, and Sad Love*, signed with
monogram and dated 3.65. In this work, similar in style to the present drawing, the bridegroom and the
figure of Love clasp hands over the genital area of Love. T.E. Morgan (p. 68) feels this work "questions
the divine happiness supposedly to be found in marriage of man and woman, and indicates the pres-
ence of male-male desire beyond the bounds set by matrimony … The male 'Love' is thus effectively
marginalized in Solomon's drawing … he is an interloper in the scene of future martial bliss both visu-
ally and morally. 'Love' when it occurs between men is 'perverse' and hence doomed to be 'sad'."

13 Prettejohn, Elizabeth: 1997, pp. 36-37.

14 Boardman, John: 1993, fig. 130, pp. 138-139.

15 Smith, Alison: "Nature Transformed, the Nude and the Model" in Barringer, Tim and Prettejohn,
Elizabeth: 1999. p. 33, fig. 16, *Aphrodite of Cnidos*, Roman copy, Museo Nazionale delle Terme, Rome.
Another copy is in the Vatican Museum.

16 Crook, J. Mordaunt: 1981, p. 321. This bookcase is currently on loan from the Ashmolean Museum,
Oxford to the National Trust, Knightshayes Court, Devon, where it sits in the Great Hall.

17 Warner, Malcolm: National Gallery of Art, Washington, 1997, cat. no. 67, pp. 194-196.

18 Christian, John: 1977, fig. 3, watercolour, 8 × 5½ in. This watercolour, which once belonged to John
Gray, a minor poet and friend of Oscar Wilde, shows Sappho before she casts herself from the cliff at
Lesbos.

19 Maas Gallery: 1964, cat. no. 132, *Sappho*, pencil, 9½ × 8 in., signed with monogram and dated
14/4/62; cat. no. 133, *Erinna*, pencil, 9½ × 7¾ in., signed with monogram and dated 16/4/62.

20 Sotheby's, London: *Early English Drawings and Victorian Watercolours*, September 21, 1988, lot 411,
red chalk, 6½ × 5 in., dated 1886.

80 Mors et Amor ("Death and Love"), 1865

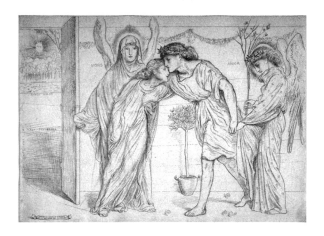

Pen and black ink, heightened with red crayon on off-white wove paper; signed and inscribed lower left *Invented and drawn by S. Solomon for his dear friend Ned August 30, 1865*. It is further in-scribed *Mors* and *Amor*, and on the landscape on the left, through the open door held by Death, is *Terra Tenebrosa* ("Land of the Shadow"), *Flvmen Mortis* ("River of Death"), *Hierosolyma* ("Jerus-alem"), and *99* within the sun

9^{15}⁄₁₆ × 13^{15}⁄₁₆ in. (25.3 × 35.4 cm)

PROVENANCE: Gift of the artist to Edward Burne-Jones; by descent to his son Philip Burne-Jones; his estate sale, Sotheby's, London, November 10, 1926, part of lot 114, bought by Dr. J. Nicoll; his estate sale, Christie's, London, October 29, 1964, lot 236, bought J. Crockett; anonymous, sale Phillips, London, January 25, 1993, lot 81, bought Maas Gallery, London; purchased March 17, 1994.

EXHIBITED: Kenderdine Gallery: 1995, cat. no. 60.

This drawing was a gift in 1865 from Solomon to Edward Burne-Jones, on his thirty-second birthday, as a token of their friendship. Solomon had first met him at Rossetti's studio, proba-bly in 1858. They were certainly well acquainted by 1859, as there is a portrait, in pencil, of

Burne-Jones by Solomon, dated 16/9/59, in the collection of the Ashmolean Museum, Oxford.[1] Their most intimate friendship dates from the early to mid 1860s, during which time there was considerable influence on each other's work. Early in their relationship Burne-Jones had been so impressed by the draughtsmanship exhibited in Solomon's drawings for *The Song of Solomon* that he considered Solomon "the greatest artist of us all; we are mere schoolboys compared with you."[2] Georgiana Burne-Jones recalled her husband's sincere admiration for Solomon's early works: "I remember his telling me before we were married about a book filled with Solomon's designs, which he said were as imaginative as anything he had ever seen – here was the rising genius – to which I listened with a jealous pang! This artist afterwards became a friend of mine as well as Edward's, and the tragedy of his broken career is one before which I am dumb; but all the more do I cling to recollections of hope and promise surely not false, though unfulfilled in this world."[3] The book referred to is possibly the early sketchbook now in the Ein Harod Museum, Israel.[4]

After Solomon was convicted of homosexual infractions in 1873, he was repudiated even by many of his former friends within the Pre-Raphaelite circle. Edward and Georgiana Burne-Jones were an exception, however, and they continued to support and help him for the rest of his life. On April 19, 1873 D.G. Rossetti wrote to Ford Madox Brown: "Have you heard these horrors about little Solomon? His intimate, Davies, writes me: 'He has just escaped the hand of the law for the second time, accused of the vilest proclivities, and is now in semi-confinement somewhere or other. I have said little about it on account of the family who have suffered bitterly. I hope I shall never see him again. Jones has been most kind and considerate to his friends, though sickened to death with the beastly circumstances.' Poor little devil! What will become of him?"[5] On February 29, 1880 Rossetti wrote to Jane Morris: "Ned Jones looked in for a minute and a half the other day and told me that poor S.S. wrote to him from hospital. He did not answer, but wrote inquiries to his doctor and learned that S. had arrived at the hospital, not only ragged but actually without shoes! I must say Ned's conduct as a correspondent is hardly consistent with the penultimate piece of news he gave me on the subject: viz: that he and his wife had judicially gone to view this Hebraic phenomenon at a friendly meeting planned for the purpose by Holiday and his wife!"[6] In 1884 William Bell Scott wrote to Alice Boyd about the relationship between Simeon Solomon and Count Stenbock: "Strange to say Solomon is to take Stenbock to Burne-Jones, whom he calls his only friend."[7]

Mors et Amor is unusual in terms of subject matter in Solomon's oeuvre from the 1860s and anticipates the Symbolist themes which figure so strongly in his later works. It predates the best known Victorian painting on this theme, George Frederic Watts' famous *Love and Death*, the first version of which was not begun until 1868 or 1869.[8] The major influence on Solomon's *Mors et Amor* would appear to be the work of D.G. Rossetti, especially his watercolour *Dante's Dream at the Time of the Death of Beatrice*. Although this work was completed in 1856, Rossetti had borrowed it back in 1863 from its original owner Ellen Heaton, because he was thinking of beginning an oil version of this subject. Another possible influence is Rossetti's watercolour from 1864, *Roman de la Rose*. Solomon would likely have seen both of these works in Rossetti's studio. *Mors et Amor* is similar in style to Solomon's drawings *The Bride, the Bridegroom and Sad Love*, of March 1865, or *The Song of Solomon* of 1868,[9] although Rossetti's influence is not as noticeable in these works. In *Mors et Amor* the bridegroom, despite being aided by Love, is not able to overcome the power of Death, who is claiming his bride. Love carries a sprig of myrtle blossoms, probably because of their association with Venus, the goddess of Love, and because they can be used to symbolize love or matrimony.[10]

The inscriptions and drawing in the upper left may suggest a connection with the book of

Revelation.[11] In Christian art the sun is symbolic of Christ.[12] The significance of the "99" within the sun is more obscure. Certainly the number 9 held symbolic meaning in the circle gathered around D.G. Rossetti. Rossetti, in a letter to Ellen Heaton of May 19,1863, wrote: "You probably remember the singular way in which Dante dwells on the number nine in connection with Beatrice in the Vita Nuova. He meets her at nine years of age, she dies at nine o'clock on the 9th of June, 1290. Of all this much is said, and he declares her to have been herself 'a nine', that is the perfect number, or symbol of perfection."[13] The mystical connotations with "perfection" of the number nine arise from its being the multiple of three times three, three being the number of the Trinity. In addition, however, the number nine has held traditional connections with hell.[14] There were said to be nine rivers in hell. Hell was also said to be comprised of nine circles, as described by Dante in the *Divine Comedy*.[14] In Hebraic writings like the Torah the ancient Hebrews used the science of names and numbers in their number-letter code to obscure the meaning of their writings from the uninitiated, while at the same time revealing their sacred meanings to the initiated. Scholars were able to penetrate the mask of allegory to receive or give divine guidance through letters or numbers. The number nine was the ultimate number. It stands for a complete cycle of growth, as for instance, the nine generations from Adam to Noah and from Noah to Abram. When Abram received his covenant from God and his new name Abraham, he was "ninety and nine years old" (Genesis 17: 1-5). Symbolically his age reduces to nine to indicate this was a time period in which a spiritual cycle had been completed. These numbers therefore did not refer to the age of the person in years, but instead to progress in spiritual attainment. The letter 'h' was added to Abram's name as this letter means light, and thus denoted the attainment of spiritual enlightenment.[15]

This is not the only work that Solomon created based on this theme. *A Love and Death*, dated 1865-74, was shown at the Solomon exhibition at the Baillie Gallery in 1905.[16] Ford lists Hollyer photographs after Solomon for *Love Confronted by Death*, *Death Leading a Maiden away from the Embrace of Love*, and *For Love is Strong as Death*.[17]

1 Rose, Andrea: 1981, p. 135, pencil on paper 11.8 × 11.7 cm.
2 Reynolds, Simon: 1984, p. 8.
3 Burne-Jones, Georgiana: 1904, Vol. I, p. 260.
4 Lambourne, Lionel: 1967, p. 60.
5 Doughty, Oswald and Wahl, J.R.: 1967, Vol. III, letter 1331, p. 1162.
6 Bryson, John: 1976, letter 106, p. 143.
7 Fredeman, William E.: 1975-1976, p. 80.
8 Christian, John: 1989, cat. no. 5, p. 106.
9 Reynolds, Simon: 1984, pls. 36 and 49. *The Song of Solomon* was a gift to Walter Pater.
10 Cheney, Liana de Girolami: "Burne-Jones: Mannerist in an Age of Modernism" in Casteras, S.P. and Faxon, A. C.: 1995, p. 110, fig. 8, p. 107. Burne-Jones used a branch of myrtle as a poetical reference to Venus in *The Godhead Fires*, one of his subjects in his second series of Pygmalion paintings.
11 Revelation 21: 2-4: "And I John saw the holy city, new Jerusalem coming down from God out of heaven, prepared as a bride adorned for her husband."
12 Ferguson, G.: 1954, p. 60. This interpretation is based on the prophecy of Malachi 4:2 : "But unto you that fear my name shall the sun of righteousness arise with healing in his wings."
13 Surtees, Virginia: 1971, Vol. I, cat. no. 168, p. 94.
14 Upstone, Robert: Tate Gallery, 1997-98, cat. no. 44, p.156.
15 Beavis, Mary Ann: I am grateful to Dr. Beavis, Assistant Professor of Religious Studies, St. Thomas More College, University of Saskatchewan, for this information.
16 Baillie Gallery: 1905-6, cat. no. 24.
17 Ford, Julia Ellsworth: 1908, pp. 74-75.

81 Amor ("Love"), 1877

Black chalk on white wove paper; signed with initials and dated *1877*, lower right; inscribed with *Amor* inside a scroll, middle left 7½ × 6⅝ in. (19.1 × 16.8 cm)
PROVENANCE: Anonymous sale, Sotheby's, London, November 6, 1996, lot 338.
LITERATURE: Ford, Julia Ellsworth: 1908, p. 77.

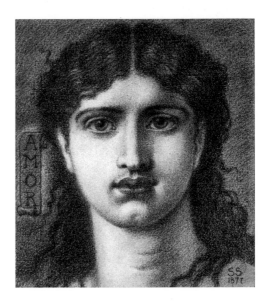

This chalk drawing dating from 1877, four years after his arrest on charges of homosexuality, is evidence of the quality of Solomon's draughtsmanship from the 1850s to 1870s, before he began his slow decline into an alcoholic vagabond. If his work had continued at its earlier level of imaginative power and technical expertise, he would have proven a formidable rival to Rossetti and Burne-Jones for the leadership of the second phase of Pre-Raphaelitism. Solomon was also involved with the early British Symbolist movement. *Amor* was only one of the many Symbolist themes that fascinated Solomon from the beginning to the end of his artistic career. The theme of Love was also prominent in the art of his friends D.G. Rossetti (see cat. no. 70) and Edward Burne-Jones (see cat. no. 12).

Few drawings by Solomon with this power and from this time period seem to have survived. A similar, very intense drawing entitled *Night*, dated 1873, was with Peter Nahum in 1989.[1] Photographs after Solomon by Frederick Hollyer included the subject *Amor*.[2,3]

The Hollyer platinotype is unlikely to be of this drawing, based on dimensions, and Love was obviously a subject drawn over and over again by Solomon. A drawing of *Amor*, from a much later date, sold at Sotheby's Belgravia on March 21, 1972.[4]

The close relationship between the work of Solomon and Burne-Jones can be assessed if one compares this drawing by Solomon to an earlier one by Burne-Jones of *Amor* of c. 1865.[5]

1 Nahum Peter: 1989, Vol. I, cat. no. 131, p. 130, Vol. II, pl. 94, pencil on white paper, 17½ × 11¾ in., signed with initials and dated 1873.
2 Ford, Julia Ellsworth: 1908, p. 77.
3 Bate, Percy: 1909, pp. 67-72, cat. no. 31, p. 70, *Amor*, 10½ × 6 in.
4 Sotheby's Belgravia: *Victorian Paintings*, March 21,1972, part of lot 14, which included six drawings including *Amor*, five signed and dated between 1896 and 1905.
5 Harrison, M. and Waters, B.: 1973, p. 81, fig. 106, red crayon, 8½ × 8½ in., Henri Dorra collection, California.

82 Christ and Peter, c. 1896

Watercolour on off-white paper; signed with monogram and dated indistinctly *189?*, lower right 10¼ × 13⅞ in. (26.1 × 35.3 cm)
PROVENANCE: ? Dr. Tom Robinson; anonymous sales, Christie's, South Kensington, May 16, 1977, lot 218; Christie's, South Kensington, July 18, 1977, lot 153, bought Neil

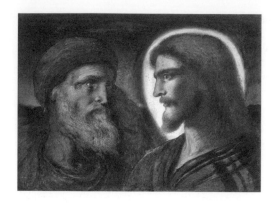

MacMillan of MacMillan and Perrin Gallery, Vancouver and Toronto; purchased July 8, 1982.

LITERATURE: Ford, Julia Ellsworth: 1908, p. 76; Reynolds, Simon: 1985, p. 178.

EXHIBITED: ? Baillie Gallery: 1906, cat. no. 103, lent by Dr. Tom Robinson; MacMillan and Perrin Gallery: 1979, cat. no. 29 (illus.); MacMillan and Perrin Gallery: 1980, cat. no. 32 (illus.); Kenderdine Gallery: 1995, cat. no. 61.

Although Solomon was born into a Jewish family, even as early as 1857 he included Christian subjects in his seventy-eight-page sketchbook, now at the Ein Harod Museum in Israel. In the 1860s he began to move away from an adherence to specific religious beliefs and practices, and became more interested in the rituals of different religions. Lionel Lambourne has noted that "during the 1860s Solomon became infected by the intense intellectual interest in Catholicism of mid-nineteenth century Oxford."[1] Like his friend Edward Burne-Jones, his interest in church ritual was probably more aesthetic than truly religious. Solomon's paintings from the 1860s and early 1870s on Christian ritualistic themes include such works as *Two Acolytes Censing, Pentecost* of 1863, *A Greek Acolyte* of 1867-68, and *The Mystery of Faith* of 1870. In the 1890s Solomon produced a great number of works on Christian themes, as can be seen from the partial list of Frederick Hollyer's photographs included in Ford's book on Solomon.[2]

Solomon's interest in Christian subjects in the 1890s may have been inspired by his friend Francis Thompson, the Catholic poet, who, like Solomon, lived the life of a vagabond. Through their mutual friend, the Catholic poetess Alice Meynell, Solomon found shelter, rest, and solace at the Carmelite Church in Kensington Church Street. It has even been claimed that he converted from his nominal Jewish orthodoxy to Catholicism.[3,4] Paul Tabor, in fact, maintains that Solomon converted to Roman Catholicism as early as 1864, through the influence of the Anglo-Catholic fervor centred at Oxford, to which he was introduced by Walter Pater.[4] It is uncertain, however, whether Solomon even knew Pater in 1864, since Reynolds notes that it is probable Oscar Browning introduced Solomon to Pater in 1868.[5] Lionel Lambourne, however, mentions that Solomon had known Pater earlier than Browning, whom he first met in 1868.[6] Although Solomon evidently flirted with Catholicism, his formal conversion is unlikely, since it would have further displeased his orthodox Jewish relatives, who already abhorred his homosexuality and alcoholism. It would have greatly prejudiced his chances for their continued support, which was already limited. He was certainly buried in a Jewish, not a Catholic, cemetery.

Christ and Peter shows how Solomon, even in his late works which frequently tend to be weak and repetitive, is occasionally capable of producing a very powerful image. He has captured well Christ's isolation as a "Man of Sorrows", even from his principal disciple, St. Peter, who was soon to deny him three times. Ford lists Hollyer photographs of three works of this subject: *And Jesus turned and looked upon Peter*, *Christ and Peter*, and *Christ and St. Peter*.[2]

1 Lambourne, Lionel: 1967, pp. 59-61.
2 Ford, Julia Ellsworth: 1908, pp. 74-77.
3 Roth, Cecil: 1961, p. 570.

4 Tabor, Paul: William & Ira Wallach Art Gallery, 1995, cat. no. 49, p. 89.
5 Reynolds, Simon: 1984, p. 2.
6 Lambourne, Lionel: "Simeon Solomon: Artist and Myth" in Geffrye Museum, 1985, p. 26. Solomon's portrait of Pater is dated 1868. T.E. Morgan also says that Solomon met Pater in 1868. See Morgan, T.E.: "Perverse male bodies. Simeon Solomon and Algernon Charles Swinburne", in Horne, P. and Lewis, R.: 1996, ch. 4, p. 76.

JOHN RODDAM SPENCER STANHOPE (1829–1908)

Spencer Stanhope was born at Cannon Hall, Yorkshire, on January 20, 1829, the second son of John Spencer Stanhope, a classical scholar, celebrated antiquarian, and explorer. Stanhope came from an aristocratic background and was educated at Rugby and Christ Church, Oxford. Despite strong parental opposition he was determined to become an artist. In the summer of 1850 Dr. Henry Acland introduced him to G.F. Watts who accepted him as a pupil. Daily he made trips to Little Holland House and through Watts he made friends with Rossetti, Burne-Jones, Holman Hunt and other artists of the Pre-Raphaelite circle. In the summer of 1853 he visited Italy with Watts. In 1859 he exhibited his first painting at the Royal Academy. From 1872–79 he was involved with his most important artistic accomplishment, the mural decorations for the chapel at Marlborough College, Wiltshire. In 1877 he was one of the artists asked to exhibit at the opening of the Grosvenor Gallery. He continued to exhibit at the Grosvenor Gallery, and later at the New Gallery. In 1880, due to ill health, he moved to the Villa Nuti at Bellosguardo near Florence. In 1901 he was one of the founders of the Society of Painters in Tempera. He died on August 2, 1908 at Bellosguardo.

83 The Wine Press, c. 1863–64

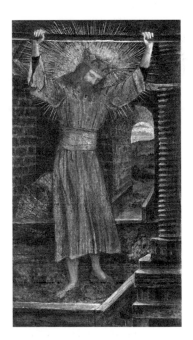

Watercolour, gouache, and gold paint on paper stretched on a wooden frame; in its original gilt oak frame; inscribed on the slip; inscribed on the back of the frame with the title on the original label, and additionally inscribed "Price 15 guineas. (Copyright reserved) R Spencer Stanhope Sandroyd Cobham Surrey"
17½ × 9¾ in. (44.5 × 24.7 cm)
PROVENANCE: George Rae of Birkenhead; by descent to his son Edward Rae and then in 1923 to his son Charles Rae; bequeathed in 1957 to his widow Mrs. Kathleen Muriel Rae, later Mrs. Robert Catto, of Ty Craine, Rhoscolyn, Anglesey; her sale, Cobern Fine Art Auctioneers, Southport, Lanc., July 29, 1992, lot 52, bought Peter Nahum, London; purchased July 14, 1993.
LITERATURE: *Catalogue of Mr. George Rae's Pictures*: cat. no. 8; Stirling, A.M.W.: 1916, p. 335; Waters, B.: Peter Nahum, 1993, cat. no. 49, pp. 71–72, illus. p. 99.
EXHIBITED: Tate Gallery: 1993; Kenderdine Gallery: 1995, cat. no. 62.

Spencer Stanhope first met Edward Burne-Jones at Little Holland House, when Stanhope was studying with G.F. Watts. Their friendship grew in 1857 during the time they spent working on the murals of the Oxford Union Debating Hall. Georgiana Burne-Jones, in her *Memorials*, quoted Stanhope: "As time went on I found myself more and more attracted to Ned; the spaces we were decorating were next to each other, and this brought me closely into contact with him. In spite of his high spirits and fun he devoted himself more thoroughly to his work than any of the others with the exception of Morris; he appeared unable to leave his picture as long as he thought he could improve it, and as I was behindhand with mine we had the place all to ourselves for some weeks after the rest had gone."[1]

In the early 1860s Stanhope and Burne-Jones often worked together, with each artist benefiting from the association. In 1862 Stanhope moved to Sandroyd, a house designed for him by Philip Webb, at Cobham in Surrey. It was there, during the summer of 1863, that Burne-Jones painted *The Annunciation (The Flower of God)* and landscape studies for *The Merciful Knight*, while Stanhope worked on *The Wine Press* and *Penelope*.[1] As well as a similarity in aim and expression, these four paintings have much in common structurally. All have figures contained within a flat foreground space, occupying most of the picture plane. Distant landscapes are visible in the background, a standard compositional device used by the Pre-Raphaelites. Their compositions were frequently flattened, producing pictures with little sense of depth. The device of a window allowed them to create a distant background without having to make the traditional middle-ground transition between it and the foreground plane.[2] These works by Burne-Jones and Stanhope are also alike in that they are early expressions of the colour harmonies that would later become so important in the work of Aesthetic painters such as Whistler and Moore. *The Flower of God*, for instance, is a harmony in red, while the *The Wine Press* is a harmony in brown and gold, carried over onto the frame. The frame is original and was very likely chosen by Stanhope with this effect in mind. These early works by Burne-Jones and Stanhope show the influence of both Rossetti and Quattrocento Renaissance art. *The Wine Press* in particular is probably based on an early German or northern Italian source.[3]

Mrs. A.M.W. Stirling, in her biography of her uncle Spencer Stanhope, stated: "In 1864 he completed his picture, *I have trodden the Wine-press alone*, perhaps the finest work he ever executed. This has been compared to Holman Hunt's *Light of the World*, but the resemblance which critics profess to discover between the two was disclaimed by Holman Hunt himself; and Stanhope's picture, though not finished for many years after Holman Hunt's masterpiece, was actually conceived and designed many years previous to it, and at a time when Stanhope was far removed from the influence of its painter. It was during a visit to Varennes in his youth that, watching the treading of the winepress by the French peasants, he evolved the design, which he did not complete till the year of Watts' marriage, when, as he was working at it in Watts' studio, Ellen Terry, the bride, came into the room and placed herself in the attitude represented by the figure in the picture."[4,5] This statement has generally been taken to refer to the oil version, in the Tate Gallery, London, but this seems unlikely, as even in Mrs. Stirling's book the oil version is said to have been painted c. 1868.[4,5] It is therefore more likely to refer to this first version in watercolour, which was largely unknown until recently, because it was in the private collection of George Rae and his descendants. The watercolour had probably never been exhibited publically until 1993. This is the most logical explanation, as obviously on stylistic grounds, the watercolour preceded the oil version, and Watts' and Ellen Terry's marriage was on February 20, 1864. The oil version is considerably larger (37 × 26 in.) than the watercolour, and is more colourful, with Christ's beautifully decorated green robe and its inner lining of red. The figure of Christ, however, lacks the power, intensity, and

emotional impact of the earlier watercolour version. In 1993 the oil and watercolour versions were exhibited together for the first time, when they were included with a group of works by Burne-Jones' contemporaries, hung just outside the *Burne-Jones Watercolours and Drawings* exhibition at the Tate Gallery.

Although the present work has been compared to Holman Hunt's *The Shadow of Death* of 1870-73, Peter Nahum has argued that it was, in fact, Stanhope who influenced Hunt and not vice versa.[6] In Holman Hunt's painting the pose of Christ is almost exactly the same as that in *The Wine Press*, apart from the angle of the head. The figure has his arms extended in a very similar fashion, and the weight is placed on the same foot.[6] Hunt's figure, however, is more likely to be based on his early, but long abandoned, *Christ and the Two Marys*. The original source for the pose of Christ in both Hunt's and Stanhope's paintings may be Dürer's print *Man of Sorrows with Hands Raised*.[2]

The Wine Press is an interesting example of the Victorian use of "typological" or "pre-figurative" symbolism. Typology is a Christian form of interpretation of the scriptures that claims to discover divinely intended anticipations of Jesus Christ in the laws, events, and people of the Old Testament. There was a great revival of Biblical typology in the 19th century, and most Victorians would have been familiar with this concept and likely to recognize these scriptural allusions.[7] The members of the Pre-Raphaelite Brotherhood, through their reading of John Ruskin's *Modern Painters*, Vol. II, became convinced of the artistic value of using typology to reconcile the demands of realistic technique with the need for spiritual truths.[7] While Millais and Rossetti used typological symbolism only in their early paintings, Hunt continued to employ it throughout his career. Stanhope's *The Wine Press* is based on a passage from Isaiah LXIII and prefigures Christ's Crucifixion and Passion, with the pose symbolizing Christ on the cross, and the wine symbolizing his blood, shed to redeem the sins of mankind.

Although Stanhope is considered one of Burne-Jones' most important followers, he evolved his own independent style. Each painter, however, was a great admirer of the other's art. In an undated letter about Stanhope to Mrs. A.M.W. Stirling, Georgiana Burne-Jones reported: "My husband, together with many others, considered his gift of colour transcendent, and said that man would be born one after another, who would rejoice in it."[4] Thomas Matthews Rooke, in his record of conversations with Burne-Jones, has also preserved Burne-Jones' opinion of Stanhope: "Faults of his pictures were what anyone could see ... His colour was beyond any the finest in Europe ... It was a great pity that he ever saw my work or that he ever saw Botticelli's. Though there may be a time for him yet. An extraordinary turn for landscape he had too – quite individual ... Rossetti was in a perfect state of enthusiasm about it – that was how he got to know him ... But his absence from London has removed him from his proper atmosphere, and from his contemporaries and their criticism, and he's got to think more and more exclusively of old pictures to that extent that he'll almost found his own pictures on them and give up his own individuality. But I did love him."[8] On the last day of Burne-Jones' life, in a conversation with Stanhope's niece, Freda Spencer Stanhope, he stated that Stanhope "is the greatest colourist of the century. If he had but studied drawing more, what a great artist he would have been!"[4]

This watercolour once belonged to George Rae, who was Chairman of the North and South Wales Bank, one of the largest in the United Kingdom at the time. Rae was one of the most important of the early collectors of Pre-Raphaelite and Aesthetic Movement art. Amongst the works in his collection was Rossetti's masterpiece *The Beloved*. A letter from Rae to Rossetti of March 5, 1866 reveals the depth of the passion he and his wife had for their art: "The same sort of electric shock of beauty with which the picture strikes one at first sight is

revived fresh and fresh everytime." Rae then described his wife Julia's involvement with this painting: "It is my belief that she spends half the day before the picture as certain devout Catholic ladies had used to do before their favourite shrines in the days of old."[9]

1 Burne-Jones, Georgiana: 1904, Vol. I, pp. 164 and 261.
2 Landow, George P.: 1979, pp.76-87 and 123. Dürer was an artist much admired by the members of the Pre-Raphaelite circle, many of whom owned prints by him.
3 Christian, John: 1973, p. 63. Christian believes it is conceivable that the model known to Stanhope was not German but North Italian, possibly the painting by Andrea Mainardi in Sant' Agostino, Cremona. Stanhope had travelled to Italy in 1853 and 1855 and may have seen this work.
4 Stirling, A.M.W.: 1916, pp. 334-335, and frontispiece.
5 Gordon, Catherine: 1996, p.5. Dr. Gordon points out that "their experience has repeatedly shown Mrs. Stirling to be a less than reliable witness." It is therefore impossible to rely on any of her information with confidence.
6 Nahum, Peter: 1993, cat. no. 49, p. 71.
7 Landow, George P.: 1980, pp. 3-5.
8 Lago, Mary: 1982, pp. 76-78.
9 Macleod, Dianne Sachko: 1996, p. 282.

FREDERIC GEORGE STEPHENS (1828-1907)

Stephens was born in London on October 10, 1828, the son of the master of the Strand Union Workhouse in Cleveland Street. Stephens was enrolled as a student in the Royal Academy Painting School on January 13, 1844. While at the Royal Academy Schools he met Holman Hunt. At Hunt's instigation Stephens was elected a member of the Pre-Raphaelite Brotherhood in 1848. Stephens, however, did little painting either prior to or after his election to the PRB. In 1850 Stephens acted as Hunt's assistant in the restoration of the frescoes at Trinity House, London. The only two paintings Stephens ever exhibited were portraits of his parents, shown at the Royal Academy in 1852 and 1854. Because of his difficulties in successfully bringing pictures to completion, Stephens largely abandoned painting in the 1850s for writing. His career as an art critic began in 1850. In 1861 he became Art Editor of *The Athenaeum*, where he continued submitting articles and reviews until 1901. He also wrote a number of monographs on Victorian painters including Hunt, Rosssetti, Mulready, and Landseer. In addition Stephens taught art for many years at University College School. He died at Hammersmith Terrace, London, on March 9, 1907.

84 Portrait of a Young Woman, c. 1865

Graphite and watercolour, heightened with white, on card; signed with monogram, lower right $15^{11}/_{16} \times 13^{3}/_{4}$ in. (39.9 × 34 cm)
PROVENANCE: The artist's widow Clare Stephens and then by descent to her son Lt.-Colonel Holman ("Holly") F. Stephens; bequeathed in 1932 to his godson Mr. J.C. Iggulden; his sale Geering & Colyier, Ashford, Kent, May 23, 1979, lot 457, bought Jeremy Maas of the Maas Gallery, London; sold to Michael Hasenclever of the Galerie Hasenclever, Munich on July 4, 1979; anonymous sales Christie's, London, December 1, 1989, lot 1079; Christie's, London, November 6, 1995, lot 52.

Works by Stephens are extremely rare, as he was a practising artist for only a short period of time before he abandoned painting for a career as an art critic. Stephens subsequently claimed "with satisfaction" to have destroyed all his paintings. This statement is obviously not accurate, as the Tate Gallery, London, owns a number of his works, although most are unfinished. As John Christian has pointed out, this portrait of a young woman by Stephens is executed in the "Venetian style", that prevailed in the 1860s, suggesting that Stephens continued to paint for longer than has generally been acknowledged.[1] Paintings of women in a Venetian style had been initiated by Rossetti's *Bocca Baciata* of 1859 and had been adopted in the 1860s by many painters within the Pre-Raphaelite circle, including Sandys, Burne-Jones, Bell Scott, Watts, and Leighton. The use of peacock feathers in this work recalls Leighton's *Pavonia* of 1859, Sandys' *Vivien* of 1863, and Watts' *The Peacock Fan* of 1865.

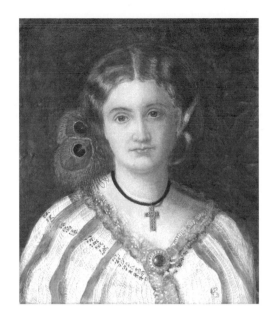

The identity of the model is not known for certain, but either the work itself must have particularly pleased Stephens, or the model must have had some significance since it escaped destruction. It is probable that it is a portrait of F.G. Stephens' wife Clare. In 1865 he had secretly married a young widow, Mrs. Clara Charles. She was completely illiterate when he met her, and Stephens taught her to read and write and how to behave properly in society. After her second marriage she changed her name from Clara to Clare. A later portrait of her by Lawrence Alma-Tadema from 1873 sold at Sotheby's, London on June 16, 1982.[2] Although this portrait is in profile, and the sitter is obviously older and more heavy set, the sitters share certain facial features in common, as well as similar hair styles. This suggests that both portraits are likely of Clare Stephens.

1 Christian, John: Christie's, London:*Fine Victorian Pictures, Drawings and Watercolours*, November 6, 1995, lot 52, p. 37.
2 Sotheby's, London: *Nineteenth Century European Paintings, Drawings and Sculpture*, June 16, 1982, lot 270, *A Portrait of Mrs. Frederic George Stephens*, oil on panel, inscribed OpCXII, 11¼ × 16 in.

JOHN MELHUISH STRUDWICK (1849-1937)

Strudwick was born on May 6, 1849 in Clapham. He studied art, first at South Kensington and then at the Royal Academy Schools, where he met with little success. His early work was influenced by the Scottish artist John Pettie. In the mid 1870s he became a studio assistant for a short time first to Spencer Stanhope and then to Burne-Jones, and both artists remained his good friends. Their influence, as well as that of the early Italian painters, shaped the direction of his art. By 1876, when he exhibited his first painting at the Royal Academy, his mature style

had already developed. From 1877 he exhibited at the Grosvenor Gallery, and in 1888 he transferred his allegiance to the New Gallery. His last contribution to the New Gallery was in 1908, the year before it held its last exhibition, and after this time he apparently gave up painting. Strudwick died on July 19, 1937.

85 Study of the Head and Shoulders of a Young Woman, early to mid 1870s

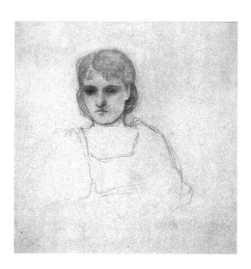

Graphite on white wove paper
10¾ × 12¹⁵⁄₁₆ in. (26.3 × 32.9 cm)
VERSO: two studies of a draped female figure
PROVENANCE: Christie's, London, June 17, 1969, part of lot 98, a sketchbook of thirty-five sheets attributed at that time to Edward Burne-Jones, bought Bennie Gray; The Pre-Raphaelite Gallery, London, 1970; Peter Nahum, The Leicester Galleries, London, by 1985; purchased July 19, 1994.
EXHIBITED: Peter Nahum: 1985, cat. no. 56 (illus.); Peter Nahum: 1989, cat. no. 158, pl. 121b (illus.); Kenderdine Gallery: 1995, cat. no. 63.

Susan Grayer, a Strudwick scholar, feels this drawing predates Strudwick's fully developed Pre-Raphaelite style, as the woman's face has a square jaw line, rather than the more characteristic pointed, almost "heart-shaped" chin, seen in his mature manner.[1] The drawing does not seem to relate to any of his known works. Drawings by Strudwick are rare, perhaps because he felt he was technically deficient in draughtsmanship, and therefore largely tended to forgo preliminary studies. George Bernard Shaw quoted Strudwick's comment that "he could not draw – never could." Shaw felt this was "a priceless gift" that saved Strudwick from mere empty virtuosity – "execution for execution sake."[2] Certainly if one looks at the drawing of the draped female figure on the verso, the drapery is not handled with the finesse of his mentor Burne-Jones. Although Studwick uses drapery in abundance, he uses it without the same concern for the underlying structural anatomy of the figure as is found in the work of Burne-Jones, Leighton, Poynter, and Moore, who all produced multiple drawings of the model, both nude and draped, to get that relationship correct.

Studwick is considered one of Burne-Jones' most important followers, but his work differs from that of his master. Although his facial types are derivative, they are prone to a cloying sweetness or delicacy absent in Burne-Jones' work. Strudwick's work is more decorative and also more colourful than Burne-Jones' late work, with great attention to detail, particularly in the draperies and accessories like furniture, musical instruments, and boxes. His output was small because of his detailed, meticulous technique.

1 Grayer, Susan: personal communication, letter dated November 8, 1994.
2 Shaw, George Bernard: 1891, pp. 97-103.

JOHN WILLIAM WATERHOUSE (1849-1917)

Waterhouse was born on April 6, 1849 in Rome, the son of William Waterhouse, a minor artist. His family returned to England in 1854. Waterhouse received his early artistic training in his father's studio and did not enter the Royal Academy Schools until 1870. In 1874 he exhibited his first painting at the Royal Academy. His early work featured classical subjects and showed the influence of Alma-Tadema. His Royal Academy exhibits of 1883, *The Favourites of the Emperor Honorius*, and of 1884, *Consulting the Oracle*, brought him much critical and popular acclaim. In 1883 he was elected to the Royal Institution of Painters in Watercolour and in 1885 he was elected an associate of the Royal Academy. In 1887 he showed the last of his history paintings at the Royal Academy, *Mariamne Leaving the Judgement Seat of Herod*, and after this time the direction of his art changed. In 1888 he exhibited *The Lady of Shalott*, the first of his works to be influenced by French plein-air painting, as well as by the second phase of English Pre-Raphaelitism. In 1895 he was elected to full membership in the Royal Academy. Waterhouse continued to exhibit major paintings at the Royal Academy throughout the remainder of his career, despite the fact that his health began to fail after about 1913. He died on February 10, 1917 and was buried at Kensal Green Cemetery.

86 Study of a Young Woman in Profile, c. early 1880s

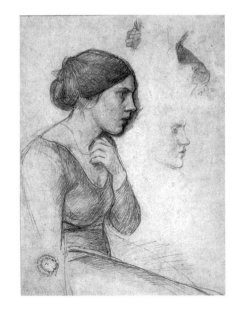

Graphite on tan wove paper; inscribed recto, in pencil, lower left, "ex-collection Mrs. J.W. Waterhouse Bot. Christie's 23-7-1926 No. 8/7 J.A.C. Nicoll" 13 × 9⁹⁄₁₆ in. (33.1 × 24.7 cm)
VERSO: branch with fruit
PROVENANCE: Mrs. J.W. Waterhouse; her sale, Christie's, London, July 23, 1926, part of lot 8, bought J.A.C. Nicoll; Rex Evans Gallery, Los Angeles; sold to Vincent Price; sold to Aldis Browne Fine Arts, Venice, California, by 1988; Sven Bruntjen, art dealer, Woodside, California; purchased, London, January 20, 1989, through Daniel Perrin.
EXHIBITED: Aldis Browne Fine Arts: 1988, cat. no. 28 (illus.); Sven Bruntjen: 1989; Kenderdine Gallery: 1995, cat. no. 64.

John William Waterhouse is perhaps the greatest of the "Last Romantics," the generation of painters that followed Burne-Jones, Leighton, and Watts, and whose works were produced at the end of the 19th and beginning of the 20th centuries. As early as 1894 the French critic Robert de la Sizeranne estimated that Waterhouse's art was a combination of the "better attributes and intentions" of Leighton and Burne-Jones.[1] Not only did his work reflect the influence of these great Victorian painters, but his bold painterly technique also owed much to French plein-air painters like Bastien-Lepage and the French-influenced artists of the Newlyn School.

The Waterhouse scholar Dr. Anthony Hobson is unable to identify any specific painting for which this is a study, but in a number of other drawings the same model and the same foundational medieval dress appears.[2] The facial features of the young woman appear similar to a model for many of Waterhouse's paintings, probably as early as the late 1870s and certainly in the early 1880s. She appears to bear a striking resemblance to Waterhouse's wife, Esther Kentworthy, whom he married on September 8, 1883.[3] It is probable that Waterhouse used his wife as a model. Hobson, for example, reported that she was likely the model for *The Lady of Shalott* of 1888, now in the Tate Gallery, London.[4] Hobson himself, however, doubts that the present drawing is of Esther Waterhouse and feels it is more likely to be of a professional model.[2]

1 Hobson, Anthony: 1980, p. 97. *Art Journal*: 1897, p.178.
2 Hobson, Anthony: personal communication, letter dated June 10, 1990. These drawings are in a sketchbook in the Victoria and Albert Museum.
3 Hobson, Anthony: 1980, cat. no. 58, p. 182, pl. 26, p. 37 *A Portrait of the Artist's Wife*, c. 1884.
4 Hobson, Anthony: 1989, p. 41. This may not be correct, however, as in a Waterhouse sketchbook at the Victoria and Albert Museum, London (E1110-1963; VAM 91.B.24) it states that the artist's sister Mary Physick was the model for the *Lady of Shalott* at the Tate Gallery.

87 Study of the Head of Lamia for "Lamia," c. 1905

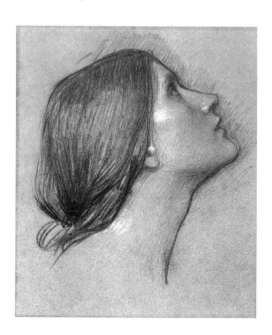

Black chalk, heightened with white, on buff wove paper; on an old label on the back is inscribed, in Waterhouse's handwriting, "J.W. Waterhouse 10 Hall Rd St Johns Wood Study" 12⅝ × 10½ in. (32.2 × 26.7 cm)

PROVENANCE: Lady Young; her sale Christie's, London, July 24, 1984, lot 219A, bought Julian Hartnoll, London; purchased July 30, 1984.

LITERATURE: Hobson, Anthony: 1980, cat. no. 359, p. 198, pl. no.117, p. 123.; Baker, James K. and Baker, Cathy L.: 1999, p. 72.

EXHIBITED: Kenderdine Gallery: 1995, cat. no. 65.

Between 1900 and 1910 Waterhouse painted some of his finest and most beautiful subjects, including *Lamia*, which was exhibited at both the Royal Academy and at the Liverpool Autumn Exhibition in 1905. The painting is based on a poem by John Keats. The Lamia of Keats' poem was a monster, able to transform itself from a serpent to a woman, who lured and then devoured its victims. It was finally detected by the philosopher Apollonius at the wedding of Lamia to his pupil, the Corinthian noble Lycius. Waterhouse, like Burne-Jones, was incapable of painting the grotesque, and instead of portraying a horrific monster, half woman and half serpent, he subtly suggested this idea by showing an innocent-appearing maiden wearing a scaly-patterned dress shedding a snakeskin.[1] Waterhouse chose

not to paint the subject from classical antiquity, as in the poem, but instead transposed it to the late Middle Ages, since the armour worn by the knight belongs more appropriately to the 15th century.[1] This was an interesting choice, since Waterhouse is best known for his classical paintings.

The model for the female figure in this painting was Muriel Foster.[2,3] She first sat to Waterhouse in 1893 for the painting *La Belle Dame Sans Merci*, and she can be identified in most of Waterhouse's important works from the following years.[3] He apparently treated her very well, and she sent a beautiful wreath to his funeral.[4]

There are two, almost identical, versions of the 1905 *Lamia*, as well as a large oil sketch, which gives some indication of the pains Waterhouse took over this subject. An entirely different composition of *Lamia* was exhibited at the Royal Academy in 1909. At least two other closely related head studies for the 1905 version exist, one of which was illustrated in the *Studio* magazine in 1908.[2,5] The latter is very close to the present drawing, except for a slightly different inclination of the head.

In discussing Waterhouse's drawings the *Studio* magazine stated: "In his drawings, as in his paintings, there is nothing that is not entirely in accordance with his belief; and the manner of these drawings is as characteristic as the sentiment by which they are pervaded. Their elegance of line, their tenderness of touch, and their daintiness of suggestion, reflect the mind of a man who thinks tenderly, and who has the poet's power of subordinating, or eliminating entirely, everything which might become a jarring note in a properly ordered harmony. Their power and firmness of statement show that his tenderness is without any taint of weakness and that the possession of a poetic temperament does not imply in his case any lack of decision on technical questions. Indeed, one of the greater virtues of his draughtsmanship is its certainty; he draws with the directness and confidence of a man who is in no doubt concerning his intentions, who knows what he desires to express, and who has by sincere self-discipline brought the practical details of his craft completely under control. Such a combination of qualities, and such a perfect adjustment of hand to mind, can be the more admired because few artists attain this completeness in anything like the same degree."[5]

1 Christian, John: Barbican Art Gallery, 1989, cat. no. 112, p. 117.
2 Hobson, Anthony: 1980, cat. no. 336, p. 197, *Miss Muriel Foster*, pencil.
3 Baker, James K. and Baker, Cathy L.: 1999, pp. 71-82. Foster was born in Greenwich in 1878 and was fifteen when she first started modelling for Waterhouse. She later became a nurse and died in 1969 at age ninety-one.
4 Hobson, Anthony: 1980, pp. 77.
5 *Studio*: 1908, p. 250, black chalk. This drawing was sold subsequently by Charles Ede of Folio Fine Art Ltd., December 1966, in his catalogue XLII.

88 Head of a Girl, a Study for "The Rose Bower," c. 1910

Red and black chalk on grey wove paper; signed lower right, *J.W. Waterhouse*
12⅝ × 9¹¹⁄₁₆ in. (32.2 × 24.5 cm)
PROVENANCE: Peter Nahum, London; purchased November 11, 1986.
LITERATURE: Hobson, Anthony: 1989, fig. 72, p. 99.
EXHIBITED: Kenderdine Gallery: 1995, cat. no. 66.

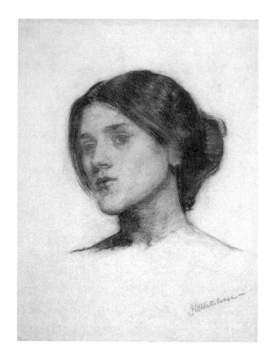

This drawing was sold originally as a study for the right-hand figure in the 1906 version of *The Danaides*, in the Aberdeen Art Gallery and Museum. The Waterhouse scholar Anthony Hobson feels, however, that the pose of the figure is much closer to the *Rose Bower*, although the same model obviously posed for both paintings. This includes, in particular, the set of the shoulders, which in the Aberdeen painting is turned away.[1]

The oil sketch, for which this is a study, is illustrated in Hobson's second book on Waterhouse.[2] The sketch does not appear to have been worked up into a finished painting. In the oil sketch the model's hair is black rather than red. It was not unknown, however, for Waterhouse to change the colour of a model's hair in a finished painting.[3] A closely related drawing, also in red chalk, was illustrated in the *Studio* magazine in 1908.[4] The model for these works was Beatrice Ethel Hackman who became Waterhouse's main model for about a ten year period from 1906-1915.[5] Hackman, who had red hair like his earlier favourite model Muriel Foster, was seventeen when she posed for *The Danaides* in 1906.

This work is typical of Waterhouse's paintings and drawings. As A.L. Baldry said in the *Studio* magazine in 1911 about Waterhouse's work: "No artist that we have amongst us to-day can be said to prove more cogently that beauty is not prettiness and that sentiment can exist without mawkishness and without feeble sentimentality. No painter surpasses him in the power to select from nature just what is worthiest of the attention of art, or combines better vigorous certainty of technical method with absolute refinement and delicacy of artistic feeling."[6] Waterhouse shared this ability to avoid mere "prettiness" and "mawkish sentimentality" with his great contemporaries like Burne-Jones, Leighton, and Moore, but it was unfortunately not always found in many lesser artists of the period, such as Henry Ryland, and occasionally even in better artists like J.M. Strudwick.

1 Hobson, Anthony F.: personal communication; letter dated June 10, 1990.
2 Hobson, Anthony F.: 1989, fig. 70, p. 98. This oil sketch belonged to Peter Nahum, London. This work was subsequently offered for sale at Christie's, London on November 13, 1992, lot 126 and again on June 7, 1996, lot 574.
3 Hobson, Anthony F.: 1980, p. 128.
4 *Studio*: 1908, p. 249, *A Study in Sanguine*.
5 Baker, James K. and Baker, Cathy L.: 1999, pp. 72-73. Hackman was also known as Beatrice Ethel Flaxman. I am grateful to Ken and Cathy Baker who confirmed my attribution of this model as Hackman in a letter of January 5, 2000.
6 Baldry, A.L.: 1911, p. 183.

89a Study for "Maidens Picking Flowers by a Stream," c. 1911

Graphite on off-white wove paper
9¹⁵⁄₁₆ × 6¹⁵⁄₁₆ in. (25.2 × 17.6 cm)
VERSO: study of a woman plaiting her hair

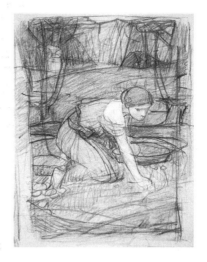

89b Study for "Listening to My Sweet Pipings," c. 1911

Graphite on off-white wove paper
6¹⁵⁄₁₆ × 9¹⁵⁄₁₆ in. (17.6 × 25.2 cm)
VERSO - study of a draped figure by
a tree

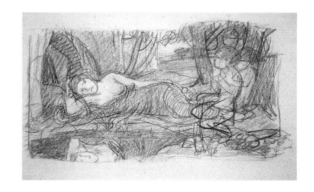

89c Study for "Gather Ye Rosebuds While Ye May" or possibly for "Narcissus," c. 1911

Graphite on off-white wove paper 9⅞ × 6⅛ in.
(25.1 × 17.6 cm)
VERSO: sketch of Greek warriors for an unidentified
painting
PROVENANCE: By descent from the artist's sister,
Mary Physick, to John Physick; his sale Christie's,
London, February 8, 1991, lots 12, 13, and 14,
respectively.
LITERATURE: Hobson, Anthony: 1980, cat. no. 391,
sketchbook, p. 200.
EXHIBITED: Kenderdine Gallery: 1995, cat. nos. 67a,
67b, 67c, respectively.

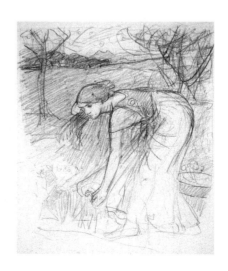

These loose sketches are characteristic of the type of drawings made by Waterhouse as initial compositional studies for paintings. They are interesting as they give us some insight into the creative side of Waterhouse's work, as well as his working methods. Unlike many of the principal artists associated with Aesthetic Classicism, such as Leighton, Moore, Poynter, and Burne-Jones, Waterhouse did not usually make extensive and elaborate working drawings for his paintings. His working methods were similar to those of Lawrence Alma-Tadema, who had a similar ability to design and then paint directly on the canvas. All Waterhouse's later work was primarily derived directly from the sketchbook and the model.

Waterhouse learned these unusual methods of working while still a student. He was able to attend the Royal Academy Schools only in the evenings, but was occasionally able to study on his own at the National Gallery by examining the works of the Old Masters. Baldry has described how he would make rapid sketches on the spot, "mere hasty notes", which would later be supplemented by drawings from memory. This strongly aided his innate ability to visualize. "His principle was, indeed, pre-eminently an intellectual one, making demands upon his sense of observation and analysis, and upon his power to re-create. It was one which guided him first in the collection of mental material, and afterwards in the assimilation of the items of knowledge so gathered ... As a result of all this he habituated himself to depend largely upon mental preconceptions in designing works of art, and to use ideas much in the same way that other men use studies, painted or drawn ... His method was in many respects quite opposed to the ordinary technical practice of the schools, and was little in sympathy with the Academic traditions. He concerned himself hardly at all with the minute imitation of set subjects that occupy the working hours of the average art student, and gave no great portion of his time to the acquisition of that ability to copy servilely which is in the art class-room accepted as the supreme essential."[1]

Baldry has also discussed Waterhouse's methods of working up a composition: "The technical processes by which his pictures are developed are straightforward enough, and differ only in details from the usual methods of the figure painter. Of the chief individuals in an important composition he would in the ordinary course make preliminary black and white drawings, dealing both with the pose of the nude figure and with the castings of the draperies, and these would be carried to a considerable degree of elaboration. For minor figures, however, he would not, except in rare cases, prepare anything but the slightest notes of their general aspect, stating their characteristics of attitude or movement with sufficient accuracy to impress upon his mind anything which might in his original mental image be incomplete or not sufficiently explained. For the rest he would be satisfied to depend almost entirely upon the view of his projected picture which had been already recorded in his mind by the combined influences of memory and trained imagination; and he would be prepared to work out his intention on the actual canvas without the assistance of sketchy reminders. The process is a simple one and practicable to a man of his exceptional training in mental vision, but it might, perhaps, seem to an artist who was not fully equipped to be lacking somewhat in adequate safeguards and liable to lead him into that hesitation which in art means destruction. That Mr. Waterhouse has in his pictures rarely shown a trace of uncertainty or mixed conviction goes far to prove that in his case, at all events, the method is justifiable."[1]

In later years Waterhouse came more and more to depend on working up his designs from the preliminary sketches, through a large-scale oil sketch, to the finished painting, often with little variation from his original idea. Some of the sketches are as large as, and in some cases even larger than, the finished painting. The oil sketches are often carried through to the point of completed studies of the principal figures, and such minor changes that are then made in the final composition involve the attitudes and relationships of the figures.[2]

The first sketch (cat. no. 89a) is a preliminary study for an unfinished oil sketch entitled *Maidens Picking Flowers by a Stream* of c. 1911.[3] This oil sketch is one of a series of Waterhouse paintings from after the turn of the century, which have as their motif, girls picking or strewing flowers in an open parkland. These works include *Windflowers*, *The Flower Picker*, and *Gather Ye Rosebuds While Ye May*. The sketch on the verso of a girl seated on the ground plaiting her hair does not seem to relate to any known picture of this date and was probably never worked up into a finished painting. The motif, however, was not unusual in Waterhouse's oeuvre and was, in fact, included in his R.A. diploma work *A Mermaid* of 1901.

The centre drawing (cat. no. 89b) is a preliminary study for *Listening to My Sweet Pipings* or *The Piping Boy*.[4] The painting was exhibited at the Royal Academy in 1911 and initially belonged to the Honorable Alex P. Henderson, one of Waterhouse's major patrons. The subject of piping boys is also not unusual in Waterhouse's work, and similar figures are found in *Hamadryad* of 1893, *The Awakening of Adonis* of c. 1900, and the sketch for *A Song of Springtime* of c. 1913. Figures playing instruments to convey a certain wistful mood to a painting are characteristic of artists associated with the Aesthetic Movement.

The last pencil sketch (cat. no. 89c) appears to relate to two similar paintings, *Gather Ye Rosebuds While Ye May*, of c. 1911, or *Narcissus*, which was exhibited at the Royal Academy in 1913, although the preparatory oil sketch is dated 1911.[5] In both paintings there is a similar figure of a girl bending down to pick flowers in a meadow, although in the paintings she does so with her right hand, and not with her left, as in this preliminary sketch. The pose of the figure and the theme portrayed of a girl stooping to pick flowers is reminiscent of Edward Burne-Jones' *The March Marigold* of 1870. It is uncertain whether Waterhouse was familiar with this painting or not. Harrison and Waters feel that the incident portrayed in *The March Marigold* may well have been inspired by the tale of Psyche, who is left in a meadow by Zephyrus and then wanders about gathering flowers.[6] Inspiration from the Psyche story might equally apply to Waterhouse's *Narcissus*, since this tale appealed to him above all during his last years.[7] Another pencil sketch for *Narcissus* was executed on the title page of the artist's copy of Tennyson's poems.[8] A second possible source of inspiration for Waterhouse's paintings might be Lawrence Alma-Tadema's *Spring in the Gardens of the Villa Borghese* of 1877, in the collection of the Madison Art Gallery, Madison, Wisconsin.

These three drawings were at one time part of a sixty-page sketchbook in the possession of Waterhouse's nephew, John Physick.[9]

1 Baldry, Alfred Lys: 1895, pp. 104, 107, 112-115.
2 Hobson, Anthony: 1980, p. 41.
3 Hobson, Anthony: 1980, fig. 136, p. 135, cat. no. 187, p. 191. See also Peter Nahum: not dated [1985], pp. 46-47, where this oil sketch is illustrated in colour.
4 Hobson, Anthony: 1980, fig. 127, p. 130, cat. no. 179, p. 191. This painting was offered for sale at Christie's, London: *Fine Victorian Pictures, Drawings and Watercolours*, November 8, 1996, lot 59.
5 Hobson, Anthony: 1980, *Narcissus*, figs. 128 and 129, p. 131, cat. no. 202, p. 192. *Gather Ye Rosebuds While Ye May*, fig. 135, p. 135, cat. no. 185, p. 191.
6 Harrison, Martin and Waters, Bill: 1973, p. 98. *The March Marigold* is illus., pl. 24.
7 Wood, Christopher: 1983, p. 239.
8 Hobson, Anthony: 1980, p. 133.
9 Hobson, Anthony: 1980, p. 200, cat. no. 391. In addition to these three drawings this sketchbook contained studies of trees and animals, as well as sketches for paintings including *The Sorceress* and *Ophelia*.

GEORGE FREDERIC WATTS (1817-1904)

G.F. Watts was born in London on February 23, 1817, the son of a Hereford piano manufacturer who had transferred his business to London. He displayed a strong predilection for drawing at an early age, and his father encouraged him to become a professional artist. From the age of ten he frequented the studio of William Behnes. On April 30, 1835 he was admitted to the Royal Academy Schools, although he attended regularly for only a short period of time. He exhibited his first paintings at the Royal Academy in 1837. In 1843 he was awarded one of the first three prizes in the first competition for the decoration of the Houses of Parliament. He left for Italy in 1843, where he stayed for much of the time in Florence as the guest of Lord Holland, the British Minister to the Grand Duke's Court. In 1847 he returned to England where his entry in the third competition for the decoration of the Houses of Parliament was successful in winning a first prize. He first met John Ruskin in 1848. In 1851 he came to live with Mr. and Mrs. Thoby Prinsep at Little Holland House, where he lived until the house was demolished in 1875. There he met most of the leading artistic and literary figures of his time. In 1865 he met Charles Rickards, a Manchester businessman, who became his most important patron. In 1867 he was elected first an associate of the Royal Academy in January and then a full academician in December. Watts moved to the new Little Holland House at 6 Melbury Road, London in 1876. In 1877 he exhibited at the first Grosvenor Gallery exhibition. Up until this time his paintings were not popular with the critics or the general public, and it was not until the 1880s that his work began to receive greater recognition and he became famous as a painter of allegories rather than as a portrait painter. He was awarded an L.L.D. by Cambridge University and a D.C.L. by Oxford University in 1882. In 1885 and 1894 he was offered a baronetcy by Gladstone, but declined. In 1902 he accepted the newly instituted Order of Merit, conferred on him by King Edward VII. On July 1, 1904 he died in London. He was buried in the churchyard at Compton, Surrey.

90 Colour Sketch for "Arion," c. 1856

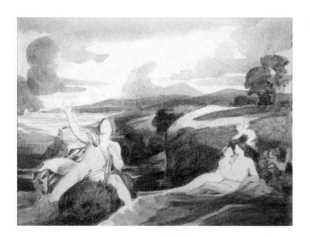

Watercolour on off-white wove paper; signed in graphite, lower right, *G.F. Watts,* and inscribed, at right centre, *Arion* 6¹⁵⁄₁₆ × 8½ in. (17.5 × 21.5 cm) - sheet size 4¼ × 5½ in. (11 × 14 cm) - image size
VERSO: landscape; watercolour and some pencil; inscribed lower left, *N. Wales,* and signed *G. Watts* 6¾ × 7¾ in. (17 × 19.5 cm) - image size
PROVENANCE: Mary Seton Watts; anonymous sale Sotheby's, London, December 21, 1978, lot 69, bought Guy Neville, London; sold to Shepherd Gallery, New York, by 1982; purchased December 17, 1985.
EXHIBITED: Shepherd Gallery: 1982; Kenderdine Gallery: 1995, cat. no. 68.

This is a colour sketch in watercolour for Watts' painting *Arion*. Arion was a famous Greek lyrical poet and musician who dwelt in the court of King Periander of Corinth. According to legend Arion left Periander's court to go to Sicily to compete in a musical contest, which he won. He then embarked, with the wealth from his prize, on a ship bound for Corinth. The sailors plotted to kill Arion and steal his treasure but, before being thrown overboard, Arion begged a last request to sing his death song. Dolphins followed the ship as if charmed by the spell and one of them bore him safely to land. The painting shows Arion, riding on the back of a dolphin, rejoicing in his narrow escape from death and looking up to the sun with an outstretched hand. Sea nymphs disport around him. The rich and splendid colours were influenced by Venetian Renaissance painting.

Arion was painted in several versions, beginning in 1856 as a fresco which was part of a scheme of nine decorative designs for the London home of Lord Somers at 7 Carlton House Terrace. This sketch would appear to be for the fresco version. A later painting, completed in 1895, in the collection of the Walker Art Gallery, Liverpool, differs significantly in its composition. Watts became interested in fresco during the time he spent in Italy as a young man in 1843-47. The most successful frescoes he painted in England were the ones for Lord Somers at Carlton House Terrace, probably because an early system of central heating provided drier conditions than would normally be found in the damp English climate. Even during the 1920s, when Watts' work was unappreciated, like Victorian painting in general, the director of the National Gallery in London considered these frescoes to be "among the artist's very finest works, constituting one of the most important surviving records of English work in the grand style."[1]

Additional studies for *Arion* are in the collection of the Watts Gallery, Compton. Drawings relating to it were included in a sketchbook, dating from the 1840s to 1850s, sold at Sotheby's, London, on June 9, 1994.[2]

1 Jefferies, Richard: Julian Hartnoll, 1991, cat. no. 3.
2 Sotheby's, London: *Victorian Pictures*, June 9, 1994, lot 213.

91 Study of the Head of Ellen Terry, c. 1864

Graphite on off-white wove paper; on the back of the frame, on an old label in M.S. Watts' hand is inscribed: "Study from nature. An original drawing by my husband. George Frederick Watts R.A. O M. M.S. Watts. Given KW.H Dorbin June 23 1906." 6¾ × 5⅞ in. (17.2 × 15 cm)

PROVENANCE: Mary Seton Watts; given to K.W.H. Dorbin, June 23, 1906; anonymous sale, Sotheby's, London, January 21, 1986, lot 61, bought Anthony Mould, London; sold to Maas Gallery, London; purchased June 22, 1988.

EXHIBITED: Hampshire House Social Club: 1913, cat. no. 87 or 88; Kenderdine Gallery: 1995, cat. no. 69.

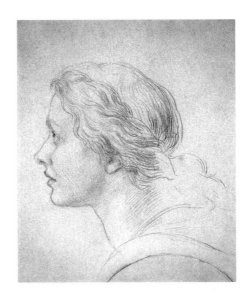

Ellen Terry was introduced to Watts by Tom Taylor, probably in the spring of 1862. A letter from Watts to Lady Constance Leslie shows that as early as 1862 Watts was already considering removing Ellen Terry from the temptations of the stage, giving her an education, and marrying her if she continued to have the affection that she then felt for him.[1] On February 20, 1864 Watts and Ellen Terry were married. He was forty-six and she was sixteen. Just under a year later they separated, with the Deed of Separation being signed on January 26, 1865. Watts was to pay her £300 annually so long as she led a chaste life, but the sum was to be reduced to £200 if she returned to the stage.[2] He may have continued to support her despite her liaison from 1868 to 1875 with the architect E.W. Godwin, which may at first have been discreetly kept from him.[2] In 1873 Ellen Terry returned to acting and she eventually became the leading English actress of her time.

On September 2, 1876 Watts applied for a divorce on the grounds of his wife's adultery with Godwin. Since there is no known reason for Watts to have wanted a divorce at this time, he probably instituted proceedings at Ellen Terry's request so that she could marry the actor Charles Wardel. On November 6, 1877 the divorce was made absolute. In Watts' evidence for the divorce proceedings he stated: "That although considerably older than his intended wife he admired her very much and hoped to influence, guide and cultivate a very artistic and peculiar nature and to remove an impulsive young girl from the dangers and temptations of the stage. That the conditions of his life were perfectly well known and entirely acquiesced in by the Respondent before his marriage and it was understood that nothing was to be changed. That very soon after his marriage he found out how great an error he had made. Linked to a most *restless and impetuous* nature accustomed from the very earliest childhood to the Stage and forming her ideas of life from the exaggerated romance of sensational plays, from whose acquired habits a quiet life was intolerable and even impossible, demands were made upon him he could not meet without giving up all the professional aims his life had been devoted to. That he did not impute any immorality at that time but there was an insane excitability indulging in the wildest suspicions, accusations and denunciations driving him to the verge of desperation and separation became absolutely necessary unless he gave up his professional pursuits which was out of the question as he had no independent means and it was arranged by his friends and those of his wife that a separation should take place. That separation took place within a year of his marriage. That he was willing to take all the blame upon himself (excepting of course charges of immorality if any had been made against him but none were made and there could have been no sort of foundation for them). That the matter pained him very much and that he refused to go into Society altogether and gave himself up entirely to study and close pursuit of his profession."[1,2]

Ellen Terry seems, in later years, to have remembered her time with Watts with fondness, and to feel that the marriage "in many ways it was very happy indeed."[1,2] Watts, however, seems to have felt guilty about the failure of his marriage. In 1883 he wrote to her: "I have nothing to add unless I may say that I never for a moment lose the pain of feeling that I have spoiled your life, I have never forgiven myself and never shall."[3] Ellen Terry was later to write that "this great man could not rid himself of the pain of feeling that he 'had spoiled my life' (a chivalrous assumption of blame for what was, I think, a natural almost inevitable catastrophe)."[4]

On November 20, 1886 Watts married his second wife, Mary Seton Fraser-Tytler. An original label on the back of the frame, in her hand, described this drawing as a "study from nature". Although she obviously knew who the model was, she apparently could not bear to acknowledge that it was a study of his first wife. Mary Seton Watts, in her extensive, three-volume annals of her husband's life, devoted less than one paragraph to his first marriage, and

never even mentioned Ellen Terry by name. "To what is well known I wish to add nothing; all who have heard his name know also that a beautiful young girl who, with her yet undeveloped genius, was destined later to fascinate and delight thousands of her generation, came into his life, that they were married in February 1864, and were parted in June 1865, and, except for the accident of one chance meeting in the streets of Brighton, never met again, the marriage being dissolved in 1877."[5] Ellen Terry seems to have been more benevolent in her feelings towards the second Mrs. Watts. After Watts' marriage to Mary Fraser-Tytler, she wrote to Lady Constance Leslie: "Now this is *very* private. See Mr. W. (the dear Signor) for me, and say, he, from first to last, has been a beautiful influence in my life, and that I pray God bless him. She too I bless for going into his life and cheering it. I have always had a great desire to tell her so, but feared it might not have been seemly in her eyes."[2] This would have certainly been the case, as Mary Seton Watts was jealous enough by nature not to be able to tolerate any female claims to Watts' friendship. She could not, for instance, abide Watts' close friend, neighbour, and later biographer, Mrs. Russell Barrington, whom Mary looked upon as a rival, and whom she referred to as "a poisonous snake."[2]

Although this drawing was sold as a study for Watts' painting *Choosing*, it more closely resembles another portrait of Ellen Terry, also in the collection of the National Portrait Gallery, London, which Wilfred Blunt has described as "hardly inferior, though less well-known."[2] This second portrait, dating from the time they had lived together, had been sent by Watts to the sitter, probably sometime after an amicable correspondence was re-established in 1882 and before his remarriage in 1886. The gift occurred as Ellen Terry wrote "when this tender kindness was established between us."[4] It appears that soon after the breakdown of his marriage Watts destroyed many of the portraits and studies he made of Ellen, so it is fortunate that this drawing survived.[6] It sums up a contemporary description of her by the dramatist Charles Reade: "Ellen Terry is an enigma. Her eyes are pale, her nose rather long, her mouth nothing in particular. Complexion a delicate brick-dust, her hair rather like tow. Yet somehow she is *beautiful*. Her expression *kills* any pretty face you see beside her."[2]

A similar drawing by Watts, thought to be of Ellen Terry, but not bearing a striking resemblance to her, was exhibited at the National Gallery of Art, Washington, D.C. in 1993.[7] A beautiful sheet of studies of the young Ellen Terry sold at Sotheby's, London, on June 3, 1998.[8]

1 Loshak, David: 1963, pp. 476-485.
2 Blunt, Wilfred: 1975, pp. 110, 114, 116-118, and 178.
3 Auerbach, Nina: 1987, p. 118.
4 Staley, Allen: Manchester City Art Gallery, 1978, cat. no. 14, p. 70. See Terry, Ellen: 1908, pp. 52-60.
5 Watts, Mary Seton: 1912, Vol. 1, p. 221.
6 Blunt, Wilfred: 1975, pp. 110-111. He quotes a letter from Marion Rawson, Eustace Smith's granddaughter: "Ellen had left him and that he was destroying all the paintings and studies he had made of her."
7 Grasselli, M.M. and Brodie, J.: National Gallery of Art, Washington, 1993, cat. no. 54, *Head of a Young Woman*, 22 × 14⅞ in., inscribed lower left in chalk "Study from Nature".
8 Sotheby's, London: *Victorian Pictures*, June 3, 1998, lot 195, *Figure studies, believed to be Ellen Terry*, pencil, 8¾ × 12¼ in. There can be little doubt these are of Ellen Terry. This sheet was exhibited previously Tate Gallery: 1954-1955, cat. no.139, p. 52, lent by David Loshak. It was exhibited subsequently at the Shepherd Gallery: 1998-99, cat. no. 75, lent by Maas Gallery, London.

92 Colour Sketch for "Britomart and Her Nurse," c. 1876

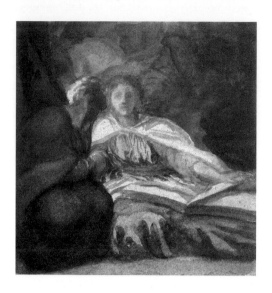

Watercolour on thick wove paper, laid down 9⅟₁₆ × 8½ in. (23.2 × 21.7 cm)

PROVENANCE: Terence Rowe, London; sold on September 1, 1962 to Maas Gallery, London; their sale, Phillips, London, February 12, 1970; John Anderson, London; Pre-Raphaelite Inc.; their sale Sotheby's, London, June 21, 1989, lot 127, bought in; Julian Hartnoll, London; purchased April 26, 1994.

EXHIBITED: Maas Gallery: 1962, cat. no. 117; Kenderdine Gallery: 1995, cat. no. 70.

This is the colour sketch for Watts' painting *Britomart and Her Nurse,* in the collection of the Birmingham City Museum and Art Gallery. When the painting was exhibited at the Royal Academy in 1878, a reviewer from the *Manchester Guardian* described it as "very large in size, very magisterial in arrangement, very rich in colour, very imposing in general effect. It is a splendid piece of decoration."[1] The painting is based on a passage from Book III of Spenser's *Faerie Queene*. Watts described the subject in a letter written from Little Holland House, Kensington, on July 20, 1900 to the painting's first owner, George Edward Belliss: "Britomart, emblem of maidenly purity, falls in love with the figure of a Knight she sees in an enchanted mirror. She and her nurse put on armour and go out into the world to seek the bodily substance of the Phantom. So far Spenser. In my picture Britomart and her nurse, who has discovered the cause of unusual pensiveness and proposed they should together look into the mirror, are before it – Britomart does not dare to look into it, fearing to have her impression disturbed, so she, having read the formula which will call up the visions, gets her Nurse to describe the appearances. I have taken advantage of this to represent the dramatis personae of the poem, and have suggested that they have passed before the disc and been described, but none of them are Britomart's knight; at last Artegal, the symbol of justice, appears. (I have made him curbing his horse, as justice must not over-ride sympathy). At the first words of the Nurse, Britomart starts but does not yet dare to look! This is the simple outline of *my* Poem, which can hardly be called an illustration of Spenser's."[2]

Although the painting was first exhibited at the Royal Academy in 1878, this watercolour sketch is difficult to date, even approximately. Pencil drawings were made for this subject as early as 1851-52. Watts was certainly working on the painting in 1876, when he wrote to his principal patron C.H. Rickards: "The Spenser picture is one of the many I hope to finish in my new studio in the new Little Holland House which being much lighter than my old work-shop, I hope may be found to send out more luminous pictures."[3] The rich colouring in both the painting and the watercolour sketch betray Watts' admiration for Venetian Renaissance painting, and particularly Titian. The figure of the knight on his horse, which looms out of the background in the watercolour, is reminiscent of the composition used by Watts in his famous sculpture *Physical Energy*.

Britomart and Her Nurse exists in several versions. The Castle Museum, Norwich, has a smaller painting that shows a considerable difference in composition, as does another small

228

study at the Watts Gallery at Compton. Two studies for it were included in the winter exhibition of the Royal Academy of Arts, London in 1906.[4] Another sheet of studies was with the London art dealer Julian Hartnoll in 1995.[5]

1 *Manchester Guardian*: "Review of the Royal Academy Exhibition", May 15,1878.
2 Birmingham City Museum and Art Gallery: 1930, cat. no.527'29, p. 208, MS Birmingham.
3 Watts, Mary Seton: "Manuscript Catalogue of the Paintings of George Frederic Watts", Watts Gallery, Compton, p. 17.
4 Royal Academy of Arts, London: 1906, cat. nos. 256 and 257, both pencil on white paper.
5 Hartnoll, Julian: personal letter dated November 1, 1995. This drawing had previously been offered for sale at Sotheby's, London, September 26, 1990, part of lot 364, and sold Sotheby's, London, July 10, 1995, part of lot 144, pencil on white paper, 22 ×15 in. This sheet largely does not relate directly to this watercolour, but contains mainly studies for the horse and knight in the background.

93 Study of the Figure of Death for "Time, Death and Judgment," c. 1878-86

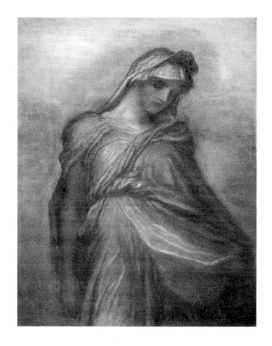

Orange chalk, heightened with white, on paper laid on canvas; on the back of the wooden support, written in chalk, is "Chapman No. 22", which is the inventory number from when Chapman's collection was stored at the Watts Gallery, Compton 36 × 28 in. (91.4 × 71.2 cm)
PROVENANCE: Mary Seton Watts; by descent to her adopted daughter Lilian Chapman (née Mackintosh); bequeathed in 1972 to her son Ronald Chapman; his sale, Sotheby's Belgravia, London, June 29, 1982, lot 170, bought Derek Lowery of the Kelmscott Gallery, Vancouver; purchased March 7, 1984.
EXHIBITED: Kenderdine Gallery: 1995, cat. no. 71 (illus.).

This is a study for the figure of Death in *Time, Death and Judgment*, a painting that exists in a number of versions. Of the three well-known large versions probably the earliest, for which this drawing is a study, is in the National Gallery of Canada, Ottawa, while the second version is in St. Paul's Cathedral, London, (currently on loan to the Watts Gallery, Compton) and the third is at the Tate Gallery, London. The possible chronology of these paintings, including which is the first or the "great picture", and which is the second version has been discussed by Barbara Bryant.[1] The first large version was shown at the Grosvenor Gallery in 1878 under the title *Time and Death*. Soon afterwards Watts added the word "Nemesis", later changed to "Judgment", to reflect the presence of the third figure. A smaller version in oil, in which Judgment carries an avenging sword rather than a pair of scales and Time is uncrowned, is in the Sheffield City Art Galleries.

Studies exist in pen and ink for the composition of *Time and Death*, probably dating from

the early 1860s.[2] A sheet of studies by Watts, that must date to c. 1864, and which included an early design for the figure of Death, was sold at Sotheby's, London, on June 3, 1998.[3] The first oil sketch for the subject *Time and Death*, again likely dating from the early 1860s, is in the collection of the Ashmolean Museum, Oxford. Another sketch for *Time and Death* was exhibited at the Royal Academy in 1865, and in 1868 was sold to Charles Rickards. On October 24, 1868 Watts wrote to Rickards about the design: "Allegory is much out of favour now and by most people condemned, forgetting that spiritual and even most intellectual ideas can be expressed by similes, and that words themselves are but symbols. The design 'Time and Death' is one of several suggestive compositions that I hope to leave behind me in support of my claim to be considered a real artist, and it is only by these that I wish to be known. I am very glad that you find the ring of poetry in it."[4] The painting that belonged to Rickards may be the one now in the collection of the Art Institute of Chicago. It closely resembles the sketch at the Ashmolean, except that a third figure is in the background, although this appears to be a later addition.[5] In these early oil sketches Death's drapery is not gathered into folds into which flowers are strewn, as in the later versions.

It is uncertain when Watts began to paint *Time, Death and Judgment* on a larger scale. According to Mrs. Watts, the painting in the National Gallery of Canada is in all probability the first of the larger canvases, but the only date she assigns it is 1886, the year in which Watts presented the painting to Canada.[6] This is the date the painting was finished, but it is obviously not when it was started. Bryant dates it to 1870s-86.[1] It had been reworked after it had been exhibited initially at the Grosvenor Gallery in 1878 as *Time and Death*, reappearing at an exhibition in New York in 1884 as *Time, Death and Judgment*. The figure of Judgment was therefore obviously added sometime between 1878 and 1884. Watts gave the second version to St. Paul's Cathedral in 1893. The third version, at the Tate Gallery, was completed in 1900.

At the New Gallery summer exhibiton of 1896 the following quotation was included in the catalogue in connection with *Time, Death and Judgment*: "Whatsoever thy hand findeth to do, do it with thy might; for there is no work, nor device, no knowledge, nor wisdom in the grave, whither thou goest." Inscribed on a watercolour replica by Cecil Schott, Watts' studio assistant, made as a design for mosaic for the facade of St. Jude's Church, Whitechapel was: "It is appointed unto man, once to die, but after this the judgement."[7] In the painting Time, bearing a scythe, his traditional attribute, and Death are portrayed "wading hand in hand together through the waves of the stream of life."[8] Mrs. Russell Barrington, Watts' friend and later biographer, described this subject: "The eyes of Time are stony, with an unchangeable, never-failing youth; not cruel, only heedless of what may happen as he inevitably presses forward, pausing neither to inflict, to spare, nor to mend ... Death, his inevitable mate, glides silently by his side, doing her work at unexpected, uncalculated moments. Her lap is full of gathered flowers, buds, blossoms, faded leaves, all together, fulfilling, as she goes, her mysterious mission of gathering to herself the young, the old, the middle-aged, indiscriminately, it would seem, but with the unswerving certainty of fate, irrespective of all human calculations or desires. Behind, in the wake of Time and Death, flies the no less inevitable Nemesis, her face hidden by the outstretched arm which carries the deciding scales."[8] According to her *Time, Death and Judgment* was the only picture to come to Watts in a vision, "before his inner sight as a picture", and on no other work had the artist "bestowed more thought or labour."[8] Mrs. Barrington noted that: "The figures are sculpturesque in character, not hewn out of smooth, delicate marble, but out of rough, enduring adamant. They are beings who move in larger conditions than those encircling humanity; creatures who view a wider horizon than that which bounds our vision."[8]

Time, Death and Judgment was to form part of Watts' scheme for a "House of Life" series of paintings, intended to decorate a vast building with "a history of the progress of man's spirit" and which Mary Seton Watts described as "the ambition of one half of his life and the regret of the other half."[9] The first allegory in this series, *Time and Oblivion*, was painted by Watts in 1848, and various other subjects were painted over the years, but the overall scheme never came to fruition. Bryant considers *Time, Death and Judgment* to be a logical continuation of Watts' thinking concerning his earlier painting *Love and Death*.[1]

Drawings in this technique and of this size by Watts are unusual, although the Watts Gallery, Compton, has a similar study for *Hope*.[10]

1 Bryant, Barbara: In Wilton, A. and Upstone, R.: 1997, cat. no. 123, pp. 263-265.
2 Loshak, David: Tate Gallery, 1954-55, cat. no. 144, pen and ink on blue paper, $7\frac{1}{2} \times 4\frac{5}{8}$ in., lent by Brinsley Ford. Two other early studies from the 1860s sold at Sotheby's Belgravia on June 24, 1980, lot 21.
3 Sotheby's, London: *Victorian Pictures*, June 3, 1998, lot 195. In this sheet four of the figures are drawn from the young Ellen Terry, while the fifth figure, in the lower left, would appear to be an early idea for Death in *Time, Death and Judgment*. This sheet was probably made in 1864, the year Watts and Ellen Terry were married, but could date anywhere from between 1862, when they first met, to January 1865, when they were formally separated.
4 Loshak, David: Tate Gallery, 1954-55, cat. no. 36, p. 32.
5 Staley, Allen: Manchester City Art Gallery, 1978, cat. no. 29, pp. 87-88.
6 Watts, Mary Seton: *Manuscript Catalogue of the Paintings of George Frederic Watts*, Watts Gallery, Compton.
7 Sotheby's, London: *Victorian Pictures*, November 12, 1992, lot 169, pp. 120-121, a large watercolour design for the mosaic, $96\frac{1}{2} \times 66$ in., consigned by Julian Hartnoll. The mosaic design had originally been on St. Jude's Church, but when it was demolished, the mosaic was transferred to the churchyard of St. Giles-in-the-Fields, Holborn.
8 Barrington, Mrs. Russell: 1905, pp. 94, 112, and 127-128.
9 Blunt, Wilfred: 1975, p. 57.
10 Christian, John: 1989, cat. no. 8, p. 108, illus. p. 29.

94 Study for "The Messenger," 1891

Black and red chalk on buff paper; signed *G.F. Watts*, and dated *February 1891*, lower right; old repair, lower margin $26\frac{1}{4} \times 16\frac{1}{8}$ in. (66.7 × 40.9 cm) - sheet size $22\frac{3}{4} \times 14$ in. (58 × 35.5 cm) - image size
PROVENANCE: Manchester Whitworth Institute, later the Whitworth Art Gallery, Manchester, by 1905; deaccessioned at their sale, Christie's, London, April 26, 1935, part of lot 80, purchased F.R. Meatyard, London; David Gould, London; sold to John Christian, London, c. 1975; his sale, Christie's, London, April 28, 1987, lot 213.
EXHIBITED: Royal Academy: 1905, cat. no. 106; Kenderdine Gallery: 1995, cat. no. 72.

The Messenger, also called *The Message of Peace*, is one of a series of paintings Watts painted on the theme of death, including *Love and Death*, *Time, Death and Judgment*, *The Court of Death*, *Death Crowning Innocence*, and *Sic Transit*.

The Messenger symbolizes Watts' concept of death, his views on which were reported by his wife: "I fancy it was near, but I have never had any fear of death; it has no horrors for me beyond the pain of leaving those who will grieve for me. I think I have shown in my work what I think of death … I want you not to mind when the day comes for me to take that journey – it leads to better things."[1]

There are two large versions of this painting and a smaller oil sketch, in grey monochrome, at the Watts Gallery, Compton.[2] One of the large versions is at the Tate Gallery, London, while the second sold at the Frankham sale, Christie's South Kensington, on September 25, 1989, lot 341. Both of the large versions, like this drawing, contain more explicit and elaborate symbolism than does the sketch at the Watts Gallery. The sketch and the Tate version are both dated 1884-85.

Hugh MacMillan, in his book on Watts, has discussed *The Messenger*: "Usually death comes in the most undesired of all forms, as loss and waste of the most precious things in life; but in Watts' picture called 'The Messenger' it comes in the most welcome of all forms as the consoler of sorrow, the giver of rest … In the picture before us it stands in front of a weary, worn-out sufferer, whose face is turned away from us so that we can only see the suffering impressed upon it. In the most tranquil and dignified attitude, it touches with its beckoning finger the aged, worn-out frame, stretched in utter weariness on its couch, and bids him leave the open book that he has been reading lying on the floor, the violin with which he has striven in vain to soothe his depressed spirit, the globe which he has used in his astronomic studies, and the palette and the chisel that have helped by the painter's and the sculptor's accomplishments to enrich and beautify his life."[3]

Watts' symbolism is always open to interpretation and not everyone would agree with MacMillan's reading of this painting. The picture may instead signify that Death eventually touches all mankind, the young as well as the old, regardless of success in the arts, science, literature, and the military. Each of the symbolic objects included in the painting may signify some aspect of a life which has come to an end. The sword and the shield in the left foreground could refer to involvement in the military and war; the open book, the violin, the painter's palette, and the sculptor's chisel and mallet refer to the contemplative pursuits of reading, music, and to the fine arts. The globe may suggest the success in travel and exploration achieved by many Victorians in the remote regions of the world. The presence of the baby borne in the left arm of Death is certainly open to interpretation. Of the baby on Death's lap in *The Court of Death* Watts said: "The suggestion that even the germ of life is in the lap of Death, I regard as the most poetic idea in the picture, the key-note of the whole."[1] The presence of the baby in *The Messenger* may therefore also be the key to its symbolic meaning. Barbara Bryant feels that the symbolic accessories added to Watts' paintings on the theme of Death, like *The Messenger* or *Sic Transit*, relate to the vanitas still-life genre, with "its focus on the fragility of man and the transience of life and beauty."[4]

The technique of this red chalk drawing is similar to many other works Watts made in the 1890s. As Barbara Bryant has noted about a similar drawing of *The Recording Angel*: "This drawing belongs to a distinct, and essentially Symbolist, category in Watts's oeuvre in which he translated his major compositions into the medium of soft red chalk studies of great subtlety … As in Watts's other red chalk drawings, the soft focus heightens the mood of silence and mystery."[5]

The Watts Gallery has a large charcoal drawing, approximately 56 × 34 in., of the figure of Death for *The Messenger*. Another study sold at Sotheby's Belgravia, June 24, 1980, lot 32.

1 Watts, Mary Seton: 1912, Vol. II, pp. 194 and 316 and Vol. I, p. 308.

2 Bryant, Barbara: "G F Watts and the Symbolist Vision" in Wilton, A. and Upstone, R.: Tate Gallery,
 1997, p. 74, fig. 44.
3 MacMillan, Hugh: 1903, p. 252.
4 Bryant, Barbara: Tate Gallery, 1997, cat. no. 126, pp. 269–270.
5 Bryant, Barbara: Tate Gallery, 1997, cat. no. 106, p. 239.

95 Adam and Eve before the Temptation (Naked and Not Ashamed), 1896

Oil on canvas; signed *G.F. Watts*, and dated *1896*, lower left; in its original gilt oak "Watts" frame 25⅝ × 15⅟₁₆ in. (65.3 × 38.3 cm)

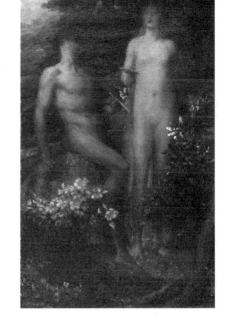

PROVENANCE: Bought from G.F. Watts by A.R. Fairfield Lauder; sold to Agnew's, London; sold to Edmund Davis on February 25, 1899; his sale, Christie's, London, July 7, 1939, lot 96, bought Agnew's, London; sold on June 3, 1943 to Edward Le Bas R.A.; ? Brook Street Gallery, London, by 1972; likely their sale, Sotheby's Belgravia, London, July 10, 1973, lot 60, bought C. Gibbs; Christie's, London, February 13, 1976, lot 17; anonymous sale Christie's, London, January 28, 1977, lot 53, bought MacMillan and Perrin Gallery, Vancouver; their sale, Sotheby's, New York, June 12, 1980, lot 23, bought in; purchased from MacMillan and Perrin Gallery, Toronto, September 7, 1982.

LITERATURE: Cartwright, Julia: 1896, illus. p. 31. The painting can be seen on the easel behind the artist in a photograph taken in his study in 1896.

EXHIBITED: New Gallery: 1896b, cat. no. 136; Agnew's: 1943, cat. no. 39; ? Lowe Art Gallery: 1972, cat. no. 52; MacMillan and Perrin Gallery: 1977, cat. no. 8 (illus.); MacMillan and Perrin Gallery: 1979, cat. no. 36 (illus.); Kenderdine Gallery: 1995, cat. no. 73 (illus.).

Adam and Eve before the Temptation is one of a series of paintings, on the theme of Adam and Eve, intended for Watts' "The House of Life." In 1886 Watts wrote to C.H. Rickards: "these designs – Eve in the glory of her innocence, Eve yielding to temptation, and Eve restored to beauty and nobility by remorse – form part of one design and can hardly be separated, any more that one would think of separating the parts of an epic poem."[1] This series eventually came to include such works as *The Creation of Eve*, *Eve Tempted*, *Eve Penitent*, *The Birth of Eve*, and *The Denunciation of Adam and Eve*. There are no replicas by Watts of *Adam and Eve before the Temptation*, or its companion *Adam and Eve after the Temptation (And They Knew That They Were Naked)*, although different versions do exist of others in this series. A number of works from this series, including *Adam and Eve before the Temptation* and its companion, belonged to the noted collector Sir Edmund Davis. Davis gave one of his paintings of Eve to the Musée du Luxembourg in Paris. Two of the other paintings from his collection, *The Creation of Eve* and *The Denunciation of Adam and Eve*, were bought after Davis'

death by Grenville Winthrop and are now in the Fogg Museum of Art, Harvard University. The Tate Gallery in London also has versions of a number of works in the "Eve" series. "

Adam and Eve before the Temptation, and its companion, were first designed by Watts in 1893-94, and then painted at Limnerslease, his home at Compton, during the two following winters.[2] It was Watts' usual habit to have several works underway in the studio at the same time and to work on a composition for many years. The major influences on his work were the Elgin Marbles and the art of the Italian Renaissance, particularly the great Venetian masters, especially Titian and Tintoretto. Watts never ceased to think of his work in terms of sculpture and, as Loshak has pointed out: "This may be the secret of one of his most striking qualities – an amazing skill and inventiveness in the designing of single figures, of closely linked groups of two or three figures, or highly compressed groups of more numerous figures. One may amplify this by saying that Watts had strong mannerist leanings; mannerist in the sense that the closely linked figure design is always paramount, and the surrounding space a kind of accretion, often quite irrational, bending itself, as it were, into conformity with the figures. This is quite different from the renaissance point of view, in which a rational, continuous, fixed space tends to rule the scale and positions of the figures placed within it."[3]

The figures in this painting were not studied from life, although Watts sculpted studies in wax for different parts of them.[2] The figure of Eve was likely based on the many studies he drew from his favourite model "Long Mary." Mary Seton Watts, in her book on her husband, wrote: "In earlier years a large number of studies were made from a model whom he always called 'Long Mary', who sat to him, and to him only, from the early 'sixties and onwards for several years. He told me he never made use of her, or of any other model, when painting a picture. He said, 'I don't want individual fact in my pictures where I represent an abstract idea. I want the general truth of nature … when painting Signor referred to the studies made in charcoal on brown paper from this most splendid model – noble in form and in the simplicity and innocence of her nature – a model of whom he often said that, in the flexibility of movement as well as in the magnificence of line, in his experience she had no equal."[1]

The use of lighting in this painting would appear to have symbolic purposes. Watts, in describing to his wife the figure of Eve in his painting *The Birth of Eve,* told her: "he wanted the figure not so much to stand in light as to emit light. The upturned face is dark in the midst of light, for the human intuitions may take the human mind into a region where reason stops … He explained that it was not an apotheosis of womanhood, but rather of the qualities with which it is natural to associate the term feminine. For this reason, over the region of the heart and breast the light is concentrated because, so to speak, there is the seat of tenderness, goodness, love."[1] Watts' use of the white flowers in the foreground is symbolic of the innocence of Adam and Eve prior to their temptation and fall.

The collector Sir Edmund Davis (1862-1939) was born in Australia and was of French-Jewish descent. He worked in South Africa, first as a dealer in ostrich feathers and later as a mining magnate from which he made his fortune. Ricketts and Shannon were friends of Davis and his wife Mary, and advised them on collecting, particularly Old Masters. In 1915 Davis gave thirty-seven paintings by British artists to the Musée du Luxembourg, which are now mostly in the Musée d' Orsay. In 1936 he gave further works to the South African National Gallery.

1 Watts, M. S.: 1912, Vol. I, p. 262 and Vol. II, pp. 44 and 139.
2 Watts, M.S.: "Manuscript Catalogue of the Paintings of George Frederic Watts", Watts Gallery, Compton, p. 104.
3 Loshak, David: Tate Gallery, 1954-1955, p. 9.
4 La Collection de Sir Edmund Davis, La Revue du Musée D'Orsay: no. 8, Spring, 1999. pp. 40-9.

PHILIP SPEAKMAN WEBB (1831-1915)

Webb was born on January 12, 1831 at Oxford, the son of a doctor. From 1849-52 he was articled to a Reading architect, John Billing. In 1852 he became chief assistant to the Gothic Revival architect George Edmund Street, whose office was then in Oxford. In 1856 William Morris was also articled to Street. Although Morris only stayed nine months, this lead to a life-long friendship and collaboration between Morris and Webb. Webb remained in Street's office until 1859, when he left to set up his own practice. One of his first commissions was a house for William and Jane Morris, Red House, built at Bexley Heath in Kent from 1859-60. In 1861 Webb was one of the partners in the newly established firm of Morris, Marshall, Faulkner & Co., for which he designed stained glass, furniture, tiles, glassware, and metalwork. Webb had much less to do with designing for the firm after its reorganization into Morris & Co. in 1875. Webb never had a large practice, compared to successful Victorian architects like Richard Norman Shaw, and primarily designed houses for his artist friends, for example, Spencer Stanhope, G.P. Boyce, Val Prinsep, G.F. Watts, and George Howard, or for clients sympathetic to his work, such as the Ionides and Alexanders. Webb attempted to avoid borrowed styles and to design merely good plain understated buildings, using local materials. He invariably insisted on being responsible for every part of all his buildings, which limited the number of commissions he was able to undertake. In 1877 he joined with Morris, Carlyle, Ruskin, and Burne-Jones to become a founding member of the Society for the Protection of Ancient Buildings. In the 1880s he was one of Morris' few friends who joined him in embracing socialism. By 1900 Webb had effectively retired from practice. He died on April 17, 1915 at Worthing.

96 The Spirit of God on the Waters: The Dove Descending, c. 1862

Graphite, brown and black ink, with blue, green, tan, and red washes on off-white paper; inscribed with colour notes in the cartoon; inscribed at the upper left "Selsley", at the upper right centre "Top", and at the lower right "NB – if necessary to the drawing of the water put fewer and stronger lines." On the back of the frame are two old labels. The first is a Morris and Co. label, 17 St. George St., Hanover Square, London, W.I, inscribed "Original cartoon by Philip Webb for stained glass 'Dove' emblem." The second label states: "These two Roundels were purchased from the late firm of Morris & Co. on the

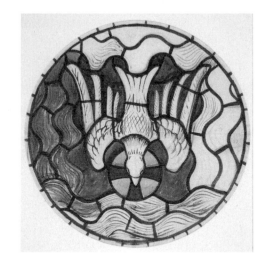

recommendation of Mr. Morley Horder as two fine examples of the work of the late Philip Webb September 1940." 27⅝ × 26⅛ in. (70.3 × 66.5 cm)

97 The Birds and the Fishes, c. 1862

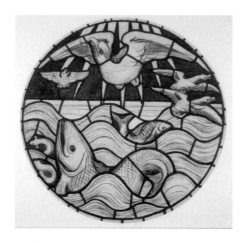

Graphite, brown and black ink, with blue and brown washes, on off-white paper; inscribed with colour notes in the cartoon; inscribed at the upper left "Selsley" and at the upper centre "centre top". On the back of the frame are two old labels. The first is a Morris and Co. label, 17 St. George St., Hanover Square, London, W.I, addressed to Donald Hope Esq., Messrs. Henry Hope and Co., Berners St., W.1. The second label states: "These two Roundels were purchased from the late firm of Morris & Co. on the recommendation of Mr. Morley Horder as two fine examples of the work of the late Philip Webb, September, 1940." 28¾ × 26¼ in. (73 × 66.7 cm)

PROVENANCE: Morris and Co.; their liquidation sale in September 1940, bought by Whitefriars Glass Company (James Powell and Sons); their sale, Sotheby's Belgravia, March 23, 1976, lots 37 and 36 respectively; anonymous sale, Christie's, London, November 5, 1993, lot 138, bought in and purchased later, on December 22, 1993.

LITERATURE: Sewter, A.C.: 1975, Vol. II, pp. 172-173, Vol. I, pl. 48; Fawcett; Jane: 1977, pp. 87-88, fig. 80; Cooper, Jeremy: 1987, p. 174, fig. 455 (cat. no. 97).

EXHIBITED: Moss Galleries: 1994 – on loan (cat. no. 97 only); Kenderdine Gallery: 1995, cat. nos. 74 and 75 respectively.

These two cartoons are for the Creation window at All Saints, Selsley, a church designed by the Gothic Revival architect G. F. Bodley, under the patronage of the Murling family of nearby Stanley Hall. Bodley himself commissioned the stained-glass windows from Morris, Marshall, Faulkner & Co., apparently the firm's first for ecclesiastical glass, although St. Michael and All Angels, Brighton, designed by Bodley in 1858 and built in 1861-62, also has early stained glass by the firm.[1] Of all its partners, Bodley was particularly close to Philip Webb, who was entrusted with the overall scheme for the interior of All Saints. This church is of great importance as an example of the early work by Morris, Marshall, Faulkner & Co., since it is the only complete scheme of glazing for a church that was designed and executed at the same period.[1] In addition to the general arrangement of the interior decorative scheme, Webb designed all the pattern-work, as well as some of the subject cartoons for the stained glass. The other windows were designed by Burne-Jones, Morris, Rossetti, and Campfield.[1] The concept of using the stained glass to create a band of rich colour around the entire church was apparently inspired by the windows in the chapel at Merton College, Oxford.

Webb produced three cartoons for the Creation window, which are listed on page three of his account book: "Designs for Circle of Adam & Beasts in Creation £1:10:0, Birds & Fishes £1:10:0, Spirit on the Waters 10s."[2] The rest of the Creation lights are presumed to have been designed by William Morris, although some appear to be adaptations of Burne-Jones' cartoons for the Creation window at Waltham Abbey. Webb's cartoon for *Adam Naming the Beasts* is in the collection of the Victoria and Albert Museum, London. One possible source of inspiration for *The Birds and the Fishes* is the panel depicting the same subject in the Great East Window in York Minster, made between 1405 and 1408.[3] The stained-glass artist

Edward Payne had great admiration for Webb's windows at Selsley: "I have just been re-leading the rose window of The Creation, which Philip Webb designed; it is beautifully simple in its construction of lead and in its imagery, so living and fresh."[4]

Full-scale cartoons for windows by Webb are extremely rare, and he more commonly designed quarries, borders, pattern-work and canopies.[2] Initially in the early years of the firm, up until about 1868-69, the responsibility for designing the setting of each window within the architectural interior to achieve the desired general effect fell to Webb, but later this was largely taken over by Morris.[2] Designs by Webb for stained glass and other drawings are found in the collections of the Birmingham City Museum and Art Gallery,[5] the Victoria and Albert Museum, London, the Ashmolean Museum, Oxford, and the William Morris Gallery, Walthamstow.

1 *William Morris Society of Canada Newsletter*: Summer 1992.
2 Sewter, A. Charles: 1975, Vol.II, pp. 23, 25, 29 and 171-173.
3 Osborne, June: 1997, fig. 20. The Great East Window was the work of John Thornton of Coventry. The panel of the creation of the birds and fishes is just one of 127 that depict the Creation and the end of the world. Webb was a great admirer of medieval stained glass and likely was familiar with this famous example in York Minster.
4 Moss, Rachel: 1995, p. 12.
5 Birmingham City Museum and Art Gallery: 1939, p. 417, cat. nos. 1011'27 and 1012'27.

JAMES ABBOTT McNEILL WHISTLER (1834-1903)

Whistler was born on July 11, 1834 at Lowell, Massachusetts, the son of a civil engineer. In 1843 the family travelled to St. Petersburg, Russia, where Whistler's father was employed by the czar to build a railroad from St. Petersburg to Moscow. After his father's death in 1849, Whistler returned to live in America. In 1851 he entered West Point Military Academy, but he was discharged in June 1854. In September 1855 he left America, never to return. He entered the studio of Charles Gleyre in Paris in June 1856. In May 1859 Whistler moved to London. In 1860 he exhibited his first painting at the Royal Academy. In March 1863 he moved to 7 Lindsey Row in Chelsea near Rossetti and subsequently met other intimates of the Pre-Raphaelite circle. In April 1863 *The White Girl* was rejected at the Paris Salon, but became the most controversial painting at the famous Salon des Refusés. From 1863-65 he painted works showing the influence of both the Pre-Raphaelites and Japanese art. He began to paint a succession of Thames Nocturnes in 1871. In 1872 the portrait of his mother was accepted by the Royal Academy, the last painting by Whistler to be exhibited there. In 1877 he exhibited the controversial *Nocturne in Black and Gold: The Falling Rocket* at the first Grosvenor Gallery exhibition. Whistler later sued John Ruskin for libel when the latter wrote that he "never expected to hear a coxcomb ask two hundred guineas for flinging a pot of paint in the public's face." In November 1878 Whistler was awarded damages of a farthing, but without costs, which left him deeply in debt, and in 1879 he was declared bankrupt. He left for Venice in September 1879 with a commission from The Fine Art Society to produce twelve etchings. He returned to London in November 1880, having made fifty etchings and over ninety pastels. In November 1884 he was elected a member, and in June 1886 president of the Society of British Artists. In 1891 the Corporation of Glasgow acquired *Arrangement in Grey and Black, No. II: Portrait of Thomas Carlyle*, the first painting by Whistler to be bought by a public collection. He was elected president of the International Society of Sculptors,

Painters, and Gravers in 1898. In 1903 he was awarded an honorary L.L.D. from the University of Glasgow. On July 17, 1903 Whistler died in London. He was buried in Chiswick Cemetery.

98 Study of a Female Nude for the "Six Projects", c. 1870

Black chalk on buff paper; inscribed by an unknown hand with a ? butterfly, lower right
10¾ × 6½ in. (27.3 × 16.6 cm)
PROVENANCE: ? Mrs. E. John Heidsieck, New York; her sale Parke Bernet, New York, February 12, 1943, lot 106; Sam David, Philadelphia; sold in April 1972 to M. Knoedler and Co., New York; their sale Sotheby's, New York, June 5, 1980, lot 299, bought Marbella Gallery, New York; sold on April 25, 1984 to M. Knoedler and Co., New York; purchased September 19, 1984.
LITERATURE: Pennell, E. and Pennell, J.: 1908, Vol. 1, p. 140 (illus.); MacDonald, Margaret F.: 1995, cat. no. 443, pp. 160-161 (illus.).
EXHIBITED: Knoedler-Modarco Gallery: 1984, cat. no. 54 (illus.); Kenderdine Gallery: 1995, cat. no. 76.

The years 1865-70 were very much a transitional period in the art of James McNeill Whistler. In 1865 he fell under a new influence, that of classical Greece, when he saw Albert Moore's *The Marble Seat* exhibited at the Royal Academy. Whistler immediately struck up a friendship with Moore, and for the next five years each was the major influence on the other's work. As a result of their collaboration, Whistler appropriated those elements of Moore's Classicism that appealed to him, while Moore became influenced by Whistler's interest in Japanese art so that his palette became lighter in colour and he became more concerned with overall decorative patterns and effects (see cat. no. 50).[1]

Between 1865 and 1870 Whistler's major artistic endeavour was the so-called "Six Projects", which are frequently said to have been commissioned by Frederick Leyland in 1866 as a series of related canvases intended as a decorative scheme.[2,3] Margaret MacDonald, however, has noted that the term "The Six Projects" was first used by Elizabeth and Joseph Pennell in their 1908 biography of Whistler, and that this title was not recorded during Whistler's life.[4] MacDonald contends that only the *Symphony in White No. IV: The Three Girls* was intended as a painting for Leyland, based on William Michael Rossetti's comment that: "Whistler is doing on a largeish [sic] scale for Leyland the subject of women with flowers ... made coloured sketches of four or five other subjects of the like class, very promising in point of conception of colour arrangement."[5] Linda Merrill asserts that the series was known as the "Venus Set" before Freer renamed them the "Six Schemes", and that the program of the paintings becomes clear once the *Symphony in White: The Three Girls*, the only painting that was intended for Leyland, is removed. Merrill feels the set depicts the classical subject of Venus "surrounded by attendants on the mythical shores of her native sea."[6] MacDonald also

believes that the drawings from 1868-70 in the collections of the Hunterian Museum in Glasgow and the Freer Gallery in Washington, D.C., for compositions of women on piers and terraces by the sea, point to far more than six "Projects".[4] Even the Pennells acknowledged that Ernest F. Fenollosa felt there were eight projects.[7] The oil sketches for the "Six Projects" exist, still in their incomplete state, in the Freer Gallery of Art, Washington, D.C. The classically draped female figures are carefully arranged for compositional effect with subtle colour harmonies.

Whistler's main problem which led to his inability to finish the "Six Projects" would appear to have been his lack of academic training, particularly in draughtsmanship.[2] In August or September 1867 he wrote about his problems to his friend, the French artist Henri Fantin-Latour: "I've several pictures in my head and they only come out with some difficulty – for I must tell you that I am now experiencing demands and difficulties way beyond the time when I was able to throw everything down on the canvas pell mell – in the knowledge that instinct and fine colour would always bring me through in the end! – Ah my dear Fantin what a frightful education I've given myself – or rather what a terrible lack of education I feel I have had! – With the fine gifts I naturally possess what a fine painter I should be by now! If, vain and satisfied with those gifts only, I hadn't shunned everything else!…Ah! how I wish I had been a pupil of Ingres! I don't go into raptures in front of his pictures – I only have a moderate liking for them … But I repeat would I had been his pupil! What a master he would have been – How *sound* a leader he would have been – drawing! My God! Colour – it's truly a vice! Certainly it's probably got the right to be one of the most beautiful of virtues – if directed by a strong hand – well guided by its master drawing – colour is then a splendid bride with a spouse worthy of her – her lover but also her master, – the most magnificent mistress possible! – and the result can be seen in all the beautiful things produced by their union! But coupled with uncertainty – drawing – feeble – timid – defective and easily satisfied – colour becomes a cocky bastard! making spiteful fun of "her little fellow", it's true! and abusing him as she pleases – treating things lightly so long as it pleases her! treating her unfortunate companion like a duffer who bores her! the rest is also true! and the result manifests itself in a chaos of intoxication, of trickery, of regrets – incomplete things!"[8] Even in the one major painting Whistler completed during this period, *Symphony in White No. III*, contemporary critics complained of his lack of draughtsmanship, while praising its colour. F.G. Stephens referred to it as "this exquisite chromatic study", but also noted: "Mr. Whistler has a good deal of feeling for beauty in line, and, if he will, can draw; therefore we hold him deeply to blame that these figures are badly drawn".[9]

Whistler soon ceased attempting large paintings of classically draped female figures, either because they were beyond his technical capabilities, or to maintain his individuality from Moore. Whistler turned instead in the 1870s to the subjects that were to be his chief contribution to the Aesthetic Movement – his Nocturnes and formal portrait arrangements. These allowed him to take full advantage of his natural ability as a colourist and his talent for subtle compositional arrangements. Whistler did not return to studies of classically draped females until the late 1880s and early 1890s, and then he generally treated them in pastel, lithography, or watercolour.

This drawing is reproduced in *The Life of James McNeill Whistler* by E. and J. Pennell as *Study of a Nude*.[10] Above it is illustrated a pastel for the "Six Projects" entitled *Sea-Beach and Figures*.[11] The drawing is obviously a nude study for the draped standing figure on the far right in the pastel, but the latter was never worked up into a large oil sketch like the "Six Projects". A sketch relating to the pastel is in the Hunterian Art Gallery, University of Glasgow, and is dated c. 1869. Similar drawings to the present one are in the University of

Glasgow and the Freer Gallery of Art, Washington.[12,13] Another study was shown at the Knoedler-Modarco Gallery in New York in 1984 in the exhibition *Notes, Harmonies and Nocturnes*.[14]

1 Wood, Christopher: 1983, p. 160.
2 Sandberg, John: 1968, pp. 59–64.
3 Taylor, Hiliary: 1978, p. 44.
4 MacDonald, Margaret: Hunterian Art Gallery, 1984, p. 23.
5 Rossetti, William Michael: 1903, p. 320.
6 Merrill, Linda: 1998, ch.2, "The Perfection of Art", p. 96.
7 Pennell, Joseph and Pennell, Elizabeth: 1908, Vol. 1, p. 148. Fenollosa referred to them as "the eight supreme 'Arrangements'."
8 Spencer, Robin: 1989, pp. 82–84.
9 Spencer, Robin: 1989, p. 80. F. G. Stephens, "Fine Arts, Royal Academy", *The Athenaeum*, May 18, 1867.
10 Pennell, E. and Pennell, J.: 1908, Vol. 1, opposite p. 140.
11 MacDonald, Margaret: 1995, cat. no. 384, p. 132, pastel and charcoal on brown paper, 5¾ × 11¼ in.
12 MacDonald, Margaret: Hunterian Art Gallery, 1984, cat. nos. 13, 35, 41, 42, 45, and 46.
13 Curray, David Park: 1984, pls. 210 verso, 211, 212, 213 verso, 214 verso, and 220 verso.
14 Knoedler-Modarco Gallery: 1984, cat. no. 53, *Nude Standing*, chalk on brown paper, 11³⁄₁₆ × 7¼ in.

99 A Muse, c. 1894-98

Pencil, pen and light and dark brown ink on light tan wove paper; inscribed on an old label, on the back of the frame, "Pen sketches by J. McNeill Whistler (1834-1903). Given to Mrs. L.J. Wright by the Artist's Executrix (Miss R. Birnie Philip) 1954." 5¾ × 4 in. (13.5 × 10 cm) - sight

VERSO: study of a nude figure

PROVENANCE: Rosalind Birnie Philip; given in August 1954 to Mrs. H.J.L. Wright; after Harold Wright's death sold Sotheby's, London, March 28, 1962, lot 11, bought Agnew's, London; sold in July 1964 to Thomas L. Howard of Richmond, Virginia; sold in January 1985 to M. Knoedler & Co., New York; sold in 1986 to Hope Davis, of Hope Davis Fine Art, New York; purchased November 17, 1987.

LITERATURE: MacDonald, M.F.: 1995, cat. no. 1420, p. 513 (illus.).

EXHIBITED: Agnew's: 1964, cat. no. 4; Knoedler-Modarco Gallery: 1984, cat. no. 57 (illus.); Kenderdine Gallery: cat. no. 77.

In the early 1870s Whistler largely abandoned classical subjects, but he did not, however, repudiate the influence of classical Greek art as noted in the conclusion of his famous "Ten O'Clock" lecture given in 1885: "the story of the beautiful is already complete – hewn in the

marbles of the Parthenon – and embroidered, with the birds, upon the fan of Hokusai – at the foot of Fusiyama."[1] This drawing, done in the 1890s, shows the influences of both classical Greek and Japanese art. The pose is reminiscent of his *Venus* cartoon, dating from 1869, and a painting of c. 1869, now known as *Tanagra*, because of its similarity to a drawing in the Hunterian Art Gallery, Glasgow, that Whistler referred to under this title.[2,3,4]

The Elgin Marbles served as an inspiration for many of the artists involved in the revival of classical painting in England in the 1860s, including Albert Moore, Edward Burne-Jones, Frederic Leighton, and G.F. Watts. An equally important source for Whistler, however, was Hellenistic terracotta statuettes dating from the third and second centuries B.C.[5] The noted collector Marcus Huish remarked that the sudden reappearance of these Tanagra figurines was for artists "as startling an irruption as that of Japanese art."[5] In the 1860s Whistler was able to examine original figurines at the home of his friend and patron, Alexander Ionides, who had purchased a considerable group in Smyrna. Ionides had begun to collect them as early as the late 1850s. The British Museum in London and the Louvre in Paris also had examples in their collection. During the 1870s figurines from the town of Tanagra were actually coming on the art market for sale. Whistler owned an album with more than thirty photographs of Greek terracottas and vases from the collection of Alexander Ionides.[6] That Whistler returned to the theme of Tanagra figures in the 1890s, particularly for drawings, pastels, lithographs, and watercolours, may have been prompted by his assisting with the sale of the Ionides' Tanagra statuettes.[6] Whistler told his friend Otto Bacher of the pleasure he experienced when the sculptor W.W. Story praised his pastels of classical figures, saying "they are as charming and complete as a Tanagra statue."[7]

The flowing garments, elegant poses, and graceful movements of these ancient terracotta statuettes clearly influenced Whistler's late work depicting draped models. In his graphic work from this period he attempted to capture the translucent quality of the loose transparent drapery worn by his models which partly revealed and partly concealed the underlying forms, much as in the sculpted Tanagra figurines. American collectors apparently found these studies too risqué and Kennedy wrote to Whistler saying that he could not sell works like his *Cameo No. 1* because of "the thinness of the drapery."[6] In early 1894 Whistler complained to Kennedy about his countrymen: "The people are still in the early stages of National greatness – to put it nicely, that requires the legs of the piano to be draped! To them a nude figure suggests at once the absence of clothes – and general impropriety only."[8]

Most of Whistler's drawings of draped or undraped classical figures are done in chalk, pastel, or watercolour. Similar studies to this drawing, in pen and ink, are in the collection of the Hunterian Art Gallery, Glasgow.[9] A study relating to the nude figure on the verso was shown in 1984, at the Knoedler-Modarco Gallery in New York, in the exhibition *Notes, Harmonies, Nocturnes*.[10] These late figure and drapery studies are handled in a much more fluid and masterly fashion then Whistler's stiff, more awkward drawings done in the late 1860s and early 1870s. It would appear, therefore, that the artist largely overcame the problems in draughtsmanship that plagued him early in his career. In this drawing of the draped figure, on the recto, Whistler first drew the figure nude, loosely in pencil, before completing it in pen and ink.

1 Whistler, James McNeill: 1892, 2nd ed., p. 159.
2 MacDonald, Margaret F.: 1995, cat. no. 357, p. 120.
3 MacDonald, Margaret: Hunterian Art Gallery, 1984, cat. no. 10, p. 19, chalk on brown paper, c. 1869–70.
4 Young, Andrew McLaren; MacDonald, Margaret; Spencer, Robin; Miles, Hamish: 1980, cat. no 92, p. 54, oil on canvas, 12¼ × 6⅞ in., Randolph-Macon Woman's College, Lynchburg, Virginia.

5 Huish, Marcus: 1900, p. 4.
6 Lochnan, Katharine: 1984, pp. 256–259.
7 Bacher, Otto: 1908, p. 81.
8 Hobbs, Susan: 1982, p. 21, Kennedy Papers, Archives of American Art.
9 Hopkinson, Martin: Iseten Museum of Art, 1987, cat. nos. 68, 69, 70, 71, 73, 76, and 77.
10 MacDonald, Margaret: Knoedler-Modarco Gallery, 1984, cat. no. 40, study for *Harmony in Blue and Gold: The Little Blue Girl*, pen on white paper, $3\frac{3}{4} \times 2\frac{7}{16}$ in.

WILLIAM LINDSAY WINDUS (1822-1907)

Windus was born on July 8, 1822 in Liverpool. He began his artistic training with local Liverpool artists like William Daniels, and later trained at the Liverpool Academy. He exhibited at the Liverpool Academy from 1845, and was elected an associate in 1847, and a member in 1848. In 1850 Windus became one of the first provincial artists to be influenced by Pre-Raphaelitism. His patron John Miller had persuaded him to go to London to the Royal Academy exhibition to see what other artists were painting. After he saw J.E. Millais' *Christ in the House of his Parents* his enthusiasm for Pre-Raphaelitism was instrumental in converting several of his associates. Windus was also instrumental in persuading the Pre-Raphaelites to exhibit at the Liverpool Academy, where between 1851–59 they were awarded the £50 first prize a total of six times. Controversies over the Liverpool Academy's support of the Pre-Raphaelites led to violent opposition from conservative factions within the Academy and caused its eventual dissolution. In 1856 Windus exhibited *Burd Helen*, his first painting at the Royal Academy showing Pre-Raphaelite influences. The success of this picture led to introductions to Madox Brown, Holman Hunt, and Rossetti, and he became one of several Liverpool members of the Hogarth Club. His next important painting *Too Late* was not shown at the Royal Academy until 1859. Unfavourable criticism of this work left him so discouraged that he virtually ceased to exhibit after 1859, except when some of his sketches were shown at the New English Art Club in 1886 and 1892. He had moved to London in the early 1880s and died there on October 9, 1907.

100 Oil Sketch for "Too Late," 1857

Oil on board; inscribed on the reverse, in John Miller's hand, "Original sketch for Too Late by W.L. Windus painted in 1857, Jno Miller" $4\frac{5}{8} \times 3\frac{5}{8}$ in. (11.8 × 9.3 cm)
PROVENANCE: John Miller, Liverpool; anonymous sale, Sotheby's, London, March 15, 1983, lot 48; anonymous sale, Sotheby's, London, November 6, 1996, lot 299.
LITERATURE: Cherry, Deborah: 1980, p. 241; Bennett, Mary: Tate Gallery, 1984, cat. no. 97, p. 173; Fredeman, William E.: 2000, letter 58.29, D.G. Rossetti to W. M. Rossetti, December 31, 1858, n. 2.
EXHIBITED: Hogarth Club: 1859.

This is the original oil sketch for *Too Late*, one of the two important Pre-Raphaelite paintings exhibited by Windus at the Royal Academy in the 1850s. The first was *Burd Helen*, exhibited in 1856. Rossetti greatly admired this work when he saw it hanging at the Royal Academy and in May wrote to his friend William Allingham: "The finest thing of all in the place, to my feeling, is a picture by one Windus (of Liverpool), from the old ballad of *Burd Helen*, another version of *Childe Waters*. It belongs, I hear, to your friend Miller."[1] Rossetti also made John

Ruskin go back and look at the painting. Ruskin added a postscript to his *Academy Notes* where he stated: "Further examination of it leads me to class it as the second picture of the year; its aim being higher and its reserved strength greater, than those of any other work except the 'Autumn Leaves'."[2] Windus was delighted with this support and wrote to Rossetti: "I assure you that you and Mr. Ruskin were the two persons in the world whose approbation I most ardently wished and scarcely dared to hope for, and that I felt the most inexpressible delight when the extract of your letter [to McCracken] was read to me, being at the time in a wretched state of despondency."[3]

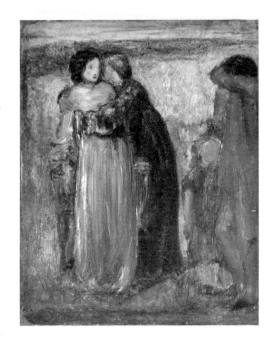

Too Late was begun in 1857, based on this sketch, and the finished painting's composition closely follows it. The figure of the lover was modelled on a Mr. Borthwick. The background was a view from one of Windus' fellow artist's garden at Liscard, near Birkenhead on the Wirral. The view looks southwest towards Bidstron Hill, and the Welsh hills can be seen on the horizon.[4] This painting, as with *Burd Helen*, was influenced by Millais' early Pre-Raphaelite works. Marillier concluded: "The picture is somewhat aggressively stiff in composition, according to the traditions of the time, but triumphs in spite of it by the evident sincerity of the feeling portrayed, the warmth of colour, and the painter's skill. It is as truly a masterpiece as any of the early 'Millais', and indeed resembles them both in treatment and subject."[4] T.E. Welby also considered *Too Late* to be Windus' most important painting: "But it is 'Too Late', with the consummately rendered face of the consumption-stricken girl and the admirable gawk of a younger sister gazing up, in an incomplete comprehension of tragedy, at the man who covers his face, that is his masterpiece. Seen in a catalogue, the title would be a warning; but there was never a picture of the sort that less needed a title."[5] Sidney Colvin, writing in the *Portfolio* in 1870, stated: "A still more remarkable work followed this two or three years afterwards. 'Too Late' was enough to give one a sinking of the heart, and to send one out of the Academy with introverted eyes and a haunting reminiscence for days or years. It showed a young lady who, having been deserted by her affianced lover, has sunk into a fatal decline; in which hopeless condition the lover, now at last 'too late' remorseful, finds her, and hides his face from the unutterable sight. The speechless, pathetic, fading, death-stamped beauty of the girl, startled like a timid and stricken fawn at her slayer's apparition, and the equally speechless agony of the man, who weeps hot stormy tears into the hands which hide his features and confess his shame, are not in the category of forgettable things. This picture, like 'Burd Helen', was painted with a singular delicacy of eye and hand; and with even higher attainment in terms of realisation, though the general effect was again filmy and retiring. Perhaps it could hardly have been otherwise, without thwarting the sentiment of the subject."[6]

The theme of the picture comes from an untitled poem by Tennyson that begins with the line "Come not, when I am dead." The painting represents an unfortunate young woman in the last stages of consumption, whose fiancé had gone away, but who returns at last when it was "too late". Ford Madox Brown said of the work: "The expression of the dying face is

quite sufficient – no other explanation is needed."[7] When the finished painting was shown at the Royal Academy, a quotation from the second verse of Tennyson's poem was included in the catalogue:

– If it were thine error or thy crime
I care no longer, being all unblest;
Wed whom thou wilt, but I am sick of time,
And I desire to rest.

Windus was a very methodical, meticulous worker and the painting progressed slowly. On March 15, 1857 John Miller, for whom the work was intended, wrote to Ford Madox Brown: "Mr. Windus is going on slowly with his most charming picture and the head of the principal figure is full of that expression of agitated and inward thought at which he had aimed and tells the story of her ruined health and broken heart. He is painting it in the sunlight but the sun seldom shines upon the picture and there is no chance of him completing it for many months."[8] In June Miller wrote again about Windus' progress: "But he is more fastidious than ever, and on the hair of one head he has spent four weeks in time and three pounds in money for a sitter and is not yet finished." Another letter from Miller commented: "He has not yet finished the hair, but what he has done is beautiful in all eyes but his own, and it has been in and out, I should think, a hundred times."[4]

Windus finally felt the painting was finished enough to send to the Royal Academy in 1859, although he remained doubtful of its merits, which was characteristic of his personality. Although he came ultimately to consider *Too Late* as his best work, in April 1859 he wrote to Madox Brown that he thought the picture "unbelievably bad" and he had "made up my mind to be slaughtered" by the critics.[9] It certainly did not help Windus' abnormally sensitive temperament or his self-confidence when Ruskin savaged the painting in one of his all-too-common petulant outbursts in his *Academy Notes*: "Something wrong here: either this painter has been ill; or his picture has been sent in to the Academy in a hurry; or he has sickened his temper and dimmed his sight by reading melancholy ballads. There is great grandeur in the work; but it cannot for a moment be compared with 'Burd Helen'. On the whole, young painters must remember this great fact, that painting, as a mere physical exertion, requires the utmost possible strength of constitution and of heart. A stout arm, a calm mind, a merry heart, and a bright eye are essential to a great painter. Without all these he can, in a great and immortal way, do nothing … Frequent the company of right-minded and nobly-souled persons; learn all athletic exercises and all delicate arts – music more especially; torment yourself neither with fine philosophy nor impatient philanthropy – but be kind and just to everybody; rise in the morning with the lark and whistle in the evening with the black-bird; and in time you may be a painter. Not otherwise."[2] The fact that the picture was so thinly painted that it looked unfinished may have partially prompted Ruskin's remarks. They may also have been prompted by the melancholy nature of the subject.[4] In a postscript to his *Academy Notes* of 1859 Ruskin added: "It is one of the most difficult and painful duties which I have to perform in these *Notes*, to guard the public against supposing that works executed under circumstances accidentally unfavourable are characteristic of a school, without at the same time hurting the artist's feelings deeply, just when all discouragement is most dangerous to him. I cannot, in justice to the Pre-Raphaelite school, allow Mr. Windus's picture – he being one of its chief leaders – to be looked upon as an example of what that school may achieve; but I trust he will accept the assurance of my deep respect for his genius, and of my conviction that, with returning strength, he may one day take highest rank among masters of expression."[2]

Ruskin's discouraging comments, combined with Windus' personal tragedy of the death of his wife in 1862, led him to largely abandon painting except for his own pleasure. William Michael Rossetti's diary for May 14, 1867 recorded: "Windus lives in a village near Preston. He says that he promised his late wife that he would never part from their daughter, which prevents his entering into any arrangement that would allow of his pursuing his profession advantageously. He has lost all power of setting to work, or of resolving to do so; yet whenever he does attempt anything he finds he paints better than ever."[4] Fortunately Windus was of independent means and did not have to paint to earn a living. In the 1860s he moved to Walton-le-Dale, near Preston in Lancashire, to live with his late wife's parents. When Windus moved to London in 1880, he burnt most of his studies and sketches, so that surviving works by him are rare.

John Miller (1796-1876), to whom this oil sketch once belonged, was an important early Pre-Raphaelite patron.[10] He was a tobacco and wood merchant and later a shipowner in Liverpool. William Michael Rossetti, in his reminiscences, remembered him as "the most open-minded of merchants, and the most lovable of Scotchmen and picture collectors."[11] In 1857 Miller assisted his artist friends in staging the first true Pre-Raphaelite exhibition, organized principally by Ford Madox Brown and held at a private home at 4 Russell Place, Fitzroy Square, London. It contained seventy-two pictures by twenty exhibitors, most of whom were closely associated with the Pre-Raphaelite circle. Later Miller became a member of the Hogarth Club, which was also largely organized by Brown, and to which most of the progressive artists, architects and art patrons of the day belonged. Miller lent his oil sketch for *Too Late* to the first exhibition held at the Hogarth Club, 178 Piccadilly, from January 1– February 26, 1859.[12]

1 Doughty, O. and Wahl, J.R.: 1965, Vol.I, p. 301.
2 Cook, E.T. and Wedderburn, A.: 1904, Vol. XIV, pp. 85-87, 233-234, and 239.
3 Rossetti, William Michael: 1899, p. 138.
4 Marillier, H.C.: 1904b, pp. 245, 248-249 and 251 n.1.
5 Welby, T. Earle: 1929, p. 85.
6 Colvin, Sidney: 1870c, p.116.
7 Bate, Percy: 1910, p. 80. Ford Madox Brown, *Magazine of Art*, 1888, pp. 122-124.
8 Ford Madox Brown family papers, private collection, Eire.
9 Ford Madox Brown family papers, letters April 10 and April 24, 1859.
10 Macleod, Dianne Sachko: 1996, pp.152-154. Although Windus' painting of *Too Late* sold at Miller's estate sale by Branch & Leete at the Hanover Galleries, Liverpool, on May 6, 1881, lot 219, the oil sketch was not included in the sale. It may either have descended in Miller's family to his son Peter or have been sold earlier.
11 Rossetti, William Michael: 1906, p. 226.
12 Cherry, Deborah: 1980, p. 241.

Bibliography

EXHIBITIONS:

Agnew's, London: *English Landscapes and Figure Subjects*, May - June, 1943.

Agnew's, London: *Victorian Painting 1837-1887*, November 22 - December 16, 1961.

Agnew's, London: *Drawings and Watercolours 1860-1960*, June 2-27, 1964.

Agnew's, London: *French and English Drawings 1780-1965*, June 14 - July 16, 1966.

Agnew's, London: *Exhibition of French & English Drawings 19th & 20th Centuries*, June 10 - July 13, 1968.

Agnew's, London: *From the Pre-Raphaelites to Picasso. An Exhibition of English and French Drawings and Prints of the 19th & 20th Centuries*, June 9 - July 12, 1969.

Agnew's, London: *Images of Victorian Life. An Exhibition of Paintings, Drawings, and Sculpture*, June 6 - July 20, 1990.

Aldis Browne Fine Arts, Venice, California: *Old and Modern Master Drawings and Watercolours from the Personal Collection of Vincent Price*, 1988.

Art Gallery of New South Wales, National Gallery of Victoria, and Art Gallery of South Australia: *Victorian Olympians*, 1975, curated by Renée Free.

Art Gallery of Ontario, Toronto; National Gallery of Canada, Ottawa; Musée du Quebec, Quebec; Winnipeg Art Gallery, Winnipeg: *The Earthly Paradise. Arts and Crafts by William Morris and His Circle from Canadian Collections*, June 25, 1993 - October 9, 1994.

Arts Council of Great Britain: *Pre-Raphaelite Drawings & Watercolours*, 1953, curated by John Commander.

Arts Council of Great Britain: *The Drawings of John Everett Millais*, 1975, curated by Malcolm Warner.

Arts Council of Great Britain: *Great Victorian Pictures their paths to fame*, 1978, curated by Rosemary Treble.

Baillie Gallery, London: *Exhibition of Paintings and Drawings by the late Simeon Solomon*, December 9, 1905 - January 13, 1906.

Barbican Art Gallery, London: *The Last Romantics. The Romantic Tradition in British Art. Burne-Jones to Stanley Spencer*, February 9 - April 9, 1989, curated by John Christian.

Berlin: *Drawings and Studies by Sir Edward Coley Burne-Jones, Bart.*, 1898.

Birmingham City Museum and Art Gallery: *The Pre-Raphaelite Brotherhood (1848 - 1862)*, June 7 - July 27, 1947.

Brighton Museum and Art Gallery and Mappin Art Gallery, Sheffield: *Frederick Sandys*, May - August, 1974, curated by Betty O'Looney.

Bristol City Museum and Art Gallery: *Imaging Rome. British Artists and Rome in the Nineteenth Century*, May 3 - June 23, 1996, curated by Elizabeth Prettejohn and M.J.H. Liversidge.

Bruntjen, Sven: *The World of Drawings and Watercolours*, Park Lane Hotel, London, January 18-22, 1989.

Bunkamura Gallery, Tokyo: *Raphael-zenpa no Yume: Rossetti to sono Eikyo* [The Dream of the Pre-Raphaelites: Rossetti and his Influence], October 18 - November 14, 1990.

Burlington Fine Arts Club, London: *Exhibition of Drawings and Studies by Sir Edward Burne-Jones Bart.*, 1899.

Christopher Wood Gallery, London: *Realism and Romance, Pre-Raphaelite and High Victorian Paintings, Watercolours, Drawings, Prints and Sculpture*, Autumn 1982.

Christopher Wood Gallery, London: *'Ye Ladye Bountiful', Images of Women and Children in Pre-Raphaelite and Victorian Art*, November 7-30, 1984.

Cincinnati Art Museum: *Drawings of Karl Friedrich Lessing*, 1972.

Delaware Art Museum: *The Pre-Raphaelite Era 1848-1914*, April 12 - June 6, 1976.

Dudley Gallery, London: *General Exhibition of Water-Colour Drawings*, 1867.

Dudley Gallery, London: *General Exhibition of Water-Colour Drawings*, 1875.

Fine Art Palace, London: *Franco-British Exhibition*, 1908, Fine Art Section.

Fine Art Society, London: *Studies for Pictures in Various Media*, 1889.

Fine Art Society, London: *Catalogue of a Collection of Designs by Walter Crane A.R.W.S. Including Original Drawings for Books, Decorations, & Pictorial Work*, exhibition no. 89, 1891.

Fine Art Society, London: *Catalogue of a Collection of Studies for Pictures, Designs and Sketches by the Late Lord Leighton P.R.A.*, exhibition no. 157, December 1896.

Fine Art Society, London: *Exhibition of Pictures, Drawings, and Studies for Pictures made by the late Sir J.E. Millais, Bart, P.R.A.*, exhibition no. 228, April 1901.

Fine Art Society, London: *Exhibition of Pictures, Drawings and Designs by the late Sir Noel Paton, R.S.A., L.L.D.,* exhibition no. 253, July 1902.

Fine Art Society, London: *Exhibition of Watercolours and Studies by Sir E.J. Poynter, Bart, P.R.A.,* November 1903.

Fine Art Society, London: *The Paintings, Water-Colours & Drawings from the Handley-Read Collection,* June 11 - 28, 1974.

Fine Art Society, London: *Victorian Painting,* Winter 1977.

Fine Art Society, London: *Centenary Exhibition,* March 23 - April 30, 1978.

Fine Art Society, London: *Morris and Company,* April 24 - May 18, 1979.

Fine Art Society, London: Catalogue, Spring 1992, April 27 - May 28, 1992.

Fogg Art Museum, Harvard University, Cambridge: *The Pre-Raphaelites. Paintings and Drawings of the Pre-Raphaelites and their Circle,* April 7 - June 1, 1946, curated by Agnes Mongan.

French Gallery, London: *7th Annual Winter Exhibition of Cabinet Pictures, Sketches and Drawings,* November, 1859.

Galleria Nazionale d'Arte Moderna, Rome: *Burne-Jones,* October 8 - November 23, 1986, curated by Maria Teresa Benedetti and Gianna Piantoni.

Galerie du Luxembourg, Paris: *Burne-Jones et l'influence des Préraphaélites,* March - April, 1972.

Geffrye Museum, London: *Solomon A Family of Painters,* November 8 - December 31, 1985.

Grafton Galleries, London: *Exhibition of Pictures by the Late Albert Moore and Works of Modern British and Foreign Artists,* January - March, 1894.

Gregory, Martyn, London: *Thomas Matthew* [sic] *Rooke, R.W.S.,* 1975.

Grosvenor Gallery: *Winter Exhibition,* 1882.

Hampshire House Social Club Exhibition, Hammersmith, London: *English Paintings and Drawings,* July 5-27, 1913.

Hartnoll and Eyre, London: *An exhibition of drawings and watercolours by T.M. Rooke 1842-1942 showing his role as principal studio assistant to Burne-Jones,* December 5-22, 1972.

Hartnoll, Julian, London: *Victorian Art Sacred & Secular,* Burlington Fine Art Fair, Royal Academy, Piccadilly, September 28 - October 12, 1979.

Hartnoll, Julian, London: *A Selection of Drawings and Oil Studies Offered for Sale by Julian Hartnoll,* Catalogue 9, December 1986.

Hartnoll, Julian, London: *A Selection of Drawings and Oil Paintings Offered for sale by Julian Hartnoll,* Catalogue 13, 1991.

Hartnoll, Julian, London: *The World of Drawings and Watercolours,* Park Lane Hotel, Piccadilly, January 22-26, 1992.

Hayward Gallery, London: *Burne-Jones. The paintings, graphic and decorative work of Sir Edward Burne-Jones,* November 5, 1975 - January 4, 1976, curated by John Christian.

Hogarth Club, London: First exhibition, January 1 - February 26, 1859.

Hunterian Art Gallery, University of Glasgow: *Whistler Pastels,* May 25 - Nov. 3, 1984, curated by Margaret MacDonald.

Iseten Museum of Art, Tokyo: *James McNeill Whistler,* September 24 - October 6, 1987, curated by Martin Hopkinson.

Kenderdine Gallery, University of Saskatchewan, Saskatoon: *The Victorian Avant Garde: The Pre-Rapahaelite and Aesthetic Movements,* September 28 - November 12, 1995, curated by Dennis T. Lanigan.

Knoedler-Modarco Gallery, New York: *Notes, Harmonies and Nocturnes. Small Works by James McNeill Whistler,* November 30 - December 27, 1984, curated by Margaret MacDonald.

Laing Art Gallery, Newcastle upon Tyne: *Albert Moore and his Contemporaries,* 1972, curated by Richard Green.

Laing Art Gallery, Newcastle upon Tyne: *Pre-Raphaelite Painters and Patrons in the North East,* October 14, 1989 - January 14, 1990, curated by Jane Vickers.

Lakeview Center for the Arts and Sciences, Peoria, Illinois: *The Victorian Rebellion, a loan exhibition of works by the Pre-Raphaelite Brotherhood and their contemporaries,* September 12 - October 26, 1971.

Leicester Galleries, London: *The Victorian Romantics. An Exhibition of Paintings and Drawings,* 1949.

Lowe Art Gallery, University of Miami: *The Revolt of the Pre-Raphaelites,* March 5 - April 9, 1972.

Maas Gallery, London: *Pre-Raphaelites and Contemporaries,* first exhibition, November 13 - December 8, 1961.

Maas Gallery, London: *The Pre-Raphaelites and Their Contemporaries*, second exhibition, November 5-30, 1962.

Maas Gallery, London: *Pre-Raphaelites Art Nouveau*, June 22, 1964a.

Maas Gallery, London: *Exhibition of Small English Pictures 1730-1930*, November 23 - December 23, 1964b.

Maas Gallery, London: *Pre-Raphaelites to Post-Impressionists. Exhibition of Drawings and Water-colours*, May 3-21, 1965.

Maas Gallery, London: *Pre-Raphaelitism*, November 2-27, 1970.

Maas Gallery, London: *The Pre-Raphaelite Influence*, June 18 - July 6, 1973.

Maas Gallery, London: *'Stunners' paintings & drawings by the Pre-Raphaelites and others*, June 24 - July 12, 1974.

Maas Gallery, London: *Victorian Paintings, Drawings & Watercolours*, March 19 - April 6, 1979a.

Maas Gallery, London: *Victorian Paintings, Drawings & Watercolours*, November 26 - December 20, 1979b.

Maas Gallery, London: *Pre-Raphaelites and Romantics*, June 20 - July 7, 1989a.

Maas Gallery, London: *Masters of British Illustration*, September 19-29, 1989b.

Maas Gallery, London: *John Ruskin and His Circle*, June 11-28, 1991.

Maas Gallery, London: *Victorian Pictures*, June 4 - July 12, 1996.

Maas Gallery, London: *Victorian Pictures*, June 4 - July 18, 1997.

Maas Gallery, London: *The World of Drawings and Watercolours*, Dorchester Hotel, London, January 25-29, 1998.

MacMillan and Perrin Gallery, Vancouver: *British Masters 1850-1950*, 1977.

MacMillan and Perrin Gallery, Toronto: *Victorian Romantics*, October 15 - November 13, 1979.

MacMillan and Perrin Gallery, Toronto: *Fine 19th and 20th Century British Drawings and Watercolours*, November 1 - December 13, 1980.

Manchester City Art Gallery, Manchester: *A Pre-Raphaelite Passion. The Private Collection of L.S. Lowry*, April 1 - May 31, 1977.

Manchester City Art Gallery, Manchester; Minneapolis Institute of Arts; and The Brooklyn Museum: *Victorian High Renaissance*, September 1, 1978 - April 8, 1979, curated by Allen Staley, Richard Dorment, L. and R. Ormond, and Gregory Hedberg.

Manchester City Art Gallery, Manchester: *Pre-Raphaelite Women Artists*, November 22, 1997 - February 22, 1998, curated by Jan Marsh and Pamela Gerrish Nunn.

Mappin Art Gallery, Sheffield: *Burne-Jones*, October 23 - November 28, 1971, curated by W.S. Taylor.

Metropolitan Museum of Art, New York: *Victorians in Togas: Paintings by Sir Lawrence Alma-Tadema from the Collection of Allen Funt*, 1973, curated by Christopher Forbes.

Metropolitan Museum of Art, New York; Art Museum, Princeton University: *The Royal Academy (1837-1901) Revisited. Victorian Paintings from the Forbes Magazine Collection*, 1975, curated by Christopher Forbes.

Metropolitan Museum of Art, New York; Birmingham City Art Gallery and Museum, Birmingham, Musée du Louvre, Paris: *Edward Burne-Jones Victorian Artist-Dreamer*, 1998-1999, curated by Stephen Wildman and John Christian.

Miriam and Ira D. Wallach Art Gallery, Columbia University, New York: *The Post-Pre-Raphaelite Print*, October 10 - December 16, 1995.

Miyazaki Yamagataya, Miyazaki, Japan: *The Pre-Raphaelites. Modern Japanese Art and British Art of the 19th Century*, May 26-31, 1977.

Moss Galleries, London: *Eighth Exhibition of Designs and Cartoons for Stained Glass and Related Subjects*, January 7-15, 1994.

Nahum, Peter, London: *Master Drawings of the Nineteenth and Twentieth Centuries*, Second Exhibition, 1985.

Nahum, Peter, London: *A Celebration of British and European Paintings of the 19th and 20th Centuries*, not dated [1985].

Nahum, Peter, London: *Burne-Jones, The Pre-Raphaelites and Their Century*, Vols. I and II, 1989, curated by Hiliary Morgan.

Nahum, Peter, London: *Burne-Jones - A Quest For Love. Works by Sir Edward Burne-Jones Bt. and Related Works by Contemporary Artists*, 1 9 9 3.

Nahum, Peter, London: *A Century of Master Drawings, Watercolours & Works in Egg Tempera*, 1995.

National Gallery, Millbank, London: *Loan Exhibition of Paintings and Drawings of the 1860 Period*, April 27 - July 29, 1923.

National Gallery of Art, Washington, D.C.: *Drawings from the O'Neal Collection*, March 7 - August 11, 1993, curated by Margaret Morgan Grasselli and Judith Brodie.

National Gallery of Art, Washington, D.C.: *The Victorians. British Painting 1837-1901*, February 16 - May 11, 1997, curated by Malcolm Warner.

National Gallery of Canada, Ottawa: *European Drawings from Canadian Collections 1500-1900*, 1976, curated by Mary Cazort Taylor.

National Gallery of Canada, Ottawa and National Gallery of Art, Washington, D.C.: *Master Drawings from the National Gallery of Canada*, 1988-89.

National Gallery of Canada, Ottawa: *The Earthly Paradise. Arts and Crafts by William Morris and His Circle from Canadian Collections*, October 22, 1993 - January 16, 1994.

National Gallery of Victoria, Melbourne: *The Pre-Raphaelites and their Circle in the National Gallery of Victoria*, 1978, curated by Sonia Dean and Annette Dixon.

National Portrait Gallery, London: *Millais Portraits*, 1999, catalogue by Peter Funnell and Malcolm Warner.

New Gallery, London: *Loan Collection and Other Decorative Works by the Late Ford Madox Brown*, Arts and Crafts Exhibition Society, 1896a.

New Gallery, London: *Ninth Summer Exhibition*, 1896b.

Newcastle University, Newcastle upon Tyne: *William Bell Scott*, 1976, curated by Lesley Milner.

Norham House Gallery, Cockermouth: *An Exhibition of Nineteenth Century Drawings*, May 23 - June 30, 1973.

Norham House Gallery, Cockermouth: *Pre-Raphaelites and Associates*, May 1974.

Piccadilly Gallery, London: *Christmas 1976. Exhibition of Drawings and Watercolours 1854-1974*, November 30 - December 23, 1976.

Portsmouth City Museum and Art Gallery, Portsmouth: *An Exhibition of Drawings by William Holman Hunt, John Everett Millais, Dante Gabriel Rossetti, Ford Madox Brown*, 1976.

Powney, Christopher and Hartnoll, Julian, London: *English Figure Drawings*, February 27 - March 16, 1979.

Royal Academy of Arts, London: *Exhibition of Works by the late George Frederick*[sic]*Watts R.A. O.M. and the late Frederick Sandys*, Winter exhibition, 1905.

Royal Academy of Arts, London: *Works by Old Masters including drawings by G.F. Watts*, Winter exhibition, 1906.

Royal Academy of Arts, London: *Works by the late Sir Lawrence Alma-Tadema, R.A., O.M.*, Winter exhibition, 1913.

Royal Academy of Arts, London: *Victorian and Edwardian Decorative Art. The Handley-Read Collection*, March 4 - April 30, 1972.

Royal Academy of Arts, London: *Frederic Leighton 1830-1896*, February 15 - April 21, 1996.

Royal Academy of Arts, London: *Victorian Fairy Painting*, November 13, 1997 - February 8, 1998, curated by Charlotte Gere and Lionel Lambourne.

Ruskin Gallery, Sheffield: *Elizabeth Siddal 1829-1862 Pre-Raphaelite Artist*, 1991, curated by Jan Marsh.

Shepherd Gallery, New York: *French and Continental Drawings, Watercolours, Paintings, and Sculpture of the 19th Century*, Spring, 1982.

Shepherd Gallery, New York: *English 19th Century Pre-Raphaelite and Academic Drawings, Watercolours, Graphics, Paintings and Sculpture*, Spring 1983.

Shepherd Gallery, New York: *English 19th Century Pre-Raphaelite and Academic Drawings, Watercolours, Graphics and Paintings*, Spring, 1986.

Shepherd Gallery, New York: *English Romantic Art 1850-1920, Pre-Raphaelites, Academics, Symbolists*, Autumn 1989.

Shepherd Gallery, New York: *English Romantic Art 1840-1920, Pre-Raphaelites, Academics Symbolists*, Autumn 1994.

Shepherd Gallery, New York: *English Romantic Art 1840-1920, Pre-Raphaelites, Academics, Symbolists*, December 2, 1998 - January 5, 1999.

Southgate Gallery, Wolverhampton: *Sidney Harold Meteyard A Late Pre-Raphaelite*, April 20 - May 5, 1974.

Staatliche Kunsthalle, Baden-Baden: *Präraffaeliten*, November 23, 1973 - February 24, 1974.

Stone Gallery, Newcastle upon Tyne: *Acquisitons*, Spring 1969.

Stone Gallery, Newcastle upon Tyne: *Some Works from Stock*, Spring 1970.

Stone Gallery, Newcastle upon Tyne: *Some Pre-Raphaelite Works*, Summer 1971.

Tate Gallery, London: *George Frederic Watts 1817 - 1904*, The Arts Council, December 9, 1954 - January 16, 1955, curated by David Loshak.

Tate Gallery, London: *The Pre-Raphaelites*, March 7 – May 28, 1984.

Tate Gallery, London: *Burne-Jones Watercolours and Drawings*, July 14 – November 7, 1993, curated by Ian Warrell.

Tate Gallery, London: *The Age of Rossetti, Burne-Jones and Watts. Symbolism in Britain 1860-1910*, October 16, 1997 – January 4, 1998.

University of Lethbridge Art Gallery, Lethbridge: *Policing Preference: Modernism and Morality. The Ruskinian Reform of Art in Canada*, October 2-14, 1993, curated by Victoria Baster.

Victoria and Albert Museum, London: *Loan Exhibition of Modern Illustration*, 1901.

Victoria and Albert Museum, London: *William Morris*, May 7 – Sept.1, 1996, curated by Linda Parry.

Walker Art Gallery, Liverpool, and the Royal Academy, London: *Millais PRB, PRA*, January – April, 1967, curated by Mary Bennett.

Walker Art Gallery, Liverpool, and Victoria and Albert Museum, London: *William Holman Hunt*, 1969, curated by Mary Bennett.

Walker Galleries, London: *Memorial Exhibition of Some of the Works of the Late Arthur Hughes*, October 1916.

Walker Galleries, London: *Henry Holiday*, 1930.

Whitechapel Art Gallery, London: *G.F. Watts A Nineteenth Century Phenomenon*, 1974.

Whitworth Art Gallery, Manchester: *The Pre-Raphaelites and their Associates in the Whitworth Art Gallery*, November 18 – December 20, 1972, curated by D. Jolley and C. Allan.

Whitworth Art Gallery, Manchester: *Walter Crane Artist, Designer and Socialist*, January 20 – March 18, 1989.

William Morris Gallery, Walthamstow: *Henry Holiday*, June 17 – September 3, 1989, curated by Peter Cormack.

York City Art Gallery, York: *The Moore Family Pictures*, August 2 – 31, 1980, curated by Richard Green.

REFERENCES:

Armstrong, Walter: "Sir J.E. Millais, Bart, Royal Academician, His Life and Work", *The Art Annual for 1885*, J.S. Virtue and Co., London, 1885.

Auerbach, Nina: *Ellen Terry. Player in her Time,* W.W. Norton and Co., New York, 1987.

Bacher, Otto: *With Whistler in Venice,* The Century Co., New York, 1908.

Baker, James K. and Baker, Cathy L.: "Miss Muriel Foster: The John William Waterhouse Model", *Journal of Pre-Raphaelite Studies*, New Series, Fall 1999.

Baldry, Alfred Lys: *Albert Moore, His Life and Works,* George Bell and Sons, London, 1894.

Baldry, Alfred Lys: "J.W. Waterhouse and his work", *Studio*, Vol. IV, No. 22, January 1895.

Baldry, Alfred Lys: "The Drawings of Sir Edward Burne-Jones", *Magazine of Art*, 1896.

Baldry, Alfred Lys: "Some Recent Work by Mr. J.W. Waterhouse, R.A.", *Studio* , Vol. 53, 1911.

Baldry, Alfred Lys: "Henry Holiday", *Walker's Quarterly*, Nos. 31-32, 1930.

Baldwin, A.W.: *The Macdonald Sisters,* Peter Davies, London, 1960.

Banham, Joanna and Harris, Jennifer: *William Morris and the Middle Ages*, Manchester University Press, Manchester, 1984.

Barringer, Tim: *Reading the Pre-Raphaelites*, Yale University Press, New Haven and London, 1999.

Barringer, Tim and Prettejohn, Elizabeth (Eds.): *Frederic Leighton: Antiquity, Renaissance, Modernity*, Yale University Press, New Haven and London, 1999.

Barrington, Mrs. Russell: *Reminiscences of G.F.Watts,* George Allen, London, 1905.

Barrington, Mrs. Russell: *The Life, Letters and Work of Frederic Leighton,* George Allen, London, Vols. I and II, 1906.

Bartram, Michael: *The Pre-Raphaelite Camera. Aspects of Victorian Photography*, Weidenfeld and Nicolson, London, 1985.

Bate, Percy: "A Note on the Art of Simeon Solomon", *Catalogue of Platinotype Reproductions of Pictures &c. Photographed and Sold by Mr. Hollyer No. 9 Pembroke Sqr., London*, Frederick Hollyer, London, 1909.

Bate, Percy: *The English Pre-Raphaelite Painters. Their Associates and Successors*, G. Bell & Sons Ltd, London, 1910.

Battiscombe, Georgina: *Christina Rossetti. A Divided Life,* Constable, London, 1981.

Becker, Edwin (Ed.): *Sir Lawrence Alma-Tadema*, Rizzoli, New York, 1996.

Bell, Malcolm: *Sir Edward Burne-Jones. A Record and Review*, George Bell & Sons, London, 1903.

Bell, Malcolm: *The Drawings of Sir Edward J. Poynter Bart. P.R.A.*, George Newnes Ltd., London, 1906.

Bendiner, Kenneth: *The Art of Ford Madox Brown*, The Pennsylvania State University Press, University Park, 1998.

Benedetti, Maria Teresa: *Dante Gabriel Rossetti*, Sansoni Editore, Florence, 1984.

Bennett, Mary: *Artists of the Pre-Raphaelite Circle: The First Generation. Catalogue of Works in the Walker Art Gallery, Lady Lever Art Gallery, and Sudley Art Gallery*, Lund Humphries, London, 1988.

Bianchi, Petra: "From *Improvvisatrice* to Beatrice: Gabriele Rossetti's Influence on his Daughter Christina", *Journal of Pre-Raphaelite Studies*, New Series 8: Spring 1999.

Birmingham City Museum and Art Gallery: *Catalogue of Paintings, &c.*, Hudson & Sons, Birmingham, 1930.

Birmingham City Museum and Art Gallery: *Catalogue of the Permanent Collection of Drawings*, Bemrose & Sons Ltd., Derby, 1939.

Blackburn, Henry George: "The Works of L. Alma-Tadema", *Grosvenor Gallery Winter Exhibition*, London, 1882.

Blunt, Wilfred: *England's Michelangelo. A Biography of George Frederic Watts*, Hamish Hamilton, London, 1975.

Boardman, John: *The Oxford History of Classical Art*, Oxford University Press, Oxford, 1993.

Bornand, Odette (Ed.): *The Diary of W.M. Rossetti 1870-1873*, Oxford University Press, Oxford, 1977.

Bramley, Henry Ramsden and Stainer, John (Eds.): *Christmas Carols, New and Old*, George Routledge and Sons, London, c. 1870.

Brough, James: *The Prince and The Lily*, Coward, McCann & Geoghegan Inc., New York, 1975.

Browne, Max: *The Romantic Art of Theodor Von Holst 1810-44*, Lund Humphries, London, 1994.

Bryson, John (Ed.): *Dante Gabriel Rossetti and Jane Morris, Their Correspondence*, Clarendon Press, Oxford, 1976.

Buchanan, Robert: *The Fleshly School of Poetry and Other Phenomena of the Day*, Strahan, London, 1872.

Burne-Jones, Georgiana: *Memorials of Edward Burne-Jones*, Macmillan and Co. Ltd., London, Vols. I and II, 1904.

Cartwright, Julia: "The Life and Work of Sir Edward Burne-Jones", *The Art Annual (Art Journal Special Supplement)*, 1894.

Cartwright, Julia: "George Frederick [sic] Watts, RA: His Life and Work", *The Art Annual (Art Journal Special Supplement)*, Easter, 1896.

Cassidy, John A.: *Algernon C. Swinburne*, Twayne Publishers Inc., New York, 1964.

Casteras, Susan (Ed.): *Pocket Cathedrals. Pre-Raphaelite Book Illustrartion*, Yale Center for British Art, New Haven, 1991.

Casteras, Susan P. and Faxon, Alicia Craig (Eds.): *Pre-Raphaelite Art in Its European Context*, Associated University Presses, London, 1995.

Catalogue of Mr. George Rae's Pictures, Redcourt, Birkenhead: (Privately printed), not dated but possibly 1872.

Cherry, Deborah: "The Hogarth Club: 1858-1861", *Burlington Magazine*, Vol. 122, April 1980.

Cherry, Deborah: *Painting Women: Victorian Women Artists*, Routledge, London, 1993.

Chew, Samuel C.: *Swinburne*, John Murray, London, 1931.

Christian, John: "Early German Sources for Pre-Raphaelite Designs", *The Art Quarterly*, Vol. 36, 1973.

Christian, John: *Symbolists and Decadents*, Thames and Hudson, London, 1977.

Christian, John: "La Roue de Fortune de Burne-Jones", *Revue du Louvre et des Musées de France*, March 1984.

Christian, John: *Burne-Jones and his Followers*, exhibition held in Japan, February 5 - June 21, 1987.

Christian, John (Ed.): *The Last Romantics*, Lund Humphries, London, 1989a.

Christian, John: *Victorian Dreamers. Masterpieces of Neo-Classical and Aesthetic Movements in Britain*, exhibition held in Japan from April 18 - October 17, 1989b.

Clifford, Edward: *Broadlands As It Was*, privately printed, London, 1890.

Cline, C.L. (Ed.): *The Owl and the Rossettis. Letters of Charles A. Howell and Dante Gabriel, Christina, and William Michael Rossetti*, Pennsylvania State University Press, University Park, 1978.

Colvin, Sidney: "English Painters and Painting in 1867", *Fortnightly Review*, 8 (October), 1867.

Colvin, Sidney: "English Painters of the Present Day. II. Albert Mooore", *Portfolio. An Artistic Periodical*, Vol. I, 1870a.

Colvin, Sidney: "English Painters of the Present Day. III. Edward Burne Jones" *Portfolio, An Artistic Periodical*, Vol. I, 1870b.

Colvin, Sidney: "English Painters of the Present Day. XI. Windus" *Portfolio, An Artistic Periodical*, Vol. I, 1870c

Comyns Carr, J.: *Coasting Bohemia*, Macmillan and Co. Ltd., London, 1914.

Cook, E.T.: *The Life of Ruskin*, George Allen & Co. Ltd., London, Vols. I and II, 1911.

Cook, E.T. and Wedderburn, Alexander (Eds.): *The Works of John Ruskin*, (Library Edition), George Allen & Co. Ltd., London, 39 Vols., 1903-12.

Cooper, Jeremy: *Victorian and Edwardian Decor from the Gothic Revival to Art Nouveau*, Abbeville Press, New York, 1987.

Crane, Walter: *Of the Decorative Illustration of Books Old and New*, George Bell & Sons Ltd., London, 1896.

Crane, Walter: "The Work of Walter Crane with Notes by the Artist", *The Art Annual (Art Journal Special Supplement)*, J.S. Virtue & Co. Ltd., London, Easter, 1898.

Crane, Walter: *An Artist's Reminiscences*, Methuen & Co. London, 1907.

Crook, J. Mordaunt: *William Burges and the High Victorian Dream*, John Murray Ltd., London, 1981.

Curry, David Park: *James McNeill Whistler at the Freer Gallery of Art*, W.W. Norton and Co., New York, 1984.

Dalziel, George and Dalziel, Edward: *The Brothers Dalziel. A Record of Fifty Years' Work in Conjunction with Many of the Most Distinguished Artists of the Period 1840-90*, Methuen, London, 1901.

Daniels, Jeffery: "Pre-Raphaelite Art 2-27 November 1970 at Maas Gallery" (Review), *Connoisseur*, November 1970.

Dante Alighieri: *Vita Nuova con traduzione inglese e illustrazioni di Dante Gabriel Rossetti*, edited by Corradio Gizzi, English translation by Antony Shugaar, Mazzotta, Milan, 1985.

De Girolami Cheney, Liana (Ed.): *Pre-Raphaelitism and Medievalism in the Arts*, Edwin Mellen Press, Lewiston, New York, 1992.

De Lisle, Fotunée: *Burne-Jones*, Methuen & Co., London, 1904.

De Mare, Eric: *The Victorian Woodblock Illustrators*, Gordon Fraser, London, 1980.

Dean, Sonia (Ed.): *Art Bulletin of Victoria*, National Gallery of Victoria, Melbourne, No. 39, 1998.

Depas, Rosalind: "The Bensons: A Family in the Arts and Crafts Movement", *Journal of Pre-Raphaelite and Aesthetic Studies*, Vol. I, No. 2, 1988.

Destrée, O.G.: *Les Préraphaélites: Notes sur L'art décoratif et la Peinture en Angleterre*, Dietrich, Brussels, 1894.

Doughty, Oswald: *A Victorian Romantic. Dante Gabriel Rossetti*, Oxford University Press, London, 2nd ed., 1960.

Doughty, Oswald and Wahl, J.R.: *Letters of Dante Gabriel Rossetti*, Vol. I (1835-1860), Clarendon Press, Oxford, 1965.

Doughty, Oswald and Wahl, J.R.: *Letters of Dante Gabriel Rossetti*, Vol. III (1871-1876), Oxford University Press, London, 1967.

Du Maurier, Daphne (Ed.): *The Young George du Maurier. A Selection of his Letters, 1860-67*, Peter Davies, London, 1951.

Dufty, A.R.: *The Story of Cupid and Psyche*, Clover Hill Editions, London, 1974.

Dumas, F.G. (Ed.): *Modern Artists: A Series of Illustrated Biographies*, J.S. Virtue & Co., London, 1883.

Elzea, Rowland: *The Correspondence between Samuel Bancroft, Jr. and Charles Fairfax Murray 1892-1916*, Delaware Art Museum Occasional Paper, No. 2, February, 1980.

Engen, Rodney: *Pre-Raphaelite Prints: The Graphic Art of Millais, Holman Hunt, Rossetti and their Followers*, Lund Humphries, London, 1995.

Fawcett, Jane (Ed.): *Seven Victorian Architects*, Pennsylvania State University Press, University Park, 1977.

Ferguson, George: *Signs and Symbols in Christian Art*, Oxford University Press, New York, 1954.

Fine Art Society Ltd.: *Drawings and Studies by the Late Lord Leighton, P.R.A.*, MacMillan and Co. Ltd., London, 1898.

Fitzgerald, Penelope: *Edward Burne-Jones*, Michael Joseph Ltd., London, 1975.

Fleming, G.H.: *That Ne'er Shall Meet Again. Rossetti, Millais, Hunt*, Michael Joseph, London, 1971.

Fontana, Ernest: "Pre-Raphaelite Suicides", *Journal of Pre-Raphaelite Studies*, New Series 7: Fall 1998.

Forbes-Robertson, Johnston: "The Tribute to a Friend", *The Times*, May 11, 1928.

Ford, Julia Ellsworth: *Simeon Solomon. An Appreciation*, Sherman, New York, 1908.

Fox, Aley: *Art Pictures from the Old Testament*, Society for Promoting Christian Knowledge, London, 1894.

Fredeman, William E.: *Pre-Raphaelitism. A Bibliocritical Study*, Harvard University Press, Cambridge, Mass., 1965.

Fredeman, William E.: "The Letters of Pictor Ignotus: William Bell Scott's Corrrespondence with Alice Boyd, 1859-1884", *Bulletin of the John Rylands University Library of Manchester*, Vol. 58, Nos. 1 and 2, Autumn 1975 and Spring 1976.

Fredeman, William E.: " 'Woodman, Spare That Block': The Published, Unpublished, and Projected Illustrations and Book Designs of Dante Gabriel Rossetti", *Journal of Pre-Raphaelite Studies*, New Series 5: Spring 1996.

Fredeman, William E.: *The Correspndences of Dante Gabriel Rossetti*, Chadwyck-Healey Ltd., Cambridge, Vols. I and II, 2000 in press.

Fyffe, Henry E.: "The Making of a Picture", *Brush and Pencil*, Vol. 10, 1902.

Gere, Charlotte: *Nineteenth-Century Decoration. The Art of the Interior*, Weidenfeld and Nicolson, London, 1989.

Gere, John A.: *Pre-Raphaelite Drawings in the British Museum*, British Museum Press, London, 1994.

Gerrish Nunn, Pamela: "Artist and Model: Joanna Mary Boyce's 'Mulatto Woman' ", *Journal of Pre-Raphaelite Studies*, New Series, Vol. II, Fall 1993.

Gibson, Robin: "Arthur Hughes: Arthurian and Related Subjects of the Early 1860s", *The Burlington Magazine*, Vol. CXII, 1970.

Goff, Barbara Munson: "Dante's La Vita Nuova and Two Pre-Raphaelite Beatrices", *Journal of Pre-Raphaelite Studies*, Vol. IV, No. 2, 1984.

Goldman, Paul: *Victorian Illustrated Books 1850-1870: The Heyday of Wood-Engraving*, British Museum Press, London, 1994.

Goldman, Paul: *Victorian Illustration*, Scolar Press, Aldershot, Hants,1996.

Gordon, Catherine (Ed.): *Evelyn De Morgan Oil Paintings*, De Morgan Foundation, London, 1996.

Gosse, Edmund William: *Lawrence Alma-Tadema, R.A.*, Chapman & Hall, London, 1882.

Gosse, Edmund: *Life of Algernon Charles Swinburne*, Macmillan and Co. Ltd., London, 1917.

Gosse, Edmund and Wise, Thomas J. (Eds.): *The Complete Works of Swinburne* (Bonsuch Edition), Vol. III, Heinemann, London, 1926.

Graves, Algernon: *The Royal Academy of Arts. A Complete Dictionary of Contributors and their Work from its Foundation in 1769 to 1904*, Henry Graves and Co. Ltd, London, 1906.

Hadley, Dennis and Hadley, Joan: "Henry Holiday 1839-1927", *Journal of Stained Glass*, Vol. XIX, No. 1, 1989-90.

Harlow, James: *The Charm of Leighton*, Jack, London, 1913.

Harris, Jack: "The Pre-Raphaelites and the Moxon Tennyson", *Journal of Pre-Raphaelite Studies*, Vol. III, No. 2, 1983.

Harrison, Anthony H. (Ed.): *The Collected Letters of Christina Rossetti*, Volume I: 1843-1873, University Press of Virginia, Charlottesville, 1997.

Harrison, Martin: *Pre-Raphaelite Paintings and Graphics*, Academy Editions, London, 1971.

Harrison, Martin and Waters, Bill: *Burne-Jones*, Barrie and Jenkins, London, 1973.

Harrison, Martin: *Victorian Stained Glass*, Barrie & Jenkins Ltd., London, 1980.

Haweis, Mrs. H.R.: *The Art of Beauty*, Chatto and Windus, London, 1878.

Hawthorne, Julian: *Shapes That Pass*, Houghton Mifflin Co., Boston and New York,1928.

Hickey, A.: "The Pre-Raphaelite Connection with Penkill", *The Review of the Pre-Raphaelite Society*, Vol. 1, No. 2, 1993.

Hickox, M.S.H.: "John Brett and the Rossettis", *Journal of Pre-Raphaelite Studies*, Vol. V, No.2, 1985.

Hickox, Mike: "John Brett's The Stonebreaker", *The Review of the Pre-Raphaelite Society*, Vol. III, No. 1,1995.

Hickox, Mike: "John Brett's Portraits", *The Review of the Pre-Raphaelite Society*, Vol. IV, No. 1, 1996.

Hill, George Birbeck (Ed.): *Letters of Dante Gabriel Rossetti to William Allingham, 1854-1870,* T. Fisher Unwin, London, 1897.

Hobbs, Susan: *Lithographs of James McNeill Whistler*, Smithsonian Institution Traveling Exhibition Service, Washington, D.C., 1982.

Hobson, Anthony: *The Art and Life of J.W. Waterhouse R.A.*, Rizzoli, New York, 1980.

Hobson, Anthony: *J.W. Waterhouse*, Phaidon Christie's, Oxford, 1989.

Holiday, Henry: "Modernism in Art", *The Builder*, March 22, 1890.

Holiday, Henry: *Reminiscences of My Life*, William Heinemann, London, 1914.

Horne, Peter and Lewis, Reina (Eds.): *Outlooks. Lesbian and Gay Sexualities and Visual Cultures*, Routledge, London, 1996.

Houfe, Simon: *The Dictionary of British Book Illustrators and Caricaturists.1800-1914*, Antique Collectors Club, Woodbridge, Suffolk, 1981.

Hudson, Derek: *Munby, Man of Two Worlds. The Life & Times of Arthur J. Munby 1828- 1910*, John Murray, London, 1972.

Hueffer, Ford Madox: *Ford Madox Brown. A Record of His Life and Work*, Longmans, Green, and Co., London, 1896.

Huish, Marcus: *Greek Terracotta Statuettes*, John Murray, London, 1900.

Hunt, William Holman: "The Pre-Raphaelite Brotherhood: A Fight for Art", *Contemporary Review*, Vol. XLIX, 1886.

Hunt, William Holman: Introduction to *Some Poems of Alfred Lord Tennyson*, Freemantle and Co., London, 1901.

Hunt, William Holman: *Pre-Raphaelitism and the Pre-Raphaelite Brotherhood*, MacMillan & Co., London, Vols. I and II, 1905.

Hunt, William Holman: *Pre-Raphaelitism and the Pre-Raphaelite Brotherhood*, Macmillan & Co., London, 2nd ed., Vols. I and II, 1913.

Huxley, Leonard: *The House of Smith Elder*, Printed for Private Circulation, London, 1923.

Ian Hodgkins & Co. Ltd, London: Catalogue 5, 1975.

Ian Hodgkins & Co. Ltd., Slad, Glos.: *A Catalogue of 19th Century Etchings, Wood & Steel Engravings, Original Drawings, Autograph Letters Etc. By British Artists*, Catalogue 53, Autumn/Winter 1990.

Ian Hodgkins & Co. Ltd.,Slad: *A Catalogue of 1860 Illustrated Books*, Catalogue 65, Autumn 1992.

Ionides, Luke: *Memories*, Dog Rose Press, Ludlow, 1996.

Ironside, Robin and Gere, John: *Pre-Raphaelite Painters*, Phaidon, London, 1948.

Kelvin, Norman (Ed.): *The Collected Letters of William Morris*, Princeton University Press, Princeton, Vol. I (1848-80), 1984.

Kestner, Joseph A.: *Mythology and Misogyny. The Social Discourse of Nineteenth Century British Classical- Subject Painting*, University of Wisconsin Press, Madison, 1989.

Kisluk-Grosheide, D.O.: "The Marquand Mansion", *Metropolitan Museum Journal*, No. 29, 1994.

Kolsteren, Steven: "Simeon Solomon and the Romantic Poets", *Journal of Pre-Raphaelite Studies*, Vol. IV, No. 2, 1984.

Konody, P.G.: *The Art of Walter Crane*, George Bell & Sons, London, 1902.

Kooistra, Lorraine Janzen: "The Jael Who Led the Hosts to Victory: Christina Rossetti and Pre-Raphaelite Book-Making", *Journal of Pre-Raphaelite Studies*, New Series 8, Spring 1999.

Lago, Mary (Ed.): *Burne-Jones Talking. His Conversations 1895-1898 Preserved by his Studio Assistant Thomas Rooke*, John Murray, London, 1982.

Lambourne, Lionel: "A Simeon Solomon Sketchbook", *Apollo*, Vol. 85, 1967.

Landow, George P.: *William Holman Hunt and Typological Symbolism*, Yale University Press, New Haven,1979.

Landow, George P.: *Victorian Types, Victorian Shadows. Biblical Typology in Victorian Literature, Art and Thought*, Routledge & Kegan Paul, Boston, 1980.

Landow, George P.: " 'Christ the Pilot': A Panel from William Holman Hunt's Unfinished Triptych", *Journal of Pre-Raphaelite Studies*, Vol. I, No. 2, 1980.

Lang, Mrs A.: "Sir Frederick [sic] Leighton, Bart. His Life and Work", *The Art Annual (Art Journal Special Supplement)*, 1884.

Lang, Cecil (Ed.): *The Swinburne Letters*, Vol. II, Yale University Press, New Haven, 1959.

Larkin, David (Ed.): *The English Dreamers. A Collection of Pre-Raphaelite Paintings*, Peacock Press / Bantam Books, Toronto, 1975.

Layard, George S.: *Tennyson and His Pre-Raphaelite Illustrators: A Book about a Book*, E. Stock, London, 1894.

Leicester Museums and Art Gallery: *Collection of Paintings*, Department of Art, 1958.

Lewis, Roger L. and Lasner, Mark Samuels (Eds.): *Poems and Drawings of Elizabeth Siddal,* Wombat Press, Wolfville, Nova Scotia, 1978.

Lochnan, Katharine A.: *The Etchings of James McNeill Whistler*, Yale University Press, New Haven, 1984.

Lochnan, K.A.; Schoenherr, D.E.; Silver, C. (Eds.): *The Earthly Paradise: Arts and Crafts by William Morris and his Circle from Canadian Collections*, Key Porter Ltd., Toronto, 1993.

Loshak, David: "G.F. Watts and Ellen Terry", *Burlington Magazine*, Vol. 105, November, 1963.

Maas, Jeremy: *Gambart Prince of the Victorian Art World*, Barrie & Jenkins, London, 1975.

Maas, Jeremy: *The Victorian Art World in Photographs*, Universe Books, New York, 1984.

MacDonald, Margaret F.: *James McNeill Whistler. Drawings, Pastels and Watercolours. A Catalogue Raisonné*, Yale University Press, New Haven and London, 1995.

Mackail, J. W.: *The Life of William Morris*, Longmans, Green, and Co., London, Vols. I and II, 1899.

Macleod, Dianne Sachko: *Art and the Victorian Middle Class: Money and the Making of Cultural Identity*, Cambridge University Press, Cambridge, 1996.

MacMillan, Hugh: *The Life-Work of George Frederick*[sic]*Watts RA*, J.M. Dent & Co., London, 1903.

Magazine of Art:: "A Note on the Cartoons of Ford Madox Brown", 1896.

Mancoff, Debra N.: *Burne-Jones*, Pomegranate, San Francisco, 1998.

Marillier, H.C.: *Dante Gabriel Rossetti, An Illustrated Memorial of His Art and Life*, George Bell & Sons, London, 1899.

Marillier, H.C.: *Dante Gabriel Rossetti An Illustrated Memorial of His Art and Life*, 3rd ed., George Bell & Sons, London, 1904a.

Marillier, H.C.: *The Liverpool School of Painters: An Account of the Liverpool Academy from 1810 to 1867, with Memoirs of the Principal Artists*, John Murray, London, 1904b.

Marsh, Jan: *Pre-Raphaelite Women: Images of Femininity and Pre-Raphaelite Art*, Weidenfeld and Nicolson, London, 1987.

Marsh, Jan: " 'Hoping you will not think me too fastidious': Pre-Raphaelite Artists and the Moxon Tennyson", *Journal of Pre-Raphaelite and Aesthetic Studies*, Vol. II, No.1, 1989.

Marsh, Jan: *Dante Gabriel Rossetti Painter and Poet*, Weidenfeld and Nicolson, London, 1999.

Marsh, Jan and Gerrish Nunn, Pamela: *Woman Artists and the Pre-Raphaelite Movement*, Virago Press Ltd, London, 1991.

Merrill, Linda: *The Peacock Room. A Cultural Biography*, Yale University Press, New Haven, 1998.

Millais, Geoffroy: *Sir John Everett Millais*, Academy Editions, London, 1979.

Millais, John Guille: *The Life and Letters of Sir John Everett Millais*, Frederick A Stokes Co., New York, Vols. I and II, 1899.

Minto, W. (Ed.): *Autobiographical Notes of the Life of William Bell Scott*, Harper & Brothers, New York, Vols. I and II, 1892.

Morley, Catherine: "Swinburne as an art critic", *Journal of Pre-Raphaelite Studies*, Vol.1, No. 2, 1981.

Morely, Catherine W.: "Swinburne's 'Notes on the Royal Academy Exhibition, 1868'," *Journal of Pre-Raphaelite Studies*, Vol. ll, No. 2, 1982.

Moss, Rachel: *Edward Payne 1906-1991*, London, 1995.

Muther, Richard: *The History of Modern Painting*, Henry and Co., London, 1895.

Newall, Christopher: *Victorian Watercolours*, Phaidon Press, London, 1987.

Newall, Christopher: *The Art of Lord Leighton*, Phaidon, Oxford, 1990.

Newman, Teresa and Watkinson, Ray: *Ford Madox Brown and the Pre-Raphaelite Circle*, Chatto & Windus, London, 1991.

Norton, Sara and Howe, M.A. De Wolfe (Eds.): *Letters of Charles Eliot Norton with Biographical Comments*, Houghton, Mifflin, New York, Vols. I and II, 1913.

Oberhausen, Judy: "Evelyn Pickering De Morgan and Spiritualism: An Interpretative Link", *Journal of Pre-Raphaelite Studies*, New Series Vol. III, No. 1, Spring 1994.

Ormand, Leonée: "Tennyson and Thomas Woolner", *The Tennyson Society*, Tennyson Research Centre, Lincoln, 1981.

Ormond, Leonée and Ormond, Richard: *Lord Leighton*, Yale University Press, London, 1975.

Osborne, June: *Stained Glass in England*, Alan Sutton Publishing Ltd., Stroud, Glos., 1997.

Packer, Lona Mosk (Ed.): *The Rossetti - Macmillan Letters*, University of California Press, Los Angeles, 1963.

Pall Mall Magazine: "The Making of a Picture. A Set of Original Studies by Sir E.J. Poynter, President of the Royal Academy, for his New Picture 'Storm Nymphs' ", Vol. XXVII, May-August, 1902.

Parris, Leslie (Ed.): *Pre-Raphaelite Papers*, Tate Gallery Publications, London, 1984.

Paton, Noel J.: *Compositions from Shakespeare's Tempest. Fifteen Engravings in Outline*, William P. Nimmo, London, 1877.

Pearsall, Ronald: *Tell Me, Pretty Maiden. The Victorian and Edwardian Nude*, Webb & Bower Ltd., Exeter, 1981.

Peattie, Roger (Ed.): *Selected Letters of William Michael Rossetti*, Pennsylvania State University, University Park, 1990.

Pennell, Elizabeth and Pennell, Joseph: *The Life of James McNeill Whistler*, William Heinemann, London, Vols. I and II, 1908.

Penrose, George: *Catalogue of Paintings, Drawings and Miniatures in the Alfred de Pass Collection*, the catalogue of the works presented by de Pass to the Royal Institution of Cornwall between 1914 and 1935, Cornish Riviera Press Ltd., Truro, 1936.

Peppin, Brigid: *Fantasy: The Golden Age of Fantastic Illustration*, New American Library, New York, 1976.

Poulson, Christine: "A Checklist of Pre-Raphaelite Illustrations of Shakespeare's Plays", *Burlington Magazine*, Vol.122, April 1980.

Prettejohn, Elizabeth: *Rossetti and his Circle*, Stewart, Tabori & Chang, New York, 1997.

Prettejohn, Elizabeth (Ed.): *After the Pre-Raphaelites. Art and Aestheticism in Victorian England*, Manchester University Press, Manchester, 1999.

Reid, Forrest: *Illustrators of the Sixties*, Faber & Gwyer Ltd., London, 1928.

Reynolds, Simon: *The Vision of Simeon Solomon*, Catalpa Press Ltd., Stroud, Glos.,1985.

Reynolds, Simon: *William Blake Richmond. An Artist's Life 1842-1921*, Michael Russell Ltd., Norwich, 1995.

Rhys, Ernest: *Sir Frederic Leighton, Bart. P.R.A., An Illustrated Chronicle with a prefatory essay by F.G. Stephens*, George Bell & Sons, London, 1896.

Rhys, Ernest: *Frederic Lord Leighton. An Illustrated Record of His Life and Work*, George Bell & Sons, London, 3rd ed., 1900.

Richards, Dennis and Cruickshank, J.E.: *The Modern Age 1760-1955*, Longmans Canada, Toronto, 1962.

Ridgway, Christopher: " 'A Privileged Insider': George Howard and Burne-Jones", lecture delivered at the Burne-Jones Centenary Day, sponsored by the Victorian Society and held at the Paul Mellon Centre for Studies in British Art, London, October 31, 1998.

Roberts, Leonard: *Arthur Hughes His Life & Works. A Catalogue Raisonné*, Antique Collectors' Club, Woodbridge, Suffolk, 1997.

Robertson, W. Graham: *Time Was*, Hamish Hamilton, London, 1931.

Rose, Andrea: *Pre-Raphaelite Portraits*, The Oxford Illustrated Press, Sparkford, Yeovil, Somerset, 1981.

Rossetti, Dante Gabriel: *Poems and Translations by Dante Gabriel Rossetti including Dante's "Vita Nuova" and "The Early Italian Poets"*, J.M. Dent and Sons Ltd., London, 1912.

Rossetti, William Michael: *Dante Gabriel Rossetti: His Family Letters, with a Memoir*, Ellis and Elvey, London, Vols. 1 and II, 1895.

Rossetti, William Michael: *Ruskin: Rossetti: Pre-Raphaelitism Papers, 1854 to 1862*, George Allen, London, 1899.

Rossetti, William Michael: *Rossetti Papers. 1862-70*, Sands, London, 1903.

Rossetti, William Michael: *Some Reminiscences of William Michael Rossetti*, Brown Langham, London, Vols. 1 and II, 1906.

Rossetti, William Michael (Ed.): *The Family Letters of Christina Georgina Rossetti*, Brown Langham, London, 1908.

Rossetti, William Michael (Ed.): *The Works of Dante Gabriel Rossetti*, F.S. Ellis, London, 1911.

Roth, Cecil (Ed.): *Jewish Art: An Illustrated History*, Massadah - P.E.C. Press Ltd., Tel Aviv, 1961.

Sandberg, John: "Whistler Studies", *Art Bulletin*, Vol. 50, 1968.

Sewter, A. Charles: *The Stained Glass of William Morris and his Circle*, Yale University Press, New Haven, Vol. I, 1974, Vol. II, 1975.

Shaw, George Bernard: "J.M. Strudwick", *Art Journal*, Vol. 53, April 1891.

Smith, Alison: *The Victorian Nude. Sexuality, Morality and Art*, Manchester University Press, Manchester, 1996.

Smith, Elise Lawton: "Myth as Spiritual Allegory in the Art of Evelyn De Morgan", *Journal of Pre-Raphaelite Studies*, New Series 7: Fall 1998.

Smith, Kathryn A.: "The Post-Raphaelite Sources of Pre-Raphaelite Painting," *Journal of Pre-Raphaelite Studies*, Vol. V, No. 2, 1985.

Spencer, Robin: *Whistler, A Retrospective*, Hugh Lauter Levin Associates Inc., New York, 1989.

Spielmann, Isidore: *Souvenir of the Fine Art Section, Franco-British Exhibition*, London,1908.

Spielmann, M.H.: "The Late Lord Leighton, P.R.A., D.C.L., L.L.D.", *The Magazine of Art*, 1896.

Spivey, Nigel: *Understanding Greek Sculpture Ancient Meanings, Modern Readings*, Thames & Hudson, London, 1996.

Stein, Richard: "The Pre-Raphaelite Tennyson", *Victorian Studies*, Vol. 24, 1981.

Stephens, Frederic George: *The Athenaeum*, No. 1843, February 21, 1863.

Stephens, Frederic George: "The Review of the Royal Academy", *The Athenaeum,* 1896.

Stirling, A.M.W.: *A Painter of Dreams and Other Biographical Studies*, John Lane The Bodley Head, London, 1916.

Stirling, A.M.W.: *William De Morgan and His Wife,* Thornton Butterworth Ltd., London, 1922.

Stirling, A.M.W.: *The Richmond Papers*, William Heinemann, London, 1926.

Strong, Roy: *Recreating the Past. British History and the Victorian Painter*, Thames and Hudson, The Pierpont Morgan Library, New York, 1978.

Studio : "Some Drawings by J.W. Waterhouse, R.A.", Vol. 44, No. 108, September 1908.

Surtees, Virginia: *Dante Gabriel Rossetti 1828 - 1882. The Paintings and Drawings. A Catalogue Raisonné*, Clarendon Press, Oxford, Vols. I and II, 1971.

Surtees, Virginia: *Rossetti's Portraits of Elizabeth Siddal*, Scolar Press, Aldershot, Hants, 1991.

Surtees, Virginia (Ed.): *Reflections of a Friendship. John Ruskin's Letters to Pauline Trevelyan 1848-1866*, George Allen & Unwin Ltd., London, 1979.

Surtees, Virginia (Ed.): *The Diaries of George Price Boyce*, Real World, Norwich, Norfolk, 1980.

Surtees, Virginia (Ed.): *The Diary of Ford Madox Brown*, Yale University Press, New Haven, 1981.

Swanson, Vern G.: *Alma-Tadema. The Painter of the Victorian Vision of the Ancient World*, Charles Scribner's Sons, New York, 1977.

Swanson, Vern G.: *The Biography and Catalogue Raisonné of the Paintings of Sir Lawrence Alma-Tadema*, Garton and Co., London, 1991.

Swinburne, Algernon: "Notes on his 'Vision of Love' and Other Studies", *Dark Blue*, July 1871.

Taylor, Hillary: *James McNeill Whistler*, Studio Vista, London, 1978.

Terry, Ellen: *The Story of My Life*, Hutchinson and Co., London, 1908.

Thirkell, Angela: *Three Houses*, Oxford Univerity Press, London, 1931.

Treuherz, Julian: *Pre-Raphaelite Paintings from the Manchester City Art Gallery*, Lund Humphries, London, 1980.

Trevelyan, Raleigh: *A Pre-Raphaelite Circle*, Chatto & Windus, London, 1978.

Troxell, Janet Camp: *Three Rossettis: Unpublished Letters to and from Dante Gabriel, Christina, William*, Harvard University Press, Cambridge, Mass., 1937.

Valentine, Helen (Ed.): *Art in the Age of Queen Victoria. Treasures from the Royal Academy of Arts Permanent Collection*, Yale University Press, New Haven and London, 1999.

Valentine, L. (Ed.): *The Nobility of Life, its Graces and Virtues*, Frederick Warne and Co. Ltd, London, 1869.

Vallance, Aymer: *William Morris His Art His Writings and His Public Life*, George Bell and Sons, London, 1897.

Vallance, Aymer: "The Decorative Art of Sir Edward Burne-Jones", *The Art Journal*, *The Easter Art Annual*, H. Virtue and Co. Ltd, London, 1900.

Vaughan, William: *German Romanticism and English Art*, Yale University Press, New Haven, 1979.

Walford, Wilson & Co., London: *A Catalogue of Books of Quality; and Manuscripts, A.L.S. and Drawings*, 1936, Catalogue 435b.

Ward, James: "Lord Leighton, P.R.A.", *Magazine of Art*, 1896.

Warr, George C.: *The Echoes of Hellas: The Tale of Troy & the Story of Orestes from Homer & Aeschylus*, translated with an introductrion & sonnets by Prof. George C. Warr M. A. presented in 82 designs by Walter Crane, Marcus Ward & Co. Ltd., London, 1887.

Watkinson, Raymond: *Pre-Raphaelite Art and Design*, Studio Vista Ltd., London, 1970.

Watts, Mary Seton: *George Frederic Watts: The Annals of An Artist's Life*, Hodder & Stoughton, New York, Vols I, II, and III, 1912.

Watts, Mary Seton: "Manuscript Catalogue of the Paintings of George Frederic Watts", not dated, Watts Gallery, Compton.

Waugh, Evelyn: *Rossetti, His Life and Works*, Duckworth's Georgian Library, London, 1931.

Wedmore, Frederick: "Some Tendencies in Recent Painting", *Temple Bar*, 53, July 1878.

Weintraub, Stanley: *Four Rossettis A Victorian Biography*, Weybright and Talley, New York, 1977.

Welby, T. Earle: *The Victorian Romantics 1850-70*, Gerald Howe Ltd., London, 1929.

Whalley, Joyce Irene and Chester, Teresa Rose: *A History of Children's Book Illustrations*, John Murray Ltd., London, 1988.

Whistler, James McNeill: *The Gentle Art of Making Enemies*, William Heinemann, London, 2nd ed, 1892.

White, Gleeson: *English Illustration. 'The Sixties': 1857-70*, Constable, London, 1897.

Wildman, Stephen: *Visions of Love and Life, Pre-Raphaelite Art from the Birmingham Collection, England*, Art Services International, Alexandria, Virginia, 1995.

Wildman, Stephen and Christian, John: *Edward Burne-Jones. Victorian Artist - Dreamer*, Metropolitan Museum of Art, New York, 1998.

William Morris Society of Canada Newsletter: "George Frederick Bodley and William Morris", Summer 1992.

Wilton, Andrew and Upstone, Robert (Eds.): *The Age of Rossetti, Burne-Jones and Watts. Symbolism in Britain 1860-1910*, Tate Gallery Publishing, London, 1997.

Wise, Thomas J. (Ed.): *The Faerie Queen*, by Edmund Spencer, illustrated by Walter Crane, George Allen, London, 1895.

Wood, Christopher: *Olympian Dreamers. Victorian Classical Painters 1860-1914*, Constable, London, 1983.

Wood, Christopher: *The Pre-Raphaelites*, Crescent Books, New York, 1994.

Wood, Christopher: *Burne-Jones*, Weidenfeld & Nicolson, London, 1998.

Wood, Esther: *Dante Gabriel Rossetti and the Pre-Raphaelite Movement*, Sampson, Low, Marston, London, 1894.

Wood, Esther: "A Consideration of the Art of Frederick Sandys", *The Artist*, Special Winter No., Vol. XVIII, London, November 1896.

Wood, T. Martin: *Drawings of Sir Edward Burne-Jones*, George Newnes Ltd., London, 1907.

Woolner, Amy: *Thomas Woolner, R.A. Sculptor and Poet. His Life in Letters*, Chapman and Hall Ltd., London, 1917.

Yamaguchi, Eriko: "The Pre-Raphaelites in Japan: A Checklist of Exhibition Catalogues and Special Issues of Periodicals", *Journal of Pre-Raphaelite Studies*, New Series III:2, 1994.

Young, Andrew McLaren; MacDonald, Margaret; Spencer, Robin; Miles, Hamish: *The Paintings of James McNeill Whistler*, Yale University Press, New Haven and London, 1980.

The following works from the Lanigan collection are in the exhibition, but are not analysed in the catalogue:

101 Edward Burne-Jones
"Summer Snow," 1863
Wood-engraving on off-white paper 6 × 4 ½ in. (15 × 11.5 cm) - image size
Provenance: Abbott and Holder, London, purchased August 1996
This is a proof wood-engraving by the Dalziel Brothers, published in Good Words, 1863, p. 380.

102 Edward Clifford
Portrait of a Young Woman, c. mid-1880s
Black chalk and graphite on off-white paper 14¹³⁄₁₆ × 10⅝ in. (37.6 × 27 cm)
Provenance: Anonymous sale, Christie's, London, November 6, 1995, lot 67, bought in; Christie's, South Kensington, January 27, 1999, bought Abbott and Holder, London; purchased May 17, 1999

103 Richard (Dicky) Doyle
An Angel Guarding Two Sleeping Children (possibly a study for "The Guardian Angel"), undated
Pen and ink and graphite on off-white paper 7½ × 4⅝ in. (19 × 11.8 cm)
Provenance: Anonymous sale, Philips, London, January 1995, bought Abbott and Holder, London: purchased February 20, 1996

104 William Maw Egley
Compositional Study for "The Martyr's Last Sleep," 1869
Graphite on off-white wove paper 6⁹⁄₁₆ × 8¹¹⁄₁₆ in. (16.7 × 22.1 cm)
Provenance: Anonymous sale, Christie's, London, June 4, 1982, part of lot 68, bought in; purchased with a group of works by Egley by Abbott and Holder, London, in 1997; purchased January 3, 1998

105 Henry Holiday
The Magdalene Anointing Christ's Feet, c. early 1860s
Graphite on off-white wove paper 10 × 14 in. (25.3 × 35.4 cm)
Provenance: Henry Holiday's studio contents; Walker's Galleries, London, 1930; Moss Galleries, London; purchased June 21, 1988
Exhibited: Art Gallery of Ontario: 1993, cat. no. A:12; Kenderdine Gallery: 1995, cat. no. 20
This is a preliminary study for a stained glass window of this subject.

106 George Howard
A Study of Two Italian Peasant Women, c. 1870
Graphite on off-white wove paper 9½ × 7¼ in. (24 × 18.5 cm) - image size
Provenance: By descent to a member of the family; bought with a group of Howard drawings by Abbott and Holder, London, in the mid 1990s; purchased November, 1999

107 **Sidney Meteyard (1868-1947)**
The Adoration of the Magi, c. 1900
Black ink and grey wash, heightened with white, on off-white wove paper
9¹³⁄₁₆ × 6⁵⁄₁₆ in. (24.9 × 16 cm)
Provenance: The artist's estate; Southlands Gallery, Wolverhampton by 1974; probably their sale Christie's, London October 15, 1974, lot 21, bought Piccadilly Gallery, London; purchased November 10, 1999
Exhibited: Southland Gallery: 1974, cat. no. 14; Piccadilly Gallery: 1976, cat. no. 47
This is a design for the central panel of a Limoges enamel panel triptych.

108 **Sir John Everett Millais**
Compositional sketch for "Apple Blossoms" (Spring), c. 1857
Verso - study of a woman with outstretched arms (possibly a preliminary study for "The Talking Oak" for the Moxon Tennyson)
Graphite on off-white wove paper 5¼ × 7½ in. (13.5 × 19 cm) - sight
Provenance: By descent to E.A Millais; his sale Christie's, London, November 14, 1967, part of lot 138, bought Agnew's, London; sold to Stone Gallery, Newcastle, by 1969; likely John C. Constable; Abbott and Holder, London by 1999; purchased January 26, 2000
Exhibited: Agnew's: 1968, cat. no. 72; Stone Gallery: 1969, cat. no. 21

109 **Louis Fairfax Muckley (1862-1926)**
An illustration for Edmund Spencer's "Fairie Queen," c. 1897
Black ink on white paper, with corrections in white, surrounded by a decorative border; signed with initials LFM, lower right 10¹⁵⁄₁₆ × 81³⁄₁₆ in. (27.8 × 22.3 cm)
Provenance: J.M. Dent & Sons; the sale of their archive, Sotheby's, London, June 19, 1987, lot 7811; anonymous sale, Sotheby's, London, October 30, 1997, lot 70, bought Abbott and Holder, London; purchased August 12, 1998
This work illustrates the lines 'And ever when she nigh approcht, the Dove / Would flit a little forward, and then stay.'

110 **Frederick Richard Pickersgill (1820-1900)**
Study for "The Pestilence of Thebes," c. 1840s
Graphite on off-white paper 11½ × 17¼ in. (29.2 × 43.8 cm)
Provenance: Bought with a group of Pickersgill drawings from an estate by Abbott and Holder, London; purchased March 13, 1998

111 **William Lindsay Windus**
Study of a Draped Female Figure for "A Lady bound, her Lover slain," 1864
Graphite on off-white paper; inscribed Dec 16, 1864, lower left 8 × 3½ in. (20.3 × 8.9 cm)
Provenance: Andrew Bain, Glentower, Hunter's Quay; George Davidson Ltd., Glasgow; anonymous sale, Lawrence, Grewkerne, Somerset, bought Martyn Gregory, London; sold to Rachel Moss, Moss Galleries, London in November 1999; purchased December, 1999.